European Painting and Sculpture, ca. 1770–1937

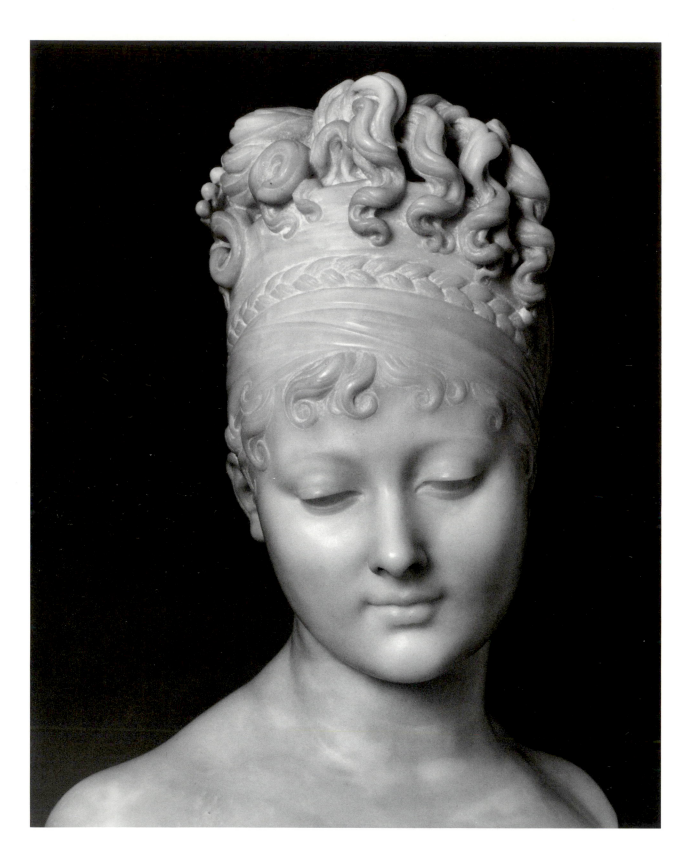

European Painting and Sculpture, ca. 1770–1937

IN THE MUSEUM OF ART · RHODE ISLAND SCHOOL OF DESIGN

Edited by DANIEL ROSENFELD

Providence, Rhode Island 1991

This project was made possible by generous grants from the National Endowment for the Arts, a Federal agency, and The Prospect Hill Foundation.

Co-edited by Ann H. Slimmon and Judith A. Singsen

Table of Contents

Contributing Authors

LORENZ EITNER

FLORENCE D. FRIEDMAN

SUSAN B. GLASHEEN

SUSAN ANDERSON HAY

CONSTANCE CAIN HUNGERFORD

JOHN M. HUNISAK

WILLIAM P. MCNAUGHT

THOMAS S. MICHIE

CHRISTOPHER P. MONKHOUSE

MAUREEN C. O'BRIEN

FRANKLIN W. ROBINSON

MARGARET ROBINSON

DANIEL ROSENFELD

ANN H. SLIMMON

DAVID E. STARK

LORA S. URBANELLI

Foreword

THIS CATALOGUE DOCUMENTS the Museum's collection of European painting and sculpture from the late eighteenth century up to the years just preceding the Second World War. At its core is the art of the nineteenth century, yet in order to present a more comprehensive view of our holdings in the modern period, its temporal scope was expanded in both directions. The Museum has an important concentration of works from the eighteenth century, later examples of which are not easy to separate from works produced after 1799. Similarly, the Museum's collection of early twentieth-century European painting and sculpture flows naturally from the nineteenth century. It seemed appropriate, therefore, given the size and range of our collection, to include works from the last three decades of the eighteenth century, falling largely under the influence of the Enlightenment, as well as those from the twentieth century that reflect the continuity of European modernism and, in particular, the influence of Cubism between the wars.

It was our intention to document every work forming a part of the collection of European painting and sculpture between ca. 1770 and 1937, to which end we have organized this catalogue into two related parts. The first part consists of eighty-five entries, arranged chronologically by date, which discuss the paintings and sculpture considered to be of greatest importance to the collection. (When more than one work by an individual artist is discussed, these have been arranged together in sequence by the date of the first work.) The second part of the catalogue consists of a critical checklist of the entire collection, in which special emphasis has been placed on problems of attribution, and which therefore has been annotated by this author, except as noted, to include available documentary information. The checklist has been designed to serve as a comprehensive index of the collection as a whole. It is divided into categories of painting and sculpture, each of which is organized alphabetically by artist's name. It includes a photograph of every work not already reproduced in the first part of the catalogue and is cross-referenced to the works for which entries have been written.

Research on this project began in 1988 with a generous grant from the National Endowment for the Arts, permitting this author to work in the following year at the Musée du Louvre, the Musée d'Orsay, the Musée Rodin, and the Bibliothèque Nationale in Paris, as well as at the National Gallery and the Courtauld Institute of Art in London. A subsequent grant from the National Endowment for the Arts, and another from the Prospect Hill Foundation, and a bequest from the Estate of Harold E. Hirsch have subsidized the publication of this catalogue; we are deeply grateful to them for making this project possible.

Many individuals have collaborated in the production of this catalogue. I would especially like to thank the contributing authors from other institutions, whose scholarship has so greatly enhanced the quality of this publication: Professor Lorenz Eitner, Stanford University; Professor Constance Cain Hungerford, Swarthmore College; Professor John M. Hunisak, Middlebury College; William P. McNaught, the American Museum in Britain; and Mrs. Margaret Robinson, Providence College. A great number of the entries have been written by members of the Museum's staff, who have embraced this project with an *esprit de corps* that has made its production especially rewarding. Dr. David E. Stark, Curator of Education at the Museum, has made a particularly important contribution, and I am deeply grateful for his willingness to serve as a principal author. Christopher P. Monkhouse and Thomas S. Michie, respectively Curator and Associate Curator of Decorative Arts, have also contributed an important number of entries, and have been helpful as well in my research on the collection's history. Their distinguished catalogue of the Museum's Pendleton Collection provided a model and high standard for this publication. I am equally grateful to Dr. Florence D. Friedman, Susan B. Glasheen, Susan Anderson Hay, Maureen C. O'Brien, Ann H. Slimmon, and Lora S. Urbanelli, also of the Museum's curatorial staff, for their scholarly contributions. I would also like to express my gratitude to Franklin W. Robinson, Director of the Museum, who has enthusiastically supported this project from its beginning.

The editorial task of pulling together the materials for this catalogue, coordinating the work of multiple authors, reconciling matters of fact and consistency, and overseeing the flow of the manuscript through the complicated process of revision and production was undertaken with dedication and skill by the co-editors: Judith A. Singsen, the Museum's Coordinator of Publications; and Ann H. Slimmon, Assistant Curator of Painting and Sculpture, who also played a

major role in compiling the checklist. I am indebted to them for the critical role they have taken in the realization of this project.

Many other members of the Museum's staff have been instrumental to the realization of this catalogue. Kathleen Bayard, formerly Assistant Director, played a major role in procuring funding for this project, and was a valued adviser in its administration. Jean Waterman, Manager of Museum Budgets, contributed generously of her time and talent to this project's financial administration. Robert G. Workman, formerly Assistant Curator of Painting and Sculpture, played an important early role in the preparation of grant applications and in the initial organization of this project. Melody Ennis, Coordinator of Slides and Photographs, administered the photography of the collection; the photographs themselves were taken with sensitivity and skill by Cathy M. Carver, Robert O. Thornton, and Michael Jorge. Louann Skorupa, the Museum's Registrar; Carole DiSandro, Director of Museum Art Classes; and Pamela Parmal, Assistant Curator of Costume and Textiles, also provided valued assistance, as have Cristina Carlotti, Linda Monteiro, Maura Reilly, Liisa Roberts, and Carol Yen, interns in the Department of Painting and Sculpture. I would particularly like to thank Debra Pelletier, Curatorial Secretary, who performed with distinction the task of preparing this manuscript for publication.

Important contributions have also been made by a number of people not a part of the Museum staff. B. Dawn Dunley and Elaine Gustafson, graduate students at Brown University, made substantial contributions as curatorial assistants throughout the early stages of organization and research. This project has also benefited from the extensive bibliographical research undertaken by Sarah Phillips, formerly of the Harvard University Libraries. Carol Terry, Director of Library Services, and Laurie Whitehill, Reference Librarian of the Rhode Island School of Design, were unfailingly helpful with our numerous research requests. Valued assistance on technical matters was provided by Thomas A. Branchick, Chief Conservator, and Sandra Webber, Associate Conservator, Williamstown Regional Art Conservation Laboratory. The preparation of the manuscript for typesetting was undertaken by William Rae with the collaboration of Lora Urbanelli. We are also grateful to Gilbert Associates for the handsome design of this catalogue.

The authors would like to acknowledge, finally, the contributions of the numerous professionals in the United States and abroad who have aided us in our research: Kirk Adair, Metropolitan Museum of Art, New York; Nicole Barbier, Musée Rodin, Paris; Barkóczi István, Szépművészeti Múzeum, Budapest; Alain Beausire, Musée Rodin, Paris; Susan Benforado, Museum of Fine Arts, Museum of New Mexico, Santa Fe; Glenn F. Benge, Art History Department, Temple University, Philadelphia; Albert Boime, Art History Department, University of California, Los Angeles; Philippe Bordes, Musée de la Revolution Française, Vizille; David Brenneman, Art History Department, Brown University,

Providence; Mungo Campbell, National Galleries of Scotland, Edinburgh; Roger Cardon, Antwerp; Susan P. Casteras, Yale Center for British Art, New Haven; Denis Coekelberghs, Association du Patrimoine Artistique, Brussels; William A. Coles, Boston; Micheline Colin, Musées Royaux des Beaux-Arts, Brussels; Terri Edelstein, University of Chicago; Madeleine Fidell-Beaufort, Paris; Richard S. Field, Yale University Art Gallery, New Haven; Sir Lawrence Gowing, London; Bonnie L. Grad, Department of Art, Clark University, Worcester; Philippe Grunchec, Ecole des Beaux-Arts, Paris; Robert Herbert, Art History Department, Mt. Holyoke College, Northampton; Werner Hofmann, Hamburger Kunsthalle, Hamburg; Ay-Whang Hsia, Wildenstein & Co., New York; Eumie Imm, Library, Museum of Modern Art, New York; Robert Kashey, Shepherd Gallery, New York; Richard Kerremans, Association du Patrimoine Artistique, Brussels; John Leighton, National Gallery, London; Jacques van Lennep, Musées Royaux des Beaux-Arts and Académie Royale des Beaux-Arts, Brussels; Sura Levine, Hampshire College, Amherst; Nancy Little, New York; Jackie McComish, National Gallery, London; Mrs. Stephanie Maison, Hazlitt, Gooden & Fox, London; Michele Majer, Metropolitan Museum of Art, New York; Jerry M. Mallick, National Gallery of Art, Washington, D. C.; Jean-Patrice Marandel, Detroit Institute of Arts; Ronald Marshall, The Stone Gallery, Burford, Oxfordshire; Ruth Meyer, Taft Museum, Cincinnati; Sir Oliver Millar, London; Rebecca Monteyene, Museum voor Schone Kunsten, Ghent; Kathryn McCauley Morton, Paris; Betty Muirden, Yale Center for British Art, New Haven; David Ogawa, Brown University, Providence; Michael Pantazzi, National Gallery of Canada, Ottawa; Guido Perocco, Venice; Theodore Reff, Department of Art, Columbia University, New York; John Rewald, New York; Susan Roeper, Sterling and Francine Clark Art Institute, Williamstown; Anne Roquebert, Musée d'Orsay, Paris; Johanna Ruyts-Van Rillaer, Katholieke Universiteit, Louvain; Agnès Scherer, Musée du Louvre, Paris; Jeremy Strick, National Gallery of Art, Washington, D. C.; John Sunderland, Witt Library, Courtauld Institute of Art, London; Mme Thevenin-Lemmen, Toulon; Philippe Thurneyssen, Vermont; Sibylle Valcke, Association du Patrimoine Artistique, Brussels; John Wetenhall, Birmingham Museum of Art, Birmingham (Alabama); Wheelock Whitney, New York; Véronique Wiesinger, Musée Nationale d'Art Moderne, Paris; Alan Wintermute, Colnaghi, New York; Dr. B. Woelderink, House of Orange-Nassau Historic Collections Trust, The Hague.

Not least of all, I would like to thank my wife, Harriet Magen, who has contributed to this project over its duration in so many substantial ways. D. R.

A History of the Collection

NINETEENTH-CENTURY EUROPEAN PAINTING and sculpture came late and piecemeal to the Museum's collections, neither the product of a single, cohesive bequest such as Charles Pendleton's 1904 gift of his collection of early American furniture, nor the result of a singleminded process that built the Museum's core collection of American painting in its earliest years.[1] At the end of the First World War, the "collection" consisted of little more than a dozen minor paintings from this period; today it numbers more than 313 objects from Europe in the period falling roughly between the Enlightenment and the outbreak of the Second World War, of which more than a few have contributed to the Museum's international renown. The collection today forms one prominent strand among many in the purposeful growth of the Museum's holdings, a process that was especially influenced by Mrs. Gustav Radeke (née Eliza Metcalf, 1855–1931) and her niece, Mrs. Murray S. Danforth (née Helen Metcalf, 1887–1984), who served successively as Presidents of the Board from 1913 to 1965. In this enterprise, they were assisted by L. Earle Rowe, Director of the School and the Museum from 1912 until his death in 1937, who oversaw the transformation of a small yet vital college museum into an institution of world distinction.

The Museum, like the works of art that are the focus of this catalogue, is a creation of the nineteenth century. Its origins are tied to the incorporation of the School of Design in 1877 with $1,675 in surplus funds from the Rhode Island Ladies' Centennial Commission, and the enthusiasm of Helen Adelia Rowe Metcalf (1830–1895), the School's founder and first chairman of its Executive Committee. Mrs. Metcalf was the wife of Jesse Metcalf (1827–1899), founder of the Wanskuk Mills, owner of the *Providence Journal,* and the School's first major benefactor. Mr. Metcalf built the first School and Museum building on Waterman Street in 1893 (called the Waterman Building, which still stands at 11 Waterman Street), and in 1897 – two years after Mrs. Metcalf's death and two years before his own – he built as a memorial to his wife the three exhibition galleries which form the earliest part of the present Museum's facilities.

The School was the practical result of a need to educate skilled draftsmen, designers, and engineers in an industrial economy that lacked the artistic patrimony of its European competitors.[2] This new industrial economy had the benefit neither of an academy nor the ateliers that had existed in

Europe for centuries, serving as a link between the fine and the applied arts. In creating the School of Design, Mrs. Metcalf had in mind something more than a trade school. The School was fashioned rather like an academy on the model of nineteenth-century institutions in France and England, but adapted to the needs of modern industry. The fine arts were at the heart of this enterprise.[3] The School was chartered to educate artists as well as designers and to advance the cause of public art education "by the exhibition of works of art," which it achieved at first by loan, and gradually by acquisition. The growth of the Museum within the institution was predicated on the link that was understood to connect the applied and the fine arts.[4]

With this in mind, the School began collecting objects of artistic interest from its very beginning, which became available to the public at large. Early acquisitions were eclectic and didactic, consisting predominantly of plaster casts, reproductions (either in engravings, autotypes, or photographs), or – of greatest lasting interest to the present collections – cultural artifacts chosen as models of design.[5] The entire first floor of the Waterman Building, constructed in 1893, was designed for the exhibition of these collections, with one room devoted to autotypes reproducing paintings from the history of art, another to the early collection of original objects, and a third to the growing collection of classical and Renaissance casts that was augmented yearly by Mrs. Radeke.

The construction of the exhibition galleries behind the Waterman building in 1897 catalyzed a more focused interest in the exhibition and acquisition of paintings (as distinguished from their reproductions). The inaugural exhibition of paintings and engravings in the new galleries featured works by Camille Corot, Gustave Courbet, Charles Daubigny, Eugène Delacroix, Edouard Detaille, Narcisse Diaz, Jules Dupré, Josef Israels, Charles-Emile Jacque, Anton Mauve, Georges Michel, and Théodore Rousseau, along with the works of such American painters as Frank Benson, William Merritt Chase, R. Swain Gifford, Winslow Homer, George Inness, Charles Stetson, Edmund Tarbell, Abbott Thayer, Charles Woodbury, and A. H. Wyant.[6] Providence had never before seen an exhibition of this scope and quality, setting a high standard for the role that would be served thereafter by the Museum as the first major art museum in Rhode Island.

By far the greatest emphasis of the exhibitions, gifts, and acquisitions stimulated by the new galleries was on the

work of living American painters, many of whom had strong ties to French Impressionism. The endowment of the Jesse Metcalf Fund in 1900 enabled the acquisition of important works by Winslow Homer, J. Alden Weir, Childe Hassam, Mary Cassatt, John White Alexander, James McNeill Whistler, Charles H. Woodbury, George Bellows, and Arthur B. Davies (among others), most of which were acquired from the Museum's annual Autumn Exhibition of contemporary American paintings. Underlying this enthusiasm, which dominated the early history of painting in the Museum, was a pattern of collecting and taste for painters of the Barbizon School. "The pictures that are now most valued," Augustus M. Lord commented in 1900 in a memorial address on the School's founders, "are the work of men like Corot, and Diaz, and Rousseau, and Daubigny, and Millet, who have studied nature lovingly, and learned to express the poetry of field and stream and sky with simple truthfulness."[7] Important collections of this work belonging to Beriah Wall and John A. Brown, Thomas Robinson, Austin H. King, the Hon. Royal C. Taft, and Walter Callender were formed in Providence in the second half of the century.[8] From around 1850 to 1897, the Vose Gallery on Westminster Street remained an important source for works by the Barbizon painters, as well as for the sale of work by contemporary Americans.[9] The market in contemporary American naturalist painting was logically reinforced by a broader interest in European painting of the preceding generation, which had inspired so many of these painters and placed them within an historical continuum. The widespread interest in naturalist painting both locally and abroad was also fostered by such institutions as the Rhode Island Art Association (founded in 1854), the Providence Art Club (founded in 1880), and the Ann Eliza Club (founded in 1885), which brought together a lively, thriving community of artists and collectors in these prosperous times.[10]

The examples of European fine arts to enter the collection at first were limited to reproductions in the form of autotypes and plaster casts, a function of the constraints on a small institution in its founding years. The first nineteenth-century (then contemporary) painting to be acquired by the Museum was a genre picture by Fritz von Uhde (94.004), given by Jesse Metcalf. A similar genre painting by Georges Jakobides was given by Manton B. Metcalf, his son, in 1899 (99.004), and an historical painting by the Belgian artist Hendrik Schaefels was given by Miss Mary Parsons in 1904 (04.142). In 1909 Mrs. Radeke gave a landscape by the contemporary Spanish painter Joaquin Sorolla y Bastida (09.071), and in 1912 she donated a then-fashionable portrait by Charles Cottet (12.033), reproduced on the the cover of the first number of the quarterly *Bulletin of the Rhode Island School of Design* (v. I, no. 1, January 1913). The Sorolla and the Cottet were the two most advanced paintings from abroad to enter the collection up to that time. Cottet, an erstwhile Impressionist, although little-known today, was a highly successful painter of his time, and a winner of a Gold Medal at the 1900 Exposition Universelle in Paris, in which year the Museum's

canvas was painted. This was the first modern French painting to enter the Museum's collection, and its prominence in the inaugural number of the Museum's new journal, in lieu of any of a number of prominent American paintings that had been recently acquired, foreshadowed the taste for European art that would shape the future holdings of the Museum.

The history of nineteenth-century European painting such as we know it today, however, was not to be told through these early gifts. Nor was it to be told through the Museum's first actual purchases, made possible by the Jesse Metcalf Memorial Fund established by his children in 1900, which concentrated on works by contemporary American painters (although this was not a condition of the bequest). The first noteworthy gift of a group of nineteenth-century European paintings came as a part of the bequest of Isaac Comstock Bates (1843–1913), who more than any other individual influenced the Museum's early emphasis on American painting.[11] Bates, who had inherited a small fortune in the family meat-packing business, was a founder of the Providence Art Club, a trustee of the School since 1885, a member of the Museum Committee from the early 1890's, and its Chairman from 1903 until his death. He was also a spirited collector and booster of the local artistic community. His bequest of 1913, the largest single gift of works of art to the Museum until that time, included a large collection of American paintings (which remains the heart of the present collection); old master prints; jewelry and metalwork; oriental pottery, porcelain, woodwork, metalwork, and cloisonné; and a small group of European paintings, including a landscape attributed to Courbet (13.793), a Diaz landscape (13.923) and a painting by Diaz of dogs (deaccessioned), two landscapes by Dupré (13.791, 13.800), and a painting of sheep by Charles-Emile Jacque (deaccessioned).

With the death of Bates and the succession of Mrs. Radeke as President and Rowe as Director, the focus of the Museum shifted dramatically, as a concerted effort was undertaken to build a collection more international, historical, and comprehensive in focus. The quarterly *Bulletin,* first published in January 1913 with Rowe as the General Editor, documented the rapid accession of carefully chosen historical examples of Egyptian, Greek, Roman, Italian and Northern Renaissance, old master European, and Asian art, acquired through the generosity of the Metcalf family (in particular Mrs. Radeke, Mrs. Jesse H. Metcalf, and Manton B. Metcalf). In this period the Museum began to display a growing concentration of fine arts relative to its collection of applied arts, and the reproductions that dominated the collections during the Museum's early years were gradually superseded by original works of art of quality.[12] The Museum's ability to build its collection was vastly expanded by the bequest in 1916 of $3,000,000 by Miss Lyra Brown Nickerson, daughter of Edward I. Nickerson, who had been an early trustee and member of the Executive Committee. From this endowment the Museum Appropriation Fund was created and then used to acquire many of the paintings that form a part of this collection today. The first modern French painting purchased

through this endowment was Eugène Carrière's *Woman Sewing* (18.499, entry 71), possibly chosen with reference to the School's prominent and recently expanded role in the education of textile designers.[13] As the Museum grew from within, it began to attract other collections. In 1920 Mrs. Virginia W. Hoppin gave a small group of paintings in memory of her husband, including an oriental subject by Narcisse Diaz (20.229); that same year Edward F. Ely left paintings by Georges Michel (20.070), Theodore Rousseau (20.071), Thomas Couture (20.069, 20.072),[14] and a painting of horses attributed to Géricault; and in the following year the Austin King Bequest brought paintings by Dupré (21.446, 21.447) and Jacque (21.448). Corot's *Banks of a River* was acquired through the Museum Appropriation Fund in 1924 (24.089, entry 17). In 1929 a group of sixteen works collected by the late Walter Callender were donated in his memory by his sons, including paintings in the Barbizon style by the Dutch painters de Zwart (29.098, 29.100) and Valkenburg (29.103), and the Belgian Leemputten (29.099), as well as the French painters Michel (29.106), Lapostolet (29.102), and Raffaëlli (29.104). Gradually, the Museum's collection of nineteenth-century European painting was forming around the nucleus of the Barbizon School paintings so admired by collectors at the turn of the century.

In the 1920's Mrs. Radeke and Rowe augmented the collections of European painting and sculpture with choice examples of work by artists who had come to be recognized as the outstanding talents of the later nineteenth century, resulting in an extraordinary sequence of acquisitions. These efforts, part of a larger campaign to expand the Museum's holdings in all areas, appear to have been coordinated with the gift of $400,000 by Stephen O. and Jesse H. Metcalf for the construction of a new building, dedicated in 1926 to their sister, Eliza Green (Mrs. Gustav) Radeke. In 1920 Mrs. Radeke gave Alfred Stevens's *First Day of Devotion* (20.288, entry 26) and a painting by Monet representing *The Bridge at Argenteuil* (later deaccessioned), the Museum's first Impressionist acquisition.[15] In 1921 an important group of contributors supplemented the Museum Appropriation Fund to acquire the first "Manet," *Young Woman in Blue*.[16] In 1922 Renoir's *Young Woman Reading an Illustrated Journal* (22.125, entry 60) was acquired, joined in the following year by Degas's *Savoisienne* (23.072, entry 35) and the *Grand Arabesque* (23.315, entry 37). An important early work by Rodin from the Constantine A. Ionides collection, *The Man with the Broken Nose* (21.341), and a later marble from Rodin's maturity, *The Hand of God* (23.005, entry 68), purchased from the collection of Samuel P. Colt of Bristol, were acquired in 1921 and 1923 respectively. A second Monet, *Rouen Cathedral, Morning*, 1894, was acquired in 1924, and two additional canvases by him, *Cliff at Etretat*, 1885, and *Nymphéas*, 1913, were added in 1929.[17] By the end of the decade, the Museum could boast a small yet distinguished collection of work by the Impressionists in addition to its collection of Barbizon paintings. After 1926 these were installed respectively in the Modern French Room and in another devoted to the

Barbizon School, forming part of a sequence of galleries that presented the collections in historical and geographical groupings.[18] Reflecting the expansion of the Museum's collection and facilities, the Board of Trustees announced in 1926 that an office of the Curator would be created; it was filled by Miriam A. Banks. In 1926 the Museum also received a sizable bequest from the estate of Henry Bixby Jackson, to be known as the Mary Bixby Jackson Fund, establishing, in addition to the Jesse Metcalf and Museum Appropriation Funds, a third major source for the purchase of works of art.[19]

The strong leadership provided by Mrs. Radeke through the 1920's was continued by Mrs. Danforth through the next four decades, during which time the European collections expanded considerably, with an increased emphasis on works of art from the earlier part of the nineteenth and late eighteenth centuries. Whereas Mrs. Radeke placed great emphasis upon building up the collection's breadth, acquiring a wide variety of objects, Mrs. Danforth was inclined to seek out objects of singular importance, advising Rowe on one occasion to forego an acquisition he had recommended in order to "best save our funds for the big things that we need."[20] The first important work of the earlier nineteenth century to be acquired by the Museum was a small, exquisite panel by Chassériau donated by Mrs. Radeke in 1928, to this day one of the few works by Chassériau in this country (28.004, entry 23). Through the influence of Mrs. Danforth over little more than a decade, the Museum would acquire important paintings by William Blake (32.219, entry 4), Hubert Robert (37.104, entry 9), Eugène Delacroix (35.786, entry 27), Camille Corot (43.007, entry 15), Théodore Géricault (43.539, entry 12), and Gustave Courbet (43.571, entry 51). In 1937 a large collection of Napoleonic decorative art was donated by Mrs. Harold Brown, which included an important bust of Mme Récamier by Chinard (37.201, entry 8).[21] Notable Impressionist paintings were also added to the collection, including Cézanne's view of the *Chestnut Trees and Farm at the Jas de Bouffan* (33.053, entry 64) and Degas's *Jockey, Red Cap* (35.539, entry 36).

Nineteenth-century French art, in particular, had become a prominent part of the Museum's holdings. On the other hand, the acquisitions made during Rowe's tenure as Director reflect a more conservative approach towards art of the twentieth century. There were a few noteworthy exceptions. In 1920 Mrs. Radeke purchased an *Ideal Head* in marble by the Polish-born sculptor Elie Nadelman, who had recently moved from Paris to New York (20.310). A painting by Augustus John (28.062, entry 75) and a portrait of Ingres by Bourdelle (28.065) acquired in 1928 reflect a cautious approach to modernism. In 1930 Mrs. Radeke donated a *Harlequin Mask* (30.050) by the Spanish sculptor Gargallo, and in 1931 Mrs. Danforth gave to the Museum a portrait by Marie Laurencin (31.362), the first Cubist works to enter the collection. Rowe believed that it was more appropriate to view the works of one's own time in temporary exhibitions, allowing the viewer "to exercise his own sense of connoisseurship," without "approv[ing] in whole or in part of the expression."[22]

In the 1930's the Museum organized a number of important exhibitions of modern art, including the 1930 exhibition of French painting that included multiple examples of work by Cézanne, Van Gogh, Gauguin, Seurat, Bonnard, Matisse, Derain, Picasso, Modigliani, and de Chirico, among others.[23] In 1931, with the help of John Nicholas Brown, the Museum organized an exhibition of the work of Matisse,[24] and in 1937, in the year following the milestone exhibition of *Cubism and Abstract Art* organized by Alfred H. Barr, Jr., at the Museum of Modern Art in New York, a circulating version of the same exhibition, comprised of more than two hundred and fifty works, was organized for the RISD Museum.[25] Between 1932 and 1935 there were also exhibitions of modern Catalan, Spanish, and British art.

Rowe's death in 1937 marked the end of an era for the Museum. In the years since Rowe's passing the Museum has benefited from the leadership of a succession of directors, each of whom has left his mark on the permanent collection, but none on the scale that Rowe was permitted during the Museum's formative years, which saw the acquisition of more than fifteen thousand objects and the construction of its present facilities. However, one area of collecting in which a visible impact on the Museum's holdings could still be made remained the acquisition of modern art. An important Blue Period painting by Picasso, *La Vie,* was purchased by Museum Appropriation in the hiatus immediately following Rowe's passing. Unfortunately, this great work was later deaccessioned and is now in the Cleveland Museum of Art.[26] In 1938 Alexander Dorner, previously the director of the Landes Museum of Hannover, Germany, was named Director, in which capacity he remained until 1941. Dorner took a very active role in the reinstallation of the permanent collection, placing a strong emphasis on cultural context by mixing the fine and applied arts in period rooms.[27] His tenure also saw the acquisition of a small number of important, unambiguously modern works of art, among them two constructions by Naum Gabo (38.061 and 38.062),[28] given by Mrs. Danforth; Henri Matisse's *Still Life with Lemons* (39.093, entry 81), the gift of Miss Edith Wetmore; Amédée Ozenfant's *Large Jug and Architecture* (39.095, entry 85), purchased with the Mary B. Jackson Fund; and a painting from the Bauhaus years by the American-born, German-trained Lyonel Feininger, *The Church at Gelmerode* (38.059), which had belonged to the National Gallery in Berlin before it was condemned by the Nazis as "decadent."

Dorner was succeeded by Gordon Washburn, who was Director from 1942 until 1949. His tenure saw the acquisition of a number of important Impressionist works through the influence of Mrs. Danforth, including Manet's *Children in the Tuileries Gardens* (42.190, entry 42), Monet's *Hyde Park, The Basin at Argenteuil,* and *The Seine at Giverny* (42.218, 42.219, and 44.541, entries 47–49), as well as Renoir's *Young Shepherd in Repose* (45.199, entry 61).[29] An assessment of the growth of the collection in these years must also take account of the efforts to reshape it. The deaccessioning of three important Monets in 1945 in order to acquire a painting

wrongly attributed to Hugo van der Goes is one example of the risk involved in second-guessing one's predecessors.[30] Another example was the exchange in 1948 of a Tahitian painting by Gauguin, *I raro te oviri,* acquired in 1933, for a painting believed at the time to be by Géricault (48.452). The most noteworthy revision of the collection, however, was the deaccessioning in 1944 of Picasso's *La Vie* (acquired in 1937) – the summation of his Blue Period – the proceeds from which were used to acquire Renoir's *Young Shepherd in Repose,* a work of very different quality and character.

During the directorship of John Maxon from 1952 to 1959, the Museum saw the collections grow in the work of non-French artists in particular. The Museum had by this time built a substantial collection of works by major French artists, and Maxon, along with his curator, Anthony Clark, was predisposed to direct the Museum's endowment towards the acquisition of works that were less clearly a part of the mainstream, although crucial to a fuller representation of the diversity and quality of nineteenth-century art in Europe. Works by Matthew Ward (53.129), William Etty (53.422, 55.085, 56.055), James Tissot (54.172, 58.186, entries 31, 33), Ernest Meissonier (54.174, entry 50), Jules Dalou (54.187, entry 54), Giacomo Favretto (56.086, entry 63), Franz Xaver Winterhalter (56.087, entry 24), Joseph Paelinck (56.090a–b, entries 10, 11), Sir Charles Eastlake (56.099, entry 13), Jean-Victor Bertin (56.214, entry 19), Atkinson Grimshaw (57.162, entry 58), Georges Lemmen (57.166, entry 69), Anton Rafael Mengs (57.281), John Constable (58.197), and William Powell Frith (58.162, entry 30), were acquired in these years. Matisse's *The Green Pumpkin* (57.037, entry 82) and Oskar Kokoschka's *Portrait of Franz Hauer* (53.121, entry 80) also augmented the Museum's presentation of the art of this century. In 1957 the Museum received an important bequest from George Pierce Metcalf, which included among its gifts Monet's beautiful view of *Honfleur* (57.236, entry 46), Picasso's *The Diners* (57.237, entry 73), and Dufy's *Club Room at the Cowes Royal Yacht Club* (57.229). Perhaps the most important acquisition of the decade, however, was the gift by Mrs. Edith Stuyvesant Vanderbilt Gerry of Manet's portrait of Berthe Morisot, called *Le Repos* (59.027, entry 43), one of the Museum's greatest treasures and the crowning piece of its Impressionist collection.

The collections have continued to grow through the succeeding directorships of David Giles Carter (1959–64), Daniel Robbins (1965–71), Stephen E. Ostrow (1971–78), and currently Franklin W. Robinson. The last decade alone has seen the addition of works by Léger (81.097, entry 84), Opie (83.221, entry 5), Boudin (1986.070, entry 44), Apoil (1986.156, entry 25), Couture (1986.207.2, entry 21), Desboutin (1987.041, entry 66), Sarazin de Belmont (1987.056, entry 18), and Carpeaux (1989.004, entry 40), suggesting that the collection is still building on the art of the century that had been so important to the founding of the School and its Museum.

This catalogue discusses eighty-five of the most noteworthy of these objects, selected for their quality and impor-

tance to the collection; it also reproduces the remainder of the collection in an annotated checklist, which facilitates a critical assessment of how far we have come since the first autotypes and plaster casts were accumulated a little more than a century ago. It is to the benefactors who made this collection a reality in such a relatively short period of time that this catalogue should properly be dedicated. D. R.

1. For a comprehensive history of the Museum, see Carla Mathes Woodward, "Acquisition, Preservation, and Education: A History of the Museum," in Woodward and Robinson 1985, pp. 11–60; for a history of the Pendleton House collection and of taste in nineteenth-century Providence, see Christopher P. Monkhouse, "Cabinetmakers and Collectors: *Colonial Furniture and its Revival in Rhode Island,*" in Monkhouse and Michie 1986, pp. 9–49; for an account of the early and deliberate formation of the American paintings collection, see Patricia C. F. Mandel, "History of the Collection," in Providence, RISD, 1977, pp. 5–11.

2. The School's purpose, as stated in its charter, was to educate artisans in the principles of art and design, "that they may successfully apply the principles of art to the requirements of trade, and manufactures."

3. A program of lectures offered free to the public in 1889 included talks by Charles Waldstein of Cambridge University, England, on "The Spirit of Greek Art"; by A. D. F. Hamlin of Columbia University on "Byzantine Architecture"; by Fred Hovey Allen on "Contemporary Art in Germany" and "Art, an Element in National Greatness"; and by Charles Eliot Norton of Harvard University on "Art in America." See "Programme of a Course of Free Illustrated Lectures on Art . . . under the auspices of the Rhode Island School of Design," 1889, in the Museum archives.

4. The School's goals were expressed in the 1890–91 annual *Report,* which explained that "any system of art education that aimed to exert an enduring influence on the growth of a National Art, must, as William Morris said . . . 'take its root among the people,' and substituting a 'vital principle for an unintelligible idea,' make 'art tell in their daily lives.'" RISD, *Report,* 1891, p. 8. "The unity of the Fine and Industrial Arts" was the subject of the dedication address given by Mr. McAllister of the Drexel Institute at the inauguration of the Waterman building in 1893; see RISD, *Report,* 1894.

5. In 1890–91, the first year in which the Museum's acquisitions are listed as a part of the annual *Report,* gifts to the Museum (by then referred to with a proper noun) included ornamental and architectural casts, a painting of the Spanish school (artist unknown), five casts of figures and heads after Donatello, a bas-relief "Victory" from the Temple of Victory in Athens, a heliotype of an engraving after a self-portrait by Titian, and other miscellaneous works of this kind. By 1890 these collections had so grown in size that the need for additional facilities was expressed; see RISD, *Report,* 1891, p. 11.

6. Providence, RISD, 1897.

7. Lord 1900, p. 21.

8. Regrettably, many of these collections were sold before the Museum was in a position, in terms of its original focus, available space, or resources, to acquire work from them: the collections of Beriah Wall and John A. Brown of Providence were sold in New York in 1886 (see New York, American Art Galleries, 1886), as was the collection of Thomas Robinson (see New York, Moore's Art Galleries, 1886).

9. They were also an important source for the exhibition of these works by the Museum. See "Paintings . . . loaned by Robert G. Vose," May 14, 1906, checklist in Museum archives, which lists works by T. Rousseau, Michel, Boudin, Bonvin, Delacroix,

Couture, Corot, Harpignies, and Daubigny, among others. In 1906, the same year in which the Museum organized an important exhibition of the "Ten American Painters," the Voses, by then operating exclusively out of Boston, lent an exhibition of works by Doré, Courbet, Corot, Rousseau, Delacroix, Millet, Daubigny, and Boudin, as well as such British painters as Reynolds, Turner, Beechey, and Bonington. See RISD, *Report,* 1906, p. 48.

10. The population of Providence doubled between 1865 and 1880, as it would again by 1910, when it ranked twentieth in size and second in per capita wealth in the United States; see Woodward and Sanderson 1986, pp. 57–59. Concerning Seth Morton Vose's gallery on Westminster Street, see Boston, Vose, 1987; an account of the Ann Eliza Club is provided in Bert and McElroy 1990.

11. This gift was shown in a memorial exhibition at the Museum in 1913; see Providence, RISD, 1913, and RISD, *Bulletin,* v. I, no. 2 (April 1913).

12. Mrs. Radeke's role in building the collection was remembered by a dealer who advised her in these years, Martin Birnbaum, who described her as "a self-effacing, public-spirited benefactor, [whose] quiet manner masked a remarkably happy flair for beauty and originality. She rarely waited for her fellow trustees to approve her suggestions. If there was any danger of losing a treasure, she would acquire it with her private funds and await their subsequent approval." Birnbaum 1960, p. 201.

13. The Metcalf Memorial Building, housing a state-of-the-art Department of Textile Design, opened on December 29, 1915, in the lot directly behind the Waterman galleries.

14. The latter, no longer attributed to Couture, revealed the initials "V. B." upon cleaning.

15. Reproduced in RISD, *Bulletin,* v. XIX, no. 3 (July 1931), p. 37.

16. This painting (21.004) has since been reattributed to an Italian follower of Manet, Gaetano Esposito. In 1921 Mrs. Radeke also gave an important watercolor by Manet of *Mlle Victorine in the Costume of an Espada* (21.483), a study for the painting now in the Metropolitan Museum of Art, New York.

17. These paintings are reproduced in RISD, *Bulletin,* v. XVIII, no. 3 (July 1930), pp. 33, 35, 37. None of these Monets are presently a part of the permanent collection. *Rouen Cathedral* was exchanged with Durand-Ruel for a view of the *Gare St. Lazare* (1878) in 1934, which in 1944 was exchanged through Wildenstein for *The Seine at Giverny* (44.541, entry 49). *Etretat, Nymphéas,* and *The Bridge at Argenteuil* were part of an exchange in 1945 for a portrait on panel believed at the time to be by Hugo van der Goes (45.042).

18. The Impressionist paintings were installed in the gallery that is today devoted to seventeenth-century European painting, while the Barbizon paintings were located in the present Neoclassical gallery. For a layout of the original installation of works in the new Eliza G. Radeke Museum Building, including installation photographs, see RISD, *Bulletin,* v. XIV, no. 2 (April 1926), pp. 18–23.

19. Concerning both the appointment of Miriam Banks and the Jackson Fund, see RISD, *Bulletin,* v. XIV, no. 4 (October 1926), pp. 46–47.

20. Letter from Mrs. Helen M. Danforth to L. Earle Rowe, August 20, 1932, in the Rowe correspondence of the Museum's archives.

21. Concerning the Brown bequest, see Monkhouse 1978.

22. Rowe's conservative policy towards the acquisition of contemporary art is noted in Banks 1937, p. 37.

23. Providence, RISD, 1930.

24. Providence, RISD, 1931.

25. The typed checklist of this exhibition in the Museum archives lists major works by Seurat, Cézanne, Picasso, Braque, Rousseau, Gris, Delaunay, Balla, Boccioni, Severini, Duchamp-Villon, Léger, Kupka, Arp, Klee, Marc, Kandinsky, Miró, Giacometti, Ernst, Brancusi, Lipchitz, Malevich, Lissitzky,

Rodchenko, Tatlin, Gabo, Pevsner, and Mondrian, to mention just a few.

26. Reproduced on the cover of RISD, *Bulletin,* v. XXVI, no. 1 (January 1938).

27. Dorner's "Plans for the Museum" was presented to the Corporation on June 1, 1938, and published in the annual *Report* of that year, pp. 25–26. Dorner's reinstallation of the Museum is discussed in Cauman 1958, pp. 128–43 ff., which includes installation photographs of several of the galleries.

28. Dorner had also acquired a version of Gabo's *Monument for an Airport* for the Landes Museum in Hannover; see Cauman 1958, p. 64.

29. Mrs. Danforth also gave a large number of important Impressionist drawings in 1942, including Degas's *Dancer with a Bouquet* (42.213), his *Before the Race* (42.214), and a study for *The Card Player* by Cézanne (42.211).

30. See above, n. 17.

Donors and Funds

Mr. and Mrs. A. M. Adler

Georgianna Sayles Aldrich Fund

R. S. Aldrich

William T. Aldrich

Anonymous Donors

Isaac C. Bates

Alice Bourne

Mrs. Harold Brown

Walter R. and John A. Callender

Roy E. Carr

Mrs. Guy Fairfax Cary

Chace Foundation

Mrs. Zechariah Chafee

William A. Coles

Johns H. Congdon, 2nd

Maria L. Corliss

Mary Corliss

Corporation Membership Dues Fund

John M. Crawford, Jr.

Helen M. Danforth Fund

Dr. and Mrs. Murray S. Danforth

Mrs. Murray S. Danforth

Dr. Halsey DeWolf

Mrs. Charles O. Dexter

Mary Dexter Fund

Sarah E. Doyle

Edward F. Ely

Ruth Ely

Robert R. Endicott

Endowed Membership Fund

Colonel Michael Friedsam

Mrs. Edith Stuyvesant Vanderbilt Gerry

Mrs. John A. Gillespie

The Honorable Theodore Francis Green

"Group 104"

Mrs. Peggy Guggenheim

Miss M. C. Harrington

Emma G. Harris

Mr. and Mrs. Norman Hirschl

Hirsch & Adler

Mrs. John S. Holbrook

Mrs. Virginia W. Hoppin

Mary B. Jackson Fund

Mr. and Mrs. Frederick Kenner

Walter H. Kimball Fund

Austin H. King

Colonel Webster Knight

Robert Leeson

Levinger Foundation

Charles K. Lock

Edgar J. Lownes Fund

Walter Lowry

Lawrence Marcus

Membership Dues

George Pierce Metcalf

Houghton P. Metcalf, Sr.

Mrs. Houghton P. Metcalf, Sr.

Jesse H. Metcalf

Jesse H. Metcalf Fund

Manton B. Metcalf

Mr. and Mrs. Michael Metcalf

Stephen O. Metcalf

Alfred T. Morris, Sr.

Museum Appropriation

Museum Associates

Museum Gift Fund

Museum Member Donations

Museum Special Reserve Fund

Museum Works of Art Fund

Museum Works of Art Reserve Fund

Paris Auction Fund

Mary Parsons

Charles L. Pendleton

Charles Brush Perkins

Mrs. Gustav Radeke

Daniel Robbins

Helen G. Robertson

David C. Scott

Ellen D. Sharpe

Henry D. Sharpe

Mrs. Henry D. Sharpe

Hope Smith

Albert M. Steinert

Mrs. Morris Stokes

Royal C. Taft

Uforia, Inc.

Estate of Otto A. Villbrandt

Mrs. George H. Warren, Jr.

Julius H. Weitzner

Edith Wetmore

Forsyth Wickes

Grenville L. Winthrop

The Wunsch Foundation

Color Plates

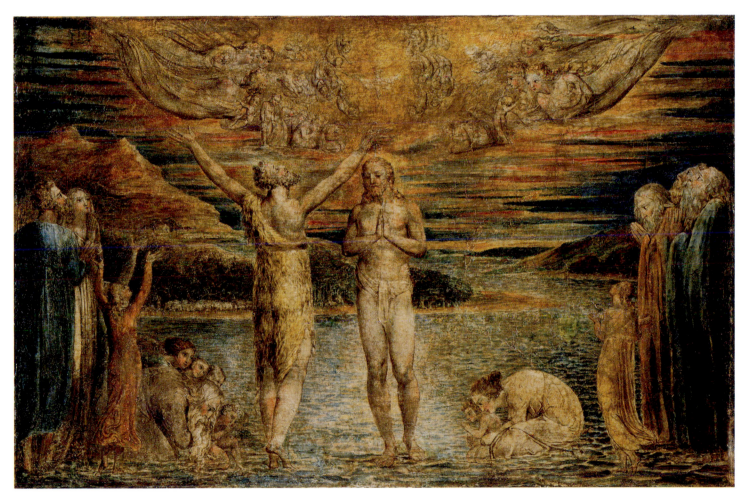

William Blake, *The Baptism of Christ*, ca. 1799–1800 (entry 4).

Hubert Robert, *Architectural Fantasy,* ca. 1802–08 (entry 9).

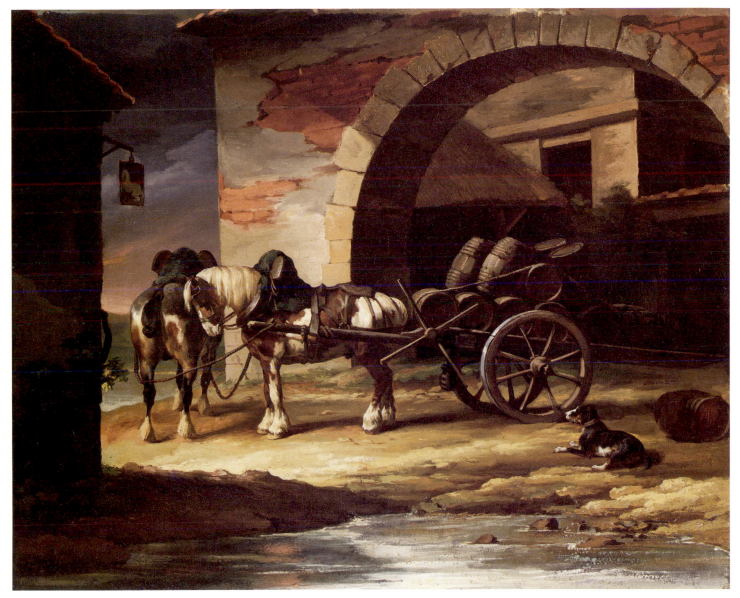

Théodore Géricault, *A Cart Loaded with Kegs,* ca. 1819 (entry 12).

Louise-Joséphine Sarazin de Belmont, *A View of Paris from the Louvre,* 1835 (entry 18).

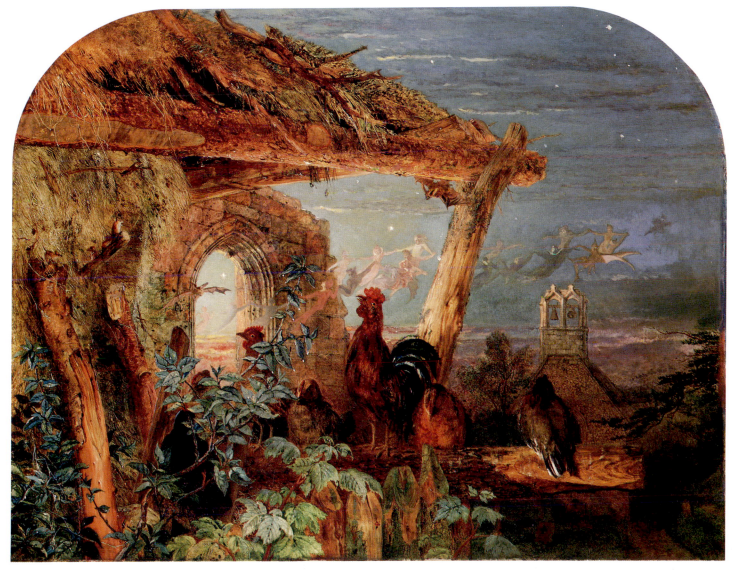

William Bell Scott, *Cockcrow*, 1856 (entry 28).

James Jacques Joseph Tissot, *Ces Dames des chars*, 1883–85 (entry 33).

Edouard Manet, *Le Repos,* ca. 1870–71 (entry 43).

Claude Monet, *The Basin at Argenteuil*, 1874 (entry 48).

Claude Monet, *The Seine at Giverny,* 1885 (entry 49).

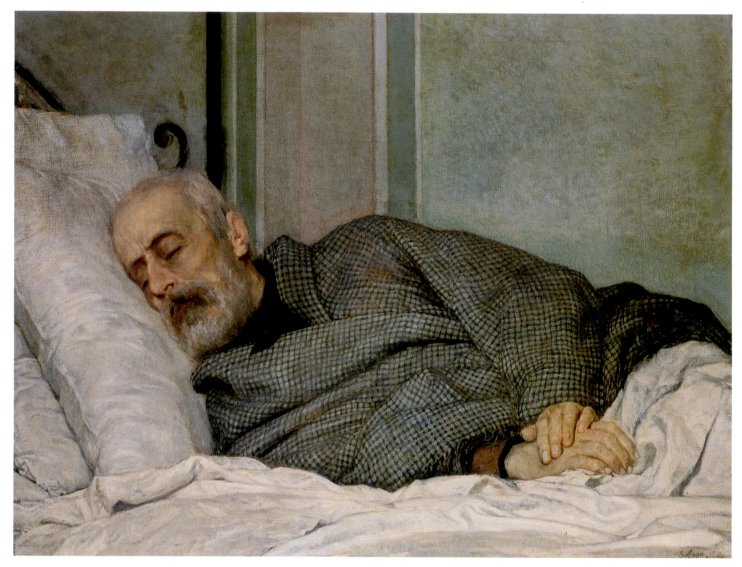

Silvestro Lega, *The Dying Mazzini*, 1873 (entry 56).

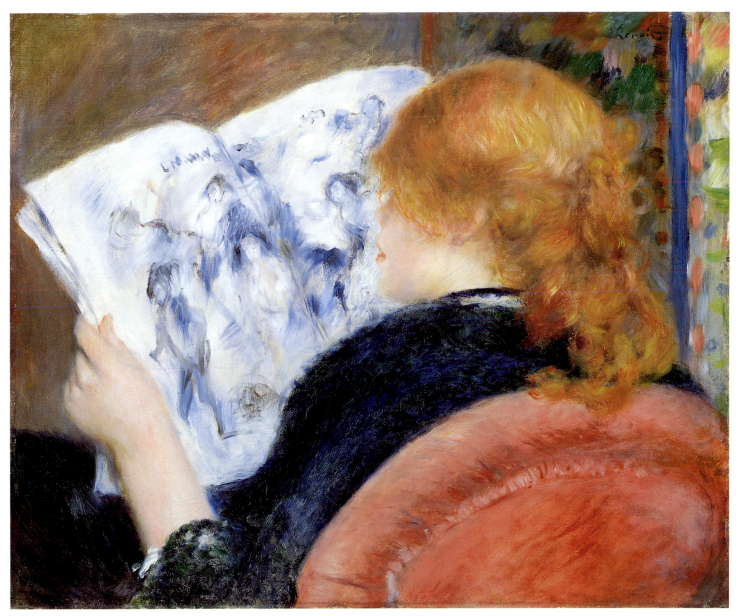

Pierre-Auguste Renoir, *Young Woman Reading an Illustrated Journal*, ca. 1880 (entry 60).

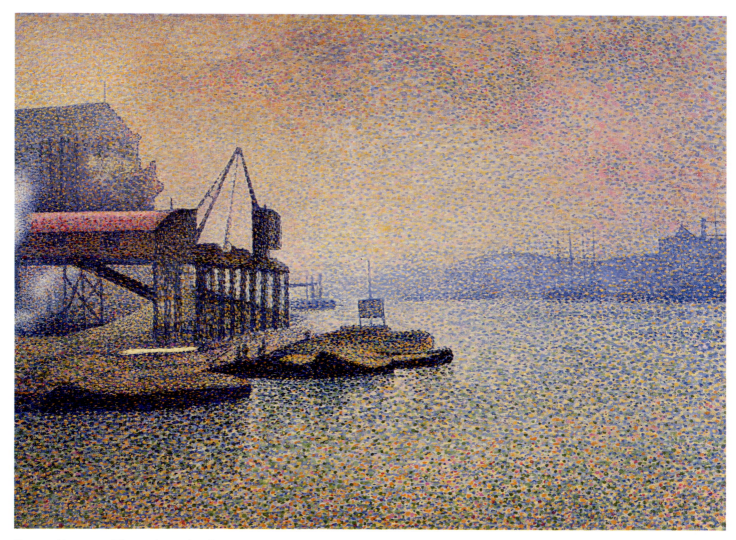

Georges Lemmen, *Thames Scene, the Elevator,* ca. 1892 (entry 69).

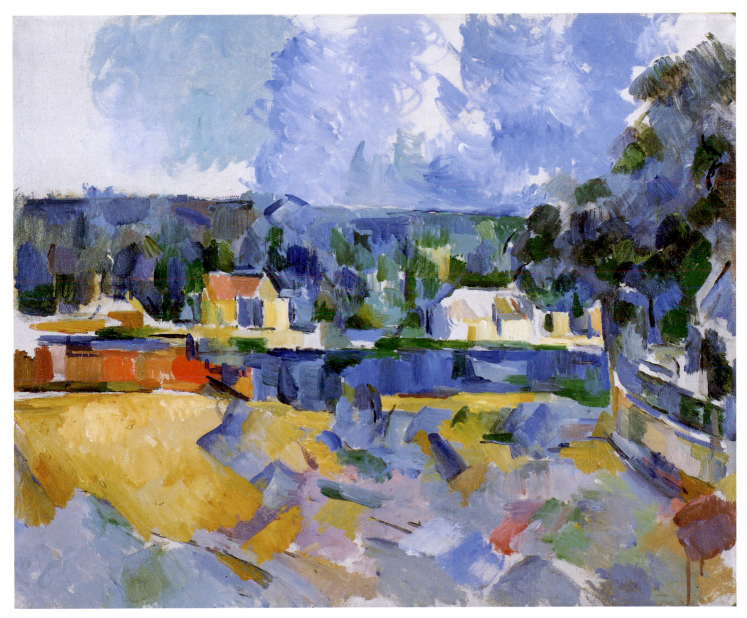

Paul Cézanne, *Banks of a River*, ca. 1904–05 (entry 65).

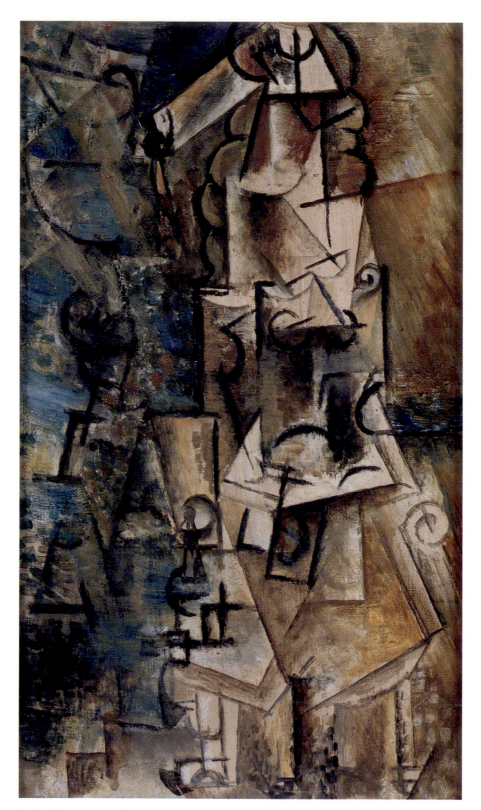

Pablo Picasso, *Seated Woman with a Book,* ca. 1911–12 (entry 74).

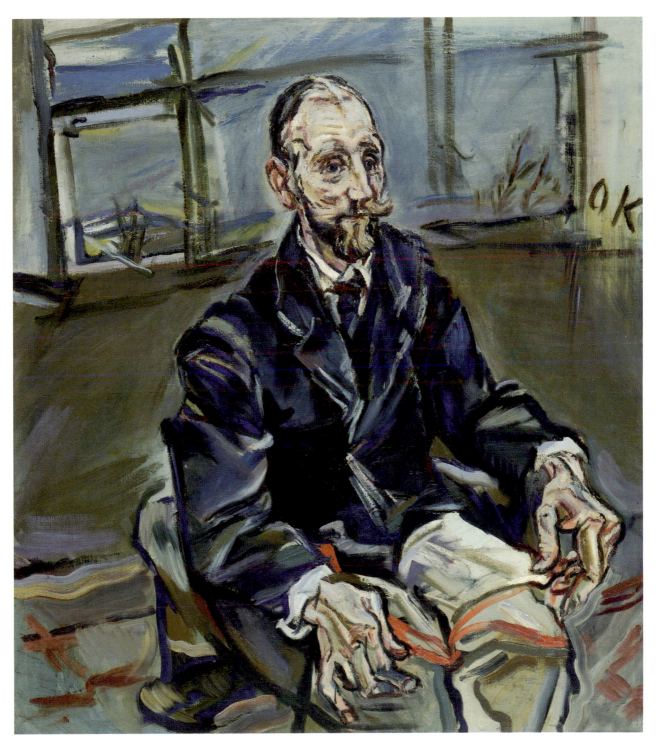

Oskar Kokoschka, *Portrait of Franz Hauer,* 1914 (entry 80).

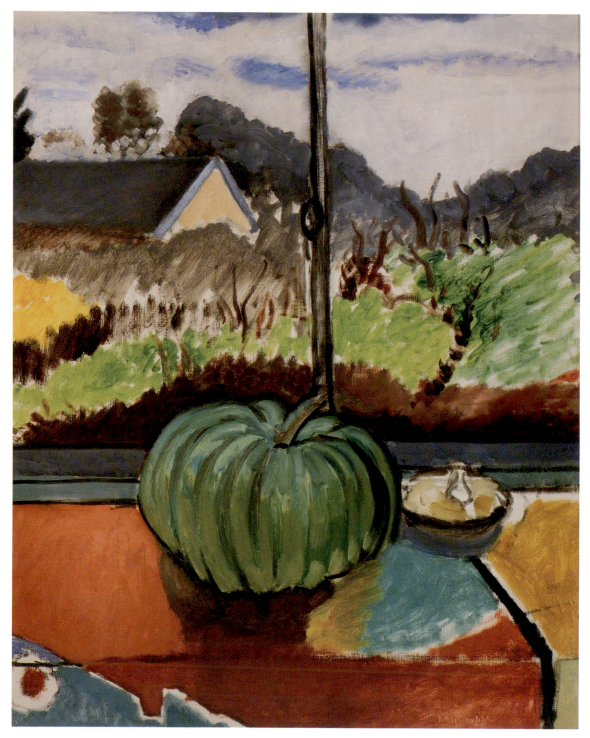

Henri Matisse, *The Green Pumpkin,* ca. 1916 (entry 82).

Entries

REVEREND MATTHEW WILLIAM PETERS
British, 1742–1814

1 *Lydia,* ca. 1776

Oil on canvas. 25″ × 30″ (63.5 × 76.2 cm)
Gift of Mrs. Guy Fairfax Cary. 62.009

PROVENANCE: Purchased in 1901 by the donor's mother, Frances Work Burke-Roche (Mrs. James Boothby Burke-Roche), from Knoedler & Co., New York; Cynthia Roche Cary (Mrs. Guy Fairfax Cary), New York.

PUBLICATIONS: Manners 1913, pp. 6, 9, 17, 20, 42, 47, 54, 62; Whitley, *Artists,* 1928, I, p. 349; RISD, *Museum Notes,* 1964, p. 5 (ill.).

CONSERVATION: About 1962 the picture was cleaned and restored by Oliver Bros., Boston.

After Matthew William Peters – the portrait and history painter from the Isle of Wight – returned from Italy following two periods of study, first in the early 1760's in Rome (under Pompeo Batoni) and Florence, and then in the early to mid-1770's in Rome and Venice, he gained the nickname of the "English Titian."[1] The source of this sobriquet can be specifically traced to a series of portraits of ladies in various states of undress, including the Museum's *Lydia.* They were directly inspired by Venuses from the hand of the Venetian master, and in particular his *Venus of Urbino,* which formed the centerpiece of the Grand Duke of Tuscany's Tribuna in the Uffizi Gallery in Florence. The extraordinary attention this picture received from English travelers on the grand tour is nowhere better illustrated than in Johann Zoffany's conversation piece, *The Tribuna of the Uffizi,* which was being painted for King George III and Queen Charlotte concurrently with Peters's second Italian sojourn. In Zoffany's painting, the *Venus of Urbino* has been taken down from the wall and removed from its frame for closer inspection by several British connoisseurs.[2]

While Titian showed his Venus stretched out full length on her bed entirely in the nude, Peters only depicted the head, shoulders and breasts of his women, leaving the rest concealed by their bed covers. In order for there to be no doubt that he was painting Venuses of the modern day, Peters provided them with contemporary night caps (except for one) and familiar names of the period, which also served as the titles for the pictures: *Belinda, Lydia, Sylvia,* and *Lucrece.*[3] He made their roles as seductresses explicit by appending the following lines of the Restoration poet and playwright John Dryden to an engraving of *Lydia,* which was published with *Belinda* by William Dickinson on December 1, 1776: "This is the Mould of which I made the Sex. / I gave them but one tongue to say us nay. / And two kind Eyes to grant."[4]

However, in the following year, when Peters submitted one of the above pictures, or a related example, under the title of *A Woman in Bed,* to the Royal Academy for its annual summer exhibition, the Council refused to allow the lines from Dryden to accompany the entry for it in the catalogue. This fear appears to have been well founded, because the critic of the *Morning Chronicle* later complained that "in its present situation it serves to prevent the pictures round it from being so much seen and admired as their merit demands, for every man who has either his wife or his daughter with him must for decency's sake hurry them away from that corner of the room."[5]

Controversy, of course, can be a boon to sales, as appears

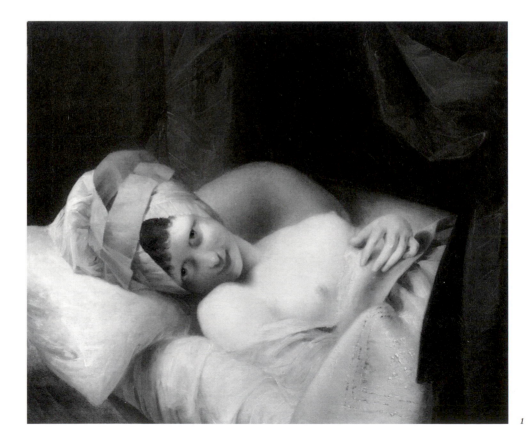

1

to have been the case with Peters's portraits of coquettish ladies. Aside from the original portrait of *Lydia,* which he painted expressly for Lord Grosvenor (now apparently lost), Peters produced approximately six copies, with the only significant variation occurring in the color of the ribbon found on the night cap.[6] In the Museum's version it is pink; in others it is blue. The prints after these portraits proved equally popular, judging from the number of different impressions that exist, with one of *Lydia* published as late as 1824.[7] Perhaps not surprisingly the highest price at public auction for a painting by Peters recorded by his biographer, Lady Victoria Manners, was for one of his versions of *Lydia* sold at Christie's for £1,522 10s to Messrs. Agnew on February 28, 1913.[8]

In the summer exhibition at the Royal Academy of 1777 Peters not only exhibited his controversial *A Woman in Bed,* but also his first religious picture, a portrait of St. John as a boy carrying a lamb in his arms and a cross with a ribbon tied to it, which was bought by Peters's greatest patron, the fourth Duke of Rutland.[9] The subject matter of the latter picture reveals another side of Peters, one that would eventually lead him to a career in the Church, matriculating for that purpose in November 1779 at Exeter College, Oxford.[10] Appropriately enough, in 1782, the first year he is listed in the Royal Academy exhibition catalogue as "Rev. William Peters," he submitted his most popular religious painting, *An Angel Carrying the Spirit of a Child to Paradise,* the original of which was acquired by Lord Exeter for his country house, Burghley, near Stamford in Lincolnshire. As was the case with his prints of coquettes, this painting was successfully engraved and published; according to a writer in the *Freemason's Magazine,* "the prints from this beautiful and interesting work were soon dispersed throughout Europe, and no print, we believe, from any picture of whatever master had so rapid and universal a sale."[11] Perhaps partly on the strength of this particular work, the Royal Academy made Peters its first Chaplain in 1784, an office he held until 1788.[12] Some of Peters's critics, however, were not going to let the more risqué portion of his work done before 1780 be forgotten. Certain wags let it be known that Lord Grosvenor felt compelled to veil his *Lydia* with a gauze called "episcopal lawn," a transparent material then generally used for the sleeves of Episcopal dignitaries' garb.[13] C.P.M.

1. Manners 1913, p. 6.
2. For the monographic study on this picture, see Millar 1967.
3. Manners 1913, pl. opp. p. 16 *(Belinda);* pl. IX *(Lydia);* pl. XIII *(Sylvia);* no pl. no. *(Lucrece).*
4. Manners 1913, p. 62.
5. Whitley, *Artists,* 1928, I, p. 349.
6. Manners 1913, p. 54.
7. Manners 1913, p. 62.
8. Manners 1913, pp. 42, 54.
9. Manners 1913, p. 10.
10. Manners 1913, p. 10.
11. Manners 1913, p. 11.
12. Hutchinson 1968, p. 236.
13. Manners 1913, pp. 6, 20.

GUILLAUME GUILLON, called
LETHIÈRE
French, born Guadeloupe, 1760–1832

2 The Death of Camilla, 1785

Oil on canvas. 46⅛" × 58⁷⁄₁₆" (117.1 × 148.3 cm)
Mary B. Jackson Fund. 72.144

PROVENANCE: B. G. Verte, Paris; purchased 1972 as "School of Vien."

EXHIBITION: Rochester, Memorial Art Gallery, 1987, pp. 124–25 (no. 36, ill.).

PUBLICATIONS: "Chronique des Arts" 1973, p. 135 (fig. 489, captioned "Anonyme, *La Mort de Camille*"); Marandel 1980, pp. 12–17 (fig. 1).

RELATED WORK: *Sketch for The Death of Camilla,* ca. 1785, oil on canvas, 12⅝" × 17" (32 × 43 cm), Dijon, Musée Magnin.

The late-eighteenth-century canvas representing *The Death of Camilla* entered the RISD collection unattributed. Research by J. Patrice Marandel has linked the work to Guillaume Guillon, called Lethière, an early practitioner of Neoclassicism in France.[1] Marandel noted that the subject was identical with the theme used in the 1785 competition for the annual Prix de Rome of the Ecole des Beaux-Arts in Paris. The discovery of Lethière's competition piece is of particular interest for the light it sheds on the formative years of French Neoclassicism, revealing the inevitable influence of Jacques-Louis David's *Oath of the Horatii* (1784, Paris, Musée du Louvre), exhibited in the Paris Salon of 1785 and recognized almost immediately as the definitive statement of a new classical esthetic that became synonymous with the French Revolution and continued to dominate European art for the next three decades.

The choice of the topic for the 1785 competition of the Ecole des Beaux-Arts reflects the impact of *The Oath of the Horatii.* The subject of David's painting derives from the early history of ancient Rome. The story of the combat between the Romans and the rival Etruscan tribe, the Albans, is recounted in literature both ancient (Livy [1, 24–26]) and modern (Corneille's tragic drama *Horace* of 1639–40). To settle a boundary dispute, three representatives from each side were chosen for hand-to-hand combat. In David's painting, the three Roman brothers, sons of Horatius the elder, swear before their father to slay their foes, while a group of women, including their sister Camilla, weep helplessly at the inevitable death of their loved ones. Camilla grieves because her fiancé is a Curiatius, one of the three Alban brothers whom her kinsmen vow to kill: either her brother or her husband-to-be will die in the conflict, reflecting the moral conflict of the drama.

Although the episode of the oath is not found in either of the two major literary accounts of the tale,[2] the death of Camilla at the hands of her brother Horatius, sole survivor of the combat, is fully narrated in Livy:

Horatius marched foremost, carrying before him the spoils of the three Curiatii, and was met before the gate Capena by his sister [Camilla], a virgin who had been contracted to one of the Curiatii. She knowing her lover's military robe, which she

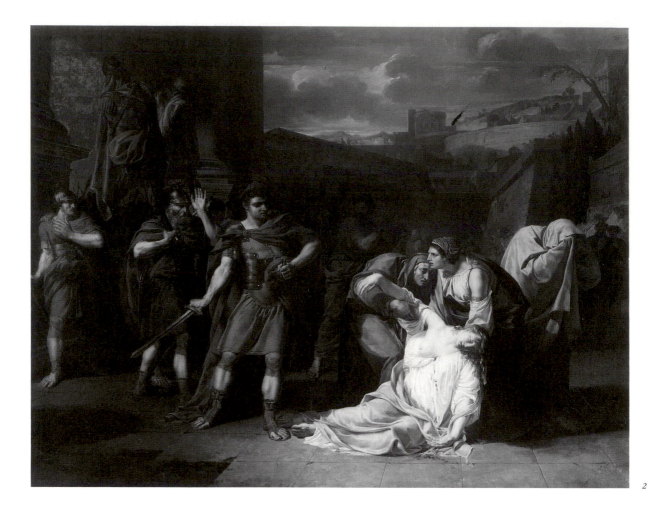

2

had wrought with her own hands, tore her hair, and with bitter wailings called on her dead sweetheart by name. The lamentation of his sister raised the indignation of the young man, elated with his victory and the great public rejoicings that had followed thereon. Therefore drawing his sword, he ran her through the body, at the same time chiding her severely. "Go hence, with thy unseasonable passion to thy lover, forgetful of thy dead brothers, and of him who is alive, forgetful of thy native country. And thus may every Roman woman perish, who mourns for the death of an enemy."[3]

Horatius was subsequently arrested for the murder, but acquitted after a moving appeal from his father. Lethière's presentation of the tragic episode follows the text closely. The young Horatius, crowned with the victor's laurel wreath, has just withdrawn his bloodstained sword from the heart of his sister with the words, "And thus may every Roman woman perish. . . ."[4] The pale body of Camilla, dressed in a virginal white robe, lies slumped on the ground, supported by a pair of women. The younger woman with face in classical profile is undoubtedly Sabina, a sister of the Curiatii and wife of one of the slain Horatii. Sabina is also represented in David's painting, seated behind Camilla, wearing a blue robe and yellow cloak, colors which Lethière has used in reverse to clothe his figure. Another debt to David is the old bearded soldier behind Horatius, one of three Romans bearing the armor of the slain Curiatii on a pole that he grasps in one hand, as the other is raised in astonishment, a gesture

reminiscent of the bystander in David's *Belisarius Receiving Alms* (1780–81, Lille, Musée des Beaux-Arts). Finally, Lethière's opposition of the upright male figures to the curvilinear, "weak" forms of the female group on the right parallels David's compositional scheme in the *Horatii*.

Lethière was born in Guadeloupe and settled in France at the age of fourteen, beginning his study of art in the provinces at the Académie Royale de Rouen. Soon after, in 1777, he studied in Paris with Gabriel-François Doyen, a painter of religious and history subjects and portraits with a "self-consciously Rubensian style."[5] *The Death of Camilla* was not the first canvas which Lethière submitted in hopes of winning the Prix de Rome. In 1784, he placed second in the Prix de Rome competition with his *Christ and the Woman of Canaan* (Angers, Musée des Beaux-Arts). His *Death of Camilla* just missed being runner-up for first prize in 1785, apparently losing because of a plot involving the machinations of a monk, which threw the results in favor of Frédéric Jean Baptiste Desmarais. However, special arrangements were made, through the intervention of an influential patroness, Mme de la Palue, to allow Lethière to spend the years from 1786 to 1790 at the French Academy in Rome.[6] Upon his return, Lethière's entries in the Paris Salons, dating from 1793 on, were typically paintings of religious or classical themes and occasional landscapes. He was appointed director of the French Academy in Rome from 1807 to 1817; there Ingres

became one of his pupils and close friends.[7] In 1819, Lethière was honored with a teaching position in Ecole des Beaux-Arts in Paris.

Lethière's *Death of Camilla,* as an academic exercise, is replete with passages recalling great works of the past with which the artist would doubtless have been familiar either through direct exposure or through prints. The positioning of the dead warriors' armor, for example, framed between columns in the upper left portion of the composition, is similar to that of Poussin's figure of Romulus overlooking the turmoil below him in *The Rape of the Sabines* (ca. 1636–37, New York, Metropolitan Museum of Art). The architectonic landscape background is also Poussinesque in conception. The pathetic body of Camilla held by the two grieving figures resembles nothing less than a lamentation or descent from the cross (cf., e.g., Rubens's *Descent* in the Antwerp Altarpiece, ca. 1611–14), while exhibiting at the same time the idealized beauty of a classically reclining nude such as the *Sleeping Ariadne* (Roman copy of a Greek original, 2nd century B.C.) in the Vatican.[8]

The RISD canvas was preceded by a painted sketch (fig. 1), which is small in scale (32 × 43 cm) and more painterly in execution.[9] The composition is virtually identical to that of the final painting, with the exception of the landscape background, which, following the example of David, is more austere in the finished version. Lethière uses smooth, concealed brushwork, sharp contours, and a friezelike arrangement of the principal figures, clothed in strong primary colors and disposed within a shallow box of space, clearly measured and delineated by the grid pattern of the paving stones. Lethière rejected the even, realistic illumination of David, however, in favor of dramatic spotlighting of the fallen Camilla, making the trail of blood streaming from the blanched skin of her body and down her white dress all the more vivid. This melodramatic tendency, perhaps inher-

ited from Doyen, characterizes much of the artist's work. Another device used to convey emotional turmoil, and which further reflects his academicism, is Lethière's use of programmed facial expressions taken from Charles Le Brun's *Treatise on the Passions* (1698), the guidebook for gesture and expression of many eighteenth-century painters, including David.[10] The faces of Horatius, the bearded soldier behind him, and Sabina are illustrations, respectively, of anger, astonishment, and fear based on Le Brun's prototypes.[11]

The intensity and energy balanced by classical restraint which distinguishes *The Death of Camilla,* painted early in Lethière's career, when the Neoclassical revolution in the arts was still evolving, eventually disappeared in his later work. Two of his largest canvases, *Brutus Condemning his Sons to Death* and *The Death of Virginia* (1811 and 1828 respectively), now in the Louvre,[12] reveal a hardening of his earlier style and an inflated scale. The results are rather lifeless exercises in academic rhetoric. *Brutus* and *Virginia* were only two of four planned canvases with which Lethière had intended to depict great revolutionary periods in Roman history. By the time the second in the cycle was completed in 1828, nine years after Géricault's *The Raft of the Medusa* had influenced the future course of French art, Lethière's style and themes had become dated. Ironically, on the eve of the Revolution of 1830, Lethière's tired classicism appeared to the new romantic generation to be as reactionary as his *The Death of Camilla* had been advanced and even revolutionary in its day. D. E. S.

1. Marandel 1980, pp. 12–17.

2. For a summary of scholars' theories on the origins of David's subject, see Brookner 1987, pp. 70–79.

3. Livy, p. 46 (I, 26). Corneille, on the other hand, indicated in his stage directions for *Horace* (Act IV, Scene 5) that the murder was to take place offstage, in accordance with the rules of classical decorum for French theater in the seventeenth century. However, in a subsequent preface to the play (the *Examen*), he states, citing Aristotle, that he does not categorically object to the violent act being shown. See Brookner 1987, p. 71.

4. See Rochester, Memorial Art Gallery, 1987, p. 124, n. 1.

5. Crow 1985, p. 169.

6. On the Desmarais *affaire,* see Marandel 1980, p. 17. The first-place winner was Victor-Maximilien Potain. Desmarais's and Potain's entries are in the Ecole Nationale Supérieure des Beaux-Arts, Paris, reproduced in Marandel 1980, figs. 6, 7. The second prize was awarded to Bernard Duvivier, whose canvas is in the Musée de Tessé, Le Mans (reproduced in Rochester, Memorial Art Gallery, 1987, p. 90 [fig. 46]). Also of interest is the entry of Anne-Louis Girodet, who would go on to greater fame than any of the prize winners, housed in the Musée Girodet, Montargis. See Cologne, Wallraf-Richartz, 1987, p. 221.

7. Ingres painted a number of portraits of Lethière's family, now in American and French collections, listed in Paris, Grand Palais, 1974, p. 537.

8. The grieving woman entirely shrouded under her cloak on the far right has been traced by Marandel (Marandel 1980, p. 16) to a more contemporary source, Doyen's *Death of Virginia* (Parma, Galleria Nazionale), exhibited in the Salon of 1759.

9. The sketch was formerly listed as Antoine-François Callet (1741–1823), (?) [sic] *La Fille de Jephté,* in Dijon, Magnin, 1938, p. 39 (no. 124). Reattribution to Lethière appears in Sandoz 1985, pp. 158–59 (pl. XVIII, Réf. zz6, n.p.).

Fig. 1 Guillaume Guillon, called Lethìere, *Sketch for The Death of Camilla,* ca. 1785, oil on canvas, 12⅝″ × 17″ (32 × 43 cm), Dijon, Musée Magnin.

10. See Wilson 1981. It should also be noted that paintings of facial expressions constituted a special category within the Prix de Rome competition from 1760 on. See Grunchec 1984, pp. 25, 37–38.

11. Le Brun, *The Expressions* (from *Traité des passions*), Paris, 1698, reproduced in Held and Posner n.d., p. 162.

12. Another *Death of Virginia* by Lethière is found in a private collection in London (Marandel 1980, fig. 11). Neither this version nor the painting in the Louvre bears as close a resemblance to the *Death of Camilla* as a preliminary sketch, presumably for the Louvre canvas, in the Musée des Beaux-Arts, Lille, dated after 1800. See Calais, Beaux-Arts, 1975, pp. 83–85 (no. 40). Finally, a drawing by Lethière for the *Death of Virginia* that bears only a slight resemblance to *The Death of Camilla* is located in the Musée de Pontoise. This has been identified as an entry by Lethière in the Salon of 1795 by Geneviève Capy (Association des Amis de Guillaume Guillon Lethière, Savigny-sur-Orge).

ANGELICA KAUFFMANN
Swiss, 1740–1807

3 *Praxiteles Giving Phryne his Statue of Cupid,* 1794

Signed and dated, upper right: *Angelica Kauffman/Pinx. Romae/ 1794*
Oil on canvas. 17¹⁄₁₆″ × 19¹⁄₈″ (43.3 × 48.6 cm)
Museum Works of Art Fund. 59.008

PROVENANCE: Commissioned by George Bowles, Esq., The Grove, Wanstead, Essex; to his sister Rebecca, Lady Rushout, later first Baroness Northwick (d. 1818); to her son-in-law, Sir Charles Cockrell; sold by one of his heirs, C. F. Rushout, Sezincourt, at Phillips and Neale's, London, 1879; descent unknown to Appleby Bros., London, from whom purchased.

EXHIBITIONS: Allentown, AAM, 1962, p. 77 (no. 57); Cleveland, CMA, 1964, no. 74; Charlottesville, UVA, 1976.

PUBLICATIONS: De Rossi 1810, p. 81; Gerard 1892, pp. 281, 340 (no. 33); Manners and Williamson 1924, pp. 164–65, 173; Clark 1959, pp. 6, 8 (fig. 7); Clark 1981, fig. 176; Roworth 1983, pp. 488–92; Roworth 1988, p. 98 (fig. 5).

CONSERVATION: Cleaned, relined, and varnished in 1981 at the Williamstown Regional Art Conservation Laboratory. Losses of pigment inpainted at that time.

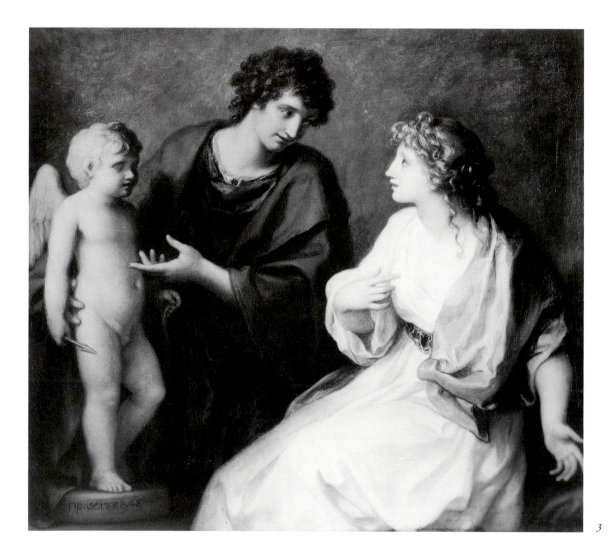

3

Born at Chur, Switzerland, Maria Anna Angelica Catharina Kauffmann received her first artistic training from her father, Johann Joseph Kauffmann, an itinerant ecclesiastical muralist and portraitist. Her talents developed during family trips to northern Italy, where she copied from old master paintings and executed portraits of family friends. It was during the early 1760's, however, while living in Florence (1762), Rome (1763), and Naples, that her painting flourished under the combined inspiration of the arts of antiquity, Italian Renaissance and Baroque painting, and the sophisticated international circle of such contemporary artists as Pompeo Batoni, Anton Raphael Mengs, Gavin Hamilton, Nathaniel Dance, and Benjamin West.[1]

During her second visit to Rome (1764–65), she befriended and subsequently painted a portrait of Johann Joachim Winckelmann, the chief theoretician and spokesman for the Neoclassical movement. It may have been Winckelmann who encouraged her to pursue history painting over portraiture. In any case, Kauffmann's facility with foreign languages, including English, considerable musical talents, and notable beauty insured her popularity with English grand-tourists abroad. She arrived in England in 1766, where she became a friend of Sir Joshua Reynolds and a founding member of the Royal Academy.

As Wendy Roworth has convincingly demonstrated, the Museum's painting belongs to a series of four originally commissioned by George Bowles, Kauffmann's single greatest patron in Britain, who is known to have owned at least forty-two of her paintings.[2] Described by de Rossi in 1810 as among her *opere leggiadrissime* ("most graceful works"), this painting was first recorded in Kauffmann's record book as "Praxiteles giving to his mistress Phryne the lovely little statue of Cupid which he had made." She further noted the circumstances of the commission: "For Mr Bowles of London 4 small pictures, height 2 spans width 2 spans 2 with the following subjects represented by half length figures . . . the price is 30 guineas each and the price for the four is 120 guineas. The above sum was received [from Bowles's agents] on 15th December 1794."[3] Kauffmann listed the subjects of the other three as "The beautiful courtesan Phryne trying to seduce the philosopher Xenocrates who however resists her and does not let himself be conquered by her wiles"; "The Nymph Egeria offering to Numa Pompilius the metal shield which was said to have fallen from heaven"; and "Roman Charity (that is to say Grecian) a young woman feeding with the milk from her breast, her old mother who is in prison and has been condemned to die of starvation as punishment for a crime she had committed."[4]

The RISD painting is the only one of the four whose location is known today and remains Kauffmann's only known painting of this subject. It portrays Praxiteles, the Greek sculptor, with the model for his celebrated sculpture of Aphrodite, Phryne, who later became his mistress. According to Pausanias, Phryne, a celebrated courtesan of fourth-century-B.C. Athens, asked the sculptor to give her the most beautiful of his works. He consented but would not reveal which sculpture he considered his best. The cunning Phryne then tricked him by sending word that fire had broken out in his studio, prompting Praxiteles to bewail the imagined loss of his Cupid, which Phryne then claimed for herself.[5] Kauffmann shows the sculptor with his gaze fixed upon Phryne, holding and pointing to the statue.

The companion picture, *Phryne and Xenocrates,* depicts the abstinent Greek philosopher resisting the efforts by the notorious courtesan to seduce him; she subsequently accuses him of being as cold as a statue.[6] As Roworth points out, both tales involve the same woman's use of treachery to win her way with a man. In one, a statue serves as the man's token of affection; in the other, the man behaves like a statue. Thus Kauffmann's two paintings of Phryne serve as complementary allegories of both positive and negative aspects of beauty and love.[7]

Two other paintings that Bowles commissioned at the same time, *Roman Charity* and *Numa Pompilius and Egeria,* would have portrayed more virtuous, noble women who give both physical and spiritual nourishment while expressing filial and marital love.[8] Two earlier Bowles commissions, *Zeuxis and the Maidens of Crotona,* ca. 1780 (Providence, Annmary Brown Memorial, Brown University), and *Alexander Giving his Beloved Campaspe to Apelles,* 1783 (Bregenz, Vorarlberger Landesmuseum), address the related themes of artists, their patrons, and their models.[9]

Whereas the two earlier paintings for Bowles were based on well-known antique legends, the RISD painting and its three companions represent little-known subjects that were both erudite and decorative, instructive without being ponderous. Considered in the context of Bowles's other pictures of antique themes, they indicate that he was a learned man with a sense of humor. For her part, Kauffmann demonstrated her own extensive knowledge of antiquity and the wit to recombine obscure historical motifs into new and original pictorial programs. T. S. M.

1. See Walch 1977, p. 98. See also Thurnher 1966.
2. Roworth 1983, p. 490. See Gerard 1892, pp. 338–41.
3. Quoted in Manners and Williamson 1924, pp. 164–65.
4. Quoted in Manners and Williamson 1924, p. 165.
5. Pausanias, *Descriptions of Greece,* "Attica," xx. 1–2 (trans. W. H. S. Jones. Cambridge: Loeb Classical Library, 1969, I, pp. 96–97), cited in Roworth 1983, p. 489, n. 8.
6. The painting is illustrated in Roworth 1988, fig. 6.
7. Roworth 1983, p. 491.
8. See Roworth 1983, p. 492.
9. For *Zeuxis,* see Roworth 1988, fig. 8. For *Alexander and Campaspe,* see Bregenz, Vorarlberger, 1968, no. 55.

WILLIAM BLAKE
British, 1757–1827

4 *The Baptism of Christ,* ca. 1799–1800

Pen and ink and tempera on paper, mounted on canvas.
12⅝″ × 19⅜″ (32.1 × 49.2 cm)
Museum Appropriation. 32.219

PROVENANCE: Thomas Butts, by ca. 1800; Thomas Butts, Jr.; sold Foster's, June 29, 1853 (73);[1] J.C. Strange by 1863; Mr. Kennedy, Boston;[2] Gordon Kennedy, Boston, by 1932; from whom purchased, 1932.

EXHIBITIONS: Philadelphia, PMA, 1939, p. 106 (no. 154, ill. p. 105); Washington, D.C., National Gallery, 1957, p. 13 (no. 3).

PUBLICATIONS: Rossetti, in Gilchrist 1863, II, p. 226 (no. 138); Rossetti, in Gilchrist 1880, II, p. 238 (no. 163); Keynes 1957, p. 30 (no. 109a, ill.); Blunt 1959, p. 105; Keynes 1971, p. 156; Bindman 1977, p. 123; Paley 1978, p. 55 (pl. 75); Butlin 1981, I, p. 329 (no. 415).

In 1799 William Blake received a commission from Thomas Butts of London for a series of fifty illustrations of scenes from the Bible.[3] Butts (1757–1845), a clerk in the office of the Commissary General of Musters, left the determination of individual subjects to Blake, who chose approximately fifteen from the Old Testament and the remaining thirty-five from the Life of Christ.[4] The Baptism of Christ from this series represents the inauguration of Christ's adulthood and ministry; it embodies Blake's vision of the Son of God as the ideal man and incorporates the artist's appreciation, to this date, of both Renaissance and Neoclassical art.

The first of three interpretations of *The Baptism of Christ* to be painted by Blake, the Museum's painting is the most typical of traditional iconography of the event, simplifying a scheme that might have been best known to Blake from Perugino's fresco of this subject in the Sistine Chapel.[5] As in the Perugino and in earlier Renaissance depictions, Christ is the central figure in Blake's painting, his classically articulated torso and limbs draped only with a loincloth. Hands joined in prayer, the radiant incarnate Christ is the only frontal figure in Blake's composition. His stance, with right foot forward in slight contrapposto, derives from the statue of Apollo Belvedere, a canon of physical perfection that was Blake's acknowledged model for the "Beautiful Man."[6] As the only frontal figure in Blake's composition, Christ is depicted with a clarity and weight that recall Masaccio's Brancacci Chapel frescoes and their own debt to classical antiquity.

Christ's counterpart and New Testament precursor, John the Baptist, is clothed in animal skins, his back turned completely to the viewer in a contrasting pose invented by Blake. With both arms upstretched, he trickles water on the head of Christ, while in the heavens above a choir of angels gathers in praise as the words of the Gospel are fulfilled: "And lo, the heavens were opened unto him and he saw the spirit of God descending like a dove, and lighting upon him" (Matthew 3:16). On either side of the central figures Blake

has placed small groups of anonymous witnesses representing the generations of man. These slender, stylized men, women, and children stand with eyes upraised or downcast in prayer, reverently averted from the light of Christ, or kneel to emulate the act of Baptism in the shallow water. Their incised, Neoclassical profiles and columnar draperies clearly distinguish them from the Renaissance form of Christ. Typical of this period in his work, Blake is eclectic in his combination of influences, asserting the primacy of line while imposing a formal, anatomical hierarchy on his figures.

In the watercolor version of *The Baptism of Christ* (ca. 1803; Oxford, Ashmolean Museum), part of a second, more extensive series of Biblical illustrations commissioned by Butts,[7] Blake includes fewer attendants and takes greater license with the iconography. Here he depicts a flaccid-limbed Christ, His back turned to the viewer, while adopting a more traditional side view of the Baptist. The focus is narrowed further in the third version,[8] an illustration for Milton's *Paradise Regained* in the Fitzwilliam Museum, Cambridge, in which Christ is again portrayed frontally as a muscular figure beside a reversed form of the Baptist. In this final version, the foreshortened, Michelangelesque torso of Satan, fleeing the scene of Biblical regeneration, dramatically shifts the content of the image and justifies the absence of all but a few witnesses.

Although Blake's work as a painter was predominantly figural, looking to man rather than nature for the model of the Sublime, the RISD version of *The Baptism of Christ* was singled out by the critic William Michael Rossetti in 1863 as one of Blake's most exquisite landscapes.[9] Notwithstanding his later disavowal of the paintings of the Venetians for their suppression of line in the service of color, Blake achieved brilliant effects in the red-, blue- and yellow-streaked sky of the *Baptism,* and in the dense grove of trees that shelters a flock of sheep on the shores beneath. He had selected the medium of tempera precisely for its ability to achieve and maintain brilliant color, detesting the oil medium for what he believed was a tendency to darken and crack. Blake's tempera technique, which eventually had the opposite effect to that desired, involved the preparation of the canvas, or in some cases a copper plate, with several layers of either whiting or carpenter's glue, followed by the application of pigments suspended in a weaker solution of that same glue. A final, clear layer of glue sealed the picture, which was then varnished with a hard white varnish of Blake's own devising.[10] The effect he sought, erroneously called "fresco" in his 1809 "Descriptive Catalogue...,"[11] was that of a panel painting, ideal for the cabinet pictures he was creating for Butts in 1799–1800.

By the mid-nineteenth century, the surfaces of many of these paintings had been adversely affected by moisture, and pigments had darkened and flaked, leaving some works in a state of irretrievable disrepair. To a great extent, however, the Museum's *Baptism* is an exception to this rule, preserving much of the brilliance and light that Blake had intended. Of

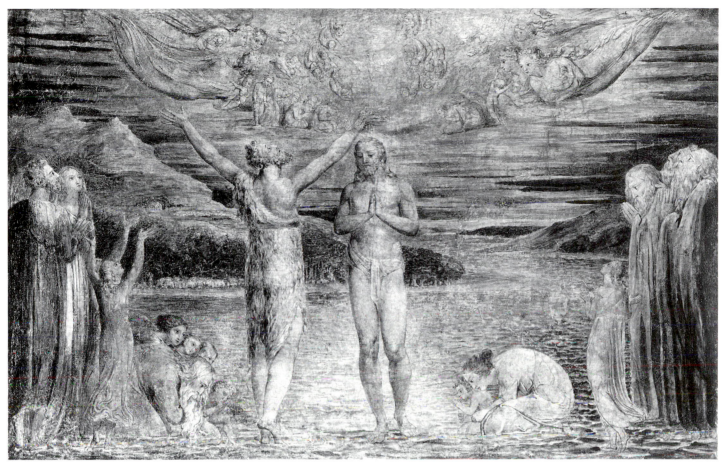

4 (color plate p. 17)

the thirty or so extant works of this first Biblical series, *The Baptism of Christ,* in which Blake realizes his vision of Christ as the sublime physical model of man, is among the most informative about Blake's philosophy of painting. In technique it aspires to the marriage of line and pigment that Blake admired in the great Renaissance fresco painters. In its extraordinary, wholly personal, interpretation of landscape, it also survives as one of a small number of paintings that successfully demonstrate Blake's unique talent as a colorist, a quality that is more commonly seen in his prints.

M. C. O'B.

1. Butlin 1981, I, p. 329 (no. 415), notes that "Streetly, Strang Street," presumably confusing J.C. Strange with his address at Streatly, is listed as the buyer in the copy of the 1853 sale catalogue in the Victoria and Albert Museum Library.

2. The painting was purchased in July 1932 from Gordon Kennedy, 395 Commonwealth Avenue, Boston. In a letter of July 11, 1932, to Helen M. Danforth, recommending the purchase, William C. Loring wrote: "A painting by William Blake owned by the Kennedy family is offered for sale (distress selling)... Years ago a New York dealer offered Mr. Kennedy's father $2500 for the painting."

3. Blake wrote of the commission of Biblical paintings in a letter to George Cumberland of August 26, 1799: "My Work pleases my employer, & I have an order for Fifty small Pictures at One Guinea each...." Cited in Keynes 1966, p. 795.

4. Bindman 1977, p. 118, calculates the distribution of Old and New Testament subjects in the Butts tempera commission, noting that the primary theme is the Life of Christ.

5. Blake was an ardent admirer of Raphael and Michelangelo and studied their paintings through engravings. Engravings would also have been his sources for other works in the Vatican, including the paintings of Perugino.

6. In "A Descriptive Catalogue of Pictures, Poetical and Historical Inventions, Painted by William Blake . . . &.," 1809, appended to Gilchrist 1863, II, p. 135, Blake wrote: "It has been said to the Artist, Take the Apollo for the model of your Beautiful Man, and the Hercules for your Strong Man, and the Dancing Faun for your Ugly Man."

7. Butlin 1981, no. 475. Butlin 1981, I, p. 335, discusses the Butts watercolor series of Biblical subjects, which numbered over eighty works.

8. *The Baptism of Christ,* from *Twelve Illustrations to Milton's "Paradise Lost,"* ca. 1816–20, Cambridge, Fitzwilliam Museum (Butlin 1981, no. 544–1).

9. In Gilchrist 1863, II, p. 226, Rossetti's "Annotated Lists of Blake's Paintings, Drawings, and Engravings; List No. 1, Works in Color," notes no. 138, *The Baptism of Christ:* "One of Blake's most beautiful landscape-backgrounds."

10. See Lister 1975, for a complete discussion of Blake's techniques and materials.

11. See n. 4.

JOHN OPIE
British, 1761 – 1807

5 *La Fille mal gardée*
(The Fugitive), 1800

Oil on canvas. 108″ × 72″ (274.4 × 182.9 cm)
Gift of the Wunsch Foundation. 83.221

PROVENANCE: Estate of the artist; Christie's, London, May 23, 1807; N. R. Colburn, Esq.; Sir Edmund Nugent, Bart.; Sotheby Parke Bernet, New York, Inc., June 11, 1981, lot 274; Wunsch Foundation, 1981.

EXHIBITIONS: London, Royal Academy, 1800, no. 154 (as *The Fugitive, or La Fille Mal Gard* [sic]); London, British Institute, 1817, no. 23 (as *The Elopement*).

PUBLICATIONS: Rogers 1878, pp. 211–12; Earland 1911, pp. 255, 345; RISD, *Museum Notes,* 1984, p. 28.

CONSERVATION: Glue lining applied prior to 1981; painting surface cleaned with naphtha and revarnished with B-72, November 1982, at the Williamstown Regional Art Conservation Laboratory.

John Opie was a significant contributor to the elevation of genre painting in England at the end of the eighteenth century, drawing inspiration from the "fancy pictures" of Thomas Gainsborough and the narratives of William Hogarth, as well as the dramatically lit scenes of Joseph Wright of Derby. Although his direct and unflattering style eventually caused his fall from favor as a portrait painter, this blunt realism enriches his genre painting with penetrating accuracy. The experience of his youth in a poor mining district of Cornwall informs his scenes of rural poverty, which are far removed from Gainsborough's pastoral fantasies of the rococo style.

Opie was encouraged to paint by the physician and art critic John Wolcot, who took the fourteen-year-old boy into his home and gave him artists' materials and prints to copy. After three years as an itinerant portrait painter in Cornwall and Devon, Opie made his debut in London, where he became known as the "Cornish Wonder." His 1780 entry in the exhibition at the Society of Artists, *Boy's Head,* was

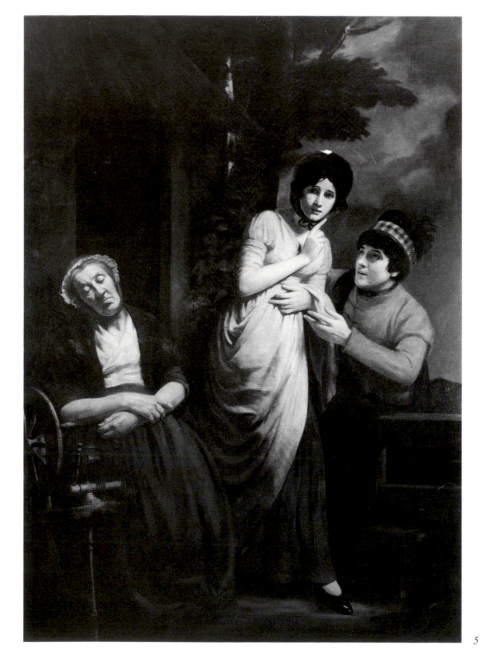

5

described in the catalogue as by "Master Oppey, Penryn, Cornwall. An instance of Genius, not having ever seen a picture."[1] By 1782 George III had purchased Opie's *Beggar and his Dog,* and his exhibited works elicited comparisons to Rembrandt and Caravaggio[2] as well as the comment, probably made by Wolcot under the pen name Peter Pindar, "There is a maturity and judgment, a truth and force of colouring in his portraits which are astonishing. We hope Sir Joshua Reynolds will take some lessons of this young man before he leaves London."[3] Society flocked to Opie's studio, and in March 1782 the artist wrote to a friend, "I have all the quality at my lodgings every day, nothing but Lords, Ladies, Dukes, Duchesses, etc."[4]

By 1783 Opie's popularity had waned as patrons began to realize that he had no interest in idealizing or flattering them and that the artist eschewed the substitution of an artificial beauty for the accuracy of nature. Wolcot later said of his protégé: "Opie I fear is too fond of imitating coarse expression . . . To him at present elegance appears affectation, and the forms of Raphael unnatural."[5] Lacking portrait commissions, Opie turned to history painting and attained critical success with *The Death of Rizzio* in 1787, the year in which he was made a Royal Academician.

La Fille mal gardée, Opie's largest known genre painting, was exhibited at the Royal Academy in 1800. Its source is a ballet of the same name choreographed by Jean Dauberval to music composed of French folk songs. The ballet was first performed in Bordeaux on July 1, 1789, and opened in London at the Pantheon Theatre on April 30, 1791.[6] The setting is the farm of the wealthy Widow Simone, whose daughter Lise, against her mother's wishes, is in love with the farmer Colas. Simone contrives to marry her daughter off to the son of the wealthy landowner, Thomas. Opie portrays the dramatic moment in Act II when Colas tries to convince Lise to elope with him while the Widow sleeps at her spinning wheel. Awaking, Simone intervenes and banishes the girl to her room, where Colas is already hiding. When Lise and Colas are revealed, the Widow, overcoming her fury, tears up the marriage contract she had arranged with Thomas and blesses the young lovers.

The moral message of the libretto, love conquers all, originates in classical literature. Set in a rural context, it reveals the tendency common in the late eighteenth century to find moral lessons in the more "natural" life of simple country folk. Opie's painting has its antecedents in the sentimental moralizing genre paintings made popular in France a generation earlier by Jean-Baptiste Greuze (1725– 1805).

Despite the shallow, stagelike space of the painting and the backdrop scale of the thatched house and railing, Opie's figures wear neither ballet costume nor farmer's garb. Nevertheless, his rendering of the rough hands and lined face of the sleeping old woman conform to his reputation as an uncompromising realist. In this he may have drawn not only on his experience as a portrait painter in the rural areas of southern England, but also on the expressive characters in Hogarth's illustrations of theatrical performances, such as *The Beggar's*

Opera, 1728–29, and *Marriage à la Mode,* 1743–45. Yet by reducing the clutter of figures and props and increasing their size, solidity, and solemnity, Opie's painting may be more closely related to Reynolds's theatrical portraits, *Sarah Siddons as the Tragic Muse,* 1784 (San Marino, Huntington Library and Art Gallery), and *Garrick between Comedy and Tragedy,* 1760–61 (private collection). Reynolds's influence is more clearly apparent in Opie's palette, which includes the darkening agent bitumen currently obscuring the luminosity of the deeper russets, greens, and browns in *La Fille mal gardée.*

La Fille mal gardée is not mentioned in Whitley's review of the 1800 Royal Academy exhibition,[7] but Fuseli might have been thinking of it when he said of Opie's work, "Not made to dandle a kid, he painted in large historic proportions, misses eloping, beggars, fortune tellers"[8] The picture remained unsold until the artist's death in 1807 and was auctioned shortly thereafter. A. H. S.

1. Dorment 1986, p. 248.
2. Northcote 1813, p. 285.
3. Whitley, *Artists,* 1928, I, p. 376.
4. Rogers 1878, p. 24.
5. Rogers 1878, p. 19.
6. New York Public Library 1974, IV, p. 2291.
7. Whitley 1928, p. 6.
8. Burke 1976, p. 301.

SIR THOMAS LAWRENCE
British, 1769–1830

6 *Portrait of John Philip Kemble* (fragment), ca. 1800

Oil on canvas. 9⁹⁄₁₆″ × 7⁷⁄₁₆″ (24.2 × 18.9 cm)
Helen M. Danforth Fund. 59.062

INSCRIPTIONS: *John Philip Kemble as the Stranger by Sir T. Lawrence* inscribed in ink on the back panel of the frame; *J. Weitzner* inscribed in blue chalk on the right vertical member of the frame; the paper label of Appleby Bros., London, affixed to the lower right corner of the back panel.

PROVENANCE: Julius Weitzner, New York (?); Appleby Brothers, London, from whom purchased for the Museum.

EXHIBITION: Waltham, Rose, 1972.

PUBLICATIONS: Garlick 1964, p. 116 (no. 4); Garlick 1989, p. 217 (no. 451h).

CONSERVATION: The canvas is unstretched and appears to be a fragment cut from a larger, unfinished picture.

After the death of Sir Joshua Reynolds in 1792, Thomas Lawrence was appointed Painter in Ordinary to the King. His election to the Royal Academy of Arts followed in 1794 at the age of twenty-five. In 1820, after nearly a year in France, Austria, and Rome as a special envoy of the Prince Regent, he succeeded Benjamin West as the third president of the Royal Academy, thus confirming his success as the foremost portrait painter of Regency Britain.

John Philip Kemble (1757–1823) was one of the most popular and prolific actors in Regency England. Just as the portraits of Lawrence have come to embody English society of the Regency period, so Kemble's dramatic roles became the standard renditions for a generation of actors and London theater-goers. Handsome, wealthy, and a loyal courtier, Kemble belonged to an extended family of actors and actresses that included his father, Roger Kemble, and two sisters, Fanny Kemble and Sarah, who married the actor William Siddons. Collectively they dominated the London stage at the end of the eighteenth century.[1]

Thomas Lawrence and John Philip Kemble had been close friends since their boyhood days in Bath. Lawrence was subsequently engaged first to Kemble's niece Sarah and then to her sister Maria, though ultimately he never married. Lawrence painted Kemble on several occasions between 1797 and the 1820's.[2] At the time this sketch was begun, Kemble was at height of his powers and, according to an early biographer, well known for his "finished pictures of despair, suffering, or abandonment" in such tragic roles as Hamlet, Coriolanus, and Cato.[3]

As the result of a later inscription on the back of the frame (see "Inscriptions"), this painting has been repeatedly identified in the secondary literature as a portrait of Kemble in the title role of *The Stranger,* from the play written by Kotzebue. However, it is more likely a preliminary study for the portrait of Kemble as Rolla (Kansas City, Nelson-Atkins Museum) or possibly as Hamlet (London, Tate Gallery). Both identifications have been proposed by Kenneth Garlick, who first suggested Rolla, but has most recently

6

published the RISD head as an early work that "may be connected with first thoughts for Hamlet."[4] According to the contemporary diary kept by Joseph Farington (1747–1821), Lawrence did paint the finished version of Hamlet "from a small study," of which several versions are recorded, although Garlick does not consider the RISD sketch to be one of them.[5]

The finished, full-length portrait of Kemble as Hamlet depicts the tragic hero looking upward as he lowers Yorick's skull in his left hand. The RISD head is conceivably a preliminary study, although its small size precludes further similarities beyond the likeness. The pose of the head, the arms, and the dark background are equally plausible as preliminary thoughts for the contemporary portrait of Kemble as Rolla, in which a Peruvian soldier clad in a billowing leopard-skin cloak holds up a child in his left hand against a stormy sky while staring at the dagger in his right hand. According to tradition, the pugilist Jackson modeled for the figure of Rolla and a son of Sheridan for the child.[6] The finished version was first exhibited at the Royal Academy in 1800, shortly after the play's London debut.

The portrait of Kemble was perhaps inspired by *Rolla, or the Peruvian Hero* (1799), a popular tragedy in five acts translated by Richard Brinsley Sheridan from the German of playwright August Ferdinand Kotzebue (1761–1819).[7] Widely criticized for their embellishment "with inconceivable rant and fustian," several other plays by Kotzebue had been translated by Sheridan and produced in Britain between 1796 and 1801. *Rolla* had appeared in at least twenty-nine English editions by 1811, its remarkable popularity due to a stirring

speech in the second scene of the second act, in which the hero declares, "Their cry is Victory or death! Our King! Our country! and our God!" This speech was widely reprinted and became the slogan of British patriots during the Napoleonic Wars.[8] According to Farington, there was a proposal to send the finished Rolla to the British Embassy in Paris in 1803; four other versions are recorded in English public and private collections.[9]

Lawrence apparently chose to depict the final moments in the tragic life of Rolla, just as Pizarro's soldiers are about to kill him as he delivers a child hostage safely to its parents. Such dramatic expressions and declamatory gestures were well-known conventions of eighteenth-century theater and a specialty of Kemble.[10] Even this fragmentary sketch of Kemble's head reflects the psychological theories of Johann Casper Lavater (1741–1801) and Charles Le Brun (1619–1690), whose widely published treatises attempted to codify a broad range of human passions by illustrating their corresponding facial expressions. History and portrait painters relied on their facial typologies, as did actors and their audiences. English translations of LeBrun had appeared as early as 1701, and subsequent editions were recommended to artists first by Jonathan Richardson in his *Essay on the Theory of Painting* (1725) and later by Hogarth and Reynolds. Le Brun's facial types certainly would have been familiar to Lawrence as well.[11] T. S. M.

1. For a biographical account of the Kemble family, see Baker 1942.

2. See Garlick 1964, pp. 115–16, and Garlick 1989, no. 451.

3. Fitzgerald 1871, II, p. 3.

4. Garlick 1989, no. 451h. From a photograph, Garlick was unable to say with certainty whether or not the RISD sketch depicted Kemble, although he wrote that "it certainly has a Kemble look" (letter to Anthony Clark dated September 24, 1959, in RISD Museum files). For the identification of the RISD head as a sketch for the *Rolla* in Kansas City, see Garlick 1964, p. 116 (nos. 3–4).

5. Farington, IV (February 1800), p. 1377, as cited in Garlick 1989, no. 451d.

6. Garlick 1989, no. 451c.

7. The title has been variously translated as *Pizarro*, *Pizarro in Peru*, and *Pizarro, or the Spaniards in Peru*.

8. See Genest 1832, VII, p. 421, and Baker 1942, pp. 230–31.

9. Garlick 1989, no. 451c, and Garlick 1964, pp. 115–16 (no. 3).

10. See Smart 1965, p. 90.

11. For Le Brun's influence on eighteenth-century English art, see Le Brun 1980, pp. vii–ix.

SIR THOMAS LAWRENCE
British, 1769–1830
(Finished posthumously by John Simpson, British, 1782–1847)

7 *Portrait of Lady Sarah Ingestre,* ca. 1827–28

Oil on canvas. 92⁹⁄₁₆″ × 56¼″ (235.1 × 142.8 cm)
Museum Works of Art Fund. 60.039

INSCRIPTIONS: *T. Brown/High Holborn/LINEN* stenciled at bottom on back of canvas. *Mr. John Simpson, 10 Carlisle St.* [illegible] written in white chalk at top center of back of canvas.

PROVENANCE: The Earls of Shrewsbury, Ingestre Hall, Staffordshire; sold at Sotheby's, London, March 23, 1960, lot 64; John Mitchell and Son, London, from whom purchased.

PUBLICATIONS: Crofton 1954, p. 68 (no. 30); Garlick 1954, pp. 43, 74 (no. 89); Garlick 1960, pp. 8–12; van Braam 1960, p. 270 (no. 3071); Garlick 1964, pp. 111–12, 313; Garlick 1989, p. 213 (no. 433).

CONSERVATION: In the course of an early restretching, perhaps by the artist, both width and height of the canvas were marginally reduced (approx. ½″). Upper right edge damaged by water during transit from London, 1960. Conserved May

7

1960 by Alfred Jakstas, Belmont, Massachusetts. Cleaned, old varnish removed, varnished, and relined in 1982 at the Williamstown Regional Art Conservation Laboratory.

This full-length portrait of Lady Sarah Elizabeth Beresford (1807–1884) was probably painted as a wedding portrait around the time of her marriage in 1828 to Henry John Chetwynd-Talbot, Viscount Ingestre and third Earl Talbot, later eighteenth Earl of Shrewsbury and Waterford. Her pose with a rose held to her breast belongs to a long iconographical tradition conveying virtue and purity, both typical attributes for wedding portraits. Left unfinished at the time of Lawrence's death in 1830, the portrait is recorded in the inventory of his studio among nearly two hundred unfinished canvases:

Claimant Lord Ingestre

Date of claim and Letters recd 26 June 1830
6 July
4 Nov. Farrer & Co.

Subject of claim Port. of Lady S. Ingestre

Money paid £362.10.0

Manner & date of payment Drummond
11 August 1814
Marq. of Waterford's dft.

No. in the Gen. List and
State of the Picture No 87–Not ½ finished.

Delivered 4 Nov. 1830 with No. 278[1]

According to Kenneth Garlick, the discrepancy between the date of initial payment in 1814 (when Lady Sarah was but seven years old) and the actual sitting, which would have taken place in 1827 or 1828, can be explained by the reference to "No. 278," an earlier portrait of Lady Sarah's mother, the Marchioness of Waterford, recorded in the inventory as only one-sixth finished. Lawrence had previously painted other members of the Talbot family, including a double portrait of Viscount Ingestre's father, the second Earl Talbot, and his younger brother painted in 1792 (Munich, Neue Pinakothek).[2]

The unfinished parts of Lady Sarah's portrait were probably her satin dress and the landscape in the background. Garlick attributed these portions to one of Lawrence's most accomplished studio assistants, John Simpson (1782–1847), on the basis of the brushwork accentuating the highlights of the satin dress.[3] The subsequent discovery of Simpson's name and address written in chalk on the back of the canvas gives added weight to this attribution.

Of the portion completed by the time of the artist's death, the head is surely by Lawrence. The overall composition of a full-length figure posed next to a balustrade against a landscape recurs with minor variations in other portraits by Lawrence, most notably those of Mrs. Harriet Byng and of Diana, Countess of Normanton.[4] The exhibition of the latter portrait at the Royal Academy in 1827 would have coincided with Lady Sarah's first sittings and may account for their similarity. In addition, Lady Sarah's full-length

pose next to a balustrade with her arm extended formed an appropriate pendant to two earlier family portraits of Elizabeth, Lady Price, by Opie, and of John Chetwynd, first Earl Talbot, by Batoni, originally hung opposite in the Yellow Drawing-Room at Ingestre Hall.[5]

Contemporary descriptions of Lady Sarah confirm the youthful, patrician beauty that Lawrence has captured with such facility. The indefatigable diarist Mrs. Arbuthnot described Lady Sarah shortly after this portrait was taken as "one of the prettiest women I ever saw."[6] Later descriptions, on the other hand, belie the innocent virtue expressed by Lady Sarah's pose and floral attributes. According to Charles Greville, she was a "foolish" and "vulgar" woman who disgraced herself and everyone else nearby by hissing at Queen Victoria as Her Majesty's coach passed at the Ascot races.[7]

Lady Sarah survived her critics, however, and lived at Ingestre Hall, the Staffordshire seat of the Chetwynd family, until her death in 1884. Built in the early seventeenth century, the house was first remodeled by John Nash between 1808 and 1813. Badly damaged by fire in 1882, Ingestre Hall was subsequently remodeled in the Jacobean style by the London architect John Birch. This and other family portraits identically framed hung in the refurbished Yellow Drawing-Room, whose style Pevsner described as "a very busy kind of free Quattrocento that deceives people into taking it for a paraphrase of the Adam style."[8] Lady Sarah's portrait remains in the frame designed by Birch. Its carved and painted swags and trailing garlands of fruit against a grey ground recall Adamesque Neoclassicism, yet are consistent with the older Jacobean style of its original architectural context. T. S. M.

1. Garlick 1964, p. 111 and Appendix IV, p. 313 (no. 381).
2. Garlick 1954, p. 17; Garlick 1989, no. 432.
3. Garlick 1960, p. 11.
4. Garlick 1960, p. 10 (fig. 2). For the portrait of Mrs. Harriet Byng, ca. 1801, see Garlick 1964, p. 46.
5. See Nares 1957, p. 926 (fig. 7).
6. Arbuthnot 1950, II, p. 389.
7. Greville 1938, IV, p. 181.
8. Pevsner 1974, pp. 154-55.

JOSEPH CHINARD
French, 1756–1813

8 *Bust of Madame Récamier*, original ca. 1801

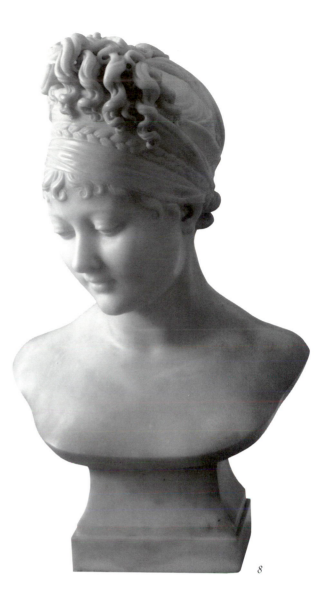

8

Signed, right side of pedestal: *Chinard de Lyon* (posthumous
copy of original)
Marble. 22¼″ × 13″ × 10″ (56.5 × 33 × 25.4 cm)
Gift of Mrs. Harold Brown. 37.201

PROVENANCE: Madame Récamier; Madame Lenormant, her
niece and adopted daughter; Hôtel Drouot, Paris, sale,
November 29, 1893, no. 2; Marquis de Gontaut-Biron; Mrs.
Harold Brown.

EXHIBITIONS: Providence, RISD, 1957, p. 12 (no. 47); London,
Royal Academy, 1972, p. 225 (no. 346); Providence, RISD, 1978;
New York, IBM, 1988; New York, NAD, 1988.

PUBLICATIONS: Paris, Hôtel Drouot, 1893, no. 2 (ill.);
Herriot 1905, pp. ii, 35; *Bulletin de l'Art* 1909, p. III; Bertaux
1909, pp. 321–36 (ill.); Tourneux 1909; Lami 1910, I, pp. 209–10;
Paris, Georges Petit, 1911, p. 12; London, Royal Academy, 1932,
p. 212 (no. 1007); Dorner 1938, pp. 13–19 (ill.); Lane 1939,
pp. 71–72 (ill.); Ledoux-Lebard 1947, p. 73; Praz 1969, p. 252;
Rocher-Jauneau, *BMML*, 1978, pp. 138, 143 (fig. v); Rocher-
Jauneau 1978, p. 53; Monkhouse 1978, pp. 194–97 (figs. 3, 6);
Lyons, Beaux-Arts, 1986, p. 102 (no. 50).

RELATED WORKS: *Bust of Madame Récamier*, ca. 1795, bronze,
h. 7½″ (19 cm), location unknown.[1] *Bust of Madame Récamier*,
ca. 1804, marble, Lyons, Musée des Beaux-Arts. *Bust of Madame
Récamier*, 1801, terra cotta, Malibu, J. Paul Getty Museum.

Juliette Récamier (née Jeanne-Françoise-Julie-Adelaïde
Bernard, 1777–1849) was one of the most fashionable and
beautiful women in Napoleonic France, and one of the more
interesting personalities of a society that rose out of the tur-
moil of the Revolution. She was the daughter of a Lyonnais
notary who moved to Paris in 1784 on becoming a *Receveur
des finances* to Louis XVI. In April 1793, at the height of the
Terror, three months after the execution of the King, she
married Jacques-Rose Récamier, a wealthy banker-financier,
who was also originally from Lyons. Juliette was only fifteen
years old at the time; her new husband was forty-three. The
bonds uniting them, according to her niece and adopted
daughter, were "of a strictly paternal character. [Jacques
Récamier] treated the young and innocent girl who bore his
name, like a daughter whose beauty charmed his eyes, and
whose celebrity flattered his vanity."[2] It has been suggested
that M. Récamier was in fact the young girl's biological
father, who, fearing the guillotine, married his daughter to
secure his fortune to her.[3]

Aided by her considerable beauty, her husband's great
wealth, and a charming and ingratiating character, Madame
Récamier became one of the most sought-after women in
turn-of-the-century Paris, in spite of her matrimonial status.
Her appearances in public during the Directory ignited a stir
among the crowds, who jostled to get a look at her.[4] In her
physical appearance she embodied the then-fashionable
Neoclassical taste: her coiffure was inspired by ancient Roman
frescoes; she wore only white, flowing garments "in the
antique manner," as she is pictured in portraits by David
(1800, Paris, Musée du Louvre) and Gérard (1805, Paris,

Musée Carnavalet), and later by François Dejuinne (after 1825,
private collection).[5] Her suitors are said to have "burned for
her with the most ardent but least rewarded passion," earning
her the reputation of a "coquette," something of which is
suggested by Chinard's portrait, as by Gérard's painting of
her.[6]

The sculptor Chinard, like the Récamiers, was of Lyon-
nais origin, and also a product of the unpredictable events
and opportunities brought on by the Revolution. He studied
at the Ecole Royale de Dessin de Lyon and apprenticed in
the studio of the Lyons sculptor Barthélémy Blaise. In 1784
a local patron, the chevalier de La Font de Juis, provided the
funds that enabled Chinard to travel to Rome, where he
remained until 1787. Returning to Rome in 1791, he was
arrested for supposed revolutionary and anticlerical senti-
ments expressed in his work. He was eventually released
from prison (and expelled from Rome) through the inter-
vention of the painter David before the Convention, and of
the Minister of the Interior, Roland, who appealed directly
to the Pope. Back in Lyons in 1792, he was imprisoned yet
again, this time because of counterrevolutionary sentiments
that were perceived in his statue of *Liberty* created for the
façade of the Hôtel de Ville in Lyons. He was acquitted in

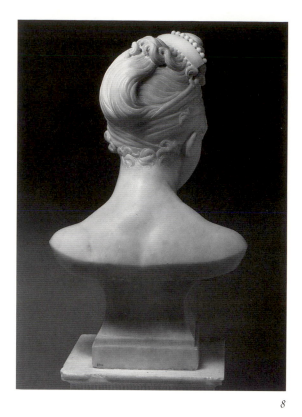

8

1794 and continued to devote much of his time and talent to the ideals of the Revolution: like David in Paris, he designed the grand republican *fêtes* that were celebrated in Lyons; throughout the course of the Revolution and Empire he created numerous busts and medallions of patriots, members of the Convention, generals, and assorted members of Napoleon's court.

The Museum has in its collection two portrait medallions in terra cotta by Chinard, part of the gift of Napoleonic art from Mrs. Harold Brown, that are typical of these "political" portraits.[7] One is a *Medallion of General Eugène de Beauharnais (1781–1824),* ca. 1805 (37.240, see checklist), representing Joséphine's son by her first husband, Alexandre, Vicomte de Beauharnais. Eugène, Napoleon's stepson and one of his most trusted generals, is depicted by Chinard in his uniform of commanding general of the Chasseurs de la Garde. It was modeled in the same year Beauharnais was made Viceroy of Italy by the self-appointed Emperor. A full marble bust of Beauharnais, now in the Versailles Museum, was exhibited by Chinard in the Salon of 1806.[8] The other medallion portrait by Chinard is of an *Unknown Man, called "General Duchesne,"* 1805 (37.241, see checklist) of which a terra-cotta version was also in the Penha-Longa Collection.[9]

Chinard probably met the Récamiers for the first time in 1795, when he came to Paris to be admitted as a member of the Institut de France. It was during this visit that he is believed to have executed his first bust of the then seventeen-year-old girl (ex coll. Penha-Longa). This youthful portrait, its sweetness reflecting the survival of Rococo influences in Chinard's Neoclassical art, represents the young girl with her head declined toward her right, her hair in a Greek turban, her torso wrapped in a semi-transparent shawl that falls to

expose her left shoulder and breast, despite her effort to hold it together with her hands.

The Museum's portrait is one of two marble busts created from a terra cotta that Chinard modeled in 1801 and probably carved after he established a studio in Carrara in 1804, where he executed marbles from earlier models.[10] A letter from Chinard suggests that another version of this bust may have been exhibited in an undetermined Salon between 1801 and 1803.[11] The RISD bust descended directly from Madame Récamier to her adopted daughter, Madame Lenormant, and then appeared in public auction in 1893; the other descended from her father to the Musée des Beaux-Arts in Lyons (fig. 1), which acquired it in 1909. It is a curious fact that the full-bust version of this portrait, as it is seen in Lyons, was widely reproduced in the nineteenth century and sold in shops offering *objets d'art,* and yet, amid the profusion of reproductions, the identity of the subject was eventually forgotten and its authorship attributed to Houdon.[12] Its identity was reestablished when the Museum's version was offered for public sale by the family in 1893.

The Museum's version, unlike its companion in Lyons, is lacking the arms and falling drapery that exposes the sitter's breasts. This gesture, adapted from Chinard's 1795 bust of Madame Récamier at the age of seventeen, is reminiscent of the ambiguous eroticism conveyed by so many of the young, disheveled women that were a specialty of Greuze. In 1801 the subject would have been twenty-three years old, more mature physically, and in her bearing and composure more a woman than a girl. From the time of its reappearance in 1893, it has been the conventional understanding, originating from Madame Lenormant, that the Museum's unique truncated version was "edited" by Madame Récamier late in her life and long after Chinard's death, when she apparently had second thoughts about its propriety. She is believed to have employed an unknown sculptor to remove the lower portion of the sculpture; he then placed a new signature on its base.[13] By removing the lower bust, the psychological complexity, eroticism, and animation of the figure are replaced by a view of the subject more solemn and withdrawn than the sculptor may have originally intended. As one late-nineteenth-century critic observed, the prudish gesture, holding a blouse that "reveals everything . . . [is conceived] to provoke desire, and not to provide the divine sensation of sovereign beauty."[14]

Though fragmentary, the Museum's bust remains one of Chinard's greatest accomplishments and one of the most distinctive portraits of the era. Even in its edited form, it reveals a synthesis of idealization and sensuality, of repose and animation, combining a fashion for antiquity with the lingering fleshiness of late-Rococo art. Chinard has suggested something of the beauty and charm that attracted so many people to Madame Récamier. He has also conveyed the rich ambiguity of this legendary personality, who could be simultaneously seductive and aloof, arousing and yet inaccessible.
D. R.

1. Ex coll. Penha-Longa, h. 19 cm, reproduced in Paris, Georges Petit, 1911, pp. 12, 43 (no. 54), and in Dorner 1938, p. 18.

2. Lenormant 1867, p. 7.

3. M[ohl] 1862, pp. 6-8, contends that this was commonly known by Madame Récamier's suitors, if not by herself. On this matter, see also Herriot 1905, pp. 17-24; Praz 1969, p. 247; de Castries 1971, p. 25; Paris, Louvre, 1989, p. 356. M[ohl] 1862, pp. 6-8, further observes that Juliette's mother, Madame Bernard, also had intimate relations with Bernard Barère de Vieuzac (1755–1841), an influential member of the Revolutionary Convention. Because of this liaison, both her husband and her son-in-law/lover were not only spared the guillotine, but also able to preserve their fortunes.

4. Lenormant 1867, pp. 8-11.

5. Praz 1969, pl. 59.

6. Praz 1969, p. 247. Counted among her most ardent suitors were Lucien Bonaparte, Napoleon's brother; Prince Augustus of Prussia (to whom, in lieu of her hand, she gave her portrait by Gérard); Benjamin Constant (who also had a long-standing affair with one of Madame Récamier's most intimate friends, Madame de Staël); and René Chateaubriand, the great essayist and romancier of the epoch. She appears to have yielded to none of them, nor to the many others, prompting Sainte-Beauve to say of her with some delicacy that she "brought the art of friendship to perfection." Quoted in Lenormant 1867, p. xii.

7. On Mrs. Harold Brown's gift to the Museum, see Monkhouse 1978.

8. Cf. Paris, Georges Petit, 1911, p. 25 (nos. 21 and 32); and Tourneux 1909, pp. 12, 20. The version that was in the Penha-Longa Collection is signed "Chinard à Lyon, an 13," which would date the portrait to 1805. In 1814, with the fall of Bonaparte, Beauharnais fled to the protection of his father-in-law, Maximilian-Joseph, King of Bavaria, who bestowed upon him the rank of Prince and possession of the Duchy of Leuchtenberg.

9. Tourneux 1909, p. 12.

10. This may be the version now in the Getty Museum, Malibu. For detailed arguments on the dating of this bust, see Bertaux 1909, pp. 333-34, and Rocher-Jauneau, *BMML,* 1978, pp. 138-42. The Museum's version was still in Chinard's hands in 1812, when Madame Récamier was exiled from Paris by Napoleon. She did not claim it until 1814, after Chinard's death, when she returned to Paris after sojourns in Lyons and Italy. See Lami 1910, I, p. 210.

11. Chinard mentions that it was in the Salon either of the year VIII (1801) or IX (1802) of the Revolutionary calendar. According to the *livret* Chinard did not exhibit in those Salons, although the Salon of the year X (1803) lists "plusieurs bustes." Cf. Bertaux 1909, p. 333, and Ledoux-Lebard 1947, p. 73.

12. Bertaux 1909, p. 324. See New York, Sotheby's, 1988, no. 65, called *Marble Bust of a Young Woman, Continental, possibly Italian, late 19th Century,* h. 26", for one such version.

13. Lenormant 1867 makes no mention of this bust in her *Souvenirs* of Madame Récamier. Bertaux 1909, p. 323, nevertheless notes that she is the source for this information, which was presumably passed along by word of mouth. "This barbarous operation," he wrote, "which wounds the very heart of the woman, is one of the anecdotal problems that remains obscure in the history of Madame Récamier—and her friends." Herriot 1905, p. 35, and *Bulletin de l'Art* 1909, p. 111, note that Madame Récamier had the bust cut down after she retreated to the Abbaye-au-Bois, where she spent the last years of her life. Lami 1910, I, p. 209, also observes that the bust was "mutilated" at Madame Récamier's request sometime after 1828, which is when her father, M. Bernard, who owned the version now in Lyons, died. Dorner 1938, p. 17, comparing the signatures on the two, observes that the signature on the Museum's version is a copy of Chinard's original, visible in the Lyons version, which substantiates the argument that it was mutilated after Chinard's death.

14. Frédéric Masson, "Mme Récamier et Napoleon," *Figaro illustré,* March 1893, quoted in Herriot 1905, I, p. ii.

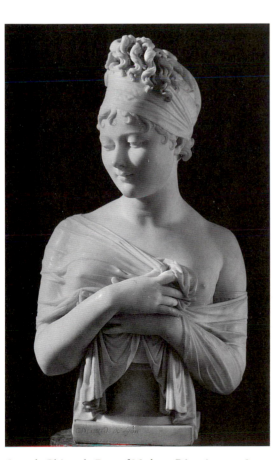

Fig. 1 Joseph Chinard, *Bust of Madame Récamier,* ca. 1804, marble, Lyons, Musée des Beaux-Arts.

HUBERT ROBERT
French, 1733–1808

9 *Architectural Fantasy*, ca. 1802–08

Oil on canvas. 45¹/₁₆″ × 58³/₁₆″ (114.4 × 147.8 cm)
Museum Appropriation. 37.104

PROVENANCE: This may be *Un Palais* that was sold anonymously at public auction (Paris?), March 23, 1908, lot 40;[1] Galerie Cailleux, Paris; Dr. and Mrs. T. Morris Murray, Boston; Giovanni Castano, Boston, from whom purchased, May 1937.

EXHIBITIONS: Paris, Cailleux, 1929; Paris, Orangerie, *Robert*, 1933, no. 23; Andover, Addison, 1942, no. 26; Poughkeepsie, Vassar, 1962, no. 12; Houston, Rice, 1969, no. 371; Williamstown, Sterling and Francine Clark Art Institute, long-term loan, 1974–76; Washington, Federal Reserve, 1979; New York, IBM, 1988; New York, Wildenstein, 1988, p. 71.

PUBLICATIONS: Nolhac 1910, p. 161; Daly 1937, pp. 72–74 (ill.); *Art News* 1938, p. 18; Cailleux 1975, p. xv, n. 25; Woodward and Robinson 1985, no. 106; Merling 1986; Bandiera 1989, p. 28 (fig. 10).

CONSERVATION: The surface was spray-varnished in 1982.

Called "Robert des Ruines" ("Robert of the Ruins") by his French contemporaries, Hubert Robert was the leading painter of architectural views and ruins during the second half of the eighteenth century. Robert was admitted to the Académie Royale de Peinture in 1766 as "un peintre de l'architecture et des ruines" ("painter of architecture and of ruins") and later became "Dessinateur des Jardins du Roi" ("Painter of the King's Gardens"). Like most eighteenth-century artists, Robert had studied in Italy. In 1759 he entered the French Academy in Rome, where he learned architectural perspective from Giovanni Paolo Pannini (1691–1765) and befriended Giovanni Battista Piranesi (1720–1778), who were respectively the elder statesman and the avant garde of architectural imagery. Together with his fellow *pensionnaire* at the Academy, Jean-Honoré Fragonard, Robert made innumerable drawings of antique monuments and ruins, and Renaissance and Baroque palaces and gardens in and around Rome, subjects that he would return to and recombine for the rest of his life.

From Piranesi, Robert would have learned the four principal conventions of Italian architectural views: *veduta ideale* (actual buildings imaginatively recombined); *veduta di fantasia* (imaginary buildings and cityscapes); *prospettiva* (theatrical, decorative illusions of architectural perspective); and *rovinismo,* which encompassed all kinds of depictions of ruins.

The Museum's *Architectural Fantasy* belongs in part to the tradition of *veduta ideale,* since it contains elements from several famous Roman monuments, but also of *veduta di fantasia.* The coffered barrel vault of the bridge, for example, resembles the vaults of the Basilica of Maxentius, whereas the winged figures of victory in its spandrels recall the Arch of Titus.[2] The bridge itself relates to drawings of the Villa Madama that Robert first made in 1759.[3] Robert has also liberally distributed famous antique sculptures at either end of

the bridge *(Horses of San Marco)* and in niches across the façade above *(Apollo Belvedere, Venus de' Medici).* In the foreground, workmen struggle to move the sculpture of *Cleopatra,* while the *Antinoüs* bas-relief from the Villa Albani rests in the shadows against the pier of the bridge. The entire composition is surmounted by the *Laocoön* group, whose discovery Robert celebrated in a painting of 1773 (Richmond, Virginia Museum of Fine Arts) and which was later installed near Robert's own lodgings and studio in the Musée des Antiques within the Louvre.

Robert's choice of an unusually low vantage point beneath a bridge that recedes dramatically toward grandiose buildings of menacing height represents a departure from the topographical tradition of Pannini and reflects the strong spiritual influence of Piranesi, whose earlier experiments with architectural volumes and scale evoke similarly disquieting sensations.[4] This particular composition is ultimately indebted to Piranesi's engraving of *The Ponte Magnifico* (1743), a print that inspired bridge and arch fantasies by other French artists in Rome, such as Charles-Michel-Ange Challe, whose 1747 drawing of a triumphal bridge and arch anticipates many features in this painting.[5]

Because Robert returned again and again to the drawings and sketches he had made in Italy, it is difficult to date his paintings precisely. There are striking similarities between this painting and three related compositions from the 1760's: a drawing entitled *Architectural Fantasy* of 1761 (Vienna, Graphische Sammlung Albertina); a second *Architectural Fantasy* in oil, dated 1768 (Durham, Barnard Castle, Bowes Museum); and the *Porte Ornée d'Architecture* (Dunkirk, Dunkirk Museum), exhibited at the Salon of 1769.[6] The similarities have led previous authors to date the RISD painting soon after Robert's return to Paris in 1765. Others, however, have noted the resemblance between the palace façade and Perrault's colonnade for the Louvre, also seen in Robert's later architectural fantasies from the 1790's, such as *The Pont Neuf* (Epinal, Musée Départemental des Vosges).[7] Likewise, the tapered, rusticated piers of the bridge resemble the walls erected in front of the Garde-Meuble in Paris between 1760 and 1775, following the designs of Jean-Jacques Gabriel.[8]

Given the fact that the subject of this painting is not a ruin, whether real or imagined, and that all the identifiable sculptures were among those ceded to Napoleon in 1797 and later brought to Paris under the terms of the Treaty of Tolentino, Mitchell Merling, a Brown University graduate student, has argued convincingly that the Museum's architectural fantasy dates between 1802, when the *Venus de' Medici* and the *Antinoüs* bas-relief finally reached Paris, and Robert's death in 1808[9]. Further evidence for a later date includes a group of workmen similar to those moving the *Cleopatra* in this picture that appears in a work dated 1800, *An Imaginary View of the Petite Galerie* (Leningrad, The Hermitage).[10]

If Merling is correct, this picture belongs to a series of paintings depicting "future ruins" of the Louvre, where Robert had lodgings and a studio and worked as curator between 1795 and 1802.[11] As an imaginary elevation for the new Musée Napoléon, the Serlian arches with pairs of rose-

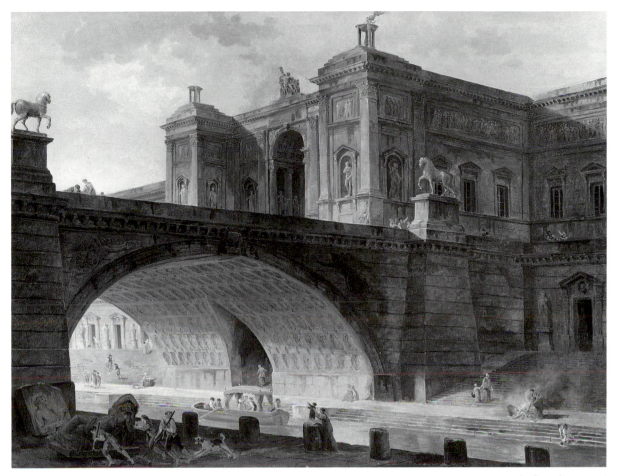

9 (color plate p. 18)

colored columns evoke Robert's designs for the reinstallation of the interior of the Grande Galerie of the Louvre, inspired by Bernini's Scala Regia, which led to the recently plundered Museo Pio-Clementino in the Vatican.[12] The location of Napoleon's new museum at the end of a bridge combining elements from the Garde-Meuble and the Arch of Titus, present and past monuments to imperial riches, also suggests an allegorical interpretation of Paris as the new Rome.[13] The unsettling implication, however, is that Paris will inevitably fall as Rome did, and Napoleon's new museum will itself be plundered and its walls serve as the foundation for future art and culture.

This simultaneous optimism, fatalism, and implied cataclysm are consistent with contemporary theories of the sublime anticipated by Diderot and codified by Edmund Burke. As the culmination of earlier compositions inspired by the Villa Madama and a mastery of Piranesian perspective, this painting reveals Robert as a proto-Romantic painter, pushing the eighteenth-century cult of ruins beyond mere decoration for fashionable antiquarians to an elevated level of moralizing history painting. T. S. M.

1. See Nolhac 1910, p. 161.

2. See Beau 1968, no. 5. The same motif appears in *Roman Baths with Laundresses* (Philadelphia, Philadelphia Museum of Art), illustrated in New York, Wildenstein, 1988, p. 23.

3. Richmond, Fine Arts, 1981, no. 23. A 1762 variant appears in Beau 1968, no. 37.

4. See Langner 1978, pp. 294–96, and Roland-Michel 1978, pp. 484–88.

5. Reudenbach 1979, fig. 70.

6. All three are discussed and illustrated in Burda 1967, pp. 52–53, figs. 24, 46, and 48.

7. Cailleux 1975, p. xv. For Robert's *Pont Neuf,* see Paris, Musées Nationaux, 1979, no. 169.

8. See Beau 1968, no. 84.

9. Merling 1986, pp. 14–15. For Napoleon's removal of antique sculpture from Italy to Paris, see Haskell and Penny 1981.

10. The Leningrad painting is illustrated in Paris, Musées Nationaux, 1979, no. 134.

11. See Paris, Musées Nationaux, 1979, pp. 6–10.

12. For Robert's Grande Galerie, see Paris, Musées Nationaux, 1979, pp. 15–20, and Corboz 1978. The allusion to the Pio-Clementino was first suggested in Merling 1986, p. 14.

13. For counterparts in contemporary French literature, see Mortier 1974, pp. 168–69.

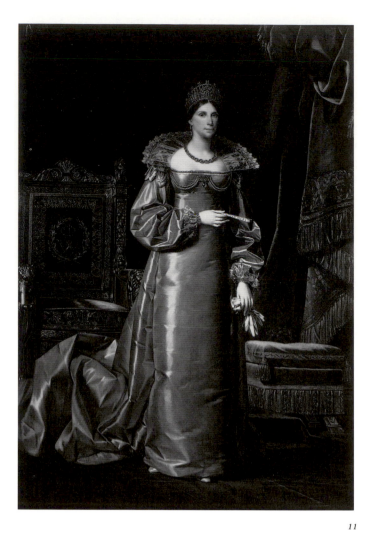

10

11

JOSEPH PAELINCK
Belgian, 1781–1839

10 *William I, King of the Netherlands,* 1817

Signed and dated, at right: J. PAELINCK/BRUXS/1817.
Oil on canvas. 88″ × 69″ (223.5 × 175.3 cm)
Museum Works of Art Fund. 56.090a

11 *Frederica Wilhelmina, Queen of the Netherlands,*
1817

Signed and dated, at right: J. PAELINCK/BRUXS/1817.
Oil on canvas. 88″ × 69″ (223.5 × 175.3 cm)
Museum Works of Art Fund. 56.090b

PROVENANCE (both paintings): Christie's, London, sale,
Sir Henry H. Howorth, December 14, 1923, no. 38; Arthur
Appleby, London; from whom purchased by the Museum.

EXHIBITION: Providence, RISD, 1970, pp. 44–45 (nos. 36, 37;
misidentified as Louis Bonaparte and Queen Hortense).

RELATED WORKS: *William I, King of the Netherlands,* 1818, oil
on canvas, 96⅞″ × 69¾″ (246 × 177 cm), Brussels, Hôtel de
Ville. *Frederica Wilhelmina, Queen of the Netherlands,* 1815, oil on
canvas, 89¾″ × 59½″ (228 × 151 cm), The Hague, collection of
the House of Orange-Nassau. *William I, King of the Nether-
lands,* 1815, oil on canvas, 85″ × 58⅝″ (216 × 149 cm), The
Hague, collection of the House of Orange-Nassau.

William I, Prince of Orange-Nassau (1772–1843), and his
wife Frederica Louisa Wilhelmina, Princess of Prussia (1774–
1837), had assumed their positions as monarchs of the newly
created Kingdom of the Netherlands two years before this
set of portraits was painted by Joseph Paelinck. The nation
which King William ruled from 1815 to 1840 was initially
comprised of the present-day countries of Belgium and Hol-
land, united, following the defeat of Napoleon, as a buffer
against future French invasion. In 1830, however, Belgium
seceded, leaving William with only half of his original king-
dom. The two handsome portraits in the RISD collection are
but one pair among a number of variants and near-identical
versions of likenesses of the royal couple painted by Paelinck,
who was appointed court portraitist in 1815.[1]

As the son of William V of Orange and Frederica Sophia
Wilhelmina, niece of Frederick the Great, King William had
ties to both Holland and Prussia. Shortly after his marriage
in 1791 to Frederica Louisa Wilhelmina, daughter of Frederick
William II, King of Prussia, he was forced into exile with his
family as warfare sparked by the French Revolution and
continuing with the Napoleonic conquest engulfed Europe
and toppled regimes throughout the continent. William
assumed the crown of the Netherlands following years of
military exploits in the campaigns against Napoleon. The

forced alliance between Holland and Belgium (the Austrian Netherlands prior to the French Revolutionary period), however, proved to be a difficult entity to govern from the start. Controversy began with the constitution of the new nation, which the Belgians found unfair in matters of representation in the national legislature, taxes, and religious policy. William himself was perceived by the southern provinces as "too Protestant, too Dutch, too autocratic"[2] for a people who were predominately Catholic and half French-speaking. (The rest of the Belgian population was comprised of Dutch-speaking Flemings.)

By the time William I ascended to the throne, Joseph Paelinck had already established himself as a successful painter. He was born in the Flemish town of Oostakker, trained in the nearby drawing academy of Ghent, and was exhibiting in the Salon of Ghent by 1802. Soon afterward, he traveled to Paris and studied in the atelier of Jacques-Louis David, then spent four years in Rome (1808–12) under the sponsorship of the city of Ghent. In Paris, Paelinck refined his Neoclassical style under the tutelage of David, who spent his final years in Brussels after the fall of Napoleon in 1815. Paelinck's career soon centered around his well-received Neoclassical efforts in religious, literary, and portrait painting.[3]

Shortly after his return home in 1812, his relationship with the new royal family was initiated with commissions for court portraits. In 1815, he was reported to have presented William I with a portrait in The Hague (prompting the queen to order a full-length likeness of herself); he was commissioned to represent the king addressing the States-General at the Town Hall in Brussels and was named official painter to the queen.[4] To be near his royal patrons, he moved from Ghent to Brussels, where the monarchy, based in The Hague, had established a second court.

The RISD paintings fall within a sequence of full-length portraits of the king and queen by Paelinck running from 1815 to the late 1820's. It may be possible to identify the painting of the king, dated 1817, with a portrait described in the Brussels newspaper L'Oracle on July 30, 1817 (p. 3). The article states that "Mr. Paelinck has just completed the portrait of our august Monarch, which he commissioned himself and is destined for England."[5] The British provenance of the two paintings and the presence in the king's portrait of a letter on the table addressed to Lord Clancarty, the British ambassador to the Kingdom of the Netherlands from 1816 to 1822,[6] lend support to the notion that the RISD canvas might indeed be the portrait in question. Richard Le Poer Trench, second Earl of Clancarty (1767–1837), was a loyal supporter of William during the prince's exile, aiding him in his subsequent efforts to gain the Dutch throne. It was Clancarty who helped engineer the annexation of the Belgian provinces by Holland in 1814–15, a fact alluded to by the inclusion of a map of the new Kingdom of the Netherlands, placed under the letter on the table.[7]

In the RISD painting, the king stands before an Empire throne adorned with lion heads on the arms and crest rail.[8] He is clad in a military uniform (having fought at Waterloo

only two years previously), his plumed bicorn resting on the table behind.[9] On his jacket he wears the medal of the Order of King William. This was a new military decoration initiated by the king in 1815, consisting of a white cross bearing the words (in Dutch) "For courage, conduct and loyalty"[10] inside a silver star. As one hand grasps the hilt of the sheathed sword at his side, the other rests on the table bearing the map, the diplomatic missive, and an inkwell. The emphasis on military valor (the uniform) and administrative and diplomatic authority (the inkwell and papers) elevates and ennobles King William in a manner similar to David's Napoleon in his Study (1812, Washington, D.C., National Gallery of Art), an appropriate prototype in terms of its synthesis of classical style with contemporary realism.[11]

Fig. 1 Joseph Paelinck, William I, King of the Netherlands, 1818, oil on canvas, 96⅞″ × 69¾″ (246 × 177 cm), Brussels, Hôtel de Ville. Photograph copyright A. C. L.-Brussels.

This portrait of the king is austere by comparison to the Museum's portrait of Queen Frederica Wilhelmina, showing her in a ceremonial Empire gown of gold silk with a long train and a wide standing collar of French lace with matching cuffs. She holds a fan in one hand and gloves in the other. The queen's royal status is conveyed by her crown and the throne behind her, which bears the royal initials F W (Frederica Wilhelmina) on the borders of the fringed curtains draped along the right side of the composition.

These portraits appear not to have been painted as a pair. The design of the throne, the red-curtained background, and the ceremonial attire in the RISD portrait of the queen are closer in appearance to a more formal portrait type of King William, examples of which are found in the Town Hall of Brussels (fig. 1)[12] and the Rijksmuseum, Amsterdam.[13] In these portraits of 1818 and 1819, respectively, William wears

Fig. 2 Joseph Paelinck, *Frederica Wilhelmina, Queen of the Nether-
lands,* 1815, oil on canvas, 89¾″ × 59½″ (228 × 151 cm), The Hague,
collection of the House of Orange-Nassau.

Fig. 3 Joseph Paelinck, *William I, King of the Netherlands,* 1815, oil
on canvas, 85″ × 58⅝″ (216 × 149 cm), The Hague, collection of
the House of Orange-Nassau.

the fur-trimmed coat of the Dukes of Brabant, with crown
and scepter poised on the table. The king's portrait in Provi-
dence, on the other hand, seems more similar to a painting
of Frederica Wilhelmina by Paelinck in the collection of the
House of Orange-Nassau (fig. 2). In that version, which has
its own companion portrait of the king (fig. 3),[14] she is dressed
less formally, with a cap rather than a crown, and stands
before an undraped background with a pilaster on the right,
resembling the setting of the king's portrait at RISD, which
includes a matching throne as well. Given the large volume
of portraits of the royal couple executed by Paelinck in close
succession and exported throughout England and Europe,[15]
it does seem possible that a pair of canvases in the same col-
lection might consist of two different portrait types, whether
by circumstance or design.

 The respectfully portrayed but rather stiffly posed figures
of William and Frederica Wilhelmina, painted within the
first few years of their reign, seem to bear out – unintention-
ally, of course – the rather dismal impression they appear to
have made while holding court in Brussels during an eleven-
month period beginning in the fall of 1816. As chronicled by
the Belgian historian Henri Pirenne,

> The nobility found the evenings at the palace mortally tire-
> some. The king repelled people with his gravity and authori-
> tarian manner. He spoke French reluctantly, spoke it poorly.
> The queen dressed poorly and tried too obviously to appear
> friendly to ever be so in fact. One felt disoriented amidst the
> Dutch entourage of the sovereigns. Their Calvinism, their
> ceremonial politeness, their coldness, everything that differed
> from Belgian mores in tastes and habits appeared strange,
> archaic or ridiculous.[16]

After tensions which had been building since the formation
of the Kingdom of the Netherlands in 1815 had reached the
breaking point in 1830, there was little that William could do
but resign himself to the Belgian secession, although it was
not officially recognized until the ratification of a treaty in
1839. By that time, the king, now reviled even by the Dutch
largely as a consequence of the economic hardship precipi-
tated by the loss of Belgium, was on the verge of abdicating.
In 1840, he officially turned over the throne to his son, who
reigned as William II until 1849. Frederica Wilhelmina had died
in 1837. After his abdication, William married the Countess
Henriette d'Oultremont, who had been a companion of his
late wife in the court of Brussels and who was both Catholic
and a Belgian. The two moved to Silesia, where William
spent his last three years; he died in 1843.[17]

 The later years of Paelinck's life were hardly more fortu-
nate than those of his royal patron. The Neoclassical style on
which he had founded his career was decisively supplanted
in 1830 by Romanticism, a movement which was both anti-
classical and fiercely nationalistic (i.e., anti-Dutch), and to
which Paelinck never reconciled himself. Faced with loss of
recognition and commissions, he began to spend more time
with his print collection than he did painting. Undoubtedly,
the artist's close ties with the royal family, which had brought
him such renown during the first part of his career, in the
end became a source of his downfall. Records show that
Paelinck was still at work on a royal portrait commission in
1827,[18] by which time his cherished status as favorite of the
Dutch court had become more of a liability than an asset.

D. E. S.

1. Richard Kerremans, "Joseph Paelinck," in Brussels, Ixelles, 1985, pp. 193–201. Kerremans's essays on Paelinck are the best source on this artist's life and works. I would like to thank both Mr. Kerremans and Denis Coekelberghs, as well as Sibylle Valcke, who also participated in the exhibition, for their kind assistance. Biographical information on Paelinck can also be found in Heins 1906, XVI, cols. 448–52, and Immerzeel 1855, part 2, pp. 290–92.

2. Van der Essen 1916, p. 151.

3. Among Paelinck's major canvases in these areas are *L'Invention de la Croix* (1812, Ghent, St. Michielskerk), *La Belle Athnia* (1820, Ghent, Museum voor Schone Kunsten), and *Portrait de la famille Snoy* (1818, Association familiale Snoy A. S. B. L.)

4. These events of 1815 were reported in the Brussels newspaper *L'Oracle* on April 13, October 16, and October 28, cited by Kerremans in Brussels, Ixelles, 1985, pp. 194, 196, 423. Paelinck's sketch of the king's address was made into a print by Gibèle in 1826 (*Installation des Etats-Généraux à Bruxelles le 21 septembre 1815*), in the Cabinet des Estampes, Bibliothèque Royale, Albert Ier. A detailed analysis of the image written by C. G. De Dijn is found in Hasselt, Bibliotheek, 1971, pp. 37–38 (no. 9).

5. Cited by Kerremans in Brussels, Ixelles, 1985, p. 423.

6. The words "A Lord Clancarty/Ambassadeur De/Sa Majesté/Britan[n]i[que]" are visible on the folded paper.

7. The lettering on the map reads "Koninkrijk der Nederlanden/en het/Groot-Hertogdom Lux[embourg]." In addition to his title of King of the Netherlands, William was also made Duke of Luxembourg. Whether the canvases in Providence are in fact associated with the press reference must, however, remain speculation in the absence of further evidence. Moreover, the portrait of the queen is problematic, since it is not mentioned in the article. Note should also be made of a manuscript reference to a full-length portrait of the king sent to England in 1815 and of the queen sent to London in 1816 (Brussels, Bibliothèque Royale, Mss. II 2680, fo. 127–fo. 128 verso), but these have not been located. My thanks once again to Mr. Kerremans and Ms. Valcke for sharing this material with me.

8. Lion heads also appear on the S-clasp of William's sword belt. In addition to being a common motif during the Empire period, lions are found on the coat of arms of the Kingdom of the Netherlands and are symbols of the House of Orange-Nassau and the Duchy of Brabant. See Hasselt, Bibliotheek, 1971, pp. 38, 41.

9. William's uniform – gray breeches and knee boots – is that of an active soldier; full dress consisted of white trousers and gloves. I am grateful to Michele Majer and Kirk Adair, Metropolitan Museum of Art, New York, for information on the king's and queen's costumes.

10. "Voor moet, beleid, trouw." In the portrait, only "Voor" and "M . . ." are visible on the top and left arms of the cross, respectively. See Wahlen 1844, pp. 166–67 (pl. LII).

11. In terms of pose and the background props, the RISD portrait of William is actually closer in appearance to earlier paintings of Napoleon by Ingres (*Bonaparte as First Consul at Liège*, 1804, Liège, Musée des Beaux-Arts), Gros (*Bonaparte as First Consul*, 1802, Paris, Musée de la Légion d'Honneur), and Lefèvre (*Napoleon I as Military Commander*, 1809, Paris, Musée Carnavalet). The possible influence of the Ingres portrait as a prototype for Paelinck is intriguing, since it includes a view of the Belgian town of Liège in the background, having been presented to that city by Napoleon himself. On Napoleonic portraiture, see Schoch 1975, pp. 58–65.

12. See Brussels, Ixelles, 1985, pp. 423–24 (no. 420), and Ghent 1821, pp. 23–24.

13. Van Thiel 1976, p. 434 (no. C 1460).

14. The portraits in the Royal Collection are on loan to the Rijksmuseum Paleis Het Loo. My thanks to Dr. B. Woelderink, Secretary of the House of Orange-Nassau Historic Collections Trust, The Hague, for this information. Additional versions of this portrait type are found in other collections in the Netherlands, documented in the Iconographisch Bureau, The Hague.

15. Portraits also went to Berlin (Immerzeel 1855, part 2, p. 291) and St. Petersburg (Brussels, Ixelles, 1985, p. 423).

16. Pirenne 1948, III, p. 432. Translated by D. E. S.

17. Despite the difficulties of his final years, William I can be credited with such accomplishments as encouraging technological progress in Holland by supporting railroad and steamship development, promoting education through the founding of state universities, and partronage of the arts. It was William who gave the Rijksmuseum in Amsterdam its present name and who took an active role in building up the state's art collection with the help of the connoisseur Cornelis Apostool. King William's line, which can be traced back to William the Silent (1533–1584), has continued into the present in Holland, where his descendant, Queen Beatrix, rules today.

18. The commission in question was for a portrait of the king, reported in the *Journal de Bruxelles,* May 6, 1827, cited by Kerremans in Brussels, Ixelles, 1985, p. 423.

THÉODORE GÉRICAULT
French, 1791–1824

12 A Cart Loaded with Kegs
(Le Haquet), ca. 1819

Oil on canvas. 23⁷⁄₁₆″ × 28⁷⁄₈″ (59.8 × 73.4 cm)
Museum Works of Art Reserve Fund. 43.539

PROVENANCE: Acquired from the artist by Dr. Laurent Thomas Biett; Delessert, Paris, sale, March 15–18, 1869, no. 151; Delessert-Bertholdi, Paris, sale, May 11, 1911, no. 27; Galerie Bernheim-Jeune, Paris; Mrs. O. Freund; Mrs. R. Millman; Paul Rosenberg and Co., New York.

EXHIBITIONS: Paris, Lebrun, 1826; Berlin, Kronprinz Palais, 1928–33; Zurich, Kunsthaus; New York, Rosenberg, 1950, no. 9; Hartford, Wadsworth, 1952, no. 20; Los Angeles, LACMA, 1971, no. 104; Kamakura, Museum of Modern Art, 1987, P-23; San Francisco, Fine Arts, 1989, no. 47.

PUBLICATIONS: Clément 1868, p. 300 (no. 96); Paris, Delessert, 1869, p. 70 (no. 151); Paris, Hôtel Drouot, 1911, p. 29 (no. 27, ill.); F. E. M. 1944, n.p. (ill.); *Art News,* Jan. 1945, p. 23 (ill.); *Gazette des Beaux-Arts* 1945, pp. 232, 239 (fig. 9); La Farge 1950, p. 31 (ill.); Berger 1952, p. 75 (pl. 77); Grunchec 1978, p. 107 (no. 133, ill.); Eitner 1983, pp. 205, 311 (pl. 32), 347 (n. 215).

The exact subject of this painting, which Géricault's biographer, Charles Clément (1868), called *"Un haquet chargé de barriques arrêté à la porte d'une brasserie,"* is not undisputed. It

has been variously called *"Beer Cart in a Brewery Yard"* (Eitner 1983) and *"Wine Cart"* or *"Charette de vin"* (Berger 1952, Grunchec 1978). Whether it is identified as the one or the other is not entirely a matter of indifference, since it may have some bearing on the picture's date – "beer cart" suggests an association with Géricault's English stay in 1820–21, while "wine cart" assumes a French subject.

Two heavy draft horses, both piebald, are shown in the outer courtyard of an industrial structure, perhaps a brewery, beneath a wide arch. They are attached in tandem to a two-wheeled cart equipped with a winch and designed for the transportation of barrels.[1] In the foreground a dog rests at the edge of a large puddle or stream. To the left, there appears the corner of a building that is identified by its signboard, the picture of a rearing horse, as either an inn or a farrier's shed.[2] A melancholy stillness pervades the scene. The horses stand immobile, as if waiting, within a space framed by the angles and curves of the massive, dilapidated structures that dominate the view. There is no sign of a human presence, nor any trace of nature, save for a glimpse of overcast sky. The declining daylight, entering from behind dark masonry, throws slanting shadows across the walls and vanishes into the black hollows of empty windows and doorways. The emphatic bigness and weight of all its forms, the powerful animals no less than the ponderous architecture, and their mournful quiescence lend a poignancy to the scene that

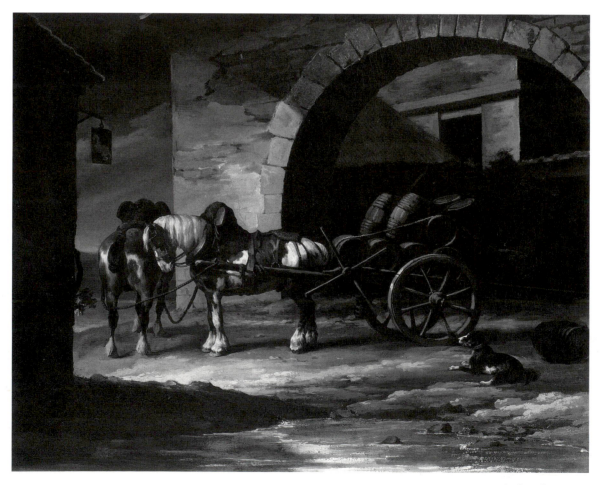

12 (color plate p. 19)

transcends the emotional range of ordinary genre.

Clearly a complete realization, rather than a preliminary study, *Le Haquet* is one of a relatively small number of fully finished, self-sufficient paintings in Géricault's work. No drawing for it is known, though a pencil-and-pen study, in the Fogg Art Museum, Cambridge, of two draft horses – the one in profile, the other in back view – bears a certain resemblance to its main motif (fig.1).[3] According to Clément,[4] Géricault painted this picture "shortly before the *Medusa*" (i.e., about 1818) for Dr. Laurent Thomas Biett (1780–1840), a physician attached to the Hospital Saint-Louis, who is known to have attended Géricault during his final illness in 1823–24.[5] Clément's unusually explicit dating of *Le Haquet* has given rise to some controversy – 1818 seems a surprisingly early date for a painting that in subject matter and mood resembles the work of Géricault's later years. Heavy draft horses observed in the bleak settings of wharves and smithies became one of his favorite themes during his English stay in 1820–21, evidently under English influence, and continued to occupy him in his last period. Berger questioned Clément's

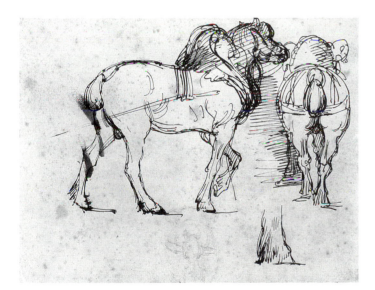

Fig. 1 Théodore Géricault, *Two Draft Horses,* pencil and pen, 8¼″ × 10⅞″ (20.9 × 27.6 cm), Cambridge, Fogg Art Museum, Harvard University Museums, Winthrop Collection.

early dating on these grounds and argued that the handling of color and choice of motif of the picture placed it among Géricault's post-English works of about 1822.[6] This was disputed by Grunchec,[7] who observed that its elaborate architectural background and its use of heavy light-and-shadow contrasts linked *Le Haquet* with Géricault's monumental landscape panels of 1818[8] and lent support to Clément's dating.

Style and conception of the painting in fact place it in the vicinity of the *Medusa*. Its execution in broad, opaque touches of somberly intense color is characteristic of a manner that Géricault developed at the time of his most strenuous efforts at expressive monumentality, before he subsided into the easier fluency and freshness of his English and post-English work. The picture's narrow range of dark, earthen

hues and its powerful modeling in abruptly juxtaposed highlights and shadows are still unaffected by the changes that Géricault's style underwent, not long thereafter, during his London stay of 1820–21. Its subject matter and mood, on the other hand, anticipate his English work and even foreshadow still later paintings, such as the *Lime Kiln* of about 1822–23. It thus provides one of the several instances of English imagery that occur among works carried out in France before the English voyage, and illustrates – like his famous lithograph of the *Boxers* (1818) and the sketches of *Stage Coaches* in the Chicago Album[9] – the early emergence of English influence in his work around the period of the *Medusa*.

Géricault was still in comfortable financial circumstances at that time and did not work on commission or for sale. The picture was probably intended as a gift to Dr. Biett. What occasion prompted it remains a matter for conjecture. It is known that, after the exhausting labor of the *Medusa,* Géricault suffered a severe episode of depression and physical illness in the late fall and winter of 1819,[10] and there is some plausibility in the supposition that Dr. Biett attended him in this illness and was compensated for his medical services with the gift of the painting.[11] A date shortly *after* the *Medusa,* when Géricault was relatively idle, would in any case seem more probable than one in the months preceding, when he was overburdened with work. L.E.

1. A cart of similar construction figures in a large oil sketch, *La Charette,* formerly in the Richard Goetz collection (cf. Paris, Durand-Ruel, 1922, no. 135, 64 × 81 cm), present location unknown. The scene represented in this sketch seems to be in France and to show the transportation of wine barrels.

2. A similar signboard, inscribed "Au Cheval Blanc," serves as an inn sign in Géricault's *Postillion at the Door of an Inn* in the Fogg Art Museum, Cambridge (see Eitner 1983, pl. 42), a painting datable to about 1822–23.

3. Berger 1946, p. 30 (pl. 37).

4. Clément 1868, p. 300 (no. 96).

5. Clément 1868, pp. 251–52.

6. Berger 1952, p. 75 (pl. 77).

7. Grunchec 1978, p. 107 (no. 133, ill.).

8. The *Landscape with Fishermen* in the Neue Pinakothek, Munich; the *Landscape with a Roman Tomb* in the Musée du Petit Palais, Paris; and the *Landscape with an Aqueduct* in the Metropolitan Museum of Art, New York. The stylistic and technical relationship is particularly close with the latter two. See Eitner 1983, pp. 142–45 (fig. 120 and pls. 25–26), and Tinterow 1990.

9. The coaching scenes, of a distinctly English type and very likely inspired by British sporting prints, occur on fols. 23 verso–25 recto of a sketchbook fragment containing studies for Géricault's lithographs of 1818 and 1819. See Eitner 1960, pp. 17 ff., 27 ff.

10. Eitner 1983, p. 201–02.

11. Dr. Biett began his service at the Hospital Saint-Louis in 1819. There exists no positive evidence that he treated Géricault in that year. It is not impossible, despite Clément's very positive statement, "cet ouvrage avait été fait pour le docteur Biète, peu de temps avant le Radeau de la Méduse," that Géricault only gave the painting to his physician at the time of his final illness in 1822–23, although he had painted it several years earlier.

13

SIR CHARLES EASTLAKE
British, 1793–1865

13 *The Celian Hill from the Palatine,* ca. 1823

Signed, lower center: *C. L. Eastlake*
Oil on canvas. 13³⁄₁₆″ × 17⁵⁄₈″ (33.4 × 44.7 cm)
Anonymous gift. 56.099

PROVENANCE: Probably one of four scenes on the Palatine painted in 1823 for Col. and Mrs. Greville Howard, of Levens Hall, near Kendal, Westmorland; Arthur Appleby, London, October 1956.

EXHIBITIONS: Providence, RISD, 1957, p. 12 (no. 54); Cleveland, CMA, 1964, no. 180; New York, IBM, 1988.

PUBLICATION: Robertson 1978, color pl. A.

When the Plymouth-born artist Charles Lock Eastlake painted this landscape of the Celian Hill from the Palatine in 1823, it was done at the midpoint of his stay in Rome, which lasted from 1816 to 1830. A fondness for recording picturesque places had been instilled in him from the very start of his artistic career, when as a schoolboy he took drawing lessons from his fellow townsman Samuel Prout (1783–1852). He had then gone to London and in 1809 had begun studying anatomy with another artist hailing from Plymouth, Prout's good friend, Benjamin Robert Haydon (1786–1846). In the course of subsequent study at the Royal Academy Schools, Eastlake worked in the Antique School under Henry Fuseli (1741–1825), then the Life School, and became acquainted with the Academy's Professor of Perspective, Joseph Mallord

William Turner (1775–1851), whom he praised in 1811 as "the first landscape painter now in the world, and before he dies will perhaps be the greatest the world ever produced."[1]

Both Eastlake and Turner admired the classical landscapes of Claude and Poussin, and both were inspired to make a pilgrimage to Italy to visit the source, as their fellow countrymen had been doing since the middle of the eighteenth century. They had before them the examples of Richard Wilson (1714–1782) and his pupil Thomas Jones (1742–1803), whose plein-air sketches enjoy a freshness of viewpoint and clarity of composition not previously seen in the work of Northern European artists. Eastlake left for Italy immediately following the Napoleonic Wars, arriving in 1816, three years before Turner. During the two months of 1819 that he was in Rome, Turner produced over fifteen hundred black-and-white sketches out of doors, which he then worked up into finished watercolors back at his lodgings. Out of the numerous finished watercolors which survive among his drawings at the British Museum, one is of the Celian Hill from the Palatine.[2] In 1823 Eastlake took almost the same vantage point when making the sketches for his oil painting at RISD. Unlike Turner, he worked on location "not in black and white, but in blue, red, and yellow,"[3] and this might explain the intensity of his palette: "Eastlake saw Italy rightly as a bright scene, and he painted her brightly, not fearing the most formidable tints which few care or dare to present untamed,"[4] to quote the art historian M. H. Grant. As Englishmen, this particular view from the Palatine would

have held special meaning for Eastlake and Turner. The early seventeenth-century façade of S. Gregorio Magno rising at the top of an imposing flight of steps in the middle ground at the far right was "to the English . . . the most important of Roman churches."[5] It was from that site that Gregory the Great was thought to have sent St. Augustine on his mission to convert England to Christianity.

Eastlake has employed the convention of populating the foreground with figures in order to enhance the topical interest, as well as to provide a point of reference regarding scale. In this instance they are male and female peasants engaged in conversation, the latter bent over what appears to be a basket of laundry. They remind us of the fact that in addition to landscapes, Eastlake made a specialty of costume pictures entirely composed of portraits of colorfully clad farm families, goatherders, and particularly *banditti*. When he sent five such pictures home for exhibition at the British Institution in 1823, "the novelty of the rich colouring, as well as the subjects, made a great impression," and in the words of the Institution's Secretary, he had "continued offers for them at the Private View, at almost any price, and could have sold them fifty times over."[6] In fact, they became so popular that three engravings after his *banditti* paintings served as direct inspiration for tableaux in J. R. Planche's *The Brigand,* a two-act Romantic drama adapted from the French that opened at Drury Lane in November 1829.[7]

As for Eastlake's landscape views made in and about Rome, not to mention Sicily and Greece, he built up a loyal following among his fellow countrymen. In 1823 he not only sent the five peasant pictures to the British Institution, but also three Roman landscapes to the Royal Academy as his first representation there; he would eventually serve as its president from 1850 until his death in 1865. Painted in 1821, the three Roman views had been done for Lord George Quin, second son of the first Marquess of Headfort. In 1822 he did two different views of the Colosseum for Col. and Mrs. Greville Howard, of Levens Hall, near Kendal, Westmorland. The Howards must have been pleased with the results, because they acquired four additional scenes painted on the Palatine by Eastlake in 1823, probably including the RISD view of the Celian Hill. As the artist's wife, Lady Elizabeth Rigby Eastlake, observed in the course of compiling his *Memoir:* "His first reputation was acquired as a landscape painter And there are those still living who bear witness, as I have hinted, that the poetic view he took of Italian landscape created such an impression on all landscape painters – foreign and English – then at Rome, as considerably to raise the standard of that art."[8] C.P.M.

1. Robertson 1978, pp. 2–4.
2. Philadelphia, PMA, 1968, pp. 192–93.
3. Robertson 1978, p. 16.
4. Grant 1926, II, p. 328.
5. Masson 1965, pp. 349–50.
6. Eastlake 1870, p. 102.
7. Robertson 1978, pp. 36–38.
8. Eastlake 1870, p. 101.

ARY SCHEFFER
Dutch, 1795–1858

14 *Equestrian Portrait of George Washington,* ca. 1825

Signed, lower left: *A. Scheffer*
Oil on paper, mounted on canvas. 18⅛″ × 11¼″
(46 × 28.6 cm)
Gift of Mrs. Murray S. Danforth. 74.060

PROVENANCE: Probably the 5th Baron Burnham; sold at Christie's, London, November 13, 1969, lot 76; where purchased by Maccario; Schweitzer Gallery, New York, from whom purchased by Mrs. Danforth for the Museum in 1973.

EXHIBITIONS: Providence, RISD, 1973; Chapel Hill, Ackland, 1978, no. 59.

PUBLICATIONS: *Gazette des Beaux-Arts* 1975, suppl. p. 40 (no. 150); Ewals 1987, p. 443.

Although Ary Scheffer is not known to have completed an equestrian portrait of George Washington, both the style and technique of this oil sketch correspond to Scheffer's work from the mid-1820's, while he was a student in the Paris studio of the Neoclassical history painter Pierre-Narcisse Guérin (1774–1833). Scheffer's early work in the 1810's reflects his brief study under Pierre-Paul Prud'hon (1758–1823) and the formative influence of Jacques-Louis David (1748–1825), whose work the Dutch-born Scheffer had first observed at the court of Louis-Napoleon in Amsterdam. By the 1820's, he had begun to vacillate between the conservative traditions of the Académie and the newer, Romantic interest in the

14

sketch espoused by his fellow students Eugène Delacroix and Théodore Géricault.[1]

In its rapid execution with loose brushstrokes and dramatic background full of diagonal movement, the Museum's sketch may be compared to Scheffer's self-portrait of 1826 (Dordrecht, Dordrechts Museum). The handling of other portions, such as the horse's hastily sketched right front leg, the subject's right arm incised by the end of the brush, and the billowing flag, resembles contemporary oil sketches by Scheffer and Géricault of the heroic events leading up to the war for Greek independence (1821–29).[2] Scheffer also owned numerous oil sketches copied by Géricault in the 1820's from celebrated equestrian portraits by Rubens and Van Dyck, the ultimate sources of inspiration for this and many other heroic equestrian portraits of the eighteenth and nineteenth centuries.[3]

Although the style of the Museum's sketch relates to Scheffer's paintings of the war in Greece, its subject derives from earlier political events revolving around the Marquis de Lafayette. A unique survivor of revolution and reform in the United States and in France, Lafayette had fought as Major General alongside Washington in the American Revolution (and named his first son George Washington Lafayette), only to be imprisoned and exiled during the French Revolution. He resisted Napoleon under the Consulate and Empire and opposed the Bourbons under the Restoration. Scheffer, himself a political activist of liberal views, had received his earliest French portrait commission from Lafayette and was a close family friend and frequent visitor to La Grange, Lafayette's estate forty miles east of Paris.[4] There, according to later accounts, Lafayette had assembled a virtual pantheon of portraits of the heroes of American democracy, the model government to which he had dedicated his life and always hoped to achieve in France.[5]

In the first salon at La Grange stood a bronze bust of Lafayette between portraits of Franklin and a copy by Scheffer "after an original portrait of Washington."[6] Adding to the problem of precise identification, Lafayette owned several other portraits of Washington in various media: a panel painting by Charles Bird King, a miniature by Charles Willson Peale, a second miniature after Stuart by Nicholas-Marcellin Hentz, an oil painting by Jean-Baptiste Le Paon, busts in bronze and faience, and probably a plaster bust by Houdon.[7] By 1789, Lafayette's brother-in-law, the Vicomte de Noailles, also owned a full-length portrait of Washington by Peale.[8] Any and all were available to Scheffer as models, and yet they are more likely to have depicted a younger Washington (d. 1799) than does this sketch.

In 1937, Kolb identified the source for the portrait of Washington in Lafayette's salon as Gilbert Stuart and dated the copy 1825.[9] However, neither the pose nor the head in the RISD sketch corresponds to any known portrait of Washington by Gilbert Stuart. A more likely source is a print after one or more portraits of Washington by John Trumbull, who so carefully recorded the likenesses of participants in the Revolutionary War and sought eyewitness descriptions to insure the accuracy of his history paintings. Lafayette had sat for Trumbull in Paris in 1788, while Trumbull inserted his portrait into the nearly completed *Surrender of Lord Cornwallis at Yorktown,* a larger version of which (1820) Lafayette would have seen hanging in the rotunda of the United States Capitol during his farewell tour of the United States in 1824.[10] As Wisdom has pointed out, other details of the Museum's sketch–Washington's uniform (epaulets, collar, and hair ribbon), the light color of his steed, the distinctively spotted saddle blanket, collapsed telescope, and bridle ornaments–all correspond to Trumbull's portrait of *Washington at Verplanck's Point* that the artist had presented to Martha Washington and that Scheffer could have seen.[11]

The circumstances surrounding this painting are unknown, although there can be little doubt that the figure represents General Washington gazing toward the American flag. It stands to reason that this sketch either relates to an unrealized commission from Lafayette for his American pantheon at La Grange, or was perhaps presented to Lafayette or to a member of his family by his friend Scheffer as a memento of Lafayette's recent triumphal tour of the United States in 1824.[12] On the same trip, Lafayette had presented to the U.S. House of Representatives a full-length portrait of himself painted by Scheffer in 1822, while retaining a smaller version at La Grange.[13]

In spite of its small size, Scheffer's sketch conveys the nervous energy of French Romantic painting, here applied to a traditionally Neoclassical subject. A date in the 1820's helps to account for the stylistic similarities to Géricault and would also be consistent with the first wave of nostalgia for the increasingly remote "fathers" of the young republic that Lafayette, like Washington, was popularly perceived to embody. T. S. M.

1. See Chapel Hill, Ackland, 1978, pp. 120–21.
2. See, for example, *The Women of Souliotes* and *The Battle of Missolonghi* by Scheffer (Paris, Institut Néerlandais, 1980, nos. 53, 55).
3. These included Van Dyck's portrait of François de Moncade, Rubens's portrait of Marie de' Medici, and studies of the horses in the wings of Rubens's Antwerp altarpiece. See Bazin 1987, II, nos. 300, 302–03, 308; Johnson 1970; and *Gazette des Beaux-Arts* 1859, p. 47.
4. Kolb 1937, pp. 85–86; Ewals 1987, p. 59.
5. Cloquet 1836, pp. 177–206, as cited in Kolb 1937, pp. 92–93. See also Flushing, Queens Museum, 1989, pp. 100, 134.
6. Kolb 1937, pp. 93, 494.
7. See Girodie 1934, nos. 59–68, and Kolb 1937, p. 93. A bust by Houdon that had descended in Lafayette's family was sold at Sotheby's, New York, sale 5860 (May 24, 1989), lot 16. For portrait series arrayed in the studies of patriotic French citizens of the Revolutionary era, see La Rochelle, Nouveau-Monde, 1989, no. 18.
8. Cambridge, Fogg, 1976, no. 17.
9. Kolb 1937, p. 494.
10. See New Haven, YUAG, 1982, no. 27.
11. New Haven, YUAG, 1982, no. 41.
12. See Flushing, Queens Museum, 1989.
13. See Cambridge, Fogg, 1976, no. 43. Scheffer's final portrait of Lafayette (1834) depicts him on his deathbed (see Flushing, Queens Museum, 1989, pl. 8).

JEAN-BAPTISTE-CAMILLE COROT
French, 1796–1875

15 *Honfleur, the Old Wharf,* ca. 1822–25

Signed, lower left: *Corot;*[1] inscribed to right of signature:
honfleur
Oil on canvas. 11¹³⁄₁₆″ × 16¾″ (30 × 42.5 cm)
Museum Works of Art Fund. 43.007

PROVENANCE: Alfred Forgeron, Paris, by 1890;[2] Edouard
Napoléon César Edmond Mortier, Duc de Trévise, Paris; sold
at auction, Sotheby's, London, July 9, 1938, lot no. 98; Knoed-
ler and Co., New York.

EXHIBITIONS: Providence, RISD, 1942; New York, Rosen-
berg, 1956, p. 10 (no. 1, ill. p. 12); Providence, RISD, 1972, p.
123 (ill. pl. 34, p. 148); New York, Shepherd, 1972, no. 13 (ill.);
Memphis, Dixon, 1987, p. 65 (no. 36, ill. p. 64); New York,
IBM, 1988; Tokyo, Odakyu, 1989, p. 140 (no. 1, ill. pl. 1).

PUBLICATIONS: Robaut 1905 (1965), II, no. 35 (ill. p. 15);
RISD, *Museum Notes,* February 1943, n. p. (ill.); RISD, *Museum
Notes,* April 1943, n. p.; Electa Editrice, *Corot,* 1952, n. p., no.
3 (ill.); Leymarie 1966, p. 21; Woodward and Robinson 1985,
p. 189 (no. 107, ill).

16 *Entrance to a Chalet in the Bernese Oberland,*[3] ca. 1850–55

Stamped, lower left, in red: VENTE/COROT
Oil on canvas. 10³⁄₁₆″ × 14³⁄₁₆″ (25.9 × 35.9 cm)
Helen M. Danforth Fund. 54.175

PROVENANCE: C. Rousset, Paris;[4] Lord Berners; heirs of Lord
Berners through David Carritt and H. M. Calmann, London.

EXHIBITIONS: Chicago, AI, 1960, no. 70 (ill.); Edinburgh,
RSA, 1965, no. 61 (pl. 34); Waltham, Rose, 1967, no. 16 (ill.);
New York, Wildenstein, 1969, no. 30 (ill.); San Francisco,
AMAA, 1986–88, p. 19 (no. 3, ill.).

PUBLICATIONS: Paris, Hôtel Drouot, 1875, p. 20 (no. 124, *A
Berne (Oberland). Entrée d'un chalet*); Robaut 1905 (1965), II, no.
731 (as *Intérieur d'un chalet de l'Oberland Bernois,* ill. p. 245); RISD,
Museum Notes, 1955, p. 14 (fig. 6.); RISD, *Treasures,* 1956, n. p.
(ill.).

17 *Banks of a River Dominated in the Distance by Hills,* ca. 1871–73

Signed, lower right: COROT
Oil on canvas. 12⁹⁄₁₆″ × 18⅛″ (32 × 45.8 cm)
Museum Appropriation. 24.089

PROVENANCE: Boussod et Valadon, Paris; Scott and Fowles,
New York.

EXHIBITIONS: Waltham, Rose, 1967, no. 17 (ill.); San Fran-
cisco, AMAA, 1986–88, p. 70 (no. 4, ill.).

PUBLICATIONS: Robaut 1905 (1965), III, no. 2105 (as *Bords de
la rivière dominés au loin par des collines,* ill. p. 279); D. R. 1924,
pp. 36–38 (ill. p. 37).

Camille Corot, the oldest of the French landscape painters
known as "the men of 1830," did not devote himself to paint-
ing until the age of twenty-six, and even then pursued a
course of study that was only briefly academic. The son of a
Parisian accountant and a dressmaker of Swiss descent, Corot
studied at a *lycée* in Rouen and then half-heartedly followed
a business career until his parents agreed to make an annual
stipend available to him in 1822, thus permitting him to
pursue studies as a painter. His first teacher, Achille Etna
Michallon (1796–1822), a landscape painter his own age,
encouraged Corot to make truthful studies from nature.
Upon Michallon's death, he studied with Jean-Victor Bertin
(see entry 19), whose classical landscapes were based on a
perception of nature as an accessory to history and who
introduced Corot to the seventeenth-century French land-
scape tradition of Poussin and Claude.

Honfleur, the Old Wharf is among the earliest known
paintings by Corot. Between 1822 and 1825, the period in
which it was painted, Corot devised a landscape style that
imposed careful observation of nature upon a somewhat
rigid compositional structure. Like Courbet, he often painted
the Normandy coast, reassessing the ports of Honfleur and
La Rochelle with each visit and gradually disassembling the
geometry he imposed in his early work. In *Honfleur, the Old
Wharf,* his armature is created from the three walls of the
empty boat basin. Behind this proscenium he carefully
reconstructs the activity of the port, precisely recording
nautical detail in the riggings of boats that are shielded by a
boatman's shed and an ancient tower. In this early work
Corot had already determined the dominant components of
his palette in the neutral greys, browns, and blues brightened
by the white pigment that he would continue to use to tone
and unify his landscape effects. Present as well is his interest
in blocking out light and dark zones, here crisply defined,
but later extended and softened to form generalized planes
of contrasting tones.

With limited experience of painting from the model,
Corot nevertheless populated the wharf with two tiny figures–
a woman, and a boy carrying a pole. This cursory staffage,
adopted from seventeenth-century Dutch landscape painting
and the more recent British watercolor tradition, remained
a constant in his work and eventually evolved to show an
enhanced understanding of the human form, as well as a
romantic and decidedly northern inspiration to his early
work and a rejection of Neoclassicism as taught by Michallon
and Bertin.

Interest in geometric structure, to the extent that it is
evident in *Honfleur, the Old Wharf,* gradually fades from
Corot's work after this period, coincident with his first trip
to Italy in 1825. During the next three years in Rome and its
environs he learned to eliminate detail and draw in the mass
and to emancipate himself, according to the French critic
Gustave Geoffroy, from the historical landscape.[5] His work
was dominated by studies from nature, landscape, and now
also figures, and he began to seize movement, spontaneity,
and the fugitive impression in his plein-air sketches. A small

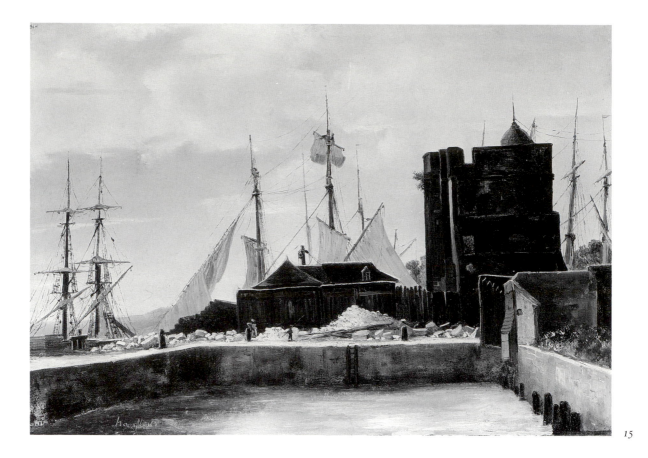

15

canvas of approximately twelve by fifteen inches, the approximate dimensions of all three of RISD's Corots, was the preferred size of these studies, with a surface of fine linen that permitted fluid paint application with little resistance or drag. Sketches of the Roman *campagna* that were ridiculed as rough and naive by the circle of French landscape painters he met at the Caffé del Greco were initially meant to be studies for larger historical works, but their flat, spontaneous effect, now free of stagelike substructure, marked the evolution of Corot's style and characterized even the classical subjects he sent to the Salon in the following decades.

By 1850 Corot had made two more extended trips to Italy as well as frequent visits to Switzerland, twice in the company of Charles Daubigny (see entry 52). The scenes he painted of Lausanne, Geneva, Fribourg, and the Bernese Oberland seem free of the influence of Turner's ambitious precedents, capturing instead the solitude and quiet beauty of the countryside and its villages. *Entrance to a Chalet in the Bernese Oberland* is more architectural than most of Corot's Swiss landscapes, but is related to views of town squares and cottage interiors that he made throughout his travels. The setting for this small picture is in the extraordinary territory of natural wonders that encompasses the twin lakes of Thun and Brienz, the Reichenbach falls, the valley of Lauterbrunnen and the spectacular peaks of the Mönch, Eiger, and Jungfrau. In this study from around 1850–55, preserved in his studio until his death,[6] Corot ignored the drama of the Alps in favor of an intimate glimpse of Swiss peasants gathered in the entrance to a mountain chalet and chatting in the shade of its eaves. Blocks of sunlight and shadow are crisply laid out,

framed by the chalet walls, united by the limited range of Corot's palette, and then loosened by the clearing of a leafy path leading away from the houses. The five small costumed figures interact comfortably, now animated by an understanding of pose, gesture, and age that Corot had acquired through years of painting models for his own pleasure. The variety of suggested surfaces—wood, stone, stucco, abundant foliage—and abrupt changes of intensity of light are set down instinctively and rapidly.

By mid-century Corot had won acknowledgment at the Salon with large studio commissions, although his impact on younger artists came from his paintings done from nature. In addition to befriending Daubigny, he knew Rousseau, Troyon, Millet, Dupré, and Diaz and often painted in the forest of Fontainebleau, thus associating himself with the Barbizon painters. His favorite setting, however, was Ville d'Avray, a village in the outskirts of Paris where his family had a country home. Throughout his life he returned to Ville d'Avray for a part of the year, repeatedly painting its limpid ponds and shaded paths. The landscapes he created there were shallow in depth and hazy in atmosphere, infused with a blue-grey tonalism that ignored the empirical optical interests the Impressionists would cultivate in this same decade, while avoiding local color except for the occasional accent. Accustomed to portraying the poetic effect made by nature on his memory (and thereby revealing the romantic tradition in his sentiments), he often applied general, evocative titles to his works, even those exhibited at the Salon, such as *Effet de matin, Le Soir, Crépuscule,* or *Intérieur de Bois.*[7] Such a recollection of nature is implied by *Banks of a River,* a souvenir

16

17

of a quiet river bend whose geography, a variant of the ponds at Ville d'Avray, is reminiscent in its stillness and simplification of Corot's favorite region in France. In the final years of his life, during which this river scene was painted, Corot repeated his landscape formula with ease, making countless variations on this theme. The shallow foreground, feathery border of reeds and grasses and hazy outline of houses that define the turn in the river frame a mirror of water that reflects the light of a brilliant sky. Two peasant figures, perhaps washerwomen, blend into the landscape, as one bends in the weighted pose of a gleaner.

The familiarity of *Banks of a River* is deceptive, for it is in the impression rather than in recognizable objects or landmarks that the memory of landscape is evoked. Here, as in countless late landscapes, Corot's pictorial resolution is like a musical chord, asserting neither subject, palette, nor technique, but blending all for an effect in which unity was more desirable than originality or verisimilitude. It confirms Delacroix's assessment that Corot did not believe one could make something more beautiful by laboring over it.[8] Rather, the loveliest, most honest of forms in landscape could only be achieved in the spontaneous touch and in those paintings inspired by direct observation of nature or from recollections accumulated over a lifetime.[9] It is in this sense that *Banks of a River* reiterates Corot's artistic goals, rendering a vision of nature that was formulaic not for the sake of pleasing his public, but to express an experience of landscape that was as recurring and personal as it was universal. M. C. O'B.

1. Robaut 1905 (1965), II, no. 35, notes that the signature was added at a later date.
2. Robaut 1905 (1965), II, no. 35, notes that it was in Forgeron's collection in 1890 and that he had paid eight francs for it.
3. The title has been reinstated from the earliest published descriptive title–*A Berne (Oberland). Entrée d'un chalet*–in the catalogue of the Vente Posthume Corot, 1875. Robaut 1905 (1965), II, no. 731, incorrectly described the scene as "Intérieur d'un chalet d'Oberland Bernois," although it was clearly an exterior view. It has subsequently been known as *Swiss Scene*.
4. Robaut 1905 (1965), II, no. 731, notes that it was purchased by Rousset at the Vente Posthume Corot (Paris, Hôtel Drouot, 1875) for 180 francs.
5. In Holme 1902, p. cxxix.
6. Robaut 1905 (1965), II, no. 731, reproduces a photograph of this painting taken by Charles Desavary, a photographer who had begun working with Robaut to document Corot's *oeuvre* before the artist's death.
7. These titles were among those submitted by Corot to the Salon of 1848.
8. Eugène Delacroix, *Journals*, March 14, 1847, tome I, p. 289, cited by Etienne Moreau-Nélaton in Robaut 1905 (1965), I, p. 114: "Il n'admet qu'on puisse faire beau en se donnant des peines infinies...."
9. In Robaut 1905 (1965), I, p. 49, Moreau-Nélaton cites Corot's notes from Italy, Carnet 66, in which he discusses the importance of covering the canvas with the first attempt: "J'ai remarqué que tout ce qui était fait du premier coup était plus franc, plus joli de forme et que l'on savait profiter de beaucoup de hasards...." ("I noticed that everything that was done in the first attempt was fresher, more charming in form, and that one learned to take advantage of chance....").

LOUISE-JOSÉPHINE SARAZIN DE BELMONT
French, 1790–1871[1]

18 *A View of Paris from the Louvre,* 1835

Signed and dated, lower left: *L. J. S. de B. Paris 1835*
Oil on canvas. 47⅛″ × 64″ (119.6 × 162.6 cm)
Helen M. Danforth Fund. 1987.056

PROVENANCE: Collection Paul Walraff; H. Shickman Gallery, New York, from whom purchased in 1987.

EXHIBITION: New York, IBM, 1988.

PUBLICATION: Rosenfeld, *"Ile de la Cité,"* 1988, pp. 31–33.

CONSERVATION: The original canvas has been glue-lined to a plain-weave canvas. The surface was cleaned and revarnished at the Williamstown Regional Art Conservation Laboratory in 1988.

Although little biographical information about this gifted painter has survived, we can surmise through known examples of her work and through the records of her submissions to the Paris Salons that she must have been an extraordinary woman as well as a painter of great talent. Women constituted a small percentage of the artists who submitted their work to the Paris Salons (ranging from about fourteen percent in the Salon of 1801 to twenty-two percent in the Salon of 1835), yet landscape painters were rare among them, owing to the demands of traveling alone and working in remote places, which is how Sarazin de Belmont appears to have spent a good part of her career.

Born in Versailles at the time of the Revolution, she studied painting with Pierre-Henri de Valenciennes (1750–1819), probably in the years just before 1812, when he was appointed professor of perspective at the Ecole des Beaux-Arts (to which women were not admitted) and when she submitted her first paintings to the Salon. (Jean-Victor Bertin, 1767–1842, was also a dedicated pupil of Valenciennes; see entry 19.) Prior to his appointment to the Ecole, Valenciennes supplemented his income by teaching drawing to young girls, among whom Sarazin may be counted.[2] From her submissions to the Paris Salon it can be determined that Sarazin was a peripatetic painter who traveled to Rome, Naples, and Sicily between 1824 and 1826; worked in the remote Pyrenees in 1831; painted in the Forest of Fontainebleau in 1834; and in Nantes and Brittany between 1836 and 1837. She received a First Class Medal in the Salon of 1834. From 1841 to 1865 she lived in Italy, painting views of the Roman *campagna,* and of Florence, Naples, and Orvieto. She resettled in Paris in 1865. Her last works were submitted *hors concours* to the Salon of 1868. She appears to have been an acquaintance of Ingres, who donated three of her Roman landscapes (among five in the collection) to the Musée Ingres in Montauban, and important works by her can be found in the museums at Toulouse, Tours, Angers, Nantes, Munich, Dresden, and San Francisco.

Sarazin would have studied with Valenciennes in the years just after he published his influential treatise, *The Elements of Perspective* (1800), and the evidence of her painting suggests that she was a follower of his teachings.[3] Valen-

ciennes advocated the supremacy of "heroic landscape" based on an intellectual appraisal of nature, in the manner of Nicolas Poussin and Claude Lorrain. At the same time that he emphasized the importance of idealizing nature, Valenciennes encouraged the painting of *études* in the open air and of studying the effects of nature directly, which was of evident importance for Sarazin, as for the emergence of plein-air painting generally in the early to mid-nineteenth century. Much of the surviving work by Sarazin belongs to this latter category – portable easel pictures that appear to have been painted at least partly on the site.[4] Also characteristic of much of Sarazin's known work is its quality of light, much in the spirit of Claude, which dominates the tone and moods of her paintings. One suspects that in practice she followed Valenciennes's recommendation to begin a landscape with the sky, from which the principal tone of the canvas should be carried to the middle- and foreground, establishing the harmony of the whole.[5]

It is likely that the RISD canvas, like many of Sarazin's smaller studies, was painted *in situ,* although it is clearly a protracted effort.[6] It was one of two paintings exhibited in the Salon of 1835, listed in the catalogue as *A View of Paris from the Gallery of Apollo,* from which it was apparently painted, looking eastward down the Seine.[7] This gallery of the Louvre, constructed under Henri IV, was rebuilt after a fire between 1661 and 1680 by Charles Le Brun. Le Brun also decorated the interior vaults of the second story, representing scenes of the Sun God, Apollo, designed to glorify the Sun King, Louis XIV. Thus called the Gallery of Apollo, it connects the Grande Galerie (which runs directly behind the viewer) to the additions made by Claude Perrault in 1668, whose façade is visible along the left edge of the painting. From this vantage, which joins at a right angle to the long façade of the Louvre, the viewer looks down the Seine towards the Ile de la Cité. The Pont-Neuf, the oldest existing bridge in Paris (completed in 1607), crosses the Seine at the tip of the island. The equestrian statue of Henri IV stands at its midpoint, facing the thick cluster of buildings that surround the Place Dauphine and rise before the towers of the Cathedral of Notre-Dame in the distance.[8] At the foot of the island sits a *bateau-lavoir,* or "laundry boat," and a coal barge with fuel to heat the water for washing. The Pont des Arts, a pedestrian bridge built in 1808, can be seen in the right foreground of the painting. It was the first iron bridge built across the Seine, connecting the Louvre to the Académie Française, a symbol of the modern world as the Pont-Neuf

was a reminder of the past. In the far distance, to the right, one can see the huge dome of Germain Soufflot's Church of Sainte-Geneviève, the highest spot on the Left Bank, completed in 1789 and dedicated to the patron saint of Paris, then in 1791 converted into a Panthéon for the burial of French heroes.

Paris in 1835 was a city that provided few dramatic vistas. It was a jumble of narrow medieval streets crowded by high buildings on either side, an almost impenetrable hive of *hôtels,* tenements, and shops through which the Seine cut like a ribbon of open space and light. The Ile de la Cité, the central focus of the painting, was one of the city's worst slums, inhabited by more than fourteen thousand people, a haven for "released convicts, thieves, murderers," according to Eugène Sue, where "black, filthy alleys led to steps even blacker and more filthy and so steep that one could climb them only with the help of a rope attached to the damp wall by iron brackets."[9]

The clutter and decay of Paris is not what Sarazin has chosen to represent. Her view is the long view, of both time and space, conveying Paris as the modern equivalent of ancient Rome, influenced by the Neoclassical vision of heroic landscape. The topographical detail resonates with allusions to the history of France, its monarchs and monuments, and to exalted past achievements that frame the activity of the modern world. The inclusion of genteel genre detail provides a foil for her preoccupation with the grandeur of the scene she represents, influenced by the golden light of Claude and the formal order of Valenciennes. Sarazin was also certainly familiar with contemporary *vedute* and topographical painting and illustration, practiced by artists such as Hubert Robert (1733–1808; see entry 9), A. J. Noël (1752–1834), Guiseppe Canella (1788–1847), Thomas Girtin (1775–1802), and Etienne Bouhot (1780–1862) – all of whom created noteworthy views of Paris in the late eighteenth and early nineteenth centuries. The allegorical paintings of Apollo by Le Brun that surrounded her as she painted from this window in the Louvre must also have informed her preoccupation with the light that dominates the mood of this painting. Nearly a half century in advance of Impressionist painting and Baron Haussmann's transformation of Paris, Sarazin presents a view of this city as the city of light and long vistas. In this luminous view, however, light is employed neither as allegory nor as the vehicle of transient optical effects that would be pursued by the Impressionist painters. It is the light of Arcadia, Southern in inspiration, which transforms Paris into a living Golden Age. D. R.

1. Although twentieth-century sources have listed Sarazin's date of death as 1870, Bellier-Auvray 1882–85, II, p. 463, closer to her in time, indicates that she lived until 1871.

2. Mont-de-Marsan, Donjon, 1981–82, p. 53.

3. See Valenciennes 1800.

4. See, for example, Ternois 1965, nos. 231, 233; Paris, Brame & Lorenceau, 1988, pp. 48–51; and New York, Wheelock Whitney, 1986, no. 6.

5. Valenciennes 1800, pp. 338–39. See also Boime 1971, pp. 136–40.

6. Examination of the painting with infrared illumination reveals detailed underdrawing and pentimenti indicating modifications to the architecture and the quays.

7. No. 1927, *Vue de Paris prise de la galerie d'Apollon.* In addition, she exhibited no. 1928, *Vue du cimetière du Père-Lachaise* (Toulouse, Musée de Toulouse), which represented the tombs of the painters David and Gros, among others. See Mont-de-Marsan, Donjon, 1981–82, p. 53. The Salon catalogue of the previous year lists seven submissions by Sarazin, representing views of the Forest of Fontainebleau, all of which were presumably smaller easel pictures. The Salon catalogues give no indication which painting was awarded a First Class Medal.

8. Henri IV was the first Bourbon king of France. The original equestrian statue, completed by Pietro Tacca in 1614, was destroyed in 1792 by order of the Consul General of the Commune. A replica was reconstructed in plaster in 1814 by H.-V. Roquier in time for the return of Louis XVIII, second to last of the French Bourbon kings, who passed before it on his triumphal return to Paris during the Restoration. The bronze statue that stands there today was completed by Frédéric Lamot in 1818.

9. Eugène Sue, *Les Mystères de Paris* [n.d.] I, pp. 1–2, quoted in Pinkney 1972, p. 10.

JEAN-VICTOR BERTIN
French, 1767–1842

19 Tivoli, ca. 1835–42

Oil on canvas. 19¼″ × 25⅝″ (48.8 × 65.7 cm)
Gift of Robert R. Endicott. 56.214

PUBLICATIONS: Providence, RISD, 1957, p. 10 (no. 29, incorrectly noted as signed *J. V. Bertin*); Gutwirth 1969, p. 313 (no. 109); Providence, RISD, 1972, p. 122 (incorrectly noted as signed *J. V. Bertin*); Gutwirth 1974, p. 357 (no. 136, incorrectly noted as signed *J. V. Bertin*).

Jean-Victor Bertin's work, and this canvas in particular, stand out as a turning point in the history of French landscape painting. Bertin, who came from a family of master wigmakers, was a pupil of Pierre-Henri de Valenciennes, one of the most influential late-eighteenth-century landscapists, and Bertin, who always acknowledged his debt to Valenciennes, continued the remarkably vital tradition established in the seventeenth century by Poussin and Claude (clearly visible even in 1835, in entry 18 in this catalogue, a painting by Louise Sarazin de Belmont, also a dedicated pupil of Valenciennes). Bertin visited Italy, apparently for several years in the first decade of the nineteenth century, and later helped establish the Prix de Rome for landscape painting, which his students almost invariably won. He himself received many medals and official commissions, especially early in his career.

The Providence painting is from the last period of Bertin's life, between 1835 and 1842.[1] It shows the dramatic waterfalls at Tivoli, with the Roman *campagna* stretching south and west toward Rome. This view had been one of the touchstones for foreigners visiting Italy since the sixteenth century, and Bertin himself represented it more than once, for example, in an oil on paper laid down on canvas, signed and dated 1826.[2] Bertin was always known as the master of the clearly composed landscape, the essence of the Neoclassical style, and this aspect of his work is apparent here: the foreground is defined by an aged, ivied tree trunk on the left, various figures, and trees on the right, a middle ground focused on the drama of the waterfalls, a sharply defined line of hills and valley, and the hazy background stretching into the distance and bathed in the late afternoon sunlight that so entranced French visitors to Italy.

In composition, this painting is not radically different from those of Valenciennes, or, for that matter, Poussin and

19

Claude. However, by the 1830's, a new naturalism had made itself felt in French landscape painting, introduced, ironically, by Bertin's student Corot, who had considered his time with the older master of no value whatever. This naturalism, exciting in itself and of profound importance for French painting in the second half of the century, makes itself felt in this late work of Bertin – its thicker brushstrokes, greater colorism and, especially, its greater interest in contemporary life. Here he has juxtaposed a rather fashionably dressed artist, sketching the site, and his female companion, with the group of Italian peasant women on the right, a contrast that would have been unusual for earlier practitioners of the Neoclassical tradition, not only for its suggestion of the contemporary but also for its hint of social and economic differences in society. F. W. R.

1. Gutwirth 1969, p. 313 (no. 109); Gutwirth 1974, p. 357 (no. 136).
2. London, Sotheby's, May 9, 1979, a finished oil sketch, 20¼″ × 15¼″, looking directly up at the waterfall (photograph, London, Courtauld Institute, Witt Library); this work was brought to my attention by Daniel Rosenfeld.

Attributed to
THOMAS COUTURE
French, 1815–1879

20 *Romans of the Decadence*

Oil on canvas. 16¹³/₁₆″ × 26½″ (42.6 × 67.3 cm)
Mary B. Jackson Fund. 54.004

PROVENANCE: Sidney W. Winslow, Sr.; Sidney W. Winslow, Jr., Boston.

EXHIBITIONS: Lawrence, UKA, 1958; Jacksonville, Cummer, 1964, p. 3 (no. 11, ill. p. 6); Waltham, Rose, 1967, no. 9 (ill., n.p.); College Park, UMAG, 1970, p. 53 (no. 4, ill.); Lexington, UKY, 1973, p. 12 (no. 19, ill. p. 27); Boston, MFA, 1976, p. 234 (no. 280, ill. p. 233); Washington, Federal Reserve, 1979; Springfield, MFA, 1980, p. 92; Providence, Brown, 1981, p. 168 (no. 9, ill. p. 169); New York, IBM, 1988.

PUBLICATIONS: RISD, *Treasures*, 1956, ill.; Hanson 1977, p. 153 (fig. 98); Woodward and Robinson 1985, p. 190 (no. 108, ill.).

RELATED WORK: Thomas Couture, *Romans of the Decadence*, 1847, oil on canvas, 183½″ × 305⅛″ (466 × 775 cm), Paris, Musée d'Orsay.

Thomas Couture's *Romans of the Decadence* (Paris, Musée d'Orsay)[1] was one of the best known and most influential paintings of the second half of the nineteenth century. Exhibited at the Salon of 1847 and immediately acquired by the Louvre, the monumental finished version was a resounding public success, uniting critics and inspiring in them a renewed faith in the future of French art. Couture was not quite thirty-two at the time of this accomplishment, but he had formed a philosophy of art and methodology that he had already begun to impart to younger painters. His own training, first in the studio of Baron Gros (1771–1835), from whom he learned to aspire to a noble style, and then with Paul Delaroche (1797–1856), whose spirit of intellectual eclecticism encouraged Couture's own, had led him to the brink of winning the Prix de Rome in 1837. When he narrowly failed to achieve that honor he abandoned the academic system and proceeded to devise a style that combined the most vital aspects of both classical and romantic painting in an art that reflected the ideas of contemporary society.

Themes of bacchanals and sexual orgies had a long and current tradition in European painting and literature and were familiar to Couture from the paintings of the Renaissance, the Flemish and Dutch Baroque, and from eighteenth-century French and British paintings and prints. Scenes of orgies, which offered dramatic potential for the depiction of luxury and depravity, appeared in nineteenth-century theatre productions and in the works of France's major novelists, and participation in evenings of drink and amorous activity was not uncommon among the declining aristocracy and its middle-class aspirants. Couture's own conception of the theme, however, was grander and more universal than that of his immediate predecessors and required a setting from ancient history in order to parallel and criticize the crumbling greatness of contemporary France.

To the entry for Couture's painting in the catalogue of the 1847 Salon were attached the lines from Juvenal's "Sixth

Satire: The Women": "*Nunc patimur longae pacis mala: saevior armis/Luxuria incubuit victumque ulciscitur orbem*" ("We are all suffering today from the fatal results of a long peace, more damaging than arms,/Luxury has rushed upon us and avenges the enslaved universe."). By association, Couture meant the painting to be read not only as the restatement of a seductive theme in the history of art, but as a comment on the ideals and behavior of his own society. A parallel was drawn by Couture's contemporaries between the erosion of Roman society and the decline of French civilization that had been precipitated by the Revolution, the overthrow of the *ancien régime,* and the defeat of Napoleon.[2] The theme was timely in an age of industrialism and increased bourgeois wealth, and its presentation in a manner and scale that rivaled the great art of the past—particularly that of Poussin, Rubens, and Veronese—assured its admiration by artists and critics alike.

Intentionally embodying contemporary ideas, *Romans of the Decadence* was also a declaration of Couture's philosophy of painting, rejecting the archaism of classical painting and the emotionalism of the Romantics, while combining elements of both styles that were useful to his program. His revelers, while derived from numerous sources in both ancient and European art, were perceived as having an air of realism about them, an effect that was heightened by Couture's characteristic freshness of paint application and by a play of lights and darks that created a flickering sense of movement across the canvas. Stabilized by the carefully constructed architecture of Corinthian columns, the orgy takes place in a shallow, stagelike setting which draws the viewer up to the edge of the proscenium, but prevents his entrance through the artful placement of still-life elements. Representing the artist and the viewer on the canvas are the so-called "Poet," seated at the base of a statue at left, and the two standing "Philosophers," who ponder the events at right—members of the intelligentsia who looked critically upon the decadence of the July Monarchy.

As counterpoint to the abandon of the revelers, statues of ancient Romans disposed among the columns silently stand witness to the decay of social order. At their center is the figure of Germanicus, alluding not only to the old order, but perhaps also to the Teutonic virtues of the conquerors who would overcome the lassitude of the Romans. Although composed of numerous interactions and groupings, the painting is neither narrative nor episodic. Its strongest focal point is the courtesan in the center, a symbol of sexual libertinism that simultaneously confronted contemporary mores while appealing to the sense of moral and intellectual freedom espoused during the years of the July Monarchy. Both static order, represented by the Roman effigies, and contemporary disorder are trapped in the crowded, de-energized disarray of this scene, representing the morning following the orgy. The mood is not the happy abandonment of Rubens's *Kermesse,* but rather one of overindulgence and fatigue bordering on despair.

The history of *Romans of the Decadence* serves as an intro-

duction to RISD's oil sketch and to the issue of the numerous small studies painted after the final version that proliferated in Couture's lifetime.[3] Widely known and discussed, and a prime subject for copies by an international army of students and followers of Couture, *Romans of the Decadence* was again exhibited at the 1855 Universal Exposition, fueling collectors' demands for replicas. RISD's painting may be counted among the finest of these copies, demonstrating on a small scale the freshness and innovative use of traditional methods that were characteristic of Couture's studio.

Stressing the importance of the painted sketch to his students, Couture insisted on its basis in a proper *ébauche,* a thin wash of oil paint in earth tones that fleshed out the preliminary charcoal drawing on the canvas.[4] This expressive underpainting, whose effect would have been literally glazed over and obscured by artists who espoused traditional norms of finish, was allowed to show through the next application of pigment in areas where Couture wished to emphasize its spontaneity. In RISD's sketch, evidence of this technique is visible in the grey-brown shadows of the columns, in the distant architecture, and in the statues of the Roman statesmen. The monochromatic effect of the underpainting is invigorated by the application of brilliant, pure colors that define the central activity of the decadent Romans and contribute to a sense of heightened realism.

The compositionally complete RISD painting is most likely a copy after the final version, rather than a preliminary study. Like an early engraved reproduction of the Louvre painting, it includes elaborations of the figures at the far right that are now cropped by the frame on the original (an observation that distinguishes the RISD sketch from copies lacking this information and may eventually assist in determining its approximate date).[5] Couture was widely admired in America, partly through the enthusiasm and teachings of his disciple William Morris Hunt, and replicas of his work were eagerly sought by American patrons. Indeed, a copy of *Romans of the Decadence* was brought to New York for exhibition in 1859 by the Victorian art dealer Ernest Gambart,[6] and in the early 1880's a study for the painting was listed in the collection of the Aesthetic Movement designer Christian Herter.[7] By family tradition, the RISD version was acquired by Sidney W. Winslow, Sr., from the artist,[8] but it is not unthinkable that Couture, who formally took on students immediately following the success of *Romans of the Decadence,* might have used studio talent to help supply copies to American patrons. In view of Couture's unparalleled role as a teacher, as well as the international reputation of *Romans of the Decadence,* the copies, particularly those that can be attributed to his studio, take on a distinct importance and warrant further investigation. M. C. O'B.

1. *Romans of the Decadence,* 1847, oil on canvas, 466 × 775 cm, Paris, Musée d'Orsay (Compin and Roquebert, 1986, III, p. 168, ill.). The most thorough discussion of the history, sources, and interpretations of this painting is Boime 1980, ch. VI: "The Romans: 'C'est La Décadence,'" pp. 131–88. I am grateful to Professor Albert Boime for his thoughtful advice regarding the issue of the small replicas of Couture's *Romans of the Decadence:* letter of November 21, 1990: "I have taken a hard line on the small replicas of the work (and they are numerous), and while they are for the most part from the studio of Couture most of them are student studies. . . . I will support your identifying this *Romans* as a copy after Couture."

2. Interpretations of the historical and political implications of this painting are given in Seznec 1943; Klagsbrun 1958; and Boime 1980.

3. In addition to RISD's painting, the following small oil sketches of *Romans of the Decadence* are recorded: Cambridge, Fogg Art Museum, Harvard University: oil on canvas, 23⅞" × 36½", Gift of Grenville W. Winthrop, 1943.224; Strasbourg, Musée des Beaux-Arts: "esquisse en réduction, peinte après coup par Couture, pour un membre de la famille d'Orléans, d'après le célèbre tableau du Louvre (1847)," oil on canvas, 22.5 × 36.2 cm, Paris, ex-coll. d'Orléans family; Paris, Musée d'Orsay: "esquisse," oil on canvas, ca. 1847, 52 × 84 cm, R. F. 1937–117 (Sterling and Adhémar 1958, I, pl. CLII). Other versions, or copies after Couture, are in Canton (Ohio), Canton Art Institute: oil on canvas, 24" × 29½", gift of John Hemming Fry, acc. no. 46.3; and Lyons, Musée des Beaux-Arts de Lyon, copy by Joseph Soumy (1831–1863). A version was sold in Berlin, Weber Sale, February 1928, no. 21, oil on canvas, 70 × 115 cm; another, after Couture, appeared in New York, Sotheby Parke-Bernet, June 4, 1975, no. 213, 21½" × 34½".

There were no small oil versions of *Romans of the Decadence* in the posthumous exhibition of Couture's work held in Paris in 1880 (see Ballu 1880). A charcoal drawing in this exhibition (no. 203, "*Les Romains de la Décadence,* Etude aux deux crayons. Appartient à Mme Henry de la House") apparently showed a variant of the final composition. (This is presumably the drawing illustrated in Seznec 1943, p. 231, and Boime 1980, p. 141, VI.7.)

4. For a discussion of Couture's methods see Boime 1977, pp. 36–37; and Boime 1980, *passim.*

5. The *Art-Union* 1847, p. 206, published an engraving of Couture's *Romans of the Decadence,* "borrowed for the purpose, from the 'Illustration Journal Universel,' a work of great merit, which aims at and achieves a high character." In this engraving, the full profile of the head of the Roman emperor at far right is visible, as is the profile of the figure (including shoulder and back) of the "Philosopher" at far right. These details appear in the RISD version, in the Lyons version by Joseph Soumy, and in the Louvre's sketch. They are not visible in the Fogg Art Museum's version.

6. See curatorial file, Fogg Art Museum, Cambridge, which suggests that their version might be the Gambart painting.

7. Strahan 1879–82, III, p. 123, "Mr. Christian Herter has contrived to obtain a study of Couture's for the celebrated 'Décadence Romaine'"

8. The RISD painting was purchased from Sidney W. Winslow, Jr., of Boston in 1954. Letters in the curatorial file state that the painting "is supposed to have been bought by the father of Mr. Sidney W. Winslow, Jr. from Couture, himself" (Berenice Davidson, Chief Curator, to Francine Klagsbrun, March 5, 1958) and "Winslow's father is supposed to have bought the painting from Couture just before the artist's death" (Davidson to Alan Gowans, November 19, 1958). A Sidney W. Winslow, Sr., a Needham (Massachusetts) shoe manufacturer born in 1854, is listed in the *Dictionary of American Biography.* No information on Winslow, Sr., as a collector, or on any exhibitions of a copy of *Romans of the Decadence* in Boston in the nineteenth century, has yet come to light.

21

THOMAS COUTURE
French, 1815–1879

21 *Gamin,* ca. 1850–60

Oil on canvas. 24¼″ × 19¾″ (61.6 × 50.2 cm)
Gift of Mrs. Houghton P. Metcalf, Sr. 1986.207.2

PROVENANCE: Beriah Wall, Providence, by 1882; Braxton
Art Company, New York; Houghton P. Metcalf, Sr., 1942.

EXHIBITION: College Park, UMAG, 1970, no. 34 (as *Portrait of
a Child*).

PUBLICATIONS: Strahan 1879–82, III, p. 94 (as *Study of a
Head*); Wall 1884, no. 40 (as *Gamin,* ill.); New York, Ameri-
can Art Galleries, 1886, no. 210; Howe 1951, no. 224 (as *Gamin*);
Bertauts-Couture 1955–56, p. 204 (as *Un Enfant,* ill. opp. p. 174,
fig. 5, *Gamin au tricorne*); RISD, *Museum Notes,* 1987, p. 29 (ill.).

RELATED WORK: Charles Walter Stetson (American, 1858–
1911), *Gamin (From the picture by T. Couture),* 1884, etching,
16⅜″ × 13″ (41.6 × 33 cm), Southampton, Parrish Art Museum,
Dunnigan Collection.

Attributed to
THOMAS COUTURE
French, 1815–1879

22 *Little Gilles*

Signed, lower left: *T. C.*
Oil on canvas. 23¹⁄₁₆″ × 18¹⁄₁₆″ (58.5 × 46 cm)
Gift of Mrs. Murray S. Danforth. 53.108

PROVENANCE: Quincy Adams Shaw, Boston (?);[1] Mrs.
Rainey Rogers (?);[2] Julius Weitzner, New York.

PUBLICATION: RISD, *Museum Notes,* 1956, p. 16 (ill.).

Following the success of *Romans of the Decadence* and paral-
leling difficulties surrounding the completion of a second
monumental commission, *Enrollment of the Volunteers,*[3]
Couture shifted away from paintings that sought to renew
the noble tradition of French art and returned to smaller alle-
gorical subjects, portraits, and genre studies. The deflection
of his interest was facilitated by the broad base of patronage
he had won through the renown of *Romans of the Decadence*
and the wide acclaim given by critics and by the students
who attended his studio after 1847.[4] Depictions of adoles-
cents, frequently dressed in Renaissance or eighteenth-
century costumes, such as *The Falconer* of ca. 1844–45,[5] had
preceded Couture's official recognition and would remain
central to his *oeuvre* until the end of his life. Such subjects
appealed not only to French patrons, but to the American
art market as well. The latter provided Couture with a steady
source of revenue from eager buyers, and by the 1880's his

22

Fig. 1 Charles Walter Stetson, *Gamin (From the picture by T. Couture)*, 1884, etching, 16⅜″ × 13″ (41.6 × 33 cm), Southampton, Parrish Art Museum, Dunnigan Collection.

paintings were in private collections across the United States.[6]

Beriah Wall, a Providence businessman, owned an exceptional group of modern French paintings that included a broad representation of Barbizon artists as well as works by Delacroix, Géricault, and Courbet.[7] In 1884 he published a deluxe catalogue of his collection, which included an etched illustration of Couture's *Gamin,* a bust-length study of a boy against a dark background.[8] The painting had been copied for Wall by Providence artist Charles Walter Stetson, who etched the small catalogue plate as well as a larger print (fig. 1), an impression of which was presumably kept by Wall after the sale of his collection in 1886.[9]

The costume of the *Gamin,* or street urchin, suggests that it is related to Couture's ongoing work on *Enrollment of the Volunteers.* While not a study for one of the figures in this painting, RISD's boy wears the loose white stock, high-collared waistcoat, and tricorne hat of an eighteenth-century aristocrat, a curious insinuation of historical detail that reveals Couture's interest in the painting of Chardin and underlines his rejection of contemporary genre subjects. Like the head of a young volunteer who appears in two versions of *Enrollment of the Volunteers,* the right side of the *Gamin* is obscured by dark shadow. The left, however, is dramatically light-struck, an effect that undercuts the boy's features and magnifies the brilliance of his scarf. Characteristically heavy white impasto further heightens the knotted cloth, while the left cheek and sleeve are animated by rapid applications of pigment in ruddy patches and long white strokes. Couture's paintings were rarely without social commentary, and this melancholy child carries overtones of the artist's disillusionment with French politics and with revolutions that seemed only to bring more wealth to the middle and upper classes.

A second Couture subject in the Museum's collection indicates the popularity of his costumed single figures among American collectors. Apparently theatrical rather than political in motif, *Little Gilles* is related to Couture's use of themes from the Commedia dell'Arte, an interest first shown in works of the 1850's. Typical of his narratives was *Supper After the Masked Ball,* ca. 1854,[10] in which the artist portrayed himself in the costume of Pierrot, seated at a table and wearily surveying the drunken sleep of the party's revelers. In the 1880's several of these scenes were owned by Americans, who were aware that they embodied satires on society, the press, and the French legal system.[11]

At least two versions of a child Pierrot, known as *Le Petit Gilles,* were in America before the turn of the century. One of these, owned by Charles Stewart Smith of New York in the early 1880's, included a background of foliage; a second (fig. 2), formerly in the collection of Couture's patron, the bronze founder Barbédienne, had been purchased by George Elkins of Philadelphia by 1892.[12] The latter became known to a wide American audience in that same year when it was reproduced in a *Century Magazine* article on Couture written by the portrait painter G. P. A. Healy.[13] At that time it appeared as *The Little Confectioner,* a title that may have originated in an interpretation of the figure derived from a nineteenth-century pantomime which explained the paleness of Pierrot's face by casting him as a miller's assistant.[14]

RISD's *Little Gilles,* which is smaller than the Smith and Elkins versions, may have been a studio copy after one of these. Like the others, it represents a half-length figure of a child dressed in a loose-fitting white smock and cap. The original model had been Couture's servant boy, whom the artist painted in the late 1870's. A contemporary account described him as "a quaint little page who waited on him [Couture] in his studio and garden, and whom it was his delight to dress up in travesty."[15] Less romantically, he was also called a menial whom Couture worked "almost off his legs."[16]

In the RISD painting, Gilles is portrayed carrying a serving tray that supports two transparent glasses holding spoons. In treatment and detail it summarizes the other versions, in which the glasses are filled with red liquid and a third glass and spoon also appear on the tray. In the RISD painting the boy's face, chest, and tray are sketched on the canvas in charcoal, then developed with the thin earth-tone washes of the *ébauche.* Observing Couture's studio methods, the cap, collar, and sleeve are abruptly modeled with rough strokes of white pigment that make no attempt to conceal the underpainting. Abbreviating the finished versions, the RISD painting directs attention to the sad face of the boy, while preserving a sketchlike quality in the remainder of the composition.

Couture's preoccupation with the figures of the Commedia dell'Arte, particularly Pierrot and Harlequin, existed in the context of a long and flourishing tradition in French literature and painting and paralleled a revival of interest in French art of the eighteenth century advanced by the articles of Théophile Gautier and the Goncourt brothers. In this regard, the art of Watteau, to whose *Gilles*[17] Couture made

pointed reference, was obviously significant. References to the art of the past were numerous, intentional, and unavoidable throughout Couture's career, but were always transformed by his thoroughly modern methods and informed by personal meaning and often by disillusionment. In the single figure studies such as *Gamin* and *Little Gilles,* Couture is seen returning to the human-scale art of the eighteenth century, in contrast to "the *great art of ancient Greece,* the *Renaissance masters* and the *admirable Flemish School,*"[18] to which he had aspired in *Romans of the Decadence.* M. C. O'B.

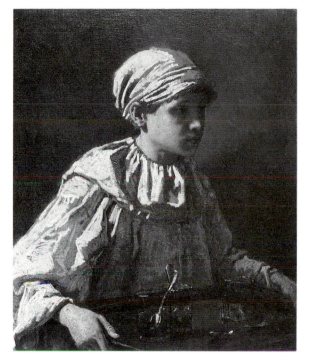

Fig. 2 Thomas Couture, *The Little Confectioner,* ca. 1878, oil on canvas, 24¾″ × 21½″ (62.9 × 54.6 cm), Philadelphia, Philadelphia Museum of Art, William L. Elkins Collection.

1. The only document suggesting this provenance is a memo in the Museum's curatorial file dated November 9, 1953, from John Maxon, then Director of the Museum, to Heinrich Schwarz, then Curator, stating: "The correct title for the Couture is 'Little Giles,' and was formerly in the collection of Quincy Adams Shaw, Boston." Quincy Adams Shaw (1825–1908) was a Harvard-educated businessman who made a fortune investing in Michigan copper mines. As a collector of Millet's works, he is discussed by Susan Fleming in Boston, MFA, 1984, pp. ix–xi. His collection is briefly described by Strahan 1879– 82, III, pp. 85–86, and in "Greta's Boston Letter" 1881, p. 72. See also Boston, MFA, 1918, for a discussion of Shaw's Millet collection.

2. In a letter of February 6, 1953, to Heinrich Schwarz (Museum curatorial files), Weitzner wrote: "I purchased this painting about 1936–37 in Boston – it came I believe from the well known collection of Mrs. Rainey Rogers." (Presumably it was the New York collector, Grace Rainey Rogers, to whom Weitzner referred.) This provenance is not otherwise documented.

3. The commission is discussed in Boime 1980, pp. 189–229, and is the subject of an exhibition catalogue, Springfield, MFA, 1980.

4. For a wide discussion of Couture's students, see Boime 1980, pp. 495–612; his American students were the subject of an

exhibition and catalogue, College Park, UMAG, Landgren, 1970.

5. Couture, *The Falconer,* ca. 1844–45, oil on canvas, 129.5 × 97.8 cm, Toledo, Toledo Art Museum (Boime 1980, p. 106, pl. V.19).

6. By 1882, Strahan 1879–82, III, p. 133, listed twenty works by Couture in American collections known to him.

7. Strahan 1879–82, III, p. 90, discussed Wall's collection as "a remarkable one to find everywhere, – a gallery for artists to pasture in." He lists (pp. 93–94) eighty-eight works by artist and title, including ten paintings by Corot and a still life by Chardin.

8. Wall 1884.

9. See Southampton, Parrish, 1984, p. 49 (no. 53): Charles Walter Stetson, *Gamin (From the picture by T. Couture),* 1884, etching, 16⅜″ × 13″.

10. Finished version, oil on canvas, 155.3 × 202.9 cm, Vancouver, B.C., Vancouver Art Gallery (Boime 1980, p. 303, pl. IX.8).

11. Strahan 1879–82, II, pp. 99–100, describes *The Trial of Pierrot* (New York, collection of Collis P. Huntington) and two versions of *Pierrot and Harlequin reading the Moniteur* (collections of Darius O. Mills, San Francisco, and Robert Hoe, Sr., New York) and refers to the inexhaustible and authentic invention of his satires.

12. The Charles Stewart Smith version passed to Dr. William MacFee, New York, at the American Art Association sale, New York, January 4, 1935 (New York, AAA, 1935, no. 49, *Le Petit Gill,* ill.); current location unknown. The Barbédienne/Elkins version is in the collection of the Philadelphia Museum of Art.

13. See Healy 1892, p. 5. The engraving by H. Davidson, again with the title *The Little Confectioner,* was also reproduced in the reprint of the article in Van Dyke 1896, opp. p. 4. It is still listed as belonging to Barbédienne in Van Dyke, although it entered Elkins's collection in 1892.

14. Boime 1980, p. 300, identifies Champfleury's pantomime, *Pierrot marquis* of 1847, a parody on a play by Ponsard in which the writer "rationalized the mysterious paleness of Pierrot's face and costume by making him a miller's assistant." Boime gives a thorough overview of the Commedia dell'Arte in France and its presence in French art and literature, pp. 292–326.

15. Strahan 1879–82, II, pp. 88–89, describing the *Petit Gilles* belonging to Charles Stewart Smith, which he illustrates with a line drawing. He further noted, p. 89, that Couture was "an indulgent though hard master on the boy, making the air ring with appeals to 'Gilles! Gilles!' from every part of the house and grounds ... and petting and spoiling him with that familiarity that is the gift of Bohemia, and which has the art of procuring such attached and long-suffering servants." Boime 1980, p. 341, takes a less sanguine view of the relationship and stresses the child's exploitation and expression of sadness.

16. Strahan 1879–82, II, p. 89.

17. Antoine Watteau, *Gilles,* 184.5 × 149.5 cm, Paris, Musée du Louvre (Posner 1984, p. 232, pl. 57).

18. From Couture's announcement of the opening of his art school in 1847, reproduced in Boime 1980, p. 135, and cited on p. 134.

THÉODORE CHASSÉRIAU
French, 1819–1856

23 *Fisherman's Wife from Mola di Gaeta*
 Embracing her Child, ca. 1849–51

Signed, lower right: *Th.^{re}Chassériau*
Oil on panel. 6¹³⁄₁₆″ × 4¾″ (17.3 × 12 cm)
Gift of Mrs. Gustav Radeke. 28.004

PROVENANCE: Mme C. Astoin by 1893; Baron Arthur Chassériau by 1911; Martin Birnbaum; from whom acquired by Mrs. Radeke for the Museum in 1928.

EXHIBITIONS: Paris, Salon de 1850–51, no. 537 (?); Chicago, AI, 1933, p. 35 (no. 229); Cambridge, Fogg, 1946, p. 17; Detroit, DIA, 1950, p. 26 (no. 40); Hartford, Wadsworth, 1952, p. 16 (no. 51); New York, Shepherd, 1975, pp. 209–10 (no. 87, ill.)

PUBLICATIONS: Gautier 1851; de Geofroy 1851, p. 941; Sabatier-Ungher 1851; *L'Artiste* 1852, pp. 79–80 (ill.); Mantz 1856, pp. 223–24; Bouvenne 1887, pp. 172, 176; Chevillard 1893, p. 278 (no. 73); Marcel 1911, pp. 91–93 (ill.); Vaillat 1913, p. 14; Rowe 1929, pp. 40–42 (ill.); Bénédite 1931, II, p. 368; Tietze 1935, pp. 279, 344 (ill.); *Art Digest* 1950, p. 13 (ill.); Birnbaum 1960, p. 201; Sandoz 1974, p. 274 (no. 136, pl. CXXV, erroneously listed as CXXVI).

CONSERVATION: A vertical strip added by the artist along the left edge of the panel was reglued and the surface of the panel cleaned in 1943.

RELATED WORKS: *Young Mother embracing her Child,* 1841, pen and ink on paper, 7½″ × 5⅞″ (19 × 15 cm), location unknown, in Sandoz 1986, p. 153 (no. 150). *Fisherman's Wife from Mola di Gaeta Embracing her Child,* 1849, oil on panel, 7⅞″ × 5½″ (20 × 14 cm), Paris, Musée du Louvre (R.F. 3923); lithograph by Lemoine, in *L'Artiste,* Ve série, v. IX, no. 5 (October 1, 1852).

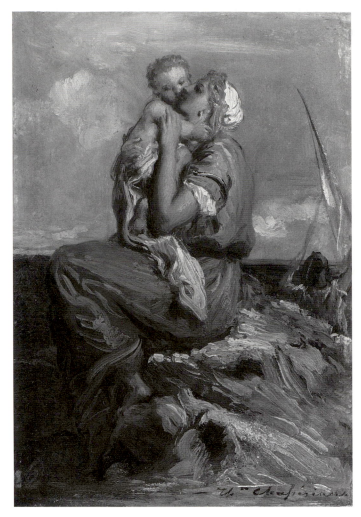

23

Because of his untimely death at the age of thirty-seven, Théodore Chassériau holds a less prominent place in the history of French Romantic painting than his talents should otherwise have allowed. He was removed by a generation from both Delacroix (b. 1798) and Ingres (b. 1780); nevertheless, his work was influenced by both, synthesizing the refined draftsmanship and composition of Ingres's Neoclassicism with the spirited brushwork, color, and emotional appeal of the Romantic Delacroix. Chassériau was born in Haiti (then Santo Domingo), where his father was a diplomat in the French consular corps and his mother belonged to a French plantation family. Although he resettled in Paris when he was barely two years old, his later penchant for exotic subjects and the warmth of his color have been attributed to his West Indian origins. In 1830, at the precocious age of eleven, he became a pupil in Ingres's studio, where he remained until 1835, when Ingres became director of the French Academy in Rome. In spite of his youth, Chassériau was a favorite of Ingres, who admired his accomplished draftsmanship, claiming that the young prodigy would someday become "the Napoleon of painting."[1] Chassériau seemed to live up to this promise when in 1836, at the age of seventeen, he made his first appearance at the Salon, where one of his three submissions, *The Curse of Cain,* was awarded a Third Class Medal.

In 1840 Chassériau followed Ingres to Rome, but their paths had already begun to diverge.[2] Over the remaining fifteen years of his brief life, Chassériau developed a style of painting that embraced the ideals of Romanticism, even while the attraction to clear linear draftsmanship and formal order that had drawn Chassériau to Ingres in the first place remained an important feature of his work. "It would seem that the artist applied a style of drawing inspired by Ingres to a romantic inspiration," Paul Mantz wrote in 1856, noting the artist's effort to reconcile these opposites.[3] Chassériau was attracted to the repertoire of literary motifs that inspired the Romantics, drawing his subject matter from Ovid, the Old Testament, Shakespeare, and Homer. He also shared the Romantic infatuation with exotic themes. In 1846, like Delacroix sixteen years before, he traveled to Algeria at the invitation of the Khalif of Constantine, whose portrait he had painted in Paris the year before, beginning an orientalist phase in his work.

The *Fisherman's Wife* is a product of the years immediately following Chassériau's visit to North Africa, representing a genre motif from the Mediterranean gateway to his Algerian destination. Sandoz, citing archival sources, has indicated that the work originates from 1849.[4] However, the composition appears to have been adapted from a drawing of 1841 representing a mother kissing her child in a landscape setting,

dressed *à l'antique,* adapted from Greek funerary sculpture.[5] The subject in its modern and picturesque incarnation was evidently inspired by Chassériau's trip to Italy in 1840–41. In the summer of 1840 Chassériau made an excursion to Naples from Rome, and it is possible that he would have passed through Gaeta immediately to the north. Théophile Gautier, who may have had the benefit of personal conversations with the artist, identified the source for the subject as the island of Ischia, which is located at the southern tip of the Gulf of Gaeta, just west of Naples.[6]

Fanciful Italian genre subjects became an important motif for Romantic artists, providing a picturesque alternative to the Neoclassical repertoire of themes. Chassériau may have been familiar with François Rude's *Neapolitan Fisherboy,* a sculpture exhibited with great sensation at the Salon of 1833, which inspired a widespread interest in Mediterranean genre subjects that provided a modern link with the coastal cultures of antiquity. The connection between antiquity and the modern world, both in subject and style, visible in the *Fisherman's Wife from Mola di Gaeta,* was noted by one critic, Sabatier-Ungher, who praised this small painting as an example of "living Greek art."[7] The Romantic Gautier, on the other hand, acknowledged its exoticism, praising Chassériau for "travelling at his own risk to unknown places. That is preferable to the imperturbable repetition of the same formula."[8]

The *Fisherman's Wife* does have antecedents in Renaissance and Baroque painting, related to representations of the Virgin and Child.[9] In his work of the 1840's, Chassériau exhibited a repeated interest in images of mothers and their children, of which the most noteworthy formed a part of the large murals on the theme of War and Peace commissioned for the Cour des Comptes in the Palace of the Quai d'Orsay, Paris.[10] In Chassériau's major public commission, completed in 1848, Peace is represented with outstretched arms, sheltering a group of artists, artisans, and mothers with young children; the most prominent mother, immediately beneath the right arm of Peace, kisses the infant child whom she holds in her arms. Chassériau's preoccupation with this theme may suggest his effort to find a secularized adaptation of a religious motif that conveys the same sentiment of affection.

There is a considerable amount of confusion about this painting and another almost identical to it in the Louvre (fig. 1).[11] One of the two panels, listed by the title *Femme de pêcheur de Mola di Gaëte embrassant son enfant,* was exhibited in the Salon of 1850–51 (one of eight paintings exhibited by Chassériau in that year), where in spite of its diminutive size it received a considerable amount of critical attention. It is impossible, however, to determine which of the two this might have been, or the circumstances in which a replica was made. There are subtle differences between the two paintings, and the freedom of execution visible in each suggests that neither is a cold copy of the other, in spite of their similarities. The brushwork in each seems spontaneous and organic, giving each an improvisatory quality that reflects a liberalized standard of finish for salon painting. Chassériau added a vertical strip along the left edge of the Museum's panel, thereby giving this version slightly more breadth, revealing more of the water's horizon to the left of the sitter's knee. It is difficult to imagine that a modification of this kind would occur in a copy, assuming such problems of detail to have been resolved in the original. Another noteworthy difference between the two versions is the placement of the mother's right hand. In the Louvre version it is placed on the back of her child; in the Museum's version it supports the infant's buttocks. In a lithograph by Lemoine published the following year, claiming to reproduce the work exhibited in the Salon of 1850–51, the composition (which is reversed) is clearly adapted from the Museum's version: the mother's hand supports the baby's buttocks, and the horizon beyond her knee extends to the left.[12]

The provenances of the two paintings further add to the confusion surrounding their relationship. The Louvre version descended from the collection of Mme Gras, who owned a painting of *Sappho* and another of *Desdemona* by Chassériau, which she appears to have acquired from the Salon of 1850–51, suggesting that her version of the *Fisherman's Wife* may have been acquired on the same occasion.[13] It is a matter of speculation whether Chassériau painted the Museum's version as a copy for himself before passing the original along to Mme Gras, or painted a replica for Mme Gras, keeping the original for himself. The double signature on the Louvre version provides no further clue, nor do the subsequent provenances of these two paintings. The Museum's version entered the collection of Mme Astoin, and by 1911 it had been acquired by the artist's great-nephew, Baron Arthur Chassériau, from whom it was acqured by Martin Birnbaum on behalf of Mrs. Radeke, who gave it to the Museum.[14] The version in the

Fig. 1 Théodore Chassériau, *Fisherman's Wife from Mola di Gaeta Embracing her Child,* 1849, oil on panel, 7⅞″ × 5½″ (20 × 14 cm), Paris, Musée du Louvre.

Louvre was also acquired by Baron Chassériau, who purchased it from the Gras collection sale in 1917.[15] The fact that Baron Chassériau sold one version (now belonging to RISD) and acquired another (now in the Louvre) might suggest that he assumed the Gras version to be the one actually exhibited in the Salon, although there is no certain proof that this was the case, and the Lemoine lithograph might suggest the contrary.[16]

The Museum also has in its collection a pencil drawing by Chassériau, a *Portrait of M. Barthe*(?) (38.145), signed and dated 1846. D.R.

1. Focillon 1928, p. 164.
2. In a letter to his brother from Rome, Chassériau wrote, "[Ingres] has lived his best years and has not the slightest comprehension of the new ideas and the changes that have taken place in art in our time; he is in complete ignorance of the poets of this day. For him that is all right; he will remain a reminder and a reproduction of certain ages of the art of the past, without having created anything for the future. My desires and ideas are in no way similar." Quoted in Goodrich 1928, p. 68.
3. Mantz 1856, p. 225.
4. Sandoz 1974, p. 272 (no. 135), cites manuscript notes by Chassériau listing works from the year 1849: "1849/[. . .] × 8. *femme de pêcheur de Mola de Gaëte embrassant son enfant* [. . .]."
5. Reproduced in Sandoz 1986, p. 153 (no. 150).
6. Gautier 1851.
7. " . . . reality in perfect unity with the ideal; the elegance of a Greek and the tenderness of a mother pure and noble like an antique cameo." Sabatier-Ungher 1851.
8. Gautier 1851.
9. It is probably in reference to these antecedents that de Gefroy 1851, p. 941, referred to this painting as a "souvenir of Florentine elegance."
10. The Palace of the Quai d'Orsay was burned down in the Commune of 1871 and for many years stood as a ruin. In 1898, to make way for the train station that today serves as the Musée d'Orsay, the remains of the Palace were razed, in advance of which an initiative by the *Gazette des Beaux-Arts* was taken to preserve what remained of Chassériau's murals. *War* was completely destroyed, but a fragment of *Peace* is today preserved in the Louvre.
11. The provenances of these two paintings are often confounded (see, for example, Paris, Orangerie, *Chassériau,* 1933, p. 22, no. 41). Sandoz 1974, no. 135, pl. CXXV, confuses the two paintings and their dimensions, reproducing the RISD panel for the example in the Louvre.
12. Lithograph by Lemoine published in *L'Artiste* 1852, opp. p. 79. The legend (p. 80) for this reproduction reads in part: "One recollects seeing this fine painting in the Salon of 1851, harmonious and sober in its pink tone, simple and moving because of its composition and sentiment."
13. Bouvenne 1887, p. 172. Cf. Chevillard 1893, p. 278 (nos. 71-72), indicating the presence of *Sappho* from the Salon of 1851 in the collection of Mme Gras, but of *Desdemona* from the same Salon in the collection of M. A. Chassériau, which would indicate that Chassériau also created a replica of this painting.
14. See Chevillard 1893, p. 286 (no. 129); Marcel 1911, p. 93; and Birnbaum 1960, p. 201.
15. See Paris, Hôtel Drouot, 1917, no. 2.
16. The Louvre has always maintained that it was their version that was exhibited in the Salon of 1850–51, although notations in the Louvre archives related to this painting indicate that this is received information, deduced by its derivation from the collection of Baron Chassériau. There is no salon registration number on the back of either panel.

FRANZ XAVER WINTERHALTER
German, 1806–1873

24 *Prince Arthur William at Age Seven Weeks,* 1850

Signed and dated, lower right: *F. Winterhalter/London 1850*; inscribed on verso: *Prince Arthur/William/Ætatis 7 weeks/June 1850*
Oil on canvas. 20⅞″ × 24⅞″ (oval) (53.1 × 63.2 cm)
Gift of Charles K. Lock. 56.087

PROVENANCE: Commissioned by Queen Victoria and given by her to the Princess Royal, Victoria Adelaide Mary Louise (later Empress Frederick III of Germany); purchased from her descendants by Charles K. Lock of New York, the donor.

PUBLICATION: RISD, *Museum Notes,* 1956, cover (ill.).

CONSERVATION: The stencil for the London firm of art suppliers, Winsor and Newton, appears on the verso. The painting retains its original gilt gessoed frame.

Few international court painters of the nineteenth century enjoyed royal patronage to the extent of the Munich-trained portraitist from Menzenshwand, Franz Xaver Winterhalter. In addition to serving both the courts of Louis-Philippe and Napoleon III between 1834 and 1870, he painted over one hundred and twenty works for Queen Victoria. Her prodigious patronage began in 1842 with half-length portraits of herself and Prince Albert, in uniform, and eventually Winterhalter portrayed members of the royal family "in almost all possible combinations of persons at all ages from ten weeks to senility," as noted by Winslow Ames in *Prince Albert and Victorian Taste.*[1] If Ames had known of the inscription on the back of the Museum's portrait of Prince Arthur William, he could have written "from seven weeks to senility." When Queen Victoria commissioned this infant portrait of her third son and seventh child, Prince Arthur William Patrick Albert (1850–1942), she may well have had in mind a miniature watercolor portrait on ivory of herself painted in

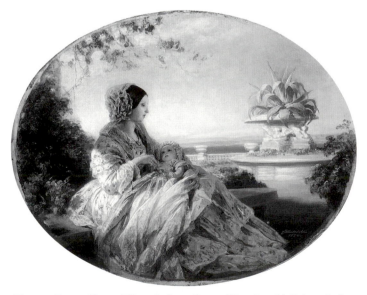

Fig. 1 Franz Xaver Winterhalter, *Queen Victoria with Prince Arthur,* 1850, oil on canvas, 23½″ × 29⅝″ (oval) (59.7 × 75.2 cm), London, Royal Collection. Photograph by Rodney Todd-White & Son.

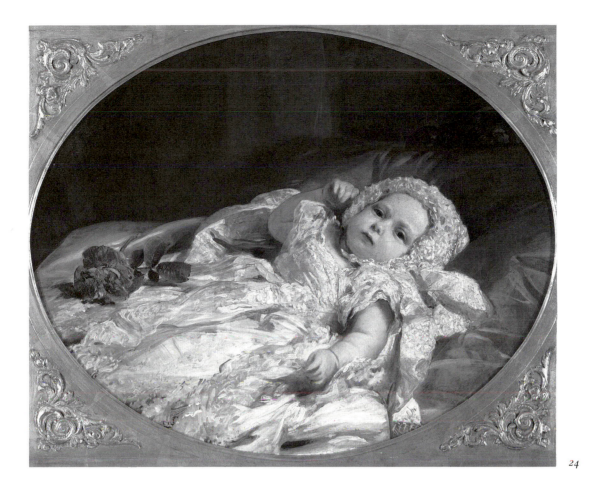

her seventh month by another German artist, Johan Georg Paul Fischer (1786–1875).[2]

As soon as Victoria and Albert started to have children, the production of their portraits commenced, perhaps the first being Charles Robert Leslie's *Christening of the Princess Royal,* executed shortly after that event, which took place at Buckingham Palace on February 10, 1841. As the eldest child, and later Crown Princess of Prussia and Empress of Germany, Victoria Adelaide Mary Louise (1840–1901) served as the subject of several portraits by Winterhalter at different stages of her life from girlhood to Princess of Prussia. It was to her that Queen Victoria gave Winterhalter's portrait of Prince Arthur William.

Queen Victoria had turned to the French court painter Eugène Lami (1800–1890) for a record in watercolor of the christening of Prince Arthur William in the private chapel at Buckingham Palace on June 22, 1850.[3] For a detailed portrait of Prince Arthur William in his christening gown, she commissioned Winterhalter, who captured in oil the textural quality of both the face of the baby and his clothing. As if to leave no question that this was a christening portrait, Winterhalter introduced a cabbage rose, a symbol of purity. According to the Queen's journal, Winterhalter began the portrait on June 25 and completed it on July 5, 1850, and was paid £40 for it.[4]

Winterhalter had the opportunity to paint Prince Arthur William on at least four other occasions, beginning with a closely related and slightly larger oval portrait of him lying in his mother's lap on the terrace at Windsor Castle (fig. 1), executed shortly after the Museum's picture. In view of its more elaborate composition with an additional sitter, Winterhalter not surprisingly charged Queen Victora £100. She gave that picture to Prince Albert for his thirty-first birthday on August 26, 1850.[5]

A year later Queen Victoria commissioned Winterhalter to paint a truly monumental portrait in which Prince Arthur William plays a central role. Entitled *The First of May,* it commemorates the first birthday of Prince Arthur William, as well as the eighty-second birthday of his godfather, the Duke of Wellington, who is shown kneeling in the foreground while presenting a metal casket to his godchild. According to Queen Victoria, Prince Albert suggested to Winterhalter the idea of basing the picture on an *Adoration of the Magi,* but with only one Magus. In addition, a view of the Crystal Palace appears over the left shoulder of the Duke of Wellington and to the right of Prince Albert, recalling that May 1, 1851, also served as the opening date for the Great Exhibition with which Albert's name is inextricably bound. The cabbage rose found in the Museum's portrait has been replaced with the branch of may (hawthorn) in the upper left corner, while Prince Arthur William clutches in his right hand a bunch of lilies of the valley, symbolizing May Day.[6]

For Prince Albert's thirty-fourth birthday, Queen Victoria commissioned Winterhalter to paint a remarkably

prophetic portrait of Prince Arthur William at age three. Shown dressed in the uniform of a Scots Guard against a blank background, the painting not only seems to anticipate Edouard Manet's *Fifer* of 1866, but also the impressive military career Prince Arthur William would eventually lead.[7] Indeed, he became the most active British Royal soldier of his generation, serving in Egypt, India, Ireland, and the Mediterranean, before becoming Governor-General of Canada from 1911 to 1916.[8] Not surprisingly, he was the favorite son of Queen Victoria, who "adored little Arthur from the day of his birth. He has never given us a day's sorrow or trouble, she may truly say, but ever been like a ray of sunshine in the house."[9] Elsewhere she confided that Prince Arthur was "dearer than any of the others put together."[10] The fondness Queen Victoria felt for Prince Arthur William also extended to his portraits, including the one by Winterhalter given to the Princess Royal and now at RISD. That picture left England for Schloss Babelsberg outside of Berlin in 1858, following Princess Victoria's marriage to Prince Frederick of Prussia, and eventually made its way to Schloss Charlottenburg in Berlin in 1888, when its owner became the Empress Frederick III of Germany.[11] Queen Victoria eventually filled the gap it left in her own collection by commissioning an exact replica by Count Seckendorff in 1882,[12] which hangs at Osborne House on the Isle of Wight today. C.P.M.

1. Ames 1967, p. 139.
2. Millar 1982, p. 119.
3. Ames 1967, p. 212 (pl. 43). Lami had come to England in 1848 in order to be with King Louis-Philippe and Queen Amélie during their exile.
4. Information based on a conversation on October 13, 1989, with the former Surveyor of the Queen's Pictures, Sir Oliver Millar, who is preparing a catalogue of nineteenth-century pictures in the Royal Collection.
5. London, National Portrait Gallery, 1988, p. 194.
6. Ames 1967, pp. 139–40, 211 (pl. 42).
7. Ames 1967, pp. 138, 212–13 (pl. 45).
8. Legg and Williams 1959, pp. 16–21.
9. Legg and Williams 1959, p. 16.
10. London, National Portrait Gallery, 1988, p. 136.
11. Information based on labels attached to the stretcher.
12. Information based on a conversation of October 13, 1989, with the former Surveyor of the Queen's Pictures, Sir Oliver Millar.

CHARLES-ALEXIS APOIL
French, 1809–1864

25 *Portrait of an Artist and his Son*, 1854

Signed and dated, upper left: *Alexis Apoil/1854*
Oil on canvas. 51¼″ × 38¼″ (130.1 × 97.2 cm)
Acquired through the generosity of the Museum Associates. 1986.156

PROVENANCE: Jacques Fischer-Chantal Kiener, Paris; Hazlitt, Gooden and Fox, Ltd., London.

EXHIBITIONS: Paris, Salon de 1855, no. 2451; Paris, Fischer-Kiener, 1985, no. 22; New York, IBM, 1988.

PUBLICATIONS: RISD, *Museum Notes,* 1987, pp. 28–29 (ill.); *Antiques & the Arts Weekly* 1987, p. 73 (ill.); *Gazette des Beaux-Arts* 1988, p. 40 (no. 232, ill.).

CONSERVATION: The canvas has been relined, and there are areas of inpainting that suppress the craquelure.

Although the work of Charles-Alexis Apoil is virtually unknown today, he appears to have enjoyed a modest success in the art world of mid-nineteenth-century Paris. From the 1840's until his death he exhibited frequently in the Paris Salons, working in oil and occasionally in pastel, specializing in portraits and in naturalistic views along the Seine that seem to have been in the character of contemporary Barbizon painting. The Salon catalogues list him as a pupil of the Romantic orientalist painter Eugène Devéria (1805–1865), by whom the Museum owns a small portrait of an *Arab Smoking a Hookah with a Woman at his Feet* (see checklist).[1] His wife, Suzanne (1825–after 1875), was the daughter of the painter Antoine Béranger and herself an artist who specialized in still lifes of flowers, which she exhibited regularly in the Paris Salons. After 1851 Apoil and his wife joined his father-in-law in the Manufactory at Sèvres, working in porcelain and enamel, while continuing to submit canvases regularly to the Salon. Their son, Charles-Edmond (1859–1941), also became a painter, exhibiting genre pictures in the Salons of the *fin de siècle*.[2]

The identity of the sitters in this portrait is unknown. Given its date, it seems very likely that this is the *Portrait de M.E.B. . . . et de son fils* that Apoil exhibited in the Salon of 1855.[3] A pentimento in the upper left corner, falling just behind the sitters' right shoulders and beneath the signature and date, reveals the traces of a large canvas resting upon an easel, which Apoil at some point must have painted out. The studio setting, paternal embrace, and the portfolio of drawings in the boy's hands suggest that this is a portrait of an artist and his son, resonant with allusions to the theme of education and the inheritance of an artistic career. The pair are depicted in a straightforward and unpretentious style that suggests Apoil's relation to mid-nineteenth-century Realism. Gustave Courbet's *The Studio of the Painter* (1854–55), the notorious pictorial manifesto of the Realist movement, is exactly contemporary with Apoil's quiet portrait and similarly preoccupied with the artistic education of the young.

Apoil's approach to his subject is intimate and conspicuously lacking the attributes and flattering devices that

might be expected of a middle-class portrait commission. The painterly execution, visible especially in the boy's beautiful turquoise smock, is typical of Realism's attachment to the physical aspects of nature. The painting's dramatic simplicity and light and the concentration of the imagery (enhanced by the tenebrism and by the removal of ancillary detail such as the easel) add to the sitters' engaging presence. The congruence of their bodies and the meaningful interplay of their hands convey the deep bonds of familial affection linking two generations of artists. D. R.

1. A *Portrait of Eugène Devéria* by Apoil, oil on canvas, in the same concentrated Realist style as the Museum's portrait, can be found in the Musée Calvet, Avignon.

2. The dates of Apoil *fils* are not given in the Salon catalogues or in the biographical dictionaries. These dates were given in the Musée d'Orsay archives, Paris.

3. Paris, Fischer-Kiener, 1985, no. 22, lists it by this title.

25

26

ALFRED STEVENS
Belgian, 1823–1906

26 The First Day of Devotion
(Interior of a Pawnbroker's Shop), 1854

Signed and dated, lower right: *Alfred Stevens. 54.*
Oil on panel. 39½″ × 32¼″ (100.3 × 81.5 cm)
Gift of Mrs. Gustav Radeke. 20.288

PROVENANCE: Theodore Havemeyer, New York, 1879; Mrs.
Emilie de Losey Havermeyer, New York, 1897; American Art
Galleries, New York, sale, November 18, 1914, no. 75 (listed
as *The Last Resort*); sold to Henry Schultheis, New York, for
$200; Mrs. Gustav Radeke, Providence.

EXHIBITIONS: Paris, *Exposition Universelle,* 1855, p. 42 (no.
408, as *Le premier jour de dévouement*); New York, NAD, 1883,
no. 24 (exhibited untitled); Southampton, Parrish, 1986,
pp. 127, 182 (no. 79, pl. XXXVII).

PUBLICATIONS: About 1855, p. III; Gebaüer 1855, p. 235;
Guide 1855, p. 147; Loudun 1855, p. 78; Delécluze 1856, p. 35;
Gautier 1856, p. 219; Strahan 1879, p. 140 (as *The Pawnbroker's
Shop*); *American Art Annual* 1915, p. 298 (as *The Last Resort*);
Rowe 1922, pp. 1–3 (ill., as *At the Pawnbroker's*).

CONSERVATION: The back of the panel was cradled at an
unknown date.

Alfred Stevens's *The First Day of Devotion* represents an early
phase in the long and successful career of one of Belgium's
leading nineteenth-century painters. An example of Stevens's
brief social-realist period of the early 1850's, it also foreshad-
ows his more familiar mature style of the years following
1855, during which he specialized in portrayals of fashion-
able young women in elegant interiors.

Stevens studied painting in Brussels between 1840 and
1844 with François-Joseph Navez, Belgium's premier Neo-
classicist, then moved to Paris, where he trained at the Ecole
des Beaux-Arts under Camille Roqueplan (1800–1855), an
academic painter of history subjects and historical genre.
Stevens returned to Brussels at the time of his grandmother's
death in 1849 and made his début in the Brussels Salon of
1851 with four historical genre paintings, winning a first-class
medal. Most of Stevens's works from this early, Romantic
phase of his career are lost.[1]

Stevens's social-realist themes first appear around 1853.[2]
They are characterized by a dark, somber palette for which
he was criticized by the press. In both subject matter and
style, these works reflect the influence of Gustave Courbet.
The exhibition of Courbet's *The Stonebreakers* at the Brussels
Salon of 1851 is often cited as the catalyst for the develop-

ment of social realism in Belgian art, although an indigenous movement toward Realism by Belgian artists had already been seen in the Brussels Salon of 1848, several years before the appearance of Courbet's early masterpieces.[3]

Alfred Stevens's most important social-realist work, *One Calls It Begging* or *The Soldiers of Vincennes* (Paris, Musée d'Orsay; fig. 1), was exhibited in the Paris Salon of 1855, concurrent with the Exposition Universelle. The canvas won Stevens a second-class medal, an honor also enjoyed by his brother Joseph for his *Dog Market in Paris* (Brussels, Musées Royaux des Beaux-Arts), a scene of pitiable dogs and their proletarian keepers. Alfred's painting of a destitute mother and her children being arrested by soldiers for vagrancy as a wealthy woman attempts to intercede clearly reveals the stylistic impact of Courbet, also seen in *The First Day of Devotion*. Although the RISD panel lacks the monumental scale of *One Calls It Begging* (52″ × 63¾″) – itself much smaller than Courbet's major canvases – it shares the somber palette, thick, dry pigment, flattened volumes and space, and rather constricted poses of the figures.

With a color scheme of blacks, whites, and earth tones punctuated with areas of red – another feature borrowed from Courbet – *The First Day of Devotion* places the viewer just outside a dark office, the letters on the door (*"Bureau de M[ont-de-Piété]"* or "pawnshop") only partially visible. A quietly despondent young woman in a red India shawl and gray silk dress, her head covered with a black bonnet, is seated in the foreground. Behind her, an old woman with her back turned inspects a case of gold items, standing poised outside the door of the office in which the pawnbroker sits behind his desk, pen in hand. The composition had been used by Stevens before in a genre piece from his early period, *The Sick Musician* (1852, Brussels, Musées Royaux des Beaux-Arts).

It appears that the Providence panel, which has also been called *The Last Resort, Interior of Pawnbroker's Shop,* and *At the Pawnbroker's,* may be the painting by Stevens in the 1855 Paris Salon listed as *The First Day of Devotion,* as described in *comptes-rendus* of the exhibition. The critic Edmond About in his review explained that Stevens's puzzling title referred to the young woman pawning her jewelry in an act of devotion to her lover:

> The *First Day of Devotion,* scene of Parisian manners, represents, if I am not mistaken, a young emancipated woman who is pawning her diamonds for the benefit of a friend of the male sex. The young woman poses a bit too much, the old woman is faultless. One can see that she knows her way around, and that she has been coming to the pawnbroker for a long time. The interior is appropriately cold, dark and rank. Never set foot in such a place![4]

Ernst Gebaüer, on the other hand, took the artist to task for the picture's ambiguities:

> The idea which Mr. Alfred Stevens wished to convey in *The First Day of Devotion* is totally lacking in clarity. Who is this woman pawning her jewelry box? Is she a young girl? Is she a wife? Is she a mother? Or rather, is she a lover? Who is she devoting herself to, anyway?[5]

The critic Eugène Loudun was more impressed by Stevens's trenchant characterizations of his three figures, observing the contrast between the vulnerable young woman and the hardened, older pair behind her:

> ...the pawnbroker...[and] the old woman...have the rigidity and glacial coldness of people who are no longer touched by the sight of misery; but the young woman seated on the straw chair – pensive, her gaze fixed, agitated by a thousand troubled thoughts – when one looks at her, one can easily see that she is not used to frequenting such places; one can imagine what it cost her to cross the sinister threshold and enter this gloomy, half-lit room; she draws our interest, we share her emotion.[6]

Fig. 1 Alfred Stevens, *One Calls it Begging* (*The Soldiers of Vincennes*), ca. 1854, oil on canvas, 52″ × 63¾″ (132.1 × 162 cm), Paris, Musée d'Orsay. Photograph copyright photo R. M. N.

The First Day of Devotion may be viewed as a transitional work. The beautiful, well-dressed woman who seems out of place in the grim pawnshop setting became a staple in Stevens's art at the same time that the Realist content of his work was diminishing. By the time he had painted *The First Day of Devotion,* Stevens was on the verge of settling in Paris and abandoning his brief fling with social realism, although the movement would reach its apex in Belgium under the leadership of Charles De Groux at the Brussels Salon of 1857.[7] By 1855, at least one painting, *The Artist in His Studio* (Baltimore, Walters Art Gallery), reveals Stevens's mature formula full-blown: a lovely, fashionably dressed contemporary woman in an elegant interior.

Stevens's predilection for feminine subjects has often been ascribed to the influence of the Belgian painter Florent Willems (1823–1905), with whom Stevens shared his Paris studio in the 1850's. Willems specialized in small-scale scenes of elegant sixteenth- and seventeenth-century ladies painted in a little-master style that earned him the name "the modern Terborch." Willems's influence on Stevens early on can be seen in the effective handling of the shiny texture of the

woman's skirt in the pawnshop painting and in the boxlike construction of interior space with a view into a second room.

Stevens's commitment after the middle 1850's to genre depictions of the fashionable world of beautiful, modishly clad women in plush surroundings put him in the artistic vanguard. His palette brightened, his brushwork loosened, and the surfaces of his canvases often yielded to flat, decorative patterning, features which connect his mature style with the progressive art of Manet, Whistler, and the Impressionists. In both his early and later works, Stevens can be seen as a painter who made limited concessions to new movements and styles while preserving anecdotal and sentimental features that both Realists and Impressionists eschewed. Perhaps because of this, Stevens enjoyed recognition and success through the final decades of his life not enjoyed by the Impressionists, highlighted by a mural commission for the Exposition Universelle of 1889 entitled *Panorama of the Century* and a one-man exhibition at the Ecole des Beaux-Arts in 1900, the first ever held for a living artist by that institution. D. E. S.

1. On Stevens's life and works, see Ann Arbor, Museum of Art, 1977. I would like to thank William A. Coles for sharing his views on the RISD painting with me.

2. *Morning of Ash Wednesday* (Marseilles, Musée de Marseilles), shown at the Paris Salon of 1853, may be the first that he exhibited.

3. *The Beggars* or *Morning in Brussels* (Brussels, Musées Royaux des Beaux-Arts) by the artist's brother, Joseph Stevens, was the most significant example of social realism in this Salon. See Stark 1979, pp. 193–200.

4. About 1855, p. 111. This and subsequent translations by D. E. S.

5. Gebaüer 1855, p. 235.

6. Loudun 1855, p. 78.

7. De Groux's three monumental social-realist statements exhibited in the watershed year of 1857 were *The Pilgrimage of St. Guido at Anderlecht* (Brussels, Musées Royaux des Beaux-Arts), *The Pilgrimage of Dieghem* (Tournai, Musée des Beaux-Arts) and *The Coffee Mill* (Antwerp, Koninklijk Museum voor Schone Kunsten).

EUGÈNE DELACROIX
French, 1798–1863

27 *Arabs Traveling,* 1855

Signed and dated, lower left: *Eug. Delacroix. 1855.*
Oil on canvas. 21�5/16″ × 25⅝″ (54.1 × 65 cm)
Museum Appropriation. 35.786

PROVENANCE: Count Anatole Demidoff, Prince of San Donato, Italy; acquired by Baron Michel de Trétaigne by 1864; Paris, sale Trétaigne, 1872, from which sold for 30,500 francs; acquired by Baronne Nathaniel de Rothschild by 1873; Baron Dr. Henri de Rothschild by 1928; Georges Bernheim, 1933; acquired from him by Knoedler & Co., New York, July 1935; sold to Martin Birnbaum, November 1935; from whom acquired in that year by the Museum.

EXHIBITIONS: Paris, Ecole des Beaux-Arts, 1885, no. 187; Paris, Louvre, 1930, no. 166; Paris, Orangerie, *Delacroix,* 1933, no. 198; Springfield, MFA, 1939, no. 18; New York, World's Fair, 1940, p. 170 (no. 247, ill.); Toronto, Art Gallery, 1940, no. 72; New York, Wildenstein, 1944, no. 37 (ill.); Worcester, Art Museum, 1946; New York, Rosenberg, 1948, no. 10 (ill.); Providence, RISD, 1949, p. 10; Buffalo, Fine Arts, 1954, no. 21 (ill.); Cambridge, Fogg, 1955, no. 25; Toronto, Art Gallery, 1962, no. 20; Paris, Louvre, 1963, no. 471; Providence, Brown, 1975, no. 88 (ill.); Providence, Brown, 1981, no. 10; Amherst, Mead, 1988, p. 35 (ill.); New York, IBM, 1988.

PUBLICATIONS: Paris, Hôtel Drouot, 1872, no. 18 (ill., Veyrassat etching); Moreau 1873, pp. 102, 275; Robaut 1885, no. 1277; Delacroix 1893, I, pp. 177–78 (April 5, 1832); Delacroix 1893, II, p. 428 (February 1, 1856); Horticq 1930, p. 154 (ill.); RISD 1935–36, pp. 9, 11 (ill.); Delacroix 1937, p. 512 (ill.); Laver 1937, p. 29 (fig. 20); Worcester 1946, p. 1; *London News* 1963, p. 25 (ill.); Gourley 1963, pp. 22–23 (ill.); Johnson 1963, p. 23 (ill.); Mras 1963, p. 72; Maltese 1965, p. 64 (no. 91, ill.); Woodward and Robinson 1985, pp. 70, 191 (no. 109, ill.); Johnson 1986, III, no. 399; Arama 1987, p. 188 (no. 53, ill.).

CONSERVATION: The canvas had been relined with linen at some time prior to its acquisition by the Museum. In 1953 a discolored varnish was removed and a new varnish applied.

RELATED WORK: An etching by Veyrassat reproducing this painting, 4⅛″ × 5⅛″ (10.5 × 13 cm), was published in Paris, Hôtel Drouot, 1872, no. 18, opposite p. 13, and catalogued by Moreau 1873, p. 102 (no. 48).

Following the forcible establishment of French rule over Algeria in 1830, it became a priority of the newly installed monarchy of Louis Philippe to cultivate friendly relations with the Sultan Abd-er-Rhaman of neighboring Morocco, whose tribes threatened the security of France's colony in North Africa. In 1831 Louis Philippe therefore appointed the Count de Mornay to head a diplomatic mission to Morocco for the purpose of concluding a treaty of nonbelligerence with the Sultan. Mornay, an intelligent and cultured young diplomat and a former gentleman-in-waiting to Charles X, sought out suitable companions for this long and arduous journey. The painter Delacroix was invited to join him at the recommendation of Armand Bertin, influential editor of the *Journal des débats,* and on January 11, 1832, the party sailed from Toulon, arriving in Tangier on January 24.[1] They would remain in North Africa for six months, with Tangier as their base, traveling south through the desert mountains with an

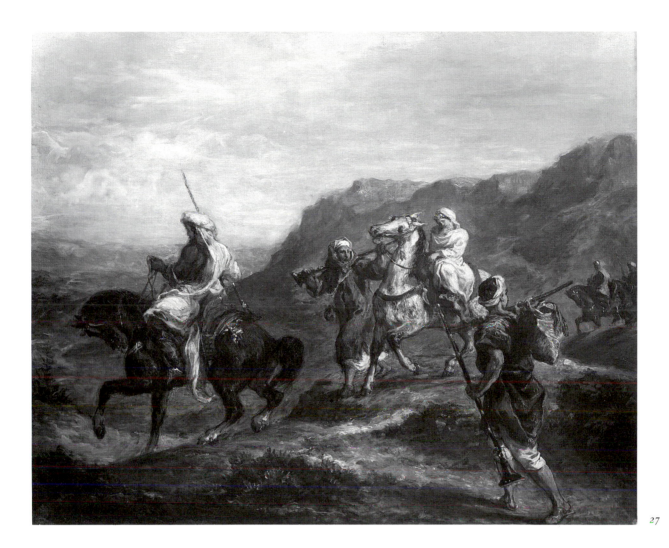

27

armed cortege of a hundred Moroccan soldiers to Meknès, where they were received by the Sultan; north to Seville and Cádiz in Spain, where they remained for a fortnight; and east to Algiers, from which they embarked for Toulon, returning on July 5.

This voyage proved to be a major influence on Delacroix's artistic development. During his travels, he filled seven albums with concise verbal descriptions of the people, customs, and places, and a profusion of rapid sketches of the myriad detail he observed. These albums, which Delacroix preserved for the rest of his life, provided a rich repertoire of images and were a principal source of inspiration for him.[2] Prior to his North African voyage, he had shown a great interest in Oriental themes, to which he was attracted by their exoticism and picturesque appeal, as well as for the examples they provided of cultural alternatives to the somber climate of life in Paris during the Bourbon Restoration. The *Massacre at Chios* (Salon of 1824; Paris, Musée du Louvre) and the *Death of Sardanapalus* (Salon of 1827; Paris, Musée du Louvre) revealed his interest in Eastern subjects on a monumental scale. Taken respectively from modern history and modern romantic literature, the first represents a tragic event from the Greek War of Independence against the Turks, the second was inspired by Lord Byron's account of an epicurean

Assyrian monarch. Whereas these earlier subjects had been imagined in his Paris studio, his exposure to the customs and cultures of the Moors, Arabs, and Jews of North Africa possessed the authority of observed fact. Their exotic appeal was buttressed with the substance of reality, which seemed to him the timeless embodiment of what had been admired by his contemporaries in classical antiquity.[3]

The Museum's canvas, painted twenty-three years after this trip, can be loosely associated with a passage recorded in his *Journal* on April 5, 1832, the day on which the French mission departed Meknès for Tangier:

> Departure from Meknès at 11:00 A beautiful valley to the right, stretching back as far as the eye can see. . . . Sky somewhat cloudy. . . . Women travelling hunched on their horses; one of them who was pulled to one side of the route in order to let us pass, a black man restraining her horse. – Children on a horse in front of their father.[4]

The painting reveals several minor discrepancies from this economical account: it is an Arab and not a Moor who restrains the woman's horse, no children are depicted, and it is this entourage, not the observer, who pass. The painting seems otherwise to correspond to this momentary encounter of passing tribesmen observed many years before and to Delacroix's descriptions of the mountainous terrain through

which he traveled between Meknès and Tangier. It is reasonable to suspect that this painting represents the mountains above Meknès, looking down towards the Sébou river in the valley below. The rugged beauty of these mountains seems to have particularly impressed him. One can glean from his *Journal* vivid images of these "mountains very clear cut, one behind another, against a pure sky" and of tribesmen with their sleeves rolled up (March 6, 1832); or of "mountains black and wild" with horsemen silhouetted against the sky (March 5, 1832). In a noteworthy passage he comments on the changes in the color of the mountains at different times of day, alternating between violet in the morning and evening and blue in the middle of the day (April 10, 1832). Elsewhere he notes such passing detail as "the red of the saddles," or "a white horse at the side" (March 2, 1832), typical of the many notebook entries of fleeting observations that informed his later paintings.

Arabs Traveling may indeed be better understood as an amalgam of observations and a selection of detail sifted from this trip. Removed from the actual experience, many years later, Delacroix was less concerned with accuracy than with the expression of the special beauty and drama of the scenes that impressed him. "I didn't begin to do anything passable in my trip to Africa until the moment when I had sufficiently forgotten small details," he wrote in his *Journal* a few years before this painting was painted, "and so remembered the striking and poetic side of things for my pictures; up to that point I was pursued by the love of exactitude, which the majority of people mistake for truth."[5]

This encounter on a mountain pass, inconsequential as it may seem from its verbal description, must have made a vivid impression for Delacroix to have returned to it more than two decades later. The trip to Meknès was dangerous. The French were fired upon several times by tribesmen hostile to Christians, and encounters of armed nomads distrustful of strangers must have been cautious and tense. The strict segregation of Moslem women from outsiders (and especially Europeans) would have added to the drama of this confrontation. During the six months of his journey, Delacroix's exposure to the women of Islam was rare. In Meknès the French party dared not wander on the terraces of their quarters for fear of being stoned or shot at by the Moors, who were jealous of the privacy of the women who gathered in the courtyard below.[6] On the singular occasion that he was secretly admitted to a harem in Algiers, he likened the occasion to what it must have been like in the times of Homer, where women were "withdrawn from the world, dwelling at its secret heart."[7]

The Arab woman on her dappled horse, surrounded on all sides by men with muskets in their hands, is the compositional and psychological focus of this painting. The movement of the foot-soldier in the foreground leads directly to her as we follow the procession down the slope. She is highlighted against the dark mountains in the distance by the brightness of her costume and of her horse. Her tiny slippered feet and luxuriant mantle suggest the comforts of the harem,

and she is set like a jewel within this primitive landscape, guarded by her rugged male companions. In contrast to her, the forward equestrian figure, whom we imagine to be her husband and the leader of this group, seems to have been inspired by portraits of heroic warriors looking back to the equestrian statue of Marcus Aurelius (161 – 180 A.D.) in Rome. It has been suggested that the footsoldier in the foreground of the painting was inspired by the assisting figure in Rubens's *Christ Bearing the Cross* (ca. 1635, Brussels), which Delacroix copied in 1850.[8] The setting of the diagonal descent of these colorful figures against this harsh territory, the dramatic vista, and the sweep of luminous sky, transforms this exotic genre picture into an image of imputed drama reminiscent of the pageants of Rubens.

Contrary to the subdued color of contemporary academic painting in France, the brushstrokes are loosely applied, with highlights of pure, bright color creating this painting's flickering and luminous effect. Although this painting is based on events that Delacroix had witnessed firsthand, its exotic appeal is far removed from the grim realities of modern life that dominated the work of mid-century Realists in France, reflecting its Romantic inspiration.

A reference to a painting believed to be the Museum's is made in an entry of Delacroix's *Journal* dated February 1, 1856: "For Demidoff, *Arabs Traveling*." This painting is not mentioned in any of the three sales of Demidoff's collection, suggesting that either he never acquired it, or sold it privately.[9] D. R.

1. The painter Eugène Isabey had first been invited, but declined. The actress Mlle Mars, Mornay's mistress, had been the intermediary through whom Delacroix was recommended. See Trapp 1971, p. 113.
2. These albums were all intact in Delacroix's studio at the time of his death. Two of them are now in the Louvre and another in the Musée Condé at Chantilly. The other four were broken up and sold piecemeal. The entries from the *Journal* for 1832 were transcribed by Joubin from these surviving notebooks. See Trapp 1971, p. 116.
3. Cf. Delacroix 1893, entries for February 4, 29, April 2, 28, 1832.
4. Delacroix 1893, I, p. 178. This passage was omitted from the Pach translation, even while the Museum's painting was reproduced in it. The first identification of this painting with this passage appears to have been made by Lee Johnson in Toronto, Art Gallery, 1962, p. 51.
5. Delacroix 1937, p. 332 (October 17, 1853).
6. Delacroix, *Correspondance*, I, p. 326 (to Pierret, April 2, 1832), cited in Trapp 1971, p. 115.
7. Lambert 1937, p. 9.
8. Providence, Brown, 1975, p. 272.
9. See Delacroix 1893, p. 428 (February 1, 1893), and Johnson 1986, III, p. 202.

28 (color plate p. 21)

WILLIAM BELL SCOTT
British, 1811–1890

28 Cockcrow, 1856

Signed, lower right, on gravestone: *William / B. Scott*
Oil on canvas. 22″ × 27″ (arched top) (55.9 × 68.6 cm)
Helen M. Danforth Fund. 78.088

INSCRIPTION: On verso, top stretcher bar: *Cockcrow 1856 / Here ended all the phantom show, / They smelt the fresh approach of day, / And heard a cock to crow. / Parnell.*

PROVENANCE: Given by the artist to Miss Alice Boyd to mark the third anniversary of their meeting, March 11, 1862; descendants of Alice Boyd; Stone Gallery, Newcastle, ca. 1970; Jeremy S. Maas and Co., Ltd., London.

EXHIBITIONS: London, Maas, 1978, no. 23; Providence, RISD, 1979, no. 201.

PUBLICATIONS: Phillpotts 1978, p. 80; Schindler 1988, pp. 248–51.

RELATED WORKS: *Cockcrow,* watercolor and body color over pencil, 11″ × 13¹¹⁄₁₆″ (28 × 37.3 cm), Edinburgh, National Gallery of Scotland (D4714, p. 2). Inscribed on the verso, "Cockcrow, painted 1857."[1] *Cockcrow,* pencil on paper, squared in pencil for transfer, incised and chalked in red on verso, 6½″ × 19¾″ (16.4 × 50.1 cm), Edinburgh, National Gallery of Scotland (D4714, verso of p. 1).

Although William Bell Scott was never a member of the Pre-Raphaelite Brotherhood, his paintings reveal his close

association with the group and their ideas. Nearly a generation older than Dante Gabriel Rossetti (1828–1882) and William Holman Hunt (1827–1910), Scott came into contact with the group through his poetry. His position as Master of the Government School of Design at Newcastle-upon-Tyne, some 240 miles from London, however, kept him away from the center of their activities for more than twenty years. Nevertheless, important elements of *Cockcrow,* such as the inclusion of imaginary spirits alongside detailed botanical renderings, overt symbolism relating to Christian morality, formal references to early Christian art, and, above all, the interconnection between the artist's painting and his poetry, closely connect *Cockcrow* to the Pre-Raphaelite movement.

Scott was born in Edinburgh, a son of the engraver Robert Scott (1777–1841). Although he originally aspired to be a poet, his father insisted on a thorough training in engraving and drawing, which he received at the Trustee's Academy in Edinburgh. He settled in London in 1837 and exhibited his first picture, *The Old English Ballad Singer,* at the British Institution in 1842. In 1843 his entry in the competition for the decoration of the Houses of Parliament, though not successful, brought him to the attention of the Board of Trade, who offered him the position of Master of the School of Design in Newcastle. During his twenty-one years in the North, he concentrated primarily on landscape painting. He also published several volumes of poetry, completed an ambitious mural cycle illustrating the history of

Northumberland for Sir Walter Trevelyan at Wallington Hall, and traveled to the Continent on several occasions.

Cockcrow, one of Scott's finest landscape paintings, was inspired by a poem by the Irish clergyman Thomas Parnell (1679–1718). Inscribed on the back of the painting's stretcher are lines from Parnell's "Fairy Tale in the Ancient English Style":

> Here ended all the phantom show,
> They smelt the fresh approach of day,
> And heard a cock to crow. [2]

These lines are taken from a moral tale probably written to teach children the importance of honesty. It tells the story of Edwin, a virtuous hunchback, who because of his deformity cannot win the affection of Edith, who is attracted instead to the handsome Sir Topaz. Edwin gets lost during a ramble through the countryside, and as the daylight is fading he takes shelter in the ruins of an old castle. Fairies arrive for their nightly revel, and when Edwin explains how his broken heart has led him there, they ask him to join in their feasting and dancing. When the cock crows, Edwin awakes to find he has lost his hunchback. Sir Topaz, on hearing of Edwin's good fortune, decides to visit the fairies for his own benefit. He lies when they demand to know why he came, and so they give him Edwin's hunchback. Parnell's poem ends with the moral, "Virtue can gain the Odds of Fate." [3]

Scott illustrates the moment of Edwin's transformation not by drawing his figure, but through the symbolic image of the new day. The viewer is situated high upon a hill, with a church spire the only indication of the valley spread out below. As the rising sun lights the lower edges of the clouds, a ring of fairies, whose gossamer figures contrast with the solid stone archway around which they join hands, begins to fade away. Ravens and roosters occupy the center, all hunched in sleep except two of the latter, who are beginning to crow. Bats return to their resting place and one bell in the tower begins to toll matins.

The composition is dominated by a crumbling stone archway and rustic thatched roof, which is similar to the structures that appear in Nativity scenes of the early Italian Renaissance. This allusion to the birth of Christ reinforces the painting's message of renewal associated with the dawn of day, as with the image of Christ as "the Light of the World." The central action of the rooster crowing also alludes to Christ's prediction that Peter will deny him three times before the cock crows, thus setting in motion the events that lead to His eventual resurrection.

For *Cockcrow* Scott borrowed forms from early Renaissance altarpieces, such as the rustic shelter, the arched top of the picture, and the elaborate gold frame, which is original to the painting. The preference for the simpler forms of early Renaissance painting, common among the Pre-Raphaelites, was influenced by John Ruskin (1819–1900) through his book *Modern Painters* (1843 and 1846), which emphasized the superiority of early Christian art and the primary importance of the precise recording of natural appearances. The Gothic arches of the church spire in *Cockcrow,* the Romantic ruins in

the pointed stone archway at the left, and the botanical accuracy of the leaves and branches in the foreground all reflect Ruskin's influence on Scott and the Pre-Raphaelites.

Although he shared with the Pre-Raphaelites a preference for detail in the truthful representation of nature, Scott did not paint his landscape *in situ* as they did. Instead, he made sketches from nature in pencil and watercolor and then created the painting in his studio. Two sketches for *Cockcrow* survive in a volume of Scott's drawings in the collection of the National Gallery of Scotland. These are not studies from nature, but are rather final compositional studies that include the arched top and fairy ring exactly as they appear in the painting. One shows that Scott originally intended to silhouette the fairies against the fading moon (fig. 1), while the other is squared in pencil for transfer (fig. 2). The result of Scott's careful preparation is a smooth integration of realistic detail with poetic imagery, unlike the jarring juxtapositions of figures and botany in Pre-Raphaelite paintings, whose settings were painted out of doors while the figures were added later in the studio. Scott manages to maintain a sense of atmosphere and depth in *Cockcrow,* despite his use of the bright, garish colors common to Pre-Raphaelite canvases.

Some elements of *Cockcrow* may be seen as a tribute to Scott's brother David, a well-known engraver and landscape painter of the Romantic period, who died in 1849. Among David's fairy paintings, *Puck Fleeing from the Dawn* (Edinburgh, National Gallery of Scotland) may have inspired *Cockcrow* in the detail of the fairy ring fading into the lightening sky. [4] In addition, themes of death and rebirth associated with the cock crowing appear at the end of William Bell Scott's "Requiem," a poem written on the occasion of David's death:

> But Hark! the cock crows, for morning is nigh,
> Sternly rending the cold, wet sky,
> While the soul of my brother recedes. [5]

Fig. 1 William Bell Scott, *Cockcrow,* watercolor and body color over pencil on paper, 11″ × 13¹¹⁄₁₆″ (28 × 37.3 cm), Edinburgh, National Gallery of Scotland.

Fig. 2 William Bell Scott, *Cockcrow,* pencil on paper, 6½″ × 19¾″ (16.4 × 50.1 cm), Edinburgh, National Gallery of Scotland.

The bells in the Gothic tower in the background of *Cockcrow,* one of which tolls while the other is still, may allude to his passing, as well as to Parnell's poem. William Bell Scott suggests his own mortality by signing the painting on a gravestone at the lower right.

The image of the two bells at the break of day, one tolling and the other still, recurs in the opening lines of Scott's poem, "Rosabell," the story of an innocent girl from the Scottish countryside whose misfortunes lead to her degradation as a city prostitute, despite her belated realization that only in death can she return to her family and the simple purity of her girlhood:

> The lark unseen o'er the village spire,
> Sings like an echo from the sky.
> "Let us go, mother, the first bell is still,
> And the second begins to ring."[6]

As in *Cockcrow,* Scott uses the dawn motif to symbolize the rebirth and renewal of man with his awakening, whether from sleep, death, or disillusionment.

Most of Scott's known landscape pictures of this period, such as *The Border Widow* (1860, Aberdeen, Aberdeen City Art Gallery), *The Gloaming* (1862, New York, E. J. McCormack Collection), and *The Gloaming: Manse Garden in Berwickshire* (1863, Philadelphia, Philadelphia Museum of Art), depict not the dawn but the moments just past sunset. This interest in the break of day and the end of day as moments of transition may have been inspired by German Romantic landscapes by artists such as Caspar David Friedrich (1774–1840), Carl Gustav Carus (1789–1869), and Karl Wagner (1796–1867).[7] Scott would have been aware of their work, as he had a lifelong interest in German art, starting with the engravings after Dürer his father gave him as a child. He visited Germany in the 1850's and in 1873 published *The Gems of Modern German Art.* Like Friedrich, Scott sought to express symbolic meaning through landscape, often, as in *Cockcrow,* alluding to themes of mortality and eternity.

In 1859 Scott met Miss Alice Boyd, who became his lifelong confidante and best friend.[8] While she visited Scott and his wife every winter in London,[9] they spent every summer at her Penkill Castle in Ayrshire. There, during the summers of 1865 through 1868, Scott completed a mural cycle of James I's "Kingis Quair" on the walls of the circular staircase, and it was there that he died in 1890. *Cockcrow,*

which descended through Miss Boyd's family before entering the Museum's collection, is said to have been given by the artist to Miss Boyd in 1862 to mark the third anniversary of their meeting.[10] It is possible that the picture's theme relates to the feelings of new beginnings brought about by their initial acquaintance. *Cockcrow* appears to have hung in Penkill's great hall (completed in 1884), as it can be identified in Arthur Hughes's painting (present location unknown) of the interior of the hall.[11] A. H. S.

1. This album of drawings was assembled and annotated by Scott in his later years as his health was failing, and it remained at Penkill Castle after his death. As in his *Autobiographical Notes,* there are many inaccuracies in his dating of events and works of art; therefore, the date of the painting is based on the inscription "Cockcrow 1856" on its stretcher, rather than the later inscription on the drawing. I am grateful to Mungo Campbell, Assistant Keeper of Prints and Drawings at the National Gallery of Scotland, Edinburgh, for discovering the second preparatory drawing and for providing information about dating and provenance.

2. In Scott's inscription, line 103 has been changed from Parnell's "Phantome-play" to "phantom show." The poems of Thomas Parnell were published posthumously by Alexander Pope in *Poems on Several Occasions,* London, 1722. See Rawson and Lock 1989.

3. Line 190.

4. See Schindler 1988, p. 250.

5. "Requiem," in Minto 1970, p. 262.

6. "Rosabell," in Minto 1970, pp. 135–52.

7. Staley 1973, p. 92.

8. For a discussion of their relationship and letters attesting to their deep affection, see Fredeman 1967, pp. 6–8.

9. Scott retired from the Newcastle Schools in 1864 and bought a house in Chelsea in 1870. See Dorment 1986, p. 367.

10. London, Maas, 1978, n.p.

11. A photogravure of the painting is reproduced in Minto 1970 between pp. 326 and 327.

30

29

WILLIAM POWELL FRITH and
RICHARD ANSDELL
British, 1819–1909, and British, 1815–1885

29 *Feeding Time*
 (My Lady's Pets), 1860

Signed and dated, lower left: *R. Ansdell. 1860*
Signed and dated, lower right: *W. P. Frith. 1860*
Oil on canvas. 30¹¹⁄₁₆″ × 24½″ (78 × 62.3 cm)
Gift of Mrs. Murray S. Danforth. 54.195

PROVENANCE: Found by Gerald Kerin in the north of England; H. M. Calmann, London, September 1954, from whom purchased.

PUBLICATION: RISD, *Museum Notes,* 1955, fig. 8.

WILLIAM POWELL FRITH
British, 1819–1909

30 *The Salon d'Or, Homburg*
 (Le jeu est fait . . . rien ne va plus), 1871

Oil on canvas. 49¼″ × 102½″ (125 × 260.35 cm)
Gift of Walter Lowry. 58.162

PROVENANCE: Sold to Louis Victor Flatow inclusive of rights, 1870 (£4,000); sold by Flatow to Mr. Roffey (?), 1874 (£1,995); Christie's, London, 1932 (£48/6s); Walter Lowry, New York.

EXHIBITION: London, Royal Academy, 1871, no. 158.

PUBLICATIONS: Fenn 1879, pp. 80–83 (ill.); Frith 1887, II, pp. 14–22; Wallis 1957, pp. 124–25; Maxon 1959, pp. 4–9 (fig. 7); Reitlinger 1964, pp. 150, 319–20; Loeffler 1964, pp. 12–14 (figs. 10–11); Reynolds 1966, pp. 49, 57–58; Beck 1973, p. 63 (pl. 37); Wood 1976, p. 44 (pl. 34); Noakes 1978, pp. 107–10; Schick 1986, pp. 30–38 (ill.).

RELATED WORK: *The Salon d'Or at Homburg,* oil on canvas, 17⅜″ × 36″ (45.1 × 91.4 cm), Ottawa, National Gallery of Canada.

Born in Yorkshire and trained at the Royal Academy Schools, William Powell Frith is best remembered today for painting highly detailed scenes of modern life; therefore he is considered the natural heir to a tradition initiated in the eighteenth century by William Hogarth. While his painting style was conservative, his choice of setting for three of his most famous pictures of ordinary life – the seaside, the race track, and the railway station – prefigured important elements of the iconography of French Impressionism, as noted by Allen Staley.[1] In his selection of the interior of a gambling casino for the Museum's *Salon d'Or, Homburg,* however, Frith quite knowingly followed in the footsteps of a Frenchman.

In his three-volume autobiography, published when the artist was almost seventy, Frith traces his initial interest in such a subject to a visit to Baden-Baden in 1843: in his own words, "The gaming-tables were in full blast, and I remember feeling a strong desire to strike out a picture from them; but the subject appeared to me too difficult to be undertaken without much more experience than I had had at that time."[2] By 1869, when he returned to the idea of producing a contemporary gaming picture, he had gained the necessary experience for producing modern crowd scenes through his *Life at the Seaside* (1852–54), *Derby Day* (1856–58), *The Railway Station* (1860–62), and *The Prince of Wales's Wedding* (1863–65). Furthermore, an historical genre picture, *King Charles the Second's Last Sunday* (1865–67), had also given him the opportunity to paint a gambling scene, albeit set in the past and based in particular on a detailed description from John Evelyn's *Diary:* " . . . about twenty of the greate courtiers and other dissolute persons were at basset round a large table, a bank of at least 2,000 in gold before them"[3]

In his autobiography, Frith explains how he came finally to begin his *Salon d'Or* in 1869. There, he records that his old friend O'Neil was keen to visit Bad Homburg, and also that the gaming tables at that German spa near Frankfurt were to be closed in 1871 at the expiration of the thirty-year lease granted to the Blanc brothers for the operation of a gambling casino. As a consequence, he felt that "it must be 'now or never,' if there was a chance for a true representation of the scene to be made."[4]

What Frith failed to mention in his autobiography was that he was familiar with at least two other pictures of contemporary gambling scenes that had recently been completed and put on public exhibition in London by Alfred Elmore and Gustave Doré. Frith may also have been familiar with a number of articles on gambling abroad appearing in the periodical literature of the day, along with Anthony Trollope's *Can You Forgive Her?* of 1864, with a chapter set in Baden-Baden, and Feodor Dostoyevsky's *The Gambler* of 1867, based on the author's personal knowledge of the gaming rooms at Homburg. It was an opportune moment to take full advantage of an apparent widespread interest in the subject.[5]

Of the two modern gaming pictures which preceded *The Salon d'Or* – both well known to Frith – the first had been painted by a close friend and fellow Royal Academician, Alfred Elmore (1815–1881). Entitled *On the Brink* (fig. 1), it

Fig. 1 Alfred Elmore, *On the Brink,* 1865, oil on canvas, 45″ × 32¾″ (114.3 × 84.2 cm), Cambridge, Fitzwilliam Museum.

was shown at the summer exhibition of the Royal Academy in 1865 and depicted a cloaked woman seated outdoors next to an open window with a glimpse of a gaming room at Bad Homburg within. From inside the window a man tries to lure her back for yet more play.[6] From the deep despair conveyed by her downcast eyes and the crumpled folds of her cape and dress highlighted by dark shadows, no question is left in the mind of the viewer that this lady is definitely " 'on the brink' of certain ruin, and possible suicide."[7]

Fig. 2 Gustave Doré, *Sketch for Le Tapis Vert,* 1867, pen and ink wash on paper, 8⅝″ × 11¼″ (22 × 28.5 cm), New York, collection of Robert Isaacson. Photograph by Glenn S. Treeson.

The second of these pictures, focused entirely on the interior of the gaming room, was Gustave Doré's *Le Tapis Vert,* a colossal painting (seventeen by thirty-four feet) begun after a visit to Baden-Baden in 1862. After it was shown at the Paris Salon of 1867, a M. Arymar arranged in 1868 for an exhibition of Doré's oil paintings, including *Le Tapis Vert,* to be held that winter in London at the Egyptian Hall on Piccadilly, almost across the street from Burlington House, which had just become the new home of the Royal Academy.[8] The critic for *The Art-Journal* on February 1, 1868, took the artist to task for his "chronicle of vice."[9] Pictures of modern life were clearly still considered controversial in the 1860's, especially when they happened to treat aspects of low life directly and on a scale traditionally thought only suitable for history painting. Frith was going to encounter the same criticism as Doré with his *Salon d'Or* in 1871, and not surprisingly that occasion elicited a comparison between the two works by a critic for *The Saturday Review* on May 20, 1871:

> Artists show fine instincts for the themes that suit them best. The gambling-table at Homburg [sic] was congenial to the genius of M. Gustave Doré and the dashing Frenchman, we think it must be conceded, beats our English Academician in repulsive realism.[10]

Unfortunately, Doré's *Le Tapis Vert* does not appear to have survived (see fig. 2, preparatory sketch), even though it was later shown for an extended period just around the corner from the Egyptian Hall at the Doré Gallery, 35 New Bond Street, in the 1870's and 1880's.[11]

When Frith returned to Bad Homburg in 1869, he carefully studied the "clustering crowd" around the tables; then, in his customary fashion he began collecting specific evidence to insure the verisimilitude of the scene. Ever since *Life at the Seaside* in 1852, he had employed photographers to record architectural details, and *The Salon d'Or,* for which large photographs were taken of the room,[12] was no exception. Whether he then employed an artist specializing in architectural subjects to paint in the background, as he did William Scott Morton (1840–1903) for *The Railway Station* and *The Prince of Wales's Wedding,* is not recorded.[13] Frith was also able to secure some of the actual fittings, such as the croupier's rakes and empty rouleau-cases, not to mention one of the

chairs from the gaming room, which he proudly confesses in his autobiography to be sitting on while writing about the creation of *The Salon d'Or.*[14]

Frith created a large number of preparatory sketches: "Many chalk drawings of separate figures and groups, many changes of composition and incident, before I could satisfy myself that I might commence the inevitable oil-sketch."[15] One of Frith's highly finished oil studies for *The Salon d'Or* (fig. 3),[16] reveals that Frith made significant changes to some of the "story lines" for his sitters. In his autobiography, he describes one particular grouping of gamblers as follows:

> In the immediate [left center] foreground sits a roué who turns to a lady standing by him with whom he seems to have tender relations, and places in her hand some bank-notes, evidently – from his smiling countenance – the result of his winnings. The lady receives the money, but whether for the purpose of risking it again or not, does not appear.[17]

Frith seems to be describing the oil sketch now at Ottawa, then apparently still in his possession, rather than the final version at RISD. In the latter picture the middle-aged roué has been transformed into a rather handsome young man who seems to be imploring his female companion to lend him more money. That she is in all likelihood his wife, rather than a mistress or coquette – as is the case with the woman in the sketch – can be determined by examining the difference in the necklines of their respective dresses.[18] "The lower the neckline, the looser the woman" could have been a saying of the time.

While in general the sketch strikes a less somber note than the final version, the woman wearing a dove-gray dress and turning from the gaming table in the center foreground remains remarkably unchanged between the two versions, except in certain minor details of her costume. It is clear that Frith intended her to serve from the start as the focal point of *The Salon d'Or,* and it is her moral dilemma in the middle of this public arena that immediately sets the tone for the entire work. In both versions Frith has enhanced her misfortune by the look of reproval on the faces of a couple (actually portraits of Frith and his wife) who stand just to her right.[19] Frith leaves no question in the mind of the viewer that this unfortunate lady will end up paying the collective price of

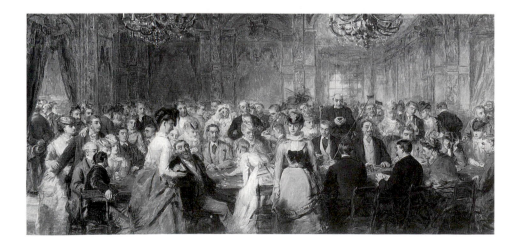

Fig. 3 William P. Frith, *The Salon d'Or at Homburg,* oil on canvas, 17⅜″ × 36″ (45.1 × 91.4 cm), Ottawa, National Gallery of Canada.

everybody's misadventures in *The Salon d'Or,* making her the heir to Elmore's tragic female in *On the Brink.*

When the Royal Academy's summer exhibition opened at Burlington House on May 1, 1871, Frith noted a crowd in front of *The Salon d'Or* the likes of which had not been seen since his *Derby Day* in 1858. Therefore, it did not surprise him two days later to discover a protective rail in front of his picture, as he noted in his autobiography.[20] As the reviewer for the *Art-Journal* observed: "The public crowd to a picture just as they rush to a criminal court; villainy is stimulating and infectious." Yet he was willing to acknowledge that "for brilliant handling, for a sharp and spicy mode of telling a story, for clever cut-throat character, for costumes the admiration of milliners, for realism in the way of gold chains, diamonds, and other precious stones, this picture has never been surpassed."[21]

Having established a particularly profitable relationship with the dealer Louis Victor Flatow (often spelled Flatou) in the display and reproduction of *The Railway Station* in 1862, Frith turned to him again in 1870, selling *The Salon d'Or* to him for £4,000, inclusive of publication rights.[22] Four years later Flatow sold the picture alone for £1,995, in the meantime having arranged for it to be engraved by Charles George Lewis (1808–1880).[23] When it was published in 1876 by Henry Graves & Co., who had previously published *The Railway Station,* the results were less than satisfactory to Frith, who complained in his autobiography that the engraver "was quite at sea in his attempts to reproduce my unfortunate gamblers." Indeed, he went on to note: "I doubt if a worse print was ever made from a figure picture since the art of engraving was discovered, and the failure was complete."[24]

In the short term, the success of *The Salon d'Or* suggested that Frith should follow it up with a sequential group of five pictures forming a modern-day version of Hogarth's *Rake's Progress.* Entitled *The Road to Ruin,* it traced the consequences of gambling on a young man of wealth, beginning with a card game at college and followed by betting on horses in the Royal Enclosure at Ascot, to which Frith personally was very much opposed. Once again this series proved popular with the general public, necessitating yet another barrier rail when shown at the summer exhibition of the Royal Academy at Burlington House in 1878.[25]

RISD's *Feeding Time* of 1860 is an uncontroversial example of the costume pictures which provided Frith with his daily bread and butter. The distinctive columnar porch attached to the English country house shown here suggests that he had consulted *The Mansions of England in the Olden Time* by Joseph Nash to find a suitable country house for the backdrop. Its superb set of folio-size lithographic plates issued between 1838 and 1849 included an illustration of just such a porch at Audley End in Essex.[26]

For the depiction of the pets in *Feeding Time,* Frith turned, as he frequently did, to Royal Academician Richard Ansdell (1815–1885), who was considered the foremost animal painter of his day after Sir Edwin Landseer (1802–1873).[27] *Feeding Time,* conforming to the moralizing tasks of Victorian painting, celebrated the British compassion for the lot of dumb animals, which had led to the establishment of the Society for the Prevention of Cruelty to Animals in 1824.

W. P. M., C. P. M.

1. Philadelphia, PMA, 1968, pp. 293–94.
2. Frith 1887, II, p. 15.
3. Strong 1978, p. 94.
4. Frith 1887, II, p. 15.
5. Magazine articles in which gambling at Homburg was featured include: "Gambling Made Easy and Comfortable," *Punch,* v. XXXIII (September 19, 1857), p. 124; "A Gambling Tour," *Bentley's Miscellany,* v. LVI (1864), pp. 465–72; and "To Homburg and Back for a Shilling," *Cornhill Magazine,* v. XII (April 1865), pp. 221–34.
6. For a recent discussion of Elmore's first modern-subject painting, *On the Brink,* see Casteras 1982, p. 72.
7. *Art-Journal* 1865, p. 166.
8. Roosevelt 1885, p. 330.
9. *Art-Journal* 1868, p. 27.
10. *Saturday Review* 1871, p. 634.
11. In the Frick Art Reference Library, New York, there is a copy of the *Descriptive Catalogue of Pictures by M. Gustave Doré* for the exhibition at the Doré Gallery at 35 New Bond Street, London, in 1876, where *Le Tapis Vert* is listed as no. 2 (p. 13). Roosevelt 1885 notes that ". . . 'Le Tapis Vert' is at present in the Bond Street Doré Gallery" (p. 250).
12. Frith 1887, II, p. 18.
13. Chapel 1982, p. 90.
14. Frith 1887, II, p. 18.
15. Frith 1887, I, p. 327.
16. Before the preparatory study for *The Salon d'Or* was acquired by the National Gallery of Canada, Ottawa, it was exhibited in London by M. Newman Ltd. in their exhibition *The Victorian Scene* (November 14–December 14, 1962), where it was illustrated in the accompanying catalogue (no. 5).
17. Frith 1887, II, p. 18.
18. For a further comparison of the study with the final work, see Loeffler 1964, pp. 10–14.
19. Wood 1976, p. 44.
20. Frith 1887, II, p. 22.
21. *Art-Journal* 1871, p. 153.
22. Reitlinger 1964, p. 150. According to Frith, however, he did not sell the picture to Flatow, but rather to a Mr. Roffey, who then had the picture engraved (Frith 1887, II, p. 16). It is more than likely that Flatow, rather than Frith, sold the picture to Mr. Roffey, having previously arranged to have it engraved.
23. Beck 1973, p. 63.
24. Frith 1887, II, p. 17.
25. Frith 1887, II, p. 130. For a visual record of the series, see Wood 1976, pp. 45–46.
26. Audley End appears as pl. VIII in Nash 1906. For a further discussion of Frith's use of plates in Nash's *Mansions,* see Strong 1978, pp. 90–91.
27. In 1855 Frith and Ansdell jointly submitted their *Feeding the Calves* to the summer exhibition at the Royal Academy (no. 343). They painted another virtually identical version of RISD's *Feeding Time,* again signed by both of them and dated 1860, which is illustrated in Noakes 1978, pl. VII. For examples of other collaborative works, see *The Pet Fawn* (New York, Sotheby Parke Bernet & Co., *Nineteenth Century European Paintings and Drawings,* June 19, 1984, lot 17); and *The Gossips,* originally painted for James Eden, Fairlawn, Lytham (London, Christie's, June 4, 1982, lot 41).

JAMES JACQUES JOSEPH TISSOT
French, 1836–1902

31 Voie des fleurs, voie des pleurs
(The Dance of Death), 1860

Signed and dated, lower left: *JacoBus Tissot. Pinxit. 1860*
Oil on panel. 14⅝″ × 48³⁄₁₆″ (37.2 × 122.3 cm)
Jesse H. Metcalf, Georgianna Sayles Aldrich, Mary B. Jackson, and Edgar J. Lownes Funds. 54.172

PROVENANCE: Private collection, Philadelphia; purchased from Julius Weitzner, New York, on September 28, 1954.

EXHIBITIONS: Paris, Salon de 1861, no. 2973; Providence, RISD, 1968, no. 2.

PUBLICATIONS: LaGrange 1861, p. 346; Gautier 1861, pp. 338–42; Merson 1861, pp. 266–68; *L'Artiste* 1862, p. 184; Gourley 1964, fig. 1; Reff 1976, I, p. 96, and II, Nb18 p. 109; Cohen 1982, p. 40; Misfeldt 1982, p. 15 (fig. 1–11); London, Barbican, 1984, p. 88 (ill.); Wentworth 1984, pp. 36–39 (fig. 12); Wood 1986, fig. 13.

RELATED WORKS: *An Allegory of the Transience of Life,* 1859, oil on canvas, 12½″ × 38½″ (34.3 × 97.8 cm); Christie's, London, Jan. 28, 1972, lot 91; Fine Art Society, London, 1973, to a private collection. *Voie des fleurs, voie des pleurs,* engraved by Greux, *L'Artiste,* v. 1, no. 8 (April 15, 1862), following p. 184.

The RISD collection includes six paintings that span the career of James Jacques Joseph Tissot: an early historical painting, *The Dance of Death;* one oil sketch, *The Two Friends,* and two watercolors[1] executed during his eleven-year exile in London; and two paintings made upon his return to Paris in the early 1880's, *Ces Dames des chars* and *In the Louvre.* Although Tissot was friendly with the Impressionists, especially Degas, and like them chose subjects from modern life, the detail and finish of his paintings are closer to contemporary academic painters such as Jean-Léon Gérôme and Hippolyte Flandrin, with whom he studied. His most frequent subject was the society woman, and despite a similarity to the fashion pages of illustrated journals, the paintings are often tinged with a Victorian moralizing tone. Tissot did not attain recognition until the end of his career, when he made his Bible illustrations, now largely forgotten.

Tissot was born in 1836 in the seaside town of Nantes. His interest in the medieval heritage of his native Brittany was manifested in his earliest drawings of Gothic buildings, perhaps indicating his unrealized intention of becoming an architect. He arrived in Paris in late 1856 and in January of 1857 registered for permission to copy in the Louvre. In Salon catalogues of 1859 and 1861 he is listed as a student of Hippolyte Flandrin and Louis Lamothe, pupils of J.A.D. Ingres, with whom Degas also studied.[2] Despite their emphasis on the Italian primitives, Tissot's earliest works indulged his passion for the Flemish and German masters and his admiration for the contemporary Belgian artist Henri Leys (1815–1869). Tissot knew Leys's work not only from the Salon, but also from a visit to the artist in Belgium in 1859.

The Dance of Death was exhibited at the Salon of 1861 under the title *Voie des fleurs, voie des pleurs* ("Path of Flowers,

Way of Tears") and was accompanied in the catalogue by the funeral Latin, *"penetrantes in interiora mortis"* ("penetrating into the depths of death"). An earlier version of the composition, *An Allegory of the Transience of Life,* 1859, perhaps served as a study for *The Dance of Death,* as the same figures are ordered differently and a reclining nude appears at the lower right. The RISD painting can clearly be identified as the Salon picture on the basis of an engraving after it by Greux published in *L'Artiste* in 1862 and by the order of the figures described by Théophile Gautier in his 1861 Salon review.[3] The narrow canvas depicts a procession of figures clothed in sixteenth-century costumes and silhouetted against a colorless sky. Death, disguised as an old woman playing the hurdy-gurdy and escorted by two bagpipers, leads the ill-fated parade down a curving slope past two open graves hidden among the rocks and briars, one containing skeletons and the other the body of a drowned child. Figures representing the various vices and levels of society follow: a pair of young lovers so drunk with passion they are not aware of the sinister musicians who lead them; a wealthy youth crowned with laurel dancing with two young women; an old hypochondriac and his much younger, coy wife, who allows the elegant courtier who follows to kiss her hand; a ragged orphan whose toys fall from her cart; a trio of festive and gaudily attired drunks staggering over a corpse laid crosswise along the path; a repugnant rich man and his weeping child bride; and a half-naked courtesan followed by personifications of Lust and Luxury whispering in her ears. Another skeletal figure of death, wearing a shroud and a coffin and carrying the Reaper's scythe and hourglass, lays a bony hand on the shoulder of the last figure, an old man who looks back in fear. A pair of feet, presumably those of a corpse, appear at the crest of the hill, while in the distance a shepherd, having lost this flock, strides in the opposite direction. Only the central figure of the man in the plumed hat, perhaps a self-portrait of the artist,[4] seems fully aware of the impending doom. Several other figures would have been rec-

ognizable to Salon visitors: the draped corpse is quoted from Gérôme's *The Dead Caesar,* exhibited with great acclaim in the Salon of the previous year[5], and the bare-breasted courtesan with her arm aloft refers to the central figure of Eugène Delacroix's *Liberty Leading the People* (Salon of 1831), which was on view at this time in the Musée du Luxembourg.

The Dance of Death received favorable reviews from Gautier, Merson, and LaGrange, despite their accusations that Tissot had imitated the style of Henri Leys.[6] Though Tissot borrowed most heavily from the elder Belgian in his paintings on the theme of Goethe's *Faust,* also exhibited in the Salon of 1861, Leys's manner of flattening space by tipping the ground plane forward and giving equal emphasis to each figure, regardless of compositional importance or atmospheric effect, appears in *The Dance of Death.* Tissot shared Leys's interest in medieval costume and color, which Gautier likened to Swiss stained-glass windows and tarot cards.[7] The harsh juxtapositions of secondary and tertiary colors, sour greens and cold yellows, stale lavenders and bluish reds, show the influence of Ingres, probably through the teachings of Lamothe, and were noted by Edgar Degas in his sketchbook along with a drawing of *The Dance of Death.*[8]

Among Tissot's early works set in the Middle Ages, *The Dance of Death* is unique in representing a genuine medieval subject. The dance of death, or *danse macabre,* has its roots in the late Middle Ages. Inspired by the large number of deaths resulting from the Hundred Years' War, famine, and the bubonic plague, the dance of death was a call to repentance and a reminder of the impermanence of the physical body and earthly attainments. Medieval versions were episodic, with a skeletal figure of death accompanying each member of society in order of his rank, from the Pope and Emperor down to the peasant and ploughman, to show that death comes to all. With the great surge of interest in medievalism in France and a number of discoveries and publications of the *danse macabre* in the first half of the nineteenth century,[9]

Tissot would have been aware of a variety of versions of the theme, especially Hans Holbein's series of woodcuts (1538), from which he might have drawn inspiration for the costumes of *The Dance of Death,* and Marchant's woodcuts after the Paris St. Innocents murals (1425), whose first page, which represents four corpses playing musical instruments, might have suggested death's disguise as a musician leading the dance.[10] The processional nature of *The Dance of Death* was more likely inspired by Tissot's boyhood memories of *danse macabre* murals closer to home: at Kermaria, a village in his native Brittany, and at Basel, not far from the Tissot family's country home at Buillon.[11]

Although the figures in the Kermaria and Basel murals may follow death reluctantly, they are neither terrified nor deceived, as are those of Tissot, who invested the *danse macabre* with a theatrical, desperate gaiety undercut by premonitions of danger. In this regard, his approach to this subject is a product of the nineteenth-century Romantic vision of the dark side of life and of the widespread historicism in this period. Tissot's treatment of the subject is lacking the nationalist nostalgia of a painter like Leys, whose historicism aims to reconstruct a time of simpler faith in his native country. Although Tissot used the historical theme as a stage set to display festive costume and accessories, there is an element of fatalism and a horror of death, graphically suggested, which may have been a recollection of the events of 1848, or perhaps an allusion to Napoleon III's military adventures. The artist's choice of the *danse macabre* for his subject may also be interpreted as an allusion to the vanity and materialism that dominated French society during the Second Empire. In this regard, Tissot's *The Dance of Death* is a striking premonition of the Commune a decade later and of his own subsequent religious conversion.

Despite their praise for Tissot's talent, Gautier labeled *The Dance of Death* a pastiche, and Merson called it "un succès de curiosité," which was nevertheless not very original[12] as

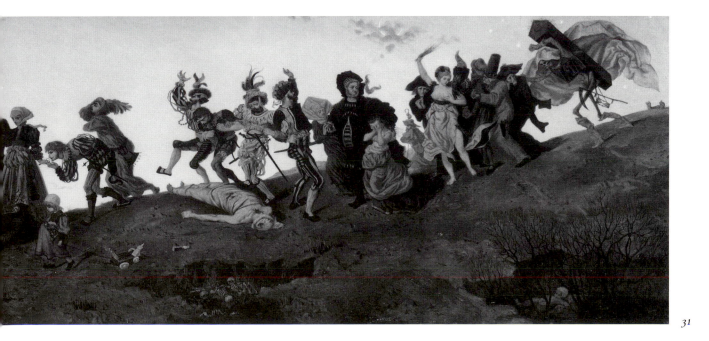

31

interest in medievalism was waning in France by 1861. Tissot must have realized that his style and theme were somewhat passé, and the following year he turned to painting subjects from modern life. The interest in costume he displayed in *The Dance of Death* he redirected to the fashions of contemporary women in Paris and London. A. H. S.

1. *Croquet,* gouache, 24″ × 14⅟16″, 60.077; *Lady at a Piano,* watercolor, 16⅝″ × 13⁷⁄16″, 64.005.

2. Tissot and Degas met in Lamothe's studio in 1859. In 1868 Degas painted Tissot's portrait, which makes reference to Tissot's early admiration of the northern masters with a Holbein-like portrait of a man in sixteenth-century costume hung on the wall behind the artist's head.

3. Gautier 1861, pp. 338–40.

4. Wentworth 1984, p. 37.

5. Zerner in Providence, RISD, 1968, n.p., says the source for Tissot's corpse is Gérôme's *Ave Caesar, morituri e salutant,* a larger canvas also exhibited in the Salon of 1859. The whereabouts of both paintings are unknown, and both are reproduced in Ackerman 1967, pp. 165 and 169. Of the two, *The Dead Caesar* is clearly the inspiration for the corpse in *The Dance of Death.* It was highly praised by Gautier, Baudelaire, and Dumas. Gérôme later repeated the draped corpse of *The Dead Caesar* in a larger composition entitled *The Death of Caesar,* which was exhibited at the Salon of 1867 and is now in the collection of the Walters Art Gallery, Baltimore.

6. Gautier 1861, p. 338; Merson 1861, p. 266; Lagrange 1861, p. 346.

7. Gautier 1861, p. 340.

8. Degas Notebook 18, p. 109, Bibliothèque Nationale, Paris, reproduced in Reff 1976.

9. The most important studies of the *danse macabre* were Achille Jubinal, *Explication de la danse des morts de la Chaise-Dieu,* Paris, 1841; E. H. Langlois, *Essai historique, philosophique et pittoresque sur les Danses des Morts,* Rouen, 1852; Francis Douce, *The Dance of Death in elegant engravings on wood with a dissertation on the several representations of that subject,* London and Bonn, 1833, 1849, and 1858; and E. G. Peignot, *Recherches historiques et littéraires sur les danses des morts,* Paris and Dijon, 1826.

10. Holbein's woodcuts were reproduced in Douce 1833, 1849, and 1858. St. Innocents was a public graveyard in Paris. On the southern wall of a covered walkway the earliest known *danse macabre* in France was painted ca. 1424–25 by an unknown artist(s). It was destroyed in 1669, but in 1485 Guyot Marchant published woodcuts and verse based on it. Discussions of the Innocents murals and reproductions from Marchant's woodcuts were included in Douce, Langlois, and Peignot (see n. 9). Four corpses playing musical instruments were illustrated on the first page of Marchant's book.

11. Plaster covering the *danse macabre* at Notre Dame, Kermaria, was peeled off to reveal the mural in 1856, according to Clark 1950, p. 30. It seems likely that Tissot would have been aware of this event. In his 1861 Salon review Gautier (p. 338) mentions Basel as a source for Tissot's *Dance of Death.* Basel had two sets of murals: one in a Dominican monastery in Grossbasel, which was modeled after an earlier *danse macabre* in an Augustinian convent in Kleinbasel. Probably the best known example of the *danse macabre,* the Grossbasel *Totentanz* became an important stop on the Grand Tour in the eighteenth century and was widely published. Though destroyed in 1805, copies had been made in 1769 and 1773 and fragments were preserved. See Douce 1858, pp. 34–36. A crucifixion is represented in the middle of both murals; perhaps it inspired the figure of the young man crowned in laurel and supported by two women in Tissot's *Dance of Death.*

12. Merson 1861, pp. 266, 268.

JAMES JACQUES JOSEPH TISSOT
French, 1836–1902

32 *The Two Friends,* ca. 1881

Signed, lower right: *J. J. Tissot*
Oil on canvas. 45⅟16″ × 20⅞″ (116 × 53.2 cm)
Anonymous gift. 60.005

PROVENANCE: Mrs. Robert Frank, London; Mrs. Murray S. Danforth, Providence.

EXHIBITIONS: London, Jeffress, 1959, unnumbered; Providence, RISD, 1968, no. 33; Williamstown, Clark, 1978; London, Barbican, 1984, no. 140.

PUBLICATIONS: Gourley 1964, fig. 4; Misfeldt 1971, fig. 120; Wentworth 1978, no. 55a; Wentworth 1984, pp. 105, 132 (pl. 148); Forbes 1975, p. 136.

CONSERVATION: Cleaned, revarnished, and reframed in 1984 at the Williamstown Regional Art Conservation Laboratory.

RELATED WORKS: *Les Deux Amis,* 1881, etching (see Wentworth 1978, no. 55). *Emigrants,* 1879, oil on canvas, formerly in Montreal, Montreal Museum of Fine Arts, present location unknown. *Goodbye, On the Mersey,* 1880–81, oil on canvas, 33″ × 21″ (83.8 × 53.3 cm), New York, Forbes Magazine Collection. *By Water* (*Waiting at the Dockside*), ca. 1881–82, watercolor, 20″ × 10¾″ (50.8 × 27.3 cm), London, Owen Edgar Gallery.

Tissot's participation in the events of the Franco-Prussian War led to his flight to England in 1871 following the fall of the Commune. He settled in London and, inspired by the work of his friend J. A. M. Whistler, explored themes of the Thames and the Pool of London, using the ships and their riggings as backgrounds for social conversation pieces of fashionable figures waiting for the ferry or lounging on shipboard.[1] His involvement after 1876 with Mrs. Kathleen Newton, a divorcée with two children born out of wedlock, resulted in his seclusion and the quiet intimacy of his work until 1879, when he moved beyond the bounds of his home and garden in St. John's Wood to subjects describing the bustling movement of London: crowded railroad platforms, carriage-clogged streets, and swarming steamer docks.

In *The Two Friends,* a gentleman, perhaps a merchant, stretches to shake hands with a young man in military uniform who leans out from the rigging of a steamer just pulling away from the dock. They form a strong diagonal from the lower left to upper right, countered only by a lifeboat and a spar overhead. Other figures engaging in leave-taking remain along the edges or are only faintly visible through the rigging and steam, reserving the center of the composition for a leitmotif of the theme: the clasped hands.[2] In the foreground two crates marked Alabama and New York refer to British-American trade in the post-Civil War era. The scene probably takes place on the Mersey rather than the Thames, as Liverpool was the main transatlantic shipping port and appears in another painting of the same year, *Goodbye, On the Mersey* (New York, Forbes Magazine Collection; see fig. 1).

In *The Two Friends* the leisurely atmosphere of the artist's Thames scenes produced in the early 1870's is replaced by the urgency of imminent departure. Like his other pictures

of parting painted in the early 1880's, *The Two Friends* may have been autobiographical; it corresponds in date to the years of Kathleen Newton's failing health and may foreshadow her death from consumption in November of 1882. She appears in *By Water* (1881–82, London, Owen Edgar Gallery), *The Ferry* (ca. 1879, present location unknown), and *Goodbye, on the Mersey* in the same triple-caped coat she wears at the lower left edge of *The Two Friends*. Nevertheless, the central theme of the painting, the leave-taking of the two male friends, may foreshadow the artist's own departure from England the following year.

In addition, the dockside pictures may be Tissot's attempt to paint a uniquely British subject: the Victorian problem of emigration.[3] The sad restlessness of the people waiting on the docks among steamer trunks and suitcases in *By Water,* the tearful waves of those left behind in *Goodbye, on the Mersey,* and the woman stumbling aboard ship in *Emigrants* (1879, present location unknown) suggest Tissot's interest in the drama of severing ties with one's native land. In the early nineteenth century the industrial revolution caused economic hardship among domestic laborers and small farmers, resulting in a great wave of emigration. In the late 1870's, after severe agricultural depression, a second wave of emigration occurred, supported by a population explosion and the official attitude of the British government, which was to regard the unemployed members of society as redundant and emigration to a British "colony," America or Australia, as a partial solution to the problem.[4] The overcast sky and subdued palette of *The Two Friends* and related paintings of parting contribute to the melancholy and ominous feelings associated with leaving home for an uncertain future.

32

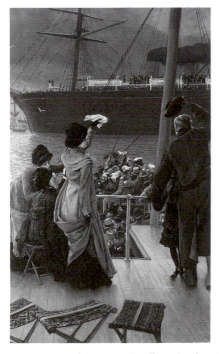

Fig. 1 James Jacques Joseph Tissot, *Goodbye, On the Mersey,* 1880–81, oil on canvas, 33″ × 21″ (83.8 × 53.3 cm), New York, Forbes Magazine Collection.

The seeming spontaneity of the composition suggests the influence of photography on Tissot's British work, as well as his interest in the "slice of life" compositions of the Impressionists. The tall, thin format and compressed space also indicate his familiarity with Japanese prints. Although *The Two Friends* is signed, it is not as finished as many of Tissot's works. The limited color scheme, mostly browns with a few touches of orange and blue, suggests that it is probably an advanced sketch for a now lost oil painting. Tissot's etching after *The Two Friends* includes in the title margin the British and American flags and the date 1881, by which we can date the RISD oil sketch.

Tissot left England for Paris immediately after the death of Kathleen Newton in 1882. Her features continued to appear in Tissot's paintings, including those representing the women of Paris. A. H. S.

1. Tissot was particularly influenced by Whistler's *The Thames Set,* 1871, a series of etchings representing river life and shipping on the Thames, and *Wapping,* ca. 1860–64, oil on canvas, exhibited at the Exposition Universelle, 1867, which clearly inspired Tissot's *The Thames,* ca. 1872, oil on canvas; see Wentworth 1984, p. 99. Tissot met Whistler in 1857 while both were copying Ingres's *Roger délivrant Angélique* in the Musée du Luxembourg; see Wentworth 1984, p. 15.

2. Wentworth 1978, p. 236.

3. Forbes 1975, p. 136. Tissot addressed the theme more directly in *Emigrants,* 1879 (formerly collection of the Montreal Museum of Art, present location unknown).

4. MacDonagh 1973, n.p.

JAMES JACQUES JOSEPH TISSOT
French, 1836–1902

33 *Ces Dames des chars*
 (The Circus), 1883–85

Signed, lower right: *J. J. Tissot*
Oil on canvas. 57½″ × 39⅝″ (146 × 100.65 cm)
Gift of Walter Lowry. 58.186

PROVENANCE: Julius Weitzner; Walter Lowry.

EXHIBITIONS: Paris, Sedelmeyer, 1885, no. 2; London, Tooth, 1886, no. 11 (as *Ladies of the Cars*); San Francisco, de Young, 1964, no. 224; Providence, RISD, 1968, no. 36; Washington, Federal Reserve, 1979; Washington, National Gallery, 1980, no. 12; New York, IBM, 1988.

PUBLICATIONS: *New York Times* 1885, p. 10; Gourley 1964, pp. 1–9 (fig. 6); Zerner 1968, pp. 32–35, 68–70 (ill. on cover); Brooke 1969, p. 6 (fig. 2); Wentworth 1978, no. 78d; Misfeldt 1982, p. 82 (fig. III–54); Wentworth 1984, pp. 165–70 (pl. 179); Woodward and Robinson 1985, no. 114 (ill.); Misfeldt 1986, p. 113; Wood 1986, p. 133.

RELATED WORKS: *Ces Dames des chars,* watercolor on silk, 13⅜″ × 6⁵⁄₁₆″ (34 × 16 cm), Dijon, Musée des Beaux-Arts (this is a copy by Tissot of the left half of the version in oil). *Ces Dames des chars,* 1885, etching and drypoint, 15¾″ × 10″ (40 × 25.4 cm); see Wentworth 1978, no. 78d.

Upon his return to Paris in 1882, after an absence of eleven years, Tissot attempted to reestablish his reputation there with a series of fifteen paintings, called "La Femme à Paris." Painted between 1883 and 1885, these large-scale pictures address the subject of the elegant *parisienne.* Each canvas depicts her in all her artificial perfection – the fashionable woman of conspicuous beauty and presence who captures attention when making an entrance at the ball or at the theatre, strolling in the park, dining in the outdoor cafe, stealing the limelight at the circus, charming the customer in a fashionable shop. The series hangs together not as a group of portraits or as a narrative progression, but rather as a monumental depiction of the excitement and fashion of urban life. Inspired by the works of Manet and Degas, "La Femme à Paris" is Tissot's attempt to gather together elements of modern life unique to Paris and to depict those whose lives are bound up in the constant agitation and tension of the city.

"La Femme à Paris" is the artist's most ambitious group of pictures in scale and in formal design, moving beyond the anecdotal nature of his earlier work to a grander format recalling history painting. In his search for monumentality in the painting of modern life, he parallels Renoir's turn from Impressionism to the classic nude and Seurat's ambitious views of Asnières and the Grande Jatte.[1] Efforts to monumentalize Impressionism are also visible in the works of Monet (see entry 49) and Cézanne (see entry 64) from this period, and Tissot's series parallels Monet's interest in serial paintings. Tissot's new awareness and incorporation of some aspects of the French avant-garde extends also to his use of brighter, more decorative color in the paintings of "La Femme à Paris," raising the temperature from the cool greyish tonality of his earlier works to warm pinks and brilliant

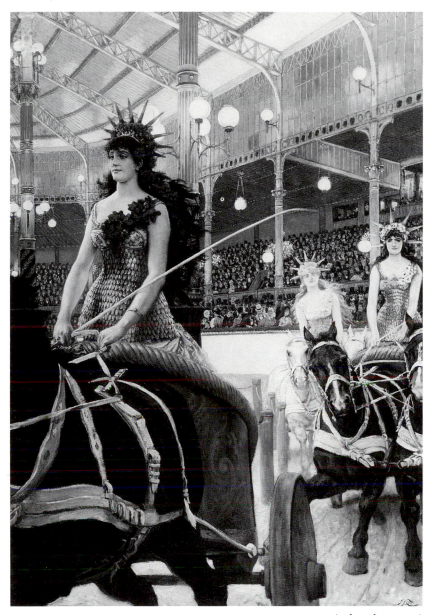

33 (color plate p. 22)

reds. The bright illumination of *Ces Dames des chars,* as a feature of the painting's style and subject, is crucial to its expression of modernity.

Ces Dames des chars, the second picture in the series, shows three costumed circus performers driving two-horse chariots around the thirteen-meter track at the Hippodrome de l'Alma, the first Paris hippodrome to be covered by a sliding glass roof that could be opened to expose the sky. Built in 1877 at the corner of avenues Josephine and Alma, the Hippodrome de l'Alma could hold eight thousand spectators in its large oval iron-and-glass expanse, supported by slender iron columns with horse-headed capitals (seen in the upper left of *Ces Dames des chars*). The Hippodrome incorporated many novel engineering features, such as animal cages beneath the ring and provisions for the fabrication of mist, fireworks, and other special effects.[2] Most impressive, however, were the new electric lights, generated by two 100-horsepower steam engines, which made possible evening performances, as depicted in *Ces Dames des chars*.[3]

Because of the strength needed to hold the reins from a standing position, the riders were called *amazones*, and their chariots were decorated with Neoclassical motifs.[4] The headdresses worn by the *amazones* may have been inspired by the 1848 seal of state, designed by Auguste Barre, representing Liberty crowned with rays of light. Tissot may also have been aware of the figure of Liberty in Elias Robert's sculptural group, *La France couronnant l'Art et l'Industrie,* which stood above the entrance pavilion of the Palais de l'Industrie at the Exposition Universelle of 1855.[5] Because of the long and well-publicized campaign to raise French funds for it, Bartholdi's *Statue of Liberty* must have been well known to Tissot. The thirty-foot head with its seven-rayed diadem was a major attraction at the 1878 Exposition Universelle, and on July 4, 1884, in a grand ceremony in Paris, the completed statue was officially presented to the United States.[6] In France the iconography of Liberty, deeply rooted in the

Revolution a century before, was a recurrent motif on the eve of its centennial, filtering into many aspects of popular culture during the Third Republic. A reviewer for *La Vie parisienne* noted the resemblance of the *amazones* to the *Statue of Liberty*,[7] and the catalogue for the London exhibition of "La Femme à Paris" referred to her as "a true daughter of the people."[8]

The composition is conceived to heighten the painting's dramatic effect. The *amazones* are monumentalized by their placement, one against the foreground plane and the others charging toward it, and by the bold cropping of the lead horse. The viewer looks up at them from a sharp angle, as if he were almost under the wheels of the first chariot, and is drawn into the space of the painting by the proximity of the action as well as by the direct eye contact maintained by the second *amazone*. Her unwavering stare and the collective gaze of the crowd (who appear to look directly at the viewer) create a sense of confrontation and tension. This is augmented by the intense glare of the electric lights and the reflections off the glass and steel surfaces, creating a claustrophobic atmosphere that suggests the commotion of the interior of the Hippodrome.

Tissot's use of a confining perspective might have drawn upon the lessons of photography as well as the circus paintings of his friend Degas. Degas's *Miss La-La of the Cirque Fernando*, 1879 (London, Tate Gallery), which also shows the interior of the Hippodrome de l'Alma, similarly uses a somewhat disorienting sharp-angled view from below to dramatize the perilousness of the acrobat's trick and to involve the viewer in the action. Toulouse-Lautrec's contemporary obsession with the stage at night, whether at theatres, clubs, dance halls, or circuses, should also be noted, and may have been informed by Tissot's circus pictures.[9]

Tissot's series was exhibited in 1885 at the Sedelmeyer Gallery, Paris, and at the Arthur Tooth Gallery in London the following year, and was poorly received. Reviewers complained that the pictures were disjointed as a series and cumbersome in composition, caught between the conventions of Victorian narrative painting and the French avant-garde.[10] A critic for *La Vie parisienne* noted that the high proportion of circus scenes, three of fifteen, had little relevance to the sophisticated life of the true *parisienne,* and added further that the face in each of the fifteen canvases was "toujours la même Anglaise."[11] The repetition of the same strange doll-like characters from painting to painting, each projecting little more than a vapid smile, provides a troubling, if not hallucinatory, unity to the series, as each plays a doll's part on the stage of her current activity. Another reviewer observed:

> They are gracious puppets set in motion in the arena where they are accustomed to going through their motions, soliciting neither commentaries nor glosses, inspiring neither admiration nor repugnance nor desire, content to be interesting and pleasant to see.[12]

The lead *amazone*'s disengaged languor in *Ces Dames des chars,* with her empty expression and her arms slack on the reins of horses supposedly racing at top speed around the track, adds a note of awkwardness to the scene. As the Tooth Gallery catalogue commented, " . . . if they are not beautiful, at all events under the glamour of the electric light and amid the applause of the amphitheatre they seem so."[13] The *amazones* bear a resemblance to Kathleen Newton, Tissot's English lover, who died in November 1881 (see entry 32, *The Two Friends*). She appears again, ghostlike, dressed in black and seated in the first row of spectators at the rail, in the center of the composition.

As a series, "La Femme à Paris" forms not so much a running narrative as a series of short stories or vignettes, like Alphonse Daudet's *Moeurs parisiennes*. In fact, Tissot had literary aspirations for "La Femme à Paris"; it was to be engraved and then illustrated by stories, each to be written by a different author, according to a *New York Times* article in 1885.[14] Although *Ces Dames des chars* was assigned to Théodore de Banville, no evidence of a text by him relating to the painting exists. *Ces Dames des chars* corresponds rather to a passage in Daudet's novel *Sappho*, published in 1884, about a character named Rosa, "une ancienne dame des chars à l'Hippodrome." She is described by her former lover who

> went to the Hippodrome one night and saw her standing up in her little chariot, just turning the corner of the track, coming straight at me, her whip in the air, her helmet wreathed in serpents and her gilded coat of mail locked around her, reaching halfway down her thighs.[15]

Tissot had formed a close friendship with Daudet when he first moved to Paris in the late 1850's,[16] and Daudet, at Tissot's request, may have had a hand in organizing authors to write stories to accompany "La Femme à Paris."[17]

It is not clear which came first, Tissot's painting or Daudet's novel. Misfeldt believes that Daudet saw sketches for the painting and decided to include such a scene in his book.[18] Wentworth asserts that *Ces Dames des chars* is based on Daudet's scene in *Sappho*, Tissot having read his friend's book in manuscript before it was published.[19] Either would seem to date *Ces Dames des chars* early in the series, sometime before mid-1884.

Only the first five paintings of "La Femme à Paris" were etched, among them *Ces Dames des chars*. The project was interrupted by Tissot's rebirth of faith in 1886 and his urgent ambition to illustrate the Bible. He never painted scenes from modern life again, perhaps because of his disappointment over the poor reception of "La Femme à Paris," but more likely because of his consuming interest in and travels to the Holy Land and the great acclaim he earned as a religious painter. A. H. S.

1. Wentworth 1984, p. 161.

2. Dupavillon 1982, pp. 87–91.

3. An undated program in Thétard 1947, p. 159, lists a "Course en Chars romaines à 12 chevaux par MM. Burramo, Gauchon et Pellet" for the evening at 8:30 p.m., "à la lumière électrique." It is the sixth of thirteen acts listed, falling before the first "entr'acte" of the evening; thus one may surmise that the action in

Ces Dames des chars takes place around 9 p.m.

4. Thétard 1947, p. 161, reproduces an undated black-and-white photograph of the two-horse chariots at the Hippodrome de l'Alma. The glittery costumes shown in *Ces Dames des chars* vary significantly from the Neoclassical capes, helmets, and togas worn by the circus women in the photograph.

5. See Pierre Provoyeur in New York Public Library 1986, p. 83.

6. See Catherine Hodeir in New York Public Library 1986, pp. 120–39.

7. *La Vie parisienne,* 1885, p. 255. "Dans son second tableau, il fait cavalcader devant nous *Les dames des chars,* trois gaillardes ressemblant à la *Liberté éclairant le Monde,* mais par malheur qui n'éclairent pas le cirque."

8. London, Tooth, 1886, no. 11, n.p.

9. Toulouse-Lautrec's *Cirque Fernando, the Ringmaster,* 1888 (Chicago, Art Institute of Chicago), which like *Ces Dames des chars* uses the cropped curve of the circus ring to heighten the sense of centrifugal action as well as to draw in the viewer, was painted several years after *Ces Dames des chars* was first exhibited.

10. Brooke 1969, p. 16.

11. *La Vie parisienne* 1885, p. 255.

12. *Courrier de l'Art,* 1885, p. 200, quoted in Brooke 1969, p. 9.

13. London, Tooth, 1886, no. 11, n.p.

14. *New York Times* 1885, p. 10.

15. Daudet 1951, p. 108.

16. Misfeldt 1986, p. 110. Daudet and his lover Marie Rieu might have served as models for Tissot's early Faust and Marguerite pictures.

17. A letter from Daudet to François Coppée asking him to contribute a story based on Tissot's *La Demoiselle d'honneur* is in the Boston Public Library, Department of Rare Books and Manuscripts, Ms. E.9.4 (65.2). See Misfeldt 1986, pp. 112–13. Misfeldt 1986, p. 112, also quotes from an unpublished, undated letter from Tissot to Daudet (in an uncited French private collection), in which the artist proposes a series of etchings on "la femme moderne," each to be accompanied by a text of two hundred to three hundred lines, and asks for Daudet's help in this project. Daudet responds, "Elle est dans tous nos romans, la femme moderne que vous demandez," and agrees to help Tissot.

18. Misfeldt 1986, p. 113.

19. Wentworth 1978, p. 308. Wentworth 1984, pp. 170–71, cites another instance in which a painting from the series was inspired by a previously written text – *La Mystérieuse* is based on Ouida's *Moths,* published in 1880 – rather than by the author assigned to it.

34

JAMES JACQUES JOSEPH TISSOT
French, 1836–1902

34 *In the Louvre,* 1883–85

Signed, lower left: *J. James Tissot*
Oil on canvas. 18½″ × 12⅛″ (47 × 32 cm)
Anonymous gift. 62.078

PROVENANCE: Monsieur Pogut; Messrs. P. & D. Colnaghi, 1955; Mrs. Murray S. Danforth.

EXHIBITIONS: Sheffield, Graves, 1955, no. 4 (as *At the Louvre, La Rotonde de Mars,* ca. 1864); Providence, RISD, 1968, no. 37.

PUBLICATIONS: Gourley 1964, fig. 8; Held 1984, pp. 300–01; Wentworth 1984, p. 163; Milner 1988, fig. 7.

RELATED WORKS: *L'Esthétique,* 1883–85, oil on canvas, 56⅞″ × 39⅜″ (144.4 × 100 cm), Ponce, Puerto Rico, Museo de Arte de Ponce, Luis A. Ferré Foundation (exhibited with "La Femme à Paris" series in 1885 and 1886). *L'Esthétique,* oil on canvas, 25½″ × 17½″ (64.8 × 44.4 cm), London, Owen Edgar Gallery (a smaller version of the above). *Visiteurs étrangers au Louvre,* ca. 1879–80, watercolor, 16¼″ × 8¾″ (41.3 × 22.2 cm), Bloomington, Indiana University Art Museum. *Visiteurs étrangers au Louvre,* Paris, Musée d'Orsay (oil study for the above without figures). *Visiteurs étrangers au Louvre,* ca. 1880, oil on canvas, 14½″ × 10½″ (36.8 × 26.7 cm), New York, private collection. *An Interior in the Louvre,* oil on board, 22″ × 15″ (55.9 × 38.1 cm), London, Sotheby's, June 19, 1990, lot no. 43 (a study without figures for the above).

Exhibited with the series "La Femme à Paris" in 1885 and 1886 were two paintings from a projected but never completed series to be called "L'Etrangère." It was to parallel "La Femme à Paris" in showcasing the pursuits of foreign women in the French capital. RISD's *In the Louvre* is a study for one of these pictures, *L'Esthétique* (fig. 1), now in the collection of the Museo de Arte de Ponce, Puerto Rico.

In the Louvre shows a corner of the Rotonde de Mars, named for the Borghese Mars displayed there, in the Salle des Antiques. The window provides a view to the northwest of the Pavillon Sully. A large vase decorated with bacchic heads atop a massive triangular pedestal with Egyptian and Roman motifs, both originally from the Borghese collection, dominates the composition. A second-century Roman bust of a woman appears to be looking out the window, while only fragments of two other marbles can be seen behind the vase and at the extreme right edge.[1]

In the Louvre is among a group of paintings of the Louvre that Tissot executed between 1879 and 1885. The earlier paintings were probably inspired by visits to the museum with Kathleen Newton, who appears in several of them, though Tissot had already explored the theme in London on the steps of the National Gallery in Trafalgar Square in *London Visitors* (ca. 1874, Milwaukee, Milwaukee Art Museum). The monumental settings of these pictures are uneasily inhabited by figures of modern life, one of whom in each painting challenges the viewer with a direct stare. Even those museum interiors without figures are pervaded by a subtle sense of confrontation and uneasiness. In *In the Louvre* the massive Borghese base presses up against the foreground plane and the vase looms over the viewer's sightline. The floor of the small niche rises up sharply to the wall behind, while the section of the façade appearing through the window could be seen only from a very low vantage point.

This disconcerting sense of being too close to the space of the composition is heightened by Tissot's addition of three figures in the Ponce version. The sense of confrontation between the viewer of Tissot's painting and the works of art depicted in it is complicated by the man who looks directly at the viewer from behind the pedestal, the fashionable woman who gazes listlessly into space, and the woman wedged in the left corner who sketches the marbles. This tension between the viewer, the painting, the works of art in the painting, the figures, and the artist himself was exploited in a more formal and less narrative way by Degas in his etchings and pastels of Mary Cassatt and her sister in the galleries.[2] Executed between 1879 and 1880, these images of modern life among the antiquities of the Louvre might have been the inspiration for Tissot's Louvre pictures. A. H. S.

1. Agnès Scherer, Département des Antiquités Grecques, Etrusques et Romaines, Musée du Louvre, kindly identified the vase, base, and bust and confirmed the location as the Rotonde de Mars (letter to the author dated October 20, 1989).

2. See Reff 1968, pp. 156–58.

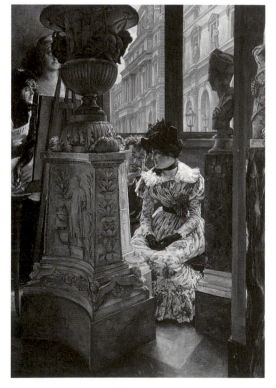

Fig. 1 James Jacques Joseph Tissot, *L'Esthétique,* 1883–85, oil on canvas, 56⅞″ × 39⅜″ (144.4 × 100 cm), Ponce, Puerto Rico, Museo de Arte de Ponce, Luis A. Ferré Foundation.

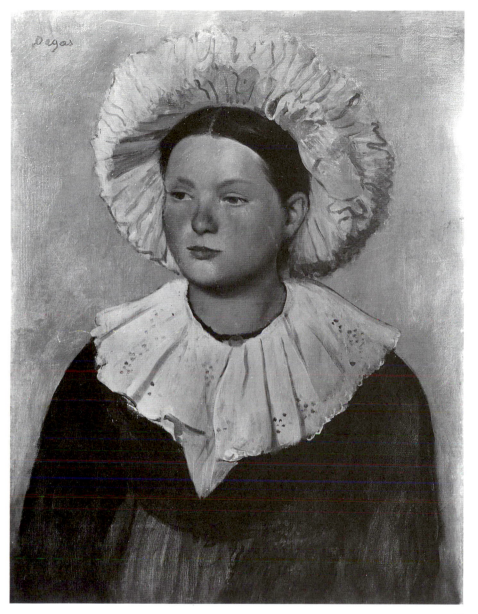

EDGAR DEGAS (born Hilaire Germain Edgar De Gas)
French, 1834–1917

35 *La Savoisienne,* ca. 1860

Signed, upper left: *Degas*
Oil on canvas. 24¾″ × 18¼″ (61.5 × 46.3 cm)
Museum Appropriation. 23.072

PROVENANCE: Acquired from the artist by Bernheim-Jeune around April 1903; from whom acquired by Durand-Ruel, Paris/New York, on October 20, 1906, for 7,500 francs; from whom acquired by the Museum on May 9, 1923.

EXHIBITIONS: Paris, Bernheim-Jeune, 1903, no. 13 (as *La Savoisienne*); Brussels, Libre Esthéthique, 1904, no. 25; Pittsburgh, Carnegie, 1908, no. 21; Cambridge, Fogg, 1911, no. 7; Boston, Saint Botolph, 1913, no. 11; New York, Knoedler, 1915, no. 21; New York, Durand-Ruel, 1916, no. 14; Northampton, Smith, 1933; Worcester, Art Museum, 1946; Cleveland, CMA, 1947, no. 20 (pl. XIX); New York, Wildenstein, 1949, no. 27 (ill.); Los Angeles, LACMA, 1958, p. 36 (no. 21); Seattle, World's Fair, 1962, p. 41 (no. 41); Boston, MFA, 1974,

no. 10; Miami, Center for Fine Arts, 1984, p. 167 (ill.); New York, IBM, 1988.

PUBLICATIONS: Grappe 1913, p. 22 (ill.); Lafond 1919, p. 17 (ill.); RISD, *Bulletin,* July 1923, p. 34; Rowe 1923, pp. 38–39 and cover (ill.); Vollard 1927, p. 25 (ill.); Hausenstein 1931, p. 166; Rowe 1932, p. 19; Adlow 1934, p. 7 (ill.); Northampton, Smith, 1934, pp. 15, 19 (ill.); Banks 1937, p. 33 (ill.); Mauclair 1937, p. 166 (fig. 52); Lemoisne 1946–49, I, no. 333 (ill.); RISD, *Treasures,* 1956, n.p. (ill.); Faison 1958, p. 229 (fig. 17); Fowle 1964, pp. 6, 9 (fig. 2); Minervino 1970, p. 103 (no. 360, pl. XXV); Edinburgh, National Gallery, 1979, no. 61; Woodward and Robinson 1985, p. 193 (no. III, ill.); Sutton 1986, p. 134 (pl. 103); Reff 1987, pp. 49–50.

CONSERVATION: The painting was relined with Belgian linen and plenderleith wax resin, stretched on a new stretcher, and the surface cleaned and revarnished in 1953.

RELATED WORK: *Portrait of a Young Woman* (after a drawing then attributed to Leonardo da Vinci), 1858–59, oil on canvas, 25″ × 17½″ (63.5 × 44.5 cm), Ottawa, National Gallery of Canada.

In spite of its well-documented provenance and frequent exposure in the early twentieth century, very little is known about this portrait of a Savoyard girl in native costume. The identity of the sitter is not known, nor are the circumstances in which this unfamiliar subject may have posed. The painting was called *La Savoisienne* when first exhibited with Bernheim-Jeune in 1903, and it was only in 1915, when it was shown by Knoedler & Co. in New York, that a date of 1873 was established. In 1946 Lemoisne, who was ignorant of the painting's early history, suggested a date of "around" 1873, apparently based on the Museum's dating at the time of its acquisition.[1] This date has never been questioned, although this painting is entirely uncharacteristic of the unconventional portrait style that Degas had developed by the end of the 1860's. In its subject, style, and the simplicity of its setting, *La Savoisienne* is an anomaly among Degas's work from this period.

Although Degas created nearly one hundred portraits between 1853 and 1873 (comprising roughly forty-five percent of his production in these years), very few of these can be dated with precision.[2] Lacking more concrete evidence than the date proposed by Knoedler in 1915 (and perpetuated thereafter), an earlier dating for this painting may be suggested, placing it in the period around 1860, shortly after Degas's return to Paris following a four-year stay in Italy. Seen in relation to his work from this period, *La Savoisienne* may be understood not as an anomaly, but as a painting with a specific and logical place in the artist's stylistic development, related to historical events of the Second Empire and to details of his personal life that may have briefly drawn him to this subject.

Historians writing about this painting have commented on its unusual character. In its first substantive publication, the Museum's Director, L. Earle Rowe, noted the absence of an interest in the simulation of naturalistic light (and, by extension, of a naturalistic setting) that linked Degas to the Impressionists. The straightforwardness of the pose, the restrained technique, and the simple dignity of the sitter, Rowe commented, distinguished *La Savoisienne* from the "blasé ballet type of later days."[3] More recently, Theodore Reff, comparing this painting to others from the early 1870's, has noted the retardataire quality of *La Savoisienne*, whose frontal composition, symmetry of design, broad forms, and neutral background are atypical of Degas's work of this period, suggesting to Reff the sporadic persistence of Ingres's influence on Degas's portraits long after Degas had ceased to be influenced by Ingres in other aspects of his painting.[4]

By the late 1860's the critic Edmond Duranty (1833–1880), a close friend of Manet and Degas and a principal figure in the circle of artists and writers who gathered at the Café Guerbois, had already identified Degas as an artist "on his way to becoming the painter of high life" in Paris.[5] In *La Nouvelle Peinture,* written in 1876, Duranty had Degas's work specifically in mind when he wrote of the modern portrait, in which the artist,

…solidly embracing nature…no longer separate[s] the figure from the background of an apartment or the street. In actuality, a person never appears against neutral or vague backgrounds. Instead, surrounding him and behind him are the furniture, fireplaces, curtains, and walls that indicate his financial position, class, and profession. The individual will be at a piano, or examining a sample of cotton in an office, or waiting for the moment to go on stage, or ironing on a makeshift table. He will be having lunch with his family or sitting in his armchair near his worktable, absorbed in thought….When at rest, he will not be merely pausing or striking a meaningless pose before the photographer's lens. This moment will be as much a part of his life as are his actions.[6]

Similarly, in his notebooks from the previous decade, Degas emphasized the importance of painting his subjects under unusual conditions of light and of representing them in natural (rather than formal) poses that reveal the uninhibited character of the sitters.[7] Almost without exception, Degas's portraits after the mid-1860's embody the qualities expressed by Duranty, "eliminat[ing] the partition separating the artist's studio from everyday life."[8] This is apparent in such early examples as *Woman Leaning near a Vase of Flowers* (erroneously called *Woman with Chrysanthemums,* 1865, New York, Metropolitan Museum of Art) or in the portrait of *James Tissot* (1867–68, New York, Metropolitan Museum of Art), as it is in paintings closer in time to the date proposed for *La Savoisienne,* such as *In a Café (The Absinthe Drinker)* (1875–76, Paris, Musée d'Orsay; see entry 66, fig. 1), showing Desboutin and Ellen Andrée in a modern Parisian setting.

La Savoisienne lacks the self-aware "modernity," penetration of character, and radical experimentation of style and technique that distinguish Degas's work after around 1865. The sitter's withdrawn pose is atypical of the ambitions for portraiture persistently explored by Degas in this period. In its tranquility, simplification of style, emphasis on clear linear contours, and graceful formal harmonies, this painting more closely resembles Degas's work of the late 1850's and early 1860's, when the influence of Ingres remained important to him and when he shared an enthusiasm for Italian Renaissance painting then in vogue among French academicians.[9] Degas's approach to this model, particularly in the treatment of the head, recalls many of the individual portrait studies he did of his cousins and aunt, Giovanna, Giulia, and Laura Bellelli, with whom he lived in Florence between 1858 and 1859, and there are numerous drawings from his notebooks of these years that reflect a similar approach to the figure.[10]

In his choice of subjects, Degas, an urbane artist born to a wealthy banking family with interests in Paris and Naples, was not attracted to the rural genre subjects inspired by latter-day Realism, which would have provided the ostensible influence for the representation of picturesque peasant types such as *La Savoisienne.* If, on the other hand, this painting is placed in the context of Degas's abundant copies after the Old Masters in the mid- to late 1850's, one can find a meaningful context for his apparent fascination with costume and for the sitter's conventional pose.[11] *La Savoisienne* seems closely related to a painting contemporary with the Bellelli studies,

Fig. 1 Edgar Degas, *Portrait of a Young Woman* (after a drawing then attributed to Leonardo da Vinci), 1858–59, oil on canvas, 25″ × 17½″ (63.5 × 44.5 cm), Ottawa, National Gallery of Canada.

the *Portrait of a Young Woman* (fig. 1; Ottawa, National Gallery of Canada), adapted by Degas after a drawing in the Uffizi that at the time was attributed to Leonardo da Vinci.[12] Both paintings represent the figure seated in a frontal position in a three-quarter length bust, pressed close to the picture plane, abutting the four edges of the canvas. Each shows the sitter in a neutral setting. The costumes are noteworthy for Degas's obvious fascination with their material qualities, as well as their remove from contemporary modes, each consisting of a white yoke set against a darker bodice and a round head-piece echoing the shape of the head. The heads of each turn slightly to the right, their gazes averted, the right cheek foreshortened, giving emphasis to the fluid linear contour of the face. In both paintings Degas has set these contours against the soft modeling of the facial features, emphasizing the harmony of rounded forms that is carried throughout the composition. Degas conveys in both subjects a quality of detachment and sobriety that is typical of his portraits from this period. While the design of the copy was deter-mined by its source, Degas was predisposed to use a similar arrangement in his portrait of a young girl after nature.[13]

Compounding the stylistic arguments for a redating of this painting are biographical and historical circumstances that perhaps suggest why Degas may have been attracted to this subject around 1860. After residing in Italy for nearly four years, the last year and a half with his relations in Florence, who were living there in exile, Degas departed for Paris around April 1859, traveling by boat from Livorno to Genoa and then inland through Turin and across the Mt. Cenis pass. "Once across the border, everyone spoke French," Degas wrote. "I was in Savoie and almost home."[14]

Degas appears to have been knowledgeable about the history of the venerable House of Savoy, which originated in the eleventh century and became one of the most power-ful duchies in Europe. In Turin, he was impressed by the Castello del Valentino, built between 1630 and 1660 by Christine de France, Duchess of Savoy, daughter of Henri IV and Marie de' Medici and the widow of Amadeus I, Duke of Savoy. Of the castle built for Christine he writes: "Tell me if this isn't the palace of a widow, sad after a brilliant youth, who often regarded the snow-covered Alps separating her from France."[15] This passage may be an allusion to the sep-aration of Savoy from France (Savoy had been seized by Napoleon in 1796 and lost at the Congress of Vienna in 1814). The poetic sensibility expressed in these lines may also allude to Laura Bellelli, Degas's beloved aunt, who was unhappily forced to join her exiled husband in Florence.[16]

Degas may have been motivated to leave Italy because of the impending war between France and Austria over the lat-ter's domination of the Italian peninsula, which would erupt in May of that year and end in July, leaving more than fifty thousand casualties. As Degas was heading north towards France, two hundred thousand French troops were crossing from Savoy to northern Italy in preparation for war, while concurrently Garibaldi was pursuing his drive for the unifi-cation of Italy.[17] *The Daughter of Jephthah* (ca. 1859–61, oil on canvas, 77″ × 115½″, Northampton, Smith College Museum of Art), begun on Degas's return to Paris and his most ambi-tious canvas to date, is an allusion to the armistice signed by the French and the Austrians in July, reflecting his interest in these events. Its subject, taken from the Book of Judges 11, is a condemnation of Napoleon III for abandoning the cause of Italian unification with this treaty, which had a direct impact on the fate of Degas's exiled Italian relations.[18]

Although there is no specific documentary evidence linking *La Savoisienne* to these events, their ramifications may have had some bearing on the choice of what was other-wise, for Degas, an unusual subject. Not only had he passed through Savoy at this time, but in 1860, as the complicated diplomatic intrigues surrounding this war played out, Savoy and Nice, then territory belonging to the Piedmont state, ruled by the king of Sardinia, were annexed by France as payment for their renewed assistance towards the unification of Italy. Plebiscites on the annexation were held in Savoy and Nice in April 1860, in which support was almost univer-sal, and with much fanfare the Emperor paid a royal visit to Savoy in August.[19] In March 1861, the Kingdom of Italy was created, and Victor Emmanuel II, king of Sardinia and a descendant of the ancient House of Savoy, was proclaimed its constitutional monarch. As a result of these events, in July 1860, Degas's uncle, the Baron Gennaro Bellelli, head of the household in which Degas had lived in Florence, was per-mitted to return with his family to their native Naples, from which he had been exiled since the Revolution of 1848, and in 1861 he became a senator in the newly created parliament.[20]

Although the suggestion of an allegorical significance for this modest portrait may be tenuous, the intersection of these historical events, with which Degas was involved on many levels, provides a plausible context for the creation of this subject, which otherwise remains an anomaly in Degas's painting. It is unlikely that he could have painted this portrait

during his brief passage through Savoy by train. More likely, perhaps inspired by the annexation of Savoy in 1860, or by its subsequent repercussions in Italy, Degas found his model in Paris, where Savoyards in their native dress had long been a familiar sight.[21] D. R.

1. Lemoisne 1946–49, no. 333, cites the article in the RISD *Bulletin* (see Rowe 1923) among his sources in which the painting is dated 1873. *La Savoisienne* was the second painting by a major Impressionist to be acquired by the Museum. The first, Renoir's *Young Woman Reading an Illustrated Journal* (22.125), acquired in 1922, is discussed elsewhere in this volume (see entry 60). At around the same time, the Museum also acquired Degas's *Grand Arabesque, Second Time* (23.315, entry 37), Rodin's *The Hand of God* (23.005, entry 68), and Corot's *Banks of a River Dominated in the Distance by Hills* (24.089, entry 17), in an apparent effort to expand its holdings of works by at least some of the great artists of the second half of the nineteenth century.

2. Of the approximately fifteen hundred paintings and pastels listed by Lemoisne, less than five percent are dated by Degas, and when he did inscribe dates, it was often much later, and sometimes inaccurately. See New York, MMA, 1988–89, pp. 20, 43.

3. Rowe 1923, p. 39.

4. Reff 1987, pp. 49–50.

5. Quoted by Manet in a letter to Fantin-Latour, cited in New York, MMA, 1988–89, p. 42.

6. Duranty 1876, translated in Washington, National Gallery, 1986, p. 44. Although Degas is not mentioned by name in this excerpt from Duranty's text, the author gave an annotated copy of his essay to the Italian critic Diego Martelli in which Duranty wrote Degas's name in the margin to indicate the object of these comments.

7. "Make of the *tête d'expression* a study of modern sentiment – Lavater, but a more relative Lavater . . . with accessory symbols Work a lot on night effects, lamp, candle, etc. The fun is in not always showing the source of light but rather the effect of light Make portraits of people in familiar and typical positions, above all, give their faces the same choice of expression one gives their bodies. Thus, if laughter is typical of a person, make him laugh" Degas Notebook 23, pp. 44–47 (1868–72), in Reff 1976, I, pp. 117–18, partially translated in Nochlin 1966, p. 62.

8. Duranty 1876 in Washington, National Gallery, 1986, p. 44.

9. At the Ecole des Beaux-Arts, where Degas studied briefly in 1855, he became a pupil of Louis Lamothe (1822–1869), who was a pupil of Hippolyte Flandrin (1809–1864), one of Ingres's most dedicated disciples. Degas remained dedicated to Lamothe, embracing his taste for the "well-executed work," throughout the 1850's. With Lamothe in the summer of 1855 he visited Flandrin in Lyons, assisting Flandrin with his frescoes for Saint-Martin-d'Ainay. Prior to his departure for Naples in 1856, Degas boasted that he had "already copied all the primitives in the Louvre," and Degas's father, who supported his son's ambitions to become a painter, exhorted him to emulate "those adorable fresco painters" of fifteenth- and sixteenth-century Italy. See Reff 1964, p. 250. Concerning Degas's place in the circle of Ingres and his followers, see New York, MMA, 1988–89, pp. 36–37 ff.

10. The following among these portraits, all dated between 1858 and 1859, may be cited: *Giovanna and Giulia Bellelli,* black chalk on paper, 11⅞″ × 9⅜″ (30.1 × 23.8 cm), Paris, Musée du Louvre (Orsay), Cabinet des dessins (R. F. 15483); *Giovanna Bellelli,* black chalk on paper, 12⅞″ × 9⅜″ (32.6 × 23.8 cm), Paris, Musée du Louvre (Orsay), Cabinet des dessins (R. F. 16585); *Giovanna and Giulia Bellelli at a Table,* oil on canvas, 27½″ × 23⅝″ (70 × 60 cm), Italy, private collection (Lemoisne 1946, II, no. 65); *Laura Bellelli*

and her two Daughters, watercolor, 16¹⁵⁄₁₆″ × 10⅞″ (43 × 27.5 cm), Paris, Musée du Louvre (Orsay), Cabinet des dessins (R. F. 23413); *Laura Bellelli,* pencil heightened with green pastel, 10¼″ × 8″ (26.1 × 20.4 cm), Paris, Musée du Louvre (Orsay), Cabinet des dessins (R. F. 11688); *Giovanna Bellelli,* black chalk on paper, 10¼″ × 8¼″ (26 × 21 cm), Algiers, Musée National des Beaux-Arts; *Giulia Bellelli,* black chalk, gray wash, and essence on paper, 9¼″ × 7¾″ (23.4 × 19.6 cm), Paris, Musée du Louvre (Orsay), Cabinet des dessins (R. F. 11689). For a comprehensive survey of Degas's portraits of the Bellelli family, see Finsen 1983. From Degas's notebooks, published in Reff 1976, see in particular Notebook 12 (August 1858–June 1859), pp. 7, 9, 12, 19 (a copy of Botticelli's *Young Man in a Capuche,* Florence, Pitti Palace, which displays a related interest in an ornamental head covering), 43, 60, 62–63.

11. Reff 1964, p. 250, cites over five hundred copies after Old Masters, the bulk of them created before 1861.

12. This drawing was subsequently attributed to Pontormo, and more recently to Bacchiacca; see Rearick 1964, p. 34. Degas also executed a drawing after this pseudo-Leonardo, *Portrait of a Young Woman* (pencil, 13¾″ × 10¼″, 35 × 26 cm, private collection), rendered in fine, fluid contours suggesting the influence of Ingres and lacking the chiaroscuro that distinguishes the original.

13. In personal correspondence with Theodore Reff, letter dated February 13, 1989, I proposed that *La Savoisienne* may be contemporary with the *Portrait of a Young Woman*. In a letter from Dr. Reff dated March 25, 1989, he replied (excerpted in part): "I'm inclined to agree with you about the dating of *La Savoisienne*. The comparison you make with Degas's painted copy after a Pontormo drawing . . . seems a very good one both in terms of style and of course of subject and composition, though one has to keep in mind Degas's different intentions in making a copy and making a portrait." In Reff 1964, p. 255, Degas's copy after the pseudo-Leonardo was dated ca. 1866. This dating has been revised to 1858–59. See New York, MMA, 1988–89, p. 76. I am very grateful to Dr. Reff for generously sharing his expertise with us.

14. Letter from Edgar Degas, Paris, April 26, 1859, to Gustave Moreau in Rome, published in Reff 1969, pp. 284–85. The inland route traveled by Degas was facilitated by the construction of the Victor Emmanuel Railway line linking Sardinia to Savoy and Savoy to points north in France, which had just been completed in 1858 as a part of Napoleon III's efforts to expand his influence to the south. In the spring of 1859, as Degas was heading north, this railway carried two hundred thousand French troops into Italy in response to the Austrian invasion of Piedmont. See Echard 1985, pp. 415–16.

15. Reff 1969, pp. 284–85.

16. Reff 1969, p. 284.

17. On the boat ride from Livorno to Genoa, Degas wrote that there were more than a hundred of Garibaldi's red-shirted volunteers, whose resolve very much impressed him; letter of April 26, 1859, in Reff 1969, pp. 284–85. Degas's notebooks of this period include a number of sketches of the advancing soldiers. See Reff 1976, Notebook 12, nos. 68–71, 84, 97. In his letter to Moreau, Degas writes: "The war will occur without a doubt. There will be absolutely no danger for you and your family to remain in Rome. Wait out events there for a while before going to Naples. The king [Ferdinand II, king of the Two Sicilies, 1810–59] is going to die soon, if he has not already. If there is a revolution, it will be brief and quiet." See also entry 56 for further discussion of these events.

18. New York, MMA, 1988–89, p. 86.

19. See *l'Illustration,* September 8, 1860.

20. For background on the Bellelli family and Degas's Italian relations generally, see Boggs 1963, pp. 273–74 ff., and Boggs 1955, p. 127.

21. I am grateful to Theodore Reff for this observation. For a comprehensive discussion of the widespread appearance of Savoyards in eighteenth-century art, see Munhall 1968.

EDGAR DEGAS (born Hilaire Germain Edgar De Gas)
French, 1834–1917

36 *Jockey, Red Cap*, ca. 1866–68

Estate stamp, lower right, in red: *Degas*
Oil on paper, mounted on cardboard, mounted on panel.
17³/₁₆″ × 12¹/₁₆″ (33.7 × 30.6 cm)
Gift of Mrs. Murray S. Danforth. 35.539

PROVENANCE: Degas Atelier, sale, 1919; Durand-Ruel, New York; Mrs. Murray S. Danforth.

EXHIBITIONS: Paris, Georges Petit, 1919, p. 30 (as *Jockey [casquette rouge]*, no. 40, ill.); New York, Wildenstein, 1949, no. 20; New York, Wildenstein, 1960, no. 19 (ill.); Edinburgh, National Gallery, 1979, no. 6 (ill.).

PUBLICATIONS: Lemoisne 1946–49, II, p. 128 (as *Jockey, Toque Rouge*, no. 264, ill. p. 129); Fowle 1964, p. 6 (fig. 4, p. 12).

RELATED WORK: *The Steeplechase*, 1866, reworked 1880–81, oil on canvas, 70⅞″ × 59⅞″ (180 × 152.1 cm), Upperville (Virginia), collection of Mr. and Mrs. Paul Mellon.

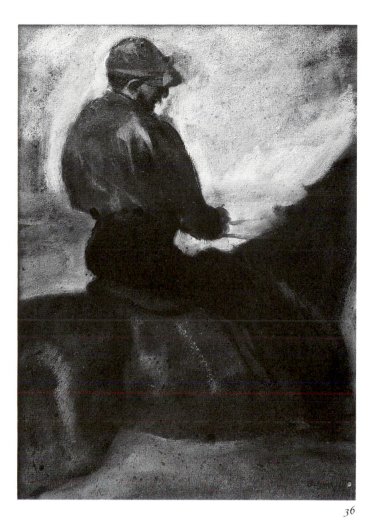

36

Between the early 1860's, when horses appeared in his history paintings, and 1900, when the subject had faded from his *oeuvre*, Edgar Degas made forty-five paintings, around two hundred and fifty drawings, and nearly two dozen pastels of equestrian and racing themes. It was in 1866 that he first submitted a racing subject, *The Wounded Jockey*, to the Salon.[1] The oil sketch, *Jockey, Red Cap*, was probably also executed around this time.[2]

Degas's interest in drawing horses was fueled by an appreciation of British sporting prints and by his visits to the Normandy estate of the Valpinçon family at Menil-Hubert, Orne. Like many of his contemporaries, Degas often relied on the works of other artists to inform his early depictions of horses. He copied the paintings of Meissonier and studied sources as diverse as Paolo Uccello, Benozzo Gozzoli, and Théodore Géricault, but it was in the green expanses of the Normandy countryside, and particularly at the nearby horse-breeding estate of Haras-le-Pin, that Degas gained firsthand experience of the landscape and subject matter of racing and hunt scenes. Easy access to British prints provided a natural reference at first, and, until he saw Eadweard Muybridge's *Animal Locomotion* photographs in the 1880's, he adopted from these the commonly held assumption that horses, when running, frequently have all four feet off the ground. His knowledge of figures, on the other hand, was based on observation, although he often used friends to simulate the poses of jockeys. Once captured in a sketch or drawing, the same figural studies were often reintroduced in successive paintings.

Preserved in Degas's studio, *Jockey, Red Cap*, an oil study in which the horse's head and legs are cropped, leaving only his muscular belly and flanks bearing the weight of the rider, became a versatile point of reference in later works. Seen in nearly three-quarter profile from the back, the tensed jockey, chin locked to his chest, arms tight to his sides, and right leg thrust forward as he reins in the horse, reappears with slight variations in a series of works over the next fifteen

years. In *Racecourse Scene*,[3] 1868, the jockey leans back to restrain his mount in a gallop; in *False Start*[4] of 1869–71, he is placed in more direct profile to restrain a horse in mid-air at the beginning of a race. In *Jockeys Before the Start*,[5] 1878–79, and in related drawings,[6] he slips behind another jockey, awaiting the call to the gate, and he appears again, reversed, in the flattened foreground of *Jockeys*,[7] ca. 1882.

Degas's repeated use of a single figure study, in combination with others and over an extended period, is particularly obvious in his horse paintings, which were clearly *genre*, or scenes of modern life, and not documents of individual races or events. For RISD's picture, as in about a dozen other oil studies of this period in which oiled paper or cardboard was used as a support, Degas used pigments suspended in a slow-drying oil binder known as *essence*.[8] With this medium he could prolong the flexibility of the sketch, permitting extended periods of manipulation and blending of colors. Patterns of light and shadow were often resolved and a more painterly surface achieved. Immediacy of effect, particularly appropriate to the subject of horse racing, was accomplished through this conscious selection of materials, as it would be in his monotypes of the 1870's.[9]

While not a horseman himself, Degas was a keen observer of the excitement, color, and social importance of the sport of racing. His ability to relay these sensations to canvas in an

incisive manner owes much to the attention he lavished on oil studies such as *Jockey, Red Cap,* and it is in this context that they may be seen as a key to the understanding of the construction of Degas's early horse paintings. M. C. O'B.

1. *The Steeplechase,* 1866, reworked 1880–81, oil on canvas, 70⅞″ × 59⅞″, Upperville (Virginia), collection of Mr. and Mrs. Paul Mellon.

2. The dating was narrowed to 1866–68 by Ronald Pickvance; see Edinburgh, National Gallery, 1979, p. 12 (no. 6). Pickvance also discusses the relationship of *Jockey, Red Cap* to the works cited in ns. 3, 5, 6, and 7.

3. *Racecourse Scene,* oil on panel, Montgomery, collection of Weil Brothers-Cotton, Inc.

4. *False Start,* 1869–71, oil on panel, 12⅝″ × 15⅞″, New Haven, Yale University Art Gallery.

5. *Jockeys Before the Start,* ca. 1878–79, oil, essence, with pastel on paper, Birmingham (Great Britain), University of Birmingham, Barber Institute of Fine Arts.

6. See *Group of Jockeys,* pencil on brown paper, New York, collection of Mr. and Mrs. Eugene V. Thaw (Edinburgh, National Gallery, 1979, p. 13, no. 9, ill.).

7. *Jockeys,* ca. 1882, oil on canvas, mounted on cardboard, New Haven, Yale University Art Gallery.

8. The "essential oils" (*essences*), generally expressed from flowers, leaves, woods, and other vegetable materials, were used by artists as additives to retard the initial drying of paints. They permitted the continuation of work on the next day, as well as extensive merging of colors into one another. Oil of cloves, which had a particularly slow rate of evaporation, was the essential oil most commonly used by nineteenth-century painters.

9. See Janis 1968, pp. xvii–xix, for a particularly insightful discussion of Degas's monotype techniques and his interest in prolonging the "flexible unfinished stage of the sketch."

EDGAR DEGAS (born Hilaire Germain Edgar De Gas) French, 1834–1917

37 *Grand Arabesque, Second Time,* ca. 1885–90

Signed, behind right foot: *Degas;* stamped, right base, beneath extended left foot: ⅕/ *CIRE/ PERDUE/ A. A. HEBRARD* Bronze. 16⅝″ × 23⅞″ × 10⅝″ (42.2 × 60.6 × 26.9 cm) Gift of Stephen O. Metcalf, George Pierce Metcalf, and Houghton P. Metcalf. 23.315

EXHIBITION: Providence, RISD, 1950.

PUBLICATIONS: Rowe 1923, pp. 38-39; RISD, *Bulletin,* 1924, p. 19; Rowe 1932, p. 19; Rewald 1944, pp. 23, 88-91 (ill.); Browse 1949, p. 389 (no. 157); Fowle 1964, pp. 4, 10-11 (fig. 3).

RELATED WORK: *Grand Arabesque, Second Time* (original wax model), brown wax, h. 19″ (48.3 cm), Upperville (Virginia), Collection of Mr. and Mrs. Paul Mellon.

Degas is estimated to have created several hundred sculptures throughout his lifetime, yet very little is known about them and their place in his work. His production of sculpture appears to have been a carefully guarded activity. He never cast any of his sculpture in bronze, only three were cast in plaster, and in his entire career he only exhibited one, *The Little Fourteen-Year-Old Dancer,* in the sixth Impressionist exhibition of 1881.[1]

Much of what is known about Degas's activities as a sculptor, therefore, is anecdotal, drawn from the recollections of friends who had the opportunity to visit his studio and to see him at work. Joseph Durand-Ruel, the artist's dealer, summarized what he knew about this body of Degas's work

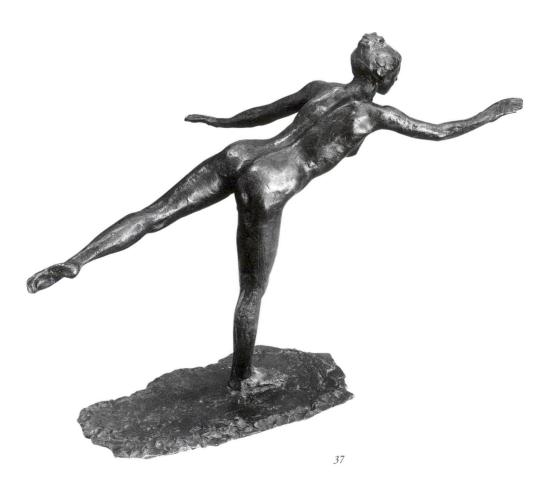

37

in a letter of 1919 to Royal Cortissoz, art critic for *The New York Tribune:*

> It is quite correct that Degas spent a good deal of time, not only in the later years of his life, but for the past thirty years, modelling in clay. Thus, as far as I can remember, that is to say perhaps forty years, whenever I called on Degas, I was almost as sure to find him modelling clay as painting. Degas must have made an enormous number of clay or wax figures, but as he never took care of them–he never put them in bronze–they always fell to pieces after a few years, and for that reason it is only the later ones that now exist.[2]

When Durand-Ruel made an inventory of Degas's studio after his death, he found about one hundred and fifty sculptures, almost all of them in wax, "scattered over his three floors in every possible place." Many of them were in an advanced state of decay. Of these, only seventy-three could be salvaged, and about half of these required some repair, which was overseen by a longtime friend of Degas, the sculptor Albert Bartholomé (1848–1928). Bartholomé engaged a uniquely gifted craftsman, Albino Palazzolo, director of the Hébrard Foundry, to supervise their casting in bronze, which occurred between 1919 and 1921. Palazzolo employed an unconventional technique that he learned in Milan from a sculptor named Barzagli, which allowed the fragile wax models to be preserved, while master bronzes served as the models for casting.[3] Seventy-two of the sculptures discovered by Durand-Ruel were cast at this time, each in an edition of twenty-two bronze examples. Each individual subject was given an arabic number by Hébrard (ours is numbered 15), and the multiple casts of each piece were numbered sequentially by letters from "a" to "t," with an additional two marked "her" for the heirs (ours is marked with the letter "i"). Sets of these sculptures were then exhibited at Hébrard's gallery in 1921 and at the Grolier Club in New York in 1922.[4] The RISD dancer, probably purchased through the latter exhibition, was given to the Museum in 1923.

When exactly Degas began modeling is unknown, as is the chronology of the work that survives. Paul-André Lemoisne, an early biographer and author of Degas's *catalogue raisonné,* suggests that Degas modeled from his very beginnings, and he quotes Bartholomé, who remembered Degas modeling a bas-relief in clay "very early, before 1870."[5] Around 1897 Degas commented to the journalist Thiébault-Sisson that he had been "making sculpture for more than thirty years. Not, it is true, on a regular basis, but from time to time, when it appealed to me or I needed to."[6] In his later years, when his eyesight began to fail, sculpture became Degas's principal, and eventually his unique, artistic activity.[7] He continued making sculpture until 1912, when he was forced to move his studio and gave up making art entirely.

On the basis of what little documentation does exist, efforts have been made to suggest a chronology of Degas's sculpture.[8] However, Degas was notoriously reluctant to ever consider his sculpture finished. In 1911 he complained to his friend Alexis Rouart, "I don't ever seem to get through with my confounded sculpture."[9] It was his habit to place work aside and return to it much later, making the precise dating of

his work problematic. Rewald places the Museum's dancer in the period 1882–95; Millard narrows these years, suggesting a date of 1885–90.[10] Both historians seem to have based their dating for this piece, and a group of related *Arabesques,* on a recollection by the painter Walter Sickert, who was shown the original wax *Grand Arabesque, Second Time* by Degas in his studio in the early 1890's, when Degas "turned the statuette slowly to show me the successive silhouettes thrown on a white sheet by the light of a candle"[11]

Sickert's observations throw some light not only on the approximate date of this sculpture, but also on Degas's techniques and his conception of the medium. Degas's experimental and improvisatory techniques were unconventional by any standard. Each of his sculptures was unique, of one size and material, and not the product of a succession of stages that progressed from small sketch to plaster model to a transformation into more durable material (typically bronze or marble). Lemoisne acknowledged that Degas was, in his words, "a deplorable practitioner."[12] He prepared his own waxes, and he would alter his armatures as he went along, with the result that his models would fall apart from the stress of constant modifications. Contrary to sculptural practice at that time, which was concerned with problems of stasis and permanence, Degas's sculpture was an exploration of movement, change, and constant improvisation. Lemoisne refers to Degas's "decomposition" of poses,[13] a view of the figure's arrested posture as a transitional moment, which, as Rewald observed, "is pregnant with the movement just completed and the one about to follow."[14] Degas may therefore have resisted preserving in bronze work which he conceived of as ongoing and which was predicated upon transition. According to Ambroise Vollard, he resisted casting his work, because "he could not take the responsibility of leaving anything behind him in bronze; that metal, he felt, was for eternity."[15]

Recent scholars, therefore, have criticized the Degas bronzes, particularly when seen in comparison to the original waxes that reappeared in 1955.[16] A proper understanding of these sculptures requires that the viewer be aware of the circumstances under which they were cast and their remove from the original models. However, any viewer who looks at any bronze sculpture should also understand that bronze casts are always many steps removed from the original model, which usually is destroyed in the process of casting. The gap between the original and the end product is intrinsic to the casting process itself, and no greater in the case of Degas's bronzes than for any other sculptor of the time who sent his works to the foundry. D.R.

1. Upperville (Virginia), Collection of Mr. and Mrs. Paul Mellon.
2. Cortissoz 1919, quoted in Millard 1976, p. 26.
3. Adhémar 1955, pp. 35 ff., notes that Degas met Palazzolo around 1910 and consulted with him often on technical matters related to his sculpture. Rewald 1944, p. 15, expressed the common assumption that Degas's original waxes were destroyed in the casting process, as is typically the case. In 1955, after they were discovered in Hébrard's basement, they were exhibited for the first time at the

Knoedler Gallery in New York (see New York, Knoedler, 1955). The original wax sculptures, including the model for the *Grand Arabesque, Second Time,* were acquired by Paul Mellon in 1956. The master bronzes were acquired by Norton Simon.

4. See Paris, Hébrard, 1921, and New York, Grolier, 1922.

5. Lemoisne 1919, p. 110. Cf. Reff 1970, p. 279, where it is argued that Bartholomé may not have known Degas before 1879.

6. Thiébault-Sisson 1921, quoted in New York, MMA, 1988–89, p. 137.

7. Vollard 1924, pp. 111–12, and Millard 1976, pp. 19–20.

8. Rewald 1944, pp. 15–16, suggested their division into three chronological groupings: 1865–81 (mostly horses), 1882–95 (mostly dancers), 1896–1912 (dancers and bathers). Millard 1976, pp. 6-8, modifies Rewald's chronology slightly, arguing in particular that Degas probably did not begin to make sculpture until the early to mid-1870s. Although Beaulieu 1969 equated sculptural poses with the representation of similar poses in Degas's datable paintings and pastels, this method is of limited usefulness in dating the sculptures, which Degas worked on erratically, often after long periods of neglect. It cannot even be determined with any certainty whether a motif existed first in two or three dimensions.

9. Quoted in Rewald 1944, p. 13.

10. Cf. Rewald 1944, p. 23, and Millard 1976, p. 24.

11. London, Leicester, 1923, p. 6. Other related arabesque sculptures (cited in Rewald 1944) include *Grand Arabesque, First Time* (R. XXXV), *Arabesque Over the Right Leg, Left Arm in Front* (R. XXXVII, R. XXXVIII), *Grand Arabesque, Third Time* (R. XXXIX, R. XL), *Arabesque Over the Right Leg, Right Hand Near the Ground, Left Arm Outstretched* (R. XLI), *Arabesque Over the Right Leg, Left Arm in Line* (R. XLII).

12. Lemoisne 1919, p. 113.

13. Lemoisne 1919, p. 112.

14. Rewald 1944, p. 11.

15. Vollard 1924, p. 112.

16. See in particular, Gary Tinterow, "A Note on Degas's Bronzes," in New York, MMA, 1988–89, pp. 609-10, and Failing 1988.

JEAN-BAPTISTE CARPEAUX
French, 1827–1875

38 *Head of the Virgin*
(for the group *Notre-Dame du Saint-Cordon*), 1864

Signed, left base: *Bte Carpeaux*; stamped behind signature, left base: CIRE/PERDUE/A. HEBRARD/2
Bronze. 13½″ × 8⅞″ × 9¾″ (34.3 × 22.7 × 24.8 cm)
Museum Appropriation. 31.005

EXHIBITIONS: Buffalo, Albright, 1932, no. 161 (pl. XXII); Providence, RISD, 1950.

RELATED WORKS: *Notre-Dame du Saint-Cordon*, 1864, charcoal and gouache, 20″ × 13¾″ (50.8 × 35 cm), Valenciennes, Musée des Beaux-Arts. *Notre-Dame du Saint-Cordon*, terra cotta, h. 13¾″ (35 cm), Paris, Musée d'Orsay (R. F. 821). *Notre-Dame du Saint-Cordon*, plaster maquette, h. 68½″ (174 cm), Paris, Musée d'Orsay (R. F. 819). *Head of the Virgin*, plaster, h. 13¾″ (35 cm), Paris, Musée du Petit Palais (P. P. S. 1553). Other Hébrard casts can be found in Nice, Musée des Beaux-Arts Jules Chéret; Washington, D. C., Hirshhorn Museum; Williamstown, Sterling and Francine Clark Art Institute.

39 *Crouching Woman,* ca. 1870

Stamped in red wax, back of base: VENTE CARPEAUX
Terra cotta. 3⅛″ × 3½″ × 3⅛″ (7.9 × 8.9 × 7.9 cm)
Membership Dues. 70.105

PROVENANCE: B. G. Verte, Paris.

40 *Hope,* 1874

Signed and dated, right base: *JB.ᵀ Carpeaux. 1874.*; stamped, right base: PROPRIETE/CARPEAUX, lettering around eagle image; oval studio stamp, left base: ATELIER DEPOT/71 RUE BOILEAU/AUTEUIL PARIS.
Terra cotta. 22″ × 14″ × 10″ (55.9 × 35.5 × 25.4 cm)
Helen M. Danforth Fund. 1989.004

PROVENANCE: Shepherd Gallery, New York.

EXHIBITIONS: New York, Shepherd, 1988, no. 12; Williamstown, Clark, 1989, p. 21 (no. 10).

PUBLICATION: Rosenfeld 1989, p. 35 (ill.).

RELATED WORKS: *Prayer*, plaster, h. 23⅝″ (60 cm), Paris, Musée du Petit Palais. *Hope*, terra cotta, h. 22″ (56 cm), Valenciennes, Musée des Beaux-Arts. *Hope*, plaster, h. 23⅝″ (60 cm), Copenhagen, Ny Carlsberg Glyptotek. *Hope*, cast iron, h. 17¾″ (45 cm), Compiègne, Musée National du Château.

41 *Bathers,* ca. 1870

Signed, lower right: *JB Carpeaux* (perhaps added later)
Oil on canvas. 18⅛″ × 24¼″ (46.3 × 61.7 cm)
Mary B. Jackson Fund. Purchased in memory of L. Earle Rowe. 53.350

PROVENANCE: Collection of the Duc de Trévise, Paris, until 1938.[1]

EXHIBITION: Chapel Hill, Ackland, 1978, p. 21 (no. 6).

PUBLICATIONS: Maxon 1954, pp. 4–5 (ill.); Hanson 1977, p. 153, n. 103.

RELATED WORK: *Flora*, 1870, oil on canvas, 24³⁄₁₆″ × 19⁹⁄₁₆″ (61.5 × 50 cm), Valenciennes, Musée des Beaux-Arts.

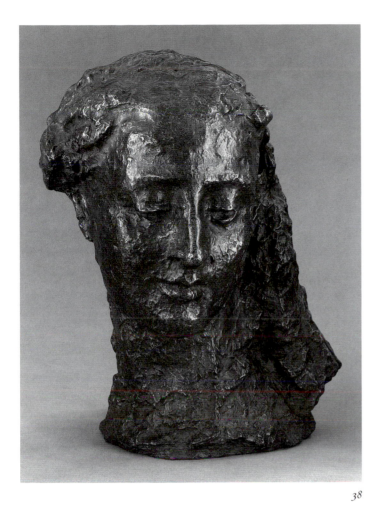

38

Carpeaux was born the son of a stonemason in the northern city of Valenciennes. He studied at the Ecole des Beaux-Arts in Paris, first as a pupil of François Rude and then, when he thought it would improve his chances to win the Prix de Rome, with Francisque Duret. He won the Prix in 1854 and studied in Rome between 1856 and 1862, remaining aloof from the academic routines followed at the Villa Medici, where the French *pensionnaires* lived and worked. The major product of his Roman sojourn, the monumental group *Ugolino and His Sons,* representing one of the most harrowing episodes from Dante's *Inferno,* was exhibited in the Ecole des Beaux-Arts in 1862, and again in the Salon of 1863. In the Salon, it was awarded a First Class Medal, despite the hostile criticism of academicians who disputed the work's lack of idealization and "calm grandeur."

The favorable official response to this work, which was acquired by the French government in spite of conservative opposition from the Ecole, set the pattern for the success and controversy of Carpeaux's career, which was rich with official commissions and rear-guard denunciations. He was named a tutor to the son of Napoleon III (for which he was given a studio in the Orangerie), and he received numerous portrait commissions from the ruling family and their entourage. In 1863 he was commissioned to execute groups of *Flora* and *Imperial France Protecting Science and Architecture* for the façade of the Pavillon de Flore of the Louvre; in 1864 he received a commission for the group called *Temperance* for the

Church of La Trinité; in 1865 the architect Charles Garnier, who was building the new Paris Opéra, commissioned Carpeaux to execute a group representing *The Genius of the Dance* for its façade, which was unveiled amid an unprecedented flurry of hostile public criticism in 1869; and in 1867 he was commissioned to execute *The Four Corners of the Earth Supporting the Celestial Globe* for the Fountain of the Observatory at the far corner of the Luxembourg Gardens. This abundance of monumental commissions produced many offspring, smaller in size and designed for private homes. In 1866 Carpeaux established an atelier in Paris to facilitate the production of this body of his work (in 1868 it was moved to Auteuil on the outskirts of Paris), in which adaptations of his monumental figures were transformed into a variety of materials and sizes and offered for sale.

The *Head of the Virgin* acquired by the Museum in 1931 is one such example of a sculpture derived from a monumental prototype, an unrealized project for a religious group representing the Virgin, Christ Child, and St. John the Baptist, called *Notre-Dame du Saint-Cordon* (literally, "Our Lady of the Blessed Cordon"), created by Carpeaux around 1864. In May of that year, Carpeaux returned to his native city of Valenciennes from Paris to participate in the inauguration of the church of Notre-Dame du Saint-Cordon, named to commemorate a miracle that, according to legend, took place in that city on Christmas day in 1008, when the Virgin Mary appeared to deliver the city from the plague, placing it under her protection by cordoning it off with a ribbon. Carpeaux provided a drawing for this occasion that was to be auctioned for the benefit of the church (fig. 1). It represents the Virgin in her role as protectress of Valenciennes, seated above the clouds on the *orbus mundi*. The medieval skyline of Valenciennes appears below her. She holds the Christ

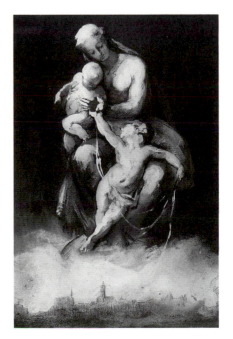

Fig. 1 Jean-Baptiste Carpeaux, *Notre-Dame du Saint-Cordon,* 1864, charcoal and gouache, 20″ × 13¾″ (50.8 × 35 cm), Valenciennes, Musée des Beaux-Arts. Photograph by Photo-Ciné Hauchard.

child in her arms, who reaches down to hand the mystical cordon to St. John the Baptist, standing at their feet.[2]

It is not clear what may have impelled Carpeaux to develop this drawing into a life-size three-dimensional group. Although there is no evidence that a formal commission was ever discussed, it is possible that he may have hoped to catalyze a commission when the drawing was presented.[3] Probably not long after the inauguration of the Church of Notre-Dame du Saint-Cordon, Carpeaux executed a large-scale plaster maquette of this group (Paris, Musée d'Orsay, R.F. 819), from which the Museum's head was taken. The commission was never developed further and never installed in Valenciennes or anywhere else. The composition appears to have been inspired by Michelangelo's *Medici Madonna,* from which Carpeaux had executed a drawing while in Florence two years earlier.[4]

Notre-Dame du Saint-Cordon is frequently confused with another religious sculpture by Carpeaux called *Temperance,* commissioned for the Church of La Trinité in Paris and completed in June 1864, at the same time that Carpeaux would have created the maquette from which the Museum's head has been taken. Appropriate to its subject, the final version

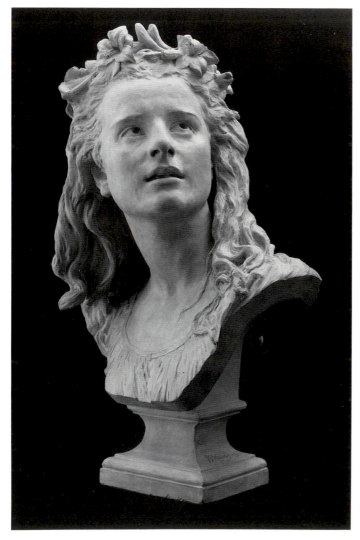

40

of *Temperance* is one of Carpeaux's most formally restrained sculptures, the antithesis of the dynamic composition conceived for *Notre-Dame du Saint-Cordon.* As the two would have been exactly contemporary, one is tempted to find in the latter some effort to redress the constraints that were required of *Temperance* and which ran counter to Carpeaux's inclinations as a sculptor.[5] Even in its isolation from the larger ensemble, the *Head of the Virgin* reflects the qualities of movement that distinguish Carpeaux's sculpture generally, achieved by the Virgin's downward gaze and the asymmetry of the composition, as well as by the vivid manipulation of the surface, modeled from small pellets of clay. The looseness of facture and the resulting play of light and shadow seem more closely related to the burgeoning Naturalist style in painting of the period than to the waning yet tenacious Neoclassical taste that continued to dominate monumental sculpture of the period. The attractive model with high cheekbones, aquiline nose, small mouth, and elongated facial proportions seems more like the representation of a contemporary young woman than an idealization of the Virgin.

Carpeaux created the first models for *Hope* (entry 40) around 1867, at the same time that he had begun to work on his ebullient group for the Opéra façade.[6] The creation of the first version of *Hope* follows the establishment of the sculptor's atelier in Paris in 1866, where he reproduced many of his original designs in editions for sale.[7] His original study from which *Hope* is derived, called *The Prayer* (Paris, Musée du Petit Palais), was a project for an unrealized statue of Joan of Arc, representing a half-length figure turning towards her left, her hair in braids, her hands joined in a gesture of prayer.[8] By removing the arms and the lower bust, modifying the sitter's hair to flow freely over her shoulders, and crowning the figure with a wreath of lilies, Carpeaux transformed a saintly, historical subject into a decorative bust whose meaning is communicated by the figure's dramatic upward glance, independent of a specific historical identity.

Along with Faith and Charity, Hope is one of the three Christian virtues. Personifications of Hope are familiar in Gothic religious sculpture, where she is shown gazing towards heaven, reaching for a crown. In Ripa's *Iconologia,* the Baroque lexicon of allegorical personifications, she is represented in a gesture of prayer, looking towards heaven, a wreath of flowers in her hair symbolic of Hope's promise.[9] It is probable that the features of this beautiful model were inspired by Amélie de Montfort, then a young girl of twenty years, whom Carpeaux was to marry in 1869.[10] This would therefore be the sculptor's first bust of Mlle de Montfort, who is also the subject of the portrait called *La Fiancée* in the Musée d'Orsay, modeled by Carpeaux in the year of their marriage.

Carpeaux took a great interest in the techniques employed for the reproduction of his work in terra cotta. He developed a special clay whose composition was pigmented according to a carefully guarded formula designed to simulate the warmth of flesh and which minimized shrinkage when fired.[11] This bust, dated 1874, was produced at a time when Carpeaux

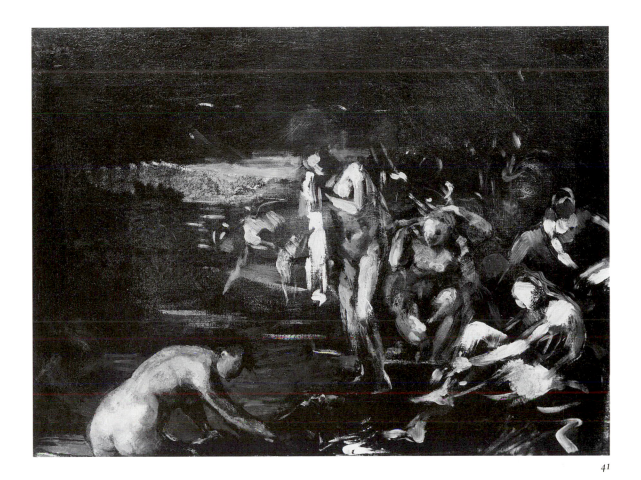

was actively engaged in the fabrication of ambitious, monu-
mental terra-cotta reproductions of *The Dance* and *Ugolino,*
virtuoso achievements in this material that are now in Copen-
hagen. The Auteuil studio had been managed by Carpeaux's
brother Emile until 1873, when he was dismissed because of
his mishandling of the sculptor's affairs, forcing Carpeaux
to reorganize his studio and take a more active role in its
technical procedures. *Hope*'s richly worked surface, enlivened
by its many traces of the sculptor's fingerprints, confirms
that once it had been removed from the mold it was care-
fully reworked, communicating the qualities of freshness
and intimacy that are particular to clay and that characterize
Carpeaux's predilection for this material.[12]

Parallel to his public career as a sculptor, Carpeaux also
produced a large body of private work as a painter. Many of
these compositions, such as the Museum's *Bathers* (entry 41),
reinterpret motifs popular in old master painting, while
others characteristically represent scenes of modern life,
focusing in particular on events surrounding the court of
Napoleon III. The earliest of Carpeaux's paintings date as
far back as 1848, although the majority appear to have been
created during the last decade of his life.[13] As is the case with
most of his paintings, the *Bathers* is not dated, although it
seems to be related to a painting of *Flora* (fig. 2) dated 1870,
which was adapted from Carpeaux's group from the Pavillon
de Flore, situated on the façade of the Louvre facing the Pont
Royal.[14] *Flora* represents a kneeling figure, her arms placed
above her head in a pose designed to create a decorative

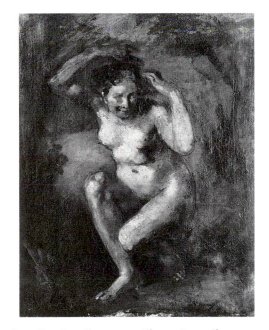

Fig. 2 Jean-Baptiste Carpeaux, *Flora,* 1870, oil on canvas, 24³⁄₁₆″
× 19⁹⁄₁₆″ (61.5 × 50 cm), Valenciennes, Musée des Beaux-Arts. Pho-
tograph by Photographie Giraudon.

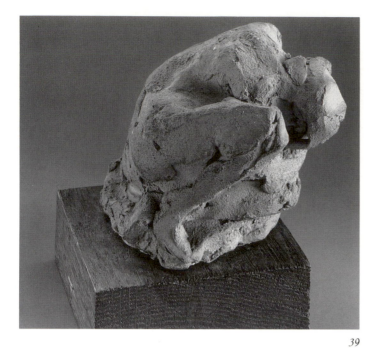

39

arabesque exposed by the contour of her torso. A paraphrase of this same figure, her posture reversed, can be found in the middle of the group of bathers standing on the riverbank to the right in the Museum's picture.

The style of the *Bathers,* created as an *"ébauche,"* or painted sketch, is typical of the loose, "unfinished" style of Carpeaux's paintings. Characteristically, the *Bathers* was conceived as an autonomous work, not as a study for a more finished painting or for a sculptural group. Individual figures are modeled in grisaille, placing light strokes against a dark ground, giving a mysterious, dreamlike mood to the scene. Carpeaux's approach to the figures is sculptural: his emphasis is on their structure, seen in terms of light and dark. Individual figures are represented with various degrees of finish. The bather reaching down into the water at the lower left, for example, is modeled with relative solidity, whereas the figure above her in the middle ground, in a complementary pose, is defined by a few summary strokes. The pose of these figures may have been inspired by the bather in Manet's *Luncheon in the Grass,* which was exhibited in the Salon des Refusés of 1863 and again in Manet's one-man exhibition at the Pont de l'Alma in 1867.[15] The very personal nature of Carpeaux's style of painting (which was for him a private medium) and his lack of concern for norms of finish reflect his independence from the academic standards by which he was trained, linking him to avant-garde tendencies in painting of the time.

Carpeaux's manner of applying broad brushstrokes that define the volume of his figures through the dramatic contrast of light and shade has been compared to his modeling technique in his small three-dimensional sketches *(esquisses),* in which pellets of clay are spread in broad, flat planes.[16] One such example is the terra-cotta *Crouching Woman* (entry 39). This figure has a solid core, indicating that it was modeled by the artist from a mass of clay worked directly in his

hands, unlike *Hope,* which is a hollow moulage, the result of a casting process. The *Crouching Woman* is a product of Carpeaux's habit of sketching in three dimensions, modeling flat planes that define the structure of the figure. It also reveals the sculptor's preoccupation with light and movement in every manifestation of his work. This preoccupation was the source of his artistic inspiration, providing the common denominator that links his painting to his sculpture. D. R.

1. Paris, Charpentier, 1938, no. 19.
2. The drawing was acquired by Carpeaux's friend, J.-G. Foucart, who had an engraving made of it by Léopold Flameng. See Clément-Carpeaux 1934, I, p. 163.
3. Clément-Carpeaux 1934, I, p. 163, suggests only that Carpeaux was encouraged by unnamed citizens of Valenciennes (presumably Foucart among them) to pursue this project.
4. This influence was first suggested in Paris, Grand Palais, 1983–84, no. 343. The drawing, charcoal on grey paper, (14.1 × 9.5 cm), is in Paris, Musée du Louvre, Cabinet des dessins (R. F. 1237), and is reproduced in Paris, Grand Palais, 1975, no. 109. It is inscribed "d'après Michel-Ange 14 avril 62."
5. See Hardy 1978, no. 127. For examples of the *Head of the Virgin* from *Notre-Dame du Saint-Cordon* by the title *La Tempérance,* see Paris, Petit Palais, 1953, no. 134 (pl. 7); Paris, Petit Palais, 1955–56, no. 93; and Nice, Chéret, 1986, no. 65. Carpeaux had difficulties with this commission, for which an early maquette was rejected because it was considered "picturesque [and] does not fulfill the conditions of monumental sculpture," as noted in a report of the commission created to evaluate work for La Trinité, quoted in Wagner 1986, p. 217.
6. See Clément-Carpeaux 1934, I, p. 209. According to Copenhagen 1936, no. 580, Carpeaux exhibited a plaster version of *Hope* in 1867, the date proposed by Clément-Carpeaux. A marble version of *Hope,* signed and dated 1869, was sold in Carpeaux's studio sale of December 20, 1873. See Lami 1910, I, p. 269, and Hardy 1978, p. 75 (no. 159). According to Wagner 1986, p. 183, undated correspondence from the mid-1860's from Carpeaux to M. Rainbeaux in the Bibliothèque Municipale of Valenciennes refers in passing to a casting of *Hope.*
7. Chesneau 1880, p. 277, in his inventory of terra-cotta busts in Carpeaux's studio at the time of his death, lists only one version of *Hope.* The following versions were included in the various public sales of Carpeaux's sculpture during his lifetime: March 21, 1872 (no. 78, listed as *"buste,"* medium and size not specified); April 29, 1873 (terra cotta, h. 65 cm; and marble, h. 60 cm); December 20, 1873 (marble, h. 57 cm, signed and dated 1869; and terra cotta, h. 57 cm); January 19, 1874 (terra cotta, h. 60 cm); May 23, 1874 (marble, h. 67 cm; and terra cotta, h. 65 cm); December 28, 1874 (terra cotta, h. 58 cm).
8. A version from Carpeaux's estate was offered at auction in his studio sale of 1913. See Paris, Manzi, 1913, no. 33.
9. "... the promise hope holds out to us, just as flowers are the promise of the rich harvest of the summer. The woman looks up to the heavenly light in prayer and ecstasy, for it is the source of all hope, and the goal of all truly lofty hopes." Ripa 1971, no. 175. In the Neoclassical period the subject was adapted to secular allegories of Hope, as in John Francis Rigaud's *Hope Nourishing the Love of Glory,* painted in Rome in 1769 (location unknown, see Monaco, Sotheby's, 1989, no. 351).
10. Calais, Beaux-Arts, 1982, no. 40.
11. Theunissen 1912, pp. 827–30.
12. For a full account of Carpeaux's employment of his brother Emile and the reorganization of his atelier in 1873, see Clément-Carpeaux 1934, I, pp. 347–48, 374–76. The author notes that Carpeaux hired two trusted assistants, Pascal and Lacave, who had

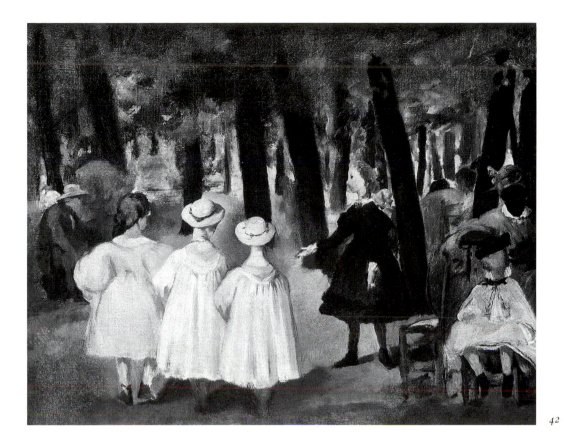

42

worked with him previously over many years, to assist with the execution of his terra cottas, and she observes (p. 376): "[Carpeaux] always loved this supple material, with its warm color, which is vibrant in the light, and which allowed him an interpretation of his work that was direct and personal."

13. Jamot 1908, p. 188. An accomplished *View of the Tiber River,* oil on canvas, Paris, Musée du Petit Palais, painted in Rome between 1856–62, suggests Carpeaux's affinity in his earliest work with Naturalist painting of the period, in particular by Corot.

14. Hardy 1978, p. 27 (no. 30).

15. Jamot 1908, p. 194, placed great emphasis on the affinites between the paintings of Carpeaux and Manet, noting their shared "modernity . . . love of reality and instinct for style."

16. Jamot 1908, pp. 188–89.

EDOUARD MANET
French, 1832–1883

42 *Children in the Tuileries Gardens,* ca. 1861–62

Oil on canvas. 14¹³/₁₆″ × 18⅛″ (37.6 × 46 cm)
Museum Appropriation. 42.190

PROVENANCE: Estate of the artist (listed as no. 79 in the studio inventory, "*Petites filles aux Tuileries,* primitif," for an estimated value of 50 francs);[1] Durand-Ruel, Paris; Macomber Collection, Boston, by 1912 or 1913;[2] Knoedler & Co., New York, 1942.

EXHIBITIONS: New York, Durand-Ruel, 1913, no. 2; Providence, RISD, 1942, no. 34; New York, CCFRS, 1943, no. 11 (ill.); Richmond, Fine Arts, 1944, p. 10 (no. 13); Worcester, Art Museum, 1946, p. 15; New York, Wildenstein, 1948, pp. 42, 43, 51 (no. 6, ill.); Montreal, Fine Arts, 1950, no. 24; Detroit, DIA, 1954, p. 15 (no. 16); Tokyo, Isetan, 1986, pp. 40, 152-53 (no. 6, ill.).

PUBLICATIONS: Proust 1897, pp. 132, 170; Duret 1902, p. 195 (no. 17); Moreau-Nélaton, n.d., no. 32; Meier-Graefe 1912, p. 111 (fig. 57); Proust 1913, p. 39; Duret 1919, no. 17; Tabarant 1931, p. 54 (no. 29); Jamot and Wildenstein 1932, I, p. 118 (no. 35), and II, fig. 364; *Art News* 1943, p. 6 (ill.); RISD, *Museum Notes,* January 1943, n.p. (ill.); Tabarant 1947, pp. 39, 534, 603 (no. 34, ill.); Sandblad 1954, pp. 19, 29 (fig. 6); Orienti 1967, p. 89 (no. 31); Fried 1969, pp. 70-71 (no. 69); Hanson 1977, pp. 67 (n. 77), 99; Paris, Grand Palais, 1983, p. 123; London, National Gallery, 1983, p. 16; Bareau 1984, p. 757 (fig. 13).

CONSERVATION: A synthetic varnish was applied to the surface in 1985 at the Williamstown Regional Art Conservation Laboratory. X-ray photographs of the painting were taken at this time.

RELATED WORK: *Music in the Tuileries Gardens,* 1862, oil on canvas, 30″ × 46½″ (76 × 118 cm), London, Trustees of the National Gallery.

In his earliest representations of contemporary life in Paris, dating from the early 1860's, Manet painted views both of bohemian culture (for example, *The Street Singer,* 1862, Boston, Museum of Fine Arts) and of middle-class urban leisure, of which *Music in the Tuileries Gardens* (fig. 1) is the first and most important example. Whereas the former acknowledged Manet's debt to mid-century Realism, the latter, concentrating on the diversions of the wealthy middle class of the Second Empire, was strongly influenced by the art criticism of his friend Charles Baudelaire and provided fertile ground for the emergence of Impressionism and its pursuit of *la vie moderne.* In both subject and style, *Music in the Tuileries* embodied the belief–expressed by Baudelaire in *The Painter of Modern Life* and stressed repeatedly in his earlier criticism–that beauty should be extracted from the "circumstantial elements" of modern life, "its fashions, its morals, its emotions."[3] *Music in the Tuileries* addressed this challenge by presenting a monumental view of the ephemeral amusements enjoyed by the contemporary *beau monde.* He combined these for the first time with plein-air techniques that had been practiced by the Naturalists, particularly Corot, Rousseau, and Daubigny. For his vision of *la vie moderne,* Manet drew from a variety of historical influences ranging from Velázquez to eighteenth-century popular prints, adapted in a style that conveyed the transience of modern life, its fashions and customs.

Music in the Tuileries, despite its setting and informality of style, was a studio picture derived at least in part from individual figure studies, as well as from sketches executed in the open air. Antonin Proust observed that in the early 1860's Manet

> ... went almost every day to the Tuileries between two and four o'clock, creating studies in plein air, under the trees, representing the children that played and the groups of nursemaids

that lounged in the chairs. Baudelaire was his customary companion. Strollers regarded with curiosity the elegantly attired painter who set up his canvas, armed with his palette, and painted with as much tranquility as if he had been in his studio.[4]

In the evening, Proust recalls, Manet would bring these sketches to the café Tortoni, where they were passed around and much admired by Manet's companions, a number of whom were ultimately to be portrayed in the large canvas. *Children in the Tuileries Gardens* appears to be one such sketch as Proust describes, perhaps the only known painted example, and one of the earliest plein-air paintings by Manet.[5]

Although the Museum's canvas is clearly related to *Music in the Tuileries* in its setting and conception, none of its figures was included in the larger canvas, which contains a good number of contemporary portraits.[6] In the RISD canvas, the Negro nursemaid is the only identifiable figure, having been painted after a model named Laure, who also posed as the servant in Manet's *Olympia* (1863, Paris, Musée d'Orsay, Galeries du Jeu de Paume).[7] The hoop that she holds is the only detail to find a place in the large canvas, abandoned beside an empty metal chair in the lower right corner. The chairs in the RISD painting have created some doubts about the setting. Tabarant maintains that the chairs represented in Manet's sketch (wood, with a straw seat) had by that time been replaced in the Tuileries by fashionably modern neo-Rococo wrought-iron chairs such as those in the foreground of *Music in the Tuileries.* Sandblad, on the other hand, has shown that the wooden chairs were still in common use, as they can be seen in a xylograph from *L'Illustration* of 1858.[8] The same wooden chairs are also prominent in Philibert-Louis Debucourt's colored aquatint *La Promenade publique* (1792), a probable source for *Music in the Tuileries,* which represents the fashions and amusements of the Parisian upper classes of the Directoire at their leisure in a public garden (also possibly the Tuileries).[9] The wooden chairs may indeed deliberately recall Debucourt's famous print, acknowledging the eighteenth-century flavor of Manet's theme, much as the

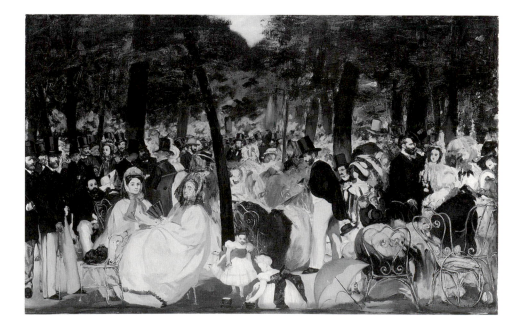

Fig. 1 Edouard Manet, *Music in the Tuileries Gardens,* 1862, oil on canvas, 30″ × 46½″ (76 × 118 cm), London, Trustees of the National Gallery.

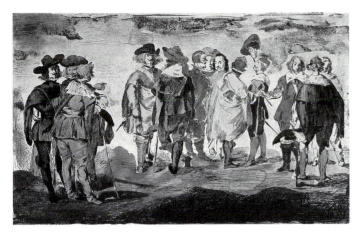

Fig. 2 Edouard Manet, *Les Petits Cavaliers,* hand-colored etching, 9⅝″ × 15⅜″ (24.5 × 39.1 cm), Boston, Museum of Fine Arts.

The large painting also echoes the pattern of tree trunks represented in the sketch.

Manet's adaptations of past art were inspired by his wish to create paintings in a modern genre that could rival the substance and monumentality of old master painting, which he paraphrased knowingly and with a keen sense of style. The Tuileries paintings introduce plein-air techniques – as they had been practiced, in particular, by Corot, Rousseau, and Daubigny – into the equation. Like these Naturalist painters, Manet tried to preserve the spontaneity and light of his plein-air sketches in a larger studio picture. In combining these techniques with his urbane view of *la vie moderne,* Manet claimed his preeminence in the invention of the urban Impressionist landscape. D.R.

wrought-iron neo-Rococo chairs in *Music in the Tuileries* contribute a touch of irony to the picture's modernity.

Although no specific figures from the RISD canvas are included in *Music in the Tuileries,* they can be related to other works created by Manet at the time, reflecting larger influences on his work. It has been suggested, on the basis of posture, that the young girl in the yellow dress sitting in front of Laure was inspired by a seated portrait of *Ambroise Adam in the Garden at Pressagny* (1861, private collection).[10] The children, who have not been identified as individual portraits, appear to have been adapted from a painting in the Louvre called *The Little Cavaliers,* attributed at the time to Velázquez. Manet made a copy of this sketch around 1856, and then etched it in three states between 1861 and 1862 (fig. 2).[11] The girl in the black dress with her right hand extended resembles the figure to the right in *The Little Cavaliers* with his right arm similarly extended. The unconventional rear view of the three girls left of center may also have been adapted from the two figures represented in the etching after Velázquez. Although Velázquez's influence on *Children in the Tuileries Gardens* is demonstrable, Manet's painting, listed in his studio inventory as a *"primitif,"* reflects a concurrent and conflicting interest in Italian primitive painting, its simplified, wooden forms and shallow, frontal space.[12] Of equal importance, finally, were the popular drawings and prints representing an urbane leisure class to which Manet was attracted – work by Debucourt and Saint-Aubin from the eighteenth century, Gavarni and Guys from the more recent past – which were casual in style, sophisticated and fashionable.

Although *Children in the Tuileries* reveals many of the same artistic influences adapted by Manet in *Music in the Tuileries,* it is most closely related to the larger painting in its naturalistic detail, which was based, as Antonin Proust tells us, on the direct observation of nature. The freely brushed foliage covering the upper third of the large studio painting was almost certainly adapted from plein-air sketches such as the RISD canvas. The leaves – given equal prominence in the RISD sketch – are rendered in viscous, highly saturated strokes that convey the sensation of light dappled through the trees.[13]

1. Jamot and Wildenstein 1932, 1, p. 118.

2. Meier-Graefe 1912, p. 111, lists painting in "Coll. MaComber [sic]." Tabarant 1947, p. 39, indicates that it was acquired by Macomber after its exhibiton at Durand-Ruel.

3. Baudelaire 1965, p. 3. *Le Peintre de la vie moderne* was begun in 1859 and completed by 1860, published in 1863, and probably known by Manet before its publication. See Hanson 1977, pp. 18 ff.

4. Proust 1897, pp. 170-71; cf. Proust 1913, p. 39. Sandblad 1954, p. 29, suggests that Proust's comments refer specifically to the RISD canvas.

5. For other related works on paper, see Tabarant 1947, no. 553, and Paris, Grand Palais, 1983, no. 39, *Corner of the Tuileries,* 1862?, India ink wash, 7⅛″ × 4⅜″ (18 × 11.2 cm), Paris, Bibliothèque Nationale; and *Study for "Music in the Tuileries,"* watercolor, ex collection Rouart, reproduced in Sandblad 1954, fig. 8, and Paris, Grand Palais, 1983, p. 122. Additionally, three sketchbook pages with figure studies in either pencil or black crayon are in the Cabinet des dessins of the Louvre, reproduced in London, National Gallery, 1983, p. 18.

6. See Tabarant 1947, p. 38.

7. Hanson 1977, p. 99. Hanson (pl. 73) also reproduces a portrait of Laure by Manet in a private Swiss collection. Tabarant 1947, p. 79, notes the annotation "Laure, very beautiful negress," next to an address in a notebook of 1862, possibly allowing for a more precise dating of the RISD canvas.

8. Cf. Tabarant 1931, p. 54, and Sandblad 1954, p. 21, n. 3, and fig. 1.

9. Sandblad 1954, pp. 36-37.

10. Bareau 1984, p. 757. It is equally possible that the Adam portrait, representing an elderly relation of Manet's in a wide-brimmed straw hat, inspired his rendering of the straw-hatted gentleman shown in profile at the far left of the Museum's canvas.

11. Sandblad 1954, pp. 37-39; Paris, Grand Palais, 1983, p. 126. A reproduction of this painting was published by Charles Blanc in his influential *Histoire des peintres (Ecole espagnole,* 1869). Sandblad has also shown that the self-portrait of Manet inserted at the far left of *Music in the Tuileries* was adapted from the figure in *The Little Cavaliers* in the same pose and relative position. Manet's prototype, who stares at the viewer, wearing a distinctive wide-brimmed hat, was at the time believed to have been a self-portrait of Velázquez.

12. Tokyo, Isetan, 1986, p. 153.

13. X-ray photographs taken in 1985 reveal no drawing or painting concealed beneath the finished surface. The paint surface is thin, suggesting that this was a spontaneous sketch, very possibly completed in a single sitting.

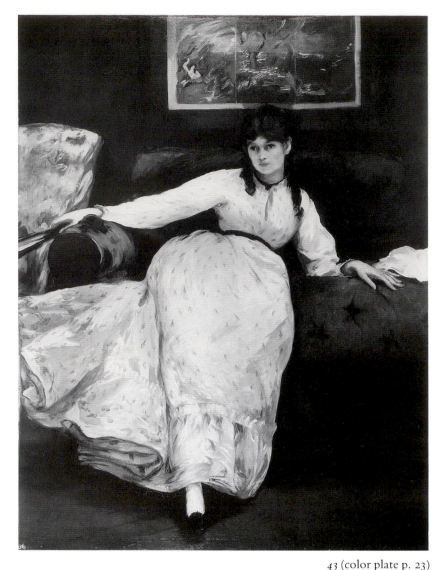

43 (color plate p. 23)

EDOUARD MANET
French, 1832–1883

43 Le Repos, ca. 1870–71

Signed, lower right corner of framed print: *Manet*
Oil on canvas. 59⅛″ × 44⅞″ (150.2 × 114 cm)
Bequest of Mrs. Edith Stuyvesant Vanderbilt Gerry. 59.027

PROVENANCE: Purchased from the artist by dealer Paul Durand-Ruel for 3000 francs in 1872; by exchange to Théodore Duret in 1880; Galerie Georges Petit, Paris, Duret sale, March 19, 1894, no. 19, from which purchased by Jean-Baptiste Faure for 11,000 francs; repurchased by Durand-Ruel, who exhibited it in his New York gallery in 1895; purchased by George Vanderbilt in 1898; by bequest to his widow, who, as Mrs. Edith Stuyvesant Vanderbilt Gerry, bequeathed it to the Museum in 1959.

EXHIBITIONS: Paris, Salon de 1873, no. 998; Paris, Ecole des Beaux-Arts, 1884, no. 57; Paris, Georges Petit, 1894, no. 19; New York, Durand-Ruel, 1895, no. 1; Philadelphia, PMA, 1966, pp. 122-23 (no. 106); Paris, Grand Palais, 1983, pp. 315-18 (no. 121); Washington, National Gallery, 1987; New York, IBM, 1988.

PUBLICATIONS: Bertall 1873; Cham, "Le Salon pour rire," 1873; Cham, "Réfusés," 1873; Francion 1873, p. 406; Mantz 1873; Bazire 1884, p. 78; Moore 1893, pp. 43-44; Meier-Graefe 1899, p. 59 (ill.); Duret 1902, pp. 81, 84-85 (ill.); Meier-Graefe 1904, frontispiece; Mauclair 1908, p. 477 (ill.); Horticq 1910(?), pp. 79-80 (pl. XXXII); Proust 1913, p. 165; Waldmann 1923, p. 77; Blanche 1924, p. 42 (fig. 29); Fourreau 1925, pp. 30 ff.; Duret 1926, pp. 100, 104-07 (fig. XXI); Moreau-Nélaton 1926, I, pp. 113-14, 133 (fig. 138); Jamot 1927, pp. 30-33 (ill.); Flament 1928, pp. 284, 306; Tabarant 1931, pp. 191-92 (no. 139); *Amour de l'Art* 1932, pp. 146, 151, 172 (fig. 58); Colin 1932, p. 37 (pl. XXXIII); George 1932, p. 2 (ill.); Jamot and Wildenstein 1932, pp. 48, 55-56, 89-90, 140 (fig. 161); Venturi 1939, II, p. 191; Graber 1941, pp. 192-93, opp. p. 156 (ill.); Jedlicka 1941, pp. 216-17; Rouart 1941, frontispiece; Tabarant 1947, pp. 182-83, 206-10; Morisot 1950, p. 179; Hamilton 1954, pp. 163-69, 172; *Art Quarterly* 1959, pp. 274, 283 (ill.); Davidson 1959, pp. 5-10, 12 (ill.); Perruchot 1959, p. 210; *Gazette des Beaux-Arts* 1960, pp. 9-10; *Gazette des Beaux-Arts* 1961, p. 49 (fig. 140); Courthion 1962, p. 108 (ill.); Orienti 1967, p. 98 (no. 131); Kloner 1968, p. 100; Ives 1974, p. 25; Dorival 1975, p. 329 (fig. 48); Broude 1977, p. 103 (ill.); Hanson 1977, pp. 47, 76-77, 166 (fig. 44); Scott 1977, p. 67 (ill.); Grayson 1981, p. 13 (fig. 4); Woodward and Robinson 1985, pp. 71, 192 (no. 110, ill.); Stuckey and

Scott 1987, p. 37 (fig. 23); Goley 1989, p. 14 (ill.); Distel 1989, p. 62 (ill.).

CONSERVATION: The painting was relined and partially cleaned sometime prior to 1983. In 1983, at the Williamstown Regional Art Conservation Laboratory, an old glue lining was removed and replaced with a wax lining; the painting was mounted on a new stretcher; there was moderate inpainting of crackle in the skirt; and it was revarnished without further cleaning.

RELATED WORKS: *The Balcony,* 1868–69, oil on canvas, 66½″ × 49¼″ (169 × 125 cm), Paris, Musée d'Orsay, Galeries du Jeu de Paume. *Berthe Morisot with a Muff,* 1868–69, oil on canvas, 29″ × 23⅝″ (73.7 × 60 cm), Cleveland, Cleveland Museum of Art. *Berthe Morisot with a Bunch of Violets,* 1872, oil on canvas, 21¾″ × 15″ (55 × 38 cm), private collection. *Portrait of Berthe Morisot with Hat, in Mourning,* 1874, oil on canvas, 24½″ × 19¾″ (62 × 50 cm), private collection. *Berthe Morisot with Fan,* 1874, watercolor, 8″ × 6½″ (20.3 × 16.5 cm), Chicago, Art Institute of Chicago.

Le Repos (*Repose*), the title by which this portrait was exhibited in the Paris Salon of 1873, represents the painter Berthe Morisot (1841–1895), the only woman to exhibit with the Impressionists in 1874. Berthe, the youngest of three daughters of a wealthy French civil servant, had been introduced to Manet in the winter of 1867–68 by their mutual friend, the painter Henri Fantin-Latour, while she was copying a canvas by Rubens in the Louvre.[1] The Manet and Morisot families grew very close in the ensuing years. Berthe, her mother, and her sister Edma became regular visitors to the weekly gatherings of artists and writers at the Manet household. In 1874 Berthe married Manet's younger brother, Eugène.

Berthe Morisot is remembered as a woman of strong and independent character who became a painter at a time when the choice of this vocation was controversial for a "well-bred" young woman of her social class. Despite prevailing attitudes, Mme Morisot indulged both her daughters in their avocation. In the early 1860's the Morisot sisters were permitted to study with Camille Corot (1796–1875), and in 1861 their family actually took a summer residence in the Ville d'Avray, where Corot lived, so that Berthe and Edma could work near him (see entry 17). Like many of the future Impressionist painters, Berthe's early work was influenced by the loosely brushed, atmospheric plein-air style of Corot. Her first submissions to the Salon, in 1864, were two landscapes in the manner of Corot, who encouraged painting in the open air.

A strong mutual affection and professional respect existed between Edouard Manet and Berthe Morisot. She began to work closely with him, and through his influence she became increasingly concerned with figural compositions and "*la vie moderne.*" Manet must have been taken by Morisot, for in the summer of 1868, shortly after they had met, he asked her to pose for *The Balcony* (fig. 1), where she is depicted sitting in the company of fellow-artist Antoine Guillemet (1842–1918) and violinist Fanny Claus (1846–1877). Morisot, the most prominent of these three figures, is seen as she would be in *Repose*: seated, wearing a white muslin summer dress, holding a fan, pensively gazing downward and to her right. When *The Balcony* was exhibited in the Salon of 1869, friends complained that Manet had given Morisot an unflattering, coarse appearance. Morisot, for her part, wrote to Edma: "His paintings, as always, create the impression of some wild fruit, a bit unripe even. I am far from disliking them . . . I look strange rather than ugly. It seems that the term *femme fatale* has been circulated among the curious."[2]

Repose is Manet's second major portrait of Morisot. It was probably begun in the summer of 1870 and interrupted in September by the Franco-Prussian War, at which time Manet joined the artillery. When Paris fell in January 1871, Manet joined his family in the south of France. In March of that year, Manet wrote to Berthe's mother, requesting permission to exhibit a portrait of Berthe in the Salon. "I have received word from Paris that there will certainly be an exhibition that will open on May 20. Would you please allow me to submit the study that I have made of Mlle B. This painting is not at all in the character of a portrait, and in the catalogue I will call it an *étude.*"[3] In the absence of any other known portrait of Berthe from this period, we can surmise that the "study" in question is the full-length portrait at RISD. Franco-Prussian hostilities did not end so quickly, however, and no Salon was held in that year. In September, Berthe and Manet were back again in Paris. At that time she wrote to Edma, "[Manet] has rediscovered that I am not too ugly, and would like to have me back as his model."[4] It is not known what further work may have been executed in the fall of 1871. The painting was certainly completed by January 1872, when

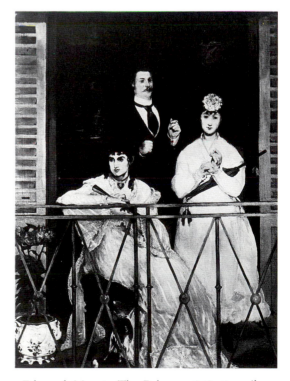

Fig. 1 Edouard Manet, *The Balcony,* 1868–69, oil on canvas, 66½″ × 49¼″ (169 × 125 cm), Paris, Musée d'Orsay, Galeries du Jeu de Paume.

it was acquired by the dealer Paul Durand-Ruel along with twenty-three other canvases by Manet purchased by him at this time.[5]

Repose was exhibited in the Salon of 1873 with a portrait of a man drinking a beer, called *Le Bon Bock* (*A Good Draft*, 1873, Philadelphia, Philadelphia Museum of Art), which was inspired by seventeenth-century Dutch portraiture in the manner of Frans Hals. The latter was the first Salon submission by Manet to be widely praised; *Repose*, on the other hand, was greeted with widespread disdain. Critics took exception to the informality of the sitter's pose and the loosely brushed technique, unprecedented in a work whose ambitious size required it to be viewed in relation to formal portraiture. The sitter was variously described as "tired and ruffled,"[6] and as "the woman with a suspicious look."[7] Another called her "a forlorn, miserable creature, and miserably dressed . . . from woebegone face to tiny foot, she is wilted, wretched, and ill-humored as can be."[8] "His canvas called *Le Repos*," another critic observed, "is a confusion defying all description; one must have faith to try to disentangle the good intentions which could be hiding under this indecent barbarous smear."[9] "His woman of *Repose* is in defiance of good taste," wrote another.[10] Charles Garnier, the architect of the Paris Opéra, expressed his distaste by dubbing Manet "the high priest of the school of daubers."[11] At least one critic was impressed by the hostile criticism inspired by *Repose*: "The crowds remain restive and suspicious before this work, which, however, seems to us to more fully contain the personal and original mark of this artist."[12]

Repose represents the sitter in an idle moment, self-absorbed, staring off into space, reclining languidly on an overstuffed couch. She is represented with her left leg tucked beneath her billowing skirts, while her right leg dangles just above the ground, her tiny foot casting a shadow that gives her the appearance of relative weightlessness. The posing sessions were apparently very uncomfortable for her. The leg tucked beneath her would lose circulation, but she was forbidden to move for fear of disturbing the arrangement of her dress.[13] The freedom of brushstroke, unprecedented even in Manet's work, further adds to the atmosphere of informality,

suggesting why Manet, in his letter to Mme Morisot, could refer to this five-foot canvas as an "*étude*."

The ambiguous posture, which one critic described as "neither standing nor seated," was certainly a cause of the indignation surrounding this portrait.[14] The depiction of women reclining on a couch or divan—a genre with roots barely a century old—customarily had erotic connotations, originating in representations of harem women and thereafter restricted to actresses, mistresses, and occasional portraits of artists' wives.[15] The most noteworthy prototypes for reclining women in Manet's own work were the *Olympia* (1863, Paris, Musée d'Orsay, Galeries du Jeu de Paume), representing a nude prostitute in her *boudoir;* another of Jeanne Duval, Baudelaire's mistress (1862, Budapest, Szépmüvészeti Museum); and the *Young Woman Reclining, in Spanish Costume* (1862, New Haven, Yale University Art Gallery), painted for the photographer Nadar and believed to be of his mistress. Perhaps in deference to conventions of middle-class propriety, Morisot was not identified in the Salon catalogue, and most reviewers either ignored or were ignorant of her identity.[16] Unlike his portrait of another woman artist, Eva Gonzalèz (1869–70, London, National Gallery), whom Manet represented at her easel, Morisot is given none of the attributes of her profession.

There has been some speculation among recent scholars that Manet may have altered the posture of his sitter from an upright frontal pose to a reclining position. However, recent X-ray analysis undertaken to document these modifications has shown that Manet did not alter the figure's position on the sofa, but had conceived her in this attitude from the start.[17] It is also unlikely, contrary to previous suggestions, that Manet unrolled a few inches of canvas at the top in order to extend the composition vertically, giving greater prominence to the image on the wall immediately behind Berthe Morisot's head.[18]

The prominence of the print in its relation to the sitter contributes to the painting's self-conscious modernity. The print has been identified as a Japanese woodblock print (*ukiyo-e*) by Kuniyoshi entitled *The Dragon King Pursuing the Ama with the Sacred Jewel* (1853; fig. 2).[19] In the late 1860's

Fig. 2 Utagawa Kuniyoshi, *The Dragon King Pursuing the Ama with the Sacred Jewel*, 1853, woodcut, triptych, each panel 14⅜" × 9¾" (36.5 × 24.8 cm), New York, Metropolitan Museum of Art, Fletcher Fund, 1929.

Manet grew increasingly receptive to the influence of Japanese prints, which enjoyed a vogue among avant-garde artists. He had incorporated them into his *Portrait of Emile Zola* (1868, Paris, Musée d'Orsay, Galeries du Jeu de Paume), and they had influenced the flatly patterned style of his lithograph *Cats' Rendezvous* (1868). In *Repose,* however, the interest in flat, undifferentiated shapes typical of the woodblock print has been replaced by a virtual riot of painterly strokes, echoing the overall style in which this otherwise restful portrait is painted. The print thus becomes a metaphor for the painting at large, and it is within this nearly abstract image that Manet has placed his signature.

Manet's *Repose* may be the prototypical Impressionist portrait, exhibited a year in advance of the first exhibition of the Impressionist painters in Nadar's studio. Although Manet declined to participate in this forum, his work was closely linked to the work of the younger Impressionists, many were his friends, and there was a reciprocal influence between them. "The head and hands are in a merely indicated, unexecuted state," Paul Mantz observed, expressing a concern that became the mainstay of critical objection to the Impressionists.[20] Mantz's concerns were echoed in a prescient passage by the Realist critic Castagnary: "He has shown more than once this kind of laziness; he is after an impression, he thinks he has caught it in passing, and he stops. The rest is lacking."[21] This "impression" is ultimately the consequence of the sitter's casual posture and the suggested fragility of her momentary self-absorption. At least one critic, the poet Théodore de Banville, expressed a preference for this "attractive portrait, from which we cannot avert our eyes, and that impresses itself upon our spirit through an intense quality of modernity – if I may be allowed a barbarous term that has become indispensable!. . . Baudelaire was indeed right to esteem M. Manet's painting, for this patient, sensitive artist is perhaps the only one in whom the refined sentiment for *la vie moderne* that comprises the exquisite originality of *Les Fleurs du mal* can be found again."[22] In thus characterizing the modernity of this painting, the poet may have responded to the ineffable melancholy that dominates this subdued portrait of Berthe and that also attracts us to her. D. R.

1. Angoulvent 1933, p. 22.
2. Morisot 1950, p. 25. Farwell 1990, p. 47, has pointed out that this correspondence, edited by Morisot's grandson, Denis Rouart, is excerpted in such a way as to exclude any reference to *Repose,* save for the Berthe's unsuccessful effort to buy it from the Duret sale in 1894; cf. Morisot 1950, p. 179.
3. Unpublished letter in the collection of Mme Ernest Rouart, daughter of Berthe Morisot, quoted in Davidson 1959, p. 6, who has summarized the chronology of events surrounding the probable date of this painting.
4. Morisot 1950, p. 67.
5. Venturi 1939, II, p. 191. Durand-Ruel acquired these pictures on January 12, 1872, after seeing two by Manet the previous day in the studio of Alfred Stevens. The entire lot was acquired for 35,000 francs. Durand-Ruel lists the price of *Repose* at 2,500 francs. In Manet's notebook the price was listed as 3,000 francs, the difference being the discount given by Manet on the entire lot. See Paris, Grand Palais, 1983, "Provenance," pp. 312, 318. Tabarant 1947, pp.

182-83, notes that the painting had been stored with Manet's friend Théodore Duret (later the executor of his estate), while Manet was in military service. In 1880 Duret acquired the painting from Durand-Ruel in exchange for a Daumier.
6. Alexandre Pothey, *Gaulois,* May 13, 1873, quoted in Tabarant 1947, p. 209.
7. Literally, "the woman who squints" ("la femme qui louche"). Marius Chaumelin, *Bien publique,* May 6, 1873, quoted in Tabarant 1947, p. 209.
8. Silvestre, quoted in Paris, Grand Palais, 1983, p. 317.
9. Ernest Duvergier de Hauranne, *Revue des deux mondes,* June 1, 1873, quoted in Hamilton 1954, pp. 165-66.
10. Dubosc de Pesquidoux, *Union,* June 30, 1873, quoted in Tabarant 1947, p. 209.
11. Charles Garnier, *Moniteur universel,* July 13, 1873, quoted in Tabarant 1947, pp. 209-10.
12. Paul Alexis, *L'Avenir national,* June 19, 1873, quoted in Tabarant 1947, p. 207.
13. Davidson 1959, p. 7.
14. Francion 1873, p. 406.
15. For a thorough discussion of the iconographic tradition see Farwell 1990, pp. 49-54.
16. Philippe Burty, writing anonymously for the *République française,* May 18, 1873, seems to have been the only critic to identify Morisot, whom he called "one of the most remarkable pupils of M. Manet"; quoted in Tabarant 1947, p. 206.
17. For a summary of this observation see Paris, Grand Palais, 1983, p. 317 and n. 11. Fifteen X-radiographs of sections of the canvas were taken by Sandra Webber, Associate Conservator of the Williamstown Regional Art Conservation Laboratory in 1989. On the basis of the evidence gathered by Ms. Webber, she observed (letter of October 16, 1989): "The execution seems broad, quick and sure with no evidence in the upper torso, shoulder or arm positioning to indicate major alteration to the final figure. All of her weight is on her proper left arm in this casual pose, and would have been much higher and more centered if an upright position had been intended, but there are no such changes visible. The tilt of her head is also unchanged and in the natural position accompanying the twist of the torso. Even the placement of the long hair curls was premeditated, as reserves were left on the canvas with the dress painted around them." Webber suggests several minor changes in the image: in particular, at the proper left edge of the skirt, where a dark edge that may suggest the underdrawing of the original contour can be detected; and above the sitter's head, indicating that it may have originally been somewhat higher. There is, however, no evidence from the X-rays, from an ultraviolet, or from a microscopic examination by the conservator, of a major alteration in the figure's pose.
18. Davidson 1959, p. 8. There is no physical evidence such as tacking holes or a seam that would support this observation, as there would have been had Manet mounted the painting to a stretcher. Paris, Grand Palais, 1983, p. 317, indicates that Manet added a strip to the top of the canvas. Physical examination, supported by X-rays, reveals a homogeneous canvas to which no such strip has been added.
19. Kloner 1968, p. 100.
20. Mantz 1873.
21. Castagnary, *Siècle,* June 14, 1873, quoted in Tabarant 1947, p. 208. Cf. Horticq 1910 (?), pp. 79-80, and Hamilton 1954, p. 169.
22. Théodore de Banville, *National,* May 15, 1873, quoted in Tabarant 1947, p. 206.

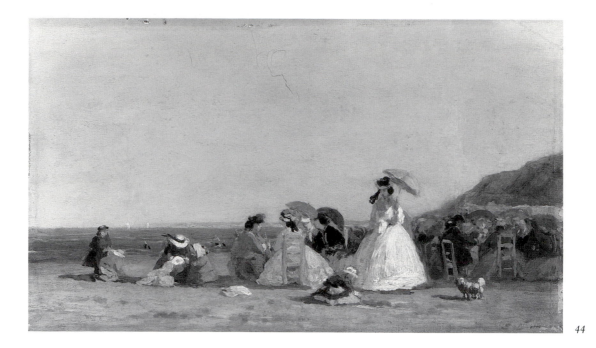

44

EUGÈNE BOUDIN
French, 1824–1898

44 *Figures on a Beach,* ca. 1863

Oil on panel, 8⁵⁄₁₆″ × 13⁷⁄₈″ (21.1 × 35.3 cm)
Gift of Mrs. Houghton P. Metcalf, Sr. 1986.070

PROVENANCE: Cadart et Luquet, Paris; Scott & Fowles, New York; Mrs. Houghton P. Metcalf.

PUBLICATION: Schmit 1984, no. 3758 (as *Sur la Plage*).

RELATED WORKS: *Scène de Plage à Trouville,* 1863, oil on panel, 10¼″ × 18⅞″ (26 × 47.9 cm), private collection (Schmit 1973, no. 276). *La Promenade sur la Plage,* 1863, oil on panel, 10¼″ × 15¾″ (26 × 40 cm), Sotheby's, October 27, 1989, lot 78 (Schmit 1973, no. 278).

45 *The Port at Trouville,* 1889

Signed, dated, and inscribed, lower left: *à son ami/F. Vinton E. Boudin 89.*
Oil on canvas. 16³⁄₁₆″ × 22″ (41.1 × 55.8 cm)
Museum Appropriation. 29.290

PROVENANCE: Frederick Porter Vinton, Boston, 1889 to 1911; lent by Mrs. Frederick P. Vinton to the Museum of Fine Arts, Boston, April 1912 to March 1913; Jesse Metcalf.

EXHIBITIONS: Newport, Art Association, 1948, no. 4 (as *Deauville*); Albuquerque, UNM, 1964, no. 11 (as *Deauville*); Santa Barbara, Museum, 1976, no. 23 (as *Le Bassin de Deauville*).

PUBLICATIONS: Benjamin 1937, p. 194 (as *Deauville*); Rowe 1937, ill. p. 2; Schmit 1973, no. 2549; Schmit 1984, no. 2549.

RELATED WORKS: *Trouville, le port marée bassé, le matin,* oil on canvas, 16⅛″ × 21⅝″ (41 × 54.9 cm), private collection (Schmit 1973, no. 2550). *Trouville, le port marée bassé,* 1889, oil on canvas, 18⅛″ × 25⅝″ (46 × 65.1 cm), private collection (Schmit 1973, no. 2551).

Boudin was born in 1824 on the coast of Normandy. He opened a framing and stationery shop in Le Havre in 1844 and through it met the artists Eugène Isabey, Constant Troyon, Jean-François Millet, and Thomas Couture, who encouraged him to paint. In 1859 he made his Salon debut, which earned him praise from Charles Baudelaire and Gustave Courbet, and in the early 1860's on the advice of Camille Corot he worked in the studio of Troyon, painting skies and absorbing from the Barbizon master a preference for the natural poetry of rustic landscape compositions over the more popular historical and anecdotal subjects. In 1874 he participated in the first Impressionist exhibition, though he declined all later invitations to exhibit with the independent group, preferring instead the official acceptance of the Salon, where he exhibited regularly between 1867 and 1897.

Although Boudin maintained a studio in Paris after 1850, the beaches and ports of his native Normandy remained the inspiration for most of his work. His technique of working directly from nature and his ability to retain the fresh, spontaneous vision of the sketches in finished paintings had a lasting influence on French painting, and particularly on the young Claude Monet, who later said of his plein-air painting excursions with Boudin in the late 1850's, "My eyes were finally opened and I really understood nature; I learned at the same time to love it."[1] Monet benefited not only from Boudin's encouragement to move beyond his adolescent skill at caricature to landscape painting, but also from the elder artist's lessons of naturalism that were to become the basis of Impressionist painting. Boudin's exhortations to "show extreme stubbornness in retaining one's first impression, which is a good one" and insistence that "it is not a single part which should strike one in a picture but indeed the whole" later earned him the label "precursor of Impressionism," and, indeed, his own paintings embody the visual

evidence of his teachings.[2]

After 1862, perhaps on the advice of Isabey,[3] Boudin repeatedly painted fashionable society on the beach at Trouville, a port town at the mouth of the Tocques River. The two-thirds-mile-long beach with its boarded promenade and nearby casino and racetrack became a very fashionable resort in the early 1860's, when important members of the court of Napoleon III, such as the Duc de Morny and the Empress Eugénie, visited. Boudin perhaps realized the possibilities for pictures that included such glamorous and popular entourages when he commented in 1863, "They love my little ladies on the beach, and some people say that there is a thread of gold to exploit there."[4] Nevertheless, in his own words, the focus of Boudin's paintings remained nature itself, "the sundrenched beaches . . . and the joy of painting them in the sea breezes,"[5] among which the fashionable society that congregated on the beaches were, as surrogates for the viewer, witness to the natural beauty of the scenery.

In *Figures on a Beach,* the well-dressed women, men, and children serve as a foil to the clear sky and crisp morning light, casting shortened shadows as the midday approaches. The wind tosses the hair of the standing woman at right center, lifts the edges of her parasol, and tosses the hat ribbons of the nanny kneeling at the left. While children play in the sand, men and women seated in straight chairs form circles for conversation. In the background two sailboats

dot the horizon, while the cliff at the right identifies the beach as that of Trouville.[6] The bold touches of orange and white approximate the effects of strong sunlight, perhaps early or late in the season, as the beach-goers appear warmly dressed and there are no bathers or bathing machines in sight. The simplicity of the composition and the dominant horizontal bands of sky, water, and beach, interrupted only by the diagonal wedge of figures and cliff, enhance the sense of open air and enveloping light.

In addition to views of the beaches dotted with idle vacationers, Boudin also painted the bustling harbors of Normandy, often crowded with pleasure craft, fishing boats, and steamers carrying passengers to and from Le Havre, France's main transatlantic port. *The Port at Trouville* shows the nearly empty harbor at Trouville on a gloomy, overcast day.[7] Only two boats remain at mid-tide, beached beside the pilings at the left and right. The nearly unrippled reflection of the large building that anchors the distant edge of the harbor and the vertical stream of smoke from a factory (or perhaps a steamer in the neighboring Deauville harbor) indicate calm, windless weather.

Boudin inscribed *The Port at Trouville* "à son ami F. Vinton."* Frederick Porter Vinton (1846–1911) was a Boston portrait painter who studied in Paris in the late 1870's with Léon Bonnat and Jean-Paul Laurens. In June of 1889 he left Boston for an eighteen-month tour of France, Italy, Holland, and England. During his time abroad, Vinton briefly took up

45

landscape painting in the manner of the Impressionists,[8] and it is perhaps through them that he came to admire Boudin's work. In 1890 Boudin's dealer, Durand-Ruel, arranged for the Chase Gallery in Boston to exhibit thirteen paintings by Boudin. Vinton bought all thirteen, and to show his appreciation Boudin sent the American artist *The Port at Trouville*.[9] The Museum owns a portrait of Vinton by John Singer Sargent (29.111). A. H. S.

1. Claude Monet, quoted in Rewald 1973, p. 38.
2. Boudin, quoted in Rewald 1973, p. 38.
3. Jean-Aubry 1968, p. 183.
4. Boudin to Ferdinand Martin, February 12, 1863. See Jean-Aubry 1968, p. 50.
5. Boudin to Martin, June 14, 1869. See Jean-Aubry 1968, p. 74.
6. See Schmit 1973, no. 276, which not only shows the cliff at right, but is very similar to the RISD panel in style and composition. This painting is inscribed "Trouville" at the lower left and dated 1863 at the lower right.
7. The title of the RISD picture, formerly *Le Bassin de Deauville,* was assigned in Schmit 1973. By comparison to other paintings of Trouville harbor done in 1889, Schmit nos. 2550 and 2551, it is clear that the RISD painting depicts Trouville.
8. See Fairbrother 1986, p. 229. See also Boston, MFA, 1911, p. 14.
9. See Knyff 1976, p. 222. Although Knyff does not specifically name the RISD picture, a survey of Schmit 1973, II and III, revealed no other painting of 1889 or 1890 inscribed to Vinton.

CLAUDE MONET
French, 1840–1926

46 Honfleur (The Seine near its Estuary), ca. 1868

Signed, lower right: *Claude Monet*
Oil on canvas. 18¹⁵⁄₁₆″ × 29″ (48.1 × 73.8 cm)
Bequest of George Pierce Metcalf. 57.236

PROVENANCE: Alex Reid, Glasgow; J. McN. Reid, London; Sam Salz, New York; Carroll Carstairs, New York; from whom purchased by Mr. and Mrs. George Pierce Metcalf, Providence, ca. 1945.

EXHIBITIONS: New York, Wildenstein, 1945, p. 25 (no. 12, ill.); Manchester, Currier, 1949, p. 23 (no. 41); Waltham, Rose, 1967, no. 20 (ill.).

PUBLICATIONS: Washburn 1949, n.p. (ill.); Wildenstein 1974, I, pp. 40, 170-71 (no. 115, ill.).

CONSERVATION: Prior to its acquisition by the Museum, the canvas was relined with a wax resin and given a new stretcher.

Although born in Paris, Monet grew up in the coastal port of Le Havre, and it was there, under the influence of Eugène Boudin (see above, entries 44-45), that he first developed his enduring interest in landscape painting. Throughout his early career, which brought him to Paris in 1859, Monet would regularly return to the Normandy coast, painting the environs of Le Havre, in particular the beaches around Sainte-Adresse, and the port and surroundings of Honfleur. Fully half of Monet's paintings before 1869 represent views in the vicinity

of Le Havre, and more than half of these paintings focus specifically on the port and environs of Honfleur, located barely two miles southeast of Le Havre on the south bank of the estuary of the Seine, which flows between these two ports into the English Channel.

According to Daniel Wildenstein, *Honfleur* was painted around July of 1868.[1] In March of that year, Monet had submitted two marine paintings to the Paris Salon, one of which was accepted, probably due to the positive influence of Charles Daubigny, a member of the jury.[2] Monet's 1868 submission to the Salon was only his fifth work to be exhibited there, and although it was poorly hung, it at least had the distinction of being singled out by caricaturists, one of whom chided that it had been painted when Monet was four-and-a-half years old.[3] Discouraged by the poor reception his work had received and beset by severe financial difficulties, Monet quit Paris for the countryside. Along with his companion, Camille Doncieux (whom he would marry in 1870), and their infant son, Jean, they found lodging at an inn in the village of Bennecourt, located on the Seine a few miles southeast of Giverny. *On the Seine at Bennecourt* (fig. 1) is the only painting from this visit that survives. Executed around June 1868, it immediately precedes *Honfleur* in the chronology of Monet's development.

Monet's sojourn at Bennecourt was rudely interrupted as a result of his financial problems. On June 29, back again in Paris, Monet wrote to his comrade, the painter Frédéric Bazille:

> I am writing a few quick words in haste in order to ask your help as soon as possible, [for] I have certainly been born under an unlucky star. I have just been thrown out of the inn where I was staying, and with no clothes on my back. I have found shelter for Camille and my poor little Jean for a couple of days in the country. As for me, I came [to Paris] this morning and am leaving this evening for Le Havre, to see if I can get some-
> thing going with my *amateur.* . . . Write to me in Le Havre, general delivery, because my family refuses to have anything to do with me, and I still don't know where I will be sleeping tomorrow.
>
> Your tormented friend, Claude Monet
>
> Yesterday I was so upset that I stupidly threw myself in the water. Fortunately, nothing bad came of it.[4]

Honfleur would have been painted immediately after these events, within a few weeks of his return to Normandy, at a time when he was virtually penniless, separated from his mistress and child, and estranged from his mother and father, who disapproved of his career and would neither support him nor acknowledge his new family. The hardships, discouragements, and frustrations dominating Monet's life at this time do not appear to have compromised the artist's singleminded approach to landscape painting, and even in some way may have fueled his development of an independent and highly personal style, based upon the direct confrontation of nature and the bold rejection of traditional representational techniques.

Monet's Normandy landscapes up to this time typically depicted marine subjects, showing views of the sea, the beaches, and the harbors with their traffic of sailing vessels.[5] The RISD painting, however, represents a view of the Seine near its estuary, located inland and upriver, probably a few miles northeast of Honfleur. This landscape is one of a small number of paintings that look to the country roads and hilly farmland around Honfleur, and it is Monet's only painting of the Seine from this region. Views of the Seine would become Monet's most oft-repeated subject (it is represented in three of the four canvases by Monet in the Museum's collection), yet this is only the fifth appearance of the subject in his work up to this time, all of them falling within the span of little more than a year.[6]

Honfleur is a paradigmatic example of Monet's emerging "naturalism," the term applied at the time by the critic Castagnary to characterize the directness of Monet's approach to nature, to be subsumed six years later by the label "Impressionist."[7] Painted *en plein air,* this canvas is noteworthy for the simplicity and unspectacular attraction of the view it represents: a quiet bank of the river bordered on one side by a farmhouse and country road, a slow barge making its way up the river, and two pedestrians barely visible at the vanishing point of the road. Whereas Monet's marine paintings from the period tend to be animated by the natural power and scale of the open sea or the picturesque traffic of large merchant and fishing ships sailing in and out of port, this view conveys the gentle movement of clouds sweeping across the sky and their effect on the light and perceived depth of the landscape. Less ambitious and less labored than *On the Seine at Bennecourt,* it is more likely the product of a single day's outing in this rural landscape on the outskirts of Honfleur; and whereas the Bennecourt view looks down, placing great emphasis on its reflection on the water's surface, *Honfleur* looks up, showing an obvious fascination with the ever-changing pattern of the clouds. It is painted with broad, dis-

Fig. 1 Claude Monet, *On the Seine at Bennecourt,* 1868, oil on canvas, 32¹⁄₁₆″ × 39⅝″ (81.5 × 100.7 cm), Chicago, Art Institute of Chicago.

embodied strokes that convey the sensation of variable light and gentle breezes on a partly cloudy day, the whole unified by a harmonious scheme of greys and blues that we can easily imagine to have been dictated by specific conditions of atmosphere and season.[8] D.R.

1. Wildenstein 1974, I, pp. 40, 170 (no. 115, ill.). The painting had previously been dated 1870; see New York, Wildenstein, 1945, p. 25.

2. *Ships Leaving the Port of Le Havre,* 1867 (W. 89), now lost, is known only through surviving caricatures; *The Jetty at Le Havre* (W. 109) was rejected by the same jury. Boudin wrote in a letter at that time that Daubigny "had to fight to get one of [Monet's] pictures admitted; that at first the *Ship* had been accepted and that, when the other came up in turn, Nieuwerkerke [the Superintendent of Fine Arts] had said to him: 'Ah, no, we've had enough of that kind of painting'" (quoted in Rewald 1961, p. 185). Daubigny was largely responsible for the liberalization of the Salon that year. There were 1,378 more entries than in the previous year, including works by Manet, Pissarro, Degas, Renoir, Sisley, and Morisot.

3. Wildenstein 1974, I, p. 161.

4. Wildenstein 1974, I, p. 425.

5. Cf. W. 112–14, views of the sea at Sainte-Adresse, which according to Wildenstein are exactly contemporary with *Honfleur.*

6. Other inland views of the region include W. 24-25, 28-30, 79-82. Among Monet's views of the Seine, exception is made here of *The Mouth of the Seine* (W. 51, Salon of 1865, his first submission to the Paris Salon), and a preliminary study for it (W. 38), which are actually wide-open marine views looking out to sea at the river's end. Monet's first view of the Seine, painted in the spring of 1867, shows *The Quai du Louvre* in Paris (W. 83, The Hague, Gemeente-museum). In the winter of 1867, he painted two views of *Ice on the Seine at Bougival* (W. 105-06, present locations unknown). In the spring of 1868, in the period just preceding the execution of the RISD canvas, he painted the portrait of Camille sitting *On the Seine at Bennecourt* (W. 110, Chicago, Art Institute of Chicago).

7. Castagnary, "Le Salon de 1866," cited in Rewald 1961, p. 148.

8. In his review of the Salon of 1865, Paul Mantz, critic for the *Gazette des Beaux-Arts,* praised Monet's "taste for harmonious schemes of color in the play of analogous tones, the feeling for values, the striking point of view of the whole" Three years later, not long before this landscape was painted, Boudin similarly praised Monet's tenacious "search for true tone, which begins to be respected by everyone." Rewald 1961, pp. 123, 189.

CLAUDE MONET
French, 1840–1926

47 *Hyde Park, London,* ca. 1871

Signed, lower left: *Claude Monet*
Oil on canvas. 15¹⁵⁄₁₆″ × 29⅛″ (40.5 × 74 cm)
Gift of Mrs. Murray S. Danforth. 42.218

PROVENANCE: Purchased from the artist by Durand-Ruel in May 1872 (*Kensington Gardens*) (?); Durand-Ruel, ca. 1891; Sotheby's, London, Harcourt Johnstone sale, June 12, 1940, no. 159; Mrs. Murray S. Danforth, Providence.

EXHIBITIONS: Providence, RISD, 1942, no. 43; New York, Wildenstein, 1945, p. 25 (no. 13); Manchester, Currier, 1949, p. 23 (no. 42); Waltham, Rose, 1967, no. 21; Providence, RISD, 1972, pp. 140–42 (pl. 49); London, Arts Council, 1973, pp. 8, 33–35, 39 (no. 2); Chicago, AI, 1975, p. 81 (no. 27); Auckland, City Art Gallery, 1985, pp. 10–11, 42–43 (no. 1).

PUBLICATIONS: Alexandre 1921, p. 54; *Connoisseur* 1936, p. 44 (ill.); Washburn 1942, p. 15 (ill.); Reuterswärd 1948, pp. 56, 58, 287 (fig. 18); London, Tate, 1957; Degand and Rouart 1958, pp. 51–52; Rewald 1961, p. 256 (ill.); Thomas 1963, p. 5 (fig. 3); Pool 1967, pp. 100–01 (fig. 73); London, Lefevre, 1969, pp. 14–15 (fig. VIII); Bortolatto 1972, no. 37 (ill.); Wildenstein 1974, I, pp. 52–55, 192–93 (no. 164, ill.); Isaacson 1978, p. 203 (no. 33); Paris, Grand Palais, 1980, p. 104; Seiberling 1988, p. 9.

CONSERVATION: In 1953 the painting was cleaned, relined with Belgian linen and plenderleith wax resin adhesive, and stretched on a new basswood stretcher.

RELATED WORKS: *Green Park,* 1871, oil on canvas, 13⅜″ × 28⅜″ (34 × 72 cm), Philadelphia, Philadelphia Museum of Art. *Train in the Countryside,* ca. 1872, oil on canvas, 19⅝″ × 25⁹⁄₁₆″ (50 × 65 cm), Paris, Musée d'Orsay (M.N.R. 218).

Following their marriage in Paris on June 28, 1870, Monet, Camille, and their three-year-old son, Jean, returned once again to the Norman coast, residing this time in a small hotel in Trouville, a popular beach resort a few miles south of Honfleur, where they would remain through the summer. On July 19, France declared war on Prussia, precipitating the debacle that would result in the surrender and abdication of Napoleon III and the establishment of the Third Republic on September 4, followed by the siege of Paris by the Prussian

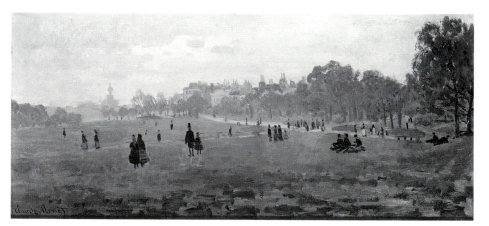

Fig. 1. Claude Monet, *Green Park,* 1871, oil on canvas, 13⅜″ × 28⅜″ (34 × 72 cm), Philadelphia, Philadelphia Museum of Art, W. P. Wilstach Collection.

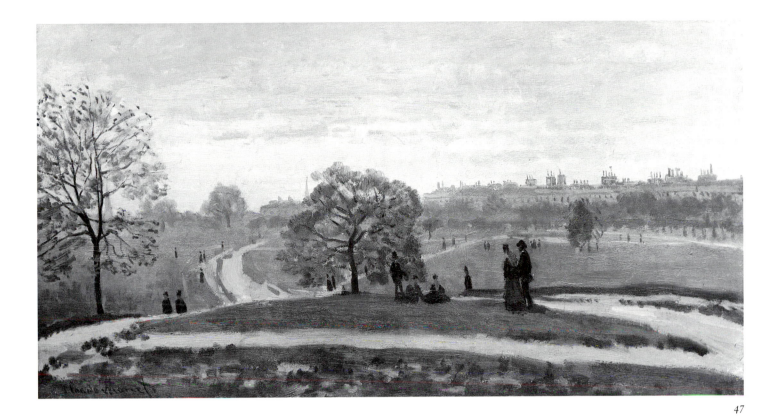

armies on the nineteenth of that month. The war, however, appears to have had little impact on the season at Trouville, where Monet spent the summer painting views of middle-class tourists, among them Camille, at their leisure by the sea.[1] It was probably less in fear of an invasion of Normandy than to avoid conscription that at some time in late September or October Monet crossed the Channel to London. He was soon followed by his family, who would remain there with him until late May of 1871.[2]

In London, Monet found a small group of fellow Frenchmen who had resettled there to avoid the war. At a café frequented by French exiles, he met Charles Daubigny, long a champion of the young Monet, who introduced him to Paul Durand-Ruel, the Paris dealer whose father had been so important to the careers of the Barbizon painters, as the son would be to the Impressionists. Durand-Ruel, who had opened a gallery at 168 New Bond Street, began to buy paintings from Monet, paying as much as 300 francs for a canvas.[3] *The Entrance to Trouville Harbor* (W. 154), painted by Monet that summer and carried with him across the Channel, was exhibited in the dealer's inaugural exhibition on the tenth of December.[4] Through Durand-Ruel, Monet discovered that his friend Camille Pissarro was also in London. The two artists spent much time together, as Pissarro later recalled:

> Monet and I were very enthusiastic over the London landscapes. Monet worked in the parks, whilst I, living at Lower Norwood . . . studied the effects of fog, snow, and springtime. We worked from Nature, and later on Monet painted in London some superb studies of mist. We also visited the museums. The watercolours and paintings of Turner and of Constable, the canvases of Old Crome, have certainly had influence upon us. We admired Gainsborough, Lawrence, Reynolds, etc., but we

were struck chiefly by the landscape painters, who shared more in our aim with regard to "plein air," light, and fugitive effects. . . . About this time we had the idea of sending our studies to the exhibition of the Royal Academy. Naturally we were rejected.[5]

Monet would make a number of working visits to London throughout his life, but this, his first, more the result of necessity than desire, seems to have been a relatively unproductive period for him, notwithstanding the enthusiasm remembered by Pissarro. In the more than six months that he remained in London, Monet painted only six known canvases, including a portrait of Camille (W. 163), three views of the Thames (W. 166-68), and two of London parks (W. 164-65), including the view of Hyde Park belonging to the Museum and a view of Green Park in the Philadelphia Museum of Art (fig. 1). Compared to the sunlit paintings from his summer honeymoon at Trouville, these early views of London seem more somber, less robust, perhaps a natural reflection of season and climate, although one is tempted to read into them the conditions of his exile, the death of Monet's father on January 17, 1871, or perhaps his knowledge of the deteriorating situation in France.

The site represented by the Museum's canvas has with reasonable certainty been identified as Hyde Park.[6] To encompass this view, Monet would have positioned himself near the park's center, looking northwest towards Lancaster Gate. To the left of the tree in the center of the canvas, along the horizon, the spires of Christchurch, Lancaster Gate, and old St. James's have been identified. The silhouettes of chimneys visible along the horizon to the right have been recognized as the houses that run along Bayswater Road.[7] In neither Hyde nor Green Park does one find a rise in the ground such

Fig. 2 Claude Monet, *Train in the Countryside*, ca. 1872, oil on canvas, 19⅝″ × 25⁹⁄₁₆″ (50 × 65 cm), Paris, Musée d'Orsay.

as the one pictured in the Museum's canvas; it has been suggested that this may be the result of a later reworking in the studio.[8] If Pissarro's reminiscence is accurate and Monet was working on his park views around the time that he and Pissarro submitted work to the Royal Academy, this would suggest that the Museum's canvas was painted in the early spring of 1871, a dating that would be consistent with the weather depicted and the virgin foliage on the trees.

Hyde Park is painted in subdued tones, dominated by grey, which suggest the light of an overcast London afternoon. The composition is organized into horizontal bands that diminish in color saturation as they recede and that are connected by the diagonal paths winding through the park. The absence of a specific focal point adds to the informality of the scene, as does the arrangement of figures, painted in broad and summary strokes, into loose clusters that lead the viewer's eye into the picture's depth. Examination with an ultraviolet light suggests that Monet had second thoughts about their placement, for at a later date he appears to have eradicated some of the figures and added others.

Hyde Park, London reveals no discernible influence of the British painters whom Monet and Pissarro admired in London's museums. Monet's response to Turner would come later, in his views of the Thames painted between 1899 and 1904, and in Venice in 1908; what he seems to share with Constable is more the outcome of his own direct confrontation of the natural world, a result of prior exposure to the work of Boudin, Jongkind, and the Barbizon painters, in particular Daubigny. Manet's *Music in the Tuileries Gardens* (see entry 42), a noteworthy park view from the previous decade, would have been known to Monet, and although Manet's painting seems to be more about culture than about nature, it is an important precedent for this motif. A closely related example in Monet's own work, *Train in the Country-side* (fig. 2), provides a panoramic park view with scattered figures and trees seen from an elevated vantage point, representing the infiltration of urbane Parisians into the nearby

countryside.[9] *Hyde Park, London* and its companion *Green Park* are Monet's first representations of spacious city parks, showing the transposition of the countryside into the city. *Hyde Park* provides a view of a groomed, artificial slice of the natural world that has been claimed by well-dressed urban dwellers at their leisure, set against the backdrop of urban façades lining the horizon. While Monet initially may have been resistant to the influences of British art during his first of many trips to London, he was evidently responsive to British cultivation of nature. D.R.

1. See Wildenstein 1974, I, nos. 154–62.

2. Wildenstein 1974, I, pp. 51-55. The precise date of Monet's departure is unknown. It was sometime after September 13 and well before December 10, when his *Entrance to Trouville Harbor* (W. 154) was exhibited at the Durand-Ruel gallery in London; see below, n. 3. Monet resided first at 11 Arundel Street, Piccadilly Circus, and then at 1 Bath Place, Kensington (to become Kensington High Street after 1894), where he had moved by the first of January.

3. Rewald 1961, p. 255. Two years earlier, in Paris, his work might have brought fifty to one hundred francs. Cf. Rewald 1961, p. 214.

4. This, along with two canvases by Pissarro, who was also introduced by Daubigny to Durand-Ruel in London, represents the public's first exposure to Impressionist painting in London and the first exhibition of Impressionist painting outside of France; see Cooper 1954, pp. 21-23.

5. W. Dewhurst, *Impressionist Painting,* London/New York, 1904, pp. 31–32, quoted in London, Arts Council, 1973, p. 14.

6. There has, however, been some confusion about the setting of both of Monet's London park views. Durand-Ruel's stock books refer to a "Parc de Richmond" (no. 1692) and a "Parc de Windsor" (no. 1697) purchased from the artist on May 11, 1872, neither of which are known to have been painted by Monet, and which are generally assumed to be the Providence and Philadelphia pictures; see London, Arts Council, 1973, p. 34. Cf. Paris, Grand Palais, 1980, p. 104, noting the sale of *Green Park* and *Kensington Gardens* to Durand-Ruel in 1872; and Wildenstein 1974, I, p. 192 (no. 164), which notes that the RISD canvas was sold to Durand-Ruel under the title *Kensington Gardens.* Chicago, AI, 1975, p. 81, on the other hand, identifies the view as *Green Park,* although no compelling argument is made for this reidentification. A view of *Green Park* exhibited with Durand-Ruel in the winter of 1872 is generally accepted as the Philadelphia picture; see Wildenstein 1974, I, p. 192 (no. 165), and Cooper 1954, p. 22, n. 1.

7. See London, Arts Council, 1973, p. 34, and Wildenstein 1974, I, p. 192.

8. London, Arts Council, 1973, p. 33. This view seems to be confirmed by examination of the picture under an ultraviolet light, which reveals substantial modifications in the middle ground, which Monet may have undertaken back in Paris, before it was acquired by Durand-Ruel.

9. Wildenstein 1974, I, p. 186 (no. 153); Paris, Musée d'Orsay, Galeries du Jeu de Paume. Although Wildenstein dates this painting from the spring of 1870, which would make it an important precedent for the Providence canvas, Herbert 1988, p. 219, has plausibly suggested a date of 1872. The location of the subject is uncertain. Wildenstein has proposed a view near Reuil or Chatou, whereas Herbert has suggested that this may be the eastern end of the Bois de Boulogne.

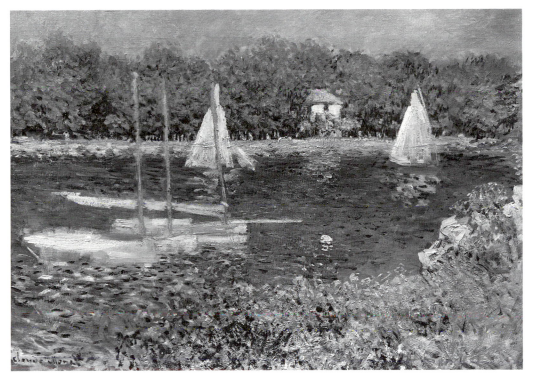

48 (color plate p. 24)

CLAUDE MONET
French, 1840–1926

48 The Basin at Argenteuil, 1874

Signed, lower left: *Claude Monet*
Oil on canvas. 21¾″ × 29¼″ (50 × 74.3 cm)
Anonymous gift. 42.219

PROVENANCE: Purchased from the artist for 80 francs by the Comte Jean de Rasty, possibly in 1877, under the title *Esquisse, Argenteuil;* purchased from Rasty by Alexandre Rosenberg for 3,500 francs, Paris, 1898; Lazare Weiller, Paris; Hôtel Drouot, Paris, sale L. Weiller, November 29, 1901, no. 32; Bernheim-Jeune, Paris; Gaston Bernheim de Villiers, Paris, 1919; M. Knoedler, New York, 1928; Carroll Carstairs Gallery, New York, 1936; Mrs. Murray S. Danforth, Providence, 1938.

EXHIBITIONS: Brussels, Libre Esthétique, 1904, p. 39 (no. 93); Paris, Bernheim-Jeune, 1921, no. 1; Paris, Bernheim-Jeune, 1925, no. 90; New York, Knoedler, 1931, no. 15; New York, Carstairs, 1935, no. 3; Boston, MFA, 1939, p. 60 (no. 83, pl. XLI); New York, Wildenstein, 1943, no. 29; New York, Wildenstein, 1945, pp. 21, 31 (no. 16); Pittsfield, Berkshire, 1946, no. 1; Providence, RISD, 1949, p. 23; Zurich, Kunsthaus, 1952, p. 20 (no. 32); St. Louis, City Art Museum, 1957, no. 18; Palm Beach, Four Arts, 1958, no. 8; Waltham, Rose, 1967, no. 22; New York, Acquavella, 1968; Chicago, AI, 1975, p. 86 (pl. 32); Los Angeles, LACMA, 1984, pp. 146-54 (no. 41); New York, IBM, 1988.

PUBLICATIONS: Bernheim-Jeune 1919, II, pl. 90; Elder 1924, pl. 16; Maus 1926, p. 323; Carstairs 1934, p. 33 (pl. XXIII); Carnegie 1936, n.p.; Frankfurter, December 1938, p. 9; *Providence* 1947, n.p. (ill.); Reuterswärd 1948, p. 282; Westheim 1953, p. 10; Hunter 1956, pp. 111-12 (pl. 7); Degand and Rouart 1958, p. 66; Seitz 1960, p. 29 (fig. 33); Rewald 1961, p. 357 (ill.); Bortolatto 1972, pp. 95-96 (no. 102, pl. XIV); Wildenstein 1974, I, pp. 72, 76, 254 (no. 325); Tucker 1982, p. 118 (fig. 87); Woodward and Robinson 1985, pp. 72, 195 (no. 113, ill.).

CONSERVATION: In 1953 the painting surface was cleaned, relined with Belgian linen and plenderleith wax resin adhesive, and stretched on a new basswood stretcher.

RELATED WORKS: *The Bridge at Argenteuil* (W. 311), 1874, oil on canvas, 23⅝″ × 31½″ (60 × 80 cm), Paris, Musée d'Orsay (R.F. 1937–41). *Highway Bridge at Argenteuil* (W. 312), 1874, oil on canvas, 23⅝″ × 31½″ (60 × 80 cm), Upperville (Virginia), collection of Mr. and Mrs. Paul Mellon. *Sailboats at Argenteuil* (W. 324), 1874, 23⅝″ × 31⅞″ (60 × 81 cm), France, private collection.

Following a year abroad that brought him first to London and then to Holland, where he sat out the Franco-Prussian War, the Commune, and its aftermath, Monet returned to Paris in the autumn of 1871. In December, through a family friend of Manet, he rented a house in Argenteuil, a small town northwest of Paris on the right bank of the Seine, seventeen miles downriver by boat, but a short seven miles by the hourly train which ran from the gare Saint-Lazare. Monet and family remained in Argenteuil until January 1878. It was their first real home – during the nine previous years Monet had lived in no fewer than eleven places – and the setting for a substantial increase in his artistic output. In the six-year period in which Monet lived in Argenteuil, he produced no fewer than 175 paintings, or roughly double the output of his previous thirteen years. Monet's Argenteuil paintings, in both style and subject, embody his complete maturity as an Impressionist: they encompass the development of the technique of "divided" strokes that convey the sensation of optical stimuli in varied conditions of light and atmosphere and the embrace of a world of urbane leisure in a natural landscape seemingly devoted to the recreation of middle-class city dwellers.

The representation of sailboats along the Seine is a prevailing feature of Monet's views of Argenteuil. In his previous

marine paintings of the waters around Le Havre, Honfleur, and Sainte-Adresse, and in later views of the ports of London and Zaandam, Monet focused almost entirely on commercial craft, painting the large merchant ships and fishing vessels that dominated the activity of these waters. Their inland counterparts, the barges that carried raw and manufactured goods up and down the river, are absent from his views at Argenteuil, even though they would have formed an important part of the river's traffic (he had included a barge in his earlier view of the Seine in *Honfleur;* entry 46). The ubiquitous sailboats of Monet's river views reflect Argenteuil's role as a major center for recreational boating, which had first become a popular sport during the Second Empire. The Seine around Argenteuil was particularly well suited to sailing, running an average depth of 21 meters and an average width of 195 meters, unencumbered by islands or curves.[1] In 1858 the Société des Régates Parisiennes established their sporting club, the Cercle de Voile, on the banks of the basin at Argenteuil. It was the site for the international sailing competitions of the 1867 Universal Exposition. By the time Monet settled there, it had become a celebrated center for pleasure boating in France, increasingly the domain of the middle classes. Boats such as those represented in the Museum's canvas could be rented for a few francs a day.

Monet was not himself a sailor (although he did acquire a large rowboat which he refurbished with a studio-shed, enabling him to paint from the middle of the river). Nevertheless, he was attracted to the water and to the idea of leisure sport suggested by his views of sailing boats. Seventy-five of Monet's Argenteuil paintings (or around forty-three percent) represent the basin of the Seine, and among these there are fifty-one paintings (or nearly thirty percent) that depict sailboats.[2] The basin, seen in the Museum's canvas, consists of the stretch of the Seine at Argenteuil where the river runs deepest (24 meters) and widest (208 meters), flowing beside the heart of town and bordered on the east (the viewer's right) by a highway bridge that runs into the center of Argenteuil, connecting it to the village of Petit-Gennevilliers on the opposite bank. The Museum's view of the basin was painted from the bank at Petit-Gennevilliers, looking across the Seine to the Promenade that runs along the Argenteuil bank; one can identify the dirt path of the Promenade, lined by a tall row of trees, which obscure the view of the town behind them. The single building appearing in this scene, formerly the ferryman's house, had been converted into a popular café-restaurant by the time that Monet painted it.[3]

The Museum's canvas has been dated to the spring or summer of 1874, contemporary with a similar view representing *The Bridge at Argenteuil* (fig. 1), which is signed and dated.[4] For the Musée d'Orsay picture, Monet must have positioned himself very near to the same spot from which he painted *The Basin at Argenteuil,* turning his glance a few degrees to the right, thus incorporating the highway bridge that is just out of view in the Museum's picture. The three boats moored in *The Bridge at Argenteuil* may be the same three boats in the foreground of the Museum's canvas. Lack-

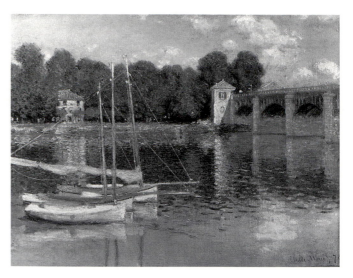

Fig. 1 Claude Monet, *The Bridge at Argenteuil,* 1874, oil on canvas, 23⅝″ × 31½″ (60 × 80 cm), Paris, Musée d'Orsay.

ing the bridge at the right end of the canvas, *The Basin* gives the impression of a more isolated setting, removed from the activity of the town. This is reinforced by the absence of figures, either by the café or along the Promenade on the opposite shore, or in the boats at sail, creating the fiction that this scene is the secluded domain of a solitary viewer.

The Museum's view of *The Basin* was painted in the immediate aftermath of the first exhibition of the Impressionist painters in Nadar's Paris studio, held in the spring of 1874, and demonstrates many of the innovations of style, then so radical, that were characteristic of Impressionism. Although a line of vision leading across the bows of the three moored boats to the old ferryman's house on the opposite shore suggests a vanishing point, the space is essentially layered, moving in horizontal bands proceeding from the bottom to the top of the canvas, recalling the spatial organization of Japanese prints. Monet has renounced conventional modeling, applying pure colors in broad and often thick strokes. The technique varies according to the object depicted: the foliage in the foreground is painted with the end of the brush in a thick, choppy impasto; the hulls of the boats, seeming to dissolve in the bright sunlight, are painted with broad, horizontal drags of the brush; the water is painted in short, parallel strokes, intermingling white and ultramarine, which suggest reflections on a surface stirred by a gentle breeze. As the space recedes, the density of the paint surfaces diminishes, giving the details closer at hand a more tangible presence. Although *The Basin* is less methodically painted than *The Bridge at Argenteuil* and more vigorous in its application of varied strokes, the pentimento of a sixth sailboat (located behind and to the left of the three moored boats) indicates that *The Basin* is a carefully calculated composition, painted over several sittings, belying the well-crafted impression that the viewer is contemplating a random and quickly rendered slice of nature.

Monet presents a vision of Argenteuil as a pastoral retreat on the water's edge where Parisians could escape the confines

of city life and renew their contact with nature. The reality was much more complicated. The construction of the railroad from Paris in 1851, making Argenteuil accessible to the masses, resulted in a dramatic growth in the town's population and industry.[5] By 1872 Argenteuil was no longer a rural community along the Seine. It had become a major industrial center, as well as a major recreational center, with significant factories for the manufacture of iron, embroidered textiles, crystal, cardboard boxes, chemicals, distilled alchohol, and milled lumber. Located downriver from Paris, its waters were progressively polluted by the tonnage of raw sewage and industrial waste poured into the river from sewer collectors at Asnières and Saint-Denis.[6] In the six years that Monet lived in Argenteuil, it very rapidly became a factory town, victim to the spoils of industry and rapid growth. Also conspicuous is the absence of any clue of this transformation in the views of the pleasure boats, gardens, and pastures that are the subjects of Monet's Argenteuil paintings. *The Basin* creates the very appealing illusion that this landscape is uniquely ours to behold, a pristine earthly refuge from the unpleasant by-products of modern life. It was this illusion that led the throngs from nearby Paris to Argenteuil, resulting in the eventual transformation of this once rural town into a blighted industrial suburb. D.R.

1. "Nowhere in the immediate vicinity of Paris does the Seine present to amateur boaters a basin as favorable in length and breadth as well as current as at Argenteuil." G. V., "Canotage," *Le Sport*, October 18, 1855, p. 4, quoted in Tucker 1982, p. 90.
2. Herbert 1988, p. 242, notes further that only three of these paintings show regattas and only two show people actually in their sailboats; twenty-one others give prominence to boats under sail, and another twenty-seven – more than half – concentrate on moored boats. Of these, among them the Museum's painting, eleven include sails in the distance, while the remaining sixteen are limited entirely to boats at anchor.
3. Herbert 1988, p. 243.
4. Elder 1924, fig. 16 (n.p.), is the first published source to date the Museum's canvas to 1874; cf. Reuterswärd 1948, p. 282, and Wildenstein 1974, I, p. 254 (no. 325), which also date this painting to 1874. According to Felix Wildenstein (Museum correspondence, letter dated 5/24/45), this painting can be said with certainty to have been painted during the spring of 1874, "at the same time as the *Pont d'Argenteuil* now in the Louvre." Other quite similar views from the same period include a version of the Paris picture presently in the collection of Mr. and Mrs. Paul Mellon (W. 312) and a view of a docked sailboat, its sails raised, called *Sailboats at Argenteuil* (W. 324). A noteworthy companion to the latter was painted by Renoir, probably at Monet's side, during a visit to Argenteuil in the summer of 1874 (Portland, Museum of Art).
5. In 1851 the town's population consisted of about 4,747 people (only about twenty-five percent greater than it had been in 1600); in the next two decades its population doubled; between 1872 and 1876 it increased by more than nine hundred people, and in the next five years it grew by an average of six hundred people a year, most of them itinerant workers in search of jobs. See Tucker 1982, pp. 15, 174-75.
6. According to Tucker 1982, p. 176, approximately 450,000 kilograms of sewage poured into the Seine daily, resulting in putrefaction and the production of noxious gases that bubbled from the sludge deposited along the banks at Argenteuil.

CLAUDE MONET
French, 1840–1926

49 *The Seine at Giverny*, 1885

Signed and dated, lower right: *Claude Monet 85*
Oil on canvas. 25⅞″ × 36½″ (65.7 × 92.7 cm)
Museum Appropriation, by exchange. 44.541

PROVENANCE: Purchased from the artist by Durand-Ruel, December 1885; Mrs. Potter Palmer, Chicago; Wildenstein & Co., New York; from whom acquired by exchange, 1944.

EXHIBITIONS: Andover, Addison, 1945; New York, Wildenstein, 1945, p. 46 (no. 50, ill.); Waltham, Rose, 1967, no. 23 (ill.); New York, MMA, 1978, pp. 21, 152, (no. 4, ill.); New York, IBM, 1988.

PUBLICATIONS: Wildenstein 1974, II, p. 166 (no. 1007, ill.); Woodward and Robinson 1985, p. 197 (no. 115, ill.).

CONSERVATION: In 1986 at the Williamstown Regional Art Conservation Laboratory a strip lining was attached to reinforce the tacking margins, and the painting was loose-lined onto an acrylic fabric. An old varnish and grime were removed from the surface, isolated areas of cleavage were consolidated, and pigment losses around the tacking margin were inpainted. No additional varnish was applied at this time.

RELATED WORKS: *The Seine Near Giverny* (W. 1006), 1885, oil on canvas, 25⁹⁄₁₆″ × 36¼″ (65 × 92 cm), private collection. *Branch of the Seine at Giverny* (W. 1008), 1885, oil on canvas, 25⁹⁄₁₆″ × 36¼″ (65 × 92 cm), Paris, Musée Marmottan.

Monet moved frequently in the first half of his career, residing in numerous spots along the Seine between Paris and Honfleur. He preferred rural locations to the city, the Seine serving as his axis, linking him to Paris and the sea. In April 1883, frustrated by financial problems and unable to work, Monet wrote to his dealer, Paul Durand-Ruel, asking for an advance that would enable him to move from the town of Poissy, where he was then living, to the country, where he hoped to resume work without distraction.[1] By the end of April he had moved to the village of Giverny, located approximately fifty miles northwest of Paris, halfway to Rouen, nestled in hills above the right bank of the Seine where it is joined by the Epte River flowing from the east. This tiny village of 279 inhabitants must have been known to Monet previously, for he had stayed briefly in Bennecourt, just less than two miles east of Giverny, in 1868 (see entry 46, fig. 1), and from 1878 to 1881 he lived in Vétheuil, six miles further east. Unlike Argenteuil, where Monet had lived from 1871 to 1877 (see above, entry 48), Giverny was rural and secluded, providing the isolation amid the river's natural beauty that he desired for his work. The train did not stop there, it was not a popular vacation spot, nor was it sought after by land speculators and industrial developers. Although he would continue to travel frequently and commute to Paris as his affairs required, Monet remained on the same property at Giverny for the rest of his life, purchasing it from his landlord in 1890. It was there that he planted his elaborate flower gardens, dug the water-lily pond with its Japanese-style footbridge, created the environment that increasingly became the

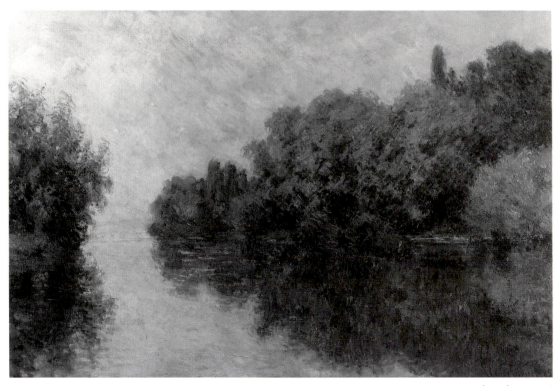

49 (color plate p. 25)

subject of his paintings, and it was there that he would die in 1926.

Monet's move to Giverny, coincident with the death of Manet on April 30, 1883, represents a major turning point in the history of Impressionism, as well as in the direction and focus of his work. The singularity of purpose which had linked the Impressionists through difficult times in the previous decade had been eroded by the growing differences between these artists. The seventh of the Impressionist group exhibitions occurred in 1882, the last in which Monet would exhibit. He had declined to show his work in the previous two Impressionist shows, as he would in the eighth and last, held in 1886. Monet, then in his mid-forties, had begun to reassess his work, growing ever more critical and frustrated with his achievements. "It has become increasingly difficult for me to be satisfied," he wrote to Durand-Ruel, "and I am beginning to wonder whether I am going crazy, or whether what I am doing is better or worse than what I had done previously, but simply that it is more difficult for me to do today things which previously I had done with greater ease."[2] And several months later: "I am working a lot . . . but to say that I am satisfied and that I have a lot of good things to show, that's different; the further I go, the more difficulty I have bringing a study to completion, and in this season, when nature changes so much, I am obliged to abandon paintings before their completion."[3] He wrote to Pissarro the following summer: "I, too, have worked a lot, but I have not been able to finish much. I am working doggedly on two paintings that have prevented me from finishing others, and in spite of the regular sun, I have had more difficulties than ever, and I have ruined many things."[4]

The Seine at Giverny, signed and dated 1885, is one of the few views of the river from the summer of that year that Monet evidently did bring to fruition. It is one of a series of three canvases that Monet painted on or around this site, near to the point at which the Seine is joined by a branch of the Epte River. Although there is no evidence to suggest that this and another similar view (W. 1006) are the paintings to

Fig. 1 Claude Monet, *Branch of the Seine at Giverny,* 1885, oil on canvas, 25⁹/₁₆″ × 36¼″ (65 × 92 cm), Paris, Musée Marmottan. Photograph by Studio Lourmel 77, Photo Routhier.

which he refers in his letter to Pissarro, they are clearly the product of a protracted effort, very different in technique from the third painting of this group, representing a similar if not identical view (fig. 1).[5] The broad and vigorous execution of the latter, which is identical in size to the Museum's canvas, gives it the character of a sketch, quickly painted before the effects of light had altered, blocking out a compositional format that may have been the point of departure for the RISD canvas. The Marmottan canvas appears to have been painted entirely *en plein air;* the RISD canvas, by comparison, may have been at least partly a studio effort.[6] In the RISD canvas, the overhanging branches in the upper left corner of the sketch, the boat strategically sitting in the channel between the island and the mainland, and the disturbance of the water's surface suggested by the broad horizontal strokes have all disappeared. Instead, Monet has built up a tightly painted network of smaller strokes, creating a thick impasto covering a broad spectral range of blue, green, purple, and vermilion. The forms are more simple and solid, reinforced by their symmetrical reflections, creating a view that is at the same time quieter, more dense and more self-contained, and less affected by the ephemeral effects of light and wind. The elimination of the anglers in the middle distance of the RISD view further eradicates the suggestion of present time.

The artist's comments about his work in his letters of this time, buttressed by such paintings as *The Seine at Giverny,* indicate the evolution of Monet's painting towards a more self-conscious, less spontaneous phase in which his goals became more defined and difficult to realize. While continuing to pursue the aims of Impressionism, rooted in an empirical approach to changing light and atmosphere, his painting became more self-sufficient, his compositions more simplified, monumentalized, and two-dimensional in appearance, with a greater emphasis on color and tonal harmonies. Monet began to work increasingly in series, repeating the same motif under varying conditions of light, the motif providing a control amid the variability of nature. One also finds a repeated emphasis on the reflection of light on water, resulting in the increased symmetry of compositions along the line where land and water meet, confounding three- and two-dimensional space, land and water, revealing the paradox of what Michel Butor has called Monet's "world turned upside-down."[7]

At a time in his career when Monet was reevaluating the direction of Impressionism in his own work, Giverny provided the solitude and rural beauty along the water's edge that he had been seeking in the years following his departure from Argenteuil. The world of leisure has been replaced by a view of nature undisturbed by humanity. *The Seine at Giverny* also reveals the increasingly abstract approach to painting that Monet was taking in these years. Its flattened space and organization into arabesques of subtle tonal complexity reveal an effort to monumentalize and poeticize his representations of nature's ephemeral effects, anticipating the series

of river views, called "Mornings on the Seine," that he would develop around 1897. Its creation at the beginning of his Giverny years suggests the importance of this setting to Monet's ever-growing modernity. D. R.

1. "I expect to leave for the country today to find a place to live, because in ten days we must leave Poissy. This all makes me very anxious, because presently I am not working at all – this now for a long time, and I am disgusted with it. If I were to set up in a fixed location, at least I would be able to paint and put a good face upon matters." Letter from Monet to Paul Durand-Ruel, April 5, 1883, quoted in Wildenstein 1974, II, p. 228 (no. 344).

2. Letter from Monet to Paul Durand-Ruel, December 1, 1883, quoted in Wildenstein 1974, II, p. 232 (no. 383).

3. Letter from Monet to Paul Durand-Ruel, October 24, 1884, quoted in Wildenstein 1974, II, p. 255 (no. 526).

4. Letter from Monet to Camille Pissarro, n.d. [summer 1885], quoted in Wildenstein 1974, II, p. 261 (no. 581).

5. There are six known views of the Seine from the summer of 1885, three (W. 1003-05) showing an identical view looking in the direction of Port-Villez, on the left bank of the Seine opposite Giverny, and the other three, including the RISD canvas, showing an identical or similar view of the Seine near the junction of the south branch of the Epte River (W. 1006-08). See Wildenstein 1974, II, pp. 166-67.

6. Concerning Monet's increased use of the studio, contrary to the myth that his paintings were all completed *en plein air,* see Tucker 1989, p. 25, and pp. 15-37 *passim,* concerning the general changes in Monet's art of the 1880's.

7. Butor 1967, p. 31.

JEAN-LOUIS-ERNEST MEISSONIER
French, 1815–1891

50 *Sketch for the "Outpost of the Hussars,"* ca. 1868

Signed, lower center: monogram *E* (reversed) *M*
Oil on panel. 12¼″ × 9⅛″ (31.1 × 23.2 cm)
Museum Works of Art Fund. 54.174

PROVENANCE: Hôtel Drouot, Paris, Sale M. L. Tabourier,
June 20–22, 1898, no. 39; H. M. Calmann, London, 1954.

EXHIBITION: New York, Shepherd, 1975, pp. 187–89 (no.
78, ill.).

PUBLICATION: RISD, *Museum Notes,* 1955, p. 15 (fig. 7).

RELATED WORKS: *Outpost of the Hussars* (first study for full
composition), 1868, oil on panel, 11½″ × 14″ (29 × 36 cm),
private collection. *Outpost of the Hussars (Petit poste de grand'
garde),* 1869, oil on panel, 10¼″ × 14¾″ (26 × 37.5 cm), Tarbes,
Musée International des Hussards.

Meissonier first exhibited at the Salon of 1834. He specialized
initially in small-scale, meticulously rendered genre scenes
of seventeenth- and eighteenth-century gentlemen and
cavaliers, typically reading, smoking, or playing cards in a
tavern. Described enthusiastically by critics like Théophile

Gautier and purchased by financially and politically powerful
collectors during the July Monarchy (until 1848) and Second
Empire (1852–70), these works brought Meissonier consid-
erable fame and prosperity. However, he aspired to paint
significant history and in 1859 persuaded the government
to convert a commission for a genre work into one for a
military painting depicting the current emperor's campaign
in Italy. The experience of producing *Napoleon III at the Battle
of Solferino* (1864, Compiègne, Musée National du Château),
however, disillusioned Meissonier about his ability to apply
his method of careful research and exhaustive detail to con-
temporary events.[1] It would be for his pupil Edouard Detaille
(1848–1912) and junior colleague Alphonse de Neuville
(1835–1885) to record the life of modern French troops,
creating battle paintings and military genre scenes whose
popularity derived in part from French nationalist sentiment
in the aftermath of the defeat by the Prussians in 1870.

Meissonier was an even more eminent contributor to the
tradition of nationalist military painting, but he turned his
talents almost exclusively to visualizing imagined moments
from past French history. During the second Empire and
then the Third Republic, he painted major scenes from the
military career of Napoleon I (d. 1821), notably *1814, The*

50

Campaign of France (1864, Paris, Musée d'Orsay), *1807, Fried-land* (1875, New York, Metropolitan Museum of Art), and *1805, The Cuirassiers Before the Charge* (1878, Chantilly, Musée Condé). As well as these many-figured epic paintings he also produced smaller works depicting one or a few ordinary soldiers on guard or relaxing off duty.

The 1869 *Outpost of the Hussars* (fig. 1),[2] shown at the Universal Expositions of 1873 and 1878, in Meissonier's 1884 retrospective, and finally his posthumous exhibition of 1893,[3] is one of the most important of such military genre paintings. Exhibiting the artist's celebrated skill at individualizing the character and mood of his figures, it focuses on four of Napoleon I's cavalrymen as, dismounted but still encumbered by sabers and rifles, they savor a brief rest. One, leaning casually against his white horse, talks reflectively with a companion, while a third, his horse grazing, concentrates on lighting his pipe; farther back a fourth hussar leads his mount away. Meissonier, who was an avid horseman, paid particular attention not only to the poses and gestures of the men, but to rendering the horses accurately, working from models in his own stables. He was equally painstaking with military attributes: the uniforms are those of eighth regiment hussars around 1804, and featured are their distinctive dangling pouches (sabretaches) and sheepskin-covered saddles, and the mustaches and before-the-ear braids that were essential to the hussars' dashing appearance.

The Museum's panel, preparatory for the figure on the right and his horse, is the earliest surviving sketch for this painting. It exemplifies Meissonier's typical practice of making separate studies of individual figures, later copying them into the final composition. Here he defined the position of the horse generally, leaving the early outline of another leg centered between the final front and back pairs. He posed the hussar, shown three-quarters from the back, with his left hand resting backwards on his hip and grasping the hilt of his long sword. He devoted his greatest effort to the brown horse's saddle, with its sheepskin cover and green roll, and the dark green uniform, trimmed in white, the pants striped with red and studded with glinting buttons. He gave special care to the cumbersome gear, notably the wide, buckled leather straps, the sabretache hanging from the belt, and great saber. Only dabs of brown in the lower right corner and a white smear setting off the horse suggest an environment.

The lower two-thirds of the panel is ruled into horizontal zones, numbered from one to six along the left edge. This sectioning facilitated Meissonier's copying the hussar and his horse to the first version of the full composition, a panel dated 1868 (fig. 2).[4] The hussar and his horse appear on the right, slightly reduced in size and somewhat sketchier, especially the horse, but with identical pose and details. In the finished version, signed a year later, Meissonier recast the activity and position of the center figure and horse in the trio, thereby shifting the emphasis from the pipe-lighter to the comfortable conversation between the center and right hussars. Like the pipe-lighter, however, the right hussar and his horse remain little changed. Meissonier substituted a different hat, completed the horse's harness, and refined various details, but otherwise essentially recopied the Museum's sketch, in which the key features of the figure were already announced so representatively. C.C.H.

1. See Hungerford 1980.
2. *Petit poste de grand' garde* or *Halte de Hussards,* 1869 (Tarbes, Musée International des Hussards, no. D. 56.4.2; bequest of Alfred Chauchard to the Louvre, 1910, R.F. 1865; dépôt 1957). Illustrated in Gréard 1897, opp. p. 316.
3. Vienna, *Exposition Universelle,* 1873, no. 481; Paris, *Exposition Universelle,* 1878, no. 631; Paris, Georges Petit, 1884, no. 80; Paris, Georges Petit, 1893, no. 903.
4. Paris, Hôtel Drouot, sale Meissonier, May 13–20, 1893, no. 97; New York, Sotheby Parke Bernet, May 4, 1979, no. 282, and October 12, 1979, no. 321.

Fig. 1 Jean-Louis-Ernest Meissonier, *Outpost of the Hussars (Petit poste de grand' garde)*, 1869, oil on panel, 10¼″ × 14¾″ (26 × 37.5 cm), Tarbes, Musée International des Hussards. Photograph by Lapeyre.

Fig. 2 Jean-Louis-Ernest Meissonier, *Outpost of the Hussars* (first study for full composition), 1868, oil on panel, 11½″ × 14″ (29 × 36 cm), private collection.

51

GUSTAVE COURBET
French, 1819–1877

51 *Jura Landscape,* 1869

Signed and dated, lower left: *G. Courbet. 69*
Oil on canvas. 23⅜″ × 28¹³⁄₁₆″ (59.5 × 73.3 cm)
Walter H. Kimball Fund and by exchange. 43.571

PROVENANCE: J. K. Newman, New York; R. C. and N. M. Vose, Boston; Julius H. Weitzner, New York.

EXHIBITIONS: New York, Weitzner, 1936, no. 31 (ill.); San Francisco, Museum of Art, 1936, no. 20 (ill.); Providence, RISD, 1956; Durham, Paul Art Center, 1960 (no. 29); Providence, RISD, 1972, p. 135 (pl. 45); Williamstown, Clark, 1974; New York, IBM, 1988.

PUBLICATIONS: Léger 1929, pl. 57; Fernier 1977, pl. 734; Courthion 1985, pl. 714.

In the 1860's Courbet turned to painting landscapes, quiet forest scenes, hunting pictures, and, later, marines, with vast expanses of sky. His major pictures of the *Stonebreakers* and *Burial at Ornans* of 1850, and *The Artist's Studio* of 1855, had been achieved, and the mood of his work generally became quieter and calmer. The Museum's *Jura Landscape* is one of many idyllic scenes of animals resting in safety, enclosed in a sanctuary of rocks and trees, and shows a favorite and beautiful place, known as Le Puits Noir (The Black Well), near the village of Ornans, where Courbet was born.

He and the other Barbizon painters were painting forest interiors, generally in Fontainebleau; but Courbet chose the country familiar to him. Having established himself in Paris, in 1839, he adopted a pattern of returning to Ornans for part of each year, and it was during these visits that he painted the Jura Mountains of the Franche-Comté in eastern France, with its streams and valleys, grottoes and gorges. Particularly in the mid-1860's Courbet would set up his easel at the entrance to the gorge of Le Puits Noir and paint it at different times of day and season and from various views.[1]

Courbet chose Le Puits Noir, where a small stream, the Brême, flows through a narrow gorge with steep rocks, as the subject for more than thirty canvases, with examples now in Paris, Baltimore, Chicago, Cambridge (Massachusetts), and Besançon.[2] He was in Ornans in 1869 until May or June, so he could have painted *Jura Landscape* from nature. It was his custom to return from the country with a quantity of paintings, some of which he completed in his Paris studio. This was the case with the Musée d'Orsay's *Deer in Covert by the Stream of Plaisir-Fontaine (Doubs),* 1866, where the animals were added some months later.[3] The fact that the seated deer in the Providence painting is identical (but in reverse) to the deer in at least four other paintings (the Musée d'Orsay's canvas; a picture in the Musées Royaux des Beaux-Arts, Brussels, with the same title, about 1866; and two paintings in private collections, *Stags in the Forest,* 1868, and *Roe-bucks,* ca. 1869),[4] together with its being painted very smoothly and differently from the rest of the canvas, suggests that Providence's *Jura Landscape* may also have been completed in the studio. Altogether, there is a sense of a

more or less successful pastiche, rather than a true integration of deer, trees, rocks, and stream.

The prime example of Courbet's additive manner of working is *The Quarry,* 1857 (Boston, Museum of Fine Arts), with its six separate elements on different pieces of canvas, literally sewn together. It was the first of Courbet's many hunt pictures, which were a natural consequence of his art and avocation. As a solitary hunter, he tramped through the forests of the Jura Mountains, tracking down wolves and hares, and in spite of his compassion for animals and his political and social sympathies for the proletariat, he shared his love of the hunt and sport of killing with the aristocracy at Rambouillet, where he followed the imperial hunts, and in Germany, where he was as proud of the large stag he had killed as he was of his reputation as a painter. He knew and painted the aristocratic rituals of the hunt: *le change,* when the stag passes his scent on to another stag; *le bat l'eau,* when the stag throws himself into a shallow pool and makes his last stand; *l'hallali par terre,* the death of the stag; and *la curée,* when the quarry is ready to be skinned and disemboweled.[5]

Landscapes generally were the only type of Courbet's paintings that were popular during his lifetime, and they formed by far the largest part of his work. They were acquired by wealthy patrons, such as the comte de Nieuwerkerke, who bought *The Sheltered Stream (Puits Noir),* 1865, now in the Musée d'Orsay, for Napoleon III,[6] and by the middle-class city dweller, who might commission a painting by its known motif, for example, a *Puits Noir,* and to some extent, even dictate the accessories it contained: a fisherman, a boat, so many rocks, a deer.[7]

Courbet loved rocks, drew and painted them all his life, and was a one-time member of the Société d'émulation du Doubs, which studied the history and rock formations of his native countryside.[8] His unorthodox way of using paint and his willingness to use whatever means to apply it quickly, with palette knife, rag, or finger for the rocks and sponge for the foliage, eliminates detail and draws attention to the surface of the canvas, so that there is a play between the surface and the view into the forest, down the stream and into the depths of the dark water and its reflections, that anticipates the later paintings of the Impressionists. The total effect is of a tranquil forest scene with an animal, alone, in safety, but whose vulnerability a hunter would recognize very well.

M.R.

1. Callen, 1980, p. 93.
2. *The Sheltered Stream,* or the *Puits Noir,* 1865, Paris, Musée d'Orsay; *The Puits Noir,* ca. 1860–65, Baltimore, Baltimore Museum of Art, Cone Collection; *The Stream of the Puits Noir,* 1868, Chicago, Art Institute of Chicago; *The Puits Noir,* 1865, Cambridge, Fogg Art Museum, Harvard University; *The River Brême,* 1865, Besançon, Musée des Beaux-Arts.
3. Boston, MFA, 1960, p. 96.
4. Fernier 1977, nos. 552, 553, 645, 729.
5. Robinson 1990, p. 1.
6. Brooklyn, Brooklyn Museum, 1988, p. 121.
7. Wagner 1981, p. 417.
8. Chu 1988, p. 57.

CHARLES-FRANÇOIS DAUBIGNY
French, 1817–1878

52 *Landscape,* 1871

Signed and dated, lower right: *Daubigny 1871*
Oil on panel. 15″ × 26⁷⁄₁₆″ (38.2 × 67.2 cm)
Mary B. Jackson Fund. 73.120

PROVENANCE: Private collection, Providence.

EXHIBITION: San Francisco, AMAA, 1986–88, p. 23 (no. 7, ill.).

PUBLICATIONS: *Gazette des Beaux-Arts,* Feb. 1974, p. 139 (no. 451, ill.); *Art Journal* 1974, pp. 247, 249 (ill., incorrectly captioned).

Charles-François Daubigny was an important member of the Barbizon school of landscape painting in mid-nineteenth-century France. Compared to other members of the Barbizon school, such as Théodore Rousseau, Jean-François Millet, or Jules Dupré, however, Daubigny spent relatively little time in the Barbizon forest – the wooded area around Fontainebleau – or the town of Barbizon at the edge of the woods, which served as the group's geographic locus. Most of Daubigny's landscapes depict sites along the Seine, Oise, and Marne rivers north of Paris. In 1860, he settled in the village of Auvers-sur-Oise and spent much of his time in a studio-boat, nicknamed "Le Botin" ("The Little Box"), which he had constructed to enable himself to paint water scenes.

The open-air esthetic and freely brushed technique of the Barbizon painters helped pave the way for the Impressionists in the latter part of the century. Daubigny's *Landscape* in the RISD collection, painted in 1871, during the formative years of Impressionism, shows the active brushwork and attention to atmospheric effects associated with artists of the Impressionist generation, such as Boudin and Monet, both of whom he knew. Other features, however, such as the dark palette, rustic theme, and expressive undertones, place the work within the older Barbizon tradition with its ties to Romantic painting.

Daubigny was born in Paris, but he spent a number of his childhood years in Valmondois, north of the capital. This village became, along with Auvers-sur-Oise, the site of many of his future landscape scenes. After initial training from his father, a landscape painter, Daubigny found work restoring paintings in the Louvre and at Versailles and accumulated enough money to travel to Italy at the age of nineteen. Returning to Paris after ten months, he worked as an illustrator for publishing houses. In 1838 a cityscape, *View of Notre-Dame and of the Ile-Saint-Louis,* was his first painting to be accepted in the Salon. In 1848 he was awarded a second-class medal, and success continued in 1853 with a first-class medal and the purchase by Napoleon III of his *Pond of Gylieu* (Cincinnati, Cincinnati Art Museum), the fifth landscape by Daubigny to have been acquired by the State.[1] The sum of these successes reflects the growing prominence of landscape in the Salons of the mid-nineteenth century and of Daubigny's contribution to the popularity of the genre, hitherto consid-

52

ered inferior to history painting.

Much of Daubigny's *oeuvre* beginning in the late 1850's consists of water scenes painted from "Le Botin," which he launched in 1857. Daubigny also traveled frequently in France and abroad, including a voyage to Switzerland in 1852 in the company of Camille Corot, trips to London (1865, 1866, 1870) and Spain (1869), as well as regular visits to the Atlantic and Channel coasts. He exhibited a landscape reportedly painted entirely out-of-doors in the Salon of 1864 (*Villerville-sur-Mer,* The Hague, Mesdag Museum),[2] reflecting his influence on the Impressionists' insistence that canvases completed in the open-air were legitimate works worthy of public exhibition; the prevailing method, even for Daubigny, dictated completion of landscapes in the studio, using outdoor sketches only as memory aids. Daubigny's support for the Impressionists was further demonstrated in 1866, when, as a member of the Salon jury, he championed Pissarro, Cézanne, and Renoir.[3]

The small size and sketchy execution distinguish the Museum's work, an informal study, from the larger, more highly finished canvases intended for exhibition in the Paris Salons, which Daubigny would more typically execute in his studio, often working from sketches such as the RISD panel. Judging from its similarity to other of Daubigny's landscapes set in rural France, the panel in Providence probably depicts a site along the Oise River close to his home in Auvers and was in all likelihood painted entirely on location.[4] The painting is consistent in format with the two sources from which Barbizon artists in general and Daubigny in particular drew their inspiration: the seventeenth-century little masters of landscape in Holland and the nineteenth-century British landscape school led by John Constable. The Anglo-Dutch esthetic manifests itself in Daubigny's low, flat horizon (interrupted only slightly by the trees on the left and gently rising slope to the right); the grayish palette; and the vigorously brushed, unstable sky.

The water meeting the shoreline in a wide V-shaped or zig-zag pattern is seen often in Daubigny's river views, as are the small, anecdotal figures near the water's edge, in this case, a woman herding geese and two washerwomen.[5] These details, along with the cow and two tiny figures on the hill in the far distance, establish an air of peaceful rusticity, stirred by the dark, shifting storm clouds. In the sky above the prosaic terrain, motion is generated by curving patterns in the clouds, painted with a stiff-bristled brush and thick paint. The vigorous handling and flickering illumination show the influence of Constable. The land and water, by contrast, are painted with more fluid pigment and a softer brush, the tonalities streaked on in relaxed, wet-on-wet strokes.

The relatively dark palette as well as the subjectivity of his approach separate Daubigny from the Impressionists. For example, Monet's depiction of a bay with billowing clouds in *Honfleur* (entry 46), a painting which is nearly contemporary with Daubigny's *Landscape,* has a lighter value scheme, a bolder, less detailed sense of form, and is executed with freer, more open brushwork. Beyond matters of style, however, the emotional overtones found in Daubigny's works, including the small RISD panel – nostalgia for the unchanging rural world, reverence for nature, tension suggested by the unsettled sky – became less important to the Impressionist generation in their quest for objective rendering of open-air light effects. While seldom indulging in the more dramatic presentations of nature's violence, majesty, or splendor favored by his Barbizon colleagues Rousseau or Narcisse Diaz, Daubigny's art, for all its realism, reveals a sensibility that remains tinged by Romanticism. D. E. S.

1. The State purchased two works from the Salon of 1851 and two more from the 1852 Salon. See Fidell-Beaufort 1975, pp. 44–45.

2. See F. Henriet, *Les Campagnes d'un paysagiste*, Paris, 1891, p. 43, cited in Fidell-Beaufort 1975, p. 55.

3. Despite Daubigny's efforts, only Pissarro was admitted. See Fidell-Beaufort 1975, p. 57.

4. I am grateful to Madeleine Fidell-Beaufort, Paris, for her assistance with this entry, particularly her suggestion for the location pictured. My thanks also to Ruth Meyer, Taft Museum, Cincinnati, and Bonnie L. Grad, Clark University, Worcester, for their help.

5. Paintings by Daubigny with similar compositions or motifs include *Sunset on the Oise,* 1865 (inv. no. R.F.1806) and *The Arques Valley,* ca. 1876 (inv. no. R.F.1807), both Paris, Musée d'Orsay; *River Landscape,* 1863, New York, Metropolitan Museum of Art; cf. also Hellebranth 1976, nos. 326, 388, and Fidell-Beaufort 1975, no. 92. A comprehensive discussion of Daubigny's river views is found in Grad 1977, pp. 76–106.

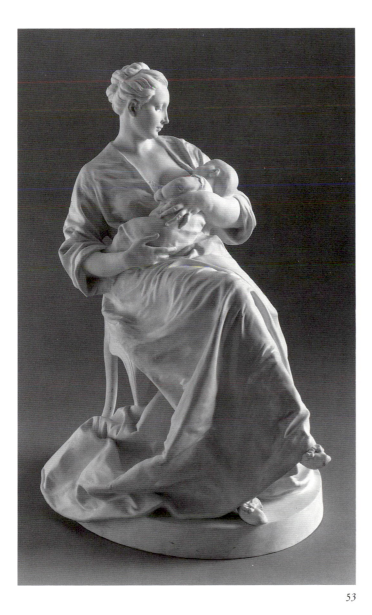

53

JULES DALOU
French, 1838–1902

53 *Maternal Joy,* original 1872

Signed, right base: *DALOU;* stamped, rear base: *S/1912* (in triangle); *SEVRES* (in rectangle); *I*
Porcelain (Sèvres). 20″ × 13⅛″ × 13¹⁵⁄₁₆″ (50.8 × 33.3 × 35.4 cm)
Gift of Mrs. Zechariah Chafee. 34.1375

EXHIBITION: Providence, RISD, 1950.

PUBLICATION: Keith 1953, pp. 3–7 (ill.).

RELATED WORKS: *Maternal Joy (esquisse),* ca. 1872, terra cotta, h. 9¾″ (24.8 cm), Middlebury, Johnson Gallery, Middlebury College. *French Peasant nursing her Child,* 1873, plaster, Paris, Musée du Petit Palais. *Boulonnaise Woman nursing her Child,* 1877, plaster, Paris, Musée du Petit Palais. *La Liseuse,* 1877, plaster, Paris, Musée du Petit Palais.

54 *Woman Reading*
(La Liseuse), 1873

Signed and dated, left base at sitter's feet: *DALOU/1873*
Terra cotta. 12″ × 17½″ × 16″ (30.5 × 44.3 × 41 cm)
Museum Works of Art Fund. 54.187

PUBLICATION: RISD, *Museum Notes,* 1955, n.p. (fig. 9).

RELATED WORKS: *Brodeuse (ébauche),* 1870, plaster, Paris, Musée du Petit Palais. *La Liseuse,* 1877, plaster, Paris, Musée du Petit Palais. *La Liseuse,* 1878, terra cotta, Paris, Musée du Petit Palais.

55 *Angel with Child,* ca. 1877

Signed, left base: *DALOU;* stamped, rear base: *CIRE/PERDUE/ A.A. HEBRARD*
Bronze. 12⅛″ × 4¾″ × 4¹⁵⁄₁₆″ (30.7 × 12.1 × 12.6 cm)
Gift of Mrs. Henry D. Sharpe. 59.152

RELATED WORKS: *Angel with Child (maquette),* ca. 1877, terra cotta, Paris, Musée du Petit Palais. *Windsor Monument,* 1878, terra cotta, Windsor, Windsor Castle, Royal Chapel.

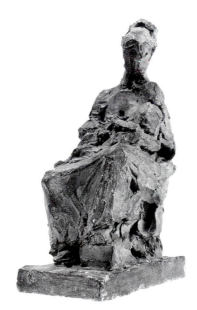

Fig. 1 Jules Dalou, *Maternal Joy (esquisse),* ca. 1872, terra cotta, h. 9¾″ (24.8 cm), Middlebury, Johnson Gallery, Middlebury College.

During the 1860's, Dalou worked exclusively in Paris and primarily as a decorative sculptor. His early training at the Petite Ecole (Ecole Gratuite de Dessin) had prepared him for this kind of work, and he excelled at it. His fine ornamental sculpture can still be seen in Paris on the façades of 4, rue de la Paix and Hôtel Menier on Parc Monceau, and on the interior of the Travellers' Club (formerly Hôtel Païva) on the Champs Elysées. Dalou also aspired to become a famous, successful sculptor and had been trained toward that end at the Ecole des Beaux-Arts. Four times he exhibited at Salons during the 1860's, but all of these sculptures were minor pieces and attracted little or no attention.

Finally, at the Salon of 1870, Dalou won recognition and achieved success with his life-size plaster statue of a modern urban woman dressed in contemporary clothing, seated and embroidering. Such a subject treated by a sculptor at this scale without any elevated historical or literary associations was a novelty that both critics and the public greeted enthusiastically. This *Brodeuse* won a Third Class Medal and was purchased by the State, which also commissioned a marble version to be carved from the plaster model. Because of the Franco-Prussian War, Dalou's involvement with the Commune, and his subsequent flight to London, this marble was never carved, but the *Brodeuse* itself was the point of departure for and direct ancestor of many of Dalou's finest works executed during the 1870's in London, where he and his family spent their nine-year exile prior to the amnesty proceedings of 1879–80. These embroiderers, sewers, and readers treated with such freshness, modernity, and artistic seriousness by Dalou are the contemporary and qualitative equivalents in sculpture of comparable subjects treated by Manet and the Impressionists. Dalou did exhibit bronze reductions of the *Brodeuse* on at least two occasions, but otherwise these genre pieces of the 1870's fall into the category of intimate works to be enjoyed on the tabletops of connoisseurs, not in public exhibitions. Private collectors were eager to acquire them, and the preferred medium was terra cotta.

During his years of exile in England (1871–80), Dalou created a number of images of contented mothers nursing their babies, among them *Maternal Joy,* the work largely responsible for establishing Dalou's reputation in England. He sent three pieces to the Royal Academy exhibition of 1872: a statuette and a portrait medallion, both in terra cotta, and a life-size version of this nursing mother, in plaster patinated to resemble terra cotta. Unlike the statuette, which was exhibited with a French title, this life-size work appeared with the English title by which it is still known. Critical response was enthusiastic toward *Maternal Joy* and the French sculptor who was making his debut at the Royal Academy. Typical of the press reaction are the words of an anonymous critic for *The Atheneum,* who on May 25, 1872, praised the statue for its "great beauty, naturalness and simplicity."

The unification of form and content seems effortless in this work, which is at once universal in its theme and tem-porally specific. Only an artist as thoroughly grounded in sculptural tradition as Dalou could have created such a masterful sense of volume, rhythm, and surface animation. Only a man as committed to the moral urgency of creating art from the experience of modern life could have so successfully fused contemporary furniture and fashion with the archetypal concept of motherhood. An idea of Dalou's methodical, painstaking, and wholly professional working method, which was typical of nineteenth-century sculptural practice, can be gained by comparing a preliminary terra-cotta *esquisse* (fig. 1) with the finished version of *Maternal Joy.* In the sketch one can observe Dalou's initial thematic concept and formal ideas emerging as he spontaneously and knowingly applied small masses of clay and manipulated them with his working tools.

It has repeatedly been observed that *Maternal Joy* is a portrait of Madame Dalou and their infant daughter, Georgette. There may be an element of truth to this assertion, but only if one believes that he based the work on memories from the past. All of the faces of his adult female figures (and probably the bodies of his nudes) echo Madame Dalou's features to some extent, but at the time Dalou created this group, their daughter was a five-year-old child and not a suckling infant.

When Dalou returned to Paris in 1880 after the amnesty proceedings of 1879–80, he brought with him reduced models of some of his most successful English-period works, including *Maternal Joy.* We know that Dalou spoke disapprovingly about the concept and practice of editions, but he nevertheless allowed some of his work to be edited during his lifetime. About 1884, Haviland produced a brown stoneware

Fig. 2 Jules Dalou, *French Peasant nursing her Child,* 1873, plaster, Paris, Musée du Petit Palais.

edition of *Maternal Joy* from Dalou's model.[1] Sèvres also did at least one porcelain edition of the piece during Dalou's lifetime; one example from such an edition was included in his estate sale.[2] The Museum's sculpture is stamped "Sèvres" and "1912." Bronze casts of *Maternal Joy* may also have been made in France or England during Dalou's lifetime. Both Hébrard and Susse did editions of the work after his death.

Once Dalou established a subject or compositional solution as his own, he often repeated it in a somewhat altered form, in the manner of a theme and variations. After his critical success in 1872 with this celebration of modern, urban motherhood, Dalou soon found himself busily engaged creating portraits and intimate themes, including nursing mothers, for private collectors. Among his patrons were some of the greatest connoisseurs and collectors of the era: the Howard, Grosvenor, and Rothschild families; Constantine Ionides; Colonel Heseltine; and Sir Coutts Lindsey. Dalou explored the possibilities of the same subject enacted by a peasant woman and her child. In 1873 at the Royal Academy, he exhibited a *Paysanne française allaitante* (fig. 2) and in 1877 a *Boulonnaise allaitante* (fig. 3); both of these life-size, terra-cotta groups recapitulated the success of *Maternal Joy*. In 1874 he did a variant on the "urban mother nursing" theme, but did not exhibit this version publicly.

In 1877 Dalou appropriated the basic pose of *Maternal Joy,* reversed the crossing of the legs, and substituted a book for the baby, transforming his nursing mother into a fully clothed modern *liseuse* (fig. 4) in plaster. This figure was edited in brown stoneware[3] and Sèvres porcelain during Dalou's lifetime; one of these porcelain *liseuses* was in his

Fig. 4 Jules Dalou, *La Liseuse,* 1877, plaster, Paris, Musée du Petit Palais.

private collection at the time of his death.[4] Another *liseuse,* this one a terra-cotta nude seated in a stuffed armchair (fig. 5), is signed and dated 1878; it was cast in bronze by Hébrard, but not edited. The Museum's terra-cotta *liseuse* is earlier, signed and dated 1873. During this decade, Dalou would sometimes cast several terra cottas from the same mold and rework the damp clay of each casting before firing it, thus producing an original variant of what had begun its existence as a multiple. The Museum's *liseuse* is an example of this procedure. Henriette Caillaux illustrated a *liseuse* which in 1935 belonged to Mme Charles Pomaret and is in many respects identical to the Museum's piece.[5] The Museum's *liseuse* was never cast in bronze or edited; it is most probably unique, but there might be other terra-cotta variants that have not yet come to light. Almost certainly the Museum's and the Pomaret versions were cast from the same basic mold, but Dalou's masterful, inventive reworking transformed each of them into an original sculpture. It is tempting to group the two seated readers and the Museum's reclining *liseuse,* all regarded as finished sculptures by Dalou, as a trinity.

When Queen Victoria decided to commission a monument to commemorate her dead grandchildren, she chose Dalou, surely on the advice of her daughter Princess Louise, who was both a sculptor and Dalou's pupil. The final version of this monument (fig. 6) consists of a seated angel who holds three infants in his arms while two older, quite animated children rest on the sculpture's base, one sitting at the angel's feet and the other standing between his knees. This

Fig. 3 Jules Dalou, *Boulonnaise Woman nursing her Child,* 1877, plaster, Paris, Musée du Petit Palais.

Fig. 5 Jules Dalou, *La Liseuse,* 1878, terra cotta, Paris, Musée du Petit Palais.

statuary group is made of terra cotta and is just under thirty-two inches high. Signed and dated 1878, it is located in the private Royal Chapel at Windsor Castle.

The work seems to embody unresolved, contradictory impulses. A royal commission but intimate in scale, an assured handling of sculptural masses but an uncertain iconographic conception – the group is poised uncomfortably between the realms of public and private art; since it is Dalou's first commissioned monument, this is perhaps understandable. Certain questions seem inevitable, but there are no satisfactory answers. Is this a guardian angel or the angel of death? Are the three infants in his arms meant to be dead, or merely sleeping, according to the frequently encountered euphemism of Victorian-era mortuary sculpture? Is the angel meant to be male, female, or neuter? Although the work was meant to be intensely serious, the upward gaze of this angel and the crowded bouquet of infants in his arms convey an unintentionally humorous note, as if this were an angelic babysitter harassed by too many royal charges.

A far more satisfactory sculpture resulted from an earlier stage in the monument's conception, which Dalou brought to an advanced state of completion. This terra-cotta maquette

54

Fig. 6 Jules Dalou, *Windsor Monument,* 1878, Windsor, Windsor Castle, Royal Chapel.

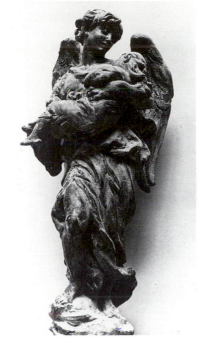

Fig. 7 Jules Dalou, *Angel with Child (maquette),* ca. 1877, terra cotta, Paris, Musée du Petit Palais.

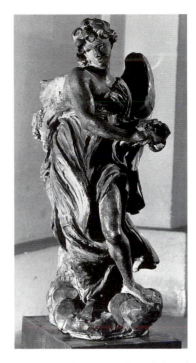

Fig. 8 Gianlorenzo Bernini, *Angel* (maquette for the Ponte Sant'Angelo, Rome), Paris, Musée du Louvre.

(fig. 7) of a standing angel holding a single child in his arms was among the contents of Dalou's studio at the time of his death in 1902. His executors had an edition cast after this maquette (many other studies and final versions of Dalou's sculptures were cast in bronze editions at this time) by the firm of A. A. Hébrard, and the Museum's bronze is one of those posthumous castings.

Dalou's works with an internal narrative or emotional focus tend to be much stronger than those in which the focus is externalized. The intense gaze of this angel at the child whom he holds so tenderly in his arms repeats the emotional intimacy seen in the Museum's *Maternal Joy.* The active pose and lively drapery rhythms, the raised leg exposed to mid-thigh, and the wings forming three-dimensional, protective echoes and volumetric complements to the volumes of the angel and child are all derived from Bernini (fig. 8). When Dalou was first faced with the task of choosing an iconographic conception appropriate for Queen Victoria's monument, he recalled Bernini's terra-cotta maquette in the Louvre collections, which he clearly had studied closely. His memory of this splendid sketch for one of the Ponte Sant'Angelo angels by the great Baroque master was still vivid at the time that he made this early sketch for the Windsor monument, even though he had not seen the Bernini for at least six years. In this precocious borrowing from a great sculptor who was largely unappreciated at the time, Dalou followed the example of his early master, Jean-Baptiste Carpeaux (see entries 38–41), whose sculptures often allude to works by Bernini as well. In place of the unfathomable,

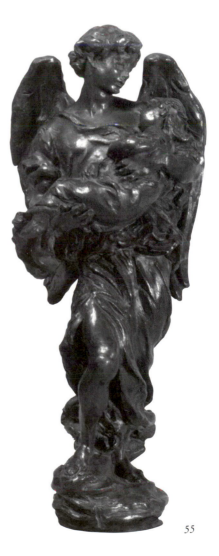

55

passionate grief with which Bernini had invested this angel who contemplates a relic of Christ's passion, Dalou substituted his own brand of comprehensible, loving, human interaction, adapting the Italian sculptor's formal language to new and modern ends.

One cannot be certain why Dalou abandoned such a superb conception and its masterful realization for something far less satisfactory in the definitive monument. One suggestion has linked the increased number of children to additional royal deaths in the 1870's. Victoria may have preferred a more literal accounting of her deceased grandchildren to Dalou's more symbolic rendering with a single child. This is only speculation, but it offers a possible explanation. Dalou may have been willing to accommodate Her Majesty even though it meant a qualitative dilution of his first, distinguished conception for the monument.

When Dalou returned to France from exile in 1880, he was a transformed artist. The Communard who fled to England in 1871 had been a sculptor on the verge of a major career based upon intimate themes taken from modern life. He came back to Paris a mature artist, a successful professional who no longer believed that intimate themes were worthy of his ambition. For the next twenty-two years, he devoted most of his considerable energies to monument-making, which he, like every other late-nineteenth-century sculptor, regarded as the highest aspiration of his profession. He abandoned the intimate themes which had been the foundation of his early career, except for the models which he brought back from England and allowed to be edited in ceramic and porcelain. J. M. H.

1. D'Albis 1971, p. 175.
2. Paris, Hôtel Drouot, 1906, no. 107.
3. D'Albis 1971, p. 175.
4. Paris, Hôtel Drouot, 1906, no. 108.
5. Caillaux 1935, pl. XV, opposite p. 112. Presumably Caillaux examined this terra cotta in the collector's home, but she gives no dimensions. Also, Caillaux was unaware of Dalou's working procedure outlined above; she merely calls the piece a "terre cuite originale."

SILVESTRO LEGA
Italian, 1826–1895

56 *The Dying Mazzini,* 1873

Signed and dated, lower right: *S. Lega 73*
Oil on canvas. 30⅛″ × 39½″ (76.5 × 100.4 cm)
Helen M. Danforth Fund. 59.071

PROVENANCE: Mr. B. Tunstall Behrens, Devizes (Wiltshire); Christie's, London, sale, June 5, 1959; Julius Weitzner, London, from whom purchased, 1959.

EXHIBITIONS: Hartford, Wadsworth, 1961, pp. 6, 25 (ill.); Providence, RISD, 1970, p. 43 (no. 32, ill.); Columbia, Museum of Art, 1972, p. 82 (no. 35, ill.); Bologna, Museo Civico, 1973, pp. lii, lvi, 48–51 (no. 57, ill.); Munich, Haus der Kunst, 1975, pp. 28, 176–77, 179 (no. 171, ill.); Williamstown, Clark, 1982, pp. 28, 34 (no. 38, ill.); Rome, Palazzo Venezia, 1982, I, pp. 143, 198–99 (no. 8.4, ill.); Los Angeles, UCLA, 1986, p. 104 (no. 29, ill.); New York, IBM, 1988.

PUBLICATIONS: Milani n. d., p. 845; Martelli 1873, pp. 124–25, 128; Pavan 1873, p. 160; Martelli 1885, pp. 11–12 (ill.); *Il Popolo* 1895; Signorini 1896, p. 12; Franchi 1902, p. 72; Càllari 1909, p. 242; Lega 1910, pp. 467–68 (ill.); Franchi 1922, p. 51; Florence, Palazzo, 1922, p. 124; Modigliana 1926, p. 15; Tinti, *Lega,* 1926, p. 64; Tinti, March 1926; Zanelli 1926, pp. 58–59; Zanelli, *Arte Romagnola,* 1926, p. 144; Corna 1930, p. 583; Tinti 1931, p. 4; *Camicia Rossa* 1938, p. 40; Franchi 1940, pp. 177, 191; Bargellini 1944, p. 290; Franchi 1945, pp. 110, 121; Viviani 1946; Franchi 1947; Calzini 1951, p. xii; Vitali 1953, p. 128 (no. 14); De Logu 1955, pp. 26, 93; Zambelli 1956, p. 89; Perer 1957, pp. 21, 29–30, 64; Borghi 1959, p. 29; Lang 1959, p. 283; *Corriere della Sera* 1960; *Nazione* 1960; *Pensiero Mazziniano* 1960; Carter 1961, p. 17; Bovi 1963; Giardelli 1965, pp. 69, 70 (n. 1), 176 (fig. 26); De Grada 1973 (ill.); Pasini 1973 (ill.); Quinsac 1973, pp. 302–03 (no. 2, ill.); Bidoli 1975; Mesirca 1975, p. 68; Monteverdi 1975, I, p. 151; Paloscia 1975; Florence, Forte di Belvedere, 1976, pp. 9, 33; Marmori 1976, p. 103 (ill.); Paloscia 1976; *Storia degli Italiani* 1976, p. 1514; Matteucci 1977, pp. 142–46 (fig. 3 and color plate); Durbé 1978, p. 53; Monneret 1978, p. 325 (dated 1872); Lyons, Beaux-Arts, 1981, p. 29; Dini 1984, p. 155 (fig. 97); Marabottini 1984, pp. 244–45, 247, 259, 261 (fig. 195); Monti 1984, p. 76; Broude 1987, pp. 167–71 (fig. 65); Cologne, Wallraf-Richartz, 1987, p. 70 (fig. 48); Matteucci 1987, I, pp. 215–22 (fig. 44), and II, pp. 130–32 (no. 144, ill., as *Gli ultimi momenti di Giuseppe Mazzini*); Lyons, Beaux-Arts, 1988, p. 75 (fig. 48); Milan, Palazzo, 1988, p. 41.

CONSERVATION: The canvas was relined and the painting surface cleaned in 1959.[1]

RELATED WORK: *Study for The Dying Mazzini,* 1873, oil on canvas, 15¾″ × 23⅝″ (40 × 60 cm), Comune di Modigliana, Museo Civico.

On March 10, 1872, Giuseppe Mazzini, the Italian patriot who had fought tirelessly for almost forty years to achieve his dream of a unified Italy, died with the knowledge that his vision had been only partially realized. In February of 1872, he had traveled, gravely ill, from the home of friends in Lugano to a residence in Pisa, where he passed his last weeks. Within several days after hearing of Mazzini's death, the painter Silvestro Lega, who had fought in one of the unification campaigns in 1859, made his way to Pisa to pay his respects to one of the great heroes of his youth. A number

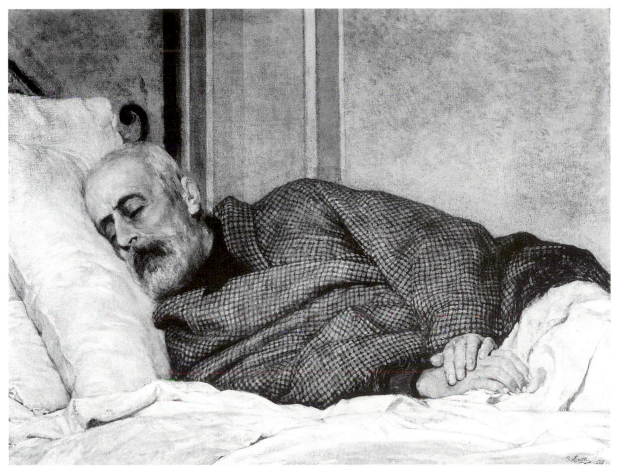

56 (color plate p. 26)

of works were inspired by this visit: an alleged sketch of the death chamber, now lost; a small study of Mazzini's head (fig. 1); and the painting in the RISD Museum, *The Dying Mazzini,* which went on exhibition at the Accademia delle Arti del Disegno in Florence on October 12, 1873.

Lega was a member of the Macchiaiolo school, a group of painters active for several decades beginning in the 1850's. They are traditionally viewed as Italian pre-Impressionists, roughly parallel to the Barbizon school of open-air landscape painters in France. Like their French counterparts, the Macchiaioli sought to capture the effects of natural, outdoor illumination with free brushwork and informal compositions painted *dal vero* (directly from life).[2] Lega's conversion to the modernism of the Macchiaioli came relatively late, following years of training and practice in academic methods that began at the academy of Florence in 1843 and continued several years later in the studio of Luigi Mussini, an exponent of Purism, a minor movement in Italy closely related to German Nazarene painting. The Purist allegiance to historical subjects painted in a smoothly brushed, finely finished style imitating Late Gothic and Early Renaissance masters of the fourteenth and fifteenth centuries stood in diametrical opposition to the informal, modernist approach of the Macchiaioli, whose collective identity emerged in the mid-1850's when they began to congregate at the Caffè Michelangelo in Florence.

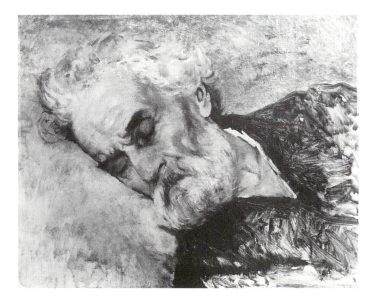

Fig. 1 Silvestro Lega, *Study for The Dying Mazzini,* 1873, oil on canvas, 15¾″ × 23⅝″ (40 × 60 cm), Comune di Modigliana, Museo Civico.

Associating only hesitantly at first with the circle of progressive artists at the café, among them Giovanni Fattori, Telemaco Signorini, and Adriano Cecioni, Lega was eventually won over. He wrote later that by 1859, "I believe I managed to distance myself completely from everything I had ever been taught."[3] *The Dying Mazzini* was created following one of the most fruitful episodes in Lega's career, during which a remarkable series of domestic genre scenes was painted at the countryside villa of the family of his friend Spirito Batelli in Piagentina, an area outside Florence. These works, which include *The Trellis* (1868, Milan, Brera Gallery) and *The Visit* (1868, Rome, National Gallery of Modern Art), conceived in terms of broad masses of shadow and fresh, open-air lighting, are among his best paintings.

That a canvas as grim and politically charged as *The Dying Mazzini* was painted directly following the idyllic pictures of the 1860's is not as surprising as it might seem in light of the strong sympathies of the Macchiaioli toward the Risorgimento, the unification and independence movement. For the most part, however, the struggle was reflected only sporadically in their paintings, often in a semicovert manner.[4] Lega himself became involved in 1848, when he joined a group of student volunteers fighting to drive the Austrians out of northern Italy, and in his younger days he was reportedly given to secretly posting radical literature on city walls late at night with paste hidden in his top hat.[5] Long before painting Mazzini, he had produced a large standing portrait of the popular Risorgimento hero Giuseppe Garibaldi holding a sword, with hands crossed, like Mazzini's (ca. 1850, Modigliana, Museo Civico), and a decade later, several battle scenes of the 1859 campaign to drive the Austrians out of Lombardy and the Veneto.[6]

Mazzini, whose fanatical commitment to the cause inspired Lega and so many others through decades of strife, began his revolutionary activities around 1830, resulting in imprisonment and exile at the age of twenty-five. Shortly afterward, he founded Young Italy, a secret organization dedicated to unification and radical reform. During the turbulent years 1848–49, in which revolts toppled regimes throughout Europe, Mazzini took part in founding and administering a short-lived Republic of Rome, for which he was again banished when the pope regained power. Undaunted, he continued his support of rebel uprisings in the 1850's and aided the triumphant 1860 expedition of Garibaldi, resulting in the union of southern Italy with the Kingdom of Sardinia in the north, which had become the nucleus for a centralized national government. In 1870, unification was finally achieved when Rome and the surrounding territory became the last section on the peninsula added to the new Kingdom of Italy, which had emerged as a constitutional monarchy under the rule of Victor Emmanuel II. However, Mazzini's passionate commitment to a revolutionary republican form of government put him at odds with the ruling power. By this time, he had grown old and severely impaired by pleuritic complications arising from chronic asthma. His death in Pisa at the home of Giannetta Nathan Rosselli, whose mother had housed him in Lugano, took place in the company of only a small circle of friends, after which the body was laid out for public viewing for four days.[7]

For many years, the following passage published in 1885 by Lega's friend, the art critic Diego Martelli, was cited as proof that the preparatory study for *The Dying Mazzini* was painted on the spot:

> When Giuseppe Mazzini died in Pisa, [Lega] hastened to the house of the illustrious apostle of thought and deed, and from what he recorded on the spot, composed a painting representing the last moments of the great Genovese.[8]

In 1926, however, Lega's biographer, Mario Tinti, skeptical that the study had been done in Pisa, proposed that "the only thing Lega produced from life was a sketch of Mazzini's room, while the figure of the great Italian was painted from memory."[9] Tinti's doubts are confirmed by the full head of hair on the figure in the sketch, compared to Mazzini's near-baldness in the RISD canvas, consistent with a photograph of the corpse (Pisa, Domus Mazziniana) that Lega is believed to have seen.[10] The model in the sketch, on the other hand, resembles Lega's model for *The Cook* (location unknown, reproduced in Matteucci 1987, II, no. 159), who may have also posed for Lega's study of Mazzini.

The Museum's painting is distinguished by its elegant simplicity. It represents Mazzini in his final hours, draped with a black and gray plaid shawl that covers the black outfit worn since his youth in symbolic mourning for the division of Italy. With the pale green wall behind providing a virtually blank background and a foreground restricted to the half-length figure and white bedding, Lega's muted composition conveys the profound sadness of the event and reverence toward his subject with remarkable economy. Martelli's analysis of the painting at the time of its exhibition at the Florence academy praised the painting's realism and lack of melodrama:

> Given the subject, one is prepared for an explosive impression.... But times have changed and melodrama is now restricted to the stage.... Today, ... realism has invaded us, a man is represented as a man, without divine attributes.... Mazzini, who was to many a myth instead of a man of flesh and bone is shown in Lega's picture, fever-ridden, during his last hours [with]... no violent chiaroscuro, no brilliant contrasts....[11]

Antonio Pavan, also writing on the work in 1873, was so impressed by Lega's realism that he warned, "The buyer of the painting will have to get used to the idea of having an actual dying man before his eyes."[12]

Although now recognized as one of Lega's best works, *The Dying Mazzini* left Italy and entered a British collection about a decade after its completion.[13] Its presence in England by 1885 is noted in an article published by Martelli in October of that year in which he laments that the picture was "taken to London [and] acquired by a foreigner, because in Italy there was no buyer for an object so grim."[14] The ambiguous reputation of Mazzini in Italy following the triumph of Victor

Emmanuel may also have contributed to the little-noticed expatriation of this iconic portrait.[15] That the painting found a home in England, the country which had offered the exiled Mazzini shelter over the years, reflects the high regard in which he was held by the British Left. However, by 1895, when Lega died, the painting's removal from Italy was equated with the loss of a national treasure.[16]

The Dying Mazzini is a singular painting, iconographically distinct from Lega's usual genre scenes and landscapes. It was undoubtedly the greatness of his subject that inspired Lega's moving portrayal. Neither an historical document in the strictest sense nor an overtly tendentious painting, the canvas represents the nineteenth-century realist esthetic at its best, communicating its tragic message with a straightforward presentation of the closely observed physical world and a penetrating sympathy for its subject. D. E. S.

1. Based on comparison with a photograph of the painting published in 1910 (reproduced in Matteucci 1977, p. 144, fig. 3), Matteucci detects earlier restorers' alterations, particularly in the area of the head. See Matteucci 1977, p. 144, and Matteucci 1987, II, p. 132.

2. Much recent scholarship cautions against the francophilic bias which has often occurred when writers have measured the Macchiaiolo movement against the norm of French Impressionism. See Los Angeles, UCLA, 1986, pp. 11–13.

3. Silvestro Lega, "Lettera autobiografica a Diego Martelli," May 2, 1870 (Florence, Biblioteca Marucelliana), in Williamstown, Clark, 1982, p. 34.

4. See Denis Mack Smith, "Tuscany and the Italian Risorgimento," and Albert Boime, "The Macchiaioli and the Risorgimento," in Los Angeles, UCLA, 1986, pp. 28–71.

5. See Signorini 1896, cited in Broude 1987, p. 167.

6. *Sharpshooters Leading Prisoners* (Florence, Gallery of Modern Art, Palazzo Pitti) and *Ambush of the Sharpshooters–Episode from the War of 1859* (Milan, private collection), both 1861.

7. See Matteucci 1987, I, p. 216.

8. Martelli 1885, p. 11, quoted in Matteucci 1987, I, pp. 216–17, translated by D. E. S.

9. Tinti, *Lega,* 1926, p. 55, quoted in Bologna, Museo Civico, 1973, p. 51, translated by D. E. S.

10. The photograph, processed in the studio of the Fratelli Alinari, is reproduced in Matteucci 1987, I, p. 217 (fig. 141).

11. Martelli 1873, pp. 124–25, quoted in Matteucci 1987, II, p. 130, translated by D. E. S.

12. Pavan 1873, p. 160, quoted in Matteucci 1987, II, p. 131.

13. Details surrounding its removal are still unclear. See Matteucci 1977 and Matteucci 1987, II, p. 131.

14. Martelli 1885, quoted in Matteucci 1987, II, p. 131, translated by D. E. S.

15. See, e.g., William Roscoe Thayer, "Mazzinianism: Hindrance to Unification," from *The Life and Times of Cavour* (Boston and New York: Houghton Mifflin Co., 1911), in Delzell 1965, pp. 25–26.

16. See Lega's obituary in *Il Popolo* 1895, quoted in Bologna, Museo Civico, 1973, p. 50.

JEAN-LÉON GÉRÔME
French, 1824–1904

57 *Moorish Bath,* ca. 1874–77

Signed and inscribed, lower right: *à ma fille Madeleine/ J.L. Gérôme*
Oil on canvas. 32¼″ × 25¹³⁄₁₆″ (81.9 × 65.7 cm)
Membership Dues. 66.280

PROVENANCE: Madeleine Masson (née Gérôme); Frédéric Masson; French and Company.

EXHIBITIONS: Dayton, Art Institute, 1972, p. 98 (no. 45, ill. p. 99); New York, IBM, 1988.

PUBLICATIONS: RISD, *Museum Notes,* 1967, pp. 40–42 (fig. 69, p. 41); Thuillier 1980 (pl. II, opp. p. 1179); Woodward and Robinson 1985, p. 194 (no. 112, ill.); Ackerman 1986, p. 236 (*Moorish Bath, no. 2, Oil Sketch,* no. 240B–2, ill. p. 237).

CONSERVATION: Cleaned, relined, and revarnished in 1984 at the Williamstown Regional Art Conservation Laboratory.

RELATED WORKS: *Moorish Bath, No. 2 (Un Bain maure; Femme turque au bain),* 1874–77, oil on canvas, 31″ × 26″ (78.7 × 66 cm), private collection. *Study for Moorish Bath,* ca. 1874, pencil on paper, 14¼″ × 8⅞″ (36.2 × 22.5 cm), Providence, Museum of Art, Rhode Island School of Design, Gift of Mr. and Mrs. Barnet Fain, Mrs. Frank Mauran, Mr. and Mrs. Alfred Morris, Jr., Mr. and Mrs. Alfred Morris, Sr., and Helen M. Danforth Fund, 1987.007.

Jean-Léon Gérôme, one of the most prominent French academic painters in the second half of the nineteenth century, was also among the foremost inventors of Orientalist themes. His training, first with Paul Delaroche and briefly in the atelier of Charles Gleyre,[1] led to his early recognition as a leader of the young Neo-Grecs with the exposition of *Le Combat de coqs (The Cock Fight)* at the Salon of 1847.[2] Although he had earlier failed to win the Prix de Rome, he had addressed the criticism that his figures were weak by concentrating on drawing and painting from the nude model, continuing this practice throughout his career, and stressing accuracy of representation in the classes he taught at the Ecole des Beaux-Arts after 1863.[3]

Inspired by a year spent in Rome with Delaroche in 1843–44, Gérôme developed an insatiable interest in travel, and beginning in 1855, when he made his first trip to Egypt, he became a meticulous recorder of the costumes and customs of the Near East. His early subjects included colorfully garbed mercenaries (*bashi-bazouks*), slave markets, Moslem worshipers in mosques and on rooftops, and exotic dancers. After a long trip to Egypt in 1868, he initiated a series of "Moorish" or "Turkish" bath scenes that would continue to interest him for the next twenty years.[4] The first of these, the small *Bain maure (Moorish Bath)* of 1870 in the Museum of Fine Arts, Boston,[5] was characteristically lavish in its attention to decoration and striking in its juxtaposition of a porcelain-skinned bather with her dark, glistening, female servant. This pretext for contrasting an exotic model with a more typically European Salon nude was again applied in RISD's *Moorish Bath,* although here the figure of the servant is swathed in the coarse robes and head scarf of the *fellaheen,*

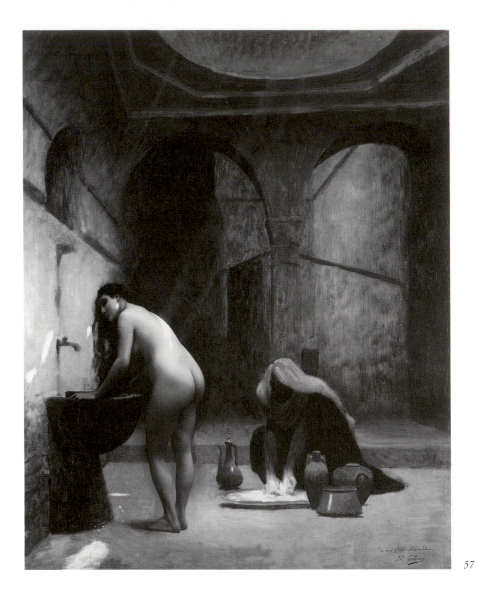

57

or peasants. Lacking any attributes of conventional Western beauty, she is made to appear masculine and even threatening in her shrouded appearance and crouching pose.

This particular *Moorish Bath,* in which the bather seems to confront her viewer, was painted in three versions, only one of which, a painting that recently reappeared on the market (fig. 1), was signed as a finished painting in Gérôme's characteristic block lettering.[6] The completed composition evidently met with Gérôme's approval, as he included it in the first folio of *Gérôme: A Collection of the Works of J. L. Gérôme in One Hundred Photogravures,* published in 1881–83 by his former student, Earl Shinn.[7] The remaining two, which are technically sketches, show a variation in the model's pose, casting her head and gaze at an angle that closely follows the curve of her back.[8] In the RISD version, the figure of the bather is the only part of the canvas to have received Gérôme's requisite degree of finish, a characteristic that is demonstrated in a carefully modeled preparatory drawing also in the Museum's collection (fig. 2). As a result, the RISD canvas offers an unusual glimpse of loose underpainting that is always invisible in his exhibited works, wherein individual brushstrokes cannot be distinguished and the surface has been smoothly glazed.

Gerald Ackerman suggests that Gérôme's attention to the nude figure in RISD's *Moorish Bath* was given in order to render the painting a proper gift, which he then inscribed in longhand to his daughter Madeleine.[9] Here the bather, leaning forward for support on the stone basin, is probably a studio model, drawn from life.[10] Her loose hair, short-waisted torso, and balanced stance are distinct from the careful coiffures, attenuated shapes, and languid poses of the women who populate his more elaborate bath scenes. While the latter are clearly influenced by the opulent bathers of Ingres, who painted without the experience of travel enjoyed by Gérôme, *Moorish Bath* has a greater sense of immediacy and realism.

The bath was an event in which all levels of Egyptian society took pleasure. For women of the wealthy class, private baths were often included in the apartment of the *hareem.* But both men and women, although always segregated, could visit the public baths, or *hammams,* of which there were more than sixty in Cairo in the nineteenth century.[11] When the women bathed, they were attended by female bath servants known as *bellanehs.* They would first disrobe in an antechamber, then enter an apartment called the *meslakh* for a steambath and massage. Next they proceeded to the *hana-*

146

feeyah, a smaller chamber whose name also referred to the taps of hot and cold water above a wall basin, seen at left in RISD's painting. The *bellaneh,* depicted crouching before a wide flat dish, carried into the bath the long-necked *ibreekh* and other vessels of clean, sweet water. She then prepared a soapy lather, using palm fibers as a sponge to scrub her mistress's back. At the conclusion of the bath, the *bellaneh* was also responsible for braiding her mistress's hair, preparing her water pipe, and serving her coffee.

Gérôme had partaken of the pleasures of the men's bath, which were chronicled by one of his companions on his 1868 trip, the painter Paul Lenoir.[12] Lenoir described in detail both a public *hammam* in Cairo and a private bath in the home of the Persian ambassador. To the former, which he visited on numerous occasions, Lenoir eventually brought his paints, and it can be assumed that Gérôme, who sketched endlessly on this trip, may have done so as well.

Gérôme had also brought to Egypt photographic equipment to assist with the documentation of architecture.[13] *Moorish Bath,* while smaller and more generalized than the interiors of many of Gérôme's bath paintings, nevertheless reveals his knowledge of these structures, whose numerous chambers were constructed of plaster and brick. The inner apartments were covered with octagonal masonry domes pierced by a number of small, round, glazed openings which admitted light. Gérôme directed the play of these narrow light shafts onto his model in *Moorish Bath* and employed their dappling, unearthly effect in later bath compositions as well. The floors were covered with white tile and patterned with black marble squares and small red tiles. Such decorative detail, so lavishly described in the majority of Gérôme's Orientalist paintings, is absent from RISD's *Moorish Bath,* although it appears in the floor of the finished version of this painting, along with an ornamented capital and refined versions of the washing vessels.

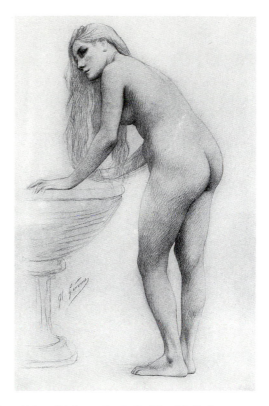

Fig. 2 Jean-Léon Gérôme, *Study for Moorish Bath,* ca. 1874, pencil on paper, 14¼″ × 8⅞″ (36.2 × 22.5 cm), Providence, Museum of Art, Rhode Island School of Design.

Although historical and archeological accuracy were part of the appeal of Orientalist painting in the nineteenth century, the underlying political motives of this genre still bear investigation.[14] The depiction of a woman in the privacy of the bath, despite its long history in European art, was still a subject for voyeurism and moral judgment of both gender and race, particularly when it was set in the exotic Near East. Unlike Manet's *Olympia,* whose French courtesan and black female servant shocked contemporary viewers, or even the more sensational Oriental bathers of his peers, Gérôme's figures seemed relatively chaste.[15] His own taste for the classical female form caused him to refine and Europeanize his bathers while distancing himself from their intimate activities. In glimpses of their attendants, who could be drawn from figures outside the protective world of the *hareem,* and in works such as *Moorish Bath* in which the nude model is not over-idealized, his talent as a realist can often be seen to greater advantage. M. C. O'B.

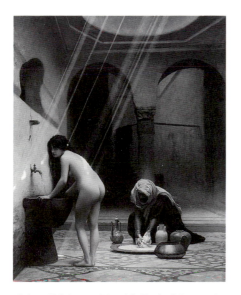

Fig. 1 Jean-Léon Gérôme, *Moorish Bath, No. 2,* 1874–77, oil on canvas, 31″ × 26″ (78.7 × 66 cm), private collection.

1. Gérôme studied in Delaroche's atelier from 1840 to 1843, then accompanied him to Rome for a year. When he returned to Paris in 1844, he spent three months with Gleyre, who had taken over Delaroche's students.

2. *Le Combat de coqs (Jeune Grecs faisant battre des coqs),* 1846, oil on canvas, 56½″ × 81½″, Paris, Musée d'Orsay (Ackerman 1986, p. 186, no. 14; ill. p. 27). The Neo-Grecs were a group of young artists who painted genre scenes of the ancient world.

3. With the curriculum reform at the Ecole des Beaux-Arts in 1863, Gérôme became one of the three *chefs d'atelier,* along with Alexandre Cabanel (1823–1889) and Isidore Pils (1815–1875). His

teaching methods are described in Ackerman 1986, pp. 168–77. See also Weinberg 1984.

4. Although Gérôme had visited Spain, his one trip to North Africa was cut short because of illness. He uses the terms *bain maure* ("Moorish bath") and *bain turque* ("Turkish bath") generically. Stevens 1984, p. 141, has noted that a Cairene location is more appropriate to Boston's *Bain maure* (see n. 5), given Gérôme's pattern of travels in the Near East.

5. *Moorish Bath (Lady of Cairo Bathing) (Bain turc ou bain maure [deux femmes])*, 1870, oil on canvas, 20″ × 16¼″, Boston, Museum of Fine Arts (Ackerman 1986, p. 226, no. 197; ill. p. 227).

6. *Moorish Bath, No. 2 (Un Bain maure; Femme turque au bain)*, 1874–77, oil on canvas, 31″ × 26″; sold Christie's, London, June 25, 1987, lot 74 (Ackerman 1986, p. 236, no. 240; ill. p. 237). This painting is now in a private collection. See n. 9 regarding Gérôme's habit of signing works.

7. Shinn, an art critic for *The Nation* who published under the pseudonym of Edward Strahan, had been a student of Gérôme in the 1860's.

8. In addition to RISD's painting there is another unlocated version. See Ackerman 1986, p. 236 (no. 240B–1, ill. p. 237).

9. Madeleine Gérôme was born in 1875. In Dayton, Art Institute, 1972, p. 98, Gerald Ackerman notes, ". . . it seems he seldom, if ever, gave away finished works since they were too valuable. Finished works are usually signed in capital letters." He also notes that the figure could have been finished and the inscription added long after the oil sketch was made.

10. The Museum's drawing of this figure (fig. 2) could have been used as the basis for the bather in all three versions of the painting. See the discussion of this drawing, in which it is compared with the painting, in RISD, *Museum Notes*, 1988, p. 38. The angle of the figure's head in the drawing clearly matches the RISD variant of the painting. There is no evidence for the speculation (RISD, *Museum Notes*, 1967, pp. 40–42, and RISD, *Museum Notes*, 1988, p. 38) that Gérôme's daughter Madeleine (a toddler, at most, when the painting was made), posed for the figure, or to suggest that any of his daughters ever posed as nude studio models.

11. For a detailed nineteenth-century account of the Egyptian bath, see Lane 1860, pp. 336–43.

12. Lenoir 1872, pp. 186–93.

13. Gérôme's brother-in-law, Alfred Goupil, an amateur photographer, accompanied him on this trip and supervised the plates, chemicals, and cameras that they transported by dromedary to Sinai (Ackerman 1986, p. 80). Lenoir 1872, p. 1, noted that ". . . le bleu cobalt et le collodion sec jouaient-ils dans nos bagages un role beaucoup plus important que la flanelle et les antidotes." (". . . cobalt blue and dry collodion played a much more important role in our suitcases than flannels and antidotes.").

14. See Nochlin 1983, for an investigation of the racial and political motives underlying Orientalist painting and its popularity in the nineteenth century.

15. Gérôme's friend, the critic Théophile Gautier, had written of the dignity and chastity of the relationship between the Muslim and his wives (Gautier 1853, pp. 164–65, cited in Stevens 1984, p. 19). In preserving these qualities in his work, Gérôme was taken to task by critic Paul Mantz, who found his bathers as cold as ivory billiard balls, lacking the merest shiver of voluptuousness (Mantz 1878, p. 437, cited in Stevens 1984, p. 141).

ATKINSON GRIMSHAW
British, 1836–1893

58 *View of Scarborough*, 1876

Signed and dated, lower right: *Atkinson Grimshaw / 1876*
Oil on board. 8⁷⁄₁₆″ × 17⁷⁄₁₆″ (21.5 × 44.4 cm)
Anonymous gift. 57.162

PROVENANCE: Mrs. Robert Frank, London.

EXHIBITION: New York, Durlacher, 1961, no. 4.

PUBLICATION: RISD, *Museum Notes*, 1962, p. 9 (ill.).

When the Yorkshire artist Atkinson Grimshaw painted his first known moonlight scene, *Whitby Harbour by Moonlight*, in 1867, there was already a well-established precedent for nocturnal views in England, most notably by Joseph Wright of Derby (1734–1797) a century earlier. As the majority of Wright's English landscapes were painted in the North of England for local landowners and industrialists, examples of his work would have been close at hand for Grimshaw to study. Between Wright and Grimshaw the prolific Pether family had contributed their share of moonlit landscapes during the first half of the nineteenth century – so much so, in fact, that the eldest member of that artistic family, Abraham Pether (1756–1812), was known in his day as "Moonlight Pether," and his influence continued unabated through the lunar-filled landscapes of his sons, Sebastian and Henry.[1] In addition to these influences, contemporary experiments in nighttime photography should not be overlooked, especially as Grimshaw used photography as an aid in his own work and lectured on the art of photography to the Leeds Photographic Society. His fascination with nocturnal light and its reflection on the water, as seen in RISD's *View of Scarborough* and several closely related pictures, forms a striking parallel with the work of the French photographer Gustave Le Gray, whose correctly exposed marine views had been recognized as a major technical breakthrough in the 1850's.[2]

While Grimshaw's lighting effects might have been up-to-date in RISD's *View of Scarborough*, his pictorial composition was executed along much more traditional lines. In order to show this Yorkshire seaside town as both a port and a resort, he filled the foreground with herring boats tied to the piers, much as Claude Joseph Vernet had done a century before in his seascape *The Italian Coast, Vesuvius in the Distance* of 1780, or for that matter Joseph Wright of Derby in a closely related work, *Vesuvius from Posillipo*, of about 1789.[3] For a focal point of his picture, however, Grimshaw replaced Mount Vesuvius with a resort hotel, namely Cuthbert Brodrick's Grand Hotel, built between 1862 and 1867, with its own eruptive silhouette of convex domes flanking a giant mansard roof. A memorable description of the latter appeared in *Building News* at the time of the hotel's opening:

> Mr. Brodrick treats us to the Palace of Aladdin of our youth, only considerably increased since then. That, if we recollect aright had only one dome; now we have four roc's eggs and more, each capped by its own particular incubator. Oh! that

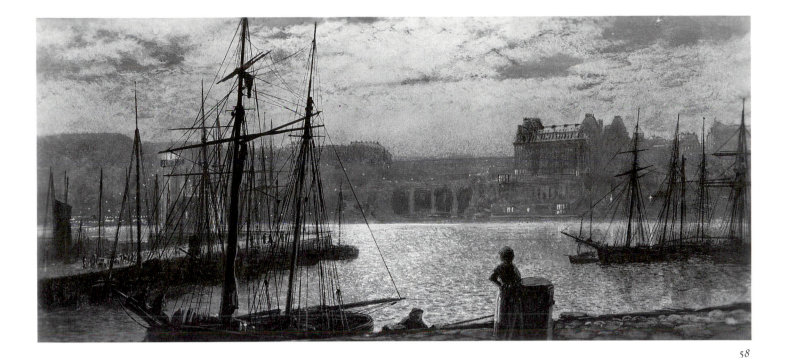

they would hatch a dividend; great would be their use, and we might then forgive their want of beauty.[4]

The great size of the Grand Hotel, including 300 individual bedrooms, made its profitability questionable, as suggested in the above description. It had been built not so much to fill an existing need, but rather to serve as a symbol of the wealth and prosperity then being experienced by the manufacturing centers of the North, and in particular Leeds.

With an eye no doubt to sales, Grimshaw lost little time in celebrating the Grand Hotel's prominence in at least three views made from the piers jutting out into Scarborough Bay. They include a view of 1871 (private collection);[5] an undated view in the Scarborough Art Gallery; and the RISD view of 1876. In each of these pictures Grimshaw surveys the scene at a different time of the night, or in the case of RISD's picture early in the morning, and from slightly different vantage points. The undated Scarborough Art Gallery picture was painted from the West Pier, the 1871 picture probably from the East Pier, and RISD's picture painted in between these two points from Sandside, with the Light House Pier emerging on the left.[6] Also, the size of the pictures differs, with RISD's being much smaller than the others, which are both twenty-four by thirty-six inches. In 1878 Grimshaw painted a fourth picture overlooking the Bay, from the 1827 bridge adjoining the Grand Hotel, a portion of which appears on the far left side. That these and other pictures from the 1870's were well received can be judged by the fact that Thomas Agnew and Son, the highly successful firm of picture dealers, regularly exhibited Grimshaw's pictures in their London and provincial galleries, where they proved popular with the new middle-class industrialists.[7] Unfortunately, Grimshaw incurred heavy debts in 1879, having guaranteed a bill for a friend who then decamped,[8]

and he spent the rest of his life trying to produce enough pictures to pay off that debt, frequently compromising his standards through too great a dependence on photography.

Despite personal misfortune, Grimshaw appears to have had a significant impact on the local art scene. The Belgian artist Henri Philippe Neümans (ca. 1845–?), who was active in Scarborough between 1868 and 1889, primarily as a portraitist, painted around 1876 a picture remarkably reminiscent of Grimshaw's work, entitled *Scarborough, Castle Hill and Harbour by Moonlight,* now in the Scarborough Art Gallery.[9] Like Grimshaw, Neümans took an active interest in photography, and both of these men in turn may have had an influence on the photographer Frank Meadow Sutcliffe, whose many photographic views taken in and around Whitby Harbour in the 1880's capture the very essence of their paintings.[10] Also it should not be overlooked that when Grimshaw settled in Chelsea in 1880, he had James McNeill Whistler for a neighbor. His son-in-law noted that Whistler "confessed to Grimshaw that he had regarded himself as the inventor of 'nocturnes' until he saw Atkinson Grimshaw's moonlights."[11]

C. P. M.

1. Maas 1969, pp. 49–51.
2. Robertson 1988, p. 114.
3. Nicolson 1968, I, p. 79.
4. *Building News* 1867, p. 334.
5. Robertson 1988, p. 63 (pl. 50).
6. For a map indicating locations for several of Grimshaw's Scarborough views, see Payne 1987, p. 21.
7. Leeds, City Art Gallery, 1979, p. 3.
8. Leeds, City Art Gallery, 1979, p. 4.
9. *Review* 1990, p. 189.
10. Robertson 1988, p. 114; Maas 1969, pp. 202–03, 205.
11. Maas 1969, p. 230.

59

GUSTAVE DORÉ
French, 1832–1883

59 *Cupid and Skulls,* ca. 1876–80

Signed, front right corner of base: *G.*^{ve} *Doré*
Terra cotta. 7″ × 5¹⁵⁄₁₆″ × 9¹¹⁄₁₆″ (18.8 × 15.1 × 24.6 cm)
Gift of Uforia, Inc. 73.148

PROVENANCE: Given by Doré to the actress Alice Ozi;
bequeathed by her to her executor, Alidor Delzant;[1] by whom
to his grandson, who sold it to M. La Brely; purchased for the
Museum from Paula Cooper Gallery, New York, 1973.

EXHIBITION: Los Angeles, LACMA, 1980, p. 240 (no. 115, ill.).

PUBLICATIONS: Paris, Hôtel Drouot, 1885, p. 33 (no. 178);
Valmy-Baysse 1930, p. 325 (ill.); Leblanc 1931, p. 544 (no. 178);
Hannover, Wilhelm-Busch, 1982, pp. 248, 264–65 (fig. 118);
Strasbourg, Musée d'Art Moderne, 1983, p. 160 (no. 154);
Renonciat 1983, p. 269 (ill.); London, Hazlitt, 1983, no. 80;
New York, Shepherd, 1985, p. 160.

RELATED WORK: *Cupid and Skulls* (second model), plaster, 6″
× 8¾″ at base (15.3 × 22.2 cm), private collection.

Gustave Doré was one of the most prolific and well-known
artists of the nineteenth century and a unique figure in the
pantheon of that century's artistic talents. He was a child
prodigy who, by the age of five, is said to have become an
accomplished draftsman and, by the age of eight, was making
his first illustrations for Dante's *Divine Comedy.* In 1848, at

Fig. 1 Gustave Doré,
Fate and Love (*Le Parque
et l'Amour*), 1877, terra
cotta, 22⅝″ × 13¾″ ×
13¾″ (57.5 × 35 × 35 cm),
Strasbourg, Musée
d'Art Moderne.

the age of sixteen, he began regularly producing caricatures
for Charles Philipon (1800–1862), editor of the *Journal pour
rire, La Caricature,* and the short-lived *Charivari.* Over the
course of his relatively short life, he became the most widely
published book illustrator ever to work in this discipline; his
considerable talents as a draftsman were combined with a
visionary imagination that gave a palpable reality to some of
the great literature of the Western world.[2]

At the same time that he enjoyed a lucrative and prolific
career as an illustrator (Leblanc estimates that he produced
more than eleven thousand works in his lifetime), the self-
taught Doré aspired to make a reputation for himself in the

official salons, first as a painter, and later as a sculptor. In spite of his tremendous popular success as an illustrator, his attempts to create monumental works of art were not well received by French critics, prompting him to look across the English Channel, where audiences appeared to be more receptive to the literary underpinnings of his work. In 1868 he opened the Doré Gallery in London, a private enterprise in which large paintings of ambitious narrative subjects taken from the same sources as his illustrations could be seen for the admission price of one shilling and where visitors could purchase original engravings that reproduced the paintings on the wall.[3] It is a measure of Doré's enormous popularity that his gallery remained open for twenty-three years (thus for nearly a decade after his death), during which time it is estimated that more than two-and-a-half-million visitors passed through its doors.[4]

In sculpture, as in everything else, Doré was self-taught and technically precocious. His first recorded attempt at sculpture was made in 1871 during one of his periodic stays in London, when he modeled a head of Christ in the yard of a house he was renting in Westminster. Blanchard Jerrold, Doré's most reliable biographer, observes that over the next six years Doré continued to work privately in this medium. He devoted his mornings to the production of illustrations for his editors, for which he had one studio, and his afternoons to painting and sculpture, for which he had another, with space partitioned off for sculpture.[5] His first major group, *Fate and Love* (*Le Parque et l'Amour*), a larger-than-life-size allegorical sculpture, was exhibited in the Paris Salon of 1877 (fig. 1). Although conventional in design, it is technically precocious for the work of an autodidact, reflecting Doré's proficiency as a sculptor, as well as his embrace of the conventions of academic sculpture of the time.[6] Over the six remaining years of his life Doré exhibited a major sculpture in every Paris Salon, and while the official response to his work was a disappointment to him (measured in terms of prizes and official commissions), he did win a Third Class Medal for a *Madonna* exhibited in the Salon of 1880 and a public commission for a *Monument to Alexandre Dumas, père,* which was installed in the Place Malesherbes.[7] Leblanc lists twenty-five sculptures by Doré reproduced in a variety of sizes and materials, all of which were created in the last decade of his life.[8]

The precise date of the Museum's *Cupid and Skulls* is unknown. However, it may be related iconographically to a cluster of datable works that are concerned with the themes of youth and death. The earliest of these, *Fate and Love* (*Le Parque et l'Amour*) (Salon of 1877), represents one of the the Parcae, a Roman goddess of fate, conceived as a stern old lady in a shroud, who is about to cut the string of life held between the hands of an adolescent Cupid standing in her embrace. In *Fame* (Salon of 1878), a nude male youth, an allegorical personification of the artist, expires in the embrace of a winged genius, or "fame," who conceals a dagger beneath the branch of laurel that she offers. *The Terror* (Salon of 1879) has a narrative and exotic quality that may be associated more with Doré's illustrations and less with the allegorical conventions of salon sculpture of the time. It represents a horrified African woman holding her infant above her head to protect him from a serpent that is about to bite her in the leg. In *Time* (1879), Doré has placed a clock in a globe around which swarm a multitude of infant Cupids who are cut down by the scythe of a winged, bearded figure of death surmounting the globe. Not only do these plump Cupids show a figural and thematic affinity with the Museum's Cupid; it is also noteworthy that this clock was made for the actress Alice Ozi,[9] from whom the Museum's *Cupid and Skulls* is said to have descended. Finally, among these meditations on mortality, *The Madonna* (Salon of 1880, Third Class Medal) represents the Virgin holding the infant Christ in her hands, his arms extended in a prefiguration of the Crucifixion. It is probable that Doré modeled the *Cupid and Skulls* within this period of time (1877–80), when his sculptural activity was at its peak and he was consistently preoccupied with the theme of death.

Two variations of the Museum's sculpture were offered in the sale of Doré's studio in 1885: the so-called "first model," which is the version belonging to RISD, and a "second model" in plaster, which shows a less resolved figure sitting among (more than upon) a smaller number of skulls.[10] The title under which the Museum's sculpture was acquired, *Love Triumphing over Death,* is almost certainly not the title given to it by Doré. It was not identified as such in his 1885 studio sale, nor in any of its subsequent published appearances, and it would be inaccurate to describe the precarious posture of this Cupid as "triumphant" in any conventional sense.[11] Doré did, in fact, execute a drawing for an unrealized sculpture called variously *Love* (or *Glory*) *Triumphing over Death,* in which the figure of Love is unambiguously triumphant. This drawing, which was reproduced on the catalogue cover of the 1885 Doré sale, represents a winged male youth – appropriately, an athletic young man rather than a putto – standing upright and holding a torch above his head while trampling a skeleton that lies beneath his feet.[12]

By comparison, the meaning of the Museum's sculpture is much less clear and susceptible to a fixed interpretation. The precarious repose of this Cupid surmounting this lumpy bed of skulls conveys something of the ambiguity of life, in which neither the promise of fulfillment, symbolized by the infant Cupid, nor the inevitability of death, symbolized by the skulls, prevails. The specific posture of this reclining child seems to be related to Doré's drawings of the sleeping infant Gargantua, reproduced among his illustrations for the works of Rabelais (1873).[13] Iconographically, Doré seems to have drawn freely from the tradition, represented variously in Renaissance medallions, engravings, and *emblemata,* and later Baroque funerary sculpture, in which images of Cupid with a skull (or skulls) suggest a *vanitas* or a *memento mori.*[14] As a *bibelot,* designed to sit on a desk or a mantle, this small sculpture serves as a meditation on the mystery of life. It is not difficult to imagine, however, that this small meditation on life and death, so monumental in conception, may have been the first thought for a funerary sculpture. D.R.

1. See also in the checklist, Jean-Jacques Henner, *Idyll* (66.025), which is inscribed to Delzant, an engraver.

2. His most popular illustrated books, which were republished in translations throughout Europe and America, included *The Works of Rabelais* (1854/1873), *The Legend of the Wandering Jew* (1856), Dante's *Inferno* (1861), Cervantes's *Don Quixote* (1863), the *Bible* (in a "popular" version by the Abbé Drioux, 1864), Milton's *Paradise Lost* (1866), *The Fables of La Fontaine* (1867), Dante's *Purgatory* and *Paradise* (1868), Blanchard Jerrold's *London, A Pilgrimage* (1872), and Coleridge's *Rime of the Ancient Mariner* (1875), to mention only a few.

3. In 1869 this moved to 135 New Bond Street, in the building now occupied by Sotheby's auction house.

4. Strasbourg, Musée d'Art Moderne, 1983, pp. 51 ff.

5. Jerrold 1891, pp. 240, 349–50; see also Leblanc 1931, p. 10.

6. Strasbourg, Musée d'Art Moderne, 1983, pp. 159–60 (no. 152), reproduces a terra-cotta reduction of this group that is in the Musée d'Art Moderne of Strasbourg. The original in the Salon was two-and-a-half meters high.

7. See Lami 1914–21, II, pp. 204–06. The following groups, all of a large scale and representing a partial list of his sculptural output, were exhibited or erected by Doré over these seven years: *Love and Fate* (Salon of 1877; Exposition Universelle, 1878); *Glory* (Salon of 1878); *The Terror* (Salon of 1879); *Dance* (project for the Monte Carlo Opéra, 1879); *Time* (Cercle de l'Union Artistique, 1879, reproduced in *L'Art*, XVI, p. 296, and now in the Musée des Arts Décoratifs, Paris); *The Madonna* (Salon of 1880, awarded a Third Class Medal); *Christianity* (Salon of 1881); *Wine* (*La Vigne*) (Salon of 1882); *Monument to Alexandre Dumas, père* (1883, Place Malesherbes). A marble group of *The Madonna*, called *Maternal Love*, was placed above the tomb of the actress Alice Ozi (1820–1893) in the Père Lachaise cemetery. This appears to have been carved by practitioners after Doré's death. See Hannover, Wilhelm-Busch, 1982, p. 265 (no. 10).

8. Leblanc 1931, pp. 543–45. The most thorough modern accounting of Doré's sculptures and their whereabouts is found in Hannover, Wilhelm-Busch, 1982, pp. 233–65.

9. See Hannover, Wilhelm-Busch, 1982, pp. 248–50, 265 (no. 9).

10. Paris, Hôtel Drouot, 1885, p. 33 (no. 178), called *Amour et têtes de mort*. There were two terra-cotta examples of the first version; the second version was unique. Both were offered for sale as one lot, with their molds and rights of reproduction. The second version, now in a private collection, was exhibited and reproduced in Strasbourg, Musée d'Art Moderne, 1983, p. 160 (no. 154). The whereabouts of any other example of either of these versions is unknown today, although it may be assumed that the Museum's terra cotta would represent a third example of the so-called "first model," which would have been acquired by Mme Ozi in Doré's lifetime, and hence was not included in the studio sale. Leblanc 1931, p. 545, citing the Dézé catalogue, also mentions a bronze version of this sculpture belonging to Doré's niece, Mme Michel-Doré.

11. This is even more the case in the "second version," in which the figure is more engulfed than propped up by the skulls.

12. See Strasbourg, Musée d'Art Moderne, 1983.

13. See Rabelais 1873, I, p. 38, and II, p. 4, in which the posture is repeated in the image of Pantagruel, son of Gargantua, nourished by the milk of 4,600 cows. For preparatory studies, see Strasbourg, Musée d'Art Moderne, 1983, p. 212.

14. For a thorough discussion of the motif in its many incarnations, see Janson 1937 and Seznec 1937. Janson includes in his survey of this subject engravings or chiaroscuro woodcuts by or after Barthel Beham (B. 27, 28, 31), Hieronymus Cock (LeBlanc 72), Hendrick Goltzius (B. 10), and Guido Reni (B. 23), among other, lesser-known artists. See Los Angeles, LACMA, 1980, p. 214 (no. 115).

PIERRE-AUGUSTE RENOIR
French, 1841–1919

60 *Young Woman Reading an Illustrated Journal*, ca. 1880

Signed, upper right: *Renoir*
Oil on canvas. 18¼" × 22" (46.3 × 55.9 cm)
Museum Appropriation. 22.125

PROVENANCE: This may be the same work as the *Femme regardant des images* purchased from Renoir in December 1885 by Paul Durand-Ruel and consigned by him to the American Art Association, New York, 1886; according to tradition, purchased by Erwin Davis, New York; Morten I. Lawrence, New York; sold, American Art Association, New York, January 29, 1919, lot 51; repurchased by Durand-Ruel, from whom purchased by the Museum through Brooks Reed Gallery, Boston.

EXHIBITIONS: New York, AAA, 1886, no. 259 (?); San Francisco, Legion of Honor, 1944, p. 23; Pittsfield, Berkshire, 1946, no. 6; Los Angeles, LACMA, 1955, no. 21; New York, Wildenstein, 1962; London, Hayward, 1985, no. 54 (French ed., no. 53); New York, IBM, 1988.

PUBLICATIONS: RISD, *Bulletin*, 1922, p. 35; André 1923, pl. 10; Rowe, "Renoir," 1923, pp. 18–20; Banks 1937, p. 32; Daulte 1971, I, no. 300; Fezzi 1972, p. 106 (no. 377); Fezzi and Henry 1985, no. 367.

CONSERVATION: The canvas had been relined prior to examination at the Boston Studio, March 1953. The surface was then cleaned and portions of blue pigment inpainted. Relined with Belgian linen and stretched on a new basswood stretcher. Surface cleaned and small losses along the edges and in the area around the signature were retouched at the Williamstown Regional Art Conservation Laboratory, August 1983.

Within the long pictorial tradition of people reading, artists have traditionally depicted readers' faces, whether to represent contemplation, typically of a religious text, or to evoke more private pleasures of bourgeois domesticity, particularly in the eighteenth century. Throughout the 1870's, Renoir himself painted several portraits of women reading.[1] Many of these, as well as others from the 1880's, such as the *Young Girl Reading* (Williamstown, Sterling and Francine Clark Art Institute) and *The Lesson* (Paris, private collection), tend to be "boudoir" pictures showing a young woman partially disrobed; in these the activity of the sitter is less significant than the intimacy of the situation.[2]

In the Museum's painting, Renoir has reversed the traditional order by giving greater prominence to what is being read than to the person reading. While the young girl's eyes are concealed by a shock of auburn hair and her back partly turned to us, the book she holds, obviously a contemporary fashion magazine, fills the central portion of the canvas. She slouches comfortably, although by 1880, such casual posture was not intended to be provocative, as opposed to eighteenth-century portraits of women reading, in which the activity of reading evokes an entire range of private pleasures and sensuous imaginings.[3] Looking over her shoulder, one sees that she is looking at double-page illustrations whose format resembles several weeklies of the period, such as *La Vie parisi-*

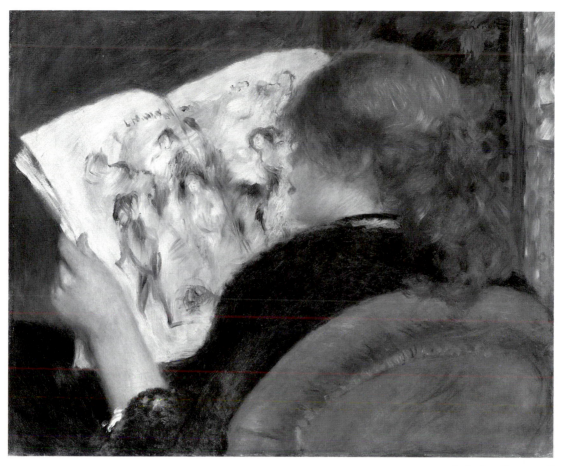

60 (color plate p. 27)

enne or Georges Charpentier's *La Vie moderne,* which first appeared in 1879.[4]

As in two paintings from 1877, *La Liseuse* (Detroit, Seyburn collection, D. 235) and *Couple Lisant* (Los Angeles, Norton Simon collection, D. 237), the figure, setting, and activity in this painting are integrated within a coherent "slice of life" that is characteristic of Renoir's work from the late 1870's. The girl's manner of reading with parted lips, once a trait associated with humble, less learned people, is used in this painting to emphasize the brevity of the moment.[5]

The model is almost certainly Aline Charigot (1859–1915), who became Renoir's wife in 1890. Previously, she had worked as a dressmaker in a Paris fashion boutique and lived with her mother, Mélanie Charigot, on the rue Saint-Georges, where she met her neighbor Renoir around 1879. She and Renoir set up house together in 1882, after which she appears regularly in his larger figural compositions, yet rarely did Renoir feature her so prominently as here.[6] Her close resemblance to the girl in the lower left foreground of the *Luncheon of the Boating Party* of 1880–81 (Washington, D.C., Phillips Collection), generally acknowledged to be Aline, supports the dating of this picture to around 1880.[7]

In general, the placement of the figure in the foreground against an ambiguous, shallow space recalls the work of Degas and the other Impressionists informed by photography and Japanese woodblock prints. Renoir placed a similarly cropped profile bust in the lower right corner of *La Place*

Clichy, ca. 1880 (Cambridge, Fitzwilliam Museum), in which he also experimented with cameralike shifts of focus and depths of field.[8] Like the street scene, the RISD painting presents a glimpse of modern life, a theme that Renoir actively pursued in the late 1870's. His use of loosely painted, bright patches of color, particularly to depict the light playing on Aline's red hair and the curtains behind her head, together with the contrast between the red chair against her blue dress, recalls *The Sleeping Girl* (Williamstown, Sterling and Francine Clark Art Institute), also of 1880.[9] Soon after, however, Renoir broke rank with the Impressionists by exhibiting at the official Salons while making a conscious effort to regain wealthy Parisian patrons more eager for fashionable, conservatively painted portraits than glimpses of everyday life. This was not true of wealthy American collectors, who were just beginning to take an active interest in the work of the Impressionists. This painting was evidently one of several consigned in 1886 by Durand-Ruel for sale at the American Art Association in New York.[10] It is believed to have been purchased there by Erwin Davis, an early benefactor of the Metropolitan Museum and one of the first New Yorkers to form a significant collection of Impressionist paintings.[11]

T. S. M.

1. See, for example, Daulte 1971, no. 73, *Madame Claude Monet Lisant* (Williamstown, Sterling and Francine Clark Institute); no. 106, *La Liseuse* (Paris, Musée d'Orsay); no. 235, *La Liseuse* (Detroit, Mrs. Wesson Seyburn); and no. 530, *A Couple Reading*

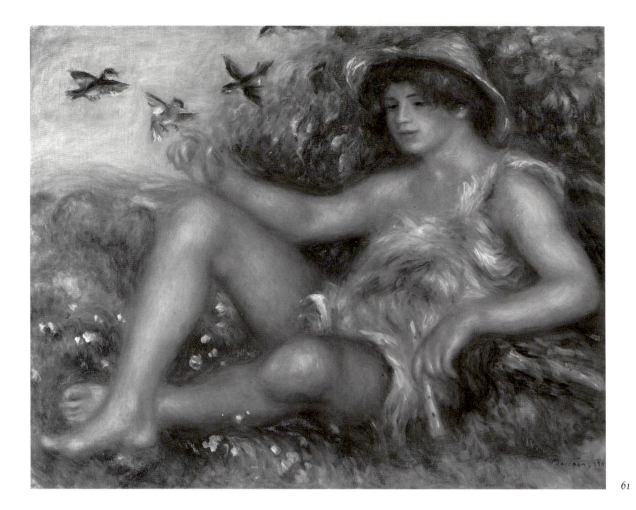

<div align="right">*61*</div>

(Los Angeles, Norton Simon collection).

 2. See Williamstown 1972, no. 908, and Daulte 1971, no. 530.

 3. For examples by Chardin and Boucher, see Chartier 1989, pp. 144–47.

 4. London, Hayward, 1985, no. 54.

 5. For historical reading practices, see Chartier 1989, pp. 124–25.

 6. Aline can be identified in Renoir's paintings as early as 1879. See, for example, *Les Canotiers à Chatou* (Washington, D.C., National Gallery of Art, D. 307). Renoir painted two portraits of her ca. 1885–86 (see London, Hayward, 1985, nos. 78, 79). Charigot also appears in Daulte 1971, nos. 355, 366, 379, 429, 441, 464, 465, 482–83, 485, 496, 504–05, 583–86, and 594, painted between 1880 and 1890.

 7. See London, Hayward, 1985, no. 54.

 8. London, Hayward, 1985, no. 49.

 9. Daulte 1971, no. 330; London, Hayward, 1985, no. 50.

 10. See Venturi 1939, II, pp. 214, 216–17.

 11. See Weitzenhoffer 1986, p. 38.

PIERRE-AUGUSTE RENOIR
French, 1841–1919

61 *Young Shepherd in Repose*
(Portrait of Alexander Thurneyssen), 1911

Signed and dated, lower right: *Renoir. 1911*
Oil on canvas. 29½″ × 36⅝″ (74.9 × 93 cm)
Museum Works of Art Fund. 45.199

PROVENANCE: Dr. Franz Thurneyssen, Wessling, Germany; Paul Rosenberg and Co., New York; Durand-Ruel Galleries, New York.

EXHIBITIONS: New York, Durand-Ruel, 1939, no. 23; New York, Duveen, 1941; New York, MOMA, 1942; Toronto, Art Gallery, 1944; Portland, Art Museum, 1944; St. Louis, City Art Museum, 1947, no. 33; Worcester, Worcester Art Museum, "Picture of the Month," May 1947; New York, Rosenberg, 1948, no. 27; Providence, RISD, 1949, p. 31; Edinburgh, RSA, 1953, no. 40; New York, Rosenberg, 1954, no. 9; Atlanta, Art Association, 1955, no. 23; Houston, MFA, 1958; New York, Wildenstein, 1958, no. 64; Wolfsburg, Rathaus, 1961, no. 132 (pl. 55); Cologne, Wallraf-Richartz, 1962, no. G161; Waltham, Rose, 1967, no. 36; New York, Acquavella, 1968; New York, Wildenstein, 1970, no. 99; Chicago, AI, 1973, no. 81; New York, Wildenstein, 1974, no. 58; Williamstown, Sterling and Francine Clark Art Institute, long-term loan, 1974–76; Washington, Federal Reserve, 1979; Roslyn, Nassau County Museum, 1984, p. 54; Winnipeg, Art Gallery, 1987; Nagoya, City Art Museum, 1988, no. 64.

PUBLICATIONS: Meier-Graefe 1911, p. 177; Meier-Graefe 1920, p. 156; Meier-Graefe 1929, p. 321 (fig. 359); Bernáth 1937, p. 163; Besson 1938, no. 44; Frankfurter 1939, pp. 7, 20; Venturi 1939, I, p. 108; Brian 1942, p. 23; Drucker 1944, pl. 154; Frost 1944; *Art News,* Oct. 1945, p. 10; *Art Quarterly* 1945, pp. 244–46; Michel 1945, p. 97; Washburn 1945, n.p.; *Worcester Telegram* 1947; *Providence,* May 1947; Laporte 1948, p. 179 (fig. 1); Pach 1958, pp. 279–82 (fig. 3); Bremen, *Bremer Nachr.,* 1961; Pach 1964, p. 122 (pl. 123); Erwin 1980, pp. 26–27 (fig. 26); White 1984, pp. 245, 250.

Since the late 1870's, Renoir had repeatedly confronted the dilemmas inherent in Impressionist figure painting. Whereas Impressionist techniques tended toward atmospheric effects that dissolve form, Renoir sought to enhance figural forms and to give them a greater sense of volume and structure. By 1881, suffering from rheumatism and having lost all enthusiasm for painting society portraits, he left Paris for an extended trip to Italy. There he found a more temperate climate and, like many artists before him, sought to reinvigorate his figure painting by looking again at ancient Roman art, as well as Renaissance and Baroque painting.[1] In the 1880's, Renoir's figural style became increasingly monumental, a shift that culminated in a celebrated series of nude bathers and informed his late portraits, such as this one of Alexander Thurneyssen.

Renoir had first met the Thurneyssen family during the summer of 1908, while staying nearby at Cagnes-sur-Mer. He painted Frau Thurneyssen there, and in 1910, at her invitation, the artist and his family made "the last of [his] travels" to spend the summer with the Thurneyssens at their home in Wessling, on a lake near Munich.[2] There Renoir executed a second portrait of Frau Thurneyssen with her daughter, Anna (Buffalo, Albright-Knox Art Gallery), and another of her son, Alexander (fig. 1). Jean Renoir later recalled Frau Thurneyssen as "ravishing" and the twelve-year-old Alexander as being "handsome as a Greek shepherd and, incidentally, portrayed as one."[3]

According to some accounts, what attracted Renoir to Munich more than the portrait commissions was the opportunity to see the fifty or more paintings by Rubens at the Alte Pinakothek.[4] Inspired by their "glorious fullness and the most beautiful color," Renoir also noted that "the layer of paint is very thin . . . ," qualities he had admired a decade before in the work of Titian and Veronese and now sought to emulate in the compositions and brushwork of the Thurneyssen portraits.[5]

Renoir did not undertake the Museum's portrait until the next year, 1911, by which time he was back in Paris, but confined to a wheelchair in his combined studio/residence on the Boulevard Rochechouart. As a result, the young Alexander traveled to Paris to sit for his portrait, portions of which are still said to have been based on a female model.[6] Alexander's striking sheepskin costume may commemorate the previous summer's many outings in the Bavarian forest, his hat is one often worn by Gabrielle, Renoir's cook and frequent model, and the flute brings to mind what Jean Renoir recalled as "a summer filled with music."[7] Viewed in the broader context of Renoir's late work, the peculiar anachro-

Fig. 1 Pierre-Auguste Renoir, *Portrait of the Young Alexander Thurneyssen,* 1908, oil on canvas, 17½″ × 14½″ (44.4 × 36.8 cm), location unknown.

nism of arcadian dress and the boy's pose, derived from the so-called "Dionysus" from the east pediment of the Parthenon, are consistent with the artist's renewed interest in the art of antiquity and the Renaissance. At the same time, the loose brushwork and luminous glazed colors reveal a considerable debt to Rubens, whose brushwork Renoir had studied closely and recommended to others.[8]

While at work on the Thurneyssen portraits, Renoir was admittedly preoccupied with the traditional craft of painting, prompted by his work the same year (1910–11) on the preface to a new French edition of Cennino Cennini's *Il Libro dell' Arte* ("Craftsman's Handbook"). He expressed to Vollard the belief that the painter "should strengthen and perfect his *métier* untiringly, but he can only do that with the help of tradition."[9] These two concerns, technique and tradition, were central to the aging artist's increasingly conservative philosophy, by which he sought to reenter the mainstream of Western art. By 1908, as if renouncing Impressionism, Renoir concluded that "nature brings one to isolation. I want to stay in the ranks."[10]

In this sense, the portrait of Alexander Thurneyssen can variously be interpreted as Renoir's tribute to Greek myth, the Venetian ideal of *poesia* and Delacroix's copies of Venetian art, the virtuoso brushwork of Titian and Rubens, and the simplified, monumental figures of Maillol. Assured as he was by 1900 of a steady income from his dealers and secure in his international reputation, Renoir freely pursued a synthesis of the linear and painterly traditions in art.[11] For Renoir, capturing Thurneyssen's likeness precisely was perhaps less urgent than striving to "fuse" the landscape with the figure.[12] From the patron's point of view, this portrait was nevertheless

62

an excellent likeness. Indeed, friends recalled Thurneyssen's pride in his high color and long auburn hair.[13] True to Renoir's idealized characterization, Thurneyssen later became a musical conductor and settled in Athens. T. S. M.

1. See White 1969 and Erwin 1980.
2. Vollard 1925, p. 138.
3. Renoir 1958, pp. 423–24.
4. White 1984, p. 245.
5. Quoted in Pach 1938, p. 109.
6. Chicago, AI, 1973, no. 81. Based on information supplied by Anthony M. Clark from the RISD Museum files, Walter Pach wrote that the portrait was "painted in France after Renoir's return from Munich, using memory or sketches and a female model" (Pach 1958, p. 279). Brian (Brian 1942, p. 32) believed that Gabrielle, Renoir's cook and frequent model, had posed for the portrait.
7. He was referring to singing lessons for Renée Rivière and his own trumpet lessons. See Renoir 1958, p. 424.
8. See Rewald 1973, pp. 210 and 236, n. 28. The composition of *Frau Thurneyssen with her Daughter* is likewise borrowed from Rubens's portrait of *Hélène Fourment and her Children* (Munich, Alte Pinakothek).
9. Quoted in Vollard 1925, p. 216.
10. Quoted in Pach 1938, p. 113.
11. See Lawrence Gowing, "Renoir's Sentiment and Sense," in London, Hayward, 1985, pp. 30–35.
12. London, Hayward, 1985, p. 278.
13. Chicago, AI, 1973, no. 81.

CAMILLE PISSARRO
French, 1830–1903

62 *Field and Mill at Osny,* 1884

Signed and dated, lower right: *C. Pissarro. 84*
Oil on canvas. 21⅜″ × 25¹³⁄₁₆″ (54.2 × 65.5 cm)
Gift of Mrs. Houghton P. Metcalf in memory of her husband. 72.096

PROVENANCE: Acquired through Martin Birnbaum, New York.

EXHIBITIONS: Paris, *Exposition Universelle,* 1900, no. 517 (?);[1] New York, IBM, 1988.

PUBLICATIONS: Pissarro and Venturi 1939, I, p. 170 (no. 626), and II, pl. 129; *Gazette des Beaux-Arts* 1973, p. 149 (ill.); RISD, *Museum Notes,* 1980, p. 22 (ill.); London, Hayward, 1980–81, p. 216 (no. 182).

CONSERVATION: The canvas was relined in 1981 at the Williamstown Regional Art Conservation Laboratory. A discolored varnish was removed at that time, pigment losses were inpainted, and a synthetic varnish was applied.

RELATED WORK: *Field and Mill at Osny,* etching, drypoint, and aquatint, 6¼″ × 9½″ (16 × 24 cm), Oxford, Ashmolean Museum (Delteil 1923, no. 59, sixth state of six).

In December 1882, having lived the greater part of the past sixteen years in Pontoise, located in the Ile-de-France thirty-three kilometers northwest of Paris, Pissarro and his family moved deeper into the surrounding countryside, taking quarters in the hamlet of Osny, eight kilometers north of

Pontoise on the Vexin plateau. Pissarro's move to Osny seems to have been the first step of a decision to leave the region altogether. Beginning in May 1883, his correspondence with his son Lucien records excursions to Meaux, Ecouen, Villiers-le-Bal, Versailles, Rouen, Cantelu, Fécamp, L'Isle-Adam, Compiègne, and finally Eragny, on the Epte River near Gisors, where he settled in April 1884 and would remain for the rest of his life.[2] Frustrated in his search, he complained in one of his letters to Lucien, "I require a spot that has beauty! I shall scour the towns and the country, if I find nothing and the house is for rent, we will see!"[3] This was a dedicated search by an artist who unlike Monet was not a peripatetic painter (see entry 49), but who preferred to paint landscapes near his studio.[4]

Osny, a mixed-agricultural hamlet of fruit and grain farmers, was a spot with sufficient beauty to absorb Pissarro during the sixteen months that he lived there while in search of more permanent surroundings. The environs of Osny were recorded in no less than twenty-four of the roughly fifty canvases painted by him between December 1882 and April 1884, recording scenes of the village, the mill running along the Voisne River, and the farmhouses resting in the gentle, hilly terrain.[5] The Museum's subject can be identified in an etching made by Pissarro in 1885 (fig. 1), some time after he left Osny, in which the image is reversed and fencing has been added around the pasture, providing a sense of confinement that is opposite to the expansiveness of the meadow in the Museum's canvas.[6] Pissarro painted three other views explicitly identified with the mill at Osny, each representing the Voisne River, its source of power.[7] By comparison to other views of the river, or to the force of water required to run a mill, it is not evident that the modest stream flowing before the trees and buildings in the middle-ground of the Museum's painting is the Voisne. In the etching the stream is altogether replaced by the distant fence, and it may be that this complex of buildings and this foreground pasture are actually part of a farm, similar to others represented by Pissarro around Osny.[8]

The move to Osny corresponds to a period of restlessness and doubt for Pissarro, accompanied by a reevaluation of the direction of his work, such as many of his Impressionist colleagues underwent in the 1880's (cf. entries 49, 60, 64). Immediately preceding his move, Pissarro had virtually abandoned painting the Pontoise landscape, preferring instead to concentrate on the local farmers, whom he represented individually or in small groups.[9] A one-man show of his recent work was held at Durand-Ruel's Paris gallery in May 1883. He sold nothing, and in its aftermath he began to look in earnest for a new location in which to paint. Gauguin, who worked with Pissarro at Osny from mid-June through early July 1883, was unable to stimulate Pissarro's enthusiasm for an eighth Impressionist exhibition.[10] Of the paintings that he made in Rouen that autumn, Pissarro confided to Lucien: "I look at them constantly [and] often find them horrible. I understand them only at rare moments"; and of the public's disregard for his work he explained, "I have the temperament of a peasant, I am melancholy, harsh and

savage in my works, it is only in the long run that I can expect to please, and then only those who have a grain of indulgence."[11]

Pissarro's purported temperament is arguably more rhetorical than real. He had spent the first years of his life in St. Thomas, Virgin Islands, the son of a Jewish businessman from Rouen who prospered in the Danish colony there. He received his formal education at a boarding school in Passy and throughout his life remained extremely well-read. His Pontoise canvases reflect a noteworthy detachment from the local provincial life, even while he lived in its midst.[12] Pissarro's rhetoric is, however, relevant to his artistic goals in this transitional period, reflecting his ambition at this time to paint subjects based on no identifiable system or style, cultivating an artlessness that is belied by the evident complexity of his brushwork and color. His letters to Lucien, who was just then launching his artistic studies in London, are filled with exhortations to avoid artistic formulas that rely on ready-made systems,[13] and to look to "primitive" painters, "our masters because they are naive and knowing."[14]

The Museum's *Field and Mill at Osny* is a fairly radical example of Pissarro's effort to cultivate a "naive and knowing" simplicity in his work at this time, and its subsequent adaptation into an etching with six states suggests that he was satisfied with the results. The artful compositional devices and effects that characterize Pissarro's paintings of the 1870's are conspicuously absent in this deliberately quiet and unspectacular view consisting of a rolling meadow that extends beyond each vertical edge, six cows, a group of simple rural buildings flanked on each side by trees in the middle ground, and a cloudless, sunlit sky. Pissarro had often included architecture in his Pontoise landscapes, yet here the buildings no longer dominate. This landscape exhibits an underlying emphasis on pictorial order, with the buildings in the exact center of the canvas serving as a visual fulcrum, balancing the cluster of trees on either side and the roughly equal expanses of field and sky. The lack of dominance of any element of this painting (land, architecture, trees, sky) reflects an effort in this period to achieve a quality of balance in his

Fig. 1 Camille Pissarro, *Field and Mill at Osny,* etching, drypoint, and aquatint, 6¼" × 9½" (16 × 24 cm), Oxford, Ashmolean Museum.

work. The dense webbing of brushwork visible in his Pontoise paintings has been replaced by a smoother technique, composed of finer, thinner brushstrokes. In the meadow in particular, the brushwork plays a major role in the organization of space, foreshadowing the artist's flirtation with pointillism towards the end of the decade.

The sparseness of the foliage and its virgin-green hues suggest that this view was painted in the early spring. Pissarro moved to Eragny on April 4, 1884; hence this must have been one of the very last paintings of the region around Pontoise. In its simplification and orderliness, it reflects an effort to pare away the extraneous from his vision of "pure" landscape. In feeling, it reflects Pissarro's sensitivity to the simple beauty of this region. D.R.

1. A label perhaps originally affixed to another painting by Pissarro on the reverse of the frame reads: "Exposition Centennale de 1900/Pissarro (Camille) né en 1830/ Ferme à Eragny" [sic]; the top left of the stretcher is inscribed in blue pencil: "No. 517, Exposition Centennale."

2. Pissarro 1943, pp. 33 (Paris; May 28, 1883), 34 (Paris; June 4, 1883), 40–48 (Rouen; October 11–November 27, 1883), 49 (Osny; December 28, 1883), 55 (Osny; February 10, 1884), 56 (Osny; February 17, 1884), 58 (Paris; March 1, 1884).

3. Osny; December 14, 1883; in Pissarro 1943, p. 49.

4. See Pissarro 1943 (Osny; December 1, 1883) and Brettell 1990, pp. 37, 100–01.

5. See Pissarro and Venturi 1939, nos. 581–98, 622–28. Pissarro had first ventured to Osny a decade before, painting at least two landscapes there in 1873. See Pissarro and Venturi 1939, nos. 220, 236.

6. The print in the Ashmolean Museum is inscribed: *"No. 5/ Epreuve d'artiste/Prairy* [sic] *& Moulin à Osny (Pontoise)/aqua cuivre/ C. Pissarro."* See Delteil 1923, no. 59; and London, Hayward, 1980–81, p. 216 (no. 182).

7. See Pissarro and Venturi 1939, nos. 592 (*Landscape at Osny, the Sluice near the Mill*), 595 (*Wash-house and Mill at Osny*), 622 (*Wash-house at Osny, Effect of Snow, Sun*). Other water views include nos. 583 (*View of the Farm*), 586 (*Banks of the Voisne*), 588 (*The Stream at Osny*), 594 (*Little Bridge on the Voisne, Osny*).

8. Pissarro's Osny landscapes include a number of views of unidentified farmhouses that resemble the cluster of buildings in the RISD canvas in type, if not in detail: Pissarro and Venturi 1939, nos. 583, 586, 588, 593–94, 596, 598, all of them dated 1883. The difficulty of identifying any of these subjects more precisely reflects Pissarro's disregard for photographic accuracy in his reinventions of architecture and topography. See Brettell 1990, pp. 5–7.

9. These subjects dominate his work between 1880 and 1882, although as late as July 1883 he wrote to Lucien that he was "obsessed with a desire to paint figures that are difficult to compose with"; Pissarro 1943, p. 38 (Osny; July 22, 1883). See Pissarro and Venturi 1939, nos. 498–580 (*passim*), and nos. 614–20.

10. On the prospect of this exhibition Pissarro wrote to Lucien: "The people of Paris are fed up: let's not start anything. And truly, I think we have had enough exhibitions"; Pissarro 1943, pp. 44–45 (October 31, 1883). The Eighth Impressionist Exhibition, in which Camille and Lucien were both to participate, was held in 1886.

11. Pissarro 1943, p. 47 (Rouen; November 20, 1883).

12. See Brettell 1990, pp. 103, 116, 133.

13. See Pissarro 1943, p. 34 (Paris; June 14, 1883).

14. Pissarro 1943, pp. 48-49 (Paris; December 9, 1883); cf. p. 39 (Osny; July 25, 1883): "Derive your taste from those who are truly strong, for you must always go to the source: in painting to the primitives...."

GIACOMO FAVRETTO
Italian, 1849–1887

63 Easter Fair on the Rialto Bridge, ca. 1886

Signed, lower left: *G. Favretto*
Oil on canvas. 83″ × 33¾″ (210.3 × 85.7 cm)
Anonymous gift. 56.086

PROVENANCE: Arthur Tooth, London, 1886; Domenico Favretto (the artist's father), November 7, 1887 (acquired following the artist's death on June 12, 1887).

EXHIBITIONS: Venice 1887, p. 21 (no. 3); Hartford, Wadsworth, 1961, p. 20; Williamstown, Clark, 1982, pp. 45–46, 73 (no. 22, ill., as *Market on the Rialto*).

PUBLICATIONS: Boito 1887, pp. 53, 55; Castelnuovo 1887, pp. 91, 93 (ill.); Centelli 1887, p. 438; Fadiga 1887, pp. 50–51, 64; *Illustrazione Popolare* 1887; Munaro 1887; Oreffice 1887; Sicco 1887, pl. I; Stella and Molmenti 1887, pp. 22–23 (no. 3); *Saturday Review* 1887, p. 447; Boito 1888, p. 3; Dietrieb 1888, p. 8; *Bologna, Esposizione* 1888, p. 9; Archinti 1889, p. 201; Molmenti 1895, pp. 10, 23 (ill.); Cervelli 1898, p. 62; Brosch 1902, p. 43; Pelandi 1912, p. 9; Nicodemi and Dufflocq 1935, p. 103; Somarè n.d., p. 217 (fig. 61); Somarè 1935, p. 53 (pl. LXI); A. V. 1937; Somarè 1938, p. 8; Clementi 1941; Pagani 1955, pp. 56–57, 348; Clark 1956, pp. 1–3 (ill. p. 2); Canaday 1961, p. 23 (ill.); Perocco 1976, p. 1297 (fig. 1585); Perocco 1986, pp. 30–33, 194 (no. 198, ill.).

Easter Fair on the Rialto Bridge appears to be one of the three paintings exhibited by Giacomo Favretto at the National Art Exposition in Venice in 1887,[1] the year in which the artist died while at the height of his fame. In the closing decades of the nineteenth century, Favretto enjoyed a reputation as one of the most celebrated Venetian artists of his day. His open-air scene of contemporary life in Venice is an outstanding example of progressive painting in Venice produced at a time when the city was inundated with foreign artists whose own views of its landmarks and monuments often overshadowed depictions of the local scene by Italian painters.

Favretto's origins were humble. His father was a carpenter who apprenticed his son in a stationery shop. Encouraged to pursue his artistic talent, which was discovered early on, he became a student at the Venice Academy of Fine Arts, where he remained from 1864 to 1870, trained by the conservative faculty, whose esthetics were grounded in Neoclassical history painting. On his own in the 1870's, he came under the influence of the freely brushed style and contemporary themes of the Macchiaioli and traveled in 1879 to Paris with his friend and fellow Venetian Guglielmo Ciardi (1842–1917), another avant-garde enthusiast. Exposure to the high-keyed color and spontaneous form of Impressionism had had its inevitable effect on Favretto's style by the time he experienced his first major success in 1880. The loss of an eye following a severe infection in 1877 had not dampened his energy or ambition, and he soon found himself a well-respected resident of a studio overlooking the Rio da Maddalena, where he was visited on more than one occasion by the Italian Queen Margherita, an admirer and patron of his art.

Favretto's mature style was as firmly rooted in Venetian art of the past as it was allied with contemporary trends.

Echoes of eighteenth-century masters can certainly be detected in the RISD canvas: the *vedute* of Canaletto and Francesco Guardi, whose painterly views of the monuments of Venice are prototypes for Favretto's Rialto arch and church steeple, and the dynamic Rococo compositions of Giovanni Battista Tiepolo, whose grand manner, simultaneously monumental and airy, Favretto emulates.[2] In addition to views of contemporary life, Favretto produced numerous historical genre scenes of life in eighteenth-century Venice painted in a neo-Rococo style that figure in a widespread Rococo revival in European painting. Favretto was also influenced by the hazy atmospheric effects and color of the Venetian Renaissance masters, in particular Giorgione and Titian, whose style, so intimately linked to the moist, sunny climate of the area, presaged the sparkling technique of the eighteenth-century school that was his more immediate source.

While views of Venetian monuments, canals, and piazzas were standard subjects in the nineteenth century for both native and foreign artists, among them Manet, Whistler, and Sargent, Favretto's success in focusing on the Venetian people rather than the architecture surrounding them distinguished his work.[3] Although Favretto was not the first painter to introduce genre scenes peopled with city residents in nineteenth-century Venetian painting,[4] he did play a major role in popularizing them. He was particularly fond of scenes in shops and market places and had already produced several large views of the market in the Campo San Polo before painting the Rialto Bridge.[5]

The section of the Rialto shown in the Museum's painting is the high arch in the center of the bridge. Since 1588 the Ponte di Rialto has spanned the Grand Canal of Venice, providing pedestrians with a three-lane thoroughfare. Favretto's figures are situated on steps below the main arch, where the commercial activity of the shops housed under the arcades that run the length of the bridge is augmented by vendors selling their wares outdoors. The Late Baroque tower of the church of San Bartolomeo (1754) with its bulbous steeple looming behind the Rialto can be recognized in the upper left portion of the canvas. Descriptions of the Rialto Bridge in guidebooks and travel accounts roughly contemporary with Favretto's painting bear out the image of bustling trade and abundant produce seen in the picture.[6] The long tradition of holiday market fairs held on the steps of the bridge is reflected in a 1923 account in which the proletarian character of the market is recorded.[7] The fair in Favretto's painting, set at Easter, is dominated by peasant and working-class shoppers and vendors, with only a few fashionably dressed urban types in the distant background.[8]

Favretto's canvas, painted from a low vantage, presents both the people and the merchandise of the marketplace. In the immediate foreground, baskets of cabbages and onions positioned beside a crouching vendor draw the eye up toward the market-goers and passers-by, who are arranged in a zigzag pattern that moves up the stairs and back into space. Favretto had used a similar composition in his second San Polo market scene (1884, Padua, private collection), but the

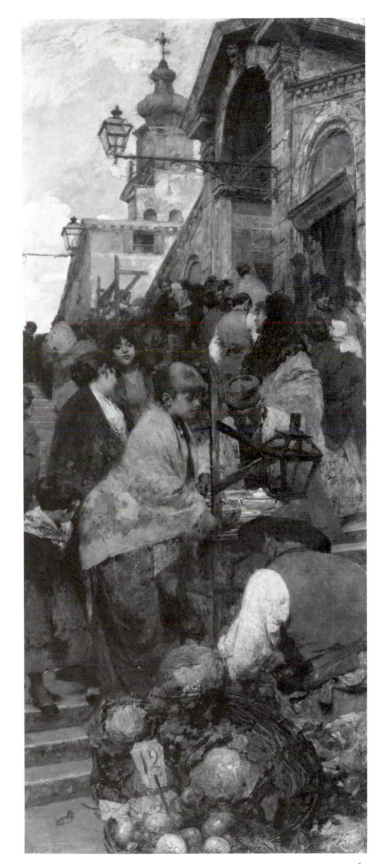

63

Rialto painting is unique in its vertical orientation, the artist's only major work in such a format. The tall, narrow proportions of the canvas correspond to the steep, constricted passageway of the bridge, which rises at a sharp incline, and aid in capturing the physical sensation of the dense crowd squeezed into a limited space.

While the painting's loose brushwork, open-air setting, and seemingly random, fragmented composition reveal the influences of Impressionism, evidence of Favretto's lingering academic tendencies are indicated by the treatment of architectural perspective and detail. It is, in fact, the differences from French Impressionism as much as the similarities that strike the modern viewer: the three-dimensional, volumetric treatment of figures and objects, the high degree of literal detail, contours that are relatively sharp, and color that is low-keyed.

Easter Fair on the Rialto Bridge might best be called naturalistic, a term used to characterize works of the late nineteenth century which were painted in a somewhat diluted Impressionist style, with greater focus on the rural and proletarian themes favored by the earlier generation of mid-century realists such as Courbet and Millet.[9] That Favretto was leaning, in his final years, toward the more "modern" (i.e., urban, upper middle-class) iconography of orthodox Impressionism is indicated by another 1887 painting, *Liston moderno,* showing a sophisticated, fashionably dressed bourgeois crowd in the Piazza San Marco that contrasts with the picturesque and ultimately romanticized plebeian gathering on the Rialto. With the *Rialto Bridge* and two other highly praised entries still on the walls of the Venice Exposition of 1887,[10] Favretto succumbed to typhoid fever and died on June 12.[11] His legacy continued in the work of his followers, Ettore Tito (1850–1941) and Alessandro Milesi (1856–1945), whose lively urban views carried the Venetian tradition of painterly realism into the twentieth century. D. E. S.

1. The exhibition of the RISD painting in the 1887 Esposizione Nazionale Artistica of Venice is confirmed by its similarity to an 1887 photograph of the original (Foto Filippi, no. 337). The handwritten measurements of the painting on the artist's entry form for the Esposizione (dimensions were not published in the 1887 catalogue) are 264 × 142 cm, larger than those of the RISD canvas, but they include the frame. I am indebted to Guido Perocco (Venice) for kindly providing me with a print of the original photograph and copies of unpublished documents from the archives of the Venice Biennale. Mr. Perocco notes slight discrepancies between the original photograph and the RISD painting and suggests that it might be a replica by Favretto himself or a skillful copy made following its acquisition by the artist's father. However, he does not rule out the possibility that it is the original (letter to the author, September 19, 1990). I would like to thank John Wetenhall (Birmingham Museum of Art) for his advice as well. The 1886 dating is based on the painting's inclusion on the entry form for the exposition cited earlier, which bears a submission deadline of December 15, 1886.

2. Favretto reproduced a painting by Tiepolo in the lower right of his *Vandalism,* an exposé of unscrupulous restoration practices, exhibited in Milan in 1880. See Renzo Trevisan, "Cenni Biografici," in Perocco 1986, p. 37.

3. In the late nineteenth century, Rubens Santoro (1859–1942) was a leader among Italian *vedute* painters specializing in traditional scenes of Venice. See Williamstown, Clark, 1982, p. 45. The reluctance of foreigners to include figures in a significant way had largely to do with the prevalent view of present-day Venice as a mere reflection of a once glorious past to be savored for the surviving remains of a grander age. This idea, promoted by John Ruskin in *Stones of Venice* (1850–53), seems to have been shared by the majority of English and American visitors, who consequently took little interest in the inhabitants. As Margaretta Lovell observes, "Contemporary Venetians were regarded with some ambivalence, even hostility . . . Most artists omitted figures from their compositions, or introduced them as minor elements in the distance"; see San Francisco, Fine Arts, 1984, p. 13. The one notable exception to this general trend was John Singer Sargent, whose inclusion of figures was often more than incidental. A view by Sargent of the Rialto Bridge seen from the water below is found in the Philadelphia Museum of Art (*The Rialto, Venice,* ca. 1911).

4. Two foreign painters working in Venice, Ludwig Passini (1832–1903), an Austrian, and Remigius Van Haanen (1812–1894), a Dutchman, are credited with this innovation in Somarè n. d., pp. 28–29, cited in Williamstown, Clark, 1982, p. 62, n. 14.

5. *Market in Campo San Polo, Venice* (1883, Rome, private collection), and *In the Market. Market in Campo San Polo* (1884, Padua, private collection).

6. *Cook's* 1890, p. 64.

7. Ragg and Ragg 1923, p. 114.

8. The lively activity and profusion of sights, sounds, and smells that made the Rialto market such a colorful, appealing attraction to tourists is captured in William Dean Howells's description of it in *Venetian Life* (1866). See Howells 1866, I, pp. 182–83. See also Cartwright 1884, pp. 38–39.

9. See Cleveland, CMA, 1981, pp. 188–264.

10. *El Liston* (1884, Rome, Galleria Nazionale d'Arte Moderna), a historical genre scene set in the eighteenth century, and *Ferry on the Maddalena* (1887, ex-collection Milan, Sacerdoti), a view of the exterior of Favretto's studio overlooking the canal.

11. The acquisition of the painting by Favretto's father, Domenico, on November 7, 1887, upon the closing of the Esposizione is recorded in a notarized document in the archives of the Venice Biennale. My thanks to Guido Perocco for this information.

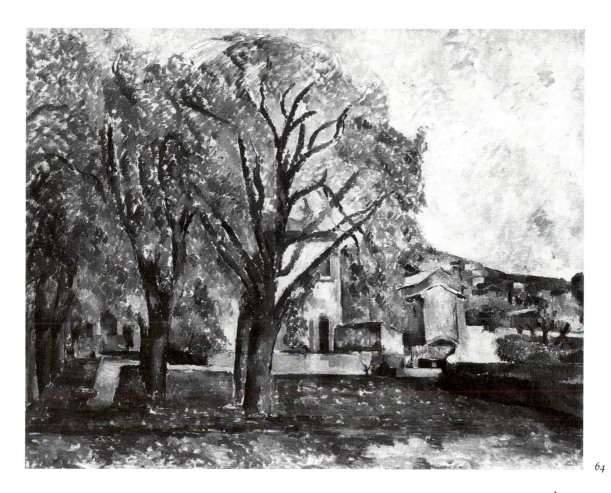

64

PAUL CÉZANNE
French, 1839–1906

64 *Chestnut Trees and Farm at the Jas de Bouffan*
(The Jas de Bouffan in Spring), ca. 1887

Oil on canvas. 25¾″ × 31⅞″ (65.4 × 80.9 cm)
Museum Appropriation. 33.053

PROVENANCE: Ambroise Vollard, Paris; Paul Rosenberg, Paris; Marcel Kapferer, Paris; Galerie Zborowski, Paris/New York; from which purchased by the Museum in 1933.

EXHIBITIONS: Zurich, Kunsthaus, 1917, no. 28 (ill.); Wiesbaden 1921, no. 381; Paris, Pigalle, 1930, p. 22 (no. 30); Chicago, AI, 1933, no. 295; Philadelphia, PMA, 1934, no. 31; Toledo, Museum, 1936, no. 27; Andover, Addison, 1945; Worcester, Art Museum, 1946; Vienna, Kulturamt, 1961, no. 26; Aix-en-Provence, Vendôme, 1961, p. 29 (no. 50); New York, IBM, 1988.

PUBLICATIONS: Gasquet 1920, p. 263 (ill.); Fontainas and Vauxcelles 1922, p. 225 (ill.); Alexandre 1930, p. 75 (ill.); Rowe 1933, pp. 50–52 (ill. on cover); Rewald 1936, p. 128 (fig. 60); Venturi 1936, no. 463; Vollard 1938, pp. 39, 49 (?); Rewald 1939, p. 276 (fig. 62); Cheney 1941, p. 231 (ill.); Graber 1942, p. 313; Worcester, March 1947; Rewald [194–?], fig. 63; Wilenski 1954, p. 76; Baigell 1968, p. 396 (ill.); Dunlap and Orienti 1970, pp. 102–03 (no. 357); Novotny 1970, p. 198; Aix-en-Provence, Granet, 1982, pp. 45, 279 (ill.); Barskaïa 1983, p. 133 (ill.); Woodward and Robinson 1985, p. 198 (no. 116, ill.).

RELATED WORKS: *Chestnut Trees and Farm at the Jas de Bouffan,* ca. 1885–87, oil on canvas, 28⅜″ × 35⅞″ (72 × 91 cm), Moscow, Pushkin Museum of Fine Arts. *Chestnut Trees and Farmhouse at the Jas de Bouffan,* ca. 1885, oil on canvas, 36″ × 29″ (91.4 × 73.7 cm), Pasadena, Norton Simon Foundation.

The Jas de Bouffan, the name of the property represented in this painting, was Cézanne's home and refuge throughout most of his life.[1] The property was located approximately two kilometers west of Aix-en-Provence, the Provençal town in the south of France where Cézanne was born. Built in the eighteenth century and once occupied by the governor of Provence, it consisted of around thirty acres, enclosed by walls, with a large garden, reflecting pool, rows of imposing chestnut trees, and an adjacent farm, visible at far right in the painting. It was purchased as a summer home by Cézanne's father, a prosperous businessman-turned-banker, in 1859, at a time when the property had fallen into disrepair. Around 1881, Cézanne had a studio built there, and he spent great amounts of time there until 1899, when it was sold to settle the family estate among the artist and his two sisters.

This property, and the surrounding countryside, loomed large in the life and work of the painter, who found in the familiarity and the isolation of this country retreat the solitude that his art and temperament required. It was in the nearby countryside that the seeds of Cézanne's artistic development were first nurtured and grew. As teenagers, he and his childhood friend, Emile Zola, spent long summer days on the banks of the Arc River, near to the Jas, reading, writing and reciting poetry, and drawing. The acquisition of this property coincided with Cézanne's decision of around December 1859 to become a painter. Following his many trips to Paris throughout the 1860's and 1870's, Cézanne regularly retreated to the Jas de Bouffan, often for long periods of time during which he frequently saw no one outside of his family. There

Fig. 1 Photograph of the Jas de Bouffan, ca. 1900. Photograph courtesy André Corsy, Aix-en-Provence, and John Rewald, New York.

he was more relaxed and could work in complete solitude, removed from the diversions of city life, with which he was uncomfortable.[2] Throughout the 1880's and 1890's Cézanne spent the preponderance of his time at the Jas de Bouffan, traveling periodically, but always returning to his family home. It is his most frequently represented subject, identified in no less than thirty-five canvases painted between ca. 1865 and 1890, of which more than fifteen, including the Museum's painting, are dated by Venturi between 1885 and 1887. Rewald, more precisely, dates the Museum's painting to ca. 1887.[3]

The execution of this painting around 1887 follows a number of important events in Cézanne's life. In March 1886 Emile Zola's *L'Oeuvre* was published. The protagonist of this novel, Claude Lantier, who was based partly on the character of Cézanne, is a brilliant yet frustrated painter unable to realize his vision, who commits suicide at the conclusion of the novel. Cézanne, with some justification, found in this character a judgment by Zola of his own work, with the result that these lifelong friends, whose artistic careers were formed during their mutual childhood, never spoke to each other again. One month later, on April 28, following many years of intrigue between the artist and his quarrelsome father, Cézanne married Marie-Hortense Fiquet, his mistress since 1869 and the mother of their illegitimate son, Paul. This liaison had been the source of constant friction between Cézanne and his strong-minded father. They were married in a proper religious ceremony, in which both of Cézanne's parents were signatories to the marriage contract, suggesting a reconciliation between Paul and his father. It may also reveal an effort by Cézanne to legitimize his son, even though his relations with Hortense had by that time become strained.[4] Six months later, on October 23, 1886, Cézanne's father died at the age of eighty-eight, leaving the painter a sizable inheritance, including partial ownership of the Jas de Bouffan. Cézanne remained in Aix throughout 1887, when it is likely that a number of views of the Jas de Bouffan – among them the Museum's canvas – were painted.

Cézanne's retreat to the isolation of the Jas de Bouffan in the 1880's resulted partially from his effort to disassociate himself from the Impressionists, with whom he had been especially close during the previous decade. The theories and techniques of Impressionism, and the influence of Camille Pissarro in particular, had been important to Cézanne's development during the 1870's. As a result of his contact with the Impressionists, Cézanne began to paint landscape scenes *en plein air,* his interest in imaginary narrative subjects declined, his palette brightened, and the linear contours prevalent in his early work were replaced by small, individual strokes that emphasized the sensation of light. He had exhibited three paintings in the first Impressionist exhibition of 1874 and sixteen works in the third exhibition of 1877, the second and last group show in which he would participate. In this latter exhibition, Cézanne was singled out for particularly harsh criticism, with the result that from 1877 to 1895, when an important one-man show was given to Cézanne by the young dealer Ambroise Vollard, his work was virtually unseen by the Paris art world.[5] "Isolation is what I am worthy of," he commented. "Thus, at least, no one gets me in his clutches."[6] On the rare occasions when he was in Paris during these years, he showed little interest in the gatherings of Impressionist painters at the café called the Nouvelle-Athènes. As Venturi has noted in his essay on Cézanne's development, between 1883 and 1887, when he was almost continually at Aix, Cézanne developed what Venturi has called his "constructive" style, which by 1885 had become particularly abstract.[7] Cézanne had grown critical of the Impressionists for experimenting too much, as well as for their dissolution of mass and eradication of local color. It was in this period that

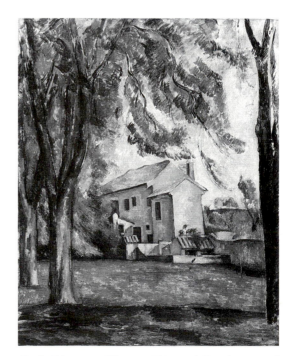

Fig. 2 Paul Cézanne, *Chestnut Trees and Farmhouse at the Jas de Bouffan,* ca. 1885, oil on canvas, 36″ × 29″ (91.4 × 73.7 cm), Pasadena, Norton Simon Foundation. Photograph by A. E. Dolinski Photographic.

Cézanne assumed the task of "making out of Impressionism something solid and durable like the art of Museums," by seeking what he was later to call "the logic of organized sensations."[8]

The Museum's painting represents the park adjacent to the house, with its dominant alley of chestnut trees that partially obscure the house behind them and close off the view to the left. The park is enclosed by a high wall to the right, which leads to the adjacent farmhouse sitting at the far corner of the courtyard, identified by its two-tiered roof. A view of the actual property that is close in feeling to the Museum's painting, showing the chestnut trees in spring bloom and the complex of buildings behind, can be seen in a photograph

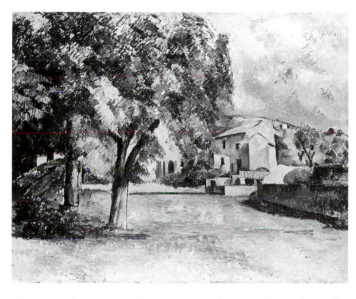

Fig. 3 Paul Cézanne, *Chestnut Trees and Farm at the Jas de Bouffan,* ca. 1885–87, oil on canvas, 28⅜″ × 35⅞″ (72 × 91 cm), Moscow, Pushkin Museum of Fine Arts. Photograph by Jim Strong.

taken around 1900 (fig. 1).[9] Cézanne painted a view of the adjacent farmhouse from near the spot at which the Museum's view was painted, turning a few degrees to the right, indicating a closely related interest in the architectonic function of the buildings and trees (fig. 2). Also very close to the Museum's canvas, painted from an identical vantage, is a somewhat thinner view of the park, chestnut trees, and farm in the Pushkin Museum, Moscow (fig. 3).[10]

The Museum's view of the Jas de Bouffan reflects the changes that were taking place in Cézanne's art at this time. The cohesion of the painting's interlocking geometric shapes reflects Cézanne's interest in structure and the stability of construction that became the predominant feature of his paintings in these years, reflecting his break with the more diffuse style of Impressionism. Even while Cézanne was moving away from Impressionism, its lingering importance to him is visible in his attention to the specific qualities of atmosphere and light, rendered by individual touches of color that convey the sensation of observed nature. In specific areas, however, such as the foreground grass, these brushstrokes

have become regularized in their application, functioning like units of construction.[11] Intersecting linear contours tie the structure of this painting together, defined by the regular rows of the trees, the walkways and walls, the interlocking blocks of architecture, whose simple shapes are echoed by the buildings on the distant hills and by the systematic applications of color from which they are constructed. Contrary to Cézanne's habit in his Impressionist period of building up thick surfaces of paint, the method of application in this painting is very loose and thin, with areas of the raw canvas exposed and traces of underdrawing visible around the tops of the trees.

The confinement of this space, its broad, rectangular forms, and its soft color convey the solitude and peacefulness of this closed world in which Cézanne chose to spend many years of his life. While these views of the Jas de Bouffan remain very much rooted in the observation of nature, one can observe in Cézanne's technique the underpinnings of an abstract style that characterize the work of his maturity.

D. R.

1. Vollard 1938, p. 17, translates this Provençal name into the French, "le gîte du vent," or "home of the wind." The biographical information that follows has been authoritatively published and republished by John Rewald, first in his doctoral dissertation, Rewald 1936, again in Rewald 1939, and definitively in Rewald 1986. The information below has been taken largely from these sources.

2. Rewald 1939, pp. 97, 153, 267-68. The writer Paul Alexis, a mutual friend of Cézanne and Zola from Aix, wrote in a letter to Zola from Aix in 1882 that living there was like living "at the bottom of a well . . . no air, no sun, intellectually . . . nobody here talks about literature, and if they talk about anything, it's how to fix one's hair." If Cézanne did not suffocate, Rewald observes, it is because he saw no one and never left the Jas de Bouffan. His hair grew long and wild, he lost track of the day and date and threw himself completely into his work.

3. Cf. Venturi 1936, nos. 460 (Prague, Národni Galerie), 461 (private collection), 462 (Moscow, Pushkin Museum), 463 (Providence, RISD), 464 (Cannes, Collection Gould), 465 (private collection), 466 (Ottawa, National Gallery of Canada), 467 (New York, Collection Schiff), 470 (private collection), 471 (private collection), 473 (Berne, Collection Tannhauser), 474 (private collection), 475 (private collection), 476 (Minneapolis, Institute of Arts), 478 (Winterthur, private collection), 480 (Paris, Musées Nationaux, Collection Walter Guillaume). Rewald 1936, p. 128, dated this painting "around" 1887–88. Subsequently, in Rewald 1939, p. 276, and publications thereafter, this dating is modified to ca. 1887, perhaps because Cézanne spent all of 1887 in Aix, but most of the following year in Paris.

4. Rewald 1976, p. 234, quotes two letters from Numa Coste and Paul Alexis, mutual friends of Cézanne and Zola, written to the latter around 1891, indicating that Hortense was living in Paris while Paul lived in Aix. Cézanne cut his wife's income in half, forcing her to move to Aix. She took a house in town, while Paul lived with his mother and sister at the Jas de Bouffan. According to Coste, Hortense was not on speaking terms with Cézanne's mother and sister.

5. He regularly submitted works to the yearly Salon, and these were regularly rejected, with the exception of an unidentified *Portrait of Monsieur L.A.* in the Salon of 1882, which was admitted through the influence of his friend, the painter Antoine Guillemet, who was a member of the jury. This was his unique submission to an official Salon. The principal venue in which his paintings could be seen was in the artists' supply store of Père Tanguy, the same

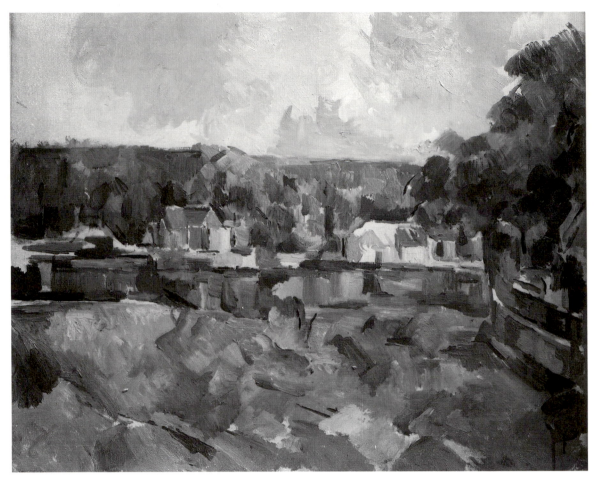

65 (color plate p. 29)

spot in which Van Gogh's paintings were occasionally shown.

 6. Rewald 1986, p. 185.

 7. Venturi 1936, I, pp. 51-52; cf. II, pp. 129-83, nos. 293-551, executed between 1878 and 1887, which Venturi calls Cézanne's "constructive period."

 8. Rewald 1986, pp. 155-59. See *Banks of a River* (entry 65, fig. 2), ca. 1904, private collection, in which Cézanne, in his late maturity, approaches the formlessness of earlier Impressionism.

 9. I am grateful to John Rewald for this photograph, which he obtained from Prof. André Corsy, grandson of the man who acquired the Jas de Bouffan from the Cézanne family in 1899.

 10. Venturi 1936, no. 462. This painting also traces its provenance back to the collection of Ambroise Vollard.

 11. The brushwork, as Meyer Schapiro has observed of Cézanne's mature paintings, serves the multiple function of representing "a bit of nature (a tree, a fruit), a bit of sensation (green, red), [and] also an element of construction which binds sensations or objects." Schapiro [1963], p. 10.

PAUL CÉZANNE
French, 1839–1906

65 *Banks of a River,* ca. 1904–05

Oil on canvas. 24″ × 29″ (60.9 × 73.6 cm)
Museum Special Reserve Fund. 43.255

PROVENANCE: Ambroise Vollard, Paris; from whom acquired by Durand-Ruel, Paris/New York, around 1939; from whom purchased by the Museum in 1943.

EXHIBITIONS: New York, Durand-Ruel, 1938; Buffalo, Albright, 1944, no. 11; Andover, Addison, 1947; Burlington, Fleming, 1947; Milwaukee, Art Institute, 1957, pp. 41, 46 (no. 69, ill.); Andover, Addison, 1961; New York, MOMA, 1977, pp. 49, 68-69, 288, 400-01 (no. 46, fig. 85); New York, IBM, 1988.

PUBLICATIONS: Venturi 1936, no. 769; Frankfurter, March 1938, p. 13 (ill.); F.E.M. 1943, pp. 1–2 (ill.); Dunlap and Orienti 1970, pp. 119–20 (no. 748); Woodward and Robinson 1985, pp. 73, 199 (no. 118, ill.).

CONSERVATION: The canvas has never been lined; a second set of tack holes around the edge indicates that it had been restretched some time before its acquisition by the Museum. In 1981 a discolored varnish and surface grime were removed, and a light surface of synthetic varnish was applied by the Williamstown Regional Art Conservation Laboratory.

RELATED WORKS: *Banks of a River,* ca. 1904, oil on canvas, 25¼″ × 31⅞″ (64 × 80.9 cm), private collection (Venturi 1936,

no. 1533; Rubin 1977, p. 281). *The Seine Near Paris,* 1904–05, watercolor, 18″ × 21⅞″ (45.7 × 55.5 cm), location unknown (Venturi 1936, no. 918; Rewald 1983, no. 627).

Although the precise location of this river view is unknown, it is widely believed to have been painted along the Seine or Marne Rivers near Paris, in the vicinity of Fontainebleau. In 1904, on the occasion of the first Salon d'Automne, in which an entire room was devoted to his work, Cézanne spent several weeks working in the landscape near Fontainebleau, where his son had rented a house. Cézanne was there again in the following summer in what was to be his last visit to Paris and its environs, and his last departure from Aix.[1] It was during one of these two visits, in the very last years of his life, that the Museum's canvas was probably painted.

The dating and location of this painting may be deduced by its close relationship to a contemporary watercolor identified by Venturi as *The Seine near Paris* (fig. 1), representing the same site.[2] From this watercolor the details of the landscape can be more clearly discerned. The composition is bordered on the right by a high, curving wall over which fall the branches of a tree that fill the upper right corner of the composition. Beneath this wall a road curves around to the right, complementing the curve of the river along which it runs. The road and the river disappear behind the wall in the middle distance. There is an embankment between the road and the river on which shrubs and several low, rectangular buildings can be identified. The viewer looks from a high vantage across the embankment and the river to distant houses and trees on the far bank. In the watercolor, these are considerably smaller in scale than in the Museum's painting. The composition of the watercolor recedes from the lower left towards the point at which the wall, road, embankment, and river converge at the midpoint of the composition. This perspectival ordering of space is a rarity in Cézanne's work,

as is the representation of pedestrians walking down the road toward this vanishing point, reinforcing the illusion of spatial recession.

Although representing the same view painted from the same vantage, the Museum's painting places considerably less emphasis on topographical detail and conventional one-point perspective. The composition has been flattened, perspectival drawing eliminated, and in place of a recessional scheme in which various points converge in depth, Cézanne has organized his composition in horizontal bands that are parallel to the upper and lower edges of the canvas. The curve of the wall to the right is the only remaining indication of linear recession. The water, rather than curving from the foreground into depth, is represented as a blue, horizontal band of tight, vertical strokes alternating in intensity, which divides the canvas into an upper and lower half. The canvas is also divided vertically at its midpoint by a column of blue strokes that carry from the sky into the foreground, diminishing in hue to a pattern of cool grey strokes along the bottom edge. To the left of the river, the pattern of blue vertical strokes is replaced by brushstrokes of identical size and direction in colors that range from purple-brown to sienna, perhaps suggesting the architecture on the near bank. With the exception of this intimation and the wall to the right, all of the foreground detail visible in the watercolor has disappeared: there is no indication of the road, the bushes, houses along the near embankment, or the pedestrians walking into the distance. These have been replaced by bold, almost ecstatic strokes of color ranging from yellow and ocher to grey and blue carried from the river behind. The descriptive function of these brushstrokes has been superseded by structural, spatial, and atmospheric functions that unify the color and light of the overall composition and define a sensation of space independent of precisely identifiable detail.

Fig. 1 Paul Cézanne, *The Seine Near Paris,* 1904–05, watercolor, 18″ × 21⅞″ (45.7 × 55.5 cm), location unknown. Photograph courtesy John Rewald and National Gallery of Art, Washington, D.C.

Fig. 2 Paul Cézanne, *Banks of a River,* ca. 1904, oil on canvas, 25¼″ × 31⅞″ (64 × 80.9 cm), private collection. Photograph by Jim Strong, courtesy John Rewald.

The virtual abstraction of Cézanne's technique, which otherwise seems wedded to the direct observation of nature, can be seen in another painting, probably contemporary with the Museum's and representing the identical site, with the same retaining wall to the right and similar houses on the far bank of the river (fig. 2). In this version, Cézanne has taken the nondescript function of his brushstrokes even further, while still preserving the sensation of a specific landscape, observed on a sunlit day. The horizontal bands of the Museum's painting have been nearly dissolved, and with them the order and relative clarity of a measurable space. Whereas the Museum's canvas seems by comparison to be heir to the classical tradition of Poussin (whom Cézanne admired greatly), this view seems on the verge of decomposing into the energy of pure light. As Cézanne emphasized in one of the rare theoretical discussions to be found in his correspondence with the painter Emile Bernard between 1904 and 1905, "the sensations of color, which give the light, are for me the reason for the abstractions which do not allow me to cover my canvas entirely nor to pursue the delimitation of the objects where their points of contact are fine and delicate; from which it results that my image or picture is incomplete." In the overlapping of planes, he argues, the artist must avoid circumscribing contours with a dark line, for which he recommends consulting nature directly.[3]

Characteristic of Cézanne's late paintings, the illusion of depth in these landscapes is a product of carefully modulated changes in color, tone, and brushstroke. The trees above the river in the Museum's version are painted in tightly compacted vertical strokes in cool tones of green and blue. The vertical strokes of the river are broader and richer in hue, by which they appear closer. The foreground, carrying tones from above, seems to cascade out towards the viewer, alternating in tones from the warm (orange-yellow) and cool (blue-grey) ends of the spectrum. Again, some indication of Cézanne's motivations may be found in his brief correspondence with Bernard. "Lines parallel to the horizon give breadth," he observed, "whether it is a section of nature or, if you prefer, of the show which the *Pater Omnipotens Aeterne Deus* spreads before our eyes. Lines perpendicular to the horizon give depth. But nature for us men is more depth than surface, whence the need to introduce into our light vibrations, represented by the reds and yellows, a sufficient amount of blueness to give the feel of air."[4] It is in part the airiness of this foreground space, achieved by the introduction of blue tones, that enables the viewer to read it as a three-dimensional space rather than a flat, modulated horizontal zone.

In spite of the relative abstraction of this painting, it is noteworthy that around this time Cézanne placed great emphasis on the need to work directly from nature and to draw his inspiration from it. In a letter to Bernard of May 12, 1904, Cézanne commented, "I progress very slowly, for nature reveals herself to me in very complex ways; and the progress needed is endless. One must look at the model and feel very exactly; and also express oneself distinctly and with force."[5] Or again in a letter to Bernard of May 26, 1904: "But I must always come back to this: painters must devote themselves entirely to the study of nature and try to produce pictures that will be an education."[6] Yet again, in a letter of July 25, 1904: "In order to make progress, there is only nature, and the eye is trained through contact with her."[7] Cézanne's last trips to the region of Paris seem to have had a special importance for him. "The North," Lawrence Gowing observed, "had associations with a closer and more analytical reading of the whole compound experience of light, atmosphere, and natural shape. It must have reminded him afresh of the part that submission to nature had played at the turning point of his development more than thirty years before."[8] This late canvas represents a very personal reworking of Impressionism, to which Cézanne had devoted nearly the last thirty years of his career. Originating from a naturalistic impetus, it is the culmination of a lifelong devotion to the realization of "a harmony which runs parallel to nature,"[9] achieved through a highly individualized and rigorously independent temperament that in his old age had lost none of its emotional intensity. D.R.

1. Cézanne 1976, pp. 304-05, 313-14.

2. Cf. Venturi 1936, nos. 769, 918; Rewald 1983, no. 627; Chappuis 1973, no. 799. Chappuis reproduces a pencil drawing that he dates to 1880–83, *River Bank with Bridge and Barges,* which is on the verso of the watercolor *The Seine near Paris.* However, Rewald 1983, no. 627, suggests the drawing is probably contemporary with the watercolor on the recto, which he dates to 1904. The dimensions of the sheet on which this watercolor and drawing have been executed very closely conform to another of *The Château of Fontainebleau,* 1904–05, pencil and watercolor on paper, 44 × 55 cm (Venturi 1936, no. 925; Rewald 1983, no. 628), giving further credence to the probable date and location of the Museum's painting.

3. Letter from Cézanne to Emile Bernard, October 23, 1905, in Cézanne 1976, pp. 316-17.

4. Letter from Cézanne to Emile Bernard, April 15, 1904, in Cézanne 1976, p. 301.

5. Cézanne 1976, p. 302.

6. Cézanne 1976, p. 303.

7. Cézanne 1976, p. 306.

8. In Rubin 1977, p. 68.

9. Letter from Cézanne to Joachim Gasquet, September 26, 1897, quoted in Cézanne 1976, p. 261.

66

MARCELLIN GILBERT DESBOUTIN
French, 1823–1902

66 *Self-Portrait,* ca. 1888

Signed, lower right, behind sitter's left shoulder: *M. Desboutin*
Oil on paper, mounted on canvas. 18⅜″ × 15″ (46.2 × 38.1 cm)
Acquired through the generosity of David C. Scott, Jr.
1987.041

PROVENANCE: Galerie de la Scala, Paris.

PUBLICATION: Rosenfeld 1988, pp. 32–33 (ill.).[1]

RELATED WORKS: *Self-Portrait (L'Homme à la Pipe),* 1879,
etching, 17¾″ × 14¾″ (45 × 37.5 cm), Moulins, Musée d'Art
et d'Archéologie. *Self-Portrait (L'Homme au grand chapeau),* 1888,
drypoint, 9⅝″ × 7⅜″ (24.4 × 18.7 cm), Paris, Bibliothèque
Nationale. *Self-Portrait,* ca. 1888, oil on cardboard, 13¾″ ×
10¼″ (35 × 26 cm), Moulins, Musée d'Art et d'Archéologie.
Self-Portrait, ca. 1890(?), oil on cardboard, 12⅜″ × 9⅝″ (31.5 ×
24.5 cm), Evreux, Musée d'Evreux. *Self-Portrait,* oil on wood
panel, 15¾″ × 11⅝″ (40 × 30 cm), Troyes, Musée de Troyes.
Self-Portrait in a fur collar, 1894, oil on canvas, Paris, collection
Landau. *The Captain: Self-Portrait,* ca. 1895(?), pen and black
ink, gray wash, 13⁵⁄₁₆″ × 11⁵⁄₁₆″ (33.8 × 28.7 cm), Cincinnati,
Cincinnati Art Museum.[2]

Marcellin Desboutin, one of the more colorful figures of
Impressionist café culture, was the epitome of the bohemian
artist of late-nineteenth-century Paris. He was the son of a
wealthy landowner from Cérilly in central France, descended
from vaguely noble ancestry on his maternal side. He
studied law in Paris at the Ecole de Droit and registered at
the bar before abandoning this career to enter the Ecole des
Beaux-Arts in 1845. He worked in the studio of Louis-Jules
Etex (1810–1889), and in 1847 he briefly entered the studio
of Thomas Couture, two years before Manet, who was later
to become a close friend of Desboutin.

Being of independent means, Desboutin did not need
to work for a living. In 1848 he quit the Ecole, and in 1850
he began to travel extensively, living in London, Amsterdam,
and then Florence. He bought a villa there called l'Ombrel-
lino, in which he resided for seventeen years, amassing a
large collection of paintings, lavishly entertaining an inter-
national society of writers and artists, and leading the life of
a dilettante expatriate who painted and dabbled in literary
pursuits, until bankruptcy forced him to resettle in Paris in
1872. While in Florence he trained himself as an etcher and
wrote several plays, one of which, *Maurice de Saxe* (cowritten
with Jules Amigues), was performed at the Comédie Française
in Paris in June of 1870.[3]

Upon his return, living in relative poverty, Desboutin was obliged to support himself through his art, which he did by selling drypoint portraits that brought him between one hundred to two hundred francs each and secured him a considerable reputation among his contemporaries, among whom Degas and Manet were his very close friends. In the next eight years Desboutin became an habitué at the Impressionist cafés, first at the Guerbois on the rue des Batignolles and then at the Nouvelle-Athènes on the Place Pigalle, where Degas portrayed him seated next to the actress Ellen Andrée in the *Absinthe Drinker* (fig. 1). In the same year Degas painted *Marcellin Desboutin and the Comte Lepic* (1876, Nice, Musée Masséna), a portrait of Desboutin in the process of etching one of his drypoint portraits. In 1875 Desboutin also posed for Manet's full-length portrait called *The Artist* (São Paulo, Museu de Arte Moderna), showing a tattered yet dignified figure who for Manet embodied the bohemian artistic life of that period. With this portrait, Manet said, "I made no claim to have summed up an epoch, but to have painted the most remarkable type [whom] I painted with as much feeling as I painted Baudelaire."[4] A more intimate, half-length watercolor portrait of Desboutin by Manet also dating from 1875 can be found in the Fogg Art Museum in Cambridge (fig. 2). In these same years, working in drypoint, Desboutin created a virtual lexicon of Impressionist portraits, including Manet, Degas, Renoir, Morisot, Zola, Goncourt, and Duranty. He became a regular contributor to the yearly Salons, specializing in portraits of the artists and writers with whom he traveled. Along with Rodin, Carrière, Meissonier, and Puvis de Chavannes, he founded the Salon of the Société National des Beaux-Arts in 1890, the rival to the more conservative Société des Artistes Français.

Desboutin was a prolific artist, who at the time of his death is said to have left between fifteen hundred and two thousand paintings in his studio, including at least a hundred self-portraits.[5] Few of these works are dated and most appear to have been created in the artist's late years. The intense self-scrutiny of the aging artist represented by these many portraits has encouraged a comparison to Rembrandt, whom Desboutin claimed as his only master.[6] The reversals of fortune suffered by Rembrandt may have reinforced Desboutin's identification with him, influencing the expression of pathos and introspection visible in many of these portraits.

From comparison with self-portraits whose dates are known, as well as the portraits of him rendered by Manet and Degas in the mid-1870's, when Desboutin was in his early fifties, it can be fairly guessed that the Museum's self-portrait was painted in the following decade, during most of which Desboutin resided in Nice.[7] He appears slightly older than in Manet's intimate watercolor portrait, nevertheless retaining many of the features described by Edmond de Goncourt in the entry to his *Journal* dated February 6, 1875: "[he has] a peculiar head, with a shock of hair like a Gorgon and an uneven, bumpy face with sudden salients – as if a thunderbolt had hit him."[8] Shown in a moment of intense self-scrutiny, he does indeed appear thunderstruck, recalling the vigorous expressive heads that Fragonard created of inspired men a century earlier. During his sojourn in Nice between 1880 and 1888, one of Desboutin's major achievements was the realization of five major etched plates after paintings by Fragonard then located in Grasse, suggesting Desboutin's interest in the eighteenth-century painter at that time.[9] Another self-portrait, in the Musée d'Art et d'Archéologie, Moulins, although somewhat more dour, seems closely related to the one at RISD in both style and date of execution (fig. 3).

Fig. 1 Edgar Degas, *In a Café* (*The Absinthe Drinker*), ca. 1875–76, oil on canvas, 36¼" × 26¾" (92 × 68 cm), Paris, Musée d'Orsay.

Fig. 2 Edouard Manet, *Portrait of Desboutin,* 1875, watercolor, 9" × 5½" (22.8 × 13.9 cm), Cambridge, Harvard University Art Museums.

Fig. 3 Marcellin Desboutin, *Self-Portrait,* ca. 1888, oil on cardboard, 13¾" × 10¼" (35 × 26 cm), Moulins, Musée d'Art et d'Archéologie.

Desboutin's vivid brushwork, applied in bold, separated strokes, recalls his penchant for the drypoint medium, in which his image would be gouged directly into the copper plate, contributing to the expression of immediacy that is characteristic of these works. Desboutin appears not to be posing so much as scrutinizing his image, looking over his shoulder towards his reflection in the mirror. The effect is of a portrait dynamically rendered; in keeping with the Impressionist esthetic, it captures a fleeting creative instant rather than a pose that has been statically preserved for posterity.[10] That Desboutin chose to sign this work further speaks for the norms of finish that had been adopted by the Impressionists, which were measured by the notion of a work's artistic completeness rather than by its attention to detail.

Although he worked within a narrow range, Desboutin was much appreciated in his old age. In 1895 the archetypal bohemian was made a Chevalier of the Légion d'honneur, and in 1900, at the Exposition Universelle, he was awarded a Grand Prix. D.R.

1. This painting was previously unpublished. For further information on Desboutin, see Rod 1895; "Nécrologie" 1902; Crépin-Leblond 1902; Lafenestre 1902; Clément-Janin 1922; Bailly-Herzberg 1972; Fontseré 1972, pp. 521-24; Rewald 1973, pp. 235, 366-67, 399; *Gazette des Beaux-Arts*, October 1974; Weisberg 1980, pp. 286-87; and Duplaix 1985.

2. See Clément-Janin 1922, pp. 231 ff., for a catalogue of self-portraits in prints.

3. Performances were interrupted by the Franco-Prussian War. By 1865 he had written at least three other plays in verse, *Ali Pacha, Le Cardinal Dubois,* and *Madame Roland,* none of which were published or performed. He also translated Byron's *Shipwreck of Don Juan* into thirty thousand lines of French verse in the summer of 1873 (it is said while fishing). See Lafenestre 1902, pp. 404-05.

4. Proust 1897, p. 206, quoted in Paris, Grand Palais, 1983, p. 373.

5. Crépin-Leblond 1902, p. 120, and Lafenestre 1902, p. 413.

6. Cf. Lafenestre 1902, pp. 404, 409; Fontseré 1972, p. 523; and Rod 1895, pp. 36 ff. This comparison is particularly applicable to the self-portraits from the 1890's, such as the ones in Evreux and Troyes.

7. A self-portrait (now lost) exhibited in the Salon of the Société Nationale des Beaux-Arts of 1891 and reproduced in the Album Michelez (F. 33) in the Musée d'Orsay, Paris, shows a figure discernibly older and grayer than the self-portrait belonging to RISD, suggesting a somewhat earlier dating for the latter. This earlier dating is encouraged by another self-portrait dated 1894, representing the artist in a fur collar, belonging to the collection of Dr. Joseph Landau; a drypoint was made from this around 1898. See Clément-Janin 1922, p. 231. One may hazard a guess that the Museum's portrait is contemporary, therefore, with the drypoint self-portrait called *L'Homme au grand chapeau,* 1888.

8. Goncourt 1956, III, February 6, 1875.

9. Lafenestre 1902, pp. 410-11.

10. See Rod 1895, pp. 34-36, for a discussion of the mobility of the subjects rendered by Desboutin as a reflection of their modernity.

AUGUSTE RODIN
French, 1848–1917

67 *Study for the Monument to Balzac,* original ca. 1892

Signed and inscribed, right base: *Rodin orig./Alexis Rudier, Fondeur, Paris*
Bronze. 50¼″ × 20½″ × 24¾″ (127.6 × 52.1 × 60.3 cm)
Museum Associates and donations from Museum Members. 66.057

PROVENANCE: Galerie Beyler, Basel; G. David Thompson, New York; Parke-Bernet, New York, sale, May 23–24, 1966, no. 18.[1]

EXHIBITION: New York, IBM, 1988.

PUBLICATIONS: Chincholle 1894; *Art News* 1930, p. 10 (?); de Caso 1966, pp. 1–28; Elsen 1967, pp. 606–17; Spear 1967, pp. 42, 92; Tancock 1976, p. 453; Woodward and Robinson 1985, pp. 72, 198–99 (no. 117, ill.).

CONSERVATION: At the time of its sale in 1966, the patina was described as "dark gold." The patina has become greener with age.

RELATED WORKS: *Study for the Monument to Balzac,* original plaster model, h. 51¼″ (130 cm), Meudon, Musée Rodin. There are only two other known Alexis Rudier casts of the same dimensions, found in the Musée Rodin, Paris, and the Art Institute of Chicago. There is also a plaster moulage (cast from a mold) of the full figure reduced (h. 29¾″), and another plaster study for the head and shoulders (h. 6¼″) in the Rodin Museum, Philadelphia, for which see Tancock 1976, p. 425 (nos. 73–74). A wax impression of a closely related study for the head alone (h. 8¼″) in the Collection Mme Marcel Pollak, Paris, is reproduced in Tancock 1976, p. 435 (no. 72–76–4). The Cleveland Museum and the Hirshhorn Museum each own a *Half-length Study of Balzac, Upper Part of Nude Standing in the "Position of a Wrestler,"* bronze (h. 18½″), also cast by Alexis Rudier, for which see Spear 1974, p. 136s (no. XXIV), who lists additionally two reductions of the same (h. 11½″) sold at auction.

In 1883, the Société des Gens de Lettres, a distinguished society of French writers, opened a public subscription for a monument to their second president, the novelist Honoré de Balzac (1799–1850).[2] Balzac was a legendary figure, renowned for his productivity as a writer (over ninety novels and tales between 1829 and 1848), his prodigious capacity for work, and his robust human appetites, which kept him in perpetual debt. He was widely perceived to have been the greatest novelist of the century and was claimed simultaneously as the father of literary Naturalism and of Symbolism in later nineteenth-century France. Thirty-six thousand francs were raised through this subscription for his monument, launched a generation after his death, and the city of Paris offered a prestigious site for it in front of the Théâtre Français in the Place du Palais-Royal (just opposite the Louvre).[3] The commission was awarded in 1888 to the reputable academic sculptor Henri Chapu (b. 1833), who died in 1891, leaving behind a small and uninspired maquette for the monument. The Naturalist writer Emile Zola, who had just become president of the Société, declined to carry on with the posthumous translation of this maquette into its monu-

mental size, maneuvering instead to have the commission awarded to Rodin.[4]

By 1891 Rodin had become the most famous and the most controversial sculptor in France, widely recognized as a revolutionary force in the sculpture of his time. The singular modernity of his work and the challenges presented by his sculpture to the norms of his discipline must have made him particularly appealing to progressives of the Société and repugnant to conservatives and traditionalists. When Rodin accepted the commission offered by Zola for the Société des Gens de Lettres in a letter of early July 1891, he agreed to finish the monument in nineteen months for the sum of 30,000 francs (the amount remaining from the original subscription).[5] The monument was completed a full seven years later and exhibited in the Salon of 1898 (fig. 1). By the time of its completion, Rodin had created more than fifty individual studies of the figure and head,[6] and throughout its evolution he was intensely criticized and pressured by both his detractors and his friends to withdraw or to finish the monument. When the final version of the *Monument to Balzac* was exhibited in the Salon, it was promptly rejected by the Société.[7] Rodin, who was then the president of the sculpture section of the Salon, withdrew his *Balzac* from the exhibition and retired it to the grounds of his home in the Paris suburb of Meudon (where it was photographed by Edward Steichen in 1908). In 1939, in an act of belated contrition, the Société des Gens de Lettres installed a bronze cast of the final monument at the intersection of the boulevards Raspail and Montparnasse in Paris, where it stands today.

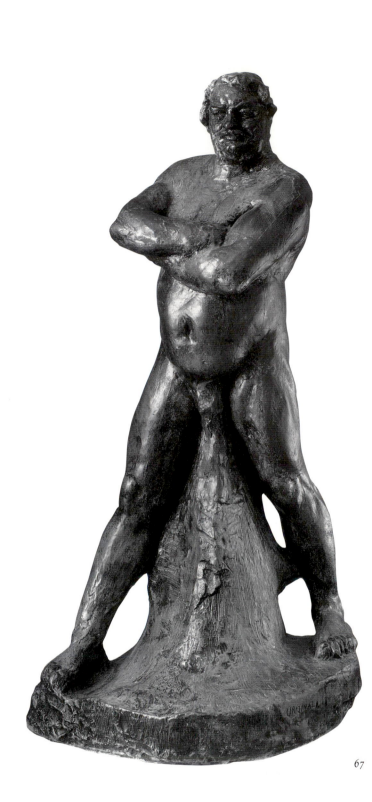

67

Fig. 1 Auguste Rodin, *Monument to Balzac,* plaster, exhibited in the 1898 Salon of the Société National des Beaux-Arts, Paris.

Fig. 2 Auguste Rodin, *Study for the Head of Balzac,* ca. 1891, terra cotta, h. 9¼″ (23.5 cm), New York, Metropolitan Museum of Art.

In a century that was famous for its art scandals, this *"affaire"* (as it came to be known) was possibly the most intense and widely followed, fueled not only by the fractious rivalries in art and literature of the time, but also by broader political conflicts in *fin-de-siècle* France.[8] Ostensibly, this scandal was fired by the radical formal modernity of Rodin's monument as well as by longstanding, establishmentarian animosity towards his sculpture in general. The intensity of this debate, however, was compounded by the no-less-divisive literary politics that set the Naturalists and the Symbolists into strident and inevitable conflict (with each claiming to be the heir to Balzac's influence), and by the acute political divisions that came to be symbolized by the trial of Colonel Alfred Dreyfus, separating progressive (pro-Dreyfus) and conservative (anti-Dreyfus) political factions in France. Rodin tried without success to remain aloof from the political controversies that ignited this affair, focusing on the artistic merits of his sculpture. Its significance to him is suggested by his observation ten years later that the *Balzac* was the most important work that he had ever done, "the result of my life, and the very pivot of my aesthetic."[9]

The Museum's cast of the imperious, nude Balzac, standing with his arms crossed and his legs astride, is in all probability an early, advanced maquette for the monument that Rodin presented to the Société in 1892, after roughly a year and a half of intensive labor on this project. A journalistic account of 1894 records that in 1892 Rodin submitted a study for inspection by the monument committee of the Société that left them "baffled":

> After having studied his subject, the drawings of him, and his books and even his own homeland, the artist had conceived a strange Balzac, in the attitude of a wrestler, seeming to defy the world. He had put over very widely spread legs an enormous belly. More concerned with the exact resemblance than with the usual conception of Balzac, he made him shocking, deformed, his head sunk into his shoulders.[10]

The committee asked Rodin to create a more flattering image of the writer, "at an age when [Balzac] was less portly, and when his neck had not yet disappeared beneath layers of fat." It is likely that this describes the Museum's study for the *Monument to Balzac,* in which, the journalist observed, Rodin had not yet resolved the conflict "between physical and ideal truth," suggesting the preoccupation of this maquette with the former.[11]

The Museum's figure has been understood as the culmination of a campaign of work immediately following the receipt of the commission, in which Rodin attempted to represent a likeness of the writer. Rodin pursued his subject with minute attention to the details of Balzac's physical appearance, native environment, and habits of dress, engaging in "scientific" research whose methods reflect Rodin's affiliation with the Naturalists.[12] Rodin's challenge was to create an inspiring public monument to a man whom he had never seen, a sedentary author who was physically unattractive.[13] Upon receiving the commission, Rodin (who had been only ten years old when Balzac died) began reading Balzac's collected writings, everything that had been written about him, and consulting the rather large Balzac iconography.[14] He traveled to Balzac's native city of Tours in August 1891 and modeled busts of the local Touraine stock from which Balzac was descended (fig. 2).[15] These, in turn, were influenced by a daguerreotype of Balzac, which, according to Rodin, provided the most accurate semblance of his appearance, the features of which seem closely related to those of the Museum's head.[16] He even commissioned a pair of pants and a vest to the writer's dimensions from Balzac's tailor, which presumably aided him in selecting a model of the writer's robust dimensions.[17] The final figure would likely have been clothed in a Dominican's habit, which Balzac

Fig. 3 Auguste Rodin, *Balzac's Robe* (cast of actual robe), 1897, plaster, h. 59″ (149.8 cm), Paris, Musée Rodin.

wore when he wrote and which Rodin used in a variety of early and late studies, as well as the final version of the monument (fig. 3).[18] The maquette that Rodin would have completed around 1892 reveals a preoccupation with the fleshy reality of the man and with an accurate depiction of his formidable physical presence, transformed by the drama of the pose and the vigor of its modeling.

Several modern interpretations of this figure have looked beyond its naturalistic origins to find its meaning as a symbolic sculpture. Athena Spear has identified this conception of Balzac as "The Creator," a psychological self-portrait influenced by Rodin's perception of the analogues between Balzac's career and his own. The mound between his legs, she suggests, is symbolic, not structural, implying the earth-fed creativity of Balzac's genius.[19] Albert Elsen has emphasized the nonnaturalistic qualities of this sculpture, observing that the head and the body were probably modeled from different subjects (the seam where they are joined is preserved in the bronze cast) and that the legs reveal a variety of anatomical distortions created for purely esthetic purposes. Elsen, like Spear, describes this figure as a metaphor of Balzac's spirit as a creative artist, conceived in the posture of an athlete, or "wrestler," whose corporeality is a measure of his prodigious talent.[20]

The naturalistic approach underlying the symbolism of this figure appears to have been a dead end for Rodin and the point of departure towards a more abstract solution. Following the presentation of the maquette to the committee, Rodin abandoned this concept of Balzac, in part because he had been asked to do so by the committee, but also because of the attention drawn to the verisimilitude of this conception.[21] One may also speculate that this sculpture was too fully realized and self-sufficient to have been draped successfully, as the conventions for decorum of a public monument to a modern figure would have required. Among the numerous surviving sketches there is none that shows this particular figure as it might have appeared when clothed. When Rodin resumed the project after some lapse in time, he employed a less portly model, achieving in the final monument an expression of Balzac more as a visionary than an athlete, less bound by the laws of gravity and physical nature. As flesh is the means of expression in the RISD maquette, it is the robe in the final monument that carries its meaning and its elevated sweep. D. R.

1. New York, Parke-Bernet, 1966, no. 18. The Parke-Bernet entry for this lot claims that this is an edition of three casts executed by Rodin during his lifetime. In fact, the date of this cast cannot be ascertained from documentation on Rudier casts available at the Musée Rodin, Paris.

2. The fullest account of the history of this commission remains Judith Cladel, "L'Affaire du Balzac," in Cladel 1936, pp. 181–228.

3. Elsen 1967, p. 607. According to Cladel 1936, p. 183, the city originally offered this site, and then a group within the Société arranged to have it relocated in the interior colonnade of the Palais-Royal, only to be relocated again when Emile Zola became its president in 1891.

4. Chapu's maquette, now lost, dryly represented Balzac seated on a high pedestal, his arms folded across his chest, while at his feet stand allegorical personifications of Truth and Fame. A photograph of the maquette as well as two preparatory drawings for the monument are reproduced in Elsen 1973, p. 16 (figs. G, H, I). These studies each represent the pose of Balzac with folded arms across his chest. In awarding the commission to Rodin, Zola rejected the advice of Anton Mercié, Alexandre Falguière, and Paul Dubois, three of Chapu's prestigious academic contemporaries, who claimed that Chapu's maquette was complete and could be carved by practitioners. Falguière offered to oversee the task himself, at his own expense, and donate the proceeds of the commission to Chapu's widow. In order to award the commission to Rodin, Zola called a vote on the issue at a special meeting of the Société for which only his supporters were notified in advance. See Cladel 1936, pp. 184 ff., and Tancock 1976, p. 428.

5. Emile Zola to Frantz Jourdain in Emile Zola, Correspondance, 1872–1902, Paris, 1929, p. 735, quoted in Elsen 1973, pp. 5–6.

6. With the exception of the final Balzac, none of these studies can be definitively dated. Forty-four of these are reproduced in Elsen 1973, pp. 14–36, and their chronology discussed on pp. 37–58. For other considerations of the chronology of these studies, cf. de Caso 1966; Spear 1967, pp. 9–30; Spear 1974, pp. 112s–118s; Tancock 1976, pp. 425–45.

7. Zola was no longer president, and his influence apparently had waned. Upon rejecting Rodin's commission, the Société declared in a communiqué to the press: "The Committee of the Société des Gens de Lettres has the obligation and the regret to protest against the sketch [l'ébauche] that Rodin has exhibited in the Salon, in which it refuses to recognize the statue of Balzac." Cladel 1936, p. 211.

8. See Tancock 1976, pp. 441–42.

9. Cladel 1936, p. 223.

10. See Chincholle 1894, quoted in Elsen 1973, p. 8.

11. See Chincholle 1894, quoted in Elsen 1973, p. 8.

12. De Caso 1966, pp. 5, 12.

13. Elsen 1967, p. 607.

14. Geffroy 1893.

15. Cladel 1936, p. 188. In a letter of September 1891 he wrote: "I am making as many models as possible for the construction of the head, with types in the country; and, with the abundant information I have secured...I have a good hope of the Balzac" (Lawton 1906, p. 205). The purchase list of the Metropolitan Museum of Art, New York, of July 22, 1910, cites the terra cotta reproduced here as "Balzac. Study for the head of Balzac after a man of Tours. The only original." See Vincent 1981, p. 19.

16. The daguerreotype plate was taken in 1842 by Bisson. Sometime around 1892 Rodin was given a photographic copy of it by Nadar, who owned the original. See Gabriel Ferry, "La Statue de Balzac," Le Monde Moderne, v. x (1899), quoted in Elsen 1973, pp. 7, 30 (fig. T).

17. Cladel 1936, p. 187.

18. Marx in 1892 described a study for Balzac draped in a Dominican's habit which "expresses a great deal through willful abbreviations..." covering a figure "full of calm and sovereign repose [whose] arms are crossed on the chest...." Quoted in Elsen 1973, p. 7.

19. Spear 1967, pp. 20, 30. De Caso 1966, p. 19, n. 36, believes that this mound was originally designed to conceal a supporting tenon.

20. Elsen 1967, pp. 607–16. Concerning the iconography of the "Athlete of Virtue," see Eisler 1961.

21. See Chincholle 1894 and Tancock 1976, p. 440.

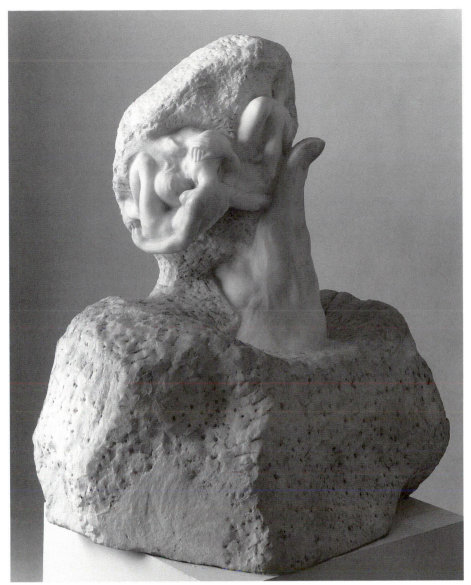

68

AUGUSTE RODIN
French, 1848–1917

68 *The Hand of God,* ca. 1898 (plaster?);
first carved ca. 1902

Incised, on base beneath thumb: *A. Rodin*
Marble. 39½″ × 32½″ × 26¾″ (100.3 × 82.5 × 67.9 cm)
Museum Appropriation. 23.005

PROVENANCE: Purchased from the artist around 1916–17 by
Colonel Samuel P. Colt; from whom purchased by the
Museum in 1923.

EXHIBITIONS: The first known marble version was exhibited
in Vienna, XVIth Secession, January 1903, and then Berlin,
VIIth Secession, April–June 1903; a marble version was also
exhibited in Manchester (England), City Art Gallery, March–
April 1905; a marble version in Paris, IIIrd Salon d'Automne,
October 18–November 25, 1905;[1] Providence, RISD, 1950.[2]

PUBLICATIONS: Rod 1898, p. 427; RISD, *Bulletin,* 1923, p. 23;
RISD, *Bulletin,* 1928, p. 11 (ill.); Alford 1950, n.p. (fig. 2);
Spear 1967, pp. 79–83, 100; Tancock 1976, pp. 622–23.

RELATED WORKS: *The Hand of God,* marble, h. 29″ (73.7 cm),
New York, Metropolitan Museum of Art, acquired in 1908.

The Hand of God, marble, h. 36⅝″ (94 cm), Paris, Musée
Rodin, completed in 1918. *The Hand of God,* plaster (from a
marble version), h. 36⅝″ (94 cm), Meudon, Musée Rodin.
The Hand of God, bronze (from a marble version), h. 26¾″
(68 cm), Philadelphia, Rodin Museum. *The Hand of God,*
plaster, h. 14″ (35.5 cm), Maryhill (Washington), Maryhill
Museum of Fine Arts. *The Hand of God,* bronze, h. 12½″
(31.75 cm), Paris, Musée Rodin.

The Hand of God is one of Rodin's most autobiographical
sculptures, invested with meanings related to his identity as
a sculptor and to the character of the work that he produced.
It draws analogies between God's creation of man, the sculp-
tor's imitation of "life" in sculpture, and Rodin's particular
preoccupation with the psychology of passion and desire. In
its combination of this muscular hand, identified by critics
as a "worker's" hand, with dreamy, ephemeral figures, it
indicates Rodin's unique ability to synthesize the normally
antithetical vocabularies of Realist and Symbolist art. In
style, it embodies the radical challenges presented by his
work to a range of formal canons advocated by contemporary
academic sculptors with regard to finish, harmony, idealiza-
tion, as well as clarity of subject matter and meaning. Carved

in Carrara marble (the material for which it seems to have been intended), it conveys the innate beauty, durability, and historical associations particular to white Mediterranean marble.

Rodin's origin as a decorative sculptor, a "worker" trained in the ateliers, influenced the techniques and formal innovations of his work, as well as the myth of the artist projected in *The Hand of God.* His early artistic education was in the Ecole Spéciale de Dessin et de Mathématiques, called the "Petite Ecole" (today the Ecole Supérieure des Arts Décoratifs), which he attended between 1854 and 1857. In spite of his precociousness, his three applications to the Ecole des Beaux-Arts were rejected.[3] Through the late 1870's, while he was attempting to establish his reputation as an artist in the official salons, Rodin was obliged to earn his living as an artisan, most notably in the atelier of Albert-Ernest Carrier-Belleuse, for whom he modeled decorative heads similar to the two in the Museum's collection (see checklist). The circumstances of Rodin's artistic education were important to his work in several ways. Shut out of the Ecole des Beaux-Arts, Rodin was never systematically exposed to the prevailing, and largely moribund, Neoclassical style promulgated there. Through the example of his work, he became one of the Ecole's principal antagonists, to which end he cultivated his identity as an "artist-worker," a man of *"métier,"* trained outside of the artistic establishment. This identity became a measure of his sculpture's sincerity and its remove from academic doctrines. As a mature and enormously successful artist and the master of his own large atelier, his long experience in the *"métier"* of sculpture became the model for the division of labor within his own ambitious enterprise and for his cultivated role as its *"Maître."*

The turning point of Rodin's career, through which he was delivered permanently from the status of artisan to *"Maître,"* was the commission from the French government in 1880 for a large portal for a proposed Museum of Decorative Arts. This work, called *The Gates of Hell,* was to illustrate scenes from Dante's *Inferno.* The museum was never built, the commission never realized, but throughout the remaining thirty-seven years of his life Rodin worked on figures for it, which he developed into an abundance of freestanding figures and groups that had an identity independent of the *Gates.* It is out of this milieu that *The Hand of God* was conceived.

The Hand of God is characteristic of Rodin's method of combining disparate elements to create a new sculpture of unique and elastic meanings, a result of his experiences with decorative sculpture, in which stock plaster components were characteristically recombined. Rodin would model his figures in clay, cast them in plaster, and then arrange these models like building blocks to form a variety of new sculptural groups, which in turn would be cast in plaster, potentially to be cast in bronze editions or carved in marble. Reproduction was the norm in these procedures, and the result was a large quantity of closely related figures and groups that were connected to each other like the states of a print. To advance his prolific output of clay models, Rodin employed a large cadre of technical assistants – artisans such as he had once been – to reproduce them in more permanent materials. Through this large commercial enterprise, he was able to produce an enormous quantity of work, influencing the critical perception of him as "a force of nature"; on a metaphorical level, his abundant productivity could be equated with the spirit of God in nature.[4]

The actual hand of *The Hand of God* has been identified as an enlargement of the hand of *Pierre de Wiessant,* one figure from the monumental group called *The Burghers of Calais,* which Rodin completed in 1886.[5] The embracing figures held by this powerful hand, although not to be found in the *Gates of Hell,* seem related to it by virtue of their size, their conception in high relief, their compositional disharmony, and their expression of sexual conflict and longing. The two lovers give the impression that they were not conceived as a homogeneous group, but rather as independent figures joined to form this disjunctive relationship. The representation of two lovers in an awkward and disquieting embrace, resting on a rough-cut marble support, is typical of a large variety of Rodin's freestanding marble sculptures of the 1880's and 1890's.[6] One unique innovation of this work is its explicit representation of a sculpture within a sculpture.

Although rooted in Rodin's work of the 1880's, as an autonomous sculpture *The Hand of God* probably dates from around 1896, when a plaster version was exhibited by Rodin in the ivth Munich Secession.[7] In 1898 (the same year that the *Balzac* was rejected by the Société des Gens de Lettres), the journalist Edouard Rod described it (by the title *Création*) on a visit to Rodin's studio: ". . . two beings emerging from a mound supported by a large Hand of God, two unfortunate, feeble beings, gaunt and sad, abandoned, the one upon the other."[8] A plaster version of *The Hand of God,* by this title, was exhibited again in Rodin's large, privately funded retrospective exhibition that he organized to coincide with the Universal Exposition of 1900 at the Place d'Alma. In the catalogue by the critic Arsène Alexandre, it is described as "a colossal hand, [holding] two embracing figures . . . an image of the principle of creation in the hands of the creator" (*"créateur"* spelled with a lower-case "c"), implying the equation of the sculptor's function with that of God.[9] When a marble version was exhibited again in the Salon d'Automne of 1905, at least one reviewer compared the powerful hand of this sculpture with the hand of Rodin, the "worker."[10] The association of Rodin with this hand, and the broader symbolic implications of this work, were reinforced in a previously unpublished photograph of Rodin taken by Edward Steichen sometime around 1902 (fig. 1), in which the figure of Rodin and the *Hand of God* overlap in a doppelgänger. This relationship was made explicit several years later in an essay by George Bernard Shaw, who observed that "[Rodin's] *Hand of God* is his own hand," equating the sculptor's prolific creativity with "the vital spirit" (*"élan vital"*), the expression of God in nature.[11]

Rodin's conception of the *Hand of God* may thus be

Fig. 1 Edward Steichen, *Rodin before the Hand of God*, ca. 1902 (?), gum bichromate print, 8¼″ × 6¼″ (20.9 × 15.8 cm), Paris, Musée Rodin.

understood as a metaphor of creation on at least two levels. On one level there is the biblical reference to the Book of Genesis, God's creation of Adam from raw earth, Eve from Adam, and their submission to Original Sin, as suggested by the figures' tormented embrace. On another level is the autobiographical reference to Rodin, creator of *The Gates of Hell* and its multitude of suffering souls who are the victims of their passions: the sculptor, like God, creates the human form from raw earth. The *non-finito* ("unfinished") technique sets into tension the figures and the material of which they are made, evoking the dichotomy between "life" and inert matter, and the role of the sculptor who godlike creates one from the other.

Of the three known marble versions of *The Hand of God*, the dating of the Museum's sculpture is the most problematic. The version in the Metropolitan Museum of Art, New York, was commissioned in 1906 and realized in the following year.[12] The version in the Musée Rodin, Paris, was begun in 1916 by the sculptor Seraphim Soudbinine and completed in 1918, after Rodin's death.[13] The version in Providence was commissioned around 1916 and acquired around 1917 by Colonel Samuel P. Colt, the arms manufacturer, who owned an estate in Bristol, Rhode Island.[14] Records from the Musée Rodin in Paris indicate that the practitioner Victor Mathet was working on versions of *The Hand of God* for Rodin between 1906 and 1908[15] and that in 1917 he finished Colt's sculpture, begun previously.[16] It could be that the Museum's version was begun by Mathet around 1906–08 and completed in 1916–17. The version that was exhibited in Vienna and Berlin in 1903 – the first of the marble versions to be executed – had a blocklike base that resembled the stone as it

might have appeared when it came from the quarry.[17] This version may be lost, or conceivably, this may be the sculpture now in Providence, its base perhaps reworked by Mathet between 1916 and 1917. D. R.

1. See Beausire 1988, pp. 238, 262, 271 (ill.). It cannot be determined whether the version exhibited in Vienna and Berlin in 1903 corresponds to the version exhibited in Manchester or Paris in 1905, or to any of the versions presently known in Providence, New York, and Paris.

2. Alford 1950.

3. This presumably was the result of the Rococo influence in his early work, then in disfavor at the Ecole. See Cladel 1936, pp. 80–81.

4. "He is himself *a force of Nature* He creates in the same way that Nature does." Rodenbach 1899, pp. 276 ff.

5. Spear 1967, pp. 79, 82 (pl. 102).

6. For example, see Grappe 1944, no. 119, *Adam and Eve Sleeping*; no. 133, *Psyche-Springtime*; no. 151, *The Metamorphoses of Ovid*; no. 156, *Cupid and Psyche*; no. 174, *Fleeting Love*; no. 175, *Avarice and Lust*; no. 183, *Paolo and Francesca*; no. 270, *Triumphant Youth*; no. 277, *Illusions received by the Earth*; and no. 294, *The Earth and the Moon*, to mention a few.

7. A plaster version of *The Hand of God* was also exhibited in a traveling exhibition of Rodin's work that went to Brussels, Rotterdam, Amsterdam, and The Hague in 1899. For a full exhibition history, see Beausire 1988, pp. 129, 152, 186, 238–39, and *passim*; cf. Barbier 1987, p. 202.

8. Rod 1898, p. 427.

9. Paris, Place d'Alma, 1900, p. 13 (no. 67).

10. *Chroniquer* 1905, n. p.

11. Shaw 1912, n. p. Shaw is referring to the philosophy of Henri Bergson, who was also impressed by *The Hand of God*, described by him as "the fleeting moment of creation, which never stops; it is in a sense the genius of Rodin himself in its eternal creative force. He that lives *in the intention,* lives free, lives creating, lives like a very god." Quoted in Frisch 1939, p. 431.

12. Paris, Musée Rodin, archives, unpublished correspondence from Edward D. Adams to Rodin, November 2, 1906.

13. Paris, Musée Rodin, archives, "Dossiers travaux," unpublished manuscript showing practitioners' accounts from around 1916 and after; and Paris, Musée Rodin, archives, unpublished correspondence from Seraphin Soudbinine to Léonce Bénédite, October 18, 1916.

14. Paris, Musée Rodin, archives, unpublished correspondence from Mr. Charles L. Wakefield-Mori to Rodin, April 1, 1916, and January 5, 1917.

15. Paris, Musée Rodin, archives, "Commandes et prix divers," unpublished account book listing work by Mathet on two versions of *The Hand of God,* one of which was for the Metropolitan Museum of Art, New York, between July 1906 and January 1908.

16. Paris, Musée Rodin, archives, "Dossiers travaux," unpublished manuscript showing practitioners' accounts from around 1916 and after.

17. A photograph of the marble *Hand of God* exhibited in the 1903 Vienna Secession is reproduced in Beausire 1988, p. 238. When it was exhibited in Vienna in 1903, Rodin placed the sculpture on its side, the palm facing up, so that the figures were extended like an offering to the world.

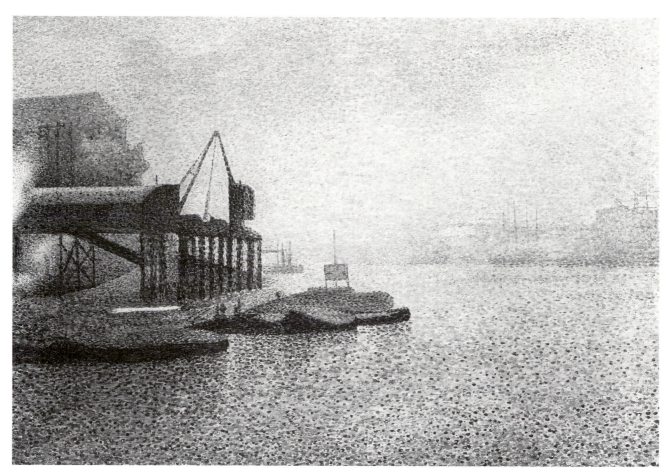

69 (color plate p. 28)

GEORGES LEMMEN
Belgian, 1865–1916

69 Thames Scene, the Elevator, ca. 1892

Oil on canvas. 23½″ × 32½″ (59.7 × 83.2 cm)
Anonymous gift. 57.166

PROVENANCE: Linje Collection; Galerie Georges Giroux,
Brussels, 1956; T. P. Grange, London.

EXHIBITIONS: Atlanta, Art Association, 1962, no. 56; New
York, Guggenheim, 1968, pp. 55, 175 (no. 130); Greenwich,
Maritime, 1977, n.p. (no. 103, ill.); Brooklyn, Brooklyn
Museum, 1980, p. 119 (no. 49); Brussels, Ixelles, 1990, pp.
132–33 (no. 61, ill.).

PUBLICATIONS: Rewald 1956, p. 120 (ill., as *Harbor View*)/3rd
ed., 1978, p. 112 (ill.); *Art Quarterly* 1957, p. 470; Ghent, Schone
Kunsten, 1980, p. 222; Kelder, *Post-Impressionism,* 1986, p. 108
(pl. 104); Kelder, *L'Héritage,* 1986, p. 108 (pl. 104); Goyens de
Heusch 1988, p. 187 (ill.); Cardon 1990, pp. 134, 136 (ill.).

CONSERVATION: In 1985 areas of flaking paint along the edges
were stabilized, and a bulge in the lower center was flattened
at the Williamstown Regional Art Conservation Laboratory.

RELATED WORKS: *Factories on the Bank of the Thames,* oil on
canvas, 25¾″ × 37⁷⁄₁₆″ (65.5 × 95 cm), Otterlo, Rijksmuseum
Kröller-Müller. *Study for Thames Scene, the Elevator,* ca. 1892,
oil on wood, 6¼″ × 9½″ (16 × 24 cm), Toulon, collection Mme
E. Thevenin-Lemmen.

Georges Lemmen was an important member of the late-
nineteenth-century Brussels avant-garde who experimented
with many of the modernist trends that entered Belgium from
Paris. Born in Schaerbeek, a northern suburb of Brussels, in
1865, he received no formal training beyond some drawing
classes at Saint-Josse-ten-Noode. When he was only seven-
teen, his work was accepted for exhibition at the Ghent Salon
of 1882. Within a few years he had begun his associations with
the major avant-garde organizations in Belgium: L'Essor, La
Libre Esthétique, L'Association pour l'Art, and, most impor-
tantly, Les Vingt (The Twenty), Belgium's leading modernist
circle from 1884 to 1893.

The exhibition of Georges Seurat's *Sunday Afternoon on
the Grande Jatte* with Les Vingt in 1887 was instrumental in
encouraging a handful of Belgian painters to experiment
with pointillism.[1] Although the reception by the Brussels
press of Seurat's *Grande Jatte* was surprisingly benign com-
pared to the attacks it had endured in the French press, crit-
ics in Belgium were less charitable toward the converts to
pointillism in their own country. Neo-Impressionists in
Brussels were soon dubbed *"les Bubonistes,"* an epithet which
likened the small dots *(points)* of which their paintings were
composed to the symptoms of bubonic plague, and the move-
ment itself was seen as an alarming epidemic spread by the
French.[2] The pointillist phase in Belgian painting was a
relatively brief one. By the mid-1890's the movement had
virtually disappeared, as various of its exponents, including

Lemmen, moved on to other styles or began working in different media.

Lemmen's Neo-Impressionist period began around 1890. His earlier work exhibited a modified Impressionist style similar to that of his colleagues in Les Vingt, but, in keeping with the traditions of Flemish realism, the more radical aspects of the French movement were tempered with greater attention to detail and tonal values. *Thames Scene, the Elevator* is one of Lemmen's two major pointillist scenes of the River Thames and the industrial structures on its shoreline. The composition of the other view, *Factories on the Bank of the Thames* (fig. 1), is almost a mirror image of the Providence painting, with the buildings occupying a wedge of space on the right, rather than on the left side of the picture.

Waterside scenes were frequent subjects for Neo-Impressionists, who, like the Impressionists, found them ideal vehicles for the study of luminous effects of sunlight reflecting off water and shining through veils of cloud and mist.[3] In the RISD canvas, the serenity and simplicity of the composition are reinforced by a subtle color scheme dominated by pinks, blues, and violets, a favorite Neo-Impressionist palette. Robert Herbert has characterized this work as a virtual demonstration piece of Neo-Impressionism, and Lemmen's best painting.[4] In preparation for *Thames Scene, the Elevator,* Lemmen composed a small oil sketch (fig. 2) on a panel, painted with broad, loose, divisionist strokes; the sky is permeated with orange particles and the water with red, both hues mingling with opposing blues and violets.[5] In his frequent recourse to this type of on-the-spot preliminary study, Lemmen was following Seurat's working method.[6] In the final canvas, painted in the studio, broad blue base tones appear to have been laid in first, followed by successive layers of dry pigment applied in more than one sitting, with a smaller brush used for each layer.

Lemmen's other river- and seascapes from his Neo-Impressionist period normally represented Belgian sites.

Fig. 2 Georges Lemmen, *Study for Thames Scene, the Elevator,* ca. 1892, oil on wood, 6¼″ × 9½″ (16 × 24 cm), Toulon, collection Mme E. Thevenin-Lemmen.

Two examples, *The Beach at Heyst* (Paris, Musée d'Orsay), and *The Meuse at Ramet* (location unknown),[7] were painted using the divisionist color and pointillist brushstrokes of the Providence canvas, but, unlike the geometric rigor and rectilinear orientation of the *Thames Scene,* the curved lines and the decorative emphasis in their compositions reveal an affinity with Art Nouveau, a movement with which Lemmen became increasingly involved through the 1890's.

Through surviving letters to his parents it is known that Lemmen made trips to England in 1892 and 1894.[8] On the basis of its color scheme, Herbert believes that the *Thames Scene* was probably painted following his first trip in 1892.[9] Lemmen's friendship with painter Willy Finch, a native Belgian of British parentage who maintained close ties with the British art world and painted a number of Neo-Impressionist views of the English coast, undoubtedly stimulated his interest in Great Britain, extending to developments in the decorative arts as well. In 1891 Lemmen published an article on one of England's most progressive decorative artists, Walter Crane, in the Belgian journal *L'Art Moderne.*[10] It was, in fact, the Arts and Crafts Movement as represented by Crane and his British colleagues that drew Lemmen's primary allegiance after his rejection in the mid-1890's of pointillism, which he eventually found to be too restrictive. As he explained in 1903, Neo-Impressionism ". . . always gives the impression, a little like the paintings of Signac, of something done according to a treatise on painting written by an engineer. . . . Despite all their talents, their [the Neo-Impressionists'] canvases smell of recipes and appear to me to be, in their own way, just as conventional as a Bouguereau."[11]

Lemmen's subsequent involvement with the Arts and Crafts Movement and Art Nouveau in Belgium included work in the decorative and graphic arts. He designed posters, typefaces, illustrations, and title pages for books and periodicals, also tapestry cartoons, and furniture. He continued to paint, but turned to the themes and style associated with the

Fig. 1 Georges Lemmen, *Factories on the Bank of the Thames,* oil on canvas, 25¾″ × 37⁷⁄₁₆″ (65.5 × 95 cm), Otterlo, Rijksmuseum Kröller-Müller. Photograph by Fotografie Beeldende Kunst, Tom Haartsen.

intimiste interiors and figure studies of French painters such as Edouard Vuillard, far removed from the systematic technique seen in the *Thames Scene* and other works from his pointillist years. D. E. S.

1. In addition to Lemmen, practitioners of the Neo-Impressionist style in Belgium included Théo van Rysselberghe, Anna Boch, Henry van de Velde, who later became better known as an architect and designer, and Willy Finch.

2. See Jane Block, "Les XX: Forum of the Avant-Garde," in Brooklyn, Brooklyn Museum, 1980, p. 27.

3. Robert Herbert (New York, Guggenheim, 1968) cites, for example, Albert Dubois-Pillet's *The Seine at Paris* (ca. 1888, New York, collection Altschul), which has a remarkably similar composition. Cf. also works by Seurat (e.g., *Port of Gravelines Channel*, 1890, Indianapolis, Indianapolis Museum of Art) and Finch (*English Coast at Dover*, 1891, Helsinki, Art Museum of the Ateneum).

4. New York, Guggenheim, 1968, p. 175.

5. I would like to thank Mme Thevenin-Lemmen for her kind responses to my enquiries about the preparatory sketch. A discussion with Roger Cardon (Antwerp) and correspondence with Johanna Ruyts-Van Rillaer (Louvain, Katholieke Universiteit) were also very helpful in preparing this entry.

6. A sketch for the Thames scene in Otterlo is in the collection Altshul, New York.

7. *La Meuse à Ramet* was in the collection of G. Hulin de Loo and on extended loan to the Museum voor Schone Kunsten, Ghent, until his death, at which time it was returned to the family, then listed in a sale, Palais des Beaux-Arts, Brussels, October 29, 1947, no. 32. My thanks to Rebecca Monteyene, M.S.K., Ghent, for information on the painting, a photograph of which is found in the Archives photographiques, Institut Royale du Patrimoine Artistique, Brussels.

8. Archives de l'Art Contemporain, Musées Royaux des Beaux-Arts de Belgique, Brussels, nos. 8838–39 (G. Lemmen). My thanks to Mme Micheline Colin for her help in locating this material.

9. There is at least one reference in Lemmen's correspondence to a boat trip on the Thames in a letter of 1894, which states: "Yesterday we [Lemmen and his wife] visited the Wolffs with whom—if the weather is nice—we will go boating on the Thames at Cookham": letter to Lemmen's father, dated July 16, 1894 (no. 8838, Archives de l'Art Contemporain, Brussels).

10. See Lemmen 1891, cited in New York, Guggenheim, 1968, p. 169.

11. Letter from Lemmen to Willy Finch, cited by Greta Vanbroekhoven, "G. Lemmen et la peinture," in Brussels, Musée Horta, 1980, pp. 7–8, trans. by D. E. S.

CONSTANTIN MEUNIER
Belgian, 1831–1905

70 *Kneeling Miner,* 1896

Signed, right base: *C. Meunier;* inscribed, left base: *J. PETERMANN-FONDEUR-BRUXELLES.*
Bronze. 9½" × 5½" × 5" (24.1 × 14 × 12.7 cm)
Membership Dues. 71.036

INSCRIPTION: Dedication plaque in bronze, countersunk in front of black marble base, engraved by Meunier: *A MON VIEIL AMI/CH. VANDERSTAPPEN/EN SOUVENIR DU 11 AVRIL 1896/C.*

PROVENANCE: Charles van der Stappen, 1896; T. Brown Hutcheson, Esquire, Linton, England (formerly Saffron Waldon), 1915; Shepherd Gallery, New York, 1970; from whom purchased, 1971.

EXHIBITIONS: Paris, Art Nouveau, 1896, n.p. (no. 14); Brighton, Fine Art, 1915; Liverpool, Walker, 1915, p. 22 (no. 281).

PUBLICATION: Hanotelle 1977, p. 152.[1]

RELATED WORK: *Kneeling Miner,* 1903, bronze, now part of the *Monument to Labor,* Laeken (Brussels).

The sculpture of Constantin Meunier represents a late phase of Realist art in Belgium, where the movement followed a course roughly parallel to that of its French counterpart during the latter half of the nineteenth century. Meunier was a native of Brussels, birthplace of Belgian Realism in the late 1840's. In 1847 he enrolled in the conservative Académie Royale des Beaux-Arts de Bruxelles and, although initially trained as a sculptor, worked from 1853 until the late 1870's primarily as a painter.

Meunier's painted subjects consisted primarily of religious and historical themes, despite his association with the circle of Realist painters that included Charles De Groux, Louis Dubois, and Hippolyte Boulenger, who constituted Belgian art's avant-garde during the third quarter of the nineteenth century. The bust-length *Portrait of a Woman,* ca. 1880, in the RISD collection (see checklist) shows that Meunier's painting style, when applied to an objective genre such as portraiture, approached the somber Realist vision often seen in the work of his vanguard colleagues, particularly De Groux, who was a close friend.

Trips in 1878 and 1881 to the grim mining and steel-producing regions in the southern provinces of Liège and Hainaut – Belgium's Black Country – so affected Meunier that views of industrial laborers and their environment came to dominate his *oeuvre* until the end of his career. After 1884, sculpture became his primary medium, although his many renderings of the Belgian proletariat include paintings, drawings, and prints.[2]

Kneeling Miner is typical of Meunier's presentation of the working classes, heroic and idealized, but straining under the harshness of an oppressive socio-economic system. Indeed, Belgium lagged far behind other industrialized European countries in granting rights to laborers. The first party sympathetic to workers, the socialist Parti Ouvrier Belge, was not founded until 1885; a series of bloody strikes

and confrontations followed. The workers' struggle was mirrored in the novels of Camille Lemonnier, founder of the Naturalist movement in Belgian literature, who had traveled with Meunier to the Black Country in 1881.[3]

Meunier's numerous two-dimensional works and relief sculpture effectively convey the plight of the oppressed masses recounted in contemporary Naturalist novels, such as *Germinal* (1885), Emile Zola's towering exposé of the mining industry in France, but Meunier is perhaps most successful in communicating the dignity and pathos of the working classes in his freestanding, non-narrative, single-figure pieces like the *Kneeling Miner.* Meunier's resting figure supports his chin with his left hand, the elbow poised on his upraised knee; the other arm, dropping down to the ground, grips an ax used by workers to cut new veins in the mine.[4]

Its date of 1896 places the work midway between the artist's first international success, *The Hammerer,* a bronze shown in the Paris Salon of 1886, and a lifesize version of the *Kneeling Miner,* completed in 1903,[5] intended as part of Meunier's grand project, *The Monument to Labor* (fig. 1), which occupied his final years; he died before its completion, and it was not realized until 1930–31.[6] Around its base are four freestanding bronze statues of laborers. In addition to the *Miner* are figures representing *Maternity* (a mother with children), an *Ancestor* (an elderly man), and a *Forger.* These figures are placed at the corners of a square joined by four bronze reliefs picturing groups of laborers at work in their respective domains *(The Mine, The Port, The Harvest,* and *Industry).* Atop the monument a *Sower* strides majestically.

The *Miner* and its three freestanding companions at the monument's base function as static foils for the dynamic movement of the figures within the relief panels and the *Sower* on top. The brooding, contemplative mood and the pose of the *Miner* bear a provocative similarity to Rodin's *The Thinker.* The resemblance was not lost on Léonce Bénédite, a reviewer of the Paris Salon of 1904, in which Meunier's 1903 *Miner* was installed near Rodin's *Thinker.* Bénédite characterized Meunier's piece as a contemporary, down-to-earth variant of Rodin's more abstractly conceived figure.[7] The generalization of detail, idealization of form, and air of exhausted resignation of the RISD miner also bring to mind the resting peasants of Jean-François Millet.[8]

The RISD *Kneeling Miner* was included in a retrospective exhibition of Meunier's work held in the early part of 1896

70

179

at the recently opened Art Nouveau gallery of Samuel Bing in Paris.[9] With subsequent exhibitions of his work in Dresden (1897) and Berlin (1898), Meunier secured an international reputation. The marble base of the Providence sculpture bears an inscription that reads, in translation, "To my old friend/Ch. van der Stappen/in memory of April 11, 1896/C. [Meunier]." The dedication refers to a celebration held in the Brussels studio of Charles van der Stappen (1843–1910), a master sculptor respected by both academic and avant-garde artists in Belgium, following Meunier's success in Paris. Although his iconography and style were more conservative than Meunier's, Van der Stappen nevertheless supported, and was even influenced by, the latter sculptor's preference for realism and stylistic individuality over academic classicism. The innovations and pedagogic reforms which Van der Stappen introduced in the Brussels Academy gained him a wide following, and his studio became a favorite meeting place for writers, musicians, and artists, including Meunier. It was reportedly Van der Stappen who inspired Meunier to return to sculpture in the late 1870's by handing him a piece of potter's clay, from which Meunier fashioned the head of an ironworker.[10]

Van der Stappen's party for Meunier was described in detail in *L'Art Moderne,* a leading journal of the Belgian avant-garde.[11] Guests included artists, writers, students, and friends of the sculptor, who listened as Camille Lemonnier read an address he had written in a souvenir album presented to the artist (now in Brussels, Musée Meunier). In his text, Lemonnier exhorted the artist to "Reign . . . throughout the ages, master of infinite gravity and compassion, who rendered humanity in its suffering and its hope." D. E. S.

1. Fig. 160 in Hanotelle 1977 incorrectly identifies the 1903 version of the kneeling *Miner* (now part of the *Monument to Labor*) as the 1896 prototype, *Kneeling Miner,* now at RISD, shown in Paris at the Bing gallery. Thiery and van Dievot 1909, p. 94 (no. 85), lists a *Mineur accroupi,* 27 cm, "reproduit en 1896," but it is not clear whether this is the RISD bronze or the plaster version which was exhibited in Brussels, Libre Esthétique, 1896, no. 299.

2. The RISD Museum owns two lithographs of workers by Meunier: *Miner* (50.116) and *Miners* (67.119).

3. Lemonnier's novel *Happe-Chair* (1886), about the lives of industrial laborers, is his best-known treatment of this theme.

4. My thanks to Sura Levine, Hampshire College, for her help in identifying the kneeling miner's specific occupation and for information about the *Portrait of a Woman.*

5. The 1903 version of the *Kneeling Miner,* destined for the *Monument to Labor,* was kept in the Musées Royaux des Beaux-Arts de Belgique, Brussels, from 1905 until its placement in the monument. It was cast in the foundry of Jean Verbeyst; J. Petermann cast the RISD statue. I would like to thank Jacques van Lennep, Musées Royaux des Beaux-Arts, Brussels, and the Musée Meunier, Brussels, for information concerning both versions.

6. Final construction of the *Monument to Labor* in Laeken, a northern section of Brussels, coincided with the Belgian centennial in 1930. Meunier had completed the sculptural components for the monument before his death, but their arrangement and the design of the monument itself was left unresolved. The latter task fell to the architect Mario Knauer.

7. Bénédite 1904, p. 432.

8. Cf., for example, *The First Steps,* 1859, drawing (Cleveland, Cleveland Museum of Art), and *The Vine-Grower,* 1859–70, pastel (The Hague, Rijksmuseum H. W. Mesdag). Although different in pose, Millet's *Man with a Hoe* (1860–62, Malibu, J. Paul Getty Museum) provides the best thematic parallel to *Kneeling Miner.* My thanks to Sura Levine for pointing this out.

9. The Bing retrospective also included a related pastel, *In the Borinage,* ca. 1896 (Paris, Hôtel Drouot, November 23, 1907, sale, Collection Thiébault-Sisson, no. 109). Similarly posed miners also appear in a large painting by Meunier, *The Mine: The Descent, Calvary and The Ascent* (Brussels, Musée Meunier), and in the related *Miners Descending,* drawing (Brussels, Musées Royaux des Beaux-Arts).

10. See Jacques van Lennep, "Charles van der Stappen," in Brussels, Beaux-Arts, 1987, pp. 380–82.

11. *Art Moderne* 1896, p. 123.

EUGÈNE CARRIÈRE
French, 1849–1906

71 *Woman Sewing,* ca. 1890–95

Signed, lower right: *Eugène Carrière*
Oil on canvas. 13¹⁄₁₆″ × 9¹³⁄₁₆″ (33.2 × 24.9 cm)
Museum Appropriation. 18.499

PROVENANCE: Purchased from Dr. R. Meyer-Riefstahl, New
York, 1918.

EXHIBITIONS: Allentown, AAM, 1968, no. 30 (ill.); Minne-
apolis, Institute, 1970; San Francisco, AMAA, 1986–88, p. 17
(no. 1, ill.).

72 *Landscape in the Orne,* 1901

Signed, lower right: *Eugène Carrière*
Oil on canvas. 12³⁄₁₆″ × 16¼″ (32.5 × 41.5 cm)
Membership Dues. 67.025

PROVENANCE: Collection of the Carrière family, Paris;
Etienne Ader, Paris.

EXHIBITIONS: Paris, Bernheim-Jeune, 1901, no. 23(?); Paris,
Ecole des Beaux-Arts, 1907, no. 224(?); Providence, RISD,
1967; Allentown, AAM, 1968, no. 47 (ill.); Minneapolis, Insti-
tute, 1970; New York, Kent, 1990, no. 4.

PUBLICATIONS: Geffroy 1902, no. 32 (ill., as *Paysage de l'Orne*);
Dubray 1931, opp. p. 70 (ill., as *Paysage*); RISD, *Museum Notes,*
1967, pp. 34–35 (no. 56, ill.); Bantens, 1983, p. 66 (fig. 27);
Bantens 1990, pp. 66–67 (no. 37, ill.).

Born in 1849 in Gournay, east of Paris, Eugène Carrière grew
up in Strasbourg, where he studied lithography and appren-
ticed in the shop of Auguste Munch before returning to Paris
to study with Alexandre Cabanel at the Ecole des Beaux-
Arts. Beginning in 1876 he showed almost yearly at the Salon
de la Société des Artistes Français, but it was not until 1885
that his reputation began to grow among critics and the
public. In the early 1880's Carrière befriended Auguste
Rodin, and in 1886 he met the Symbolist poet Jean Dolent.
With Dolent he began to attend monthly dinners held by
"les Têtes de Bois," a group of loosely affiliated artists and
writers of the Symbolist movement. There he met Odilon
Redon and Félix Bracquemond as well as the Symbolist
writers Charles Morice, Mme Rachilde, Paul Fort, and the
influential critic Roger Marx, whose favorable reviews did
much to expand Carrière's audience. By the early 1890's he
had met Verlaine and Mallarmé and had become a good
friend of Gauguin, who held him in high regard.[1]

Coincident with his acquaintance with the Symbolist
avant-garde in the late 1880's, Carrière's mature style began
to emerge, and he began to develop more fully his interest
in the evocation of mood, to which end he focused increas-
ingly on an essential image. Members of his family became
his main subjects, represented as if emerging from a dark
mist. He began, according to his friend and critic Elie Faure,
to perceive that in painting the daily life of his family, he
was painting the life of all people.[2] "I see other men in me,
and I find myself in them," he wrote in an exhibition cata-
logue of 1896, and this universalist principle prevailed until

71

the end of his life.[3] "I felt profoundly how much humanity
in reality forms one being of which we are a part," he wrote
in 1903.[4]

An engraving of 1888 (one of his first), depicting a
mother nursing her child and entitled *Reality has the Magic of
Dreaming* (fig. 1),[5] places this directly observed subject in an
abstract background of light and shadow, divorcing the
figures from a naturalistic setting, thus emphasizing the uni-
versality of an everyday event. *Woman Sewing,* representing
Mme Carrière at her needlework, likewise takes the direct
observation of a domestic commonplace as its point of

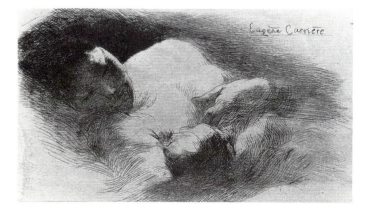

Fig. 1 Eugène Carrière, *Reality has the Magic of Dreaming,* 1888,
etching, 3⅜″ × 5⅜″ (8.6 × 13.7 cm), Providence, Museum of Art,
Rhode Island School of Design.

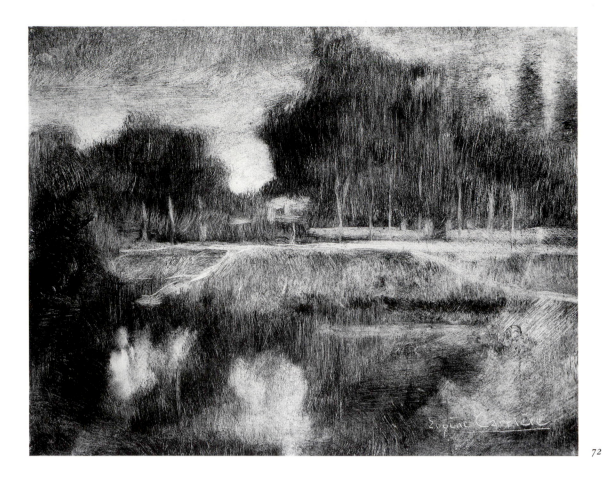

departure. With the suppression of any background detail and the somber brown palette, Carrière transforms a mundane, naturalistic subject into one that is full of suggestive meanings. His expressive concerns seem to correspond to Mallarmé's Symbolist dictum, published in 1891: "... to suggest [an object], that is the dream ... to evoke an object little by little to reveal a state of soul."[6]

Asked by Faure about his increasing use of abstraction, Carrière said that when he looked at a model, his eye picked out only the flesh tones: "the blouse, the dress, even the mass of the hair ... I saw everything disappear; everything retired into the shadow."[7] By focusing on what he perceived to be the essential character of his subject, Carrière's portrait of his wife at the simple, everyday task of sewing evoked for him the symbolic portrait of all women sewing.

Carrière painted women sewing at least four other times,[8] reflecting his idealization of women, expressed also in his many portraits of mothers and children. Carrière devoted his mature art to the women in his life. His wife and four daughters provide his predominant subjects, posing again and again for his domestic paintings. Sewing represented one of the quintessential tasks of women as he saw it; he called sewing "a task so beautiful and so healthy," when his daughter Nelly was learning in 1901,[9] and, when he wrote of his childhood, his earliest memory was of his mother next to him, sewing.[10]

Landscape, on the other hand, is a subject Carrière came to only late in his career. In 1895 Gauguin commented to

Jean Dolent that Carrière's landscapes were as yet unknown, indicating that he had begun to paint them by that date, and his letters show that he was still painting them at least until his first operation for throat cancer in 1902.[11] Most of the more than twenty-seven landscapes painted between those dates are related in their simplicity of color and composition. They are painted in characteristic monochromatic sienna tones that are similar to grisaille, representing the skyline with tall trees or cliffs and a large abstract foreground with undulating, formless shapes. Striations on the surface, as in RISD's landscape, became visible in Carrière's painting after 1890 and may be related to the techniques of lithography, which he had taken up again in 1890 for the first time since his apprenticeship in the 1860's.

Geffroy's title for the Museum's painting in a catalogue of 1902, *Paysage de l'Orne,*[12] suggests that the subject may be Bagnoles-de-l'Orne, a spa in Normandy where the Carrières spent some months in 1901 for Mme Carrière's phlebitis. However, the painting does not seem to depict the hilly terrain of Bagnoles proper, which is situated between the walls of a deep gorge, but may rather be of flatter scenery nearby in the Department of the Orne.

As do his paintings of family life, Carrière's landscapes reflect the Symbolist belief in nuance and dream, which evoke the essence of reality underlying surface appearances. *Landscape in the Orne* again transforms the literal reality of park and trees into a quasi-abstraction, with its lack of detail in the foreground, its attention to the planes of the picture,

and its restricted brown palette. For Carrière, the essential reality was the continuity of life. "In nature, . . . everything is related, the hill and the plain, the tree, the earth, and man," he said in 1889.[13] For him both his landscapes and his paintings of family life expressed his own Symbolist view: "To evoke in the spirit the sense of nature, and of life, that is the true role of art."[14] S.A.H.

1. Bantens 1990, p. 36.
2. Faure 1908, p. 52.
3. Carrière 1907, p. 11.
4. Letter to Francis Jammes, January 2, 1903, cited in Carrière 1907, p. 253.
5. RISD owns, in addition, a Carrière lithograph, *Meditation*, 50.341, and a drawing, *Mother and Child*, 58.072.
6. "Réponse à une enquête," in Huret 1891, quoted in Bantens, 1990, p. 70.
7. Faure 1908, p. 75.
8. *La Couseuse au Chat* (ca. 1876, present location unknown, reproduced in London, Marlborough Fine Arts, 1970, no. 1) is painted in an Impressionist mode reminiscent of the style of Fantin-Latour, with details of setting still readable. *La Couturière* (location unknown), also with more detail of background and a younger Mme Carrière, is reproduced in Geffroy 1902, p. 48, and *La Couseuse* (location unknown) in Dubray 1931, opp. p. 62. *Fillette Cousante* (location unknown) was included in Paris, Ecole des Beaux-Arts, 1907, no. 32.
9. Letter to his daughter Nelly, Bagnoles, 1901, in Carrière 1907, p. 107.
10. Carrière 1907, "Premières années d'Eugène Carrière," p. 190.
11. Quoted in Bantens 1983, p. 65.
12. Geffroy 1902, pl. 32.
13. Quoted in Séailles 1889, pp. 162–63; quoted in Bantens 1990, p. 87.
14. Carrière 1907, "L'Homme visionnaire de la réalité," p. 34.

PABLO PICASSO
Spanish, 1881–1973

73 *The Diners* (*Les Soupeurs*), 1901

Signed, lower right: *Picasso*
Oil on cardboard. 18⅝″ × 24⁹⁄₁₆″ (47.4 × 62.4 cm)
Bequest of George Pierce Metcalf. 57.237

PROVENANCE: Galerie Kahnweiler, Paris; from whom acquired by André Lefèvre; Galerie Balay et Carré, Paris; Simon Galleries (?), Berlin; Carroll Carstairs Gallery, New York; from whom acquired by George Pierce Metcalf in 1939.

EXHIBITIONS: Paris, Vollard, 1901, no. 37, as *Brasserie* (?); Portland, Art Museum, 1970; New York, IBM, 1988.

PUBLICATIONS: Fagus 1901 (?); Ozenfant 1931, p. 83; Cassou 1940, pp. 37, 165 (ill.); Cirici-Pellicer 1950, p. 104 (no. 50); Elgar 1956 (ill.); Zervos 1957, I, no. 67; Daix and Boudaille 1967, pp. 42, 45, 158, 184 (no. V.66); Woodward and Robinson 1985, p. 200 (no. 119, ill.).

CONSERVATION: The picture surface was cleaned using only natural solvents, and the lifting of pigment was consolidated locally with adhesive in 1981 at the Williamstown Regional Art Conservation Laboratory. At that time, a strip lining and a fiberglass-covered honeycomb support were attached to the reverse. No new varnish was added at this time.

RELATED WORKS: *At the Café de la Rotonde*, 1901, oil on canvas, 18½″ × 32½″ (47 × 82.5 cm), Washington, D.C., collection of Mr. and Mrs. David Lloyd Kreeger (Daix and Boudaille 1967, no. V.45). *In the Restaurant*, 1901, watercolor, 11⁷⁄₁₆″ × 15⅜″ (29 × 39 cm), location unknown (Daix and Boudaille 1967, no. V.46).

Les Soupeurs (*The Diners*), as this painting has come to be known, was painted by Picasso in his twentieth year, during his second visit to Paris in the spring of 1901. It forms a part of the first mature phase of the young artist's meteoric development, bracketed at one end by his exposure to French art of the *fin de siècle* during his first visit to Paris in the autumn of 1900, and at the other by the so-called "stained glass" style, which he had developed by the autumn of 1901, the prelude to the Blue Period style, created by winter of the same year.[1] *The Diners* belongs to a cluster of works painted by Picasso in this concentrated period of time, which focused for the most part on scenes of night life of the *demi-mondes* in which he traveled at that time, respectively in Paris, Madrid, and Barcelona, and then back again in Paris by the spring of 1901. A group of sixty-five of these paintings, as well as an unspecified number of drawings, were exhibited at the Galerie Vollard in June 1901, the first exhibition of Picasso's work in Paris.[2]

This was a period of great restlessness for Picasso and of a rapid crystallization of ideas in the development of his work. In 1899 Picasso, having abandoned his academic artistic training at the Royal Academy of San Fernando in Madrid, was living in Barcelona, an eighteen-year-old member of the bohemian counter-culture of artists and poets who congregated at the café called Els Quatre Gats (a Catalan spelling which in English means "The Four Cats"). These included the playwright and poet Santiago Rusiñol, the painters

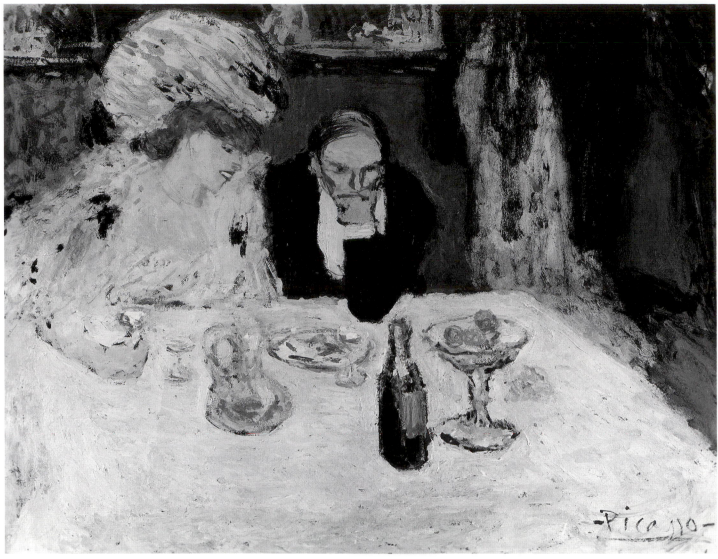

Ramón Casas, Isidro Nonell, Sebastián Junyer-Vidal, Angel and Mateu Fernández de Soto, Carlos Casagemas, the sculptor Manolo Hugué, the writer Ramón Reventos, the art historian Miguel Utrillo (Maurice Utrillo became his adopted son), and the poet Jaime Sabartés. In February 1900, Picasso held the first exhibition of his work at Els Quatre Gats, and around the same time several paintings by "Pablo Ruiz" (his paternal surname) were selected for the Spanish section of the Universal Exposition in Paris.[3]

It was ostensibly the Universal Exposition of 1900 that brought Picasso to Paris in the autumn of that year, accompanied by the painter Casagemas, with whom he had been sharing a studio in Barcelona. Paris provided Picasso with his first opportunity to see Impressionist and Post-Impressionist works firsthand, in particular those by Degas, Toulouse-Lautrec, and Van Gogh. He joined the colony of Spanish artists living in Montmartre, who acquainted him with modern art galleries like those of Ambroise Vollard and Berthe Weill, who bought three canvases from Picasso and introduced him to Pedro Mañach, a Catalan industrialist and collector with an interest in picture dealing. Mañach offered

Picasso 150 francs a month for all the work he produced, allowing him a modicum of financial independence.[4] This small commercial success, compounding the stimulus of the artistic culture, undoubtedly encouraged Picasso to settle in Paris permanently in 1901.

The nocturnal life of Paris – the life of cafés, of the Moulin Rouge and the Moulin de la Galette, the elegance and debauchery that attracted Degas, Forain, and Toulouse-Lautrec – also attracted Picasso, providing the subjects for the few paintings that he produced during his visit of autumn 1900. His major work, inspired by Toulouse-Lautrec, represents a view of *Le Moulin de la Galette* at night (New York, Solomon R. Guggenheim Museum). Illuminated by artificial light and accented by flashes of bold color, this painting is the first to depict the milieu that is also the subject of *The Diners,* representing the fashionable young ladies and typically somewhat older gentlemen in their evening attire who sought their pleasures on the margins of propriety.

Picasso and Casagemas left Paris for Spain quite suddenly just before the end of December 1900, possibly due to a lover's rebuff that seems to have devastated Casagemas. Picasso

resettled in Madrid, where he remained through April 1901, returned briefly to Barcelona, and then continued on again to Paris, arriving around May. When Picasso returned to Paris, he installed himself in Casagemas's studio on the Boulevard Clichy, located just above the café in which Picasso's unfortunate companion, overwhelmed by his unhappy love affair, had taken his life after returning to Paris two months earlier.

Although this was an unsettled period for Picasso, it was also a period of intense productivity, resulting in a noticeable change in his art. He began to introduce purer, brighter colors applied in bold marks, reflecting the influence of a divisionist technique that he would have observed during his first visit to Paris. As Daix has commented, one can begin to detect an acid and often sardonic quality in his approach to his subjects, which for the most part focused on the nocturnal world in which he traveled.[5] During his brief return to Barcelona, he made provisions for an exhibition of recent pastels in this boldly colored style, which opened at the Sala Parés in June.[6] Once back in Paris, Picasso was introduced to Ambroise Vollard by Mañach, with a view to an exhibition. According to Vollard, Picasso showed him about a hundred paintings, which led to the exhibition that opened on June 24 along with the work of the Basque painter Francisco de Iturrino (1864–1924).[7]

Although the precise date of *The Diners* cannot be determined, its probable date of execution can be narrowed to a period between around May and September of 1901. In April 1901, shortly before his return to Paris, Picasso dropped the "Ruiz" from his signature and began signing his works by the familiar "Picasso," as in *The Diners*.[8] By September 1901, Picasso abandoned the intense color and pronounced brushwork visible in *The Diners* (typical of the Vollard style generally) for the "stained glass" style, in which the brushwork becomes less pronounced and areas of color become flatter and bounded by dark, linear contours. *The Diners* may have been the painting listed as number thirty-seven in the catalogue of the Vollard exhibition of late June, identified by the title *Brasserie*.[9] In a review of this exhibition by Félicien Fagus, he includes among the "lucky finds" observed in Picasso's work "the yellow and white of a woman's hat," plausibly referring to the magnificent bonnet worn by the female companion in the RISD painting.[10] The setting for *The Diners* may be identical to the one represented in a painting that is incorrectly called *At the Café de la Rotonde* (Washington, D.C., collection Mr. and Mrs. David Lloyd Kreeger),[11] which shows a background dominated by the same reds and yellows; two women at a café table facing the viewer, the woman to the left leaning towards the woman seated next to her; and a waiter, cut off by the top of the canvas, serving them from the right. In the Museum's painting the form of the waiter has been replaced by what appear to be the woman's wrap and the gentleman's overcoat, hanging on a hook above the vermilion bench. Picasso has identified the actual setting of *At the Café de la Rotonde* as the café called l'Hippodrome, which was often frequented by Toulouse-

Lautrec.[12] Located on the Boulevard Clichy in the building just next to and beneath Picasso's studio, this was the setting in which Casagemas took his life in February 1901. It seems likely, as a matter of convenience, that many of Picasso's café pictures from this period were actually painted here.

The fleeting gestures of the sitters, the deliberate imbalances of the composition and awkward "cutting" of the frame, as well as the vigor and immediacy of Picasso's technique, give *The Diners* the impression of a subject directly observed and painted on the site. Critics at the time were inclined to compare Picasso's harsh skill of observation to the art of Goya.[13] At the same time these devices reveal Picasso's receptivity to a variety of formal influences associated with Impressionism (which, it should be remembered, he had only seen for the first time in 1900) and Post-Impressionism. The motif is a common Impressionist theme, with numerous examples in the work of Manet, Degas, Forain, and Toulouse-Lautrec. The still life of fruit and compote, bottle and glasses that sit on the table and in part allow this white expanse to be read as a receding space, is a distant echo of the foreground of Manet's *Bar at the Folies-Bergère* (1881–82, London, Courtauld Institute), which Picasso would have certainly seen at the Universal Exposition of 1900.[14] Picasso's embrace of the work of Toulouse-Lautrec, until around then a colorful habitué of the fast-moving quarter of the Boulevard Clichy, is indicated by Picasso's 1901 painting of his bedroom-studio on the Boulevard Clichy showing Toulouse-Lautrec's poster of *May Milton* above the bed.[15]

Picasso, at both this early stage of his career and throughout his life thereafter, had an insatiable appetite for examining and exploiting the work of other artists, which he adapted freely to his own purposes.[16] In his review of the 1901 exhibition, Félicien Fagus noted the wide variety of influences that were visible in Picasso's work, including "Delacroix, Manet (everything points to him, whose painting is a little Spanish), Monet, Van Gogh, Pissarro, Toulouse-Lautrec, Degas, Forain, Rops perhaps. . . . Each influence is transitory, set free as soon as caught: one sees that Picasso's haste has not yet given him time to forge a personal style; his personality is in this haste, this youthful impetuous spontaneity."[17] If he was inspired in particular by Manet, Degas, and Toulouse-Lautrec in his choice of subject and bias, focusing on a jaded milieu of cheap elegance and easy seduction, the intensity and range of color that convey the psychological atmosphere of these artificially illuminated settings anticipates by several years the high-pitched coloristic effects visible in the works of Matisse and the Fauves. "Like all pure painters he adores color for itself and each substance has its proper color," Fagus observed.[18] Picasso would very soon abandon these coloristic innovations for the muted palette of the Blue Period, yet had he not proceeded in the ensuing years to revolutionize the norms of representation with the invention of Cubism, he might still have been remembered as an important precursor of Expressionism at the beginning of the new century. D. R.

1. The analogy to stained glass in Picasso's works of late 1901–02 was made in Fagus 1902, a review of the artist's work at the Galerie Berthe Weill in September of that year; reprinted in Daix and Boudaille 1967, p. 334.

2. See Paris, Vollard, 1901.

3. Rubin 1980, p. 28. Cf. Daix and Boudaille 1967, p. 25.

4. Penrose 1962, p. 64.

5. Daix and Boudaille 1967, p. 34.

6. The exhibition was organized by Miguel Utrillo and Ramón Casas, editors and founders of the review *Pèl y Ploma*. See Utrillo 1901, translated in Daix and Boudaille 1967, p. 333.

7. Penrose 1962, p. 72.

8. Daix and Boudaille 1967, p. 13.

9. Daix and Boudaille 1967, p. 158, suggests that this title may refer to the RISD painting, or to a handful of other known works that conform to this description. Cf. nos. V.45, *La Café de la Rotonde* (oil on canvas), and Addenda No. A.4, *Café in Montmartre* (oil on cardboard), the only known oils. There are also a number of known watercolors that are related: V.67, *In the Restaurant* (watercolor); V.44, *In the Café* (watercolor); V.80, *Woman Seated on the Terrace of a Café* (watercolor).

10. Fagus 1901, translated in Daix and Boudaille 1967, p. 333.

11. Daix and Boudaille 1967, p. 175 (no. V.45).

12. Daix and Boudaille 1967, p. 175 (no. V.45).

13. Utrillo 1901 remarks that at the time Picasso was nicknamed "Little Goya" by his French friends and suggests that this was not a matter merely of outward physical appearance. Cf. Fagus 1901, in which "a harsh imagination, somber, corrosive, sometimes magnificent" follows the "bitter, mournful genius" of Goya.

14. No. 448 in the Centenary of French Painting. See Cooper 1954, pp. 101-02 (no. 36).

15. *The Blue Room*, 1901, oil on canvas, Washington, D.C., Phillips Collection. See Daix and Boudaille 1967, p. 197 (no. VI.15). *The Diners* is also strikingly reminiscent of Degas's *In a Café* (*The Absinthe Drinkers*) (see entry 66, fig. 1). However, it is unlikely that he could have known this picture, which at the time was in a private French collection, other than through its reproduction. See New York, MMA, 1988–89, p. 286 (no. 172).

16. See Penrose 1962, p. 45.

17. Fagus 1901, in Daix and Boudaille 1967, p. 333.

18. Fagus 1901, in Daix and Boudaille 1967, p. 333.

PABLO PICASSO
Spanish, 1881–1973

74 *Seated Woman with a Book,* ca. 1911–12

Signed on verso, upper right, in black: *Picasso*
Oil on canvas. 16¼″ × 9½″ (41.2 × 24 cm)
Museum Works of Art Fund. 51.094

PROVENANCE: Acquired by Wilhelm Uhde, Paris, between 1912 and 1914;[1] Hôtel Drouot, Paris, sale Wilhelm Uhde, May 30, 1921, no. 50, as *La Dame au fauteuil (Woman in an Armchair)*, for 1000 francs; purchased by Alphonse Kann, Saint-Germain-en-Laye; Carroll Carstairs Gallery, New York; from whom purchased by the Museum.

EXHIBITION: New York, IBM, 1988.

PUBLICATIONS: Paris, Hôtel Drouot, 1921, no. 50; Zervos 1938, p. 215; Zervos 1957, II, no. 300 (pl. 146); Russoli and Minervino 1972, no. 442; Daix and Rosselet 1979, p. 265 (no. 398); Woodward and Robinson 1985, p. 201 (no. 120, ill.).

CONSERVATION: In 1981 the canvas was lined and the surface cleaned with a natural solvent at the Williamstown Regional Art Conservation Laboratory.

The changes that occurred in Picasso's art between 1901, when he first settled in Paris, and 1911–12, when this hermetic and nearly abstract work was painted, reflect the enormous ground that the artist had covered in the very short span of a decade. The cryptic figure represented in *Seated Woman with a Book,* composed of an abstract scaffolding of lines and modeled passages, epitomizes the "analytical" Cubist style that Picasso, working closely with Georges Braque, had developed between 1910 and 1911, in which traces of the subject can barely be discerned.[2] It reflects the culmination and perfection of the style that, in 1912, would be transformed by them into a "synthetic" phase comprised of larger, more simplified forms, painted with a more varied palette, in which subjects again become more clearly identifiable.

The invention of the term "Cubism," which Picasso never liked, is credited to a conversation between the art critic Louis Vauxcelles and Henri Matisse, who described paintings "with little cubes" that Braque had submitted in 1908 to the Salon d'Automne. Vauxcelles wrote in that year of Braque's reduction of everything to "geometric schemes, to cubes," and in 1909 he wrote of "the cubic... and hardly intelligible oddities" that Braque had submitted to the Salon des Indépendants.[3] Braque and Picasso had begun working in a very close collaboration by this time, exchanging ideas in a rare artistic symbiosis; by 1911, their work had grown so close as to be almost indistinguishable.[4] Although the identifiable "cubes" had disappeared from the art of Braque and Picasso by early 1910, the term "Cubism," which had originated as a derogatory term, was taken up by sympathetic critics to describe a variety of artists' works, including not only Picasso and Braque, but also Juan Gris, as well as a number of the artists represented in this volume, including Metzinger, Gleizes, the Duchamp brothers, Laurencin, Le Fauconnier, Delaunay, Léger, and Marchand.[5] Although the styles and aims of these artists differed considerably, they all partici-

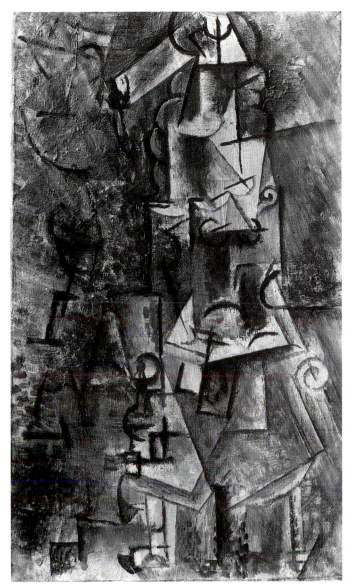

74 (color plate p. 30)

In the paintings that followed, among them *Seated Woman with a Book,* the Cubism of Picasso and Braque entered a phase that approached pure abstraction, but stopped short of completely abandoning their subjects. Representation, William Rubin has observed, remained an obsession for Picasso, who delighted in the ambiguous sign that permitted him to develop analogies between forms.[7] However, so great was his desire to dissect forms and recreate them that Kahnweiler, Picasso's principal dealer at the time, was moved to encourage the artist to always provide descriptive titles for his works.[8]

The ambiguity of the subject matter of this painting is suggested by the metamorphoses of its title. It was sold from the collection of Wilhelm Uhde, a dealer, critic, and one of the major early supporters of Cubism, as *Femme assise dans un fauteuil (Woman Seated in an Armchair),* whereas in the archives of Daniel Henry Kahnweiler, who may have sold it to Uhde, it is listed as "*Femme à la mandoline,* printemps 1912 (coll. Uhde 1912)" (*Woman Playing a Mandolin,* spring 1912 . . .).[9] Christian Zervos, first preserving Uhde's title,[10] subsequently revised it to *Femme assise au livre,* presumably in consultation with the artist.[11] Daix and Rosselet more cautiously call the painting *Seated Woman,* leaving it to the viewer to discern additional details.

Although at a glance the female figure is very difficult to distinguish from the abstract structure of lines and inter-penetrating planes, one can begin to read such clues as the figure's crossed legs; the legs, seat, arm, and back of a chair; what may be a table and glass above her left foot; a book that rests upon her lap, as well as what may be a portfolio resting beneath it; the sitter's breasts, indicated by two round circles; and the profile of what may be read as her face, look-ing towards the viewer's right. Many other forms cannot be so easily read, adding to the hermeticism of the picture, compelling the viewer to wrestle with its fluid ambiguities. The figure emerges from a transparent, crystalline structure built of ascending, pyramidal forms, which, when read individually, give little indication of the organic figure they describe. Just as Picasso achieves a heightened spatial com-plexity by the limitation of his formal devices to a vocabulary of straight lines, curved arcs, and interpenetrating planes, likewise he achieves a luminous chromatic effect from a muted palette of ocher, sienna, grey, silver, and dull whites. The areas of choppy blue strokes that run vertically along the left side of the canvas and to the right of the figure along what may be read as a horizon suggest that this woman may be sitting on a balcony, or before a window overlooking the sea. This is one of the rare examples from the period in which Picasso combines figure and landscape motifs. In it, the figure not only merges with its surrounding space, but the space may also be read as the fusion of inside and out.

The dating of this painting is problematic. Zervos has suggested a dating of winter 1911–12,[12] whereas Daix tenta-tively suggests that it may have been executed in spring 1911, and Kahnweiler in the spring of 1912.[13] The open, vertical scaffolding that defines the figure was first explored by

pated in a reevaluation of the relationship between art and nature based on a rejection of the "optical" principles that were the legacy of Impressionism. They all shared a notion of the work of art as a conceptual activity whose "reality" was separate from the world of appearances, and of its identity as an object, unique and distinct from nature, that engaged the viewer in a balance between the abstract elements of which it was made and its representational potential.

It was in 1910, in the work begun by Picasso that summer at Cadaqués, on the coast of Catalonia, and then continued back in Paris in the fall, that the closed, cubic structures so far developed by Braque and himself were replaced by an open, linear scaffolding. As Kahnweiler observed, Picasso "had taken the great step; he had pierced the closed form."[6] Picasso was now not only able to present an abstracted, con-ceptualized view of nature that combined multiple points of view, but also to integrate the figure and its surrounding space, for which he employed a vocabulary that deliberately confounded his abstract formal means with the illusion of a palpable reality occupied by discernible figures or objects.

Picasso in the series of etchings and related drawings begun in Cadaqués in the summer of 1910 and continued that autumn in Paris, which would account for the seaside view.[14] The figure also seems related to the *Accordionist* (New York, Solomon R. Guggenheim Museum), painted in the summer of 1911 in Céret, which resembles the Museum's *Seated Woman* in composition and in many of its details. This was a period, as Golding has pointed out, in which Picasso's style appeared to change least radically, having reached a period of poise and equilibrium.[15] By winter 1911–12, Picasso had begun to regularly introduce letters, numbers, and words as a part of his imagery, and soon thereafter he and Braque would introduce elements of collage, beginning a new phase in the development of Cubism. Whatever its place in the Cubist chronology, this *Seated Woman* embodies the desire to penetrate into the nature of form and to reinvent the relationship between art and nature that constituted the revolution that was Cubism. Modern painting in its aftermath would never be the same. D. R.

1. Daix and Rosselet 1979, p. 265.
2. See Apollinaire 1913, p. 19: "*Picasso: analytical cubism, 1909–13.* Representing planes to denote volumes, Picasso gives an enumeration so complete and so decisive of the various elements which make up the object, that these do not take the shape of the object, thanks to the effort of the spectator, who is forced to see all the elements simultaneously just because of the way they have been arranged." Cf. Barr 1946, pp. 66–73, and Rosenblum 1976, pp. 70–71.
3. Vauxcelles 1908 and Vauxcelles 1909. Facsimile reprint of the former in Fry 1966, p. 51. For the origins of the term "Cubism" cf. also Kahnweiler 1920, pp. 5–6; Golding 1968, p. 21; and New York, MOMA, 1989, pp. 359, 436 (n. 77).
4. At Braque's suggestion, their paintings of this period were not signed, in what has been described as a deliberate gesture toward impersonal authorship. See Golding 1968, p. 93, and New York, MOMA, 1989, p. 19.
5. With the exception of Picasso, Braque, Delaunay, and Le Fauconnier, all of these artists exhibited work in the *Section d'Or* exhibition at the Galerie de la Boëtie in October 1912.
6. Kahnweiler 1920, p. 10.
7. New York, MOMA, 1989, pp. 23–24.
8. Penrose 1962, p. 159.
9. Daix and Rosselet 1979, p. 265.
10. Zervos 1938, p. 215.
11. Zervos 1957, II, no. 300.
12. Zervos 1957, II, no. 300.
13. Daix and Rosselet 1979, p. 265.
14. See for example *Standing Nude*, Cadaqués or Paris, summer–autumn 1910, charcoal, 19″ × 12⅜″ (48.3 × 31.4 cm), New York, Metropolitan Museum of Art; and *Mlle Léonie on a Chaise Longue*, State III, from *Saint Matorel* by Max Jacob, Paris, autumn 1910; published Paris, Henry Kahnweiler, 1911; New York, Museum of Modern Art. Reproduced in New York, MOMA, 1989, pp. 166–67.
15. Golding 1968, p. 91.

AUGUSTUS EDWIN JOHN
British, 1879–1961

75 *On the Slopes of Arling Jack,* ca. 1911

Signed, lower right: *John*
Oil on panel. 20⅟₁₆″ × 12″ (50.9 × 30.5 cm)
Museum Appropriation. 28.062

PROVENANCE: Sir James Murray, London; purchased 1928 for the Museum by Martin Birnbaum for £632:10:0.

EXHIBITIONS: London, Fine Art Society, 1928; Newport, Art Association, 1948.

PUBLICATION: RISD, *Bulletin*, 1929, pp. 14–15 (ill. on cover).

Augustus John began his career as a student at the Slade School, London's foremost art academy at the turn of the century, which he attended from 1894 to 1898. Under the tutelage of Henry Tonks and Philip Wilson Steer, both members of the New English Art Club (along with Theodore

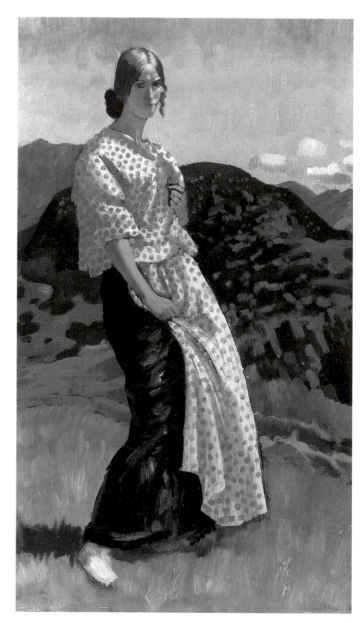

75

Roussel, John Singer Sargent, and Walter Sickert), John learned about and began to practice French plein-air painting methods. Along with classmates Harold Gilman and Spencer Gore, John developed a preference for working from models out of doors, rather than from sketches in the studio.[1] By 1899, he had had his first exhibition at the Carfax Gallery in London, as well as an invitation to exhibit in the Spring and Fall shows of the N. E. A. C.

John's career took a decisive turn in 1901 while briefly teaching outside of London at Liverpool's University College. In addition to learning to etch, John began in earnest to explore what became a lifetime preoccupation with gypsy culture and language. During frequent excursions to Romany camps in the Welsh countryside, he would etch portraits of the gypsies living there. Between the work produced during his recurrent painting trips to gypsy campsites in Britain and Provence (journeys which now included an extended family of lovers and their children) and his studio work in London and occasionally Paris, John's artistic reputation became firmly established.

The period considered to be John's finest, between about 1907 and 1914, coincides with his close association with the Welsh primitive painter James Dickson Innes (1887–1914). Already under the influence of the French Post-Impressionists, John was further inspired by Innes's style to make even flatter, more boldly colored renditions of his family, set in the barren landscape of North Wales, where the painters traveled together.

On the Slopes of Arling Jack was undoubtedly painted during one of these sojourns. The panel is typical of the size and type that John took on his painting trips, fitting neatly into a slotted travel box.[2] A related work, entitled *Lily in North Wales*,[3] differs only slightly in costuming and the direction of the pose and shows the same rocky slope with mountains in the distance. Another small panel, *Lily at Tan-Y-Grisiau*,[4] with a similar pose and costume, establishes the identity of our model as Lily, a family friend, and the location in the mountains of northern Wales, near Ffestiniog, a slate-mining area, now part of a large national park. Indeed, all three of the panels belong to a body of work painted around 1911 in these hills with either Lily, Dorelia (Dorothy) McNeill (mother of many of John's children), her sister Edie, or a certain Nora Brownsword as subjects; and for many this group of works constitutes the pinnacle of John's creative output. After Innes's untimely death from tuberculosis in 1914, John began to concentrate on commissioned portraiture, turning away from his plein-air painting excursions.

On the Slopes of Arling Jack was purchased by the Museum in 1928, the year that John was elected to full membership in the Royal Academy. L. S. U.

1. Harrison 1981, pp. 20–24.
2. Easton and Holroyd 1974, p. 18.
3. Illustrated in Rothenstein 1944, fig. 9, oil on panel, 20″ × 12″, it was last known to be in the collection of Mrs. Cyril Kleinwort.
4. Illustrated in Rothenstein 1944, fig. 19, oil on panel, 25½″ × 21½″, present whereabouts unknown.

JEAN METZINGER
French, 1883–1956

76 *Portrait of Albert Gleizes,* 1911–12

Signed, lower right: *Metzinger*
Oil on canvas. 25⅝″ × 21⅜″ (65 × 54.3 cm)
Paris Auction Fund and Museum Works of Art Fund. 66.162

PROVENANCE: Collection Mlle Henry, Paris; purchased from Leonard Hutton Galleries, New York.

EXHIBITIONS: Paris, la Boëtie, 1912, p. 6 (no. 120); Cologne, Kunstverein, 1964, no. 47; New York, Hutton, 1964, p. 18 (no. 50, ill.); Waltham, Rose, 1967, fig. 51; Buffalo, Albright-Knox, 1967, p. 45 (pl. 34); Los Angeles, LACMA, 1970, p. 76 (no. 213, pl. 72); London, Tate, 1983, p. 437 (no. 229, ill.); Iowa City, UIMA, 1985, p. 55 (no. 44, ill.); New York, IBM, 1988.

PUBLICATIONS: Fry 1966, fig. 44; Iowa City, UIMA br., 1985, p. 3 (ill.); Metzinger and Robbins 1990, pl. 10.

CONSERVATION: In 1982 the painting was cleaned, inpainted, and revarnished at the Williamstown Regional Art Conservation Laboratory. It had been relined previously.

RELATED WORKS: *Study for Portrait of Albert Gleizes,* 1911, pencil on paper, 7⅞″ × 6⅛″ (20 × 15.5 cm), Paris, Musée d'Art Moderne de la Ville de Paris. *Study for Portrait of Albert Gleizes,* 1911, pencil on cream paper, 8¼″ × 6⅛″ (21 × 15.5 cm), Paris, Musée National d'Art Moderne, Centre Georges Pompidou.

The Museum's *Portrait of Albert Gleizes* by Jean Metzinger was painted sometime in late 1911 or early 1912, the year the artist and the sitter, both Cubist painters, wrote *On Cubism*.[1] The book, which was the first attempt to systematically describe a new and revolutionary art, established the authors as important early theoreticians of Cubism. Soon translated into English and Russian, *On Cubism* went through fifteen editions in its first year and became a manifesto for artists who rejected Impressionism for a more conceptual and abstract approach to painting.[2] It appeared not long after the major Cubist exhibition called the *Section d'Or* (*Golden Section*) at the Galerie de la Boëtie, Paris, a show organized primarily by Jacques Villon, Metzinger, and Gleizes.[3] The Museum's portrait was one of twelve paintings by Metzinger exhibited there; several by Gleizes were also included.

Metzinger and Gleizes first met in 1909 or 1910, perhaps introduced by a mutual friend, Alexandre Mercereau, a socialist writer who earlier had cofounded the Abbaye de Créteil community of artists and writers of which Gleizes had been a member.[4] In 1911 Gleizes and Metzinger grouped themselves with Le Fauconnier, Léger, and Delaunay in Room 41 of the spring Salon des Indépendants. Two more collaborations followed in the next year – the *Section d'Or* exhibition and their joint authorship of *On Cubism*. Although the latter was the fruit of conversations between the two authors, the book probably reflected the ideas of artists meeting at Courbevoie and Puteaux as well, including Le Fauconnier, Gris, Léger, Delaunay, and the Duchamp brothers.

In certain early Cubist paintings of 1910, Metzinger presented simultaneous views by breaking up figures and background into many facets that obscured the subject in

76

the "analytical" manner of Picasso and Braque, and like them he briefly limited his palette. In the Museum's *Portrait of Albert Gleizes,* it is clear that Metzinger was moving away from the analytical style of Picasso and Braque's recent work. The figure is rendered in flat, synthetic planes and is distinct from the space around it, which has been loosely painted in pale pink over gray. Although Metzinger's palette is still quite limited, color has become more integral to the composition of the work.

The portrait is composed of three main vertical areas of nearly equal size. In the left third, the sitter's shoulder and palette are presented in frontal view by simplified, outlined shapes, while in the middle section, the figure is shown in large facets from different viewpoints in a series of vertical strips. In a dramatic shift of point of view, the strip to the right of the center shows the hat from above and the face and body from the side and front. In the center and right strips, parts of the face and hat are carefully painted with small brushstrokes and are modeled to suggest volume in contrast to the flatness of the rest of the figure. The shape representing the sitter's cheek suggests the influence of Léger, who employed tubular forms at this time. The third section of the painting, at right, shows a shadowy profile of the back of the figure's head and shoulders intersecting with a frontal view of the upper torso.

A preliminary drawing of 1911 (fig. 1) indicates that

Metzinger originally conceived the figure within an asymmetrical grid in which the facial features are organized into triangles placed at right angles to real and implied straight edges. In the painting, facial forms have been readjusted so that irregular details are confined to the central shaft of color, reinforcing the picture's dichotomy between realistic and abstract elements, and its rectangular structure has been replaced by vertical strips extending to the edges, thus anchoring the image to the picture plane and emphasizing its spatial ambiguity, which is compounded by areas of rough texture that reinforce an awareness of the picture's surface.

While Metzinger's contributions to Cubism as a writer and promoter have been broadly acknowledged, his paintings, and the Museum's portrait in particular, have been compared unfavorably to the analytical Cubism of Picasso and Braque. Douglas Cooper has described Metzinger as an artist with a basically naturalistic vision upon which he imposed a mathematical system, an artist who did not understand Braque and Picasso's analytical method.[5] Edward Fry has contended that Metzinger "rather naively combined separate eyepoints" in the portrait and imitated Gris's system of composition.[6] On the other hand, William Seitz has found that Metzinger solved the conflict of representation versus abstraction in the Museum's portrait by "mixing new and old wine—in this instance quite successfully—in one bottle."[7] Daniel Robbins has pointed out the absurdity of judging

Metzinger's work against the canon of "analytical" Cubism, arguing that this term was coined by later critics to describe a phase specific to the art of Picasso and Braque.[8]

The differences between this painting and the works of Picasso and Braque reflect, if anything, the complexity of Cubism at this stage of its development. Metzinger was well aware of Picasso and Braque at this time and had, in his own critical fashion, responded in a style that sought a more clearly defined approach to the conceptual problems of Cubism. This portrait, with its simplification of form, reflects Metzinger's contribution to the emerging synthetic phase of Cubism. It also evokes a seminal period in the history of modern art, commemorating the collaboration of two of the leading painters of the Cubist epoch on perhaps the most important theoretical document of Cubism and in the organization of the *Section d'Or* exhibition. S.B.G.

1. While the painting is usually given a date of 1912, two preliminary sketches, one in the Musée d'Art Moderne de la Ville de Paris (fig. 1), and another in the collection of the Musée National d'Art Moderne, Centre Georges Pompidou, Paris, are inscribed 1911. The painting is dated 1911 in Metzinger and Robbins 1990, pl. 10.

2. Strazdes 1986, p. 89. *On Cubism* appears in translation in Herbert 1964 and abridged in Fry 1966.

3. See Paris, la Boëtie, 1912; Golding 1968, pp. 331–32; and Fry 1966, p. 101.

4. Iowa City, UIMA, 1985, pp. 13–14. This collective believed in the social role of art and favored communal artistic efforts. Modern art, they thought, should be related to modern life. See New York, Guggenheim, 1964, p. 13; Gamwell 1980, pp. 13–14.

5. Los Angeles, LACMA, 1970, pp. 76–78. In London, Tate, 1983, p. 437, Cooper and Tinterow called the picture's palette "an illogicality which one does not find in paintings by Braque and Picasso." Cf. Buffalo, Albright-Knox, 1967, p. 45, which notes to the contrary that the palette pulls the composition together.

6. Fry 1966, p. 30.

7. Waltham, Rose, 1967, p. 9.

8. Iowa City, UIMA, 1985, p. 10.

Fig. 1 Jean Metzinger, *Study for Portrait of Albert Gleizes,* 1911, pencil on paper, 7⅞″ × 6⅛″ (20 × 15.5 cm), Paris, Musée d'Art Moderne de la Ville de Paris.

ROBERT DELAUNAY
French, 1885–1941

77 *The Towers of Laon,* ca. 1914

Signed and inscribed, lower left: *Les tours de Laon/R. Delaunay*
Encaustic on board. 9⁷⁄₁₆″ × 7¾″ (24 × 19.7 cm)
Jesse H. Metcalf Fund, with gifts from the Chace and Levinger Foundations. 67.088

PROVENANCE: Collection Chanaux, Paris; Jan Nicholas Streep, Paris.

PUBLICATION: Buckberrough 1982, p. 339, n. 1.

CONSERVATION: In 1983 the surface of the painting was cleaned, and flaking at the top left corner and bottom right was consolidated at the Williamstown Regional Art Conservation Laboratory.

RELATED WORK: *The Towers of Laon,* 1912, oil on canvas, 63¾″ × 51⅛″ (162 × 130 cm), Paris, Musée National d'Art Moderne, Centre Georges Pompidou.

This small panel of Laon Cathedral by Robert Delaunay presents a motif introduced in a series of paintings executed in January 1912, the largest (63¾″ × 51⅛″) and most important of which is now in the Musée National d'Art Moderne, Centre Georges Pompidou, in Paris (fig. 1).[1] The version in the RISD Museum appears to be a reprise of the Paris canvas. It was probably painted while Delaunay was visiting Portugal in August 1914,[2] intended for an old school friend, Chanaux, with whom he had been an apprentice in the decorative arts at the Rosin studio in Belleville about ten years earlier.[3] The encaustic, or wax-based paint, in which the panel was executed is a medium with which the artist was experimenting at this time.

The style that Delaunay and his wife Sonia, a painter and textile designer, pioneered in the years prior to World War I is known as Orphism, a label coined by the avant-garde poet and art critic Guillaume Apollinaire.[4] An offshoot of Cubism, Orphism uses the overlapping, geometric planes favored by Picasso and Braque, but instead of their austere, neutral palette substitutes bright, prismatic colors. By juxtaposing sequences of contrasting hues, Delaunay produced passages that seem to vibrate, creating pictorial motion intended to parallel the energy of the physical world. The Delaunays' color theory, central to the development of Orphism, was bound up in the law of "simultaneous color contrasts" devised by the chemist Michel-Eugène Chevreul (1786–1889), whose ideas had been incorporated in the painting of nineteenth-century artists such as Eugène Delacroix and Georges Seurat.[5]

Delaunay came from a privileged background, attending a succession of *lycées* before dropping out at seventeen and entering into apprenticeship at the Rosin studio in Belleville. He quickly joined the circles of the Parisian avant-garde, producing paintings in his early years which exhibit the influence of Neo-Impressionism, Fauvism, and Cubism. Delaunay's independent style emerged around 1909–11 with views of the Eiffel Tower and buildings of Paris seen from a window, fragmented into Cubist planes and depicted from multiple points of view. Delaunay called this his "destructive

Fig. 1 Robert Delaunay, *The Towers of Laon,* 1912, oil on canvas,
63¾" × 51⅛" (162 × 130 cm), Paris, Musée National d'Art Moderne,
Centre Georges Pompidou.

period," referring to his Cubist dissection of form, with col-
liding planes and directional upheavals that made his struc-
tures look as if they were collapsing or tumbling apart.

In their panoramic scope, Delaunay's early paintings
resemble the Cubist landscapes that Picasso and Braque
painted around 1909, but unlike the preference of the ortho-
dox Cubists for neutral, timeless motifs, Delaunay was
drawn to the iconography of modern urban life and high
technology. His dizzying, multi-perspectival, motion-filled
style was deliberately calculated to convey the excitement of
the new world of twentieth-century machinery, architecture,
and modes of transportation, which provided the modern
city-dweller with visual perspectives that were higher and
speeds that were faster than those ever experienced before.[6]
Delaunay perceived parallels to the new technology in medi-
eval architecture, which drew him to make it the subject of
many of his paintings. Prior to the Laon canvases and panels,
he had painted views from the spire of Notre-Dame in Paris
and interiors of St. Severin in 1909–10. As with the Laon
paintings, the Gothic structures are viewed as engineering
marvels of an earlier age whose verticality and skeletal design
are the antecedents of technological showpieces like the Eiffel
Tower.

Delaunay's decision to spend the early days of 1912 in
Laon, accompanied by Sonia and their son Charles, resulted

from a desire to distance himself briefly from the urban environment and evaluate his progress. The work he had completed before his departure had become so highly abstracted that the representational elements were almost unreadable.[7] In his views of Laon,[8] Delaunay pulls back from abstraction somewhat with a style that continued to be characterized by planes that break up solid mass and surrounding space, but with less distortion than before. The large *Towers of Laon* in the Centre Pompidou, the prototype for the RISD panel, was preceded by a more schematic oil study in the Hamburger Kunsthalle.[9]

While the Providence version repeats the composition of the Paris *Towers of Laon,* it is more boldy simplified. Both works show the cathedral from the east end, seen behind a screen of trees, houses, and a section of the old citadel wall. An avenue of pink and violet trees, more solidly colored in the small version compared to the variegated hues in the prototype, curves around the right foreground. In the left foreground is the buttressed citadel wall. The brown and blue triangles and parallelograms directly above it represent the houses which flank the north side of the cathedral. Further back stands the cathedral itself. The two towers that appear tallest, rising almost to the top of the picture, are those on either end of the transept. The shorter crossing tower midway between them is distinguished by its triangular roof, purple in both paintings. Further to the left, overlapping the lower portion of the south transept tower, is the east front with its triangular pediment and two flanking cone-shaped pinnacles, all green.

As Hans Platte has demonstrated by comparing the Paris version with a photograph of the site taken from the same angle, Delaunay's painting is remarkably accurate, despite the Orphist stylization that turns the entire scene into a kaleidoscopic assemblage of brilliantly colored planes that are both solid and semitransparent.[10] Delaunay's prior involvement with the geometric reduction and arbitrary coloration of Cubism and Fauvism is evident in his square clouds of green, the pink tree leaves, and the purple and green church. Buckberrough hypothesizes, based on a painting by Delaunay of a stained-glass window of the cathedral (1912, Bern, Museum of Fine Arts), that the bright colors flooding the composition are meant to suggest the effects of light streaming through colored panes, or reflections on a glass surface, as if the whole scene were viewed through, or reflected in, a window. Delaunay had already explored similar effects in his paintings of the interior of St. Severin.[11]

The number of smaller versions or replicas of the large *Towers of Laon* indicates that it was a painting which was important to Delaunay.[12] By the time the RISD version was painted, its prototype had gained international exposure at exhibitions in Zurich and Berlin.[13] Stylistically, the *Towers of Laon* was a turning point for Delaunay in two respects. First, the colored planes took on a new transparency not seen in his previous work. Secondly, the composition is arranged circularly, with the arc of the trees and pathway reiterated by wider arcs and circular arrangements of color and planes within the picture.[14] In both of these respects, the Laon paintings represent a bridge toward Delaunay's "constructive" phase beginning in 1912 with a highly abstract "Window" series wherein city views are transformed into light-filled, translucent arrangements of interpenetrating rectangular and arc-shaped color planes.[15] By 1913, his "Circular Forms" series, in which compositions are reduced to overlapping, colored discs, brought him closer to total abstraction than any other French painter at that time.[16] D. E. S.

1. See Hoog 1967, pp. 52–53 (no. 19).

2. A pencil inscription on the reverse reads "[?] Août 1914/ Cathédral de Laon/à la [?]."

3. Provenance information found in a telegram from Sonia Delaunay to Daniel Robbins of March 7, 1967 (Museum files), which states " . . . tableau appartenant à Madame Chanaux[,] femme [de l']ami d'école de Delaunay. . . . " Delaunay entered the Rosin Decorative Studio, in Belleville, which supplied backdrops for theaters, in 1902 and stayed for two years.

4. Apollinaire first introduced the term, derived from the name of the mythological musician Orpheus, in a lecture in 1912 and published it the following year in his book *Méditations esthétiques: Les Peintres cubistes.* He used it in a broad sense to characterize the painting of the Delaunays, Fernand Léger, Francis Picabia, Marcel Duchamp, Pablo Picasso, Marie Laurencin, Albert Gleizes, and Jean Metzinger. Although the Orphist label subsequently came to be associated more or less exclusively with the Delaunays, Virginia Spate, in her recent monograph on Orphism, argues that, in addition to Robert Delaunay, the movement embraces paintings by Frank Kupka, Léger, Picabia, and Duchamp. See Golding 1968, pp. 38–39, and Spate 1979.

5. See Vriesen and Imdahl 1967, pp. 42–46, 78–84.

6. The Italian Futurists and the Cubist Fernand Léger were also exploring such themes at about the same time. On their relationship to Delaunay's work, see Buckberrough 1982, pp. 57–59.

7. See, for example, *Window on the City No. 3* (1911–12, New York, Solomon R. Guggenheim Museum) and Buckberrough 1982, p. 79. Delaunay was already familiar with Laon, having lived there during his military service in 1907–08, at which time he executed a painting (now lost) of the cathedral. See Vriesen and Imdahl 1967, p. 22.

8. Besides paintings of the towers of Laon, other works from this period show the road leading to the cathedral and the town (Habasque 1957, nos. 91–93).

9. *The Towers of Laon,* 1912, oil on canvas, 21⅞″ × 18⅛″ (55.5 × 46 cm). On the Hamburg study, see Platte 1958.

10. Platte 1958, p. 40. In his article, Platte also discusses the relationship of Lyonel Feininger's Expressionist paintings of medieval churches to Delaunay's work.

11. See Buckberrough 1982, pp. 83–84.

12. Habasque 1957 lists a watercolor *Tours de Laon* (no. 754) and two encaustic paintings, both entitled *La Cathédrale de Laon* (nos. 94, 142). Nos. 754 and 142 bear signed dedications. Habasque also cites two sketches of the subject on the reverse of other paintings: no. 115, *La Cathédrale de Laon,* and no. 131, *Les Tours de Laon.* The RISD panel is not included in Habasque's catalogue.

13. Zurich, Kunsthaus, 1912, no. 33, and Berlin, Der Sturm, 1913, no. 7.

14. See Buckberrough 1982, pp. 82–83, 239.

15. See, for example, *Simultaneous Windows (2nd Motif, 1st Part),* 1912, New York, Solomon R. Guggenheim Museum.

16. Paintings in the "Circular Forms" series are sometimes said to have begun in 1912, but recent scholars contend that 1913 is a more accurate dating. See Buckberrough 1982, pp. 182–83, and Spate 1979, pp. 376–77.

ERIC GILL
British, 1882–1940

78 *The Crucifixion*

Painted stone. 10⅞" × 7" × 1¼"
(27.7 × 17.8 × 3.2 cm)
Gift of John M. Crawford, Jr. 1987.089

PROVENANCE: Eric Gill to Sir Francis Mezwell (?); Elmer Adler; Bruce Colin; Philip C. Duschnes (?); John M. Crawford, Jr.

PUBLICATION: RISD, *Museum Notes,* 1988, p. 33.

Eric Gill's conversion to Catholicism in 1912, which he considered the single most important event of his life, marked the beginning of the predominance of religious subject matter in nearly all his public work. Gill described the artist as "a partner with God in creation"[1] and felt that all art should glorify His truth, goodness, and beauty. In what Gill considered a natural extension of this tenet, most of his private work, artistic exercises, and a few unrealized church commissions centered on graphic displays of human sexuality. Indeed, Gill spent his entire artistic career attempting a blend of eroticism and the divine.

78

A craftsman of many talents, Gill's primary area of training was in lettering. Early on, he learned to carve letters in stone, and his great mastery of the technique brought him numerous commissions for heraldic shields and tombstones. Gill designed eleven different styles of typeface throughout his career, including one which bears his name, and was able to support himself on this letter carving alone.

Gill carved his first sculptural figure in 1910, and within a year created enough work to hold a solo exhibition at the Chenil Gallery in London. In 1912, eight sculptures were included in the important Second Post-Impressionist Exhibition in London. Through this exposure, Gill enjoyed a brief association with the English avant-garde, but soon chose to isolate himself in a series of artistic/religious communities of his own founding, avoiding what he called the "truly abominable" art world.[2]

The Crucifixion, a subject that he repeated in dozens of examples, is characteristic of Gill's somewhat polemical approach to sculpture and his ambiguous relation to the contemporary avant-garde. Although Gill rather emphatically discredited art from all other periods in history, the clean, linear stylization and bas-relief format of this work reveal his great respect for the sculptors of early Greece and the Middle Ages. Its simplification of form is a product of a direct carving technique, in which the artist works directly in the stone in the absence of a clay model. His advocacy of direct carving harkens back to the stone carvers of the Middle Ages. It could also be seen in the pre-World War I Vorticist work of Henri Gaudier-Brzeska and Jacob Epstein. While most sculptors learned to model their works in wax or clay, submitting them to a technician for reworking in stone, Gill felt this approach perpetuated a division of labor that separated the artist from his final product. Like John Ruskin and William Morris before him, Gill fought against the distinction between art and craft, that byproduct of modern industrial society. Ironically, his views of the artisan in society, which looked back to medieval practices, anticipated, indeed influenced, the "modernist" views of the next generation of sculptors in England, notably Henry Moore and Barbara Hepworth.

The Crucifixion is typical of Gill's carved work at its best. Consistent in size and style with other nonpublic sculptures throughout his career, the Museum's piece, however, remains difficult to date. As with many of Gill's stone carvings, this work has been touched with paint, the remnants of red visible around the halo. Although his attempt to reestablish the importance of religious sculpture in England was unsuccessful, Gill's vision, whether in lettering, wood engraving, or sculpture, sacred or secular, is elegant and sensuous. L. S. U.

1. Rutherston 1927, p. 12.
2. Yorke 1982, p. 88.

RAYMOND DUCHAMP-VILLON
French, 1876–1918

79 *Seated Woman,* 1914; cast 1915

Signed, right side of base: *R. Duchamp-Villon;* stamped, back
of base: *Roman Bronze Works/New York*
Bronze with gold-washed patina. 28″ × 8″ × 9½″
(71.12 × 20.32 × 24.13 cm)
Mary B. Jackson Fund and Membership Dues. 67.089

PROVENANCE: Commissioned by John Quinn, New York,
August 1915, for $85; Quinn Estate, 1924–27; Arthur B.
Spingarn Collection, New York; Parke-Bernet, New York,
sale no. 2539, April 5, 1967, no. 72.

EXHIBITIONS: New York, Art Center, 1926, no. 91; New
York, AAA, 1927, p. 247 (no. 720, ill.).

PUBLICATIONS: Quinn 1924, n.p.; Pach 1924, pl. 71; Watson
1926, pp. 27, 190 (ill.); Basler 1928, ill.; New York, Parke-
Bernet, 1967, no. 72; RISD, *Museum Notes,* 1967, pp. 51–54
(fig. 83); Hamilton and Agee 1967, pp. 83–84, 119–20;
Providence, RISD, 1975, pp. 66–68; Zilczer 1978, pp. 42–44,
89–90, 157 (fig. 24); Zilczer 1980, p. 13; Robbins 1983, pp.
22–30; Herbert 1984, pp. 251–54; Woodward and Robinson
1985, pp. 73, 202 (no. 121, ill.).

RELATED WORKS: *Seated Woman,* 1914, bronze, h. 28″ (71.1
cm), New Haven, Yale University Art Gallery, Collection
Société Anonyme. *Seated Woman,* 1914, charcoal on white
paper, 17″ × 10″ (43.2 × 25.4 cm), Providence, Museum of Art,
Rhode Island School of Design, 67.090. *Seated Woman,* 1915,
gilded bronze on black marble base, h. 25³⁄₁₆″ (64 cm), Cologne,
Museum Ludwig.

Duchamp-Villon's death at the age of forty-two from typhoid
fever contracted as a medical officer during the First World
War curtailed the career of one of the most gifted sculptors
to emerge under the influence of Cubism. Duchamp-Villon
was the second of six children of a remarkable Rouen family
that produced four artists, including Jacques Villon (1875–
1963), Marcel Duchamp (1887–1968), and Suzanne Duchamp
(1889–1963). In 1894 Duchamp-Villon began the study of
medicine at the University of Paris, which was interrupted
in 1898 when he was stricken by rheumatic fever. During his
convalescence he began to model in clay, eventually aban-
doning medicine for sculpture. He changed his name to
Duchamp-Villon in 1901 to differentiate himself from his
artist-siblings, and from 1905 he exhibited regularly in the
progressive Salon d'Automne, becoming a juror in 1907, and
vice-president of its jury in 1910.

In 1907 Duchamp-Villon and his brother Jacques moved
to a studio in Puteaux, on the outskirts of Paris, which by
1911 had become the location of regular meetings of a large
group of artists and critics that included the three Duchamp
brothers, Albert Gleizes, Jean Metzinger, Henri Le
Fauconnier, Fernand Léger, and Robert Delaunay (all dis-
cussed in this catalogue), as well as the poet-critic Guillaume
Apollinaire. Partly through the influence of Duchamp-Villon,
a gallery (Salle VII) was devoted to this circle of artists in the
1911 Salon d'Automne, and in 1912 he collaborated on the
organization of the *Salon de La Section d'Or* at the Galerie de
la Boëtie.[1] Along with his brothers, Duchamp-Villon was

79

an important contributor to the New York Armory Show of
1913, and through his association with Walter Pach, one of
its organizers, he came to the attention of the collector John
Quinn, who became his most important patron, eventually
acquiring sixteen of his sculptures, including the Museum's
Seated Woman.

Fig. 1 Raymond Duchamp-Villon, *Seated Woman,* 1914, charcoal on white paper, 17″ × 10″ (43.2 × 25.4 cm), Providence, Museum of Art, Rhode Island School of Design.

The first cast of *Seated Woman,* a bronze now at the Yale University Art Gallery, New Haven, was completed early in 1914 and exhibited at the Galerie André Groult in Paris that April.[2] In the summer of 1915, John Quinn purchased the original plaster from Duchamp-Villon with the authorization to make a second cast, which is the version now belonging to the Museum. This cast was fabricated by the Roman Bronze Works in Brooklyn in August 1915. The gilding of this version distinguishes it from the cast at Yale. In a letter from Duchamp-Villon to Walter Pach, the sculptor emphasized that while the gilding made the sculpture more expensive, "it gives the piece its definitive appearance as I conceive it." He also stipulated in this letter, which arrived too late for the Museum's cast, that the pedestal should be in black marble, its bottom (beneath the sitter's right foot) sunk into the base, and its back edge fitted to the bronze along an incised vertical line that is visible in the Museum's cast. The letter also included a diagram, which seems to have been lost, indicating how the marble pedestal should be fitted to the bronze.[3] Because of discrepancies in the design of the pedestal, Quinn was authorized to make a third cast (now in Cologne, Museum Ludwig), conforming to these instructions, for which he paid the sculptor an additional 500 francs. In a letter to Quinn of September 16, 1915, Duchamp-Villon stipulated that this was to be the last authorized cast, reserving for himself the option to carve a version in marble, stone, or wood.[4]

The Museum owns a unique drawing in charcoal of this figure by Duchamp-Villon, also from the Quinn Collection (fig. 1), which appears to be a drawing made after the finished sculpture, rather than a preparatory sketch.[5] The vertical line

at the sitter's heels has encouraged the suggestion that this may be the "explanatory sketch" sent by Duchamp-Villon to Pach on August 22, 1915, although this line clearly describes the vertical edge of the block on which she sits and yields little technical information about the design of the pedestal.[6] This is a carefully executed drawing, which provides some insight into Duchamp-Villon's conception of this figure and its basis in geometry. A halo left by erasures around the entire contour of the figure, as well as within, and pentimenti of removed lines indicate that Duchamp-Villon devoted considerable attention to a precise definition of the contours and masses. In the drawing, the sculpture's volumes are conceived as uninflected, closely fitted planes of light and shadow, the latter defined by regular cross-hatchings. These planes are smooth, angular, and hard-edged. They form a configuration of geometric parts fitted together like the volumes of a stream-lined machine. Internal modeling has been suppressed, and with it the picturesque effects that might convey a naturalistic conception of a supple human figure.

The simplified forms of the *Seated Woman* reflect a reaction to the modeling and romanticism of Rodin among sculptors as diverse as Brancusi, Maillol, Lipchitz, and Modigliani, all of whom were active in Paris in the years just before the First World War. These artists shared a more conceptual, geometric approach to the human figure, whether influenced by classical art, primitive art, or modern technology. In an unpublished essay of 1911, Duchamp-Villon compared sculpture to the abstract art of music, "a world of special harmonies" created from its properties of line, plane, and volume, whose "cadences" and "rhythms" provide its themes.[7] His mature work avoids the use of traditional literary and narrative subjects, relying instead on a pared-down vocabulary of geometric forms influenced by the explicitly modern esthetic of technology.

The *Seated Woman* is a product of Duchamp-Villon's idealistic embrace of the machine as a symbol of modernity and an important example of his effort to synthesize machine and organic forms.[8] The gilded surface of the Museum's bronze suggests the hard-surfaced, metallic qualities of a polished, machine-tooled object. The dynamism of the figure's coiled pose may have been adapted from Michelangelo's *Madonna and Child* in the Church of San Lorenzo in Florence, while the division of its body parts into uninflected, interlocking geometric volumes recalls the common studio mannequin, a standard mechanical prop for arranging poses.[9] Duchamp-Villon's next major achievement, the *Large Horse,* a mechanized metaphor of modern horsepower begun in the same year, continues his preoccupation with the synthesis of machined and biological forms, linking him with others in the Puteaux circle, in particular Marcel Duchamp, Fernand Léger, and Francis Picabia. D. R.

1. See Golding 1968, pp. 30–32 and *passim,* for a discussion of the circumstances surrounding this exhibition.
2. Paris, André Groult, 1914, no. 19. Robbins 1983, pp. 22–24, documents the history of the various casts.
3. Letter from Duchamp-Villon to Walter Pach, August 22, 1915, cited in Robbins 1983, pp. 23–25. Duchamp-Villon's instruc-

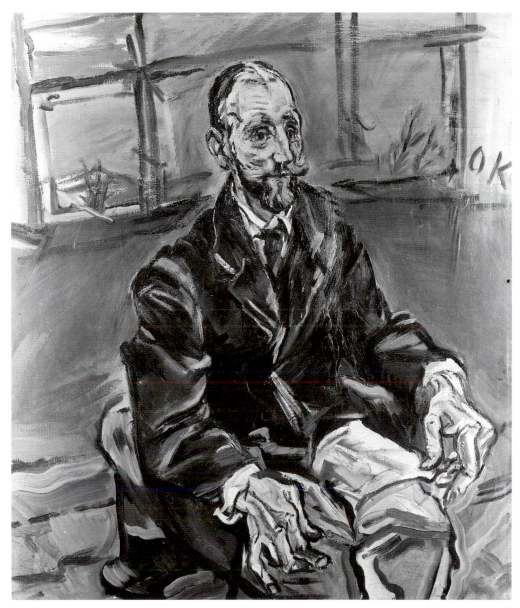

80 (color plate p. 31)

tions were repeated vebatim in a letter from Quinn to the Roman Bronze Works, dated August 26, 1917, now in the John Quinn Memorial Collection, New York Public Library.

4. Cited in Robbins 1983, p. 23. For this purpose, Duchamp-Villon authorized Quinn to make a plaster replica of the original plaster for him. Owing to the war and the sculptor's fatal illness, a carved version was never realized. Sometime after the sculptor's death and before 1962, this plaster replica served as the model for an edition of eight bronzes cast by the Georges Rudier foundry in Paris. The original plaster, given by Quinn to Pach, is now lost.

5. Cf. Zilczer 1980, p. 13, and Robbins 1983, p. 26.

6. Robbins 1983, p. 26, suggests that this line may describe the tenon that descends from the bottom of the sculpture into the base below, visible in the Yale cast.

7. Raymond Duchamp-Villon, "Projet d'article sur le Salon d'Automne de 1911," first published in Hamilton and Agee 1967, pp. 109–10.

8. See Pach 1924, p. 19.

9. Hamilton and Agee 1967, p. 83.

OSKAR KOKOSCHKA
Austrian, 1886–1980

80 *Portrait of Franz Hauer,* 1914

Signed, upper right: *OK*
Oil on canvas. 47⁷/₁₆″ × 41¹¹/₁₆″ (120.6 × 105.8 cm)
Georgianna Sayles Aldrich Fund and Museum Works of Art Fund. 53.121

PROVENANCE: Acquired by Kunstmuseum Düsseldorf, 1924; confiscated by the Nazi government, 1937, subsequently sold; Dr. Walter Feilchenfeldt, Zurich, from whom purchased, 1953.

EXHIBITIONS: Munich, Haus der Kunst, 1958, p. 119 (no. 36, as *Joseph Hauer*); Vienna, Künstlerhaus, 1958, p. 117 (no. 36, as *Joseph Hauer*); The Hague, Gemeentemuseum, 1958, n. p. (no. 25, as *Josef Hauer*); London, Arts Council, 1962, p. 32 (no. 42); Hamburg, Kunstverein, 1962, n.p. (no. 21, ill.); Middletown, Davison, 1964; Baltimore, Museum, 1964, p. 46 (no. 111, ill.); New York, Marlborough-Gerson, 1966, pp. 14, 35 (no. 15, ill.); London, Tate, 1986, pp. 306–07, no. 33 (ill.);

Zurich, Kunsthaus, 1986, p. 307 (no. 34, ill.); New York, Guggenheim, 1986, p. 208 (no. 28, ill.); New York, IBM, 1988.

PUBLICATIONS: Hoffmann 1947, p. 302 (no. 87, as *Herr Hauer*); *Art Quarterly* 1953, p. 257 (as dated 1913); RISD, *Museum Notes,* 1955, n.p. (fig. 12); Wingler 1956 and 1958, p. 304 (no. 92, ill., as *Josef Hauer*); Werner 1959, p. 42 (ill.); Haftmann 1960, II, p. 104 (ill.); Schwarz 1961, pp. 51–53 (fig. 10); Hodin 1966, p. 109; Comini 1974, pp. 123–26 (fig. 114).

CONSERVATION: Areas of the surface were coated with wax at an unknown date to consolidate flaking and losses to ground. In 1985 the surface was cleaned, wax residue removed, and revarnished after layers of interlayer cleavage were consolidated at the Williamstown Regional Art Conservation Laboratory.

RELATED WORK: *Franz Hauer,* ca. 1914, charcoal on paper, 16³⁄₁₆″ × 12³⁄₁₆″ (41.1 × 30.9 cm), Munich, Staatsgalerie Moderner Kunst.

As a young painter in Vienna on the eve of World War I, Oskar Kokoschka created a remarkable series of portraits, considered by many to constitute the best work of his long career. Reflecting on his youthful masterpieces later in life, the artist described them in the following way:

> My early black portraits arose in Vienna before the World War; the people lived in security yet they were all afraid. I felt this through their cultivated form of living which was still derived from the Baroque; I painted them in their anxiety and pain.[1]

Franz Hauer is one of these "black portraits," a particularly affecting depiction of an eccentric patron of Kokoschka and his avant-garde colleagues. The expressionistic distortions applied by Kokoschka to the likeness of this sympathetic and generous supporter served both as a vehicle for the painter to convey his own feelings during a turbulent period in his life and as an effective means by which to present the psychology of the sitter.

As is frequently pointed out, *Franz Hauer* and the sequence of "psychological portraits" of which it is a part were products of the same cultural milieu which gave rise to the psychoanalytic theories of Sigmund Freud, also active in Vienna at this time. Vienna's position in the late nineteenth and early twentieth centuries as a major European center of progressive thought and artistic production was confirmed by the presence of leading figures of modern music (Mahler, Schönberg), philosophy (Wittgenstein), literature (Hofmannsthal), and, of course, the visual arts. Members of the famed Vienna Secession movement, such as the painter Gustav Klimt, who embraced the esthetics of Art Nouveau as an alternative to the academic mode, were colleagues who eventually saw themselves supplanted in the first decade of the new century by a younger generation of painters who worked in an expressionist style.[2]

Kokoschka and Egon Schiele, a close friend, emerged as the chief exponents in Austria of the expressionist movement, which had made its first appearance in Germany in 1905, moving quickly from Dresden to Berlin and Munich. The expressionists' distortions of shape, space, and color with aggressive, often crude application of pigment is perceptible in Kokoschka's painting from the time of the first public showing of his work in 1908 at the *Kunstschau,* an exhibition where art by those dissatisfied with the Secession group was displayed. The stir caused by Kokoschka's startling, violent works, along with a production of his experimental play, *Murderer Hope of Women,* in conjunction with the 1909 *Kunstschau,* quickly established the artist's reputation as a young maverick, eager to shock the public.[3]

For a time in 1910–11, Kokoschka lived in Berlin, where he provided illustrations for the avant-garde periodical *Der Sturm (The Storm).* His portrait painting, which he had begun to pursue in earnest in 1909 through the encouragement of Adolf Loos, one of Kokoschka's first subjects (1909, Berlin, Staatliche Museen), leaves the viewer with unforgettable impressions of the sitters' mottled skin and flattened bodies rendered with nervously applied, often scumbled or scribbled pigment. Subjects ran the gamut from artists, scientists, writers, and musicians to eccentric aristocrats, many of whom he was introduced to through Loos.

Franz Hauer (1867–1914) began collecting Kokoschka's works when the artist was still an obscure young painter. A true eccentric, Hauer came from a bourgeois background. He was trained to be a butcher, but came to be known as "the innkeeper who sold the best wine in Vienna"[4] to Kokoschka and his friends, after acquiring the tavern popularly known as the "Griechenbeisl"[5] through his wife, the sister-in-law of the former proprietor. Hauer was not the only member of his family with a passion for the arts – his younger brother Joseph Matthias (1883–1959) was an avant-garde composer – but Franz's enthusiasm for collecting contemporary painting became his private obsession.[6] The several hundred paintings displayed in his home and the personal support which he provided to struggling artists, such as Schiele, left him little time for the five children he had been obliged to raise as a single parent since the death of his wife in 1907, or to run his tavern, the management of which he eventually relinquished. Hauer's noble spirit and loyal character were recalled years later by Kokoschka in a letter (written on the occasion of the portrait's acquisition by RISD in 1953) to Heinrich Schwarz, the curator who was responsible for its purchase:

> On good [Mr.] Hauer, I know only that he was first a servant in the Griechenbeisl, married the widow, had a lung ailment from working hard in his youth, found relaxation and inspiration in art, had a remarkable eye for quality, thanks to his innocence, listened at the right time to Adolf Loos, who encouraged him in his endeavors, even though his own family made fun of him. Adolf Loos brought out the hidden karat of gold in everyone who had the good fortune to meet him . . . Unfortunately, Mr. Hauer did not live very long. Nevertheless, he opened the way to Berlin for me, where I founded the *Sturm* with Herwarth Walden, in the early years, when I was still totally unknown – a bit notorious, at best – by buying a few of my paintings. Peace to his ashes, he was one of the last great and genuine Viennese with culture at a time when the nobility and bourgeoisie had begun to barter away Austrian culture, instead of wanting to renew it. . . .[7]

Hauer's pulmonary illness, referred to in the letter, was tuberculosis; his death, shortly after the portrait was completed, was the result of appendicitis. His ill health is evident

Fig. 1 Oskar Kokoschka, *Franz Hauer*, ca. 1914, charcoal on paper, 16³⁄₁₆″ × 12³⁄₁₆″ (41.1 × 30.9 cm), Munich, Staatsgalerie Moderner Kunst.

in Kokoschka's rendering of his pasty skin, gaunt face, and emaciation. His thinness is emphasized by the oversized coat he wears, which dwarfs his body, and the long, twisted fingers, which nervously leaf through the book on his lap. The long, sad face with its gentle expression and soulful eyes suggest the "bashfulness, timidity and a kind of dreaminess" of this "kind and sensitive man,"[8] which undoubtedly helped endear him to Kokoschka and Schiele. Both artists produced black-and-white studies of Hauer's face, Schiele a rather stylized etching (U. S. A., private collection)[9] and Kokoschka a charcoal drawing in the Staatsgalerie Moderner Kunst, Munich (fig. 1). The more realistic but no less intense treatment of Hauer's bearded head in Kokoschka's study, showing virtually the same pose and expression as the finished work, reveals a penchant for objectivity found in many of his drawings, in contrast to the expressionistic distortions of his paintings.

Not only are the thin face and frail body of Hauer distorted in Kokoschka's portrait, rendered in multicolored slashes of thick paint, but the unusual vantage point and spatial disorientation add to the impression of isolation and pathos. The severely attenuated body with enlarged hands and long, twisting fingers has prompted comparison with El Greco, a master of whom early twentieth-century modernists (especially Picasso) were particularly fond. The similarity to El Greco also extends to Kokoschka's break-up of his surface into shards of nervously brushed, variegated colors shot through with areas of random lights and to the air of spirituality with which the figure is invested.[10]

The broad impasto style in which *Franz Hauer* is painted, characterized by thick strokes of wet pigment and flat areas bounded by black outlines, appears within Kokoschka's

oeuvre around 1913 and is seen in other prewar portraits of seated men, like *Carl Moll* (ca. 1913, Vienna, Oesterreichische Galerie), *Emil Löwenbach* (1914, Beverly Hills, Robert Gore Rifkind Foundation), and *Albert Ehrenstein* (1913–14, Prague, National Gallery).[11] The similarity of all of these portraits to the style of Van Gogh is unmistakable, and the close relationship between the *Franz Hauer* and Van Gogh's *Portrait of Joseph Roulin* (1888, Boston, Museum of Fine Arts), which Kokoschka would have seen in a Berlin exhibition in 1914,[12] confirms the importance of Van Gogh as a source of both style and composition for the Austrian expressionist.

The early period of Kokoschka's *oeuvre* came to an end with the artist's enlistment in the Austro-Hungarian military to fight in World War I. After recovery from serious bullet and bayonet wounds sustained on the eastern front, he settled in Dresden in 1917, where he taught at the academy for six years. His subject matter between the wars expanded to include landscapes and cityscapes, many of the latter inspired by his extensive world travels. Under the Nazi regime, Kokoschka was labeled a degenerate artist and forced to endure the removal of his works from German museums in 1937–38. The Hauer portrait, which had entered the Düsseldorf Museum in 1924, was deaccessioned at this time. Sensing the Nazi threat, Kokoschka moved to Prague in 1934, then resettled in London in 1938 until the end of the war. He took the opportunity after 1946 to continue his world travels, then moved to Switzerland in 1953, where he continued to paint until cataracts impaired his vision. D. E. S.

1. Kokoschka, quoted by Leopold Zahn, in "Oskar Kokoschka," *Das Kunstwerk*, II (1948), p. 29, cited in Selz 1957, p. 165.

2. For a recent study of turn-of-the-century Vienna, see New York, MOMA, 1986.

3. On Kokoschka's literary works, which include poems as well as plays, see Lischka 1972 and Schvey 1982.

4. Information given to Daniel Robbins by the artist at the Museum of Modern Art, New York, in October 1966, now in RISD Museum files.

5. "Griechenbeisl" was derived from the actual name of the tavern, the Reichenberger Beisel, combined with its location, in the Griechengassel. See Comini 1974, p. 123.

6. Among the other artists collected by Hauer are Schiele, L'Allemand, Fahringer, Sterrer, Egger-Lienz, and Faistauer. Of the hundreds of paintings owned by Hauer, there were only a handful which were not by young contemporary Austrians. See Schwarz 1961, p. 52. Comini 1974, p. 230, no. 28, notes an autobiography by Hauer's son Leopold (Leopold Hauer, *Der Maler Leopold Hauer, Selbstbiographie*. Vienna, 1962) as a source of information on Franz Hauer's collection.

7. Schwarz 1961, p. 53, translated by D. E. S.

8. Schwarz 1961, p. 53.

9. There are also a number of preparatory studies for the etching, noted in Comini 1974, pp. 125, 231, n. 36.

10. Richard Calvocoressi, in London, Tate, 1986, p. 307, compares the Hauer portrait to El Greco's *Giulio Clovio*, ca. 1571, in the Museum of Capodimonte, Naples. Calvocoressi, in London, Tate, 1986, p. 192, n. 2, also points out the frequent comparisons to Grünewald's Isenheim Altarpiece, inspired by the shocking skin colors in Kokoschka's paintings.

11. See Hodin 1966, p. 109.

12. Schwarz 1961, p. 54.

HENRI MATISSE
French, 1869–1954

81 *Still Life with Lemons,* ca. 1914

Signed, lower left: *Henri Matisse*
Oil on canvas. 27⅝″ × 21³⁄₁₆″ (70 × 53.8 cm)
Gift of Miss Edith Wetmore. 39.093

PROVENANCE: Collection Sidney Osborn; Edith Wetmore.

EXHIBITIONS: New York, MOMA, 1951; Cambridge, Busch-Reisinger, 1955; Denver, Denver Art Museum, 1956, no. 21; Baltimore, Museum, 1964, p. 90 (no. 152); Waltham, Rose, 1967, no. 60; London, Arts Council, 1968; Fort Worth, Kimbell, 1984, p. 98 (no. 28, ill. p. 27); Barcelona, Palau Meca, 1985; Tokyo, Isetan, 1987, pp. 124, 147 (no. 22).

PUBLICATIONS: Barr 1951, pp. 181, 187–89, 190, 231, 397 (ill.); Luzi and Carrà 1971, p. 94 (no. 192); Elderfield 1978, p. 202 (figs. 72–73); Gowing 1979, p. 122 (no. 108); Schneider 1984, pp. 391, 399, 404, 441, 478; Cowart and Fourcade 1986, p. 177; Flam 1986, pp. 376, 378 (fig. 376), and p. 501, sect. 14, n. 3.

Henri Matisse was born in 1869 in a small town in northern France, where he spent an uneventful youth that gave no hint of his future artistic achievements. At nineteen, he went to study law in Paris, but after completing his studies and working briefly at the bar, he suffered an attack of appendicitis. It was during his convalescence that he took up painting for the first time, eventually abandoning law to devote his life to art. Early in his career Matisse studied with the Symbolist painter Gustave Moreau, who encouraged his students to pursue their inner visions before imitating nature. Matisse's earliest works evolve from an Impressionist style to a more abstract use of the Impressionist brushstroke influenced by Neo-Impressionism. By 1904 he had begun to realize a more personal style and initiated a short-lived movement that encouraged the use of brilliant color as a means of personal expression. The movement received its name when a critic condemned Matisse and his followers, branding them *"Les Fauves"* ("Wild Beasts"), although even these early works

reflect Matisse's abiding interest in the harmony of his pictorial devices. Matisse soon abandoned Fauvism for a more decorative approach, but color and color-related issues would continue to dominate his work.

The revolutionary vision of Cubism emerging around 1910 also influenced Matisse.[1] Cubism not only challenged the old rules of perspective that distort objects to make them look three-dimensional; it tried to show objects temporally by representing them in simultaneous views. In the process, it rejected straightforward illusion and emphasized instead the ambiguous relationship between abstraction and representation. The result, in analytic Cubism, was a fragmentation of objects and space, rejected by Matisse as too radical a departure from nature. Synthetic Cubism, emerging around 1912, partly in response to the hermetic nature of analytic Cubism, forsook the dull palette of the analytic phase. It used color to clarify form and frequently employed the technique of *papier collé,* in which images were constructed partly out of glued sheets of colored paper, producing deliberately ambiguous spatial effects. Ordinary words or phrases with evocative meanings were frequently included, which underlined the conceptual focus of the works.

Matisse's *Still Life with Lemons,* painted in 1914–15,[2] reveals the brilliant palette of the Fauves, but owes much to Cubism in its structure and content. The broad, flat areas of color recall *papier collé* constructions, a medium to which Matisse possibly makes reference in the upper right corner of the canvas, where he depicts a drawing done on an ordinary sheet of white paper; in another possible nod to Cubist playfulness, the paper assumes the shape of a window, a favorite motif throughout Matisse's work. The strong, unalloyed colors of the blue area at left (although thinly and unevenly applied), red wedge at bottom, and green wall at right also suggest paper cutouts. The simultaneous presentation of surfaces from different viewing angles than those of the profile lemons and vases is equally indebted to Cubism.

Simplification is an important element in Matisse's work, differentiating him from the Cubists, who relished complexity and ambiguity.[3] His colors are generally solid, vivid hues, with objects reduced to their most essential forms, simplicity being associated in this painting with the lack of artifice found in children's drawings. The white paper at the upper right represents a drawing of a pewter vase by the artist's fourteen-year-old son, Pierre, whose simple execution obviously pleased his father, since he used it in several other paintings.[4] Flam believes that the drawing "suggests the childlike as one of the painting's central metaphors...,"[5] although Matisse was fully aware that consciousness of meaning, lacking in a child's drawing, was implicit in his own.[6]

Part of Matisse's intent in this experiment with abstract, simply conceived shapes is to point to their underlying connections. The picture's full title explains the purpose: *Still Life with Lemons which Correspond in Their Forms to a Drawing of a Black Vase Upon the Wall (Nature morte de citrons dont les formes correspondent à celles d'un vase noir dessiné sur le mur).*[7] The lemons and the dish and the black vase were not pre-sented for their accurate depiction (there is no light source and only a hint of modeling in the lemons), but to show at a glance the formal relationships among them: how the round, curving body of the vase echoes the plump, rounded bodies of the lemons; how the sinuous contours of the vase correspond to the curves of the blue footed dish. Taken a step further, these visual analogies also suggest correspondences with female forms, a favorite theme of Matisse.

The only other object in the *Still Life* is a book, but unlike books in traditional still lifes, the book in the RISD painting is an abstract floating object only given concrete identity by its painted title, *Tapis* ("Rugs"), recalling the synthetic Cubists' use of words in their compositions. Schneider notes that Pierre's drawing of the vase is "rendered linearly, so that it looks as flat as a carpet...,"[8] emphasizing the decorative function of the flat, abstract forms throughout the painting. Matisse may also be making reference to the many patterned backdrops of wallpaper, tablecloths, and fabrics that fill so many of his pictures and which are here summed up in a word.

Still Life with Lemons is a subtle game of contrasts:[9] the child's sketch with the father's painting; an image of a drawing of a vase with a painting of "real" objects; and natural colors for the lemons with arbitrary, joyful hues for the tables and wall. By setting up these oppositions, Matisse embraces the playful antics of Cubism, while always maintaining what is purely Matisse: that unique sensibility for the decorative, appealing quality of everyday objects and the underlying connections that unite them. F. D. F.

1. Barr 1951, p. 188, states that there is clear evidence that Matisse spent time with the Cubists Juan Gris, Jean Metzinger, and possibly also Pablo Picasso during 1914–15, and he was certainly familiar with their work before then.
2. Flam 1986, p. 501, sect. 14, n. 3, cites Barr 1951, p. 397, who dates the work to the autumn of 1914. Flam notes that the painting was photographed in March 1914 (Bernheim-Jeune photo no. 429). These dates are basically in accord with the RISD Museum file information, which states that "according to a letter from Pierre Matisse, dated July 8, 1943, this painting was executed in Paris in 1914–15." The letter itself is not in the file, nor is another letter from Alfred H. Barr, Jr., of the Museum of Modern Art, New York, on July 9, 1951, confirming that the picture was done during the winter of 1914–15.
3. Schneider 1984, p. 404, describes this painting as having "the pared down precision of a blueprint."
4. Most notably *Woman on a High Stool,* 1914 (New York, Museum of Modern Art).
5. Flam 1986, p. 376.
6. See Flam 1986, p. 501, sect. 14, n. 3, who cites Apollinaire's discussion with Matisse about children's drawings.
7. Barr 1951, p. 187, states that this title was only added after a visit by Gris and Metzinger, who commented on these correspondences. See also Forth Worth, Kimbell, 1984, p. 99, n. 11; and Schneider 1984, p. 391, who notes that it was the only explanatory title Matisse ever gave a painting. The fact that this title is the result of Matisse's exchange with Section d'Or Cubists may further reflect the influence of Cubism on his work at this time.
8. Schneider 1984, p. 399.
9. Schneider 1984, pp. 391 ff.; and Flam 1986, pp. 376 ff.

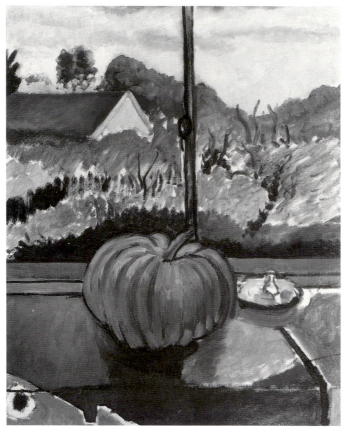

82 (color plate p. 32)

HENRI MATISSE
French, 1869–1954

82 *The Green Pumpkin,* ca. 1916 [1]

Signed, lower right: *Henri Matisse*
Oil on canvas. 31½″ × 25⅜″ (80 × 64.4 cm)
Anonymous gift. 57.037

PROVENANCE: Collection Flechtheim, Berlin, ca. 1920; Collection Meirowsky, Switzerland (acquired from Flechtheim); Collection Mayer, Geneva, 1954; Wildenstein, New York, 1954.

EXHIBITIONS: Waltham, Rose, 1967 (no. 59); Purchase, Neuberger, 1986, pp. 18, 21 (ill. on cover); New York, IBM, 1988.

PUBLICATIONS: Basler 1924, n.p.; RISD, *Museum Notes,* 1957, ill. on cover; Elderfield 1978, pp. 200–01 (fig. 70); Woodward and Robinson 1985, p. 204 (no. 123); Flam 1986, pp. 422–23, 428, 432 (ill.), and 504, n. 34.

RELATED WORK: *The Blue Window,* 1913, oil on canvas, 51½″ × 35⅝″ (130.8 × 90.5 cm), New York, Museum of Modern Art, Abby Aldrich Rockefeller Fund.

While Matisse never strayed too far from the representation of nature, *The Green Pumpkin* is based more on the realist tradition than most of his work. The painting depicts a view from the artist's bedroom window at Issy-les-Moulineaux (then a rural suburb outside Paris) looking north to the pitched rooftop of his studio.[2] According to Matisse, the window was "set over a chimney piece,"[3] which appears to have created a ledge. The artist clearly delighted in arranging its surface with a variety of objects, including vases, jars,

and bedroom accessories, as displayed in *The Blue Window* (fig. 1), and a pumpkin in the RISD view.[4]

Depicted in the round with a bumpy, ridged surface and full contours, the pumpkin rests in a discernibly three-dimensional space. Depth is suggested by the angle of recession indicated by the edge of what appears to be fabric laid over the top and side surfaces of the ledge. The window reveals an autumnal scene rendered in natural hues and painted in a style reminiscent of the late-nineteenth-century work of Cézanne.[5] The landscape is rendered in a pattern of decorative bands of color that, apart from the depth suggested by the orthogonals of the rooftop, reads as an uninhabitable, flat space. The background blends with the foreground: the contour of the pumpkin echoes the undulating lines of the treetops, and the triangular eave of the studio repeats similar patches of color throughout the interior space.

As stated in his *Notes of a Painter* of 1908, Matisse worked both from nature and imagination, preferring neither to the exclusion of the other.[6] Here he plays the exterior space, which includes a studio building, against the interior, which he obviously also used as a studio while composing this picture. The viewer stands inside with the artist, looking out. An unripe green pumpkin, part of the outdoor world, has been brought indoors and surrounded with abstract, decorative shadows in unnatural, Fauvist hues. At the bottom left, flat and purely decorative forms in the drapery lie under the three-dimensional pumpkin and dish with gourd beside it,[7] both of which seem to float on the planar, fabric-covered ledge.

The window was one of Matisse's favorite subjects. In *The Blue Window* of 1913, a more abstract work than the RISD picture, the same Issy view is depicted (fig. 1), but the exterior and interior are bathed in a unifying blue light, with the central upright of the closed window echoing the tree trunk to the right and the vertical forms below. There is a conscious union of exterior and interior in *The Blue Window,* whereas in the RISD painting inside and outside, though visually blending, are clearly two separate spaces.[8] More so than in *The Blue Window,* the closed window in *The Green Pumpkin* acts as a dividing barrier.

The harmonious composition and warm palette of *The Green Pumpkin* call to mind Matisse's expressed purpose in painting. In his *Notes of a Painter,* he remarked that "what I dream of is an art of balance, of purity and serenity, devoid of troubling or depressing subject matter . . . a soothing, calming influence on the mind, something like a good armchair which provides relaxation from physical fatigue."[9]

F. D. F.

1. Flam, 1986, p. 504, n. 34, observes that in November of 1916 the painting, in its preliminary stages, was photographed by the Paris dealer Bernheim-Jeune.

2. Elderfield 1978, p. 90.

3. Elderfield 1978, pp. 200–01 (ns. 2–3), citing Barr.

4. Cf. the more abstract treatment in *The Gourds,* also of 1916, in the Museum of Modern Art, New York, cited in Barr 1951, p. 190, and Flam 1986, p. 410 (fig. 412).

5. Indeed, Matisse revered Cézanne as "a sort of god of painting" and early in his career had purchased Cézanne's *Three Bathers,*

Fig. 1 Henri Matisse, *The Blue Window,* 1913, oil on canvas, 51½"
× 35⅝" (130.8 × 90.5 cm), New York, Museum of Modern Art.

which he often kept on view in his studio (Flam 1986, p. 20, citing
Jacques Guenne on p. 483, n. 7).

6. "A distinction is made between painters who work directly
from nature and those who work purely from imagination. Per-
sonally, I think neither of these methods must be preferred to the
exclusion of the other." Quoted in Flam 1978, p. 39.

7. For the possibility that the object beside the pumpkin holds
a gourd, cf. the gourd at bottom right in *The Gourds,* cited in n. 4.

8. Flam 1986, p. 423, comments on this "tension between the
interior and exterior spaces."

9. Translated in Flam 1978, p. 34.

GEORGES BRAQUE
French, 1882–1963

83 *Still Life,* 1918

Signed and dated, on verso: *G. Braque/18*
Oil on canvas. 18¼" × 28⅞" (46.5 × 73.4 cm)
Mary B. Jackson Fund. 48.248

PROVENANCE: Collection Léonce Rosenberg, Paris, 1919;
Galerie Georges Moos, Geneva; Theodore Schempp & Co.,
New York, 1948.

EXHIBITION: Omaha, Joslyn, 1951, n. p., unnumbered.

PUBLICATIONS: Bissière 1920, n. p., no. 12 (ill.); *Effort Moderne*
1924, n. p. (ill.); Isarlov 1932, p. 21 (no. 234); *Cahiers d'Art* 1933,
p. 39 (ill., as dated 1919); Huyghe 1934, p. 229 (ill., fig. 285, as
dated 1919, coll. Léonce Rosenberg); Faison 1958, p. 230 (fig.
19); Valsecchi and Carrà 1971, p. 94 (no. 164, as *Fruttiera,* 1919);
Mangin 1973, n. p., no. 26 (as *Compotier et journal*); Pouillon
1982, pp. 64, 66, 67 (fig. 2, as *Compotier et journal*); Woodward
and Robinson 1985, p. 203 (no. 122, ill.).

CONSERVATION: The painting was relined, cleaned, and
revarnished in 1981 at the Williamstown Regional Art Conser-
vation Laboratory.

RELATED WORK: *Still Life with Musical Instruments,* 1918, oil
on canvas, 25½" × 36¼" (64.8 × 92 cm), Pasadena, Norton
Simon Museum (Norton Simon Art Foundation).

Georges Braque's *Still Life,* a simple, horizontal arrangement
of a pear and grapes in a fruit dish beside a newspaper, was
painted shortly after his discharge from the French army in
World War I, after sustaining a severe head wound. The treat-
ment of objects and space in flat, geometric shapes and frag-
mented planes identifies the painting as a late example of the
Cubist style that Braque had pioneered with Pablo Picasso
in the decade preceding the war. It also represents Braque's
entry into a new stylistic phase that signals his artistic inde-
pendence from his former colleague. The relaxed composi-
tion, loose paint handling, harmonious color scheme, and
gently curved forms exhibited in the RISD canvas would
become trademarks of Braque's mature artistic style, sus-
tained through the rest of his life.

Braque's association with Picasso during the formative
years of Cubism began approximately seven years after he
had moved to Paris in 1900 to pursue an artistic career. Ini-
tially, Braque was drawn to the colorful, painterly exuberance
of the avant-garde Fauvist movement, aligning himself with
such painters as Raoul Dufy and Othon Friesz, both of
whom he had known in his hometown of Le Havre. Around
1906–07, Braque's painting style shifted toward the geometric
rigor and boldly experimental treatment of form and space
that also engaged Picasso. The two artists' collaborative
relationship, which lasted until Braque's conscription in
1914, took them through the early "analytic" and later "syn-
thetic" stages into which the Cubist movement is divided.
The latter phase, to which the RISD still life belongs, is char-
acterized by flat, solidly colored shapes and a treatment of
objects which involves geometric simplification, but less
fragmentation than had been visible in the earlier analytic
period. Indeed, the fruit and newspaper in the 1918 *Still Life*

are much easier to recognize than the props used in an hermetic analytic work such as *Still Life with Violin* of 1911 (Paris, Musée National d'Art Moderne, Centre Georges Pompidou), in which the instrument and accompanying paraphernalia on the table are so abstracted that they can barely be deciphered.[1]

The war separated Braque from Picasso, who, as a Spaniard, was exempt from French military service. Fighting in Carency, Braque was hit by an exploding shell in 1915. The resulting head wound, which required trepanation (skull surgery), put him in a coma and left him temporarily blinded.[2] He was officially discharged and by 1916 was able to resume painting, but his close collaboration with Picasso had ended. After Braque's recovery, Léonce Rosenberg, who once owned the Museum's *Still Life,* began to handle the works of Braque and other Cubist painters, which he exhibited in his gallery, *L'Effort Moderne,* opened during the war. It was here that Braque held a one-man exhibition in 1919 which gained him critical praise and confirmed his status as a leading painter in post-war France.[3]

The Providence *Still Life* belongs to the brief period between 1917 and 1919, the date of *Café-Bar* (Basel, Kunstmuseum), a monumental still life representing a summation of the themes and formal devices with which he had been experimenting since his recovery. During this time, as Jean Leymarie notes, Braque produced small, cabinet-sized paintings, such as the RISD *Still Life,* in addition to his rarer large-scale efforts, such as the *Café-Bar* or the related *Still Life on a Table* of 1918 (Philadelphia, Philadelphia Museum of Art). He would typically work on several canvases simultaneously, sometimes taking years to complete a single painting.[4]

The subject matter of these works was almost exclusively still lifes,[5] with recurring objects, such as musical instruments, goblets, pipes, sheet music, newspapers, pears, and grapes, as seen in the Museum's painting.[6] The common nature of the objects chosen, carefully arranged and respectfully treated, has prompted comparisons with Jean-Baptiste Chardin's dignified presentations of the objects of middle-class life in the eighteenth century.[7] Like Chardin, or Cézanne, a more immediate source of inspiration, Braque's focus is deliberately restricted, usually to the top of a table or sideboard, occasionally moving back far enough to show the entire piece of furniture, as in the many pedestal-table *(guéridon)* paintings, to which the Basel *Café-Bar* and Philadelphia *Still Life on a Table* belong. Unlike Picasso and Gris, he eschews setting his still lifes before an open window to expand spatial distance and establish contrast in scale.[8] Not until 1938, in fact, does the open-window background appear in Braque's painting.[9]

Many characteristics of Braque's *Still Life* – among them, the flat, solid planes, some of which are covered with a pattern of vermilion stippling over green – are a continuation of the decorative style in which he and Picasso had begun to work in 1914. This so-called "rococo" phase of synthetic Cubism, in which overlapping planes were painted in bright colors and often decorated with pointillist dots, had evolved from the technique of pasting foreign materials *(collages)*, or just paper *(papiers collés)* – often with printed decorative patterns – to the canvas.[10] Braque was apparently pleased with the particular vermilion and green pattern used in the Museum's *Still Life,* for it is seen in a number of other

works from the same period, including the Basel *Café-Bar*.[11]

Still Life with Musical Instruments, 1918 (fig. 1), shares with the RISD *Still Life* not only the patterned areas, but also the concentration of still-life elements within an overall geometric shape (an octagon rather than a diamond) surrounded by a black background. Braque's use of black after the war has been cited as a device useful in maintaining the spatial ambiguity so important to the Cubist esthetic, for it provides an area "behind" the central compositional elements, yet because of its flatness, the illusion of depth is negated.[12] Jean Leymarie emphasizes the mysterious, nocturnal implications of black,[13] while Braque himself stated, in a letter to Kahnweiler in 1919, that black represented a welcome relief from the whites of his *papiers collés* and from the restrictive palette of the Impressionists, to whom black was anathema.[14] Black invades the central compositional area of the Providence *Still Life* as well, serving alternately to outline objects and to "shade" the fruit and various areas of the brown diamond field, although it is important to point out that, given the absence of a consistent light source, there are no conventional shadows and highlights in the painting. Finally, the letters of the newspaper masthead ("*Le Jou . . .*" for "*Le Journal,*" or "The Newspaper") are outlined and filled in with black as well, although their warped shapes and freehand execution are a far cry from the careful stenciled lettering of the analytic period.[15] The profusion of organic curves complementing the geometric components of the composition, the improvisational arrangement of the tilted planes, and Braque's evident pleasure in the visible manipulation of pigment, especially in the lighter areas, are clear indications of the relaxed, fluid style that he would pursue over the next four decades.

The large diamond shape which bounds the composition was used several times between 1917 and 1919, along with a variety of other shapes, such as lozenges, octagons, and mandorlas, to frame still-life objects.[16] The rejection of the square or rectangular canvas which the diamond shape implies dates back to Braque's and Picasso's introduction of oval canvases during the analytic years, which has been interpreted as a means of subverting the figure/ground relationship of traditional painting by allowing the artists to devote all picture space to their fragmented subject.[17] This device served to reinforce the key Cubist concept of the "picture-object" *(le tableau-objet),* the notion that a painting was an object in and of itself and not just a reinterpretation of outside reality viewed through the imaginary window of the square canvas. This was an idea shared by exponents of other contemporary abstract movements as well.[18] Far from a mere demonstration of esthetic theory, however, Braque's lyrical *Still Life* represents a personal, inventive response to a representational subject while simultaneously pursuing the tenets of the style that the artist himself pioneered. D. E. S.

1. See also Picasso's *Seated Woman* (entry 74).

2. The war took its toll on others in the Cubist circle as well. The sculptor Raymond Duchamp-Villon and the poet Guillaume Apollinaire, an early defender of the Cubists in his art reviews, both

Fig. 1 Georges Braque, *Still Life with Musical Instruments,* 1918, oil on canvas, 25½″ × 36¼″ (64.8 × 92 cm), Pasadena, Norton Simon Museum (Norton Simon Art Foundation).

died in combat. In addition, Daniel-Henry Kahnweiler, Picasso's and Braque's dealer, had been forced to leave France because of his German background.

3. See New York, MOMA, 1949, pp. 87–88, 170.

4. Leymarie 1961, p. 60.

5. Braque painted a few figure studies in 1917–18, including *Woman with Mandolin* (1917, Villeneuve d'Asq, Musée d'Art Moderne du Nord) and the large *Musician* (Basel, Offentliche Kunstsammlung, Kunstmuseum), but then turned exclusively to still-life subjects until 1921–22. See Cooper 1970, p. 221.

6. The latter three motifs are seen, individually or in combination, in *Café-Bar* (Basel), *Still Life on a Table* (Philadelphia), *The Pedestal Table* (1918, Eindhoven, Stedelijk Van Abbé Museum), *Still Life with Fruit Dish (Le Radical)* (1918, Basel, Kunstmuseum), and *Fruit Dish with Bunch of Grapes and Glass* (1919, Paris, Musée National d'Art Moderne, Centre Georges Pompidou), to cite only a few examples. For a comprehensive discussion of the still lifes with these motifs, see Pouillon 1982, pp. 60–67.

7. See Leymarie 1961, pp. 66–67; Russell 1959, pp. 24–25.

8. In many respects, Braque's still lifes immediately after the war, including the RISD canvas, show a remarkable similarity to Gris's work, an observation supported by his statement that, besides Picasso, "the only one who studied Cubism conscientiously, to my mind, was Gris." Cited in Zurcher 1988, p. 125.

9. Russell 1959, p. 23.

10. Examples of pre-war works with pointillist passages include Picasso's *Green Still Life* (1914, New York, Museum of Modern Art) and Braque's *Man with the Guitar* (1914, Paris, Musée National d'Art Moderne, Centre Georges Pompidou). On Braque's *papiers collés,* which were begun in 1912, see Washington, National Gallery, 1982.

11. Other paintings with the vermilion-and-green patterned planes include *Guitar and Fruit Dish (The Black Pedestal Table),* (1919, Paris, Musée National d'Art Moderne, Centre Georges Pompidou); *Guitar, Glass, Glass and Fruit Dish and Sideboard* (1919, New York, Solomon R. Guggenheim Museum); and *Still Life with Musical Instruments* (1918, Pasadena, Norton Simon Museum). The patterned areas are identified as wallpaper in Pouillon 1982, p. 62.

12. Zurcher 1988, pp. 125, 134.

13. Leymarie 1961, p. 67.

14. Letter dated October 30, 1919, quoted in Zurcher 1988, p. 134.

15. The inclusion of lettering, another space-flattening device, was a staple of Cubist painting from the time of the analytic period; it continued through the synthetic Cubist years in the form of actual

printed material in the *papiers collés.* "*Le Journal*" or fragments thereof were common. "Le Jou…" might also refer to the French word for play (*jouer* or *le jeu,* meaning "to play" or "the game," respectively), referring to the play on words, the game of illusion in which the Cubist painter engages the viewer, and so on. See Robert Rosenblum, "Picasso and the Typography of Cubism," in Penrose and Golding 1973, pp. 49–75.

16. Examples include *Geometric Still Life* (1917, Otterlo, Rijksmuseum Kröller-Müller), *The Cup* (1917–18, Philadelphia, Philadelphia Museum of Art), *The Fruit Dish* (1919, private collection; see Pouillon 1982, p. 66), and *Still Life (Fruit, Bottle and Pipe)* (1918; see Valsecchi and Carrà 1971, no. 155).

17. See Cooper 1970, p. 53.

18. Cf. the diamond compositions of Mondrian, which also represent an alternative to the square canvas in the early twentieth century. See Washington, National Gallery, 1979. Ultimately, the concept of the *tableau-objet* was carried to the extreme in the 1960's with the shaped canvases of Minimalist Frank Stella.

FERNAND LÉGER
French, 1881–1955

84 *Flowers,* 1926

Signed and dated, lower right: *F. Léger/ 26*
Oil on canvas. 36⅝6″ × 25¾″ (92.2 × 65.5 cm)
Anonymous gift. 81.097

PROVENANCE: Rose Fried Gallery, New York, 1951; Katherine Urquhart Warren.

EXHIBITION: Providence, RISD, 1983, no. 11 (ill. on cover).

PUBLICATION: Fox 1982, pp. 28–29 (ill.).

This small but monumental painting is an important example of a crucial period in Fernand Léger's development. In many ways a prototypical Cubist, Léger by the mid-1920's had evolved a distinctly individual version of Cubism, called Purism, an intense, utopian vision of the world transformed by clean, machinelike design.

There were several factors influencing this evolution. In 1924, the artist had opened a school with Amédée Ozenfant (for a discussion of Ozenfant's *Large Jug and Architecture,* 1926, see entry 85). In 1925, Léger painted *The Balustrade* (New

84

York, Museum of Modern Art), specifically for installation within Le Corbusier's Pavillon de l'Esprit Nouveau at the Exposition Internationale des Arts Décoratifs in Paris. The Providence painting, dated 1926, is close to the work of Ozenfant and Le Corbusier, and indeed, even the latter's architecture, with its sleek, clean forms, and flat and curved surfaces peeling out of and into other forms. At this time, Léger was creating a kind of *architecture polychromie* and various *peintures murales* (1924), projects which are reminiscent not just of Le Corbusier, Ozenfant, and Auguste Herbin, his fellow practitioners of Purism, a concentrated, abstracted form of Cubism, but also of the Dutch movement called de Stijl, especially the architectural environments of Gerrit Rietveld and the theories of Theo van Doesburg. Léger was also an admirer of the geometric abstraction associated with the Russian Revolution, and in particular the simple forms in the Suprematism of Kasimir Malevich, and El Lissitzky's "prouns." Also reinforcing his impulse toward the geometrical and "mechanical" was his new-found interest in film; his first film, *Ballet mécanique* (1924), presents over time the multiple views of a single object which a Cubist painting presents all at once, in a single image.[1]

All of these influences come together in this masterpiece of the machine esthetic, applied to the motif of flowers in a vase. The work is still Cubist in its treatment of space, with its overlapping planes; for example, the horizontal black bar on the left, behind the stems of the flowers, joins the thick vertical black bar, which ends up in front of the vase holding the flowers. Similarly, the black border runs around the whole composition and then joins it, going beneath the bottom of the vase. The use of such devices tends to lock the whole composition together and flatten it out, while references to real objects, and even touches of spatial illusion, are retained. The painting's thin, unobtrusive frame is part of this whole approach, for it helps to make the canvas merge with the wall, part of the machine of the whole room, while the restrained colors within the work itself, especially the white, are typically Purist and architecturally flat.

Léger made many still lifes in the middle 1920's; his *Rose and Compass,* 1925 (New York, Sotheby's, May 10, 1988, no. 28), juxtaposes these two objects as equals with great clarity and lack of sentimentality. By the same token, in his *Still Life,* 1927 (Bern, Kunsthaus), two flowers on long, twisting stems float freely, eccentrically, over a highly disciplined, geometric composition. Similarly, in the Providence painting, the geometrization of the physical world is so intense, so passionate, that the flowers – already simplified and an emblem of the world in all its irregularity – become a noble extension of that deeply regular underlying structure.

F. W. R.

1. This discussion of the artistic context of Léger in the 1920's is greatly indebted to Green 1976, chap. 10, "Painting and Architecture: Léger's Modern Classicism and the International avant-garde," pp. 286–309.

AMÉDÉE OZENFANT
French, 1886–1966

85 Large Jug and Architecture, 1926

Signed and dated, lower right: OZENFANT 1926
Oil on canvas. 119¾″ × 58½″ (304 × 149 cm)
Mary B. Jackson Fund. 39.095

PROVENANCE: Acquired in 1939 from M. Parish, Watson and Co., Inc., New York.

EXHIBITIONS: Paris, Hodebert-Barbazanges, 1928; Paris, *Salon,* 1935; Providence, RISD, 1949, p. 71; New York, Knoedler, 1973, p. 21 (no. 12, ill.); Saint-Quentin, Lécuyer, 1985, p. 102 (no. 64, ill).

PUBLICATIONS: *Art News* 1940, p. 24; Cauman 1958, pp. 136, 154 (ill.); Ozenfant 1968, p. 300; Hamilton 1972, p. 268 (fig. 156); Ball 1981, pp. 98, 131, 132, 136, 142 (ill.).

CONSERVATION: In 1973 the canvas was relined with wax resin, cleaned, and coated with Acryloid B72 as a protective varnish; dents were flattened, some cracking areas inpainted; and the canvas was fitted to a new expansion-bolt stretcher.

RELATED WORKS: *Study for Jug with Architecture,* 1925, gouache on blue paper, 14½″ × 11″ (36.8 × 28 cm), York, York City Art Gallery. *Jug with Architectural Background,* 1926, oil on canvas, 51½″ × 27″ (131 × 69 cm), private collection (on loan to the Kunsthaus, Zurich).

In 1918, Amédée Ozenfant and Charles-Edouard Jeanneret co-authored *After Cubism,* a book which boldly declared the end of Cubism and its replacement by a new movement, which they named Purism. Brief in duration (1918–25) and with few adherents, Purism sought a return to clearly painted, recognizable objects in a style that reflected the modern machine age with its clean, precise forms and lack of ornamentation. The first Purist exhibition, held in Paris in 1918, was followed by the publication of *L'Esprit Nouveau* in 1920, a periodical which promoted Ozenfant's and Jeanneret's theories. By 1926, when Ozenfant's *Large Jug and Architecture* was painted, Jeanneret had left painting to take up architecture under the pseudonym Le Corbusier, the last issue of *L'Esprit Nouveau* had been printed, and Purism as a movement had ended. Although a "post-Purist" work, strictly speaking,[1] RISD's large canvas effectively demonstrates the Purists' divergence from the conventions of Cubism. The monumental scale and the flat, solid shapes used to represent the five classical vases placed in front of an architectural cornice are far removed from the fragmented forms and easel-picture format of the typical Cubist still life.

Ozenfant was born and grew up in Saint-Quentin in northern France (Picardy), the son of artisans. At nineteen he moved to Paris, where he studied architecture, painting, and drawing. During World War I, exempt from conscription because of his delicate health (he had suffered from pleurisy and typhoid in childhood), he founded the lively avant-garde journal *L'Elan* (1915), whose contributors included Picasso, Matisse, Derain, and the poet Apollinaire. Ozenfant met Jeanneret in 1917. During their years of collaboration from 1918 to 1925, they fostered the notion of Purism as a reform

movement that sought to rationalize the intuitively based art of the Cubists in a manner similar to the Neo-Impressionists' systematization of Impressionism.[2] By introducing recognizable manufactured objects, such as vessels and musical instruments, depicted in a flat, streamlined style that was theoretically comprehensible to all classes of society, the Purists believed they were creating an art that was both modern and socially relevant. Moreover, their emphasis on ideal proportions and the esthetic principles of order, measure, and balance inspired by a tradition that could be traced through such classically inspired artists as Fouquet, Poussin, Corot, Seurat, and Cézanne[3] made for an art which was as timeless and universal as it was progressive.

Large Jug and Architecture is one of three mural-sized canvases painted by Ozenfant in 1926. The mural-sized format of all three works and the inclusion of the classical cornice in the RISD piece reflect Ozenfant's interest in the relationship of painting to architecture. This concern was stimulated by Le Corbusier's increasing involvement with architecture in the mid-twenties, including the design for Ozenfant's new studio/home in Paris on the Avenue Reille (1923) and the Pavillon de l'Esprit Nouveau, which was part of the Exposition Internationale des Arts Décoratifs held in Paris in 1925. Ozenfant's *Doric Vases* (1925, Switzerland, private collection), featuring a monumental, silhouetted Greek amphora, although smaller in size than the RISD canvas, hung in Le Corbusier's Pavillon.

In the Museum's painting, the emphasis placed on architecture is a feature not seen in Ozenfant's paintings before this time, which focused exclusively on still-life objects.[4] The integral, harmonious relationship between vessel and cornice seems to be the theme of this painting. The swelling curve of the architecture above is not only echoed in the contour of the classical wine jug (*oenochoe*) below, but, beginning with the lip of the vessel, the edge of the wall converges with the shape of the vase. This dovetailing of object and architecture differs from Ozenfant's gouache study of 1925 in the York City Art Gallery (fig. 1), in which the lower portion of the wall curves in a direction parallel to, but not identical with, the body of the jug. A smaller variation of the RISD painting also from 1926 (fig. 2), virtually identical with the Providence canvas except for minor variation in color and design, exhibits a comparable "marriage of contours"[5] in pursuit of a purified harmony, although its color is somewhat more varied.

The overt classicism of *Large Jug and Architecture,* typical of many of Ozenfant's Purist paintings of the twenties, reflects the Purists' effort to reconcile machine-age esthetic principles with the universal laws of beauty, order, harmony, and proportion rooted in the art of the ancient Greeks. Both Jeanneret and Ozenfant wrote articles on ancient art in *L'Esprit Nouveau,* which also contained art-historical essays by others on classical subjects. All this may be viewed within the context of a general revival of classicism between the wars seen in the works of many European artists, writers, and composers, most visibly, perhaps, in the classicizing figural paintings by

Fig. 1 Amédée Ozenfant, *Study for Jug with Architecture,* 1925, gouache on blue paper, 14½″ × 11″ (36.8 × 28 cm), York, York City Art Gallery.

Fig. 2 Amédée Ozenfant, *Jug with Architectural Background,* 1926, oil on canvas, 51½″ × 27″ (131 × 69 cm), private collection (on loan to the Kunsthaus, Zurich).

Picasso, such as *Three Women at the Spring* (1921, New York, Museum of Modern Art).[6]

A discussion of the theoretical notions later developed in *Large Jug and Architecture* can be found in a 1922 issue of *L'Esprit Nouveau* that contained essays by both Jeanneret and Ozenfant on ancient Greek art. Ozenfant's essay, "Greek Vases," praised the formal purity of these antique vessels, whose shapes were based on the perfect, ideal, mathematical form of the sphere. The concentric pattern of the deeply grooved brushstrokes on the body of the large brown jug in the RISD painting emphasizes its spherical shape. Ozenfant further explained how the vessels were "built from the profiles of the same spirit as those that engendered the essential forms of the Parthenon . . . The profiles of these vases are the profiles of the cornices."[7] The Jug and Architecture paintings begun three years later appear to be an exploration of these theories.[8] D. E. S.

1. Ball 1981, p. 129, characterizes the years 1926–30 as a period of "lingering purism."

2. The analogy between Purism and Post-Impressionism was made by Alfred H. Barr in New York, MOMA, 1936, p. 166.

3. See Ball 1981, p. 94.

4. As Ball 1981, p. 131, points out, the occasional architectural motifs in Ozenfant's previous paintings served only as incidental background elements.

5. Ball 1981, p. 136.

6. See London, Tate, 1990, and Hamilton 1972, p. 456.

7. Ozenfant, "Greek Vases," *L'Esprit Nouveau,* no. 16 (May 1922), quoted in Ball 1981, pp. 95–96.

8. The other two mural-sized paintings completed by Ozenfant in 1926 are *Large Still Life* (Paris, Musée d'Art Moderne de la Ville de Paris) and *Woman at Fountain* (Lund, Arkiv för Dekorativ Könst). Both depart further than RISD's *Large Jug and Architecture* from original Purist principles with their inclusion of such features as illusionistic shadow and a human figure.

A NOTE ON THE CHECKLIST

Every work in the Museum's collection of European painting and sculpture between ca. 1770 and 1937 is included in the checklist, which is divided into categories of painting and sculpture, each organized alphabetically by artist's name. The checklist is cross-referenced to the entries in the first part of the catalogue and includes a photograph of every work not already reproduced there. Checklist photographs are identified by the numbers [P 1] through [P 172] for each painting, and by the numbers [S 1] through [S 56] for each sculpture. The titles of works have been given in English with the exception of those that do not translate accurately or are well known by titles in another language. The checklist has been annotated to include available documentary information. Bibliographic references in the checklist are not included in the "List of Sources Cited in the Entries." Please note that the *Bulletin of the Rhode Island School of Design* (referred to as *Bull RISD*), first published in January 1913, was continued as *Museum Notes, Rhode Island School of Design (Museum Notes, RISD)* starting in January 1943, and then as *Bulletin of Rhode Island School of Design, Museum Notes (Bull RISD, Museum Notes)* in November 1955; there were occasional minor variations in the title and lapses in the numbering system over the years.

Checklist of the Collection

[P 1]
In the style of
SIR LAWRENCE ALMA-TADEMA
British, 1836–1912
Attributed to "Faker 338" [Arthur Hill?]
Greek Girl Standing by a Column Looking Out over a Bay
Oil on panel. 18″ × 12⅞″ (45.7 × 32.7 cm)
Museum Purchase. 59.006

Style of Alma-Tadema [P 1]

Von Amerling [P 2]

[P 2]
FRIEDRICH VON AMERLING
Austrian, 1803–1887
Sketch for the Portrait of Franz Joseph in his Coronation Robes, ca. 1848
Oil on paper. 10⅝″ × 8½″ (27 × 21.6 cm)
Museum Works of Art Fund. 57.169

BIBLIOG.: *Bull RISD, Museum Notes*, XLV:2 (December 1958), cover.

This is a study for the portrait by von Amerling in the Schönbrunn Palace, near Vienna, where Franz Joseph was born in 1830, the son of Archduke Franz Carl and Archduchess Sophia, descendants respec-

tively of the Hapsburg and Wittelsbach lines. Franz Joseph was enthroned Emperor in 1848, at the age of eighteen, and ruled the Hapsburg Empire until his death in 1916, two years before it was dissolved at the conclusion of World War I.

[P 3]
LOUIS ANQUETIN
French, 1861–1932
Portrait of Madeleine Bernard, 1892
Signed and dated, lower left: *Anquetin/92*
Oil on canvas. 24⅛″ × 20″ (61.5 × 50.9 cm)
Membership Dues. 68.137

BIBLIOG.: *Bull RISD, Museum Notes*, LV:2 (December 1968), p. 25 (no. 18); John Rewald, *Post Impressionism, From van Gogh to Gauguin*. London, 1978, p. 183 (ill.); Paris, Brame & Lorenceau, *Anquetin, la Passion d'être Peintre*, March 26–April 20, 1990, p. 126 (ill.).

Anquetin, of the Symbolist milieu of *fin-de-siècle* Paris, was one of the most important practitioners of the style called "*cloisonnisme*" by the critic Edouard Dujardin, a term suggested by the flat, brightly colored, contoured shapes of medieval *cloisonné* and associated with the work of Anquetin, Vincent van Gogh, Emile Bernard, and Toulouse-Lautrec, among others. John Rewald has identified the sitter as Madeleine Bernard (1871–1895), the younger sister of the painter Emile Bernard and the subject of numerous portraits by her brother and Paul Gauguin at Pont-Aven, in particular Bernard's *Madeleine in the Bois d'Amour*, 1888 (Paris, Musée d'Orsay), and Paul Gauguin's *Portrait of Madeleine Bernard*, 1888–89 (Musée de Grenoble). She was engaged to the painter Charles Laval, a follower of Gauguin whom she met in Pont-Aven, having rejected Gauguin's amorous advances. Laval died of tuberculosis in 1894, as did Madeleine a year later in Cairo.

Anquetin [P 3]

CHARLES-ALEXIS APOIL
French, 1809–1864
Portrait of an Artist and his Son, 1854
Signed and dated, upper left:
Alexis Apoil/1854
Oil on canvas. 51¼″ × 38¼″
(130.1 × 97.2 cm)
Acquired through the generosity of the Museum Associates. 1986.156
[see entry no. 25]

Auguste [P 4]

[P 4]
JULES-ROBERT AUGUSTE
French, 1789–1850
Arab Soldier
Oil on board. 13¼″ × 7¼″ (33.5 × 18.2 cm)
Membership Dues. 67.026

BIBLIOG.: *Bull RISD, Museum Notes, Recent Acquisitions*, 1966–67, pp. 30–33 (no. 51, ill.).

This painting is said to have descended through the collections of Eugène Delacroix, Paul Huet, Perret-Carnot, and Pierre Miquel, from whom it was purchased by the Museum.

Austrian [P 5]

[P 5]
Austrian, last quarter of the 18th century
Portrait of Marie Antoinette
Oil on canvas. 37¼″ × 31⁹⁄₁₆″
(94.5 × 80.3 cm)
Gift of Miss M. C. Harrington. 57.295

[P 6]
V. B.
Probably French, mid-19th century
Landscape with Woodchoppers
Signed, lower right, beneath log: *V. B.*
Oil on canvas. 23¹¹⁄₁₆″ × 28¾″
(60.2 × 73 cm)
Gift of Miss Ruth Ely. 20.072

At the time of its acquisition, this painting was identified as School of Thomas Couture. When it was cleaned in 1953, the initials V. B. were revealed. The artist has not been identified.

[P 7]
JERRY BARRETT
British, 1814–1906
The Letter, 1854
Oil on canvas. 30¼″ × 25⅛″
(76.8 × 63.8 cm)
Bequest of Ellen D. Sharpe. 54.147.79

V.B. [P 6]

[P 8]
SIR WILLIAM BEECHEY
British, 1753–1839
Portrait of John Cook of Norwich, 1784
Signed and dated, at left: *WB 1784*
Oil on canvas. 27¼″ × 19½″
(69.2 × 49.5 cm)
Helen M. Danforth Fund. 79.009

Beechey, who became a court painter to George III, lived in Norwich between 1782 and 1787, where he set up a successful practice in the execution of portraits and conversation pieces. Along with John Cook, a Norwich gentleman, among others, Beechey founded the United Friars Society of Norwich, a charitable relief organization established in 1785 to benefit "decayed" tradesmen and their widows and orphans. In 1786 Beechey exhibited a conversation piece of the *United Friars* at the Royal Academy (now lost) that included portraits of himself and Cook among the assembled group.

[P 9]
JEAN-JOSEPH BENJAMIN-CONSTANT
French, 1845–1902
The Pasha's Soldiers, ca. 1880
Signed, lower right: *Benj. Constant*
Oil on canvas. 55″ × 35¾″ (139.7 × 90.8 cm)
Gift of Charles Brush Perkins in memory of Charles Francis Brush. 73.123

[P 10]
HANS JOHAN FREDRIK BERG
Norwegian, 1813–1874
Man Reclining in a Turkish Robe, 1848
Signed and dated, lower left: *H. Berg/1848*
Oil on paper, mounted on canvas.
10⅛″ × 16⁷⁄₁₆″ (25.6 × 41.8 cm)
Anonymous gift. 57.161

Benjamin-Constant [P 9]

Barrett [P 7]

Beechey [P 8]

Berg [P 10]

JEAN-VICTOR BERTIN
French, 1767–1842
Tivoli, ca. 1835–42
Oil on canvas. 19¼″ × 25⅝″
(48.8 × 65.7 cm)
Gift of Robert R. Endicott. 56.214
[see entry no. 19]

WILLIAM BLAKE
British, 1757–1827
The Baptism of Christ, ca. 1799–1800
Pen and ink and tempera on paper, mounted
on canvas.
12⅝″ × 19⅜″ (32.1 × 49.2 cm)
Museum Appropriation. 32.219
[see entry no. 4]

[P II]
JACQUES-ÉMILE BLANCHE
French, 1861–1942
Portrait of Virginia Woolf, 1927
Signed and dated, lower left:
J. E. Blanche/1927
Oil on canvas. 16¼″ × 13⅛″
(41.2 × 33.3 cm)
Museum Works of Art Fund. 54.178

BIBLIOG.: *Museum Notes, RISD,* XII:1 (Fall
1954), pp. 9–12. *Gazette des Beaux-Arts*
(January–February 1988), pp. 165 ff.

Blanche [P II]

[P 12]
**THÉOPHILE-ÉMILE-ACHILLE
DE BOCK**
Dutch, 1851–1904
Landscape
Signed, lower right: *Th. de Bock*
Oil on canvas. 11¾″ × 19¾″
(29.9 × 50.2 cm)
Gift of Mr. and Mrs. Michael Metcalf.
82.288.3

De Bock [P 12]

[P 13]
Attributed to
LOUIS-LÉOPOLD BOILLY
French, 1761–1845
The First Month
Oil on canvas. 8⅝″ × 6⁹⁄₁₆″ (21.9 × 16.6 cm)
Museum Works of Art Fund. 70.018

[P 14]
Attributed to
LOUIS-LÉOPOLD BOILLY
French, 1761–1845
The Ninth Month
Oil on canvas. 8⁹⁄₁₆″ × 6⅝″ (21.7 × 16.9 cm)
Museum Works of Art Fund. 70.019

[P 15]
GIOVANNI BOLDINI
Italian, 1845–1931
Mrs. Peter Cooper Hewitt, ca. 1911–13
Signed, lower right: *Boldini*
Oil on canvas. 39⅝″ × 28⅞″
(100.6 × 73.3 cm)
Gift of Mrs. Guy Fairfax Cary. 57.044

BIBLIOG.: Ettore Camesasca, *L'opera com-
pleta di Boldini.* Milan: Rizzoli, 1970, p. 131
(pl. 552).

Lucy Work Hewitt was the daughter of a
wealthy financier. In 1887 she married
Peter Cooper Hewitt, heir to a successful
iron-manufacturing fortune and the son
of a mayor of New York. Boldini, perhaps
the most prominent society portraitist of
the period, required that his subjects pose
for him in his Paris studio on the Boule-
vard Berthier, which had previously been
occupied by John Singer Sargent. While
Sargent's flamboyant female portraits may
have influenced Boldini's "whiplash"
style, this convention of portraiture, pos-
ing a patron out of doors in the imagined
gardens of her estate, looks back to the
influence of Gainsborough. According to
Pamela Parmal, this Museum's Assistant
Curator of Costume and Textiles, the
evening dress worn by Mrs. Cooper
Hewitt resembles several dating from 1911
to 1913 from the House of Worth, the
Paris couturier, whose archives are now in
the Victoria and Albert Museum, London,
thus establishing the painting's date. The
portrait descended to the sitter's only niece,
Cynthia Roche Cary, who donated it to
the Museum in 1957. C. P. M.

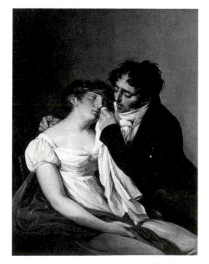

Attributed to Boilly [P 13]

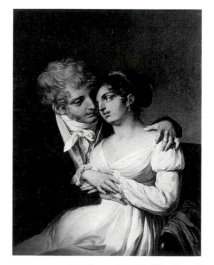

Attributed to Boilly [P 14]

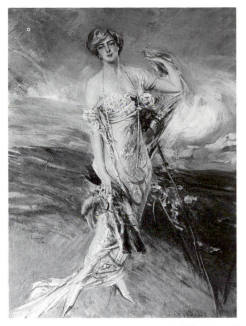

Boldini [P 15]

Bone [P 16]

EUGÈNE BOUDIN
French, 1824–1898
Figures on a Beach, ca. 1863
Oil on panel. 8⁵⁄₁₆″ × 13⅞″ (21.1 × 35.3 cm)
Gift of Mrs. Houghton P. Metcalf, Sr.
1986.070
[see entry no. 44]

EUGÈNE BOUDIN
French, 1824–1898
The Port at Trouville, 1889
Signed, dated, and inscribed, lower left:
à son ami/F. Vinton E. Boudin. 89.
Oil on canvas. 16³⁄₁₆″ × 22″ (41.1 × 55.8 cm)
Museum Appropriation. 29.290
[see entry no. 45]

[P 16]
HENRY PIERCE BONE
British, 1779–1855
*Copy after Michiel Janszoon Van Mierevelt,
Dutch, 1567–1641, "Portrait of William, Earl
of Craven,"* 1852
Signed, dated, and inscribed, on verso:
*W.m Earl Craven/Sep.t 1852. Painted by
Henry Pierce/Bone, after Mierevelt, in the
Gallery/of the Earl of Craven, Combe Abbey*
Enamel on copper. 4¾″ × 3¾″
(12.1 × 9.6 cm)
Gift of Miss Sarah E. Doyle. 08.134

Attributed to Bonington [P 17]

Bonvin [P 18]

[P 17]
Attributed to
RICHARD PARKES BONINGTON
British, 1802–1828
Girl Writing a Letter
Oil on canvas. 8½″ × 6⅜″ (21.6 × 16.2 cm)
Gift of Mrs. Murray S. Danforth. 43.180

[P 18]
FRANÇOIS BONVIN
French, 1817–1887
Portrait of a Seated Woman, 1871
Signed, dated, and inscribed, lower right:
F.C. Bonvin à mon ami Carie 71 Paris
Oil on panel. 10⅝″ × 8⅜″ (27 × 21.4 cm)
Membership Dues. 71.047

[P 19]
SIR FRANK BRANGWYN
British, 1867–1956
A French Farmyard, Montreuil, 1902
Signed, lower right: *FB*
Oil on canvas. 24½″ × 29½″
(62.2 × 74.9 cm)
Gift in the name of Walter Callender, by
his sons, Walter R. and John A. Callender.
29.101

BIBLIOG.: New York, American Art
Association, *Sale of the Collection of William
Merritt Chase*, March 7–8, 1912, no. 151
(as *Sunlight and Shadow*); *Bull RISD*, XVIII:1
(January 1930), pp. 2–8; Vincent Galloway,
The Oils and Murals of Sir Frank Brangwyn.
Leigh-on-Sea: F. Lewis, 1962, p. 42 (no.
374, as *A French Farmyard, Montreuil*).

The son of a designer, Brangwyn trained
from 1882 to 1884 in William Morris's
workshop. Brangwyn's *oeuvre* numbers
more than twelve thousand objects, includ-
ing easel and mural paintings, furniture,
stage and architectural designs, prints,
illustrations, and stained glass. This par-
ticular canvas, with the characteristic con-
tours and contrasts of light which allowed

Brangwyn [P 19]

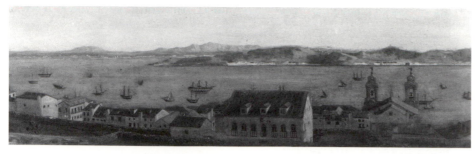

British [P 21]

British [P 23]

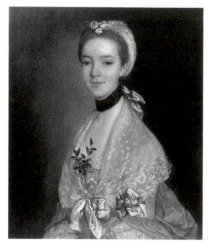

British [P 20]

his paintings to be compared to stained-glass windows, was acquired by the American painter William Merritt Chase, who visited Brangwyn's studio in 1903 and 1904 in order to arrange for visits from his students from the Shinnecock Summer School. L. S. U.

GEORGES BRAQUE
French, 1882–1963
Still Life, 1918
Signed and dated, on verso: *G. Braque/18*
Oil on canvas. 18¼″ × 28⅞″
(46.5 × 73.4 cm)
Mary B. Jackson Fund. 48.248
[see entry no. 83]

[P 20]
British, second half of the 18th century
Portrait of a Woman
Oil on canvas. 29¾″ × 25″ (75.6 × 63.5 cm)
Gift of Mrs. Murray S. Danforth. 85.140

[P 21]
British, early 19th century
Entrance to the Harbor of Lisbon, ca. 1811
Oil on canvas. 5¹⁄₁₆″ × 16⅞″ (12.8 × 41.7 cm)
Museum Works of Art Fund. 60.092

BIBLIOG.: J.E.S., "Curioso Aspecto de Lisboa nos comecos do Seculo XIX," *Olisipo*, XXVI:102 (April 1963), pp. 94–96.

[P 22]
British, first quarter of the 19th century
Portrait of a Man
Oil on canvas. 30¼″ × 25⅜″
(76.8 × 64.7 cm)
Bequest of Charles L. Pendleton. 04.167

[P 23]
British, first half of the 19th century
Portrait of a Young Cricketer, ca. 1830
Oil on canvas. 31¼″ × 25″ (79.4 × 63.5 cm)
Gift of Mr. and Mrs. Frederick Kenner. 81.299

[P 24]
British or **French**, mid-19th century
Trees
Oil on canvas. 20⅜″ × 15″ (51.2 × 38.2 cm)
Gift of Mr. and Mrs. A. M. Adler. 70.173

This work was previously attributed to John Constable. It has also been suggested that it may be by Paul Huet.

British [P 22]

British or French [P 24]

[P 25]
British, late 19th century
Female Portrait (Annie Miller?)
Signed and dated, lower left: *M/1856*
(spurious)
Oil on canvas. 14¹⁵⁄₁₆″ × 11⅝″ (36.2 × 30 cm)
Museum Gift Fund. 55.087

This work is believed to be a portrait of
Annie Miller, Holman Hunt's protégé and
the subject of paintings by Sir John Everett
Millais (notably *The Bridesmaid*, Cam-
bridge, Fitzwilliam Museum) and Dante
Gabriel Rossetti. This work was once
attributed to Millais, but widespread con-
sensus among Millais scholars is that this
painting is not by him, but perhaps by a
younger follower of the Pre-Raphaelites.
The monogram and date appear to be a
later addition.

[P 26]
FRIEDRICH BROCKMANN
German, 1809–?
Portrait of a Man, 1827
Signed and dated, at sitter's left shoulder:
F.(?)Brockmann/1827
Oil on canvas. 21⅛″ × 17³⁄₁₆″
(53.7 × 43.8 cm)
Bequest of Miss Ellen D. Sharpe. 54.147.82

[P 27]
DAVID YOUNG CAMERON
British, 1865–1945
Old Inverlochy
Signed, lower right: *DYC*
Oil on canvas. 30¼″ × 40¼″
(76.8 × 102 cm)
Gift of Miss Ellen D. Sharpe. 21.003

BIBLIOG.: *Bull RISD,* XIII:1 (January 1925),
pp. 6–8 (ill.).

[P 28]
JOSEPH CARAUD
French, 1821–1905
Mother and Daughter, 1870
Signed and dated, lower right:
J. Caraud 1870
Oil on panel. 17½″ × 21½″ (44.4 × 54.6 cm)
Gift of Roy Carr. 64.036

JEAN-BAPTISTE CARPEAUX
French, 1827–1875
Bathers, ca. 1870
Signed, lower right: *JB Carpeaux* (perhaps
added later)
Oil on canvas. 18⅛″ × 24¼″
(46.3 × 61.7 cm)
Mary B. Jackson Fund. Purchased in
memory of L. Earle Rowe. 53.350
[see entry no. 41]

British [P 25]

EUGÈNE CARRIÈRE
French, 1849–1906
Woman Sewing, ca. 1890–95
Signed, lower right: *Eugène Carrière*
Oil on canvas. 13¹⁄₁₆″ × 9¹³⁄₁₆″
(33.2 × 24.9 cm)
Museum Appropriation. 18.499
[see entry no. 71]

EUGÈNE CARRIÈRE
French, 1849–1906
Landscape in the Orne, 1901
Signed, lower right: *Eugène Carrière*
Oil on canvas. 12¹³⁄₁₆″ × 16¼″
(32.5 × 41.5 cm)
Membership Dues. 67.025
[see entry no. 72]

Cameron [P 27]

Brockmann [P 26]

Caraud [P 28]

217

Cézanne [P 31]

[P 29]
KARL CASPAR
German, 1879–1956
Noli Me Tangere (Christ in the Garden with Mary Magdalene)
Signed, lower right: *KC*
Oil on canvas. 28½" × 23⅞"
(72.4 × 60.7 cm)
Given in memory of Miss Mary Helena Dey by an anonymous donor. 64.037

Caspar [P 29]

Cazin [P 30]

[P 30]
JEAN-CHARLES CAZIN
French, 1841–1901
Landscape with Windmill
Signed, lower left: *J.C. CAZIN*
Oil on canvas. 17⅛" × 15⅛"
(43.5 × 38.3 cm)
Bequest of George Pierce Metcalf. 57.232

This painting was cleaned and revarnished in 1985.

[P 31]
PAUL CÉZANNE
French, 1839–1906
Copy after Titian's "Pietà," ca. 1864
Oil on paper, mounted on canvas.
7¹³⁄₁₆" × 11¾" (19.8 × 29.8 cm)
Gift of Julius H. Weitzner. 56.178

Inscribed on stretcher, verso: *Copie d'après Le Titien par M. Paul Cézanne, ce tableau m'a été donné par M. Murer à Auvers-sur-Oise. Je l'ai fait rentailer* [sic]. *Rocagel. Meniel* [?] *(S. et O.).*

Although drawing after works of art in the Louvre was a frequent exercise for Cézanne when he first studied in Paris, painted copies by him are very rare and difficult to attribute. John Rewald, who accepts this painting as a genuine work by Cézanne and will include it in his forthcoming *catalogue raisonné* of Cézanne's paintings, relates it to the *Preparation for the Funeral (The Autopsy)* (Venturi 105, ca. 1869, oil on canvas, 19¼" × 31½", 49 × 80 cm, private collection). However, the technique of execution, less broad and expressionistic than Cézanne's works from the end of the decade, may suggest a slightly earlier date, contemporary with a painted copy after Delacroix's *Barque of Dante* (Paris, Musée du Louvre) by Cézanne (ca. 1864, oil on canvas, 8⅞" × 13", 22.5 × 33 cm, Cambridge [Massachusetts], private collection; ill. in London, Royal Academy of Arts, *Cézanne, The Early Years*, April 22–August 21, 1988, no. 5). The inscription on the stretcher identifies the original owner as Eugène Murer, a boyhood friend of the painter Armand Guillaumin. "It was through Guillaumin," Murer wrote, "a schoolmate of mine in Moulins, that I first met Cézanne, his neighbor on the quai d'Anjou" (see Anne Distel, *Les Collectionneurs des impressionnistes*. Düdingen/Guin [Switzerland]: Editions Trio, 1989, pp. 208–15). Murer became an important patron of the Impressionists and proprietor of a Rouen hotel,

where he would exhibit their work and would sometimes barter room and board in exchange for their paintings (see John Rewald, ed., *Camille Pissarro, Letters to his Son Lucien*. New York: Pantheon Books, 1943, pp. 42–43). Murer settled in Auvers-sur-Oise in 1881.

[P 32]
PAUL CÉZANNE
French, 1839–1906
Still Life with Apples, ca. 1878
Oil on canvas. 9⅛" × 15⅝" (23.2 × 39.7 cm)
Gift of Mrs. Murray S. Danforth. 41.012

Although the attribution of this painting has sometimes been doubted, a label on the stretcher bearing the number 3501 has been identified by John Rewald as a stock number from the inventory of Cézanne's dealer, Ambroise Vollard, who lists this painting by the erroneous description "*pommes sur une chaise renversée* (20 × 39 cm)." A similar still life, probably painted at the same time, can be found in the Barnes Foundation, Merion. The Museum's painting descended from the collection of Mme Paul Guillaume, Paris. It will be included in Dr. Rewald's forthcoming *catalogue raisonné* of Cézanne's paintings.

PAUL CÉZANNE
French, 1839–1906
Chestnut Trees and Farm at the Jas de Bouffan (The Jas de Bouffan in Spring), ca. 1887
Oil on canvas. 25¾" × 31⅞"
(65.4 × 80.9 cm)
Museum Appropriation. 33.053
[see entry no. 64]

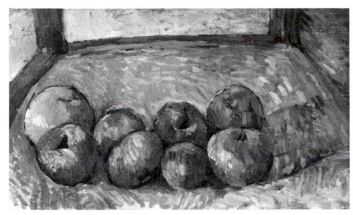

Cézanne [P 32]　　　　　　　　　　Chintreuil [P 34]

PAUL CÉZANNE
French, 1839–1906
Banks of a River, ca. 1904–05
Oil on canvas. 24″ × 29″ (60.9 × 73.6 cm)
Museum Special Reserve Fund. 43.255
[see entry no. 65]

THÉODORE CHASSÉRIAU
French, 1819–1856
Fisherman's Wife from Mola di Gaeta
Embracing her Child, ca. 1849–51
Signed, lower right: *Th.ͬᵉ Chassériau*
Oil on panel. 6¹³⁄₁₆″ × 4¾″ (17.3 × 12 cm)
Gift of Mrs. Gustav Radeke. 28.004
[see entry no. 23]

[P 33]
ANTOINE CHINTREUIL
French, 1816–1873
White Chateau, ca. 1855
Signed, lower right: *Chintreuil*
Oil on canvas. 23¼″ × 39⅛″ (59 × 99.3 cm)
Museum Gift Fund. 71.079

This may be a view of Villeneuve-les-Avignon, the subject also of a painting by Chintreuil's mentor, Corot, in the Musée des Beaux-Arts, Reims.

[P 34]
ANTOINE CHINTREUIL
French, 1816–1873
Landscape, 1860
Signed and dated, lower left: *Chintreuil/60*
Oil on panel. 7⅛″ × 13⁷⁄₁₆″ (18.1 × 34 cm)
Gift of Uforia, Inc. 73.145

[P 35]
JOHN CONSTABLE
British, 1776–1837
Portrait of Mrs. Edwards, ca. 1818
Oil on canvas. 29¹⁵⁄₁₆″ × 25¹⁄₁₆″
(76 × 63.7 cm)
Corporation Membership Dues Fund.
58.197

BIBLIOG.: Graham Reynolds, *The Later Paintings and Drawings of John Constable.* New Haven and London: Yale University Press, 1984, no. 18.12.

The sitter is the daughter of Mrs. Tuder, the subject of a portrait of identical dimensions in the Cannon Hall Museum, Barnsley. These and a third painting of *The Rev. Dr. William Walker* (private collection), Rector of Layham, Suffolk, signed and dated 1818, all descended through the Tuder family and are believed to have been painted at the same time.

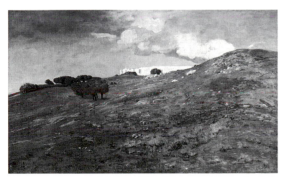

Chintreuil [P 33]

Constable [P 35]

JEAN-BAPTISTE-CAMILLE COROT
French, 1796–1875
Honfleur, the Old Wharf, ca. 1822–25
Signed, lower left: *Corot*; inscribed to
right of signature: *honfleur*
Oil on canvas. 11¹³⁄₁₆″ × 16¾″
(30 × 42.5 cm)
Museum Works of Art Fund. 43.007
[see entry no. 15]

JEAN-BAPTISTE-CAMILLE COROT
French, 1796–1875
Entrance to a Chalet in the Bernese Oberland,
ca. 1850–55
Stamped, lower left, in red: *VENTE/COROT*
Oil on canvas. 10³⁄₁₆″ × 14³⁄₁₆″
(25.9 × 35.9 cm)
Helen M. Danforth Fund. 54.175
[see entry no. 16]

JEAN-BAPTISTE-CAMILLE COROT
French, 1796–1875
*Banks of a River Dominated in the Distance
by Hills*, ca. 1871–73
Signed, lower right: *COROT*
Oil on canvas. 12⁹⁄₁₆″ × 18⅛″ (32 × 45.8 cm)
Museum Appropriation. 24.089
[see entry no. 17]

[P 36]
Attributed to
JEAN-BAPTISTE-CAMILLE COROT
French, 1796–1875
Cows and Water
Signed, lower right: *COROT*
Oil on canvas. 8⅛″ × 12⅞″ (20.6 × 32.8 cm)
Gift of Mrs. Houghton P. Metcalf.
1986.207.3

[P 37]
CHARLES COTTET
French, 1863–1924
Girl with Muff, 1900
Signed, at sitter's right elbow: *Cottet*;
dated, below sitter's left shoulder: *1900*
Oil on board. 37³⁄₁₆″ × 23⁹⁄₁₆″
(94.5 × 59.8 cm)
Gift of Mrs. Gustav Radeke. 12.033

BIBLIOG.: *Bull RISD,* I:I (January 1913),
pp. 2–3.

GUSTAVE COURBET
French, 1819–1877
Jura Landscape, 1869
Signed and dated, lower left: *G. Courbet. 69*
Oil on canvas. 23⅜″ × 28¹³⁄₁₆″
(59.5 × 73.3 cm)
Walter H. Kimball Fund and by exchange.
43.571
[see entry no. 51]

[P 38]
After **GUSTAVE COURBET**
French, 1819–1877
Landscape with a Mill near Ornans
Signed and dated, lower left: *G. Courbet/
69* (spurious)
Oil on canvas. 18⅜″ × 24⁷⁄₁₆″
(47.7 × 62.8 cm)
Museum Works of Art Fund and Mrs.
Murray S. Danforth. 46.095

The Courbet attribution has been rejected
by Michel Laclotte and Jacques Foucart,
both of the Department of Paintings of
the Louvre.

Cottet [P 37]

[P 39]
After **GUSTAVE COURBET**
French, 1819–1877
Landscape
Oil on canvas. 8⅝″ × 12¹¹⁄₁₆″
(21.9 × 32.3 cm)
Bequest of Isaac C. Bates. 13.793

A later signature, *G.C.*, formerly at lower
left, has been removed.

THOMAS COUTURE
French, 1815–1879
Gamin, ca. 1850–60
Oil on canvas. 24¼″ × 19¾″
(61.6 × 50.2 cm)
Gift of Mrs. Houghton P. Metcalf, Sr.
1986.207.2
[see entry no. 21]

Attributed to Corot [P 36]

After Courbet [P 38]

After Courbet [P 39]

Attributed to Couture [P 40]

Attributed to **THOMAS COUTURE**
French, 1815–1879
Romans of the Decadence
Oil on canvas. 16¹³⁄₁₆″ × 26½″
(42.6 × 67.3 cm)
Mary B. Jackson Fund. 54.004
[see entry no. 20]

Attributed to **THOMAS COUTURE**
French, 1815–1879
Little Gilles
Signed, lower left: *T. C.*
Oil on canvas. 23¹⁄₁₆″ × 18¹⁄₁₆″
(58.5 × 46 cm)
Gift of Mrs. Murray S. Danforth. 53.108
[see entry no. 22]

[P 40]
Attributed to **THOMAS COUTURE**
French, 1815–1879
Mother and Child
Signed, left: *T. C.*
Oil on canvas. 8″ × 10¾″ (20.3 × 27.3 cm)
Bequest of Edward F. Ely. 20.069

[P 41]
PHILIBERT LÉON COUTURIER
French, 1823–1901
Farmyard with Chickens
Signed, lower left: *P. L. Couturier*
Oil on canvas. 14⅞″ × 21¾″
(37.8 × 55.2 cm)
Gift of Alfred T. Morris, Sr. 81.302

[P 42]
HENRI-PIERRE DANLOUX
French, 1753–1809
Study for the Portrait of Sir William Jerningham, 1795
Oil on canvas, mounted on panel.
15¹³⁄₁₆″ × 10¼″ (40.2 × 26 cm)
Bought with a gift of the Honorable Theodore Francis Green. 57.039

BIBLIOG.: Jean-Patrice Marandel, "Une Esquisse de Danloux," *Antologia di Belle Arti*, 2 (June 1977), pp. 203–05.

Prior to its identification by Marandel as the work of Danloux, this small painted

Couturier [P 41]

Danloux [P 42]

sketch had variously been attributed to Gilbert Stuart and Thomas Sully. Its attribution to Danloux is based upon its close relationship to his sketch for the *Portrait of the Abbé de Saint-Far* in the Musée Carnavalet, Paris, which Danloux painted during his exile in London after 1791, and to the finished *Portrait of Sir William Jerningham*, location unknown, a photograph of which is reproduced in the 1910 publication of the journal kept by Danloux's wife during their exile (see Baron R. de Portalis, *Pierre Danloux et son journal*. Paris, 1910, pp. 242–44). From this journal it is known that Danloux painted Jerningham's portrait in May 1795.

221

After Daumier [P 43]

After Daumier [P 45]

CHARLES-FRANÇOIS DAUBIGNY
French, 1817–1878
Landscape, 1871
Signed and dated, lower right:
Daubigny 1871
Oil on panel. 15″ × 26⁷⁄₁₆″ (38.2 × 67.2 cm)
Mary B. Jackson Fund. 73.120
[see entry no. 52]

[P 43]
After **HONORÉ DAUMIER**
French, 1808–1879
*Landscape with Don Quixote and
the Dead Mule*
Oil on canvas. 23¼″ × 32″ (59.1 × 81.5 cm)
Museum Appropriation. 32.258

There appear to be two authentic versions
of this painting: one belonging to the
Metropolitan Museum of Art, New York
(ex coll. Cementron, Paris); the other for-
merly in the collection of Baron Napoléon
Gourgaud, Paris.

[P 44]
After **HONORÉ DAUMIER**
French, 1808–1879
Mme Pipelet, the Concierge
Signed, lower left: *H. Daumier* (spurious)
Oil on panel. 18¼″ × 15¹⁄₁₆″
(46.3 × 38.3 cm)
Museum Appropriation. 32.257

Mme Pipelet was the concierge of the
house on the boulevard Pigalle, where
Daumier lived before moving to the Ile
Saint-Louis. She is the subject of a litho-
graph from the series *Bohémiens de Paris*
(D. 836), from which this painting may
have been copied.

After Daumier [P 44]

[P 45]
After **HONORÉ DAUMIER**
French, 1808–1879
Second-Class Carriage
Signed, lower right: *H. Daumier* (spurious)
Oil on panel. 7⁷⁄₁₆″ × 10⅝″ (18.9 × 27 cm)
Gift of Mrs. Gustav Radeke. 21.343

This painting is a copy after Daumier's
painting, formerly in the Oscar Schmitz
Collection, Dresden.

[P 46]
ALEXANDRE DECAMPS
French, 1803–1860
Bazaar in Cairo, ca. 1833
Signed, lower right: *DC*
Oil on canvas. 11³⁄₁₆″ × 9⁷⁄₁₆″ (28.4 × 24 cm)
Gift of Hirschl and Adler. 68.014

BIBLIOG.: A. Moreau, *Decamps et son
oeuvre.* Paris, 1869, pp. 143, 214; C. Clé-
ment, *Decamps.* Paris, 1886, p. 34; *Bull
RISD, Museum Notes,* LV:2 (December 1968),
pp. 30–32.

The provenance of this painting can be
traced to the Deforge collection and is
reproduced in its sale catalogue of March 6,
1857.

EDGAR DEGAS (born Hilaire Germain
Edgar De Gas)
French, 1834–1917
La Savoisienne, ca. 1860
Signed, upper left: *Degas*
Oil on canvas. 24¾″ × 18¼″
(61.5 × 46.3 cm)
Museum Appropriation. 23.072
[see entry no. 35]

EDGAR DEGAS (born Hilaire Germain
Edgar De Gas)
French, 1834–1917
Jockey, Red Cap, ca. 1866–68
Estate stamp, lower right, in red: *Degas*
Oil on paper, mounted on cardboard,
mounted on panel. 17³⁄₁₆″ × 12¹⁄₁₆″
(33.7 × 30.6 cm)
Gift of Mrs. Murray S. Danforth. 35.539
[see entry no. 36]

EUGÈNE DELACROIX
French, 1798–1863
Arabs Traveling, 1855
Signed and dated, lower left:
Eug. Delacroix. 1855.
Oil on canvas. 21⁵⁄₁₆″ × 25⅝″ (54.1 × 65 cm)
Museum Appropriation. 35.786
[see entry no. 27]

Decamps [P 46]

[P 47]

WILLIAM DELAMOTTE
British, 1775–1863
Landscape with Ruins, 1813
Signed and dated, on rock in foreground:
W.D. 1813
Oil on canvas. 9¹/₁₆″ × 12¹/₁₆″ (23 × 30.8 cm)
Museum Works of Art Fund. 57.170

ROBERT DELAUNAY
French, 1885–1941
The Towers of Laon, ca. 1914
Signed and inscribed, lower left: *Les tours
de Laon / R. Delaunay*
Encaustic on board. 9⁷/₁₆″ × 7¾″
(24 × 19.7 cm)
Jesse Metcalf Fund, with gifts from the
Chace and Levinger Foundations. 67.088
[see entry no. 77]

Delamotte [P 47]

Denis (recto) [P 48]

Denis (verso) [P 48]

[P 48]

MAURICE DENIS
French, 1870–1943
Classical Landscape with Figures (recto), 1898
Signed and dated, lower left: *M/A/V/D/
Rome 98*
Figure in a Formal Garden (verso, unfin-
ished), 1920
Oil on canvas. 24¼″ × 35⁹/₁₆″
(61.3 × 90.3 cm)
Gift of Mr. and Mrs. Norman Hirschl.
69.203

[P 49]

ANDRÉ DERAIN
French, 1880–1954
Two Roses in a Glass Vase, ca. 1927–28
Signed, lower right: *Derain*
Oil on canvas. 16¼″ × 13″ (41.3 × 33 cm)
Gift of Mrs. Murray S. Danforth. 42.216

BIBLIOG.: Malcolm Vaughan, *Derain.*
New York, 1941, pl. 67.

According to Vaughan, this painting was
executed around 1927–28. It was exhibited
in a summer exhibition at the Museum of
Modern Art, New York, June 15–Septem-
ber 28, 1930 (no. 27), on loan from Carroll
Carstairs, who acquired it from Jacques
Seligmann, who is believed to have acquired
it directly from the artist.

Derain [P 49]

MARCELLIN GILBERT DESBOUTIN
French, 1823–1902
Self-Portrait, ca. 1888
Signed, lower right, behind sitter's left
shoulder: *M. Desboutin*
Oil on paper, mounted on canvas.
18⅜″ × 15″ (46.2 × 38.1 cm)
Acquired through the generosity of David
C. Scott, Jr. 1987.041
[see entry no. 66]

[P 50]
**EUGÈNE-FRANÇOIS-MARIE-JOSEPH
DEVÉRIA**
French, 1805–1865
*Arab Smoking a Hookah with a Woman at his
Feet*, 1835
Signed and dated, lower left:
Eug. Deveria/1835
Oil on canvas. 10¹³⁄₁₆″ × 13⅞″
(27.5 × 35.3 cm)
Membership Dues. 71.067

Diaz [P 52]

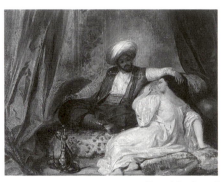

Devéria [P 50]

Dufy [P 53]

Diaz [P 51]

[P 51]
NARCISSE DIAZ DE LA PEÑA
French, 1807–1876
Eastern Princess, 1876
Signed and dated, lower right: *N. Diaz. 76*
Oil on panel. 13½″ × 9¼″ (34.3 × 23.5 cm)
Gift of Mrs. Virginia W. Hoppin in mem-
ory of William H. Hoppin. 20.229

[P 52]
NARCISSE DIAZ DE LA PEÑA
French, 1807–1876
Landscape
Signed, lower right: *N. Diaz*
Oil on panel. 7½″ × 10½″ (19 × 26.7 cm)
Bequest of Isaac C. Bates. 13.923

[P 53]
RAOUL DUFY
French, 1877–1953
*Club Room at the Cowes Royal Yacht
Club*, 1934
Signed and dated, lower left: *Cowes 1934/
Raoul Dufy*
Oil on canvas. 23¹¹⁄₁₆″ × 28¾″ (60 × 73 cm)
Bequest of George Pierce Metcalf. 57.229

BIBLIOG.: Maurice Lafaille, *Raoul Dufy,
Catalogue raisonné de l'oeuvre peint*. Geneva,
1973, II, p. 390, no. 926; *Revue du Louvre*,
XIII:4–5 (1963), p. 232, no. 25.

Similar views of the headquarters of the
Royal Yacht Squadron, located on the Isle
of Wight, were painted again by Dufy in
1935 (Lafaille no. 927, private collection)
and 1936 (Lafaille no. 928, New York,
Collection of Harry Abrams). A pen-and-
ink drawing, which may have been the
study for the three versions of this subject,
is in the Musée National d'Art Moderne,
Paris.

[P 54]
EDMUND DULAC
British, born France, 1882–1953
The Birth of Eve, 1925
Signed and dated, lower right: *Edmund
Dulac/25*
Oil on canvas, mounted on panel.
48³⁄₁₆″ × 36³⁄₁₆″ (122.4 × 98 cm)
Bequest of Miss Ellen D. Sharpe. 54.147.87

BIBLIOG.: J.C. Rogers, *Modern English
Furniture*. New York: Charles Scribner's
Sons, 1930, pp. 52 (ill.), 157 (ill.); Colin
White, *Edmund Dulac*. New York: Scrib-
ner's, 1976, pp. 116–18 (ill.).

The original gouache of this subject
(11½″ × 13¾″, Collection of Mr. Ralph O.
Esmerian, New York) was part of a series
of *Bible Scenes and Heroes* which had been
commissioned to illustrate the covers of
American Weekly, the Sunday Supplement
of *The New York Weekly American*. It was
rejected because Adam and Eve were rep-
resented without navels. This painting,
executed after the gouache and reversing
the position of Adam's arms, was exhibited
in the Winter Exhibition of "The Interna-
tional," London, September 1925.

[P 55]
JOHN DUN(N)
Irish, 1768–1841
Maria Annunciata (Caroline Bonaparte Murat), Queen of Naples (?), ca. 1812
Signed, on pedestal beneath sitter's left hand: *N. DUN*
Watercolor on ivory. 8⅛″ × 6″
(20.63 × 15.25 cm)
Gift of Mrs. Harold Brown. 37.206

BIBLIOG.: Christopher Monkhouse, "Napoleon in Rhode Island, The Harold Brown Collection at the Rhode Island School of Design," *Antiques,* CXIII:I (January 1978), p. 198 (ill.).

This is believed to be a portrait of Napoleon's youngest sister, Caroline (1782–1839), wife of General Joachim Murat, who became Queen of Naples in 1808. It descended from the collection of Mme Thayer to the marquis de Biron, from whom it was acquired by Harold Brown. It was originally attributed to Eugène Isabey, an attribution which is belied by the signature.

Dun(n) [P 55]

Dupré [P 58]

Dupré [P 56]

Dulac [P 54]

[P 56]
JULES DUPRÉ
French, 1811–1889
The Old Windmill
Signed, lower left: *J. Dupré*
Oil on canvas. 9½″ × 12¾″ (24.2 × 32.3 cm)
Bequest of Austin H. King. 21.447

BIBLIOG.: *Bull RISD,* X:2 (April 1922), pp. 15–19.

[P 57]
JULES DUPRÉ
French, 1811–1889
Landscape
Signed, lower left: *Jules Dupré*
Oil on canvas. 6⅝″ × 16¼″ (16.8 × 41.2 cm)
Bequest of Isaac C. Bates. 13.800

[P 58]
JULES DUPRÉ
French, 1811–1889
Cottage in the Berry
Signed, lower right: *J. Dupré*
Oil on panel. 6½″ × 8½″ (15.9 × 21.6 cm)
Gift of Miss Hope Smith. 63.006

Dupré [P 57]

[P 59]
JULES DUPRÉ
French, 1811–1889
Cattle at Rest
Signed, lower right: *J. Dupré*
Oil on canvas. 11⅜″ × 8¹⁵⁄₁₆″
(28.9 × 22.7 cm)
Bequest of Austin H. King. 21.446

BIBLIOG.: *Bull RISD,* X:2 (April 1922),
pp. 15–19.

Dupré [P 59]

[P 60]
JULES DUPRÉ
French, 1811–1889
Cows Drinking
Signed, lower left: *Jules Dupré*
Oil on panel. 6¼″ × 8⅝″ (15.8 × 21.8 cm)
Bequest of Isaac C. Bates. 13.791

[P 61]
FRANÇOIS-NICOLAS DUPUIS
French, late 18th–early 19th century
Landscape with Figures
Signed, lower right, on barrel: *Dupuis*
Oil on canvas. 18¹⁄₁₆″ × 21¾″ (46 × 55.3 cm)
Gift of Alfred T. Morris, Sr. 80.260

SIR CHARLES EASTLAKE
British, 1793–1865
The Celian Hill from the Palatine, ca. 1823
Signed, lower center: *C. L. Eastlake*
Oil on canvas. 13³⁄₁₆″ × 17⅝″
(33.4 × 44.7 cm)
Anonymous gift. 56.099
[see entry no. 13]

[P 62]
GAETANO ESPOSITO
Italian, 1858–1911
The Sigh, ca. 1880
Oil on canvas. 24¼″ × 19⅞″
(61.1 × 50.6 cm)
Gift of William T. Aldrich, R. S. Aldrich,
G. P. Metcalf, S. O. Metcalf, J. H. Metcalf,
and Mrs. Gustav Radeke, and Museum
Appropriation. 21.004

BIBLIOG.: *Bull RISD,* IX:1 (January 1921),
p. 10; *Bull RISD,* XII:2 (April 1924), pp. 12–
14; Adolphe Tabarant, *Manet et ses oeuvres.*
Paris: Gallimard, 1947, p. 520 (no. 342);
Bull RISD, Museum Notes, XLIII:2 (December 1956), pp. 5–6; Williamstown, Sterling
and Francine Clark Art Institute, *Italian
Paintings, 1850–1910, from Collections in
the Northeastern United States,* October–
December 1982, pp. 10–11.

This painting, acquired as an original work
by Edouard Manet, is listed as a forgery
by Tabarant and originally bore a Manet
signature, a later addition which has since
been removed. It was identified as the
work of Esposito by Dr. Bruno Molajoli,
Director General of the Fine Arts for
Naples and the Campagna, in 1955, and
was first published as such by Anthony
Clark in *Museum Notes, RISD,* of December
1956.

Esposito [P 62]

[P 63]
WILLIAM ETTY
British, 1787–1849
Back View of a Standing Male Nude in a Boat
(*Study for Charon?*), ca. 1818–20
Oil on paper, mounted on panel.
27″ × 19¾″ (sheet) (68.7 × 50.2 cm)
Anonymous gift. 56.055

BIBLIOG.: Denis Farr, *William Etty.* London: Routledge & Kegan Paul Ltd., 1958,
no. 226.

[P 64]
WILLIAM ETTY
British, 1787–1849
Seated Female Nude, ca. 1825
Oil on board. 21⅜″ × 16¹⁄₁₆″
(54.3 × 40.8 cm)
Mary B. Jackson Fund. 53.422

BIBLIOG.: Denis Farr, *William Etty.* London: Routledge & Kegan Paul Ltd., 1958,
no. 227; *Museum Notes, RISD,* XI:2 (Winter
1954), n.p. (ill.).

Dupré [P 60]

Dupuis [P 61]

Etty [P 63]

Etty [P 64]

Etty [P 65]

[P 65]
WILLIAM ETTY
British, 1787–1849
Male Head, ca. 1832–34
Signed, on verso: *Wm. Etty. RA*
Oil on canvas. 7⅜″ × 6⁹⁄₁₆″ (18.7 × 16.7 cm)
Museum Gift Fund. 55.085

The same sitter is represented in Etty's *The Persian*, ca. 1832, in the Tate Gallery, London. Both the Museum's head and *The Persian* may have been studies for *Godfrey de Bouillon the Crusader Arming for Battle*, 1833–34, City Art Gallery, Manchester.

GIACOMO FAVRETTO
Italian, 1849–1887
Easter Fair on the Rialto Bridge, ca. 1886
Signed, lower left: *G. Favretto*
Oil on canvas. 83″ × 33¾″
(210.3 × 85.7 cm)
Anonymous gift. 56.086
[see entry no. 63]

[P 66]
JEAN-LOUIS FORAIN
French, 1852–1931
The Absinthe Drinker
Signed, on verso: *J. L. Forain*
Oil on panel. 8¹⁄₁₆″ × 5³⁄₁₆″ (20.6 × 13.2 cm)
Anonymous gift. 60.024

BIBLIOG.: *Bull RISD, Museum Notes*, XLIX:2 (December 1962), p. 11.

Dr. Alicia Faxon has suggested that this café scene may be related to Manet's *The Plum* of ca. 1877 in the National Gallery of Art, Washington, D. C. There is a related watercolor of a woman in a café in the Fogg Art Museum, Harvard University, Cambridge.

[P 67]
JEAN-LOUIS FORAIN
French, 1852–1931
Courtroom Scene
Signed, upper right: *Forain*
Oil on canvas. 23³⁄₁₆″ × 28¹⁵⁄₁₆″
(60.4 × 73.6 cm)
Gift of Stephen O. Metcalf, G. Pierce Metcalf, and Houghton P. Metcalf. 23.316

Forain's preoccupation with courtroom scenes begins around 1908 and continues sporadically into the 1920's.

[P 68]
MARIANO FORTUNY
Spanish, 1838–1874
Bust of an Arab Boy in Profile
Stamped, lower right, in red: *Fortuny*
Oil on canvas. 24¹⁄₁₆″ × 19″ (61 × 48.2 cm)
Helen M. Danforth Fund. 59.066

Fortuny [P 68]

Forain [P 66]

Forain [P 67]

227

French [P 69]

[P 69]

French, first quarter of the 19th century
Still Life with Beef and Onions
Oil on canvas. 18¼″ × 21¼″ (46.4 × 54 cm)
Museum Gift Fund. 55.086

[P 70]

French, second quarter of the
19th century
Portrait of a Gentleman
Oil on canvas. 18⅞″ × 15⅞″ (48 × 40.5 cm)
Anonymous gift. 54.041

French [P 70]

[P 71]

French, mid-19th century
Wooded Rocks at Città Castellana
Inscribed, lower left: *VENTE/COROT*
Oil on canvas. 11¹³⁄₁₆″ × 16⅜″ (30 × 41.5 cm)
Gift of Uforia, Inc. 73.144

Although this may have come from the
sale of the contents of Corot's studio, this
painting is certainly not by him. It has
variously been attributed to Charles-
Gilbert Chevalier (French, 1803–?), and
to Jules-Louis-Philippe Coignet (French,
1798–1860).

WILLIAM POWELL FRITH and
RICHARD ANSDELL
British, 1819–1909, and British, 1815–1885
Feeding Time (My Lady's Pets), 1860
Signed and dated, lower left: *R. Ansdell.
1860*
Signed and dated, lower right: *W. P. Frith.
1860*
Oil on canvas. 30¹¹⁄₁₆″ × 24½″
(78 × 62.3 cm)
Gift of Mrs. Murray S. Danforth. 54.195
[see entry no. 29]

WILLIAM POWELL FRITH
British, 1819–1909
*The Salon d'Or, Homburg (Le jeu est fait . . .
rien ne va plus)*, 1871
Oil on canvas. 49¼″ × 102½″
(125 × 260.35 cm)
Gift of Walter Lowry. 58.162
[see entry no. 30]

[P 72]

WILLIAM FROST
British, 1810–1877
Study for "Una and the Wood Nymphs,"
ca. 1847
Oil on paper, mounted on panel.
16¹⁄₁₆″ × 23¾″ (panel) (41.2 × 60.4 cm)
Museum Works of Art Fund. 56.091

This appears to be a study for the painting
of this title in the British Royal Collection,
exhibited at the Royal Academy, London,
in 1847 (no. 14).

[P 73]

Attributed to **LOUIS GAUFFIER**
French, 1761–1801
Amor Omnibus Idem (Love is the same for all),
1795
Inscribed, on tomb: *PALLIDA MORS O QUO
PULSAT PEDE/PAUPERUM TABERNAS,/
REGUM QUE TURRES./A . . . ANNO . . . C./
M.DCC.XCV* ("Pale death beats down with
equal step the hovels of the poor and the
towers of kings. A. C. 1795")
Oil on canvas. 15⅞″ × 12¾″
(40.3 × 32.4 cm)
Mary B. Jackson Fund. 72.145

BIBLIOG.: London, Heim Gallery, *Paintings
and Sculpture 1770–1830*, September 11–
December 21, 1972, no. 6 (ill.); "Neo-
Classicism on the Market," *Burlington Mag-
azine* (November 1972), p. 759; "Chronique
des Arts," *Gazette des Beaux-Arts* (February
1973), p. 134 (no. 485); Marc Sandoz,
Antoine-François Callet, 1741–1823. Paris:
Editart Les Quatres Chemins, 1985, p. 152,
Y45.

This painting was purchased as a work by
Antoine François Callet (1741–1823), an
attribution possibly inspired by the initials
accompanying the date inscribed on the
tomb. It is likely, however, that "A. C."
refers to "*Anno Christo,*" distinguishing
this dating from the Revolutionary calen-
dar then common in France. Sandoz (*op.
cit.*) listed this work among a group of
"uncertain" attributions to Callet. Accord-
ing to Philippe Bordes (orally, February 15,
1991), Director of the Musée de la Révolu-
tion Française, Vizille, the porcelainlike
qualities of this figure and its placement in
a landscape rendered with meticulous
attention to detail closely resemble the
work of Gauffier, winner of the Prix de
Rome in 1784. He lived in Rome until
1793 and in Florence until the year of his
death in 1801. This allegory of the triumph
of love over death represents Eros holding
a level, on which is inscribed the phrase
"love is the same for all" in Latin. The relief
on the tomb shows the three Fates, and

French [P 71]

Frost [P 72]

Attributed to Gauffier [P 73]

German or Danish [P 76]

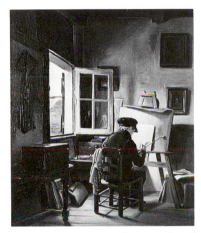

German [P 75]

the inscription above them from Horace (Book I, ode 4) forms part of the conventional Baroque iconography of death, published in Cesare Ripa's *Iconologia,* and still common in the eighteenth century.

THÉODORE GÉRICAULT
French, 1791 – 1824
A Cart Loaded with Kegs (Le Haquet),
ca. 1819
Oil on canvas. 23⁷/₁₆″ × 28⁷/₈″
(59.8 × 73.4 cm)
Museum Works of Art Reserve Fund.
43.539
[see entry no. 12]

[P 74]
After **THÉODORE GÉRICAULT**
French, 1791 – 1824
Officer of the Chasseurs of the Imperial Horse Guard (Charging Chasseur)
Oil on canvas. 14⁵/₈″ × 11⅛″
(37.2 × 28.3 cm)
Museum Appropriation. 48.452

This painting, along with another study after Géricault's *Charging Chasseur,* descended from the Schwitzer collection, Berlin. According to Lorenz Eitner of Stanford University, these are not by Géricault, but are copies by a later hand. This study is very close to Géricault's *Sketch for the Charging Chasseur,* 1812 (oil on canvas, Paris, Musée du Louvre, R. F. 210). The final version of Géricault's subject, exhibited in the Salon of 1812, is also in the Louvre (Inv. 4885).

[P 75]
German, first half of the 19th century
The Studio, ca. 1830
Oil on panel. 11½″ × 9¹/₁₆″ (29.1 × 23 cm)
Museum Works of Art Fund. 56.092

This portrait of a young artist in his studio, accessioned as the work of a Danish painter, is now believed to have been painted by a Hamburg artist who may have studied at the Copenhagen Academy.

[P 76]
German or **Danish**, first half of the 19th century
Snowball Fight
Oil on canvas. 13″ × 17¹/₁₆″ (33 × 43.5 cm)
Anonymous gift. 57.160

Like *The Studio* (56.092), this painting may have been by a North German artist working at the Academy in Copenhagen. It has also been associated with the work of Wilhelm-Ferdinand Bentz (Danish, 1804 – 1832), a pupil of Christoffer-Wilhelm Eckersberg (Danish, 1783 – 1853).

[P 77]
German (?), 19th century
Portrait of Gustav Radeke's Father
Oil on canvas. 12¹/₁₆″ × 9⅜″
(30.6 × 23.8 cm)
Bequest of Miss Ellen D. Sharpe. 54.147.77

After Géricault [P 74]

German [P 77]

German [p 78]

After Van Gogh [p 80]

German [p 79]

[p 78]
German (?), 19th century
Portrait of Gustav Radeke's Mother
Oil on canvas. 13¼″ × 11¹/₁₆″
(33.3 × 28.2 cm)
Bequest of Miss Ellen D. Sharpe. 54.147.78

[p 79]
German (?), 19th century
Portrait of Dr. Gustav Radeke as a Young Boy
Oil on canvas. 19″ × 16″ (48.3 × 40.7 cm)
Bequest of Miss Ellen D. Sharpe. 54.147.76

JEAN-LÉON GÉRÔME
French, 1824–1904
Moorish Bath, ca. 1874–77
Signed and inscribed, lower right: *à ma fille Madeleine/J. L. Gérôme*
Oil on canvas. 32¼″ × 25¹³/₁₆″
(81.9 × 65.7 cm)
Membership Dues. 66.280
[see entry no. 57]

[p 80]
After **VINCENT VAN GOGH**
Dutch, 1853–1890
Landscape near Auvers-sur-Oise, 1890
Oil on canvas. 13⅜″ × 16⁹/₁₆″ (34 × 42 cm)
Given in memory of Miss Dorothy Sturges by a friend. 35.770

BIBLIOG.: Berlin, Galerie Paul Cassirer, *Van Gogh*, May–June 1914, no. 54; J.-B. de la Faille, *L'Oeuvre de Vincent van Gogh*. Paris-Bruxelles, 1928, no. 800; J.-B. de la Faille, *Vincent van Gogh*. New York-Paris, 1939, no. 788.

De la Faille, who accepts this as an original van Gogh, gives the provenance as Ambroise Vollard, Paris; Carl Moll collection, Vienna (1909); M. Goldschmidt, Frankfurt-am-Main; and Tannhauser Art Gallery, Paris. He dates it to June 1890, during the last weeks of van Gogh's life, when he moved from St. Remy to Auvers-sur-Oise, where he was under the care of his close friend, Dr. Gachet, and where, on July 27 of that year, he took his life. Scholars have long been equivocal about the attribution of this painting to van Gogh. Dr. Mark Roskill (letter of November 23, 1964) has noted inconsistencies between the view represented in this painting and the actual topography of the church at Auvers and has noted irregularities in the paint handling and color when compared to authentic works by van Gogh of the same period. He believes this may be a pastiche after a *View of Auvers* by van Gogh formerly in the collection of Mrs. Edward Hutton (F. 801), and he suggests that the Museum's canvas may have been executed by Amédée Schuffenecker, the brother of Gauguin's friend, the painter Emile Schuffenecker. A spurious van Gogh, *Landscape with Corn Shocks* (Stockholm, National Museum, F. 560), is stylistically similar to

the one at RISD and can be traced back to 1912–13; it may also be by Schuffenecker. In the absence of evidence that might link this painting to van Gogh, we have continued to identify this as a pastiche by an unknown hand.

[p 81]
EVA GONZALÈZ
French, 1849–1883
Profile of a Young Man
Signed, lower left: *Eva Gonzalez*
Oil on panel. 8¾″ × 4¹⁵/₁₆″ (22.3 × 12.5 cm)
Gift of Mr. and Mrs. Norman Hirschl. 70.172

Gonzalèz [p 81]

[P 82]
**FRANCISCO JOSÉ DE GOYA
Y LUCIENTES**
Spanish, 1746–1828
Two Children Reading, ca. 1824
Lamp black and egg tempera on ivory.
2″ × 2″ (5.2 × 5.3 cm)
Gift of Mrs. Gustav Radeke. 21.129

BIBLIOG.: Martín Sebastián Soria, "Las
miniaturas y retratos-miniaturas de Goya,"
Cobalto (Barcelona), XLIX:2 (1949), pp. 2–3
(fig. 10); Eleanor A. Sayre, *The Changing
Image: Prints by Francisco Goya.* Boston:
Museum of Fine Arts, 1974, p. 307 (no.
255).

This miniature is closely related to a late
lithograph by Goya, *Woman Reading to
Two Children*, around 1824 (Hof. 270).
The sitters have tentatively been identified
as the children of Doña Leocadia Zorrilla
de Weiss, who lived with Goya during his
final years in Bordeaux. By his own
account, Goya is believed to have painted
around forty miniatures on ivory during
the winter of 1824–25. This miniature
is believed to have descended from the
Habich collection, Kassel (no. 308? in the
1899 Stuttgart sale).

Goya [P 82]

[P 83]
Attributed to **FRANCISCO JOSÉ
DE GOYA Y LUCIENTES**
Spanish, 1746–1828
Portrait of Gerónima Goicoechea y Galarza,
1805
Inscribed, on verso: *1805/a los 15 años/
Geronima/por Goya*
Oil on copper. 3½″ (diameter) (8.89 cm)
Gift of Grenville L. Winthrop. 34.1366

Attributed to Goya [P 83]

[P 84]
Attributed to **FRANCISCO JOSÉ
DE GOYA Y LUCIENTES**
Spanish, 1746–1828
Portrait of Cesárea Goicoechea y Galarza,
1806
Inscribed, on verso: *1806/a los 12 años/la
Cesarea*
Oil on copper. 3½″ (diameter) (8.89 cm)
Gift of Mrs. Murray S. Danforth. 34.1365

BIBLIOG. (for 34.1365 and 34.1366): A. L.
Mayer, "Zu Goya," *Pantheon*, Band IX,
XXV:1 (April 1932), pp. 113–16 (ill.); *Bull
RISD*, XXV:1 (January 1937), pp. 7–10;
Martín Sebastián Soria, "Las miniaturas y
retratos-miniaturas de Goya," *Cobalto*
(Barcelona), XLIX:2 (1949), p. 4 (figs. 11–
12); F. J. Sanchez Cantón, *Vida y Obras de
Goya.* Madrid, 1951, pp. 80, 170; Pierre
Gassier and Juliet Wilson, *The Life and
Complete Work of Francisco Goya.* New
York, 1971, II, nos. 847–48.

The subjects of these two portraits are the
sisters of Gumersinda Goicoechea, to
whom Goya's son, Javier, was married on
July 8, 1805. Portraits of Javier and Gumer-
sinda, of the same format and dimensions,
were offered for sale from the Bergeret
collection, Paris, in 1970 (ex collection
Dr. Xavier De Salas Bosch?, reproduced
by Cantón, *op. cit.*, fig. 30, along with a
discussion of the Museum's portraits).
Eleanor Sayre, Museum of Fine Arts,
Boston, has expressed reservations about
their attribution to Goya without rejecting
them completely, hence their qualification
here as attributed works.

ATKINSON GRIMSHAW
British, 1836–1893
View of Scarborough, 1876
Signed and dated, lower right: *Atkinson
Grimshaw/1876*
Oil on board. 8⁷/₁₆″ × 17⁷/₁₆″
(21.5 × 44.4 cm)
Anonymous gift. 57.162
[see entry no. 58]

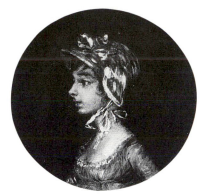

Attributed to Goya [P 84]

[P 85]
FRANÇOIS-ADOLPHE GRISON
French, 1845–after 1890
Apothecary Shop
Signed, lower left: *Grison*
Oil on canvas. 14⁵/₈″ × 11½″
(37.5 × 29.2 cm)
Bequest of Austin King. 21.449

Grison [P 85]

GUILLAUME GUILLON, called
LETHIÈRE
French, born Guadeloupe, 1760–1832
The Death of Camilla, 1785
Oil on canvas. 46⅛″ × 58⁷/₁₆″
(117.1 × 148.3 cm)
Mary B. Jackson Fund. 72.144
[see entry no. 2]

De Guinhald [P 86]

[P 86]
BERNARD DE GUINHALD
French, 1885–?
Thermignon, Savoie
Signed, lower right: *de Guinhald*
Oil on canvas. 18⅛″ × 15″ (46 × 38.2 cm)
Gift of Col. Michael Friedsam. 24.011

[P 87]
JEAN HÉLION
French, 1904–1987
The Chimney Sweep, 1936
Oil on canvas. 57¼″ × 44¾″
(145.42 × 113.66 cm)
Gift of Mrs. Peggy Guggenheim. 54.188

BIBLIOG.: Peggy Guggenheim, ed., *Art of This Century: Objects, Drawings, Photographs, Sculpture, Collage, 1910–1942.* New York, 1942, p. 95 (ill.).

[P 88]
JEAN-JACQUES HENNER
French, 1829–1905
Idyll
Signed and inscribed, lower left: *Henner/ à/ Delzant*
Oil on canvas. 13¹¹⁄₁₆″ × 17½″
(34.4 × 44.4 cm)
Endowed Membership Fund. 66.025

This motif, often repeated by Henner with minor variations, is related to the *Idylle* of the Salon of 1872 (Paris, Musée d'Orsay), showing the identical composition, reversed and in a vertical format. A variation similar in composition to the RISD canvas, in which the flutist is a male, is found in the Musée des Beaux-Arts, Dijon. This painting was sold by the descendants of Alidor Delzant, an engraver of the late nineteenth century, at the Hôtel Drouot, December 15, 1965 (no. 186, *Deux nymphes dans une clairière*). Closely related in setting is a drawing also in the Museum's collection, *Nude Woman by a Well*, in black chalk on white paper (67.029).

Henner [P 88]

[P 89]
SIR HUBERT VON HERKOMER
British, born Germany, 1849–1914
Portrait of George H. Corliss, 1886
Signed and dated, lower right: *H. H. 86*
Oil on canvas. 48⅛″ × 37⅛″
(122.3 × 94.3 cm)
Gift of Miss Mary Corliss in memory of Miss Maria L. Corliss. 35.533

In 1849, George Corliss (1817–1888), an American engineer and inventor born in Easton, invented the steam engine that bears his name. Herkomer made his second visit to the United States from December 1885 until May 1886, when he presumably painted this portrait. Corliss is represented with the plans for the steam engine in his hands.

Von Herkomer [P 89]

[P 90]
WILLIAM HILTON, JR.
British, 1786–1839
Triumph of the Duke of Wellington, 1817
Oil on canvas. 38¼″ × 60⅝″
(97.15 × 154 cm)
Museum Works of Art Fund. 56.088

BIBLIOG.: Algernon Graves, *The British Institution.* London, 1908, p. 269.

This is an overall sketch for Hilton's 1817 decorations for the Houses of Parliament, destroyed in the fire of 1834. These decorations represented the Duke of Wellington's triumphal entry into Madrid in August 1812, following the British liberation of Spain from French occupation. They are described by Algernon Graves (*op. cit.*) as follows: "[Wellington] was received, on his entrance into Madrid, with an enthusiastic gratitude, as the Liberator of Spain. All ranks and conditions of people eagerly pressed forward to testify their joy and admiration."

Hélion [P 87]

232

Hilton [P 90]

After Hogarth [P 93]

[P 91]
FERDINAND HODLER
Swiss, 1853–1918
Portrait of Fraulein Kyburz, 1873
Oil on canvas. 29″ × 15¼″ (73.7 × 38.8 cm)
Endowed Membership Fund. 66.275

BIBLIOG.: C. A. Loosli, *Ferdinand Hodler*. 1921–24, no. 1200; Bern, Kunstmuseum, *Hodler*, 1921, no. 13; *Bull RISD, Museum Notes, Recent Acquisitions*, LIV:2 (1966–67), pp. 42–45.

The Kyburz family, from the Alpine village of Langenthal, were known to Hodler through his maternal uncle, Neukomm, a shoemaker with whom Hodler, an orphan, lived in the neighboring village of Steffisbourg between 1869 and 1870. This painting, one of the earliest works by Hodler in this country, was made during a visit to the Kyburz household in 1873. This painting came from the D. Schmidt collection, Geneva. It was cleaned and revarnished in 1983.

[P 92]
CHARLES HOFFBAUER
French, 1875–1957
Infantry Captain in the Trenches at Reims, Spring, 1915, 1915
Inscribed, on verso: *in the trenches in front of Reims (dig in the white chalk of Champagne) The P.C. of a Capt. of Infantry made on the spot Spring 1915 C.H.*
Oil on panel. 8¾″ × 12⁵⁄₁₆″ (22.2 × 32.8 cm)
Gift of the Mary Dexter Fund. 66.282

BIBLIOG.: *Bull RISD, Museum Notes, Recent Acquisitions*, LIV:2 (1966–67), pp. 54–56.

Hoffbauer served as a combat artist in World War I. A watercolor sketch for this painting, bearing the inscription "aux cavaliers de Courcy Le Mai 1915," was reproduced in *L'Illustration*, no. 3820 (May 20, 1916, facing p. 477). This painting was purchased from Hoffbauer's widow, who settled in Providence.

[P 93]
After **WILLIAM HOGARTH**
British, 1697–1764
The Ballad Singer
Oil on canvas. 25⁵⁄₈″ × 30¼″ (65.1 × 76.8 cm)
Gift of Mrs. Murray S. Danforth. 35.531

Frederick Antal, in a letter of 1947, suggested that this work formerly attributed to Hogarth "is a later (perhaps even end of the 18th century) imitation of Hogarth, put together from various motives of the Noon, the Enraged Musician etc. It seems to me all the more probable as I believe that the type of the ballad singer is already one of Gillray's."

Hoffbauer [P 92]

[P 94]
JOHN HOPPNER
British, 1758–1810
Portrait of a Lady
Oil on canvas. 30″ × 25″ (76.2 × 63.5 cm)
Given in memory of Sofia W. Vervena by her friends. 76.011

Hoppner, a fashionable portrait painter rumored to be the son of George III, exhibited over 160 pictures at the Royal Academy in his lifetime. It was known that, as a rule, the Whig ladies sat for Hoppner, while Tory ladies preferred his friend and rival, Thomas Lawrence (see below).

Hodler [P 91]

Hoppner [P 94]

Huet [P 95]

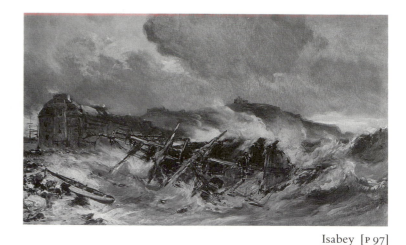

Isabey [P 97]

[P 95]
PAUL HUET
French, 1803–1869
Landscape (Paysage aux grands arbres),
ca. 1860
Oil on panel. 15″ × 18⅛″ (38.1 × 46 cm)
Museum Works of Art Fund. 67.157

BIBLIOG.: *Bull RISD, Museum Notes*, LV:2
(December 1968), p. 44.

Based on the loose brushwork, it has been
suggested that this painting dates from the
early 1860's.

[P 96]
EUGÈNE ISABEY
French, 1803–1886
Cardinal de Richelieu
Oil on canvas. 9¾″ × 7⅝″ (24.7 × 19.3 cm)
The Elizabeth Carr Collection, bequest of
Roy E. Carr. 78.118

This appears to be a pastiche after the por-
trait of Cardinal de Richelieu (1585–1642)
by Philippe de Champagne (1602–1674) in
the Louvre.

[P 97]
EUGÈNE ISABEY
French, 1803–1886
Shipwreck
Stamped, lower right: VENTE/E. ISABEY
Oil on canvas. 16⅝″ × 27⅞″
(42.2 × 70.4 cm)
Gift of "Group 104." 62.085

[P 98]
Attributed to **EUGÈNE ISABEY**
French, 1803–1886
Rossini, 1830
Signed and dated, at left: *E. Isabey/1830*
Oil on vellum. 4⅛″ × 3⅜″ (oval)
(10.48 × 8.57 cm)
Gift of Mrs. Gustav Radeke. 20.378

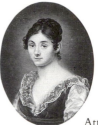

Attributed to Isabey [P 99]

[P 99]
Attributed to **EUGÈNE ISABEY**
French, 1803–1886
Portrait Bust of a Young Woman, 1831
Signed and dated, at right: *E. Isabey/
pinxit(?)/1831*
Oil on vellum. 2¹¹⁄₁₆″ × 2¹⁄₁₆″ (oval)
(6.83 × 6.67 cm)
Gift of Mrs. Gustav Radeke. 20.379

[P 100]
JOSEF ISRAELS
Dutch, 1824–1911
Two Children Wading at the Shore, ca. 1872
Signed, lower left: *Josef Israels*
Oil on panel. 11¹⁄₁₆″ × 16″ (28.2 × 40.6 cm)
Bequest of George Pierce Metcalf. 57.234

BIBLIOG.: Providence, Department of
Art, Brown University, and Museum of
Art, RISD, *To Look on Nature. European and
American Landscape 1800–1874*, Museum of
Art, RISD, February 3–March 5, 1972,
pp. 172–73.

The date of this painting is based on its
similarity to a datable painting in the
Rijksmuseum, Amsterdam, *Children at the
Sea*, 1872, oil on canvas (no. 1284d). The
beach is at Scheveningen, where the artist
spent his summers after 1871 and where
he died in 1911.

Isabey [P 96]

Attributed to Isabey [P 98]

Israels [P 100]

[P 101]
CHARLES-ÉMILE JACQUE
French, 1813–1894
Sheep at Rest
Signed, lower right: *Ch. Jacque*
Oil on panel. 7⅝″ × 11¾″ (19.4 × 29.9 cm)
Bequest of Austin King. 21.448

BIBLIOG.: *Bull RISD*, X:2 (April 1922),
pp. 15–16.

Jacque [P 101]

Jacque [P 102]

[P 102]
CHARLES-ÉMILE JACQUE
French, 1813–1894
Landscape with Sheep and Shepherdess
Signed, lower left: *Ch Jacque*
Oil on canvas. 20½″ × 16½″
(52.1 × 41.9 cm)
Bequest of Emma G. Harris. 26.401

[P 103]
GEORGES JAKOBIDES (JACOBIDES)
Greek, active in Munich, 1853–after 1900
The Children's Quarrel
Signed, lower left: G. JAKOBIDES
Oil on canvas. 45½″ × 71″
(115.6 × 180.3 cm)
Gift of Manton B. Metcalf. 99.004

AUGUSTUS EDWIN JOHN
British, 1879–1961
On the Slopes of Arling Jack, ca. 1911
Signed, lower right: *John*
Oil on panel. 20¹⁄₁₆″ × 12″ (50.9 × 30.5 cm)
Museum Appropriation. 28.062
[see entry no. 75]

[P 104]
JEAN-BARTHOLD JONGKIND
Dutch, 1819–1891
The Inn, 1867
Signed and dated, lower right:
Jongkind/1867
Oil on canvas. 17¹⁄₁₆″ × 13⅜″
(43.3 × 33.9 cm)
Mary B. Jackson Fund. 29.139

BIBLIOG.: *Museum Notes, RISD,* II:6 (September–October 1944), p. 2.

Labeled on back of frame: *Durand-Ruel/ Paris and New York/Jongkind No. 2894(?)/ Lauberye.* This painting was in the collection of Dr. and Mrs. Henry Angell, Boston. It was cleaned and lined with a wax adhesive in 1950.

Jakobides [P 103]

ANGELICA KAUFFMANN
Swiss, 1740–1807
Praxiteles Giving Phryne his Statue of Cupid, 1794
Signed, upper right: *Angelica Kauffman/ Pinx. Romae/1794*
Oil on canvas. 17¹⁄₁₆″ × 19⅛″
(43.3 × 48.6 cm)
Museum Works of Art Fund. 59.008
[see entry no. 3]

Klee (recto) [P 105]

Jongkind [P 104]

[P 105]
PAUL KLEE
Swiss, 1879–1940
Urns (recto), *Self-Portrait as a Canary Magician* (verso), 1922
Signed and dated, recto, beside upper left margin: *Klee/1922 182*
Oil on tissue paper, removed from cardboard. 15⅜″ × 19⅛″ (39.05 × 48.57 cm)
Anonymous gift in memory of William Warren Orswell. 46.470

EXH.: Cologne, Kunsthalle, *Paul Klee*, April 7–June 4, 1979, no. 80.

Klee painted *Urns* over *Self-Portrait as a Canary Magician*, which had been painted on cardboard, after pasting a sheet of tissue paper over the original. When this was discovered in 1966, the tissue was removed from the cardboard to reveal the *Self-Portrait*, seen from the back, on the tissue's reverse.

Klee (verso) [P 105]

[P 106]

HENDRIK PIETER KOEKKOEK
Dutch, 1843–1890
Kluyre Forest, 1861
Signed and dated, lower right: *H.P.K. 1861*
Oil on panel. 8⁷⁄₁₆″ × 7⁷⁄₁₆″ (21.5 × 18.9 cm)
Museum Works of Art Fund. 57.168

Koekkoek [P 106]

OSKAR KOKOSCHKA
Austrian, 1886–1980
Portrait of Franz Hauer, 1914
Signed, upper right: *OK*
Oil on canvas. 47⁷⁄₁₆″ × 41¹¹⁄₁₆″
(120.6 × 105.8 cm)
Georgianna Sayles Aldrich Fund and Museum Works of Art Fund. 53.121
[see entry no. 80]

[P 107]

CHARLES LAPOSTOLET
French, 1824–1890
View of Dieppe
Signed, lower right: *C. Lapostolet*
Oil on canvas. 17¼″ × 31⅛″ (43.5 × 79 cm)
Gift in the name of Walter Callender, by his sons, Walter R. and John A. Callender. 29.102

Laurencin [P 108]

[P 108]

MARIE LAURENCIN
French, 1883–1956
Girl with Pink Fan, ca. 1925
Signed, upper right: *Marie Laurencin*
Oil on canvas. 25⅝″ × 21¼″ (65.2 × 54 cm)
Gift of Mrs. Murray S. Danforth. 31.362

BIBLIOG.: *Bull RISD*, XX:1 (January 1932), pp. 12–14; Daniel Marchesseau, *Marie Laurencin*. Tokyo: Kyuryudo, 1980, p. 139 (fig. 12); Daniel Marchesseau, *Marie Laurencin, 1883–1956, Catalogue raisonné de l'oeuvre peint*. Nagano-Ken: Editions du Musée Marie Laurencin, 1986, p. 174 (no. 349, ill.).

Throughout the 1920's and thereafter until her death, Laurencin, in addition to her identifiable portraits, produced innumerable representations of attractive, anonymous young women dressed fancifully, often in suggested theatrical settings, wearing ribbons, hats, or flowers in their hair, holding animals, bouquets, musical instruments or, as in the Museum's painting, fans. Representations of women holding fans date from her early years, including *Woman with Fan (Self-Portrait)*, 1912, and *La Toilette*, 1912 (Marchesseau, *op. cit.*, 1986, nos. 69–70). A drawing of a *Young Girl with Fan* was exhibited by Laurencin in the Armory Show of 1913 in New York (no. 385). Paintings of unidentified ladies with fans by Laurencin from the 1920's include *Woman in the Forest*, 1920 (Los Angeles, Armand Hammer Collection); *Woman Painter and Her Model*, 1921 (Marchesseau, *op. cit.*, 1986, no. 182); *Venus*, 1922 (Marchesseau, *op. cit.*, 1986, no. 255); and *Young Lady with Poodle*, 1925 (Marchesseau, *op. cit.*, 1986, no. 346).

D. E. S.

[P 109]

SIR JOHN LAVERY
British, 1856–1941
Portrait of Lady Diana Manners, 1912
Signed, lower left: *J. Lavery*; inscribed on verso: *Lady Diana. Portrait. By Lavery. 5 Cromwell Place. London. 1912*
Oil on canvas. 40⅛″ × 30³⁄₁₆″
(101.9 × 76.7 cm)
Gift of G. Pierce Metcalf and Houghton P. Metcalf. 26.008

BIBLIOG.: *The Studio*, LIII (1914), p. 12; Boston, Robert C. Vose Galleries, *Exhibition of the Portraits and Landscapes of Sir John Lavery, R.A.*, December 29, 1925– January 16, 1926, no. 15; *Bull RISD*, XIV:3 (July 1926), pp. 25–27.

Lady Diana Manners Cooper, daughter of the Duke and Duchess of Rutland, was one of the more independent members of the British aristocracy of the early twentieth century. She edited the periodical *Feminina*, in 1920 took up an acting career in film, and appeared in Morris Gest's production, *The Miracle*, playing the roles of the Virgin Mary and a nun. This portrait was painted shortly before her marriage to Captain Duff Cooper, the first Viscount Norwich.

Lapostolet [P 107]

Lavery [P 109]

SIR THOMAS LAWRENCE
British, 1769–1830
Portrait of John Philip Kemble (fragment),
ca. 1800
Oil on canvas. 9⁹⁄₁₆″ × 7⁷⁄₁₆″
(24.2 × 18.9 cm)
Helen M. Danforth Fund. 59.062
[see entry no. 6]

SIR THOMAS LAWRENCE
British, 1769–1830
(Finished posthumously by John Simpson,
British, 1782–1847)
Portrait of Lady Sarah Ingestre, ca. 1827–28
Oil on canvas. 92⁹⁄₁₆″ × 56¼″
(235.1 × 142.8 cm)
Museum Works of Art Fund. 60.039
[see entry no. 7]

Lawrence [P 110]

[P 110]
SIR THOMAS LAWRENCE
British, 1769–1830
Lady Grace Carteret
Oil on canvas. 29¾″ × 24½″
(75.6 × 62.3 cm)
Gift of Miss Ellen D. Sharpe. 32.267

[P 111]
EDWARD LEAR
British, 1812–1888
Corfu from near the Village of Virós, 1858
Signed and dated, lower left: *Corfu./E
Lear./1858.*; inscribed on back of stretcher:
Corfu from near the Village of Viro
Oil on paper, mounted on canvas.
15⁷⁄₁₆″ × 9¹⁵⁄₁₆″ (39.2 × 25.3 cm)
Bought with a gift of the Honorable
Theodore Francis Green. 56.085

BIBLIOG.: *Bull RISD, Museum Notes,* XLIII:2
(December 1956), pp. 9–11; Frederick
Cummings and Allen Staley, *Romantic Art
in Great Britain,* Detroit, Institute of Arts,
1968, p. 283 (no. 199, ill.); Providence,
Brown University, *To Look on Nature:
European and American Landscape, 1800–1874,*
Providence, Museum of Art, Rhode Island
School of Design, February 3–March 5,
1972, pp. 243–44 (pl. 94); L. Candace
Pezzera, *How Pleasant to Know Mr. Lear,*
Museum of Art, Rhode Island School of
Design, October 14–November 21, 1982,
p. 11 (no. 18, ill.).

Lear, the British landscapist, draftsman,
and author, first visited Corfu in 1848,
returning again for intermittent stays
between 1856 and 1858, drawn by "the
splendor of olive grove & orange garden,
the blue of sky . . . the violet of mountain,
rising from peacockwing-hued sea &
topped with lines of silver snow" (let-
ter from Lear to Chichester Fortescue,
December 6, 1857, quoted in Lady
Strachey, ed., *The Letters of Edward Lear.*
New York: Duffield and Company, 1908).
This view was painted above the village of
Virós looking towards the town of Corfu
and the snow-capped mountains of the
Albanian coastline. An appendix in Lady

Lear [P 111]

Strachey's edition of Lear's letters lists
three other painted views of Corfu among
seven oil paintings cited by her for the
year 1858 (not including the Museum's).
The Museum's work may be related to a
series of illustrations – Lear called them
"Painting = Sympathizations" – for an
unrealized project intended to accompany
an edition of the poetry of Alfred Lord
Tennyson, with whom Lear had become
friends in England several years before.
 M. C. O'B.

[P 112]
FRANS VAN LEEMPUTTEN
Belgian, 1850–1914
Sheep Grazing
Signed, lower left: *Frans Van Leemputten*
Oil on canvas. 19⅝″ × 27⅝″
(49.8 × 70.3 cm)
Gift in the name of Walter Callender, by
his sons, Walter R. and John A. Callender.
29.099

BIBLIOG.: *Bull RISD,* XVIII:1 (January
1930), pp. 2–6 (ill.).

Van Leemputten [P 112]

Le Fauconnier [P 113]

Lepine [P 114]

Lhote [P 115]

[P 113]
HENRI LE FAUCONNIER
French, 1881–1946
Village in the Mountains, 1911–12
Oil on canvas. 39⅜″ × 31¹¹⁄₁₆″
(100 × 80.5 cm)
Membership Dues. 71.061

BIBLIOG.: *Bull RISD, Museum Notes,*
LIX:4 (January 1973), pp. 21–38.

This landscape is believed to be one of a
series of paintings created in the summer
of 1911 during a visit to Savoy. Three of
these paintings, including one entitled *Vil-
lage dans la montagne*, were exhibited in the
Salon d'Automne of 1911. It cannot be
determined whether the Museum's paint-
ing was one of these. A related scene of
the same title is found in a private Swiss
collection (38¾″ × 31″, reproduced in *Bull
RISD, Museum Notes,* LIX:4, p. 34). Ann
Murray (*Bull RISD, Museum Notes,* LIX:4,
p. 36) hypothesizes that the Museum's
version represents the culmination of Le
Fauconnier's mature Cubist phase, while
the simplified, planar forms of the version
in Switzerland show the increasing influ-
ence of Kandinsky on his work after 1911.
A painting by this title also was exhibited
in the Moderne-Kunst-Kring exhibition
in Amsterdam (October 6–November 7,
1912).

SILVESTRO LEGA
Italian, 1826–1895
The Dying Mazzini, 1873
Signed and dated, lower right: *S. Lega 73*
Oil on canvas. 30⅛″ × 39½″
(76.5 × 100.4 cm)
Helen M. Danforth Fund. 59.071
[see entry no. 56]

FERNAND LÉGER
French, 1881–1955
Flowers, 1926
Signed and dated, lower right: *F. Léger/26*
Oil on canvas. 36⁵⁄₁₆″ × 25¾″
(92.2 × 65.5 cm)
Anonymous gift. 81.097
[see entry no. 84]

GEORGES LEMMEN
Belgian, 1865–1916
Thames Scene, the Elevator, ca. 1892
Oil on canvas. 23½″ × 32½″
(59.7 × 83.2 cm)
Anonymous gift. 57.166
[see entry no. 69]

[P 114]
STANISLAS LEPINE
French, 1835–1892
View of Paris
Signed, lower left: *S. Lepine*
Oil on canvas, mounted on panel.
13⅞″ × 15⅞″ (35.3 × 40.3 cm)
Gift of Daniel Robbins and Robert Leeson.
73.010

[P 115]
ANDRÉ LHOTE
French, 1885–1962
The Garden, 1914
Signed, lower left: *A.LHOTE*
Oil on canvas. 18⅜″ × 13⅛″
(46.7 × 33.3 cm)
Membership Dues. 67.158

BIBLIOG.: *Bull RISD, Museum Notes,* LV:2
(December 1968), pp. 57–58.

[P 116]
EUGENIO LUCAS Y PADILLA
Spanish, 1824–1870
*The Romeria de San Isidro at San Antonio
de la Florida,* ca. 1856–57
Oil on canvas. 20¼″ × 27″ (51.4 × 68.5 cm)
Museum Appropriation. 32.239

BIBLIOG.: *Bull RISD,* XXI:1 (January 1933),
pp. 15–16; Elizabeth de Gue Trapier,
Eugenio Lucas y Padilla. New York, 1940,
p. 21 (pl. XIV); Dallas, Meadows Museum,
Goya and the Art of His Time, December 7,
1982–February 6, 1983, pp. 102–03.

This painting represents the popular festi-
val (*romeria*) celebrating the feast day of
Saint Isidore, patron saint of Madrid. It is
painted in a retardataire style that recalls
Goya's 1788 painting of the same subject,
in the Prado. Lucas painted at least four
other versions of this subject. This paint-
ing was cleaned and relined in 1943.

Maclise [P 117]

[P 117]

DANIEL MACLISE
British, 1806–1870
The Dying Dyer or the Blue Devils
Oil on paper, mounted on board.
9¾″ × 14⅞″ (24.76 × 37.78 cm)
Museum Works of Art Fund. 58.146

BIBLIOG.: *Bull RISD, Museum Notes,* XLV:3
(March 1959), pp. 4–7 (fig. 9).

The title, *The Dying Dyer/or the Blue Devils,*
and the artist's name, Daniel Maclise,
P.R.S.A., are printed in black in small
capitals on the front of the lower member
of the old frame.

ÉDOUARD MANET
French, 1832–1883
Children in the Tuileries Gardens, ca. 1861–62
Oil on canvas. 14¹³⁄₁₆″ × 18⅛″
(37.6 × 46 cm)
Museum Appropriation. 42.190
[see entry no. 42]

ÉDOUARD MANET
French, 1832–1883
Le Repos, ca. 1870–71
Signed, lower right corner of framed print:
Manet
Oil on canvas. 59⅛″ × 44⅞″
(150.2 × 114 cm)
Bequest of Mrs. Edith Stuyvesant
Vanderbilt Gerry. 59.027
[see entry no. 43]

[P 118]
JEAN-HIPPOLYTE MARCHAND
French, 1882–1941
Self-Portrait, ca. 1909–12
Signed, upper left: *JHMarchand*
Oil on board. 26¹⁄₁₆″ × 19¼″
(66.2 × 48.8 cm)
Museum Works of Art Fund. 66.015

BIBLIOG.: Buffalo, Albright-Knox Art
Gallery, *Painters of the Section d'Or, the
Alternatives to Cubism,* 1967, no. 26.

The provenance of this painting can be
traced to the Marchand Estate. It is one of
no less than eleven self-portraits painted
by Marchand between 1906 and 1912. One
of these self-portraits may be the *Etude de
tête* exhibited among the five works sub-
mitted by Marchand to the *Salon de La
Section d'Or* in 1912 (no. 99).

HENRI MATISSE
French, 1869–1954
Still Life with Lemons, ca. 1914
Signed, lower left: *Henri Matisse*
Oil on canvas. 27⅝″ × 21³⁄₁₆″ (70 × 53.8 cm)
Gift of Miss Edith Wetmore. 39.093
[see entry no. 81]

HENRI MATISSE
French, 1869–1954
The Green Pumpkin, ca. 1916
Signed, lower right: *Henri Matisse*
Oil on canvas. 31½″ × 25⅜″ (80 × 64.4 cm)
Anonymous gift. 57.037
[see entry no. 82]

Marchand [P 118]

[P 119]
G. MAZZOLINI
Italian, 19th century
Mother and Child, 1861
Signed and dated, lower right:
G. Mazzolini dipinse/Roma 1861
Oil on canvas. 24½″ × 19⁹⁄₁₆″
(62.2 × 49.8 cm)
Gift of Johns H. Congdon, 2nd. 65.014

JEAN-LOUIS-ERNEST MEISSONIER
French, 1815–1891
Sketch for the "Outpost of the Hussars,"
ca. 1868
Signed, lower center: monogram
E (reversed) *M*
Oil on panel. 12¼″ × 9⅛″ (31.1 × 23.2 cm)
Museum Works of Art Fund. 54.174
[see entry no. 50]

Mazzolini [P 119]

Lucas [P 116]

Attributed to Mengs [p 120]

[p 120]
Attributed to
ANTON RAPHAEL MENGS
German, 1728–1779
Portrait of a Young Man, after 1770
Signed, upper left: *Ant. Raffael Mengs* (perhaps added later)
Oil on canvas. 39″ × 28⅞″ (99.1 × 73.4 cm)
Corporation Membership Dues Fund. 57.281

BIBLIOG.: *Bull* RISD, *Museum Notes*, XLV:4 (May 1959), pp. 3–8, 16.

This portrait was previously in the collection of Viscount Ullswater, Campsea Asche, Suffolk. Professor Harald Olsen, of the Royal Museum of Fine Arts, Copenhagen, has identified a replica by the Danish painter Peter Als (1726–1776), a pupil of Mengs who was in Rome between 1756–60, which is a copy of the head and shoulders of the RISD portrait. Anthony Clark, however, has proposed a date of after 1770 for the Museum's portrait.

JEAN METZINGER
French, 1883–1956
Portrait of Albert Gleizes, 1911–12
Signed, lower right: *Metzinger*
Oil on canvas. 25⅝″ × 21⅜″ (65 × 54.3 cm)
Paris Auction Fund and Museum Works of Art Fund. 66.162
[see entry no. 76]

[p 121]
CONSTANTIN MEUNIER
Belgian, 1831–1905
Portrait of a Woman
Signed, lower right: *C Meunier*
Oil on canvas. 21⅜″ × 16⅝″
(54.3 × 42.3 cm)
Gift of Uforia, Inc. 73.134

Meunier [p 121]

[p 122]
GEORGES MICHEL
French, 1763–1843
Landscape
Oil on paper, mounted on canvas.
14⅝″ × 19⁷⁄₁₆″ (37.2 × 49.4 cm)
Bequest of Edward F. Ely. 20.070

BIBLIOG.: *Bull* RISD, IX:3 (July 1921), pp. 26–27 (ill.).

In the photograph published in 1921, this painting shows a figure walking along the road with a walking stick. At the time that this painting was cleaned in 1953, it was determined that this figure was added by a later hand, and it was removed.

[p 123]
GEORGES MICHEL
French, 1763–1843
Landscape
Oil on canvas. 20⅞″ × 28⅞″
(50.8 × 73.4 cm)
Gift of Miss Hope Smith and Brockholst M. Smith in memory of the Honorable Royal C. Taft. 59.032

[p 124]
Attributed to **GEORGES MICHEL**
French, 1763–1843
The Stone Bridge, 1822
Signed and dated, lower left: *Michel/1822*
Oil on board. 7¹³⁄₁₆″ × 11¼″
(19.9 × 28.6 cm)
Gift in the name of Walter Callender, by his sons, Walter R. and John A. Callender. 29.106

Michel [p 123]

Michel [p 122]

Attributed to Michel [P 124]

Monticelli [P 126]

[P 125]
Attributed to **AMEDEO MODIGLIANI**
Italian, 1884–1920
Portrait of Anna Zborowska
Oil on canvas. 26¹/₁₆″ × 20¹/₁₆″
(66.2 × 51 cm)
Anonymous gift. 33.069

BIBLIOG.: *Bull RISD,* XIII:3 (July 1933),
pp. 46–49.

The sitter, Anna Zborowska, and her hus-
band, the poet Leopold Zborowski, were
close friends and supporters of Modigliani
and the subjects of numerous works by
him (Arthur Pfannstiel's 1929 catalogue
lists nine painted portraits of Anna, of
which six originate from the collection of
Leopold Zborowski). The Museum owns
two drawings representing Anna and
Leopold, given by Miss Edith Wetmore in
1932. Although doubts have been expressed
about the authenticity of this painting,
Museum records indicate that it was pur-
chased by the donor directly from
Leopold Zborowski, and in 1953 it was
authenticated by the sculptor Jacques
Lipchitz, who had been close to Modigliani
and the Zborowskis.

CLAUDE MONET
French, 1840–1926
Honfleur (The Seine near its Estuary),
ca. 1868
Signed, lower right: *Claude Monet*
Oil on canvas. 18¹⁵/₁₆″ × 29″
(48.1 × 73.8 cm)
Bequest of George Pierce Metcalf. 57.236
[see entry no. 46]

CLAUDE MONET
French, 1840–1926
Hyde Park, London, ca. 1871
Signed, lower left: *Claude Monet*
Oil on canvas. 15¹⁵/₁₆″ × 29¹/₈″
(40.5 × 74 cm)
Gift of Mrs. Murray S. Danforth. 42.218
[see entry no. 47]

CLAUDE MONET
French, 1840–1926
The Basin at Argenteuil, 1874
Signed, lower left: *Claude Monet*
Oil on canvas. 21³/₄″ × 29¹/₄″
(50 × 74.3 cm)
Anonymous gift. 42.219
[see entry no. 48]

CLAUDE MONET
French, 1840–1926
The Seine at Giverny, 1885
Signed and dated, lower right:
Claude Monet 85
Oil on canvas. 25⁷/₈″ × 36½″
(65.7 × 92.7 cm)
Museum Appropriation, by exchange.
44.541
[see entry no. 49]

[P 126]
ADOLPHE MONTICELLI
French, 1824–1886
Figures in a Landscape
Signed, lower right: *Monticelli*
Oil on panel. 14½″ × 18¹⁵/₁₆″
(36.8 × 48.1 cm)
Gift of Albert M. Steinert. 48.428

[P 127]
ADOLPHE MONTICELLI
French, 1824–1886
Two Women and a Child
Oil on canvas. 12″ × 7¹⁵/₁₆″
(30.4 × 20.2 cm)
Gift of the Estate of Albert M. Steinert.
67.144

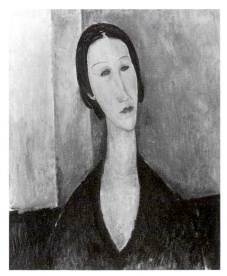

Attributed to Modigliani [P 125]

Monticelli [P 127]

Morland [P 128] De Noter [P 130]

[P 128]
GEORGE MORLAND
British, 1763–1804
The Ass Race, ca. 1789
Oil on canvas. 14″ × 17⅝″
(35.5 × 44.8 cm)
Gift of Manton B. Metcalf. 21.481

BIBLIOG.: J. Hassell, *Memoirs of the Life of the late George Morland.* London, 1806, pp. 117, 166; George C. Williamson, *George Morland, His Life and Work.* London, 1904, pp. 103, 133; *Bull RISD,* XII:1 (January 1924), p. 2; *Bull RISD,* XII:2 (April 1924), pp. 14–15.

This painting was exhibited at the Society of Artists, London, 1790 (no. 193), along with a companion piece, *A Mad Bull* (no. 194). Hassell lists this painting as "The Ass Race, A hurly-burly scene, although not without point." An etching with color aquatint reproducing this painting, engraved by Morland's brother-in-law, William Ward (1766–1826), and published by P. Cornman in 1789, is also found in the Museum's collection (23.343). The painting was cleaned in 1953.

[P 129]
Northern European, first quarter of the 19th century
Portrait of a Young Lady, ca. 1820
Oil on canvas. 29¾″ × 23⁹⁄₁₆″
(75.5 × 59.9 cm)
Gift of Julius H. Weitzner. 57.294

This painting was formerly attributed to Christoffer-Wilhelm Eckersberg (Danish, 1783–1853). Although it is a work of genuine quality and of the same period, few Eckersberg scholars support this attribution. Dr. Haavard Rostrup, former Keeper of the Department of Modern Art, Ny Carlsberg Glyptothek, Copenhagen; Hanne Westergaard, Curator, Statens Museum for Kunst, Copenhagen; Harald Olsen, Royal Museum of Fine Arts, Copenhagen; and Dr. Colin J. Bailey, Edinburgh College of Art, have independently suggested that the author of this work may be a follower of Eckersberg from the Hamburg School, or perhaps a Swedish painter who may have studied at the Copenhagen Academy.

[P 130]
DAVID ÉMIL JOSEPH DE NOTER
Belgian, 1825–1900
Still Life
Oil on panel. 15½″ × 21¾″
(40 × 57 cm)
Gift of Dr. Halsey DeWolf. 57.176

JOHN OPIE
British, 1761–1807
La Fille mal gardée (The Fugitive), 1800
Oil on canvas. 108″ × 72″
(274.4 × 182.9 cm)
Gift of the Wunsch Foundation. 83.221
[see entry no. 5]

Orpen [P 131]

[P 131]
SIR WILLIAM ORPEN
British, 1878–1931
Wojeck Halsuijn: The Polish Messenger, 1903(?)
Signed, lower right: *Orpen;* inscribed, upper left: *Wojeck Halsuijn/Polski Gondy*
Oil on canvas. 30⅛″ × 25⅛″
(76.6 × 63.8 cm)
Gift of Dr. and Mrs. Murray S. Danforth. 29.277

BIBLIOG.: *Bull RISD,* XIX:1 (January 1931), pp. 1–2; P. G. Konody and Sidney Dark, *Sir William Orpen, Artist and Man.* London, 1932, p. 266(?).

Orpen, a prolific portraitist, painted numerous self-portraits in imaginary roles. The features of this sitter, although identified by name, closely resemble the artist's own. This may be the painting listed as *The Fur Cap* (1903) in Konody and Dark's chronology of Orpen's painting.

Northern European [P 129]

Orpen [P 132]

[P 132]
SIR WILLIAM ORPEN
British, 1878–1931
Portrait of Mr. S. O. Metcalf, 1925
Signed and dated, lower right: ORPEN 1925
Oil on canvas. 33¼″ × 30¼″
(84.2 × 76.3 cm)
Bequest of George Pierce Metcalf. 57.226

BIBLIOG.: P. G. Konody and Sidney Dark,
Sir William Orpen, Artist and Man. London,
1932, p. 273.

AMÉDÉE OZENFANT
French, 1886–1966
Large Jug and Architecture, 1926
Signed and dated, lower right:
OZENFANT 1926
Oil on canvas. 119¾″ × 58½″
(304× 149 cm)
Mary B. Jackson Fund. 39.095
[see entry no. 85]

JOSEPH PAELINCK
Belgian, 1781–1839
William I, King of the Netherlands, 1817
Signed and dated, at right: J. PAELINCK/
BRUXS/1817.
Oil on canvas. 88″ × 69″
(223.5 × 175.3 cm)
Museum Works of Art Fund. 59.090a
[see entry no. 10]

JOSEPH PAELINCK
Belgian, 1781–1839
*Frederica Wilhelmina, Queen of the
Netherlands,* 1817
Signed and dated, at right: J. PAELINCK/
BRUXS/1817.
Oil on canvas. 88″ × 69″
(223.5 × 175.3 cm)
Museum Works of Art Fund. 56.090b
[see entry no. 11]

[P 133]
Circle of
AMABLE-LOUIS-CLAUDE PAGNEST
French, 1790–1819
Study of a Man
Oil on canvas. 30″ × 32¼″
(76.2 × 81.91 cm)
Gift of the Wunsch Foundation. 1987.113.3

Pagnest, although not listed by Delécluze
among J.-L. David's pupils, is represented
in the front row of artists at work in Léon-
Matthieu Cocherau's *Interior of David's
Studio,* Salon of 1814 (Paris, Musée du
Louvre, Inv. 3280). Because of his early
death, he left few paintings; among them
are two portraits in the Louvre and an
academic male nude which in 1813 was
awarded first prize in the *concours de la
demi-figure peinte* at the Ecole des Beaux-
Arts, Paris, and which has been in its col-
lection ever since (Inv. N. 1479), accessible
to students who frequently made copies.
This academic nude study was at Christie's,
London, *Important Continental Pictures of
the 19th and 20th Centuries,* sale, June 19,
1981, lot 40, attributed in the catalogue to
Géricault.

At the time of the actual sale this attri-
bution was withdrawn, and the painting
was associated with the academic nude by
Pagnest. There are no less than four known
copies by other artists of Pagnest's origi-
nal, many of them incorrectly attributed to
Géricault, including the Museum's version
and one also in the collection of the Ecole
des Beaux-Arts. Two known studies of the
same model appear to have been painted
at the same *séance de pose* in 1813 by unknown
hands, representing the same figure from
slightly different points of view; these can
be found in the Musée de la Ville de Poitiers
and in a private collection (ex coll. Hans E.
Buhler, sale, Christie's, London, Novem-
ber 15, 1985, no. 6, bearing a spurious
Géricault signature). The RISD painting
descends from the Bodin collection, sale,
Hôtel Drouot, Paris, December 13, 1922,
no. 49, at which time it also bore a Géri-
cault signature.

**REVEREND MATTHEW
WILLIAM PETERS**
British, 1742–1814
Lydia, ca. 1776
Oil on canvas. 25″ × 30″
(63.5 × 76.2 cm)
Gift of Mrs. Guy Fairfax Cary. 62.009
[see entry no. 1]

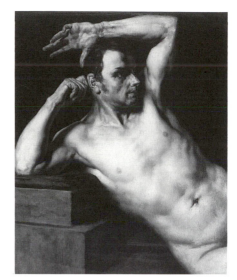

Circle of Pagnest [P 133]

[P 134]
GLYN W. PHILPOT
British, 1884–1937
A Spaniard
Signed, lower right: G. W. P.
Oil on canvas. 18¼″ × 16⅛″
(46.4 × 41 cm)
Gift of Mrs. Gustav Radeke. 21.342

PABLO PICASSO
Spanish, 1881–1973
The Diners (Les Soupeurs), 1901
Signed, lower right: *Picasso*
Oil on cardboard. 18⅝″ × 24⁹⁄₁₆″
(47.4 × 62.4 cm)
Bequest of George Pierce Metcalf. 57.237
[see entry no. 73]

PABLO PICASSO
Spanish, 1881–1973
Seated Woman with a Book, ca. 1911–12
Signed on verso, upper right, in black:
Picasso
Oil on canvas. 16¼″ × 9½″
(41.2 × 24 cm)
Museum Works of Art Fund. 51.094
[see entry no. 74]

Philpot [P 134]

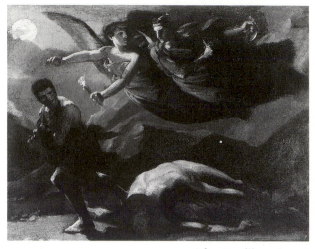

After Prud'hon [P 135]

Attributed to Puvis de Chavannes [P 136]

CAMILLE PISSARRO
French, 1830–1903
Field and Mill at Osny, 1884
Signed and dated, lower right:
C. Pissarro. 84
Oil on canvas. 21⅜″ × 25¹³⁄₁₆″
(54.2 × 65.5 cm)
Gift of Mrs. Houghton P. Metcalf in
memory of her husband. 72.096
[see entry no. 62]

[P 135]
After **PIERRE-PAUL PRUD'HON**
French, 1758–1823
Divine Vengeance and Justice Pursuing Crime
Oil on canvas. 12⅞″ × 16¹⁄₁₆″
(32.6 × 40.8 cm)
Gift of Mrs. Murray S. Danforth, in
memory of Eliza G. Radeke on the occa-
sion of the 75th Anniversary of the Rhode
Island School of Design. 53.371

BIBLIOG.: Sylvan Laveissière, *Prud'hon,
"La Justice et la Vengeance divine poursuivant
le Crime."* Paris: Editions de la Réunion
des Musées Nationaux, 1986, pp. 103–04
(no. 85 B).

Laveissière lists this painting among six
sketches by unknown hands copied after
Prud'hon's large canvas commissioned for
the Palais de Justice, exhibited in the Salons
of 1808 and 1814, and accessioned by the
Louvre in 1826 (Inv. 7340). The RISD paint-
ing differs considerably in technique from
a known sketch by Prud'hon of the same
subject belonging to the Getty Museum
in Malibu. A label on the stretcher of
the Museum's canvas reads: *"Etude par
Prud'hon/offerte par le Maître/à . . . de
Bois . . ./Vente de Boisfremont en 1879."*
Charles Boulanger de Boisfremont (1773–
1838), a pupil and friend of Prud'hon,
worked in a derivative style. Sales of his

collection were held in 1864 and 1870,
neither listing a study for *La Justice.*
Suzanne Gutwirth, nevertheless, has noted
that de Boisfremont frequently assisted
Prud'hon in the completion of his works,
and one may speculate that this is a copy
by him. Jacques Foucart, Curator of Paint-
ings at the Louvre, has suggested, on the
other hand, that it may be a copy by the
Baron François Gérard (1770–1837), also a
pupil of David. While this attribution can-
not be confirmed, it attests to the high
quality of this painted sketch, whose hand
remains unidentified.

[P 136]
Attributed to
PIERRE PUVIS DE CHAVANNES
French, 1824–1898
Christ Healing the Paralytic, ca. 1856 (?)
Signed, lower right: *P. Puvis de C.*
Oil on paper, mounted on board.
16½″ × 12¹⁵⁄₁₆″ (42 × 33 cm)
Gift of Mrs. Gustav Radeke. 28.003

The provenance for this painting is given
as ex-collections Martin Birnbaum (?),
Freund-Deschamps, and Jean Dollfus.
However, it is not mentioned in the sales
catalogues of the Freund-Deschamps col-
lection (Paris, Hôtel Drouot, May 1912) or
of the Dollfus collection (Paris, Hôtel
Drouot, 1912). Although doubts have
been expressed about the authenticity of
this work, Aimée Price Brown, who has
been writing a catalogue of Puvis's paint-
ing, has suggested that this may be an
early painting by Puvis, reflecting the
influence of Delacroix. The signature is
identical to the one applied by Puvis to his
drawings. A photograph of a related and
more finished version of this subject (pres-
ent location unknown), inspired by Luke
(5:26), signed and dated 1856, is found in
the archives of the Musée d'Orsay, Paris.

[P 137]
MARTIN FERDINAND QUADAL
Austrian, 1736–1811
Self-Portrait, ca. 1785
Oil on canvas. 14⅝″ × 10¾″
(37.2 × 27.3 cm)
Gift of the Wunsch Foundation. 1987.113.2

This self-portrait by Quadal appears to be
a study for, or replica of, the self-portrait
of the artist with his dog found in the
Uffizi, Florence. That work is dated July
1785. A copy of the Uffizi portrait, dated
1788, was sold at Sotheby's, New York,
Old Master Paintings, January 11, 1990
(no. 129).

Quadal [P 137]

Raeburn [P 138]

[P 138]
SIR HENRY RAEBURN
British, 1756–1823
Portrait of Robert Sym, ca. 1810
Oil on canvas. 30″ × 25″
(75.2 × 63.5 cm)
Gift of Mrs. Murray S. Danforth. 35.270

BIBLIOG.: Sir Walter Armstrong, *Sir Henry Raeburn*. London and New York, 1901, p. 113; N. Scott Moncrieff, ed., *Portrait of Robert Sym, by Sir Henry Raeburn, R.A., (1756–1823)*. Privately published, n.d. [1930?].

Robert Sym (1752–1845), a gentleman of independent means and "writer to the signet" (lawyer) from Edinburgh, inspired the character Timithy Tickler in the *Noctes Ambrosianae*, written for *Blackwood's Magazine* between 1822 and 1835 by his nephew, John Wilson (Christopher North). This painting was inherited by Wilson and passed along to his descendants, from whom it was acquired by Mrs. Danforth. An engraving after this portrait was made by Robert C. Bell. From Raeburn's papers,

it can be determined that this portrait was painted around 1810, at the same time that he completed a portrait of Sym's close friend, Lord William Craig.

[P 139]
JEAN FRANÇOIS RAFFAËLLI
French, 1850–1924
Street Scene – Winter
Signed, lower right: *J F RAFFAËLLI*
Oil on panel. 22¼″ × 28⅞″
(56.6 × 73.4 cm)
Gift in the name of Walter Callender, by his sons, Walter R. and John A. Callender. 29.104

[P 140]
JEAN FRANÇOIS RAFFAËLLI
French, 1850–1924
Place de la Concorde, Paris, ca. 1899
Signed, lower right: *J F RAFFAËLLI*
Oil on canvas. 28¼″ × 32¼″
(71.4 × 81.9 cm)
Gift of Colonel Webster Knight. 28.040

BIBLIOG.: New York, Durand-Ruel Galleries, *Catalogue of Paintings, Drypoints and Etchings . . . by Jean François Raffaëlli*, 1899, no. 28; *Bull RISD*, XVI:3 (July 1928), pp. 31–32.

An autograph letter dated 1899 from Raffaëlli in the Museum's archives indicates that this painting was bought by Dr. James D. Tantum of Trenton from the Durand-Ruel exhibition. The painting was cleaned and relined in 1952.

PIERRE-AUGUSTE RENOIR
French, 1841–1919
Young Woman Reading an Illustrated Journal, ca. 1880
Signed, upper right: *Renoir*
Oil on canvas. 18¼″ × 22″
(46.3 × 55.9 cm)
Museum Appropriation. 22.125
[see entry no. 60]

PIERRE-AUGUSTE RENOIR
French, 1841–1919
Young Shepherd in Repose (Portrait of Alexander Thurneyssen), 1911
Signed and dated, lower right: *Renoir. 1911*
Oil on canvas. 29½″ × 36⅝″
(74.9 × 93 cm)
Museum Works of Art Fund. 45.199
[see entry no. 61]

[P 141]
ÉDOUARD FRÉDÉRIC WILHELM RICHTER
French, 1844–1913
Lady Standing before an Open Window, 1862
Signed and dated, lower right: *Ed. Richter. 1862. Paris.*; signed and dated, at base of French window: *Ed. Richter. 186(?).*
Oil on canvas. 35⁹⁄₁₆″ × 25¹¹⁄₁₆″
(90.3 × 65.3 cm)
Helen M. Danforth Fund. 60.003

Richter [P 141]

Raffaëlli [P 139]

Raffaëlli [P 140]

Rico [P 142]

[P 142]
MARTIN RICO Y ORTEGA
Spanish, 1833–1908
Fishermen's Houses–Giudecca, ca. 1896
Signed, lower right: *Rico*
Oil on panel. 13¾″ × 9½″
(34.9 × 24.2 cm)
Bequest of George Pierce Metcalf. 57.238

[P 143]
LOUIS ANTOINE LÉON RIESENER
French, 1808–1878
La Bacchante, 1836
Signed and dated, lower right:
L. Riesener/1836
Oil on canvas. 42¼″ × 49⅞″
(107.3 × 126.5 cm)
Edgar J. Lownes Fund. 69.078

BIBLIOG.: Théophile Gautier, *La Presse,*
March 23, 1835; Raymond Escholier, *Léon
Riesener, 1808–1878.* Paris: Pavillon des
Arts, n.d., no. 39; *Bull RISD, Museum Notes,*
LVI:4 (Summer 1970), pp. 36–37 (no. 38).

Exhibited in the Salon of 1836, from
which it was purchased by Alexandre
Dumas, this painting was praised by
Théophile Gautier for its brilliant
brushwork and color. A second version,
dated 1855, now in the Louvre [R.F. 394],
was exhibited by Reisener in the Exposi-
tion Universelle of that year and then in
the Salon of 1864. This painting descended
from the Alexandre Dumas sale, Paris,
Hôtel Drouot, May 8–13, 1892, from
which it was purchased by the painter
Albert-Auguste Fourie.

[P 144]
LOUIS RIOU
French, 1893–?
A Street in the Isle-Adam
Signed, lower left: *Louis Riou*
Oil on canvas. 21½″ × 25¹¹⁄₁₆″
(54 × 65.3 cm)
Gift of Miss Ellen D. Sharpe. 29.024

HUBERT ROBERT
French, 1733–1808
Architectural Fantasy, ca. 1802–08
Oil on canvas. 45¹⁄₁₆″ × 58³⁄₁₆″
(114.4 × 147.8 cm)
Museum Appropriation. 37.104
[see entry no. 9]

[P 145]
Attributed to **GEORGE ROMNEY**
British, 1734–1802
Vice-Admiral Sir William George Fairfax
Oil on canvas. 30½″ × 25¼″
(77.47 × 64.13 cm)
Bequest of Miss Ellen D. Sharpe.
54.147.74

BIBLIOG.: *Bull RISD, Museum Notes,* XLII:2
(November 1955), pp. 1–12 (ill. p. 2).

At the time of its acquisition, the subject
was identified by an inscription on a label
on the stretcher (now lost) and confirmed
by comparison to an engraving of Fairfax
(1739–1813) in the *Naval Chronicle,* v, 465.
John Maxon accepted the attribution to
Romney and proposed a date of ca. 1795.
Malcolm Cormack, Yale Center for British
Art, upon examination of the painting,
questioned this attribution, suggesting it
may rather be "after Romney."

Attributed to Romney [P 145]

[P 146]
HENRIETTE RONNER
Dutch, 1821–1909
Indefatigables
Signed, lower left: *Henriette Ronner*
Oil on panel. 9⅝″ × 12¹³⁄₁₆″
(24.4 × 32.5 cm)
Gift of Miss Maria L. Corliss. 29.109

Riesener [P 143]

Riou [P 144]

Ronner [P 146]

H. Rousseau [P 147]

H. Rousseau [P 148]

[P 147]
HENRI ROUSSEAU
French, 1844–1910
A Corner of the Park at Bellevue. Autumn, Sunset, 1902
Signed, lower left: *Henri Rousseau*
Oil on canvas. 23³⁄₁₆″ × 19³⁄₄″
(61.2 × 50.3 cm)
Gift of Mrs. Henry D. Sharpe. 77.114

BIBLIOG.: Christian Zervos, *Rousseau.* Paris: Editions "Cahiers d'Art," 1927, no. 15; Jean Bouret, *Henri Rousseau.* Neuchâtel: Ises et Calendes, 1961, no. 131; Dora Vallier, *Henri Rousseau.* Paris: Flammarion, 1961, no. 143; Dora Vallier, *L'Opera completa di Rousseau, il Doganiere.* Milano: Rizzoli, 1969, no. 223; Henry Certigny, *Le Douanier Rousseau en son temps, biographie et catalogue raisonné.* Tokyo: Bunkazai Kenkyujyo, 1984, I, no. 184.

This painting was exhibited in the eighteenth Salon de la Société des Artistes Indépendants, Paris, 1902 (no. 1544), from which it was purchased for 90 Frs. It was in the Collection Paul Guillaume, Paris, between 1927 and 1933.

[P 148]
HENRI ROUSSEAU
French, 1844–1910
Flowers in a Vase, ca. 1909–10 (?)
Signed, lower right: *Henri Rousseau*
Oil on canvas. 16¼″ × 13⅛″
(41.3 × 33.3 cm)
Gift of Mrs. Murray S. Danforth. 42.220

BIBLIOG.: Christian Zervos, *Rousseau.* Paris: Editions "Cahiers d'Art," 1927, opp. p. 1 (ill., no. 14 ?); Jean Bouret, *Henri Rousseau.* Neuchâtel: Ises et Calendes, 1961, no. 116; Dora Vallier, *Henri Rousseau.* Paris: Flammarion, 1961, no. 175; Dora Vallier, *L'Opera completa di Rousseau, il* *Doganiere.* Milan: Rizzoli, 1969, no. 236; Henry Certigny, *Le Douanier Rousseau en son temps, biographie et catalogue raisonné.* Tokyo: Bunkazai Kenkyujyo, 1984, I, no. 150.

This painting was acquired by Mrs. Danforth from the Carroll Carstairs Gallery, New York. Vallier traces it to the collection of Paul Guillaume, Paris, and proposes a date of 1909–10; Certigny and Bouret date it to ca. 1897 and 1899 respectively. A similar composition and backdrop are seen in *Flowers* (London, Tate Gallery), for which they favor a dating of ca. 1909–10. It seems arguable that the RISD painting is contemporary with it.

[P 149]
THÉODORE ROUSSEAU
French, 1812–1867
Landscape
Signed, lower left: *TH Rousseau*
Oil on panel. 7⅝″ × 10⅜″
(19.3 × 26.4 cm)
Gift of Miss Ruth Ely. 20.071

BIBLIOG.: *Bull RISD,* IX:3 (July 1921), p. 27.

The picture surface was cleaned in 1943.

T. Rousseau [P 149]

LOUISE-JOSÉPHINE SARAZIN DE BELMONT
French, 1790–1871
A View of Paris from the Louvre, 1835
Signed and dated, lower left: *L. J. S. de B. Paris 1835*
Oil on canvas. 47⅛″ × 64″
(119.6 × 162.6 cm)
Helen M. Danforth Fund. 1987.056
[see entry no. 18]

[P 150]
HENDRIK F. SCHAEFELS
Belgian, 1827–1904
Return of the Sea Beggars, 1876
Signed and dated, lower right:
Hendrik F. Schaefels 1876. Antwerp
Oil on canvas. 27¾″ × 43″
(75 × 109.3 cm)
Gift of Miss Mary Parsons. 04.142

Schaefels [P 150]

ARY SCHEFFER
Dutch, 1795–1858
Equestrian Portrait of George Washington,
ca. 1825
Signed, lower left: *A. Scheffer*
Oil on paper, mounted on canvas.
18⅛″ × 11¼″ (46 × 28.6 cm)
Gift of Mrs. Murray S. Danforth. 74.060
[see entry no. 14]

Schiavoni [P 151]

[P 151]
FELICE SCHIAVONI
Italian, 1803–1881
Duchess of Caumont la Force (née Georgina Smythe), 1838
Signed and dated, to right:
F. Schiavoni. f./1838
Oil on panel. 8″ × 6⁹⁄₁₆″ (20.2 × 16.8 cm)
Helen M. Danforth Fund. 60.036

[P 152]
LEO SCHIERTZ
German, 1840–1881
Man Wearing a Fez
Oil on board. 12⅝″ × 10″ (32.1 × 25.4 cm)
Gift of the Estate of Otto A. Villbrandt.
80.246

WILLIAM BELL SCOTT
British, 1811–1890
Cockcrow, 1856
Signed, lower right, on gravestone:
William/B. Scott
Oil on canvas. 22″ × 27″ (arched top)
(55.9 × 68.6 cm)
Helen M. Danforth Fund. 78.088
[see entry no. 28]

[P 153]
JOAQUIN SOROLLA Y BASTIDA
Spanish, 1863–1923
Fountain in the Forest, La Granja, 1907
Signed and dated, lower right:
J Sorolla B 1907
Oil on canvas. 32″ × 41¹⁵⁄₁₆″
(81.1 × 106.8 cm)
Gift of Mrs. Gustav Radeke. 09.071

BIBLIOG.: *Bull RISD,* VIII:1 (January
1920), pp. 7–8.

Schiertz [P 152]

ALFRED STEVENS
Belgian, 1823–1906
The First Day of Devotion (Interior of a Pawnbroker's Shop), 1854
Signed and dated, lower right:
Alfred Stevens. 54.
Oil on panel. 39½″ × 32¼″
(100.3 × 81.5 cm)
Gift Mrs. Gustav Radeke. 20.288
[see entry no. 26]

[P 154]
After ALFRED STEVENS
Belgian, 1823–1906
Mother and Child in an Interior
Signed, lower right:
Alfred Stevens (spurious)
Oil on panel. 7⅛″ × 11″ (18.1 × 28 cm)
Museum Works of Art Fund. 59.001

The attribution of this painting to Stevens
has been doubted by William A. Coles, a
Stevens scholar, in a letter of October 23,
1989 (Museum files).

[P 155]
CUTHBERT EDMUND SWAN
Irish, 1870–1931
Bengal Tiger
Signed, lower left: *CE SWAN*
Oil on board. 6¹⁵⁄₁₆″ × 10″ (17.8 × 25.4 cm)
Museum Works of Art Fund. 71.138

Swan [P 155]

Sorolla [P 153]

After Stevens [P 154]

248

Tassaert [P 156]

[P 156]
NICOLAS FRANÇOIS OCTAVE TASSAERT
French, 1800–1874
Bathers
Signed, lower right: *O. T.*
Oil on canvas. 18¼" × 13½"
(46.5 × 34.3 cm)
Membership Dues. 70.020

[P 157]
NICOLAS FRANÇOIS OCTAVE TASSAERT
French, 1800–1874
After the Ball
Signed, lower right: *O. T.*
Oil on panel. 8⁹⁄₁₆" × 6³⁄₁₆"
(21.7 × 15.7 cm)
Membership Dues. 70.021

Tassaert [P 157]

Taylor [P 158]

[P 158]
LEONARD CAMPBELL TAYLOR
British, 1874–1969
Interior of Liverpool Town Hall, 1925
Signed, lower left: *L. Campbell Taylor*
Oil on canvas. 33⁹⁄₁₆" × 28"
(85.3 × 71.2 cm)
Bequest of Miss Ellen D. Sharpe.
54.147.90

BIBLIOG.: *The Royal Academy Illustrated.*
London, 1925, p. 75; Herbert Furst, *Leonard Campbell Taylor, R.A., His Place in Art.*
Leigh-on-Sea, 1945, pp. 86–87 (ill.), 145.

Taylor painted a companion to this painting that was exhibited at the Royal Academy in 1926, representing the State Dining Room of the Liverpool Town Hall (coll. C. W. Heppenstall, Pittsburgh). The Liverpool Town Hall, represented here with Victorian figures, was designed by John Wood of Bath (1704–1754) in 1748.

JAMES JACQUES JOSEPH TISSOT
French, 1836–1902
Voie des fleurs, voie des pleurs (The Dance of Death), 1860
Signed and dated, lower left: *JacoBus Tissot. Pinxit. 1860*
Oil on panel. 14⅝" × 48³⁄₁₆"
(37.2 × 122.3 cm)
Jesse H. Metcalf, Georgianna Sayles Aldrich, Mary B. Jackson, and Edgar J. Lownes Funds. 54.172
[see entry no. 31]

JAMES JACQUES JOSEPH TISSOT
French, 1836–1902
The Two Friends, ca. 1881
Signed, lower right: *J. J. Tissot*
Oil on canvas. 45¹¹⁄₁₆" × 20⅞"
(116 × 53.2 cm)
Anonymous gift. 60.005
[see entry no. 32]

JAMES JACQUES JOSEPH TISSOT
French, 1836–1902
Ces Dames des chars (The Circus), 1883–85
Signed, lower right: *J. J. Tissot*
Oil on canvas. 57½" × 39⅝"
(146× 100.65 cm)
Gift of Walter Lowry. 58.186
[see entry no. 33]

JAMES JACQUES JOSEPH TISSOT
French, 1836–1902
In the Louvre, 1883–85
Signed, lower left: *J. James Tissot*
Oil on canvas. 18½" × 12⅛" (47 × 32 cm)
Anonymous gift. 62.078
[see entry no. 34]

Tobeen [P 159]

[P 159]
FÉLIX TOBEEN
French, 1880–1924(?)
The Old Bridge, ca. 1912
Signed, lower right: *Tobeen*
Oil on canvas. 15¹⁄₁₆" × 21⅝"
(38.3 × 55 cm)
Gift of Mrs. Murray S. Danforth. 66.013

BIBLIOG.: New York, Leonard Hutton Galleries, *Albert Gleizes and the Section d'Or,* October 29–December 5, 1964, no. 59; Buffalo, Albright-Knox Art Gallery, *Painters of the Section d'Or,* September 27–October 22, 1967, no. 39.

Tobeen, who came to Paris from Ciboure in 1910, was an exhibitor at the *Salon de La Section d'Or,* held at the Galerie de la Boëtie in October 1912, and appears to have been loosely connected to the Puteaux Cubists. This painting, which may show the same view represented by André Derain in *The Old Bridge at Cagnes,* 1910, in the National Gallery of Art, Washington, D.C., is believed to have been painted in 1912, although it was not among the paintings exhibited by Tobeen at the *Section d'Or.* It descended through the Galerie Bernheim-Jeune to Théodore Duret, Léonce Rosenberg, and the Libaude collection, Paris.

249

Tofanelli [P 160]

[P 160]

STEFANO TOFANELLI
Italian, 1752–1812
Portrait of Count Alessandro Castracane of Lucca, 1781
Inscribed with the name of the sitter and signed with monogram on the letter held by the count; dated on verso: *1781*
Oil on canvas. 24″ × 19½″ (61 × 49.6 cm)
Museum Gift Fund. 55.081

BIBLIOG.: *Bull RISD, Museum Notes*, XLII:2 (November 1955), pp. 1–12 (ill. p. 8); Anthony M. Clark, "The Wallraf-Richartz Portrait of Hewetson," *Wallraf-Richartz Jahrbuch*, XXII (1960), pp. 197–98 (fig. 116); Anthony M. Clark, *Studies in Roman Eighteenth-Century Painting*. Washington, D.C.: Decatur House Press, n.d., pp. 139–41, no. 179.

Ex coll.: Mrs. Helen H. Cowie, Rievensleigh, Dowanhill, Glasgow; Christie's (London), sale, May 18, 1951, no. 112; acquired through Colnaghi, London.

This is believed to be Tofanelli's earliest known portrait.

[P 161]

JAN ZOETELIEF TROMP
Dutch, 1872–?
Dutch Dooryard
Signed, lower right: *J. ZOETELIEF TROMP*
Oil on canvas. 16⅜″ × 21¹⁵⁄₁₆″ (41.6 × 55.8 cm)
Gift of Mrs. Houghton P. Metcalf. 1986.207.1

[P 162]

FRITZ KARL HERMANN VON UHDE
German, 1848–1911
The Busy Family
Signed, lower right: *Uhde* (?)
Oil on paper, mounted on panel. 18⅞″ × 24¹⁄₁₆″ (47.9 × 61.2 cm)
Gift of Jesse H. Metcalf. 94.004

This is the first surviving work by a then-contemporary European painter to enter the Museum's collection.

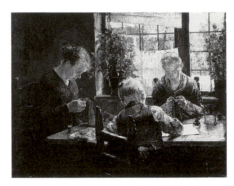

Von Uhde [P 162]

Utrillo [P 163]

[P 163]

MAURICE UTRILLO
French, 1883–1955
The White Chateau, ca. 1911–12
Signed, lower left: *Maurice Utrillo. V.*
Oil on canvas. 24″ × 32⅛″ (60.9 × 81.6 cm)
Anonymous gift. 44.088

BIBLIOG.: Francis Carco, *Maurice Utrillo et son oeuvre*. Paris, 1921, p. 31 (ill.); *Museum Notes, RISD*, II:6 (September–October 1944), n.p. (ill.); Paul Petrides, *L'Oeuvre Complet de Maurice Utrillo*. Paris, 1962, II, no. 554.

This painting was in the collection of Paul Guillaume (1912). It was acquired in the early 1920's by a Berlin collector, who took it out of Germany when Hitler came to power. It was acquired from the Perls Gallery, New York, in 1944.

[P 164]

MAURICE UTRILLO
French, 1883–1955
La Rue du Mont Cenis, Paris
Signed, lower right: *Maurice Utrillo. V.*
Oil on board, mounted on panel. 22½″ × 30⅞″ (57.1 × 78.4 cm)
Gift of Miss Edith Wetmore. 36.209

BIBLIOG.: *Bull RISD*, XXV:1 (January 1937), pp. 10–12 (ill.).

Removal of a cardboard backing from this painting in 1943 revealed another street scene, unfinished, on the reverse, which was obscured when the painting was once more mounted on panel at that time. A photograph of the subject on the reverse is preserved in the Museum's files.

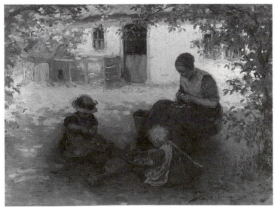

Tromp [P 161]

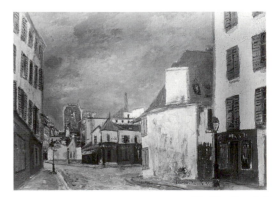

Utrillo [P 164]

Utrillo [p 165]

[p 165]
MAURICE UTRILLO
French, 1883–1955
Street Scene
Oil on panel. 19⅝″ × 28¾″ (49.8 × 73 cm)
Signed, lower left: *Maurice Utrillo. V.*
Bequest of George Pierce Metcalf. 57.230

[p 166]
BERTHA VALKENBURG
Dutch, 19th century
Dutch Girl at Well
Signed, lower right: *Bertha Valkenburg*
Oil on canvas. 19⅝″ × 15¾″
(49.8 × 40 cm)
Gift in the name of Walter Callender, by
his sons, Walter R. and John A. Callender.
29.103

[p 167]
JACQUES VILLON
French, 1875–1963
Head of a Woman, 1914
Signed, lower right: *JV*; signed and dated,
on back of canvas: *Jacques Villon 1914*
Oil on canvas. 21⁹⁄₁₆″ × 18⅛″ (oval)
(54.7 × 46 cm)
Mary B. Jackson Fund. 70.058

BIBLIOG.: Daniel Robbins, *Jacques Villon.*
Cambridge: Fogg Art Museum, 1976,
pp. 83–84 (no. 63, ill.); Judith Zilczer,
*"The Noble Buyer": John Quinn, Patron of
the Avant-Garde.* Washington, D.C.:
Smithsonian Institution Press, 1978, p. 145
(no. 75, ill.); Thomas Williams and Lutz
Riester, *An Exhibition of European Master
Drawings from the 16th to the 20th Centuries,*
New York, Paul Drey Gallery, January 7–
25, 1991, p. 92 (ill.).

This painting was first exhibited at the
Carroll Galleries, New York, in March
1915; it was acquired by John Quinn, New
York, in July 1916 for 800 Frs. It was
acquired by the painter and novelist
Wyndham Lewis (who bought it for $35
from the Quinn Estate in 1927), and later
by Sir Roland Penrose. It is a portrait of
Jacques Villon's sister, Yvonne, and one
of a series of oval portraits created by
Villon between 1912 and 1914 that includes
Young Girl at the Piano (1912, oil on canvas,
New York, coll. Mrs. George Acheson)

Valkenburg [p 166]

Villon [p 167]

Ward [p 168]

and *Portrait of a Man* (1913, oil on canvas,
Columbus, coll. Mr. and Mrs. David
Howald Shawan), respectively portraits of
Yvonne and their father.

The Museum's painting may have been
the basis for Villon's *Seated Woman* (1914,
Paris, coll. Louis Carré et Cie), which is
closely related to the *Seated Woman* in the
Museum's collection by Villon's brother,
Raymond Duchamp-Villon, who shared a
studio in Puteaux with Jacques (see entry
no. 79 and Robbins, *op. cit.,* pp. 83–85).
The grid calibrating the left half of the
sitter's face reflects Villon's prevailing
interest in geometry and mathematical
theory, the subject of frequent discussions
among the circle of Cubist artists who
met at Puteaux. A drawing closely related
to the Museum's *Head of a Woman* has
recently been discovered (see Williams
and Riester, *op. cit.,* pp. 92–93, no. 42); in
the drawing it can be discerned that the
figure's closed left hand is against her
cheek. In the Museum's painting this and
other physiognomic details have become
flatter and more abstract.

[p 168]
EDWARD MATTHEW WARD
British, 1816–1879
A Game of Charades, ca. 1840
Oil on canvas. 44⅛″ × 56⅛″
(112.1 × 142.3 cm)
Museum Works of Art Fund. 53.129

BIBLIOG.: *Museum Notes, RISD,* XI:2
(Winter 1954), n.p. (ill.).

An old label on the original stretcher read:
"*Charades* an *early* production" [*sic*]. By
reason of its costumes and style, this
painting has been dated to 1839 or the
early 1840's; it reflects the influence of
Hogarth into the nineteenth century.

Wertmüller [P 169]

[P 169]
ADOLPH ULRICH WERTMÜLLER
Swedish, 1749–1811
Portrait of Mlle Mars
Oil on canvas. 26″ × 22″ (66 × 55.9 cm)
Bequest of Charles L. Pendleton. 04.166

FRANZ XAVER WINTERHALTER
German, 1806–1873
Prince Arthur William at Age Seven Weeks, 1850
Signed and dated, lower right:
F. Winterhalter/London 1850;
inscribed on verso: *Prince Arthur/William/Ætatis 7 weeks/June 1850*
Oil on canvas. 20⅞″ × 24⅞″ (oval)
(53.1 × 63.2 cm)
Gift of Charles K. Lock. 56.087
[see entry no. 24]

[P 170]
CHRISTIAN ZEITTER
British, active 1824–1862
Sunrise on the Danube, 1844
Signed and dated, lower left: *ZEITTER/1844*
Oil on canvas. 25½″ × 39½″
(64.7 × 101 cm)
Gift of Mrs. John A. Gillespie in memory of Francis Giles Lodge. 67.135

[P 171]
WILLEMUS H. P. J. DE ZWART
Dutch, 1862–1931
The Wagoner
Signed, lower left: *Ws. Zwart*
Oil on panel. 10¹¹⁄₁₆″ × 14³⁄₁₆″
(27.2 × 36 cm)
Gift in the name of Walter Callender, by his sons, Walter R. and John A. Callender. 29.100

[P 172]
WILLEMUS H. P. J. DE ZWART
Dutch, 1862–1931
Traction Horses
Signed, lower left: *Wm. Zwart*
Oil on canvas. 18⅛″ × 31⅜″
(46 × 79.7 cm)
Gift in the name of Walter Callender, by his sons, Walter R. and John A. Callender. 29.098

Zeitter [P 170]

De Zwart [P 171]

De Zwart [P 172]

Arp [S 1]

[S 1]
JEAN (HANS) ARP
French, 1887–1966
Untitled, 1926
Signed and dated, on verso: *Arp/1926*
Painted masonite relief. 29⅝″ × 25″ × ½″
(75.3 × 63.5 × 1.3 cm)
Gift of Mrs. George H. Warren, Jr. 66.356

BIBLIOG.: *Bull RISD, Museum Notes, Recent Accessions,* LIV:2 (1966–67), p. 48.

Barlach [S 2]

[S 2]
ERNST BARLACH
German, 1870–1938
Reading Monks, 1932
Signed and dated, right base:
E. Barlach/1932
Bronze. 22⅝″ × 17″ × 13″
(57.3 × 42.3 × 33 cm)
Museum Works of Art Fund. 50.135

BIBLIOG.: Friedrich Schult, *Ernst Barlach, Das Plastische Werk.* Hamburg, 1959, I, nos. 246, 249.

The original models for this group, of a much smaller dimension, date from 1921.

[S 3]
ERNST BARLACH
German, 1870–1938
Russian Girl, ca. 1937
Stamped, on underside of base:
Schwarzburger Werk-/stätten für Porzellankunst/monogram representing a fox
Porcelain. 9¹⁄₁₆″ × 8⅜″ × 9⅛″
(23 × 21.3 × 23.2 cm)
Gift of Lawrence Marcus. 52.529

BIBLIOG.: Friedrich Schult, *Ernst Barlach, Das Plastische Werk.* Hamburg, 1959, II, no. 476.

A carved version of this figure in wood, dated 1937, is in the Busch-Reisinger Museum, Harvard University, Cambridge.

[S 4]
ANTOINE LOUIS BARYE
French, 1796–1875
Tiger and Snake
Signed, rear base: *BARYE*
Wax over tinted plaster.
12¾″ × 16¼″ × 10½″
(32.4 × 41 × 26.7 cm)
Anonymous gift. 68.146

BIBLIOG.: *Bull RISD, Museum Notes,* LVI:4 (Summer 1970), pp. 15, 17. Concerning Barye's fabrication of plaster and wax models see: Roger Ballu, *L'Oeuvre de Barye.* Paris, 1890; Paul Vitry, "La salle Barye au Musée du Louvre," *Les Musées de France,* no. 6 (1913), pp. 93–96; Jeanne L. Wasserman, ed., *Metamorphoses in Nineteenth-Century Sculpture.* Cambridge, 1975, pp. 79–88; Jean-René Gaborit and Jack Ligot, *Sculptures en cire de l'ancienne Egypte à l'art abstrait.* Paris, 1987, pp. 147–55.

According to Ballu (*op. cit.,* p. 153) and Vitry (*op. cit.,* p. 66), Barye would sometimes rework plaster impressions cast from original clay models by covering them with a coating of wax that would enable him to incise the surface, modifying

Barlach [S 3]

its detail. Very few of these plaster-and-wax models have survived. The Walters Art Gallery, Baltimore, has in its collection a plaster-and-wax *Panther of Tunis,* h. 3.9″ (10 cm), which was used as the model for a bronze edition (for which a cast is also in the Walters Art Gallery). There are no other known casts of the RISD group in any material. Based on the examination of a photograph, Professor Glenn F. Benge, Temple University, has suggested that the *Tiger and Snake* may be closely related to a project for a *surtout de table* consisting of nine animal groups made by Barye for the Duc d'Orléans around 1833–34, and may possibly be a study for the *Python Killing a Gnu* (Baltimore, Walters Art Gallery), which was one of these nine groups.

N.B. In the 1840's, Barye's small animal bronzes, considered ornamental work (*orfèvrerie*) rather than sculpture, were systematically rejected from the Paris Salon, prompting him to set up his own foundry and sales room in order to sell his work directly to the public, bypassing the Salon, hitherto the primary marketplace for sculpture. Barye published a catalogue of roughly one hundred of his works and proceeded to manufacture unlimited numbers on order. Although he rigorously controlled the quality of his output and

Barye [S 4]

After Barye [s 5]

After Barye [s 7]

After Barye [s 6]

After Barye [s 8]

introduced the system of numbering individual pieces (which he did sporadically), this enterprise was a financial failure, and in 1845 his financial backer, an industrialist named Emile Martin, took over the management of Barye's editions, farming out their manufacture to private foundries. Barbédienne was the best known of these, but was only one of dozens of foundries of varied ability fabricating works in the name of Barye, in the absence of the artist's supervision. By the time that Barye regained control of his enterprise around 1857, this practice had resulted in the appearance of thousands of examples of Barye's work, often signed, although by him only in name. After his death in 1875, the original models from which his casts were made were sold at auction, along with the rights of reproduction, resulting in a cottage industry in posthumous casts which were technically legitimate, but even further removed from the artist. The best of these bear the foundry marks of Barbédienne, Susse Frères, and Thiébaut Frères.

Compounding the proliferation of Barye's work was the widespread practice of *surmoulage,* in which illegitimate impressions were taken from bronze casts, removing them one step further from the original model. Castings from Barye's own workshop are exceedingly rare, representing a very small fraction of the works attributed to him. The bronzes listed below, of widely varied quality, are the products of this industry. They have been listed as "After Barye" to indicate their origins from Barye's models, as well as their remove from the sculptor's hand.

[s 5]
After **ANTOINE LOUIS BARYE**
French, 1796–1875
Tiger, Head Lowered and *Tiger, Head Raised,* originals 1831
Stamped, lower left: *BARYE;* and lower right: *BARYE*
Bronze, two reliefs, each ca. 2¾″ × 4⅝″
(6.9 × 11.7) (sight)
Gift of Henry D. Sharpe. 49.035

[s 6]
After **ANTOINE LOUIS BARYE**
French, 1796–1875
Bear Erect, original 1833
Signed, front right base: *BARYE*
Bronze. 9½″ × 5″ × 4″
(24.13 × 12.7 × 10.16 cm)
Gift of Henry D. Sharpe. 49.029

[s 7]
After **ANTOINE LOUIS BARYE**
French, 1796–1875
Horse Surprised by a Lion, original ca. 1833
Signed, rear base: *Barye*; stamped: *Barye 8*
Bronze. 14¾″ × 14″ × 5⅞″
(37.4 × 35.5 × 14.9 cm)
Gift of Henry D. Sharpe. 49.033

[s 8]
After **ANTOINE LOUIS BARYE**
French, 1796–1875
Deer on the Alert, original ca. 1830–34
Signed, front base: *BARYE*
Bronze. 7¼″ × 6⁷∕₁₆″ × 3¾″
(18.4 × 16.4 × 9.5 cm)
Gift of Henry D. Sharpe. 49.030

[s 9]
After **ANTOINE LOUIS BARYE**
French, 1796–1875
Elk Surprised by a Lynx, original ca. 1834
Signed, right front base: *Barye*; stamped: *Barye 8*
Bronze. 9¼″ × 13¼″ × 5¼″
(23.5 × 33.6 × 13.3 cm)
Gift of Henry D. Sharpe. 49.032

[s 10]
After **ANTOINE LOUIS BARYE**
French, 1796–1875
Deer on the Alert, original 1838
Signed and dated, rear base: *BARYE 1838*
Bronze. 7⁹∕₁₆″ × 6⁷∕₁₆″ × 3⅛″
(19.2 × 16.3 × 8.6 cm)
Gift of Henry D. Sharpe. 49.031

[s 11]
After **ANTOINE LOUIS BARYE**
French, 1796–1875
Bull, original 1841
Signed, left front base: *BARYE*
Bronze. 7¼″ × 10½″ × 3¾″
(18.4 × 26.7 × 9.5)
Gift of Mrs. Morris Stokes. 46.326

After Barye [s 9]

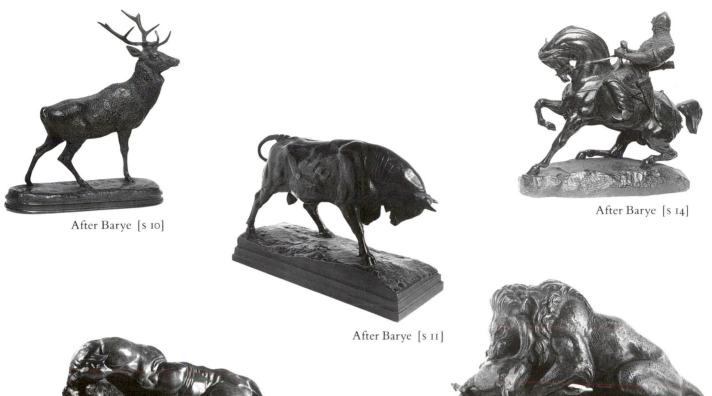

After Barye [s 10]

After Barye [s 11]

After Barye [s 14]

After Barye [s 12]

After Barye [s 15]

After Barye [s 13]

[s 12]
After **ANTOINE LOUIS BARYE**
French, 1796–1875
Jaguar Devouring a Hare, original 1848
Signed, right base: *A.L. Barye*
Bronze. 8⅜″ × 20⅞″ × 9″
(21.3 × 53 × 22.8 cm)
Gift of Mrs. John S. Holbrook. 45.183

[s 13]
After **ANTOINE LOUIS BARYE**
French, 1796–1875
Parrot Resting on an Oak Branch
Signed, rear base: *BARYE*
Bronze. 8¼″ × 5¼″ × 4¼″
(20.9 × 13.3 × 10.8 cm)
Gift of Mrs. Charles O. Dexter. 43.242

[s 14]
After **ANTOINE LOUIS BARYE**
French, 1796–1875
Tartar Warrior Checking his Horse
Signed, front base: *BARYE;*
stamped: *BARYE/BARYE/5*
Bronze. 12⅞″ × 14⅜″ × 5⅝″
(32.7 × 36.5 × 14.3 cm)
Gift of Henry D. Sharpe. 49.034

[s 15]
After **ANTOINE LOUIS BARYE**
French, 1796–1875
Lion Devouring a Boar
Signed, left base: *BARYE*
Bronze. 7½″ × 11″ × 5⅝″
(19 × 27.9 × 14.3 cm)
Gift of Helen G. Robertson. 71.051

[s 16]
After **ANTOINE LOUIS BARYE**
French, 1796–1875
Ibex
Signed, front base: *BARYE*
Bronze. 4″ × 4¼″ × 1⅝″
(10.2 × 10.8 × 4.1 cm)
Gift of Roy E. Carr. 78.116

After Barye [s 16]

[S 17]
After **ANTOINE LOUIS BARYE**
French, 1796–1875
Lioness
Signed, front base: *BARYE*
Bronze. 3⁹⁄₁₆″ × 7¹¹⁄₁₆″ × 2¾″
(9 × 19.5 × 6.9 cm)
Gift of Roy E. Carr. 78.117

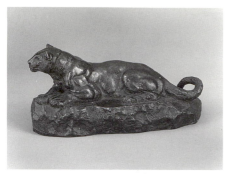

After Barye [S 17]

[S 18]
MARIANO BENLLIURE Y GIL
Spanish, 1862–1947
Study for "The Song of Love," 1886
Signed and dated on back: *M. Benlliure/86*
Terra cotta. 13¼″ × 6¼″ × 6½″
(33.6 × 15.9 × 16.5 cm)
Museum Works of Art Fund. 56.118

BIBLIOG.: Carmen de Quevedo Pessanha, *Vida Artística de Mariano Benlliure.* Madrid, 1947, pp. 153–54.

This group appears to be an early maquette, with minor variations in the arrangement of the female figure's arms and drapery, for the monumental marble group, *Canto de Amor,* completed by Benlliure in Rome in 1900.

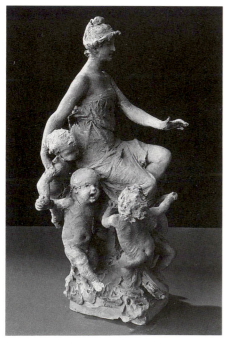

Benlliure [S 18]

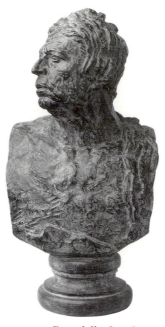

Bourdelle [S 19]

[S 19]
ÉMILE-ANTOINE BOURDELLE
French, 1861–1930
Portrait of J.A.D. Ingres, 1908
Signed, sitter's left shoulder:
EMILE ANTOINE BOURDELLE; inscribed on back, near base: *ALEXIS RUDIER/Fondeur Paris*
Bronze. 26½″ × 17″ × 12″
(66.6 × 43.2 × 30.5 cm)
Museum Appropriation. 28.065

BIBLIOG.: *Bull RISD,* XVII:1 (January 1929), pp. 7–11; Ionel Jianou and Michel Dufet, *Bourdelle.* Paris, 1965, p. 89.

Bourdelle was born in Montauban, which was also the city of Ingres's birth. One of Bourdelle's earliest recorded works was a bust of Ingres, now lost, modeled when Bourdelle was fifteen, which won him a scholarship at the Ecole des Beaux-Arts de Toulouse. A version of this bust was first exhibited by Bourdelle in the Salon of the Société Nationale des Beaux-Arts, 1908. It was first cast in bronze for the Musée Ingres in Montauban; this is believed to have been the second cast, belonging to Bourdelle. In addition to this Alexis Rudier cast, an edition also was cast by the Hébrard foundry, of slightly smaller dimensions (h. 25¼″). This posthumous portrait appears to be based on a photograph of Ingres taken in 1866 by Pierre Petit and reproduced in Henry Lepauze, *Ingres, sa vie, son oeuvre.* Paris, 1911, p. 545.

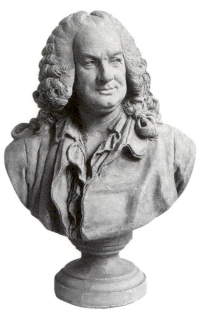

Caffieri [S 20]

[S 20]
JEAN-JACQUES CAFFIERI
French, 1725–1792
Bust of Jean-Baptiste Rousseau, 1786
Incised on back after firing (probably by a later hand): *Jean Baptiste/R Rousseau/né à Paris 1670 mourut Brux 17??/fait par Caffieri 1786.*
Terra cotta. 25½″ × 17″ × 10″
(64.8 × 43.2 × 30.5 cm)
Museum Appropriation. 30.042

BIBLIOG.: Jules Guiffrey, *Les Caffieri: sculpteurs et fondeurs-ciseleurs.* Paris, 1877, pp. 374–75, 379; *Bull RISD,* XVIII:4 (October 1930), pp. 51–53; Providence, Brown University, *The Portrait Bust, Renaissance to Enlightenment,* Providence, Museum of Art, Rhode Island School of Design, March 5–May 30, 1969, p. 15.

Jean-Baptiste Rousseau (1671–1741), no relation to the Swiss philosopher Jean-Jacques, was an important French lyrical poet and playwright of the early eighteenth century. His most successful play was *Le Flatteur* of 1696. Because of defamatory verses unjustly attributed to him in 1707, he was banished from France from 1712 to 1741, living in Holland and then Brussels, where he moved the year of his death. This terra-cotta bust is related to the marble bust of Rousseau by Caffieri, one of seven busts (including portraits of Corneille and Molière) made by him for the foyer of the Comédie-Française. According to Guiffrey, it is based on the 1734 portrait of Rousseau by Jacques-André-Joseph-Camelot Aved (1702–66) in the Musée de Versailles. Two other known terra-cotta examples of Caffieri's bust of Rousseau of the same dimensions are in the Musée de Versailles and the Worcester Art Museum.

[S 21]
Circle of **ANTONIO CANOVA**
Italian, 1757–1822
Female Head
Marble. 17″ × 10¾″ × 10″
(43.2 × 35 × 25.4 cm)
Museum Works of Art Fund. 57.172

BIBLIOG.: Anthony M. Clark, *The Age of Canova, an Exhibition of the Neo-Classic,* Providence, Museum of Art, Rhode Island School of Design, November 6–December 15, 1957, p. 9 (no. 1).

Anthony Clark suggested that this may be an unrecorded work from the Canova studio. Hugh Honour, in a letter to Clark of 1959, doubted the Canova attribution, noting the difficulty of attaching an alternative name to such works as this showing his influence.

[S 22]
Circle of **ANTONIO CANOVA**
Italian, 1757–1822
Female Head (Sappho), ca. 1810
Bronze. 15¼″ × 8¼″ × 9¾″
(38.8 × 21 × 34.8 cm)
Museum Works of Art Fund. 56.098

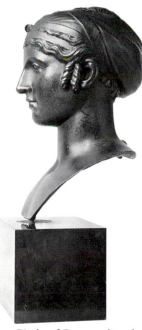

Circle of Canova [S 22]

JEAN-BAPTISTE CARPEAUX
French, 1827–1875
Head of the Virgin (for the group NOTRE-DAME DU SAINT-CORDON), 1864
Signed, left base: *B^te Carpeaux;* stamped behind signature, left base: *CIRE/PERDUE/ A. HEBRARD/2*
Bronze. 13½″ × 8⅞″ × 9¾″
(34.3 × 22.7 × 24.8 cm)
Museum Appropriation. 31.005
[see entry no. 38]

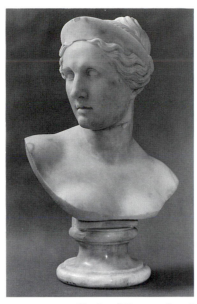

Circle of Canova [S 21]

JEAN-BAPTISTE CARPEAUX
French, 1827–1875
Crouching Woman, ca. 1870
Stamp in red wax, back of base: *VENTE CARPEAUX*
Terra cotta. 3⅛″ × 3½″ × 3⅛″
(7.9 × 8.9 × 7.9 cm)
Membership Dues. 70.105
[see entry no. 39]

JEAN-BAPTISTE CARPEAUX
French, 1827–1875
Hope, 1874
Signed and dated, right base: *JB.^T Carpeaux. 1874.;* stamped, right base: *PROPRIETE/ CARPEAUX,* lettering around eagle image; oval studio stamp, left base: *ATELIER DEPOT/71 RUE BOILEAU/AUTEUIL PARIS.*
Terra cotta. 22″ × 14″ × 10″
(55.9 × 35.5 × 25.4 cm)
Helen M. Danforth Fund. 1989.004
[see entry no. 40]

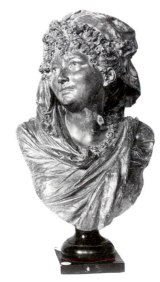

Carrier-Belleuse [S 23]

[S 23]
ALBERT-ERNEST CARRIER-BELLEUSE
French, 1824–1887
Bust of a Woman
Signed on back: *A Carrier Belleuse*
Terra cotta. 20″ × 13¼″ × 11¾″
(50.8 × 33.6 × 29.8 cm)
Membership Dues. 69.075

BIBLIOG.: Jeanne L. Wasserman, ed., *Metamorphoses in Nineteenth-Century Sculpture.* Cambridge, 1975, pp. 42, 44.

[S 24]
ALBERT-ERNEST CARRIER-BELLEUSE
French, 1824–1887
Bust of a Woman
Signed on back: *A Carrier Belleuse*
Terra cotta. 19⅞″ × 12¹¹⁄₁₆″ × 10¾″
(50.5 × 32.3 × 27.3 cm)
Membership Dues. 69.076

BIBLIOG.: *Bull RISD, Museum Notes,* LVI:4 (Summer 1970), pp. 15, 20; Jeanne L. Wasserman, ed., *Metamorphoses in Nineteenth-Century Sculpture.* Cambridge, 1975, pp. 42, 44.

JOSEPH CHINARD
French, 1756–1813
Bust of Madame Récamier, original ca. 1801
Signed, right side of pedestal: *Chinard de Lyon* (posthumous copy of original)
Marble. 22¼″ × 13″ × 10″
(56.5 × 33 × 25.4 cm)
Gift of Mrs. Harold Brown. 37.201
[see entry no. 8]

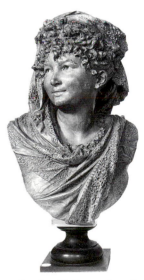

Carrier-Belleuse [S 24]

Chinard [s 25]

Chinard [s 26]

D'Angers [s 28]

[s 25]

JOSEPH CHINARD
French, 1756–1813
Medallion of General Eugène de Beauharnais (1781–1824), ca. 1805
Signed and inscribed, bottom of bust:
Chinard à Lyon
Terra cotta. 7⅞″ d. (19.7 cm d.)
Gift of Mrs. Harold Brown. 37.240

[s 26]

JOSEPH CHINARD
French, 1756–1813
Medallion of an Unknown Man, called "General Duchesne," ca. 1805
Signed and inscribed, bottom of bust:
Chinard. memb. de plusieurs académie [sic]
Terra cotta. 7½″ d. (19 cm d.)
Gift of Mrs. Harold Brown. 37.241

JULES DALOU
French, 1838–1902
Maternal Joy, original 1872
Stamped, right base: *DALOU;* stamped, rear base: *S/1912* (in triangle); *SEVRES* (in rectangle); *I*
Porcelain (Sèvres). 20″ × 13⅛″ × 13¹⁵⁄₁₆″ (50.8 × 33.3 × 35.4 cm)
Gift of Mrs. Zechariah Chafee. 34.1375
[see entry no. 53]

JULES DALOU
French, 1838–1902
Woman Reading (La Liseuse), 1873
Signed and dated, left base at sitter's feet:
DALOU/1873
Terra cotta. 12″ × 17½″ × 16″
(30.5 × 44.3 × 41 cm)
Museum Works of Art Fund. 54.187
[see entry no. 54]

JULES DALOU
French, 1838–1902
Angel with Child, ca. 1877
Signed, left base: *DALOU;* stamped, rear base: *CIRE/PERDUE/A.A. HEBRARD*
Bronze. 12⅛″ × 4¾″ × 4¹⁵⁄₁₆″
(30.7 × 12.1 × 12.6 cm)
Gift of Mrs. Henry D. Sharpe. 59.152
[see entry no. 55]

[s 27]

JULES DALOU
French, 1838–1902
Bather Drying Her Foot
Signed, left base: *DALOU;* stamped, rear base: *CIRE/PERDUE/A.A. HEBRARD I.*
Bronze. 7″ × 3¹⁵⁄₁₆″ × 3⅞″
(17.8 × 10 × 9.9 cm)
Edgar J. Lownes Fund. 53.116

Dalou [s 27]

[s 28]

PIERRE-JEAN DAVID, called
DAVID D'ANGERS
French, 1788–1856
Portrait Medallion of General Bertrand, 1841(?)
Signed and dated (?), at bottom: *David/ 1481?* (reversed); inscribed behind sitter's head: *Bertrand*
Bronze. 3″ d. (7.6 cm d.)
Gift of Mrs. Harold Brown. 37.127

BIBLIOG.: *Bull RISD, Museum Notes,* LXXVI:1 (October 1989), pp. 16–17.

Henri Gratien Bertrand (1773–1847) was closely connected throughout his life to the career and memory of Napoleon. An

engineer by training and a brigadier general to Napoleon by the age of twenty-seven, he served the Emperor in a variety of military and diplomatic capacities, in 1811 becoming the Governor General of Illyria. He remained in the military his entire life, although his career was interrupted by a five-year exile with Napoleon on Saint Helena. In 1840 he was assigned the task of returning Bonaparte's ashes to France, and in 1847 he published his memoirs of Napoleon's Egyptian and Syrian campaigns. A Napoleonic court suit worn by Bertrand around 1810 (1989.014), as well as a velvet court train of around 1804 (37.215) belonging to his wife, perhaps worn to events surrounding the coronation of Napoleon, are also in the Museum's collection.

[s 29]

PIERRE-JEAN DAVID, called
DAVID D'ANGERS
French, 1788–1856
Portrait of Alexandre Brongniart, 1846
Signed and dated, at bottom: *David 1846;* inscribed behind sitter's head: *Alex Brongniart.*
White bisque porcelain on blue ground.
6⅝″ d. (16.8 cm d.)
Museum Appropriation. 20.015

BIBLIOG.: *Bull RISD,* XVI:2 (April 1928), pp. 18–21.

Ex coll. Virlet d'Aoust, to whom, according to an old label on the reverse, it was given by the sitter on his deathbed. Brongniart (1770–1859) was the Director of the Porcelain Manufacture at Sèvres from 1800 until his death.

D'Angers [s 29]

EDGAR DEGAS (b. Hilaire Germain
Edgar De Gas)
French, 1834–1917
Grand Arabesque, Second Time, ca. 1885–90
Signed, behind right foot: *Degas;* stamped,
right base, beneath extended left foot:
¹⁵/ᵢ/CIRE/PERDUE/A.A. HEBRARD
Bronze. 16⅝″ × 23⅞″ × 10⅝″
(42.2 × 60.6 × 26.9 cm)
Gift of Stephen O. Metcalf, George Pierce
Metcalf, and Houghton P. Metcalf. 23.315
[see entry no. 37]

[s 30]
CHARLES DESPIAU
French, 1874–1946
L'Américaine, 1926–27
Signed, back of neck: *C. Despiau;*
Stamped, beneath signature:
CIRE/C. VALSUANI/PERDUE
Bronze. 15″ × 8″ × 9½″
(38.1 × 20.3 × 24.1 cm)
Museum Appropriation. 28.042

BIBLIOG.: *International Studio,* LXXXIX
(March 1928), p. 41; *Bull RISD,* XXII:4
(October 1934), pp. 53–58.

Léon Deshairs, *C. Despiau,* Paris, 1930,
pl. 39, dates this bust 1926–27 and iden-
tifies the subject as Mrs. Stone of New
York. This bust was cast in an edition of
five.

[s 31]
CHARLES DESPIAU
French, 1874–1946
Le Réalisateur, ca. 1929
Signed, left base: *C. Despiau;* stamped,
rear base: *CIRE/VALSUANI/PERDUE*
Bronze. 29¾″ × 16″ × 21¼″
(75.5 × 40.6 × 54 cm)
Gift of Mrs. Murray S. Danforth. 33.002

BIBLIOG.: *Bull RISD,* XXII:4 (October
1934), pp. 53–58.

The title of this work may be loosely trans-
lated as, "the man who makes things hap-
pen." This is a cast from a maquette for

Despiau's *Monument to Emil Mayrisch,*
tomb of a Luxembourg steel manufacturer
and philanthropist erected by the architect
Auguste Perret in the Parc Colpach,
Luxembourg, in 1929. The final version
includes a drapery hanging over the
figure's left leg. Six different plaster states
of this maquette form a part of Mme
Despiau's gift of forty-six sculptures by
her late husband to the Musée National
d'Art Moderne, Paris.

GUSTAVE DORÉ
French, 1832–1883
Cupid and Skulls, ca. 1876–80
Signed, front right corner of base:
G.ᵛᵉ Doré
Terra cotta. 7″ × 5¹⁵/₁₆″ × 9¹¹/₁₆″
(18.8 × 15.1 × 24.6 cm)
Gift of Uforia, Inc. 73.148
[see entry no. 59]

Despiau [s 30]

RAYMOND DUCHAMP-VILLON
French, 1876–1918
Seated Woman, 1914; cast 1915
Signed, right side of base: *R. Duchamp-
Villon;* stamped, back of base: *Roman
Bronze Works/New York*
Bronze with gold-washed patina.
28″ × 8″ × 9½″ (71.12 × 20.32 × 24.13 cm)
Mary B. Jackson Fund and Membership
Dues. 67.089
[see entry no. 79]

Despiau [s 31]

[s 32]
SIR JACOB EPSTEIN
British, born United States, 1880–1959
Portrait of Muirhead Bone, ca. 1916
Bronze. 10⅞″ × 8″ × 9″
(27.6 × 20.3 × 22.9 cm)
Museum Appropriation. 24.053

BIBLIOG.: *Bull RISD,* XII:4 (October
1924), p. 38; Judith Zilczer, *"The Noble
Buyer": John Quinn, Patron of the Avant-
Garde.* Washington, D.C.: Smithsonian
Institution Press, 1978, p. 159.

Zilczer indicates that this cast of Epstein's
portrait of the Scottish draftsman and
engraver (1876–1953), which she dates
1916, was acquired by the collector John
Quinn from the artist in 1918 for $336. It
was consigned by the Quinn Estate to
Scott & Fowles, New York, who included
it in an exhibition of Epstein's sculpture in
1924, from which it was acquired by the
Museum.

Epstein [s 32]

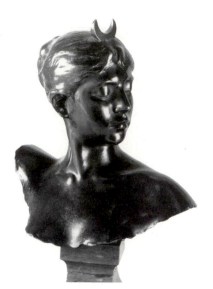

Falguière [s 33]

[s 33]
ALEXANDRE FALGUIÈRE
French, 1831–1900
Diana
Signed, back right: *A. Falguière*; stamped on plate attached to bottom of base: *THIEBAU FRERES/FONDEURS/PARIS* [sic]
Bronze. 4³/₁₆″ × 3⁷/₈″ × 3″
(10.6 × 9.8 × 7.7 cm)
Helen M. Danforth Fund. 1987.061

Falguière's original, life-size figure of *Diana* was first exhibited in plaster in the Salon of 1882 (no. 4353) and in marble in the Salon of 1887 (no. 3942). The sculpture was enormously popular, encouraging Falguière to fabricate ·a considerable number of reductions in various sizes of the bust alone, in marble and bronze, cast by the Thiébaut Foundry. Although these were created to satisfy a commercial market, they are of a consistently high level of craftsmanship.

[s 34]
NAUM GABO
American, born Russia, 1890–1977
Construction in Space, Monument for an Airport, ca. 1932
Plastic on steel. 16½″ × 16½″ × 26″
(41.9 × 41.9 × 66 cm)
Gift of Mrs. Murray S. Danforth. 38.061

Gabo was active in Russia until 1922, Berlin until 1932, Paris until 1935, and England until 1946, when he moved to the United States, becoming a citizen in 1952. The two works by Gabo belonging to the Museum are a part of his European *oeuvre* and hence are included in this catalogue. The earliest version of *Monument for an Airport*, dated 1925–26 (19½″ × 28⁷/₈″; 49.5 × 73.3 cm), was exhibited in the *Cubism and Abstract Art* exhibition at the Museum of Modern Art, New York, in 1936 (no. 73, ill.).

The Museum's version is based on a model in the Tate Gallery, London (ca. 1932, plastic, 2½″ × 4¾″ × 3″; 6.3 × 12.1 × 7.6 cm). According to Ronald Alley, Keeper of the Modern Collection of the Tate, this model was the product of an unrealized commission for Imperial Airways, which wanted an advertising device promoting the identity of the airline that could be broadly reproduced in sizes varying from desktop to monument. Other known versions include a 4″ (10.2 cm) high version belonging to the widow of Marcus Brumwell, the advertising agent responsible for the commission, and a larger version measuring 16³/₈″ × 42½″ × 22½″ (41.6 × 108 × 57.5 cm), exhibited in New York at the Museum of Modern Art (*Naum Gabo – Antoine Pevsner,* 1948, no. 9), and offered by Annely Juda Fine Art, London, in 1989. The Museum's sculpture has deteriorated physically and is rarely exhibited.

[s 35]
NAUM GABO
American, born Russia, 1890–1977
Construction in Space (The Crystal),
ca. 1937
Plastic. 19¼″ × 26¾″ × 17¾″
(48.9 × 67.9 × 45 cm)
Gift of Mrs. Murray S. Danforth. 38.062

BIBLIOG.: *Museum Notes,* VII:5 (May 1950), n.p. (fig. 3); London, Tate Gallery, *Naum Gabo, Sixty Years of Constructivism,* February 11–April 20, 1987, p. 21 (ill.).

According to correspondence from the artist's widow in the Museum's archives, this sculpture was exhibited in Paris in 1937. It appears to be the same version exhibited in Hartford at the Wadsworth Atheneum (*Constructions in Space, Gabo,* March 22–30, 1938, no. 8?), and a photograph of Gabo from his estate shows him with it there (see above, London, Tate Gallery, *op. cit.,* p. 21). Around this time, according to the artist's widow, it was given the title *The Crystal* to differentiate it from other *Constructions in Space,* Gabo's preferred title for his works. It was exhibited in New York at the Julian Levey Gallery (*Naum Gabo, Constructions in Space, Sculpture,* April. 5–May 1, 1938), from which it was purchased by Alexander Dorner, then Director of the Museum, on behalf of Mrs. Danforth. A small model for this sculpture is in the Tate Gallery, London. The plastic from which this sculpture is made is called "Rhodoid." Because of its poor physical condition, it is rarely exhibited.

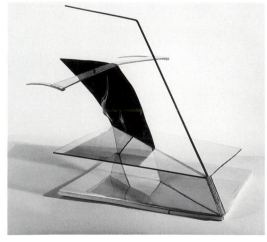

Gabo [s 34]

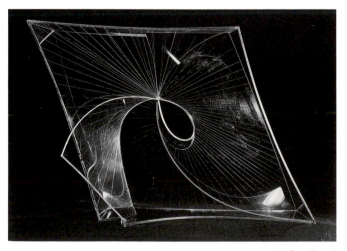

Gabo [s 35]

Gargallo [s 36]

[s 36]
PABLO GARGALLO
Spanish, 1881–1934
Harlequin Mask, ca. 1927–28
Copper. 8⅝" × 12⅜" × 4"
(21.9 × 31.4 × 10.2 cm)
Gift of Mrs. Gustav Radeke. 30.050

BIBLIOG.: *Bull RISD,* XXIV:3 (July 1936), pp. 42–43; Pierre Courthion, *L'Oeuvre complet de Pablo Gargallo.* Paris, 1973, pl. 52.

Gemito [s 37]

[s 37]
VINCENZO GEMITO
Italian, 1852–1929
The Water Carrier, original 1880
Bronze. 15¾" × 9¼" × 10½"
(40 × 23.5 × 26.7 cm)
Bequest of Miss Ellen D. Sharpe. 54.147.23

BIBLIOG.: Carlo Siviero, *Gemito.* Naples: Morano, n.d., pp. 202–03 (ill.); Fortunato Bellonzi and Renzo Frattarolo, *Appunti Sull'Arte di Vincenzo Gemito.* Rome, 1952, p. 26.

[s 38]
German (?), early nineteenth century
Seated Female Figure with Griffin
Plaster. 6⁹⁄₁₆" × 4" × 4⅝"
(16.6 × 10.2 × 11.7 cm)
Museum Purchase. 62.114

ERIC GILL
British, 1882–1940
The Crucifixion
Painted stone. 10⅞" × 7" × 1¼"
(27.7 × 17.8 × 3.2 cm)
Gift of John M. Crawford, Jr. 1987.089
[see entry no. 78]

[s 39]
ÉMILE HÉBERT
French, 1828–1893
And Always! And Never! (Et Toujours! Et Jamais!)
Signed, on bottom of tombstone: EMILE HEBERT; inscribed on tombstone: ET TOUJOURS/ ET JAMAIS!!
Terra cotta. 9⅛" × 3½" × 4"
(23.2 × 8.9 × 10.2 cm)
Walter H. Kimball Fund. 74.034

BIBLIOG.: Charles Baudelaire, trans. J. Mayne, *Art in Paris 1845–1862.* London: Phaidon, 1965, pp. 151, 211–12; Paris, Hôtel Drouot, *Vente Emile Hébert,* October 5, 1893, no. 3; Jeanne Stump, "The Sculpture of Emile Hébert: Themes and Variations," *The Register of the Spencer Museum of Art,* v:10 (Spring 1982), p. 32 (ill.).

A plaster version of this sculpture was exhibited in the Salon of 1859 (no. 3296) and a bronze in the Salon of 1863 (no. 2406), which may be the version now in the Spencer Museum of Art, University of Kansas, Lawrence. A terra-cotta version of it was sold in the Hébert Estate sale of October 5, 1893 (see Bibliog.), along with three molds and "all rights of reproduction." It cannot be determined whether the Museum's terra cotta is a cast from one of these molds. The source from which the title is believed to have been taken remains unidentified; the subject is a variation of the theme of "Death and the Maiden," whose origins can be traced to the later Middle Ages. Baudelaire, in his review of the Salon of 1859, questioned the ambiguity of the title, but devoted much praise to the sculpture, suggesting its suitability as a funerary monument (see Baudelaire, *op. cit.,* p. 211).

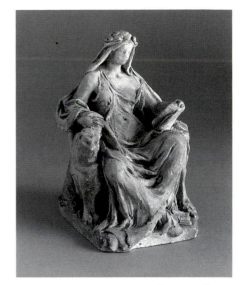

German [s 38]

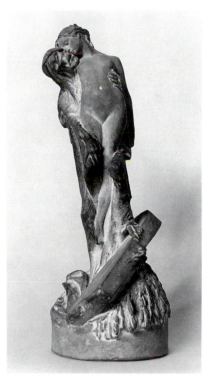

Hébert [s 39]

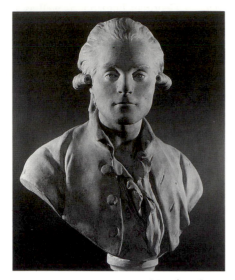

Houdon [s 40]

[s 40]
JEAN-ANTOINE HOUDON
French, 1741–1828
Portrait of a Young Man, ca. 1774 (?)
Signed and dated, beneath sitter's left
shoulder: *Houdon. F. 1774*
Tinted plaster. 25¼″ × 16½″ × 11″
(64.1 × 41.9 × 28 cm)
Museum Works of Art Fund. 55.101

BIBLIOG.: Claude Phillips, "The Troca-
dero Museum," *Art Journal*, 1889, p. 174
(ill. of version in Paris, Musée des Monu-
ments Français); Claude Phillips, "Jean-
Antoine Houdon," *Art Journal*, 1893, pp.
79–80 (ill. of version in Paris, Musée des
Monuments Français); *Bull* RISD, *Museum
Notes*, XLIV:4 (May 1956), pp. 1–4 (ill. on
cover and inside cover); Louis Réau,
Houdon. Sa vie et son oeuvre. Paris: F. de
Nobele, 1964, II, p. 58 (no. 287).

Very little is known about this bust,
which in the late nineteenth century was
misidentified as *Robespierre*. The Museum's
cast is dated 1774 (the signature and date
appear to have been added later). Réau
(*op. cit.*, no. 287, *Bust of an Unknown Man*)
lists three versions: one in plaster, signed
Houdon ft., formerly in the collection of
Jacques de Saint-Pierre; a cast from a lost
terra cotta (ex-collection Gontaut-Biron),
belonging to Henri Chapu, the late-
nineteenth-century sculptor, who made
an additional cast for the Musée des
Monuments Français, Paris (Réau, *op.cit.*,
pl. CXLVI, 287A); and one formerly in the
Thoën collection, Brussels, which is the
version now belonging to the Museum
(Réau, *op. cit.*, pl. CXLVI, 287B). The
authenticity of a fourth version (not listed
by Réau), in plaster, identified as a *Bust of
Laurent Gilbert* (Orléans, Musée d'Orléans),
has been doubted (see Georges Giacometti,
La Vie et l'oeuvre de Houdon. Paris, 1929, II,
p. 61). The Museum's bust is frequently

described as a terra cotta, although it is
actually plaster tinted to resemble fired clay,
a practice common to Houdon (see, Réau,
op. cit., I, pp. 475–76). Small metal pins
throughout the surface of the sculpture
(called *détail*) were used to guide the carving
process, the *mise-au-point* ("pointing"),
indicating that this may have been an orig-
inal plaster that served as the model for a
marble version.

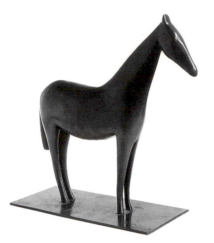

Mataré [s 41]

[s 41]
EWALD MATARÉ
German, 1887–1965
Horse, 1928
Monogram on underside of horse.
Bronze. 10⅛″ × 4″ × 10³⁄₁₆″
(25.7 × 10.2 × 25.9 cm)
Museum Works of Art Fund. 60.013

BIBLIOG.: *The Studio*, 147 (May 1954),
p. 149, reproduces a version carved in
wood.

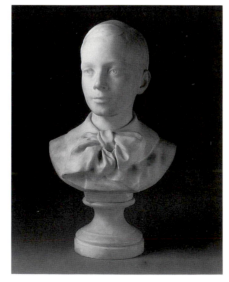

G. Michel [s 43]

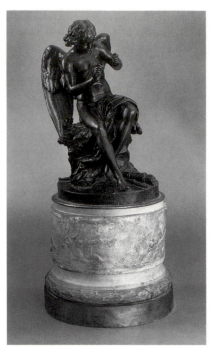

Attributed to C. Michel [s 42]

CONSTANTIN MEUNIER
Belgian, 1831–1905
Kneeling Miner, 1896
Signed, right base: C. MEUNIER;
inscribed, left base: J. PETERMANN–
FONDEUR/BRUXELLES.
Bronze. 9½″ × 5½″ × 5″
(24.1 × 14 × 12.7 cm)
Membership Dues. 71.036
[see entry no. 70]

[s 42]
Attributed to **CLAUDE MICHEL**, called
CLODION
French, 1738–1814
Love the Hunter (L'Amour Chasseur)
Signed, rear base: CLODION (reversed "N")
Bronze, on a terra-cotta base representing
a frieze of infants and dogs hunting.
Figure: 13¼″ × 6½″ × 8″
(34.9 × 16.5 × 20.3 cm); base: h. (total):
8⅛″ (20.6 cm); relief: 5⅞″ (14.9 cm)
Gift of Forsyth Wickes. 58.174

BIBLIOG.: Copenhagen, Charlottenborg,
Exposition de l'art français au XVIIIe siècle,
August 25–October 6, 1935, p. 180 (no.
616); *Bull* RISD, *Museum Notes*, XLV:4
(May 1959), pp. 1–2; New York, M.
Knoedler & Co., *The French Bronze, 1500–
1800*, November 6–28, 1968, no. 72.

[s 43]
GUSTAVE FRÉDÉRIC MICHEL
French, 1851–1924
Portrait Bust of a Young Boy, 1887
Signed, on back: *G. Michel/Paris 1887*
Marble. 21½″ × 12¼″ × 8¼″
(54.6 × 31.1 × 21 cm)
Gift of Alice Bourne. 50.163

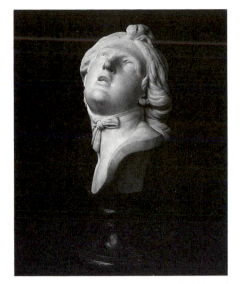

S. Michel [s 44]

Manufacture du Porcelaine
du C. Nast [s 46]

circles of Georgian England, as well as a sculptress whose portraits included busts of George III and Admiral Nelson. According to Susan Benforado, who has written her doctoral thesis on this artist, this may be Damer's portrait of her personal friend Georgiana Spencer, the Duchess of Devonshire (d. 1808), whose bust "from a [plaster?] cast by Mrs. Damer by Nollekens" was described in the early nineteenth century in Goodwood House, near Chichester, the county seat of the Dukes of Richmond and the repository of a noteworthy sculpture gallery. Damer is distinguished among sculptors of her time for having carved her own work rather than employing practitioners for the task; in fact, this is the only known sculpture by Damer to be carved and signed by another sculptor, perhaps owing to Nollekens's reputation as an artist of great distinction. In style this bust closely resembles a self-portrait of the sculptress (ca. 1785–86, Florence, Uffizi Gallery) and another of *Miss Farren as Thalia* (1789, London, National Portrait Gallery), among other portraits in this Neoclassical style, from which its dating has been established.

[s 44]
SIGISBERT FRANÇOIS MICHEL,
called **SIGISBERT**
French, 1728–1811
Female Head, 1798
Signed and dated, on back, edge of left shoulder: *SIGISBERT. 1798*
Marble. 9⅜″ × 7⅛″ × 5¼″
(34.3 × 18.1 × 14.3 cm)
Museum Works of Art Fund. 55.109

Sigisbert came from a dynasty of sculptors from Nancy that included his grandfather Jacob-Sigisbert Adam (1670–1747); his uncle Lambert-Sigisbert Adam (1700–1759), with whom he trained; François-Gaspard-Balthasar Adam (1710–1761), another uncle, succeeded by Sigisbert as sculptor to the King of Prussia until 1770; and most notably his brother, Clodion (see above, Claude Michel). Sigisbert, who specialized in small decorative sculpture, spent much of his mature career producing work in the atelier of Clodion, hence works in his own name are rare. Works by him were exhibited in the Salons of 1791, 1793, 1799, and 1800.

[s 45]
JULES MOIGNIEZ
French, 1835–1894
Birds
Signed, right base: *J. MOIGNIEZ*
Bronze. 4⅝″ × 7⅜″ × 4⅝″
(11.7 × 18.7 × 11.7 cm)
Gift of Mrs. Henry D. Sharpe. 63.046.8

[s 46]
**MANUFACTURE DU PORCELAINE
DU C[IE]. NAST**
Paris, active 1783–1831
Napoleon Bonaparte, ca. 1797
Inscribed, on socle: *Buonapart*
Bisque porcelain. 12⅛″ × 6″ × 5⁵⁄₁₆″
(30.8 × 15.2 × 13.5 cm)
Gift of Mrs. Harold Brown. 42.205

BIBLIOG.: Christopher Monkhouse, "Napoleon in Rhode Island, The Harold Brown Collection at the Rhode Island School of Design," *Antiques,* CXIII:1 (January 1978), p. 201 (ill.).

[s 47]
JOSEPH NOLLEKENS,
after **ANNA SEYMOUR DAMER**
British, 1737–1823, and British, 1748–1828
Ideal Portrait (Georgiana Spencer, The Duchess of Devonshire?), ca. 1780
Signed and inscribed, rear base: *NOLLEKENS Fᵀ./from a Model by/the Hon. Mʳˢ. Damer.*
Marble.
18⅝″ (including socle) × 8⅞″ × 8½″
(47.3 × 22.5 × 21.6 cm)
Museum Works of Art Fund. 55.111

BIBLIOG.: *Bull RISD, Museum Notes,* XLIV:4 (May 1958), p. 6 (figs. 4–5).

Anna Seymour Damer, to whom Horace Walpole bequeathed Strawberry Hill, was a well-connected woman in aristocratic

Moigniez [s 45]

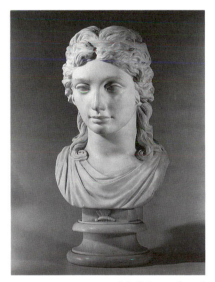

Nollekens [s 47]

Attributed to Pacetti [S 48]

Poupelet [S 52]

[S 48]
Attributed to **CAMILLO PACETTI**
Italian, 1758–1826
The Triumph of Titus
Terra cotta. 13¾″ × 23¾″ × 2⅝″
(34.9 × 60.3 × 6.7 cm)
Museum Works of Art Fund. 59.053

Percy [S 49]

[S 49]
SAMUEL PERCY
Irish, 1750–1820
Bust of Richard Reynolds, 1810
Signed and dated, lower right: *F. Percy/
1810.*
Wax, mounted on wood.
7½″ × 6⁵⁄₁₆″ × 2½″ (19 × 16 × 6.4 cm)
Edgar J. Lownes Fund. 85.091

[S 50]
FREDERICK WILLIAM POMEROY
British, 1857–1924
Perseus with the Head of Medusa, 1898
Signed and dated, right base: *F. W. Pomeroy
Sc./1898*
Bronze. 19⅛″ × 6½″ × 9½″
(48.6 × 16.5 × 24.1 cm)
Mary B. Jackson Fund. 76.055

BIBLIOG.: *Bull RISD, Museum Notes*, LXVII:2
(October 1980), p. 25.

A larger-than-life-size plaster version of
this figure was exhibited in the Royal
Academy, London, in 1898, by the full
title *Perseus as a Symbol of the Subduing and
Resisting of Evil* (no. 1964).

Pomeroy [S 50]

[S 51]
JANE POUPELET
French, 1878–1932̇
Head of a Smiling Boy, ca. 1920
Bronze. 3¹¹⁄₁₆″ × 3¾″ × 3⅝″
(9.4 × 9.5 × 9.2 cm)
Bequest of Miss Ellen D. Sharpe. 54.147.22

[S 52]
JANE POUPELET
French, 1878–1932
Woman at her Toilette, ca. 1925
Signed, right base: *JANE POUPELET*
Bronze. 15½″ × 24″ × 8¼″
(39.4 × 60.9 × 20.9 cm)
Bequest of Miss Ellen D. Sharpe. 54.147.25

Poupelet [S 51]

ALEXANDRE-CHARLES RENAUD
French, 1756–1817
Prometheus, 1787
Terra cotta. 28⅛" × 20½" × 14¼"
(71.4 × 52 × 36.2 cm)
Anonymous gift. 63.012

In 1777 Renaud was awarded first prize in the Prix de Rome competition for sculpture established in 1775 by the Etats de Bourgogne for students of the Ecole de Dessin of Dijon. Renaud stayed in Rome until 1781, traveled then to Florence, and between 1786 and 1806 was active in Marseilles. A version of this group and a pendant representing *Milo of Crotona* were submitted by Renaud as *morceaux de réception* to the Académie de Peinture et de Sculpture de Marseilles, to which he was admitted in 1787. Plaster versions of both of these groups (h. 32⅝"; 83 cm) preserving the seams of a piece mold are located in the Musée de Dijon, the city of Renaud's birth. In the Dijon cast Prometheus wears no fig leaf, and his left hand is clenched in a fist. A marble version was offered in the Magnan de la Roquette sale, Paris, November 21, 1841 (no. 165), with the claim that it was based on a drawing provided for Renaud by Roquette. There is also a bronze version of this figure in the Corcoran Gallery of Art, Washington, D.C.

Renaud [s 53]

Rodin [s 54]

[s 54]
AUGUSTE RODIN
French, 1848–1917
Mask of the Man with the Broken Nose,
original 1863–64; cast ca. 1882
Bronze. 11¹³⁄₁₆" × 7" × 6¾"
(30 × 17.8 × 17.2 cm)
Gift of Mrs. Gustav Radeke. 21.341

PROV.: Constantine A. Ionides, Brighton.

BIBLIOG.: Truman H. Bartlett, "Auguste Rodin, Sculptor," *American Architect and Building News*, XXV:682 (1889), rpt. in Albert E. Elsen, ed., *Auguste Rodin: Readings on His Life and Work*. Englewood Cliffs, 1965, pp. 20–21; *Bull RISD*, XI:1 (January 1923), pp. 6–7; Jeanne L. Wasserman, ed., *Metamorphoses in Nineteenth-Century Sculpture*. Cambridge, 1975, pp. 156 (figs. 7, 7a), 157; John L. Tancock, *The Sculpture of Auguste Rodin*. Philadelphia, 1976, p. 478.

The original version of the *Man with the Broken Nose* was a full head, modeled in the round in the winter of 1863–64; the subject was an odd-job man named Bibi. Regarding the model's appearance, Rodin commented that he chose Bibi because "he had a fine head; belonged to a fine race – in form – no matter if he was brutalized. It was made as a piece of sculpture, solely, and without reference to the character of the model, as such. I called it 'The Broken Nose,' because the nose of the model was broken" (Bartlett, *op. cit.*, in Elsen, *op. cit.*, pp. 20–21). According to Rodin, who was extremely poor at this time and could not afford to heat his studio, the clay model froze, and the back of its head split off. Rodin nevertheless considered this bust "the first good piece of modeling I ever did," determining the course of his future work (Bartlett, *op. cit.*, in Elsen, *op. cit.*, p. 21), and it is from this fragment that the Museum's mask was taken. Casts

of the *Man with the Broken Nose* as a mask and as a full head and bust (from a repaired and augmented model) are abundant, having been executed by Rodin throughout his life and posthumously.

This particular cast was probably made around 1882, when a bronze was exhibited at the Grosvenor Gallery in London, and is one of four identifiable casts acquired around this time by friends and patrons of Rodin living in England. These include versions acquired by the artist Alphonse Legros (now in Oxford, Ashmolean Museum), the sculptor Gustave Natorp (now in Cambridge, Fogg Art Museum), and the poet Robert Browning (Sotheby, Wilkinson and Hodge, London, May 1–8, 1913, no. 1274). Ionides, introduced to Rodin by Legros, was a major collector who donated nearly twelve hundred works from his collection to the Victoria and Albert Museum in 1901. Correspondence from Ionides to Rodin (Musée Rodin archives, Paris, May 21, 1883), inviting Rodin and Legros to look at an unnamed bust by Rodin recently acquired by him from a private dealer, may very likely refer to the mask now at RISD. In 1884 Ionides also acquired a cast of *The Thinker* from Rodin.

AUGUSTE RODIN
French, 1848–1917
Study for the Monument to Balzac, original ca. 1892
Signed and inscribed, right base: *Rodin orig./Alexis Rudier, Fondeur, Paris*
Bronze. 50¼" × 20½" × 24¾"
(127.6 × 52.1 × 60.3 cm)
Museum Associates and donations from Museum Members. 66.057
[see entry no. 67]

AUGUSTE RODIN
French, 1848–1917
The Hand of God, ca. 1898 (plaster?); first carved ca. 1902
Signed, on base beneath thumb: *A. Rodin*
Marble. 39½" × 32½" × 26¾"
(100.3 × 82.5 × 67.9 cm)
Museum Appropriation. 23.005
[see entry no. 68]

Soitoux [s 55] Troubetzkoy [s 56]

[s 55]

JEAN FRANÇOIS SOITOUX
French, 1816–1891
Genius of Combat (Putto with the Instruments of War), ca. 1855
Plaster. 12¾″ × 10⅜″ × 7¹¹⁄₁₆″
(32.4 × 26.4 × 19.5 cm)
Bought with the help of an anonymous gift. 56.182

BIBLIOG.: *Bull RISD, Museum Notes*, LIV:3 (March 1968), pp. 3–7; Peter Fusco and H. W. Janson, *The Romantics to Rodin*. Los Angeles, 1980, pp. 357–58 (no. 215).

This figure, previously attributed to François Rude (1785–1855), has been identified by Jacques de Caso as a maquette by Soitoux, a devoted pupil of David d'Angers, for the decoration of the balustrade of the attic of the newly constructed interior wing of the Louvre, begun in 1854 by the architect Hector Lefuel. The sculpture, one of nearly a hundred by a variety of artists, was commissioned from Soitoux in 1855 for 3,200 Frs. and completed in 1857, when the monumental stone was exhibited in the Paris Salon, along with sculptures by Soitoux of *Denis Papin* and *Montaigne*, also designated for the decoration of the Louvre. A sculpture representing *Astronomy* was also commissioned from Soitoux in 1854 for this balustrade. The Museum's maquette for the *Genius of Combat* may be the version initially shown by Soitoux to Lefuel. The final working model for the monumental stone version of this sculpture, which still stands on the balustrade of the Louvre, also can be found in the collections of the Louvre.

[s 56]

PRINCE PAUL PETROVITCH TROUBETZKOY
Russian, 1866–1938
Indian Scout, 1893
Signed and dated, front base: *Paolo Troubetzkoy 1893*
Bronze. 23¹⁄₁₆″ × 21½″ × 12⅛″
(60 × 54.6 × 30.8 cm)
Bequest of George Pierce Metcalf. 57.241

BIBLIOG.: Christian Brinton, *Catalogue of Sculpture of Prince Paul Troubetzkoy.* New York, 1911, p. 127.

The subject was inspired by Buffalo Bill's Wild West Show, which the sculptor attended in Milan. A version was exhibited in Rome in 1894, where it was awarded a gold medal.

A. V. 1937. A. V., "Giacomo Favretto nel cinquantenario della morte," *L'Avvenire d'Italia* (Rome), August 20, 1937.

About 1855. Edmond About, *Voyage à travers l'Exposition des Beaux-Arts*. Paris: Librairie de L. Hachette et Cie., 1855.

Ackerman 1967. Gerald M. Ackerman, "Gérôme and Manet," *Gazette des Beaux-Arts*, ser. 6, v. LXX (September 1967), pp. 163–76.

Ackerman 1986. Gerald M. Ackerman, *The Life and Work of Jean-Léon Gérôme with a Catalogue Raisonné*. New York: Sotheby's Publications, Harper and Row Publishing, Inc., 1986.

Adhémar 1955. Jean Adhémar, "Before the Degas bronzes," *Art News*, v. 54, no. 7 (November 1955), pp. 34–35, 70.

Adlow 1934. Dorothy Adlow, "A Degas Portrait," *Christian Science Monitor*, April 24, 1934, p. 7.

Aix-en-Provence, Granet, 1982. Aix-en-Provence, Musée Granet, *Cézanne, ou la peinture en jeu (actes du Colloque tenu à Aix-en-Provence au musée Granet, du 21 au 25 juin 1982)*. Limoges: Adolphe Ardant, 1982.

Aix-en-Provence, Vendôme, 1961. Aix-en-Provence, Pavillon de Vendôme, *Exposition Cézanne,* July 1–August 15, 1961.

Albuquerque, UNM, 1964. Albuquerque, University of New Mexico, *Art Since 1889*, October 20–November 15, 1964.

Alexandre 1921. Arsène Alexandre, *Claude Monet*. Paris: Les Editions Bernheim-Jeune, 1921.

Alexandre 1930. Arsène Alexandre, "L'Exposition Cézanne à la Galerie du Théâtre Pigalle," *La Renaissance*, v. 3, no. 2 (February 1930), p. 75.

Alford 1950. John Alford, "A Century of Sculpture," *Bulletin of Rhode Island School of Design, Museum Notes*, v. 7, no. 5 (May 1950), n. p.

Allentown, AAM, 1962. Allentown, Allentown Art Museum, *The World of Benjamin West*, May 1–July 1, 1962.

Allentown, AAM, 1968. Allentown, Allentown Art Museum, *Eugène Carrière 1849–1906: Seer of the Real*, November 2, 1968–January 26, 1969.

American Art Annual 1915. *American Art Annual*, v. XII (1915).

Ames 1967. Winslow Ames, *Prince Albert and Victorian Taste*. London: Chapman and Hall, 1967.

Amherst, Mead, 1988. Amherst, Mead Art Museum, *Delacroix and the Romantic Image: Oriental Themes, Wild Beasts, and the Hunt*, October 7–November 30, 1988.

Amour de l'Art 1932. *L'Amour de l'Art (Manet, numéro du centenaire)* (May 1932).

Andover, Addison, 1942. Andover, Addison Gallery of American Art, *Architecture in Painting*, November 16–December 16, 1942.

Andover, Addison, 1945. Andover, Addison Gallery of American Art, *The Impressionistic Period*, January 15–February 13, 1945.

Andover, Addison, 1947. Andover, Addison Gallery of American Art, *Seeing the Unseeable*, January 3–March 3, 1947 (no cat.).

Andover, Addison, 1961. Andover, Addison Gallery of American Art, *The Changing Character of Western Art*, July 8–September 25, 1961.

André 1923. Albert André, *Renoir*. Paris: G. Crès et Cie, 1923.

Angoulvent 1933. Monique Angoulvent, *Berthe Morisot*. Paris, 1933.

Ann Arbor, Museum of Art, 1977. William A. Coles, *Alfred Stevens*, Ann Arbor, University of Michigan Museum of Art, September 10–October 16, 1977; Baltimore, Walters Art Gallery, November 20, 1977–January 1, 1978; Montreal, Musée des Beaux-Arts, February 2–March 19, 1978.

Antiques & the Arts Weekly 1987. "Portrait given to Rhode Island School," *Antiques & the Arts Weekly*, March 13, 1987, p. 73.

Apollinaire 1913. Guillaume Apollinaire, *Les Peintres cubistes, méditations esthétiques*. Paris: Eugène Figuière et Cie., 1913. (Trans. Lionel Abel, *The Cubist Painters, Aesthetic Meditations*. New York: Wittenborn and Company, 1944.)

Arama 1987. Maurice Arama, *Le Maroc de Delacroix*. Paris: Les Editions du jaguar, 1987.

Arbuthnot 1950. Francis Bamford and the Duke of Wellington, eds., *The Journal of Mrs. Arbuthnot, 1820–1832*, 2 v. London: Macmillan and Co., 1950.

Archinti 1889. Luigi Archinti, "L'Arte italiana all'Esposizione," *Parigi e l'Esposizione Universale del 1889*, no. 26. Milan: F.lli Treves, October 1889, p. 201.

Art Digest 1950. "Detroit sees France from David to Courbet," *Art Digest*, v. 24, no. 9 (February 1, 1950), p. 13.

Art Journal 1974. "Recent Acquisitions," *Art Journal*, v. XXXIII, no. 3 (Spring 1974), pp. 247–49.

Art-Journal 1865. "The Royal Academy," *The Art-Journal*, v. XXVII (June 1, 1865).

Art-Journal 1868. "Exhibition of Pictures by Gustave Doré, Egyptian Hall," *The Art-Journal*, v. VII, new series (February 1, 1868), p. 27.

Art-Journal 1871. "The Royal Academy, Gallery No. III," *The Art-Journal*, v. X, new series (June 1, 1871), p. 153.

Art Moderne 1896. "Le raout Meunier," *L'Art Moderne* (April 19, 1896), p. 123.

Art News 1930. "Rodin Bronzes, Balzac Galleries," *Art News*, v. XXVIII, no. 16 (January 18, 1930), p. 10.

Art News 1938. "Providence: Accession of a Hubert Robert Architectural Study," *Art News*, v. XXXVI, no. 14 (January 1, 1938), p. 18.

Art News 1940. "Art Throughout America," *Art News*, v. XXXVIII, no. 31 (May 4, 1940), p. 24.

Art News 1943. "Art News of America," *Art News*, v. XLII, no. 10 (October 1–14, 1943), p. 6.

Art News, Jan. 1945. *Art News*, v. XLIII, no. 18 (January 1–14, 1945).

Art News, Oct. 1945. *Art News*, v. XLIV, no. 12 (October 1–14, 1945).

Art News 1950. *Art News*, v. XLIX, no. 1 (March 1950).

Art Quarterly 1945. *Art Quarterly*, v. VIII, no. 3 (Summer 1945).

Art Quarterly 1953. "Accessions of American and Canadian Museums," *Art Quarterly*, v. XVI, no. 3 (Autumn 1953), p. 257.

Art Quarterly 1957. "Recent Accessions," *Art Quarterly*, v. XX, no. 4 (Winter 1957), p. 470.

Art Quarterly 1959. "Accessions of American and Canadian Museums," *The Art Quarterly*, v. XXII, no. 3 (Autumn 1959), pp. 273–85.

Art-Union 1847. *The Art-Union Monthly Journal of the Fine Arts*, Enlarged Series, v. VI, no. 108 (London) (June 1847).

Atlanta, Art Association, 1955. Atlanta, Atlanta Art Association Galleries, *French Painting, David to Rouault*, September 20–October 4, 1955; Birmingham, Birmingham Museum of Art, October 16–November 5, 1955.

Atlanta, Art Association, 1962. Atlanta, Atlanta Art Association, *Landscape into Art*, February 2–25, 1962.

Auckland, City Art Gallery, 1985. Auckland, City Art Gallery, *Claude Monet – painter of light*, April 9–May 28, 1985; Sydney, Art Gallery of New South Wales, June 11–July 23, 1985; Melbourne, National Gallery of Victoria, August 6–September 17, 1985.

Baigell 1968. Matthew Baigell, "The Beginnings of 'The American Wave' and the Depression," *Art Journal*, v. XXVII, no. 4 (Summer 1968), pp. 387–97.

Bailly-Herzberg 1972. Janine Bailly-Herzberg, "Marcellin Desboutin and his World," *Apollo*, no. 95 (June 1972), pp. 496–500.

Baker 1942. Herschel Baker, *John Philip Kemble. The Actor in his Theater*. Cambridge: Harvard University Press, 1942.

Ball 1981. Susan L. Ball, *Ozenfant and Purism: The Evolution of a Style, 1915–1930*. Ann Arbor: UMI Research Press, 1981.

Ballu 1880. Roger Ballu, *Catalogue des oeuvres de Thomas Couture exposées au Palais de l'Industrie précédé par un essai sur l'artiste*. Paris, 1880.

Baltimore, Museum, 1964. Baltimore, Baltimore Museum of Art, *1914/An Exhibition of Paintings, Drawings and Sculpture Created in 1914: In Celebration of the 50th Anniversary of the Baltimore Museum of Art*, October 6–November 15, 1964.

Bandiera 1989. John D. Bandiera, "Form and

Meaning in Hubert Robert's Ruin Caprices: Four Paintings of Fictive Ruins for the Château de Méréville," in Art Institute of Chicago, *Museum Studies*, v. 15, no. 1 (1989), pp. 20–37.

Banks 1937. Miriam A. Banks, "Mr. Rowe, the Director of the Museum," *Bulletin of the Rhode Island School of Design*, v. XXV, no. 2 (April 1937), pp. 23–37.

Bantens 1983. Robert James Bantens, *Eugène Carrière; His Work and His Influence*. Ann Arbor: UMI Press, 1983.

Bantens 1990. Robert James Bantens, *Eugène Carrière, The Symbol of Creation*. New York: Kent Fine Art, Inc., 1990.

Barbier 1987. Nicole Barbier, *Marbres de Rodin*. Paris: Editions du musée Rodin, 1987.

Barcelona, Palau Meca, 1985. Ajuntament de Barcelona, *Henri Matisse 1904–1917*, Barcelona, Palau Meca, May–June 1985.

Bareau 1984. Juliet Wilson Bareau, "The Portrait of Ambroise Adam by Edouard Manet," *Burlington Magazine*, v. CXXVI, no. 981 (December 1984), pp. 750–57.

Bargellini 1944. Piero Bargellini, *Caffè Michelangelo*. Florence: Vallecchi Editore, 1944.

Barr 1931. Alfred H. Barr, Jr., *Henri Matisse*. New York: Museum of Modern Art, 1931.

Barr 1946. Alfred H. Barr, Jr., *Picasso, Fifty Years of his Art*. New York: Museum of Modern Art, 1946.

Barr 1951. Alfred H. Barr, Jr., *Matisse: His Art and His Public*. New York: Museum of Modern Art, 1951.

Barskaïa 1983. Anna Barskaïa, *Paul Cézanne, Tableaux dans les Musées Soviétiques*. Leningrad: Ed. d'Art Aurora, 1983.

Bartlett 1889. Truman Bartlett, "Auguste Rodin, Sculptor," *The American Architect and Building News*, v. XXV, no. 682 (January 19, 1889); no. 683 (January 26, 1889); no. 685 (February 9, 1889); no. 688 (March 2, 1889); no. 689 (March 9, 1889); no. 696 (April 27, 1889); no. 698 (May 11, 1889); no. 700 (May 25, 1889); no. 701 (June 1, 1889); no. 703 (June 15, 1889).

Basler 1924. Adolphe Basler, *Henri Matisse*. Leipzig: Klinkhardt und Bierman, 1924.

Basler 1928. Adolphe Basler, *La Sculpture Moderne en France*. Paris, 1928.

Baudelaire 1965. Charles Baudelaire, trans. Jonathan Mayne, *The Painter of Modern Life and other Essays*. London/New York: Phaidon, 1965.

Bazin 1987. Germain Bazin, *Théodore Géricault. Etude Critique, Documents et Catalogue Raisonné*, 2 v. Paris: La Bibliothèque des Arts, 1987.

Bazire 1884. Edmond Bazire, *Manet*. Paris: A. Quantin, 1884.

Beau 1968. Marguerite Beau, *La Collection des dessins d'Hubert Robert au Musée de Valence*. Lyons: Audin, 1968.

Beaulieu 1969. Michèle Beaulieu, "Les sculptures de Degas: essai de chronologie," *La Revue du Louvre et des Musées de France*, no. 6 (1969), pp. 369–80.

Beausire 1988. Alain Beausire, *Quand Rodin exposait*. Paris: Editions Musée Rodin, 1988.

Beck 1973. Hilary Beck, *Victorian Engravings*. London: Victoria and Albert Museum, 1973.

Bellier-Auvray 1882–85. Emile Bellier de la Chavignerie and Louis Auvray, *Dictionnaire général des artistes de l'école française*, 2 v. Paris: Renouard, 1882–85.

Bénédite 1904. Léonce Bénédite, "Les Salons de 1904: La Sculpture," *La Revue de l'Art ancien et modern* (June 1904).

Bénédite 1931. Léonce Bénédite, *Théodore Chassériau, sa vie et son oeuvre*, 2 v. Paris: Les Editions Braun, 1931.

Benjamin 1937. Ruth L. Benjamin, *Eugène Boudin*. New York: Raymond and Raymond, 1937.

Berger 1946. Klaus Berger, *Géricault Drawings and Watercolors*. New York, 1946.

Berger 1952. Klaus Berger, *Géricault und sein Werk*. Vienna, 1952.

Berlin, Der Sturm, 1913. Berlin, Der Sturm, *12te Ausstellung: Robert Delaunay*, January 27–February 20, 1913.

Bernáth 1937. Aurél Bernáth, "Composition in Modern Painting," *Magyar Müvészet*, v. XII (1937), entire issue.

Bernheim-Jeune 1919. J. and G. Bernheim-Jeune, eds., *L'Art moderne, et quelques aspects de l'art d'autrefois, cent-soixante-treize planches d'après la collection privée de MM. J. & G. Bernheim-Jeune*, v. II. Paris: Bernheim-Jeune, 1919.

Bert and McElroy 1990. Catherine Little Bert and L.J. McElroy, "Advocates of Art, the Early Years of the Ann Eliza Club (1885–1896)," *Sketches*, v. I, no. 1 (December 1990).

Bertall 1873. Bertall, "Revue comique du Salon," *L'Illustration* (May 24, 1873).

Bertauts-Couture 1932. G. Bertauts-Couture, pref. by Camille Mauclair, *Thomas Couture: sa vie, son oeuvre, son caractère, ses idées, ses méthodes, par lui-même et par son petit-fils*. Paris: Maurice le Garrec, 1955.

Bertauts-Couture 1955–56. G. Bertauts-Couture, "Thomas Couture: sa technique et son influence sur la peinture française de la seconde moitié du XIX siècle," *Etudes d'Art*, no. 11/12 (1955–56), pp. 157 ff.

Bertaux 1909. E. Bertaux, "Le buste de Madame Récamier par Chinard," *Revue de l'Art ancien et moderne*, v. 26, no. 152 (November 1909), pp. 321–36.

Besson 1938. Georges Besson, *Renoir*. Paris, 1938.

Bidoli 1975. Giuseppe Bidoli, "L'arte delle macchie," *Il Secolo d'Italia* (Rome), November 30, 1975.

Bindman 1977. David Bindman, *Blake as an Artist*. Oxford: Phaidon, 1977.

Biographie nationale 1906. *Biographie nationale de Belgique*. Brussels: H. Thiry-van Buggenhoudt, 1906.

Birnbaum 1960. Martin Birnbaum, *The Last Romantic*. New York: Twayne Publishers, 1960.

Bissière 1920. Roger Bissière, *Georges Braque*, Les Maîtres du Cubisme series. Paris: Editions de "l'Effort Moderne," 1920.

Blanche 1924. Jacques-Emile Blanche, *Manet*. Paris: F. Rieder & Cie., 1924.

Blunt 1959. Anthony Blunt, *The Art of William Blake*. New York/London: Columbia University Press, 1959.

Boggs 1955. Jean Sutherland Boggs, "Edgar Degas and the Bellellis," *Art Bulletin*, v. XXXVII, no. 2 (June 1955), pp. 127–37.

Boggs 1963. Jean Sutherland Boggs, "Edgar Degas and Naples," *Burlington Magazine*, v. CV, no. 723 (June 1963), pp. 273–76.

Boime 1971 and 1977. Albert Boime, *The Academy and French Painting in the Nineteenth Century*. London: Phaidon, 1971 and 1977.

Boime 1980. Albert Boime, *Thomas Couture and the Eclectic Vision*. New Haven/London: Yale University Press, 1980.

Boito 1887. Camillo Boito, "La Mostra Nazionale di Belle Arti in Venezia," *Nuova Antologia*, 3rd series, v. XII, fasc. XXI (November 1, 1887), pp. 53, 55.

Boito 1888. Camillo Boito, "Ricordo della Esposizione, S. V. P. 1887," *Società Veneta Promotrice di Belle Arti*. Venice: Tip. Emiliana, 1888.

Bologna, Esposizione 1888. "Liston odierno. Quadro di G. Favretto," *Bologna, Esposizione Emiliana 1888*, no. 31. Bologna, 1888, p. 9.

Bologna, Museo Civico, 1973. Dario Durbé and Cristina Bonagura, *Silvestro Lega (1826–1895)*, Bologna, Museo Civico, June 14–August 26, 1973.

Borghi 1959. Mino Borghi, "Silvestro Lega," *Rivista delle province*, 1959.

Bortolatto 1972. Luigina Rossi Bortolatto, *L'opera completa di Claude Monet, 1870–1889*. Milan: Rizzoli, 1972.

Boston, MFA, 1911. Arlo Bates, *Memorial Exhibition of the Works of Frederick Porter Vinton*, Boston, Museum of Fine Arts, November 1911.

Boston, MFA, 1918. Boston, Museum of Fine Arts, *Quincy Adams Shaw Collection: Italian Renaissance Sculpture, Paintings and Pastels by Jean François Millet*, April 1918.

Boston, MFA, 1939. Boston, Museum of Fine Arts, *Art in New England. Paintings, Drawings, Prints from Private Collections in New England*, June 9–September 10, 1939.

Boston, MFA, 1960. Boston, Museum of Fine Arts, *Gustave Courbet 1819–1887*, February 26–April 14, 1960; Philadelphia, Philadelphia Museum of Art, December 17, 1959–February 14, 1960.

Boston, MFA, 1974. Barbara S. Shapiro, *Edgar Degas, the Reluctant Impressionist*, Boston, Museum of Fine Arts, June 20–September 1, 1974.

Boston, MFA, 1976. Boston, Museum of Fine Arts, *Romans and Barbarians*, December 17, 1976–February 27, 1977.

Boston, MFA, 1984. Alexandra Murphy, with contributions by Susan Fleming and Chantal Mahry-Park, *Jean-François Millet*, Boston, Museum of Fine Arts, March 28–July 1, 1984; Tokyo, Nihonbashi Takashimaya, August 9–September 30, 1984; Sapporo, Hokkaido Municipal Modern Art Museum, October 9–November 11, 1984; Yamaguchi, Yamaguchi Municipal Fine Arts Museum, November 22–December 23, 1984; Nagoya, Nagoya Matsukaya, January 3–February 8, 1985; Kyoto, Kyoto Municipal Museum of Art, February 28–April 14, 1985; Mamanushi, Mamanushi Prefectural Museum, April 30–May 19, 1985; New York, IBM Gallery of Science and Art, June 11–27, 1985.

Boston, Saint Botolph, 1913. Boston, Saint Botolph Club, *Impressionist Painting Lent by Messrs. Durand-Ruel and Sons*, January 20–31, 1913.

Boston, Vose, 1987. Boston, Vose Galleries of Boston, Inc., *Vose Galleries of Boston, Inc., A Commemorative Catalogue*, 1987.

Bouvenne 1887. Aglaus Bouvenne, "Théodore Chasseriau [sic]," *L'Artiste*, v. 57, no. 2 (September 1887), pp. 161–78.

Bovi 1963. Arturo Bovi, "Vita semplice di Silvestro Lega," *Historia* (February 1963).

Bregenz, Vorarlberger, 1968. Bregenz, Vorarlberger Landesmuseum, *Angelika Kauffmann und ihre Zeitgenossen*, July 23–October 13, 1968; Vienna, Osterreichisches Museum für angewandte Kunst, November 8, 1968–February 1, 1969.

Bremen, *Bremer Nachr.*, 1961. *Bremer Nachrichten* (Bremen), April 8, 1961.

Brettell 1990. Richard R. Brettell, *Pissarro and Pontoise, The Painter in a Landscape*. New Haven/London: Yale University Press, 1990.

Brian 1942. Doris Brian, "This Century's Share of Renoir," *Art News*, v. XLI, no. 4 (April 1–14, 1942), pp. 22–23, 32–33.

Brighton, Fine Art, 1915. Brighton, Fine Art Galleries of Brighton, *Exhibition of Belgian Modern Art*, May–June 1915.

Brooke 1969. David S. Brooke, "James Tissot's Amateur Circus," in Boston, Museum of Fine Arts, *Bulletin,* v. LXVII, no. 347 (1969), pp. 4–17.

Brooklyn, Brooklyn Museum, 1980. Brooklyn, Brooklyn Museum, *Belgian Art, 1880–1914,* April 23–June 29, 1980.

Brooklyn, Brooklyn Museum, 1988. Sarah Faunce and Linda Nochlin, *Courbet Reconsidered,* Brooklyn, Brooklyn Museum, November 4, 1988–January 16, 1989; Minneapolis, Minneapolis Institute of Arts, February 18–April 30, 1989.

Brookner 1987. Anita Brookner, *Jacques-Louis David.* New York: Thames and Hudson, Inc., 1987.

Brosch 1902. L. Brosch, "Giacomo Favretto," *Die Kunst Unserer Zeit,* Lieferung 3. Munich: F. Haufstaengl Kunstverlag, 1902, p. 43.

Broude 1977. Norma Broude, "Degas's 'Misogyny,'" *Art Bulletin,* v. 59, no. 1 (March 1977), pp. 95–107.

Broude 1987. Norma Broude, *The Macchiaioli: Italian Painters of the Nineteenth Century.* New Haven/London: Yale University Press, 1987.

Browse 1949. Lillian Browse, *Degas Dancers.* New York: The Studio Publications, n.d. [1949].

Brussels, Beaux-Arts, 1987. Brussels, Musées Royaux des Beaux-Arts de Belgique, Musée d'Art Moderne, *Académie Royale des Beaux-Arts de Bruxelles,* 1987.

Brussels, Ixelles, 1985. Denis Coekelberghs and Pierre Loze, *1779–1830: Autour du Néo-Classicisme en Belgique,* Brussels, Musée Communal des Beaux-Arts d'Ixelles, November 14, 1985–February 8, 1986.

Brussels, Ixelles, 1990. Serge Goyens de Heusch and Philippe Roberts-Jones, *L'Impressionnisme et le fauvisme en Belgique,* Brussels, Musée Communal des Beaux-Arts d'Ixelles, October 12–December 16, 1990.

Brussels, Libre Esthétique, 1896. Brussels, La Libre Esthétique, February 22–March 30, 1896.

Brussels, Libre Esthétique, 1904. Brussels, La Libre Esthétique, *Exposition des peintres Impressionnistes,* February 25–March 29, 1904.

Brussels, Musée Horta, 1980. Brussels, Musée Horta, *G. Lemmen,* October 16–November 16, 1980.

Buckberrough 1982. Sherry A. Buckberrough, *Robert Delaunay: The Discovery of Simultaneity.* Ann Arbor: UMI Research Press, 1982.

Buffalo, Albright, 1932. Buffalo, Albright Art Gallery, *The Nineteenth Century: French Art in Retrospect (1800–1900),* November 1–30, 1932.

Buffalo, Albright, 1944. Organized by the Embassy of the Provincial Government of the French Republic in the United States, *French Paintings of the Twentieth Century (1900–1939),* Buffalo, Albright Art Gallery, December 1944; Cincinnati, Cincinnati Art Museum, January 1945; St. Louis, St. Louis Art Museum, March 1945.

Buffalo, Albright-Knox, 1967. Richard V. West, *The Painters of the Section d'Or,* Buffalo, Albright-Knox Art Gallery, September 27–October 22, 1967.

Buffalo, Fine Arts, 1954. Buffalo, Buffalo Fine Arts Academy, *Painters' Painters,* Buffalo, Albright Art Gallery, April 16–May 30, 1954.

Building News 1867. *Building News,* May 17, 1867.

Bulletin de l'Art 1909. "Musées de Province. Un buste de Mme Récamier, par Chinard, au musée de Lyon," *Bulletin de l'Art ancien et moderne,* v. 11, no. 418 (April 3, 1909), p. 111.

Burda 1967. Hubert Burda, *Die Ruinen in den Bildern Hubert Roberts.* Munich, 1967.

Burke 1976. Joseph Burke, *English Art 1714–1800.* Oxford: Oxford University Press, 1976.

Burlington, Fleming, 1947. Burlington, Robert Hull Fleming Museum, February 15–April 30, 1947 (no cat.).

Butlin 1981. Martin Butlin, *The Paintings and Drawings of William Blake,* 2 v. New Haven: Yale University Press for the Paul Mellon Centre for Studies in British Art, 1981.

Butor 1967. Michel Butor, "Monet or the World Turned Upside-Down," in Thomas B. Hess and John Ashbery, eds., *Avant-Garde Art.* London: Collier-Macmillan Ltd., 1967.

Cahiers d'Art 1933. *Cahiers d'Art.* Paris: Editions "Cahiers d'Art," 1933.

Caillaux 1935. Henriette Caillaux, *Dalou. L'Homme. L'Oeuvre.* Paris, 1935.

Cailleux 1975. Jean Cailleux, "Hubert Robert's Submission to the Salon of 1769," Supplement to *Burlington Magazine,* v. CXVII, no. 871 (October 1975) pp. i–xvi.

Calais, Beaux-Arts, 1975. Calais, Musée des Beaux-Arts, *Peinture française, 1770–1830,* June 29–August 25, 1975; Arras, Musée d'Arras, September 7–November 3, 1975; Douai, Musée de Douai, November 15, 1975–January 12, 1976; Lille, Palais des Beaux-Arts, January 25–March 29, 1976.

Calais, Beaux-Arts, 1982. Calais, Musée des Beaux-Arts, *De Carpeaux à Matisse, La Sculpture française de 1850 à 1914 dans les collections publiques du Nord de la France,* March 18–June 6, 1982; Lille, Musée des Beaux-Arts, June 15–August 31, 1982; Arras, Ancienne Abbaye Saint-Waast d'Arras, September 15–November 15, 1982; Boulogne-sur-Mer, Musée des Beaux-Arts et d'Archéologie, December 1, 1982–February 1, 1983; Paris, Musée Rodin, February–April 1983.

Càllari 1909. Luigi Càllari, *Storia dell'arte contemporanea italiana.* Rome: Ermanno Loescher & C., 1909.

Callen 1980. Anthea Callen, *Courbet.* London: Jupiter Books, 1980.

Calzini 1951. Raffaele Calzini, *12 opere di Silvestro Lega nella Raccolta Stramezzi.* Milan: Edizione del Milione, 1951.

Cambridge, Busch-Reisinger, 1955. Cambridge, Busch-Reisinger Museum, Harvard University, *The Arts of Matisse,* May 9–June 8, 1955.

Cambridge, Fogg, 1911. Cambridge, Fogg Art Museum, Harvard University, *Loan Exhibition of Paintings and Pastels by H. G. E. Degas,* April 5–14, 1911.

Cambridge, Fogg, 1946. Cambridge, Fogg Art Museum, Harvard University, *Between the Empires, Géricault, Delacroix, Chassériau, Painters of the Romantic Movement,* April 30–June 1, 1946.

Cambridge, Fogg, 1955. Cambridge, Fogg Art Museum, Harvard University, *Landscape, Massys to Corot,* May 6–June 3, 1955.

Cambridge, Fogg, 1976. Agnes Mongan, ed., *Harvard Honors Lafayette,* Cambridge, Fogg Art Museum, Harvard University, December 3, 1975–March 12, 1976.

Camicia Rossa 1938. "Ritratto di Silvestro Lega," *Camicia Rossa* (Rome), February 1938.

Canaday 1961. John Canaday, "Salute to Italy," *New York Times,* April 23, 1961, p. 23.

Cardon 1990. Roger Cardon, *Georges Lemmen (1865–1916).* Antwerp: Petraco-Pandora, 1990.

Carnegie 1936. Carnegie Corporation of New York, *Catalogue of Selected Color Reproductions,* v. 2. New York: Raymond and Raymond, Inc., 1936.

Carrière 1904. Eugène Carrière, "Sur l'Ecole de Rome et l'éducation des artistes," *Les Arts de la Vie* (October 1904), pp. 195–99.

Carrière 1907. Eugène Carrière, *Ecrits et lettres choisies.* Paris: Société du Mercure de France, 1907.

Carrière 1966. Jean-René Carrière, *De la Vie d'Eugène Carrière.* Paris: Edouard Privat, 1966.

Carstairs 1934. Caroll [sic] Carstairs, *Postscript to Criticism.* London: Seeley Service & Co., Ltd., 1934.

Carter 1961. David G. Carter, "Treasure-of-the-Month: *The Death of Mazzini,*" *Providence Sunday Journal Magazine,* February 26, 1961.

Cartwright 1884. Julia Cartwright, "The Artist in Venice," *Portfolio,* v. 15 (1884), pp. 38–39.

Cassou 1940. Jean Cassou, trans. Mary Chamot, *Picasso.* London, 1940.

Castelnuovo 1887. Enrico Castelnuovo, "Lettere al Direttore," *L'Esposizione Artistica Nazionale Illustrata–Venezia 1887,* no. 12 (June 19, 1887), pp. 91, 93.

Casteras 1982. Susan P. Casteras, *The Substance of Shadow: Images of Victorian Womanhood.* New Haven: Yale Center For British Art, 1982.

Cauman 1958. Samuel Cauman, *The Living Museum: Experiences of an Art Historian and Museum Director–Alexander Dorner.* New York: New York University Press, 1958.

Centelli 1887. Attilo Centelli, "Giacomo Favretto e le sue opere," *L'Illustrazione Italiana* (Milan), June 16, 1887, p. 438.

Cervelli 1898. Bruno Cervelli, "Un quadro del Favretto," *Natura ed Arte,* v. VIII, no. 13 (June 1898–99), p. 62.

Cézanne 1976. Paul Cézanne, ed. John Rewald, *Cézanne, Letters.* New York: Hacker Art Books, Inc., 1976.

Cham, "Le Salon pour rire," 1873. Cham, "Le Salon pour rire," *Charivari* (May 23, 1873).

Cham, "Réfusés," 1873. Cham, "Promenade au Salon des Réfusés," *Charivari* (June 8, 1873).

Chapel 1982. Jeannie Chapel, *Victorian Taste. The Complete Catalogue of Paintings at the Royal Holloway College.* London: A. Zwemmer Ltd., 1982.

Chapel Hill, Ackland, 1978. John Minor Wisdom, ed., *French Nineteenth-Century Oil Sketches: David to Degas,* Chapel Hill, Ackland Memorial Art Center, March 5–April 16, 1978.

Chappuis 1973. Adrien Chappuis, *The Drawings of Paul Cézanne: A Catalogue Raisonné.* Greenwich: New York Graphic Society, 1973.

Charlottesville, UVA, 1976. Charlottesville, University of Virginia Art Museum, *European Art in the Age of Jefferson,* March 16–April 23, 1976.

Chartier 1989. Ed. Roger Chartier, trans. Arthur Goldhammer, *A History of Private Life. Vol. III: Passions of the Renaissance.* Cambridge: Belknap Press, 1989.

Cheney 1941. Sheldon Cheney, *The Story of Modern Art.* New York: Viking Press, 1941.

Chesneau 1880. Ernest Chesneau, *J.-B. Carpeaux, sa vie et son oeuvre.* Paris: A. Quantin, 1880.

Chevillard 1893. Valbert Chevillard, *Un Peintre Romantique, Théodore Chassériau.* Paris: Alphonse Lemerre, 1893.

Chicago, AI, 1933. Chicago, Art Institute of Chicago, *A Century of Progress, Exhibition of Paintings and Sculpture,* June 1–November 1, 1933.

Chicago, AI, 1960. Intro. by S. Lane Faison, notes by James Merrill, *Corot 1796–1875; An Exhibition of his Paintings and Graphic Works,* Chicago, Art Institute of Chicago, October 6–November 13, 1960.

Chicago, AI, 1973. Chicago, Art Institute of

Chicago, *Renoir Paintings and Drawings,* February 3–April 1, 1973.

Chicago, AI, 1975. Susan Wise, ed., *Paintings by Monet,* Chicago, Art Institute of Chicago, March 15–May 11, 1975.

Chincholle 1894. Charles Chincholle, "Balzac et Rodin," *Le Figaro,* November 25, 1894.

"Chronique des Arts" 1973. "La Chronique des Arts," *Supplément à la Gazette des Beaux-Arts,* no. 1249 (February 1973).

Chroniquer 1905. "Le Long des Cimaises. Le Salon d'Automne," *Le Chroniquer de Paris,* November 2, 1905.

Chu 1988. Petra Ten-Doesschate Chu, "It Took Millions of Years to Compose That Picture," in Brooklyn, Brooklyn Museum, 1988, pp. 55–65.

Cirici-Pellicer 1950. Alexandre Cirici-Pellicer, *Picasso avant Picasso.* Geneva, 1950.

Cladel 1936. Judith Cladel, *Rodin, sa vie glorieuse, sa vie inconnue.* Paris: Bernard Grasset, 1936.

Clark 1950. James M. Clark, *The Dance of Death in the Middle Ages and the Renaissance.* Glasgow, 1950 (reprinted as *Death and the Visual Arts.* New York: Arno Press, 1977).

Clark 1956. Anthony M. Clark, "Two Ottocento Paintings," *Bulletin of Rhode Island School of Design, Museum Notes,* v. 43, no. 2 (December 1956), pp. 1–3.

Clark 1959. Anthony M. Clark, "Five Roman Masters of the Settecento," *Bulletin of Rhode Island School of Design, Museum Notes,* v. 45, no. 4 (May 1959), pp. 3–8.

Clark 1981. Anthony M. Clark, "Roma mi è sempre in pensiero," in Edgar Peters Bowron, ed., *Studies in Roman Eighteenth-Century Painting,* Art History Series IV. Washington: Decatur House Press, 1981.

Clément 1868. Charles Clément, *Géricault, étude biographique et critique.* Paris: 1868 (3rd ed. 1879, reprinted 1973).

Clément-Carpeaux 1934. Louise Clément-Carpeaux, *La Vérité sur l'oeuvre et la vie de J.-B. Carpeaux,* 2 v. Paris: Dousset et Bigerelle, 1934.

Clément-Janin 1922. [Noël] Clément-Janin, *La Curieuse Vie de Marcellin Desboutin.* Paris: H. Floury, 1922.

Clementi 1941. R. Clementi, "Maestri dell'Ottocento. Le narrazioni pittoriche del veneziano Favretto," *L'Osservatore Romano,* March 29, 1941.

Cleveland, CMA, 1947. Cleveland, Cleveland Museum of Art, *Works by Edgar Degas,* February 5–March 9, 1947.

Cleveland, CMA, 1964. Henry Hawley, *Neo-Classicism. Style and Motif,* Cleveland, Cleveland Museum of Art, September 21–November 1, 1964.

Cleveland, CMA, 1981. Gabriel P. Weisberg, *The Realist Tradition: French Painting and Drawing, 1830–1900,* Cleveland, Cleveland Museum of Art, November 12, 1980–January 18, 1981; Brooklyn, Brooklyn Museum, March 7–May 10, 1981; St. Louis, St. Louis Art Museum, July 23–September 20, 1981; Kelvingrove, Glasgow Art Gallery and Museum, November 5, 1981–January 4, 1982, pp. 188–264.

Cloquet 1836. Jules G. Cloquet, *Recollections of the Private Life of General Lafayette.* New York: Leavitt, Lord and Co., 1836.

Cohen 1982. John Cohen, "Death and the Danse Macabre," *History Today,* v. 32 (August 1982).

Colin 1932. Paul Colin, *Edouard Manet.* Paris: Librairie Floury, 1932.

College Park, UMAG, 1970. Cat. by Jane Van Nimmen, intro. by George Levitine, and essays by Alain de Leiris and Jane Van Nimmen, *Thomas Couture: Paintings and Drawings in American Collections,* College Park, University of Maryland Art Gallery, February 5–March 15, 1970.

College Park, UMAG, Landgren, 1970. Marchal E. Landgren, *American Pupils of Thomas Couture,* College Park, University of Maryland Art Gallery, March 19–April 26, 1970.

Cologne, Kunstverein, 1964. Cologne, Kölnischer Kunstverein, *Autour du Cubisme,* April 3–May 18, 1964.

Cologne, Wallraf-Richartz, 1962. Cologne, Wallraf-Richartz Museum, *Europäische Kunst 1912. Zum 50. Jahrestag der Ausstellung des 'Sonderbundes westdeutscher Kunstfreunde und Künstler,'* September 14–December 9, 1962.

Cologne, Wallraf-Richartz, 1987. Ekkehard Mai and Anke Repp-Eckert, *Triumph und Tod des Helden: Europäische Historienmalerei von Rubens bis Manet,* Cologne, Wallraf-Richartz Museum, October 30, 1987–January 10, 1988; Zurich, Kunsthaus Zurich, March 3–April 24, 1988.

Columbia, Museum of Art, 1972. Annie-Paule Quinsac, *Ottocento Painting in American Collections,* New York, New York Cultural Center, November 15–December 31, 1972; Columbia, Columbia Museum of Art, January 9–February 4, 1973; St. Petersburg, Museum of Fine Arts, February 26–March 25, 1973; Jacksonville, Cummer Gallery of Art, April 3–29, 1973; Cambridge, Massachusetts Institute of Technology, May 5–June 15, 1973.

Comini 1974. Alessandra Comini, *Egon Schiele's Portraits.* Berkeley: University of California Press, 1974.

Compin and Roquebert 1986. Isabelle Compin and Anne Roquebert, *Catalogue sommaire illustré des peintures du musée du Louvre et du musée d'Orsay,* v. III *(Ecole Française A-K).* Paris: Editions de la Réunion des musées nationaux, 1986.

Connoisseur 1936. "As Monet Saw Hyde Park," *Connoisseur,* v. 97 (January 1936), p. 44.

Cook's 1890. *Cook's Handbook to Venice.* London: Thomas Cook and Son, n. d. [1890].

Cooper 1954. Douglas Cooper, *The Courtauld Collection. A Catalogue and Introduction.* London: University of London, The Athlone Press, 1954.

Cooper 1970. Douglas Cooper, *The Cubist Epoch.* London: Phaidon Press Ltd., 1970.

Copenhagen 1936. *A Guide to the Department of Modern Works of Art.* Copenhagen: Ny Carlsberg Glyptotek, 1936.

Corboz 1978. André Corboz, *Peinture militante et architecture révolutionnaire. A propos du thème du tunnel chez Hubert Robert.* Stuttgart: Birkhäuser, 1978.

Corna 1930. P. A. Corna, *Dizionario della storia dell'arte italiana.* Piacenza: C. Tarantola, 1930.

Corriere della Sera 1960. "Mazzini morente di Lega rintracciato negli Stati Uniti," *Il Corriere della Sera* (Milan), May 26, 1960.

Cortissoz 1919. Royal Cortissoz, "Degas as He was Seen by His Model," *New York Tribune,* October 19, 1919, section IV, p. 9.

Courthion 1962. Pierre Courthion, *Edouard Manet.* New York: Harry N. Abrams, Inc., 1962.

Courthion 1985. Pierre Courthion, trans. Marina Anzi Robertini, *L'opera completa di Courbet.* Milan: Rizzoli, 1985.

Cowart and Fourcade 1986. Jack Cowart and Dominique Fourcade, *Henri Matisse: The Early Years in Nice, 1916–1930.* New York: Harry N. Abrams, 1986.

Crépin-Leblond 1902. Marcellin Crépin-Leblond, "Sur Marcellin Desboutin," *Bulletin de la Société d'Emulation du Bourbonnais* (1902), pp. 120–36.

Crofton 1954. Anthony Crofton, comp., "A Catalogue of the Pictures at Ingestre Hall, Staffordshire...," in *Collection for a History of Staffordshire,* The Staffordshire Record Society, N. S., v. 48 (1954), pp. 53–105.

Crow 1985. Thomas E. Crow, *Painters and Public Life in Eighteenth-Century Paris.* New Haven/London: Yale University Press, 1985.

D. R. 1924. D. R., "A Painting by Corot," *Bulletin of the Rhode Island School of Design,* v. XII, no. 4 (October 1924), pp. 36–38.

D'Albis 1971. Jean D'Albis, "Some unpublished ceramics of Dalou," *Connoisseur,* v. 177, no. 713 (July 1971), pp. 175–81.

Daix 1982. Pierre Daix, *Cubists and Cubism.* New York: Rizzoli, 1982.

Daix and Boudaille 1967. Pierre Daix and Georges Boudaille with Joan Rosselet, trans. Phoebe Poole, *Picasso, The Blue and Rose Periods, A Catalogue Raisonné of the Paintings, 1900–1906.* Greenwich: New York Graphic Society, 1967.

Daix and Rosselet 1979. Pierre Daix and Joan Rosselet, *Picasso, The Cubist Years, 1907–1916, A Catalogue Raisonné of the Paintings and Related Works.* London: Thames and Hudson, 1979.

Daly 1937. D. Daly, "A Painting by Hubert Robert," *Bulletin of the Rhode Island School of Design, Museum Notes,* v. 25, no. 4 (October 1937), pp. 72–74.

Daudet 1951. Alphonse Daudet, trans. E. Wilkins, *Sappho.* New York: Pantheon Books, 1951.

Daulte 1971. François Daulte, *Auguste Renoir. Catalogue Raisonné de l'Oeuvre Peint,* v. I *(Figures, 1860–90).* Lausanne: the author, 1971.

Davidson 1959. Bernice F. Davidson, "Le Repos, A Portrait of Berthe Morisot by Manet," *Bulletin of Rhode Island School of Design, Museum Notes,* v. 46, no. 2 (December 1959), pp. 5–11, 12.

Dayton, Art Institute, 1972. Org. by Bruce H. Evans, intro. and commentaries by Gerald M. Ackerman, essay by Richard Ettinghausen, *Jean-Léon Gérôme (1824–1904),* Dayton, Dayton Art Institute, November 10–December 30, 1972; Minneapolis, Minneapolis Institute of Arts, January 26–March 11, 1973; Baltimore, Walters Art Gallery, April 6–May 20, 1973.

De Caso 1966. Jacques de Caso, "Balzac and Rodin in Rhode Island," *Bulletin of Rhode Island School of Design, Museum Notes,* v. 52, no. 4 (May 1966), pp. 1–28.

De Castries 1971. René de La Croix, duc de Castries, *Madame Récamier.* Paris: Hachette, 1971.

De Geoffroy 1851. Louis de Geoffroy, "Le Salon de 1850–51," *Revue des Deux Mondes,* v. IX (1851), pp. 926–65.

De Grada 1973. Raffaele De Grada, "Silvestro Lega, Il Macchiaiolo di Modigliana al Museo Civico di Bologna," *Giorni* (Milan), July 25, 1973.

De Logu 1955. Giuseppe De Logu, *Pittura Italiana dell'Ottocento.* Bergamo: Istituto Italiano d'Arti Grafiche, 1955.

De Rossi 1810. Giovanni Gherardo de Rossi, *Vita de Angelica Kauffmann, pittrice.* Florence, 1810 (reprinted London: Cornmarket, 1970).

Degand and Rouart 1958. Léon Degand and Denis Rouart, *Claude Monet.* Lausanne: Skira, 1958.

Delacroix 1893. Eugène Delacroix, *Journal d'Eugène Delacroix,* 2 v. Paris: Librairie Plon, 1893.

Delacroix 1937. Eugène Delacroix, trans. Walter Pach, *The Journal of Eugène Delacroix.*

New York: Covici Friede, 1937.

Delécluze 1856. M. E. J. Delécluze, *Les Beaux-Arts dans les Deux Mondes en 1855*. Paris: Charpentier, Librairie-Editeur, 1856.

Delteil 1923. L. Delteil, *Le Peintre-Graveur illustré: Camille Pissarro, Alfred Sisley, Auguste Renoir*, v. XVII. Paris: chez l'Auteur, 1923.

Delzell 1965. Charles F. Delzell, ed., *The Unification of Italy, 1859–1861: Cavour, Mazzini, or Garibaldi?* New York: Holt, Rinehart and Winston, 1965.

Denver, Denver Art Museum, 1956. Denver, Denver Art Museum, *Turn of the Century*, October 1–November 18, 1956.

Detroit, DIA, 1950. Detroit, Detroit Institute of Arts, *French Painting from David to Courbet*, February 1–March 5, 1950.

Detroit, DIA, 1954. Detroit, Detroit Institute of Arts, *The Two Sides of the Medal, French Painting from Gérôme to Gauguin*, 1954.

Dietrieb 1888. Willy Dietrieb, *Una critica tedesca dell'Esposizione artistica veneziana. Vita popolare e paesaggio*. Florence: Loescher & Seeber Editori, 1888.

Dijon, Magnin, 1938. Dijon, Musée Magnin, *Peintures et dessins de l'Ecole française*, 1938.

Dini 1984. Piero Dini, *Silvestro Lega–Gli anni di Piagentina*. Turin: Umberto Allemandi e C., 1984.

Distel 1989. Anne Distel, *Les Collectionneurs des impressionnistes*. Düdingen/Guin: Editions Trio, 1989.

Dorival 1975. Bernard Dorival, "Quelques sources méconnues de divers ouvrages de Manet," *Bulletin de la Société de l'Histoire de l'Art Français* (1975), pp. 325–40.

Dorment 1986. Richard Dorment, *British Painting in the Philadelphia Museum of Art*. Philadelphia: Philadelphia Museum of Art, 1986.

Dorner 1938. Alexander Dorner, "Portrait Bust of Mme. Recamier," *Bulletin of the Rhode Island School of Design*, v. XXVI, no. 3 (December 1938), pp. 13–19.

Douce 1858. Francis Douce, *Holbein's Dance of Death Exhibited in elegant engravings on wood with a dissertation on the several representations of that subject*. London: Henry G. Bohn, 1858 (first ed. 1833).

Drucker 1944. Michel Drucker, *Renoir*, Bibliothèque Française des Arts. Paris: Pierre Tisné, 1944.

Dubray 1931. Jean-Paul Dubray, *L'Art et la vie. Eugène Carrière*. Paris: Editions Marcel Seheur, 1931.

Dunlap and Orienti 1970. Ian Dunlap and Sandra Orienti, *The Complete Paintings of Cézanne*. New York: Penguin, 1970.

Dupavillon 1982. Christian Dupavillon, *Architectures du cirque*. Paris: Editions du Moniteur, 1982.

Duplaix 1985. Bernard Duplaix, *Marcellin Desboutin, Prince des Bohèmes*. Moulins-Yzeure: Imprimeries Réunies, 1985.

Duranty 1876. Louis Emile Edmond Duranty, *La Nouvelle Peinture à propos du groupe d'artistes qui expose dans les galeries Durand-Ruel*. Paris: E. Dentu, 1876.

Durbé 1978. Dario Durbé, intro. by Lamberto Vitali, *I Macchiaioli*. Rome: De Luca, 1978.

Duret 1902. Théodore Duret, *Histoire de Edouard Manet et de son oeuvre*. Paris: H. Floury, 1902.

Duret 1919. Théodore Duret, *Histoire de Edouard Manet et de son oeuvre, avec un catalogue des peintures et pastels*. Paris, 1919.

Duret 1926. Théodore Duret, *Histoire de Edouard Manet et de son oeuvre*, 4th ed. Paris: Bernheim-Jeune, 1926.

Durham, Paul Art Center, 1960. Durham, Paul Art Center, University of New Hampshire, *Paintings of New England Colleges*, October 13–mid-November 1960.

Earland 1911. Ada Earland, *John Opie and His Circle*. London: Hutchinson & Co., 1911.

Eastlake 1870. Lady Elizabeth Rigby Eastlake, *Memoir of Sir Charles Lock Eastlake*. London: John Murray, 1870.

Easton and Holroyd 1974. Malcolm Easton and Michael Holroyd, *The Art of Augustus John*. London: Secker and Warburg, 1974.

Echard 1985. William E. Echard, ed., *Historical Dictionary of the French Second Empire, 1852–70*. Westport: Greenwood Press, 1985.

Edinburgh, National Gallery, 1979. Ronald Pickvance, *Degas 1879 (Paintings, pastels, drawings, prints and sculpture from around 100 years ago in the context of his earlier and later works)*, Edinburgh, International Festival 1979, National Gallery of Scotland, The Mound, August 13–September 30, 1979.

Edinburgh, RSA, 1953. Edinburgh, Royal Scottish Academy, *Paintings of Renoir*, August 22–September 12, 1953; London, Tate Gallery, September 24–October 25, 1953.

Edinburgh, RSA, 1965. Cecil Hilton Gould, *Corot*, Edinburgh, Edinburgh Festival Society, Arts Council of Great Britain, and Royal Scottish Academy, October 8–November 14, 1965.

Effort Moderne 1924. *Bulletin de l'Effort Moderne*, no. 5 (May 1924).

Eisler 1961. Colin Eisler, "The Athlete of Virtue: The Iconography of Asceticism," *De Artibus Opiscula*, XL, *Essays in Honor of Erwin Panofsky*. New York, 1961.

Eitner 1960. Lorenz Eitner, *Géricault, an Album of Drawings in the Art Institute of Chicago*. Chicago, 1960.

Eitner 1983. Lorenz Eitner, *Géricault, his Life and Work*. London, 1983.

Elder 1924. Marc Elder, *A Giverny, chez Claude Monet*. Paris: Bernheim-Jeune, 1924.

Elderfield 1978. John Elderfield, *Matisse in the Collection of The Museum of Modern Art*. New York: Museum of Modern Art, 1978.

Electa Editrice, *Corot*, 1952. Astra-Arengarium, Collana di Monografie d'Arte, Pittori, no. 36, *Corot*. Milan/Florence: Electa Editrice, 1952.

Elgar 1956. Frank Elgar and Robert Maillard, *Picasso*. New York: Praeger, 1956.

Elsen 1967. Albert Elsen, "Rodin's 'Naked Balzac,'" *Burlington Magazine*, v. CIX (November 1967), pp. 606–17.

Elsen 1973. Albert Elsen, Stephen C. McGough, and Steven H. Wander, *Rodin & Balzac*, Stanford, Stanford University, Museum of Art, Spring 1973.

Erwin 1980. Joan Hammond Smith Erwin, "Renoir and Pompeian Wall Painting." M.A. thesis, Brown University, 1980.

Ewals 1987. Leo Ewals, *Ary Scheffer. Sa Vie et son oeuvre*. Nijmegen, 1987.

F. E. M. 1943. F. E. M. [Florence E. Montgomery], "New Cézanne," *Museum Notes, Rhode Island School of Design*, v. 1, no. 9 (December 1943), n.p.

F. E. M. 1944. F. E. M. [Florence E. Montgomery], "A New Painting by Théodore Géricault," *Museum Notes, Rhode Island School of Design*, v. 2, no. 3 (March 1944), n.p.

Fadiga 1887. Domenico Fadiga, *Atti della Reale Accademia di Belle Arti di Venezia 1887* (April 7, 1887), pp. 50–64.

Fagus 1901. Félicien Fagus, "L'Invasion espagnole; Picasso," *La Revue Blanche*, v. 25 (1901), pp. 464–65 (reprinted in Daix and Boudaille 1967, p. 333).

Fagus 1902. Félicien Fagus, "Gazette d'Art, Peintres espagnoles," *La Revue Blanche* (September 1, 1902).

Failing 1988. Patricia Failing, "Cast in Bronze: The Degas Dilemma," *Art News*, v. 87, no. 1 (January 1988), pp. 136–41.

Fairbrother 1986. Trevor J. Fairbrother, *The Bostonians: Painters of an Elegant Age, 1870–1930*. Boston: Museum of Fine Arts, 1986.

Faison 1958. S. Lane Faison, Jr., *A Guide to the Art Museums of New England*. New York: Harcourt, Brace and Company, 1958.

Farington 1923. Joseph Farington, R.A., ed. James Grieg, *The Farington Diary*, 2 v. New York: George H. Doran Company, 1923.

Farwell 1990. Beatrice Farwell, "Manet, Morisot, and Propriety," in T. J. Edelstein, ed., *Perspectives on Morisot*. New York: Hudson Hills Press, 1990, pp. 45–56.

Faure 1908. Elie Faure, *Eugène Carrière: Peintre et Lithographe*. Paris: H. Fleury, 1908.

Fenn 1879. W. W. Fenn, "Our Living Artists, William Powell Frith, R. A.," *Magazine of Art*, v. II (1879).

Fernier 1977. Robert Fernier, *La Vie et l'oeuvre de Gustave Courbet: Catalogue raisonné*, 2 v. Lausanne/Paris: Fondation Wildenstein, 1977.

Fezzi 1972. Elda Fezzi, ed., *L'opera completa de Renoir nel periodo impressionista, 1869–1883*. Milan: Rizzoli, 1972.

Fezzi and Henry 1985. Elda Fezzi and J. Henry, *Tout l'oeuvre peint de Renoir*. Paris: Flammarion, 1985.

Fidell-Beaufort 1975. Madeleine Fidell-Beaufort and Janine Bailly-Herzberg, trans. Judith Schub, *Daubigny*. Paris: Editions Geoffroy-Dechaume, 1975.

Finsen 1983. Hanne Finsen, *Degas og familien Bellelli*. Copenhagen: Ordrupgaard, 1983.

Fitzgerald 1871. Percy Fitzgerald, *The Kembles. An Account of the Kemble Family . . .*, 2 v. London: Tinsley Bros., n.d. [1871].

Flam 1978. Jack D. Flam, ed., *Matisse on Art*. New York: E. P. Dutton, 1978 (1st ed. London: Phaidon Press, Ltd., 1973).

Flam 1986. Jack D. Flam, *Matisse: The Man and his Art, 1869–1918*. Ithaca: Cornell University Press, 1986.

Flam 1988. Jack Flam, ed., *Matisse, A Retrospective*. New York: Hugh Lauter Levin Associates, Inc., 1988.

Flament 1928. Albert Flament, *La Vie de Manet*. Paris: Librairie Plon, 1928.

Florence, Forte di Belvedere, 1976. Dario Durbé, *I Macchiaioli*, Florence, Forte di Belvedere, May 23–July 22, 1976.

Florence, Palazzo, 1922. Florence, Società delle Belle Arti di Firenze (Palazzo del Parco di S. Gallo a Firenze), *La Fiorentina Primaverile*, April 8–July 31, 1922.

Flushing, Queens Museum, 1989. Flushing, Queens Museum, *Lafayette, Hero of Two Worlds*, June 8–August 13, 1989; Philadelphia, Historical Society of Pennsylvania, October 5, 1989–January 12, 1990; Lexington, Museum of Our National Heritage, February 11–May 20, 1990.

Focillon 1928. Henri Focillon, "Chassériau ou les deux romantismes," in Louis Hautecoeur et al., *Le Romantisme et l'Art*. Paris: Henri Laurens, 1928, pp. 161–85.

Fontainas and Vauxcelles 1922. André Fontainas and Louis Vauxcelles, *Histoire générale de l'art français de la Révolution à nos jours*. Paris: Librairie de France, 1922.

Fontseré 1972. Jacqueline Fontseré, "Musée départemental de Moulins. II. Oeuvres de Marcellin Desboutin," *La Revue du Louvre et des Musées de France*, no. 6 (1972), pp. 521–24.

Forbes 1975. Christopher Forbes, *The Royal Academy Revisted: Victorian Paintings from the Forbes Magazine Collection*. New York: Forbes Magazine, 1975.

Fort Worth, Kimbell, 1984. Michael Mezzatesta, *Henri Matisse: Sculptor/Painter: A Formal*

Analysis of Selected Works, Fort Worth, Kimbell Art Museum, May 1–September 24, 1984.

Fourreau 1925. Armand Fourreau, *Berthe Morisot.* Paris: F. Rieder & Cie., 1925.

Fowle 1964. James Fowle, "A Note on Degas," *Bulletin of Rhode Island School of Design, Museum Notes,* v. 51, no. 2 (December 1964), pp. 3–20.

Fox 1982. J. H. F. [Judith Hoos Fox], "Les Fleurs," *Bulletin of Rhode Island School of Design, Museum Notes,* v. 69, no. 2 (October 1982), pp. 28–29.

Franchi 1902. Anna Franchi, *Arte e artisti toscani dal 1850 ad oggi.* Florence: Fratelli Alinari Editori, 1902.

Franchi 1922. Anna Franchi, "I Macchiaioli Toscani–Ricordi e Aneddoti," *La Lettura* (January 1922).

Franchi 1940. Anna Franchi, *La mia vita.* Milan: Garzanti, 1940.

Franchi 1945. Anna Franchi, *I Macchiaioli Toscani.* Milan: Garzanti, 1945.

Franchi 1947. Anna Franchi, "Umanità dei Macchiaioli," *L'Araldo dell'Arte* (Milan), November 20, 1947.

Francion 1873. Francion, "Salon de 1873, v," *L'Illustration* (June 14, 1873), pp. 406 ff.

Frankfurter, March 1938. Alfred M. Frankfurter, "Cézanne: Intimate Exhibition, Twenty-one Paintings shown for the Benefit of Hope Farm," *Art News,* v. XXXVI, no. 26 (March 26, 1938).

Frankfurter, December 1938. Alfred M. Frankfurter, "Panorama of a Great Decade, The 1870s," *Art News,* v. XXXVII, no. 10 (December 3, 1938), pp. 9–12.

Frankfurter 1939. Alfred M. Frankfurter, "The Portraiture of Renoir," *Art News,* v. XXXVII, no. 26 (March 25, 1939), pp. 7, 20.

Fredeman 1967. William E. Fredeman, *A Pre-Raphaelite Gazette: The Penkill Letters of Arthur Hughes to William Bell Scott and Alice Boyd, 1886–97.* Manchester: The John Rylands Library, 1967.

Fried 1969. Michael Fried, "Manet's Sources: Aspects of his Art, 1859–1865," *Artforum,* v. VII (March 1969), pp. 28–82.

Frisch 1939. Victor Frisch and Joseph T. Shipley, *Auguste Rodin, A Biography.* New York: Frederick A. Stokes Co., 1939.

Frith 1887. William Powell Frith, *My Autobiography and Reminiscences.* London: Richard Bentley and Son, 1887.

Frost 1944. Rosamund Frost, *Pierre Auguste Renoir.* New York: Hyperion Press, n.d. [1944].

Fry 1966. Edward F. Fry, *Cubism.* New York/Toronto: McGraw-Hill Book Co., 1966.

Gamwell 1980. Lynn Gamwell, *Cubist Criticism.* Ann Arbor: UMI Research Press, 1980.

Garlick 1954. Kenneth Garlick, *Sir Thomas Lawrence.* London: Routledge and Kegan Paul, 1954.

Garlick 1960. Kenneth Garlick, "A Portrait by Sir Thomas Lawrence," *Bulletin of Rhode Island School of Design, Museum Notes,* v. 47, no. 2 (December 1960), pp. 8–12.

Garlick 1964. Kenneth Garlick, ed., *A Catalogue of the Paintings, Drawings, and Pastels of Sir Thomas Lawrence, The Walpole Society,* v. 39 (1962–64).

Garlick 1989. Kenneth Garlick, *Sir Thomas Lawrence. A Complete Catalogue of the Oil Paintings.* New York: New York University Press, 1989.

Garlick and Macintyre 1978. Kenneth Garlick and Angus Macintyre, eds., *The Diary of Joseph Farington,* 17 v. New Haven: Yale University Press, 1978.

Gasquet 1920. Joachim Gasquet, "Ce qu'il m'a dit," *L'Amour de l'Art* (December 1920).

Gatti 1925. Guglielmo Gatti, *Pittori Italiani dall'Ottocento ad oggi.* Rome: Maglione-Strini, 1925.

Gautier 1851. Théophile Gautier, "Salon de 1850–51," *La Presse,* February 1851.

Gautier 1853. Théophile Gautier, *Constantinople.* Paris, 1853.

Gautier 1856. Théophile Gautier, *Les Beaux-Arts en Europe, 1855.* Paris: Michel Lévy Frères, 1856.

Gautier 1861. Théophile Gautier, *Abécédaire du Salon de 1861.* Paris: E. Dentu, 1861.

Gazette des Beaux-Arts 1859. Gazette des Beaux-Arts, ser. 1, v. II (April 1, 1859).

Gazette des Beaux-Arts 1945. Gazette des Beaux-Arts, ser. 6, v. XXVII (April 1945).

Gazette des Beaux-Arts 1960. "La Chronique des Arts," *Supplément à la Gazette des Beaux-Arts,* no. 1093 (February 1960).

Gazette des Beaux-Arts 1961. "La Chronique des Arts," *Supplément à la Gazette des Beaux-Arts,* no. 1104 (January 1961).

Gazette des Beaux-Arts 1973. "Recent Accessions," *Gazette des Beaux-Arts,* ser. 6, v. LXXXI (February 1973).

Gazette des Beaux-Arts, Feb. 1974. "La Chronique des Arts," *Supplément à la Gazette des Beaux-Arts,* no. 1261 (February 1974), p. 139.

Gazette des Beaux-Arts, Oct. 1974. "La Chronique des Arts, Editorial, Desboutins nous montre ses amis impressionnistes et leurs amateurs vers 1874," *Supplément à la Gazette des Beaux-Arts,* no. 1269 (October 1974).

Gazette des Beaux-Arts 1975. Gazette des Beaux-Arts, ser. 6, v. LXXXV (March 1975).

Gazette des Beaux-Arts 1988. "La Chronique des Arts, Principales acquisitions des Musées en 1987," *Gazette des Beaux-Arts,* no. 1430 (March 1988).

Gebäuer 1855. Ernst Gebäuer, *Les Beaux-Arts à l'Exposition universelle de 1855.* Paris: Librairie Napoléonienne des arts et de l'industrie, 1855.

Geffroy 1893. Gustave Geffroy, "L'Imaginaire," *Le Figaro* (Paris), August 29, 1893.

Geffroy 1902. Gustave Geffroy, *L'Oeuvre de E. Carrière.* Paris: L'Edition d'Art, 1902.

Genest 1832. John Genest, *Some Account of the English Stage,* 10 v. Bath: H. E. Carrington, 1832.

George 1932. Waldemar George, "The Impressionism of Manet," *Apollo,* v. XVI, no. 91 (July 1932), pp. 1–6.

Gerard 1892. Frances A. Gerard, *Angelica Kauffmann, A Biography.* London: Ward and Downey, 1892.

Ghent 1821. *Annales du Salon de Gand* [1820]. Ghent: P. F. de Goesin-Verhaege, 1821.

Ghent, Schone Kunsten, 1980. Ghent, Stad Gent, Museum voor Schone Kunsten, *Het Landschap in de Belgische Kunst, 1830–1914,* October 4–December 14, 1980.

Giardelli 1965. Mario Giardelli, *Silvestro Lega.* Milan, 1965.

Gilchrist 1863. Alexander Gilchrist, *Life of William Blake, "Pictor Ignotus." With Selections from his Poems and other Writings,* 2 v. London/Cambridge: Macmillan and Co., 1863.

Gilchrist 1880. Alexander Gilchrist [Anne Gilchrist, ed.], *Life of William Blake, With Selections from his Poems and other Writings. A New and Enlarged Edition illustrated from Blake's Own Works with Additional Letters and a Memoir of the Author,* 2 v. London: Macmillan and Co., 1880.

Girodie 1934. André Girodie, *Exposition du centenaire de Lafayette.* Paris: Musée de l'Orangerie, 1934.

Gleizes and Metzinger, 1913. Albert Gleizes and Jean Metzinger, *On Cubism.* London: T. Fisher Unwin, 1913.

Golding 1968. John Golding, *Cubism, A History and Analysis, 1907–1914.* New York: Harper and Row, 1968.

Goley 1989. Mary Anne Goley, "John White Alexander's *Panel for Music Room,*" *Bulletin of the Detroit Institute of Arts,* v. 64, no. 4 (1989), pp. 5–15.

Goncourt 1956. Edmond and Jules de Goncourt, *Journal, Mémoires de la vie littéraire,* 4 v. Paris: Fasquelle et Flammarion, 1956.

Goodrich 1928. Lloyd Goodrich, "Théodore Chassériau," *Arts,* v. XIV, no. 2 (August 1928), pp. 63–100.

Gourley 1963. Hugh J. Gourley, "From the Museum's Collection," *Rhode Island School of Design Alumni Bulletin,* v. 20, no. 3 (1963).

Gourley 1964. Hugh J. Gourley, "Tissots in the Museum's Collection," *Bulletin of Rhode Island School of Design, Museum Notes,* v. 50, no. 3 (March 1964), pp. 1–9.

Gowing 1979. Lawrence Gowing, *Matisse.* New York/Toronto: Oxford University Press, 1979.

Goyens de Heusch 1988. Serge Goyens de Heusch, pref. by Philippe Roberts-Jones, *L'Impressionnisme et le fauvisme en Belgique.* Antwerp: Fonds Mercator, 1988.

Graber 1941. Hans Graber, *Edouard Manet.* Basel: Benno Schwabe & Co., 1941.

Graber 1942. Hans Graber, *Paul Cézanne, nach eigenen und fremden Zeugnissen.* Basel: Benno Schwabe & Co., 1942.

Grad 1977. Bonnie L. Grad, *An Analysis of the Development of Daubigny's Naturalism Culminating in the Riverscape Period (1857–1870).* Ph.D. dissertation, University of Virginia. Ann Arbor: UMI, 1977.

Grant 1926. M. H. Grant, *A Chronological History of the Old English Landscape Painters.* London, 1926.

Grappe 1913. Georges Grappe, *Edgar Degas.* Berlin: Otto Beckmann, 1913.

Grappe 1944. Georges Grappe, *Catalogue du Musée Rodin,* fifth ed. Paris: Musée Rodin, 1944.

Graves 1972. Algernon Graves, *The Royal Academy of Arts. A Complete Dictionary of Contributors and their work from its foundation in 1769 to 1904.* New York: Lenox Hill Publishers, 1972 (first published 1905–06).

Grayson 1981. Marion L. Grayson, "Berthe Morisot, 'A Woman Among the Lunatics,'" *Pharos,* v. 18, no. 1 (October 1981), pp. 4–13.

Gréard 1897. Vallery C. O. Gréard, *Meissonier, His Life and his Art.* New York: A. C. Armstrong and Son, 1897.

Green 1976. Christopher Green, *Léger and the Avant-garde.* New Haven/London: Yale University Press, 1976.

Greenwich, Maritime, 1977. Harley Preston, *London and the Thames: Paintings of Three Centuries,* Greenwich, National Maritime Museum (London, Somerset House), July 6–October 9, 1977.

"Greta's Boston Letter" 1881. "Greta's Boston Letter," *Art Amateur,* v. 5, no. 4 (September 1881), p. 72.

Greville 1938. Charles Greville, eds. Lytton Strachey and Roger Fulford, *The Greville Memoirs, 1814–1860,* 7 v. London: Macmillan and Co., 1938.

Grunchec 1978. Philippe Grunchec, *Tout l'oeuvre peint de Géricault.* Paris, 1978.

Grunchec 1984. Philippe Grunchec, *The Grand Prix de Rome: Paintings from the Ecole des Beaux-Arts, 1797–1863.* Washington, D. C.: International Exhibitions Foundation, 1984.

Guide 1855. Guide dans l'Exposition universelle des produits de l'Industrie et des Beaux-arts de toutes les nations, 1855. Paris: Paulin et Le Chevalier, 1855.

Gutwirth 1969. Suzanne Gutwirth, "Jean-

Victor Bertin (1767–1842), un paysagiste néo-classique." Unpublished dissertation, Ecole du Louvre, 1969.

Gutwirth 1974. Suzanne Gutwirth, "Jean-Victor Bertin, Un paysagiste néo-classique (1767–1842)," *Gazette des Beaux-Arts,* v. 83 (May–June 1974), pp. 337–58.

Habasque 1957. Guy Habasque, *Robert Delaunay: Du cubisme à l'art abstrait.* Paris: S.E.V.P.E.N., 1957.

Haftmann 1960. Werner Haftmann, trans. Ralph Manheim, *Painting in the Twentieth Century,* 2 v. New York: Praeger, 1960.

The Hague, Gemeentemuseum, 1958. The Hague, Gemeentemuseum, *Oskar Kokoschka,* July 31–October 1, 1958.

Hamburg, Kunstverein, 1962. Hamburg, Kunstverein, *Oskar Kokoschka,* December 8, 1962–January 27, 1963.

Hamilton 1954. George Heard Hamilton, *Manet and his Critics.* New Haven: Yale University Press, 1954.

Hamilton 1972. George Heard Hamilton, *Painting and Sculpture in Europe 1880–1940.* Harmondsworth: Penguin Books Ltd., 1972.

Hamilton and Agee 1967. George Heard Hamilton and William C. Agee, *Raymond Duchamp-Villon, 1876–1918.* New York: Walker and Co., 1967.

Hannover, Wilhelm-Busch, 1982. Dirk Kocks, "Gustave Doré als Bildhauer," in Hannover, Wilhelm-Busch-Museum, *Gustave Doré, 1832–1883,* October 17, 1982–January 9, 1983.

Hanotelle 1977. Micheline Hanotelle, *Echanges artistiques franco-belges entre les sculpteurs dans le dernier quart du XIXe siècle.* Paris: L'Ecole du Louvre, unpublished *mémoire,* 1977.

Hanson 1977. Ann Coffin Hanson, *Manet and the Modern Tradition.* New Haven/London: Yale University Press, 1977.

Hardy 1978. André Hardy and Anny Braunwald, *Catalogue des peintures et sculptures de Jean-Baptiste Carpeaux à Valenciennes.* Valenciennes: Musée des Beaux-Arts, 1978.

Harrison 1981. Charles Harrison, *English Art and Modernism 1900–1939.* London/Bloomington: Allen Lane/Indiana University Press, 1981.

Hartford, Wadsworth, 1952. Hartford, Wadsworth Atheneum, *The Romantic Circle, French Romantic Painting, Delacroix and his Contemporaries,* October 15–November 30, 1952.

Hartford, Wadsworth, 1961. Hartford, Wadsworth Atheneum, *Salute to Italy: One Hundred Years of Italian Art,* April 2–May 28, 1961.

Haskell and Penny 1981. Francis Haskell and Nicholas Penny, *Taste and the Antique. The Lure of Classical Sculpture, 1500–1900.* New Haven/London: Yale University Press, 1981.

Hasselt, Bibliotheek, 1971. Hasselt, Provinciale Bibliotheek (Kasteel te Duras), *Willem I, Koning der Verenigde Nederlanden,* July 1971.

Hausenstein 1931. Wilhelm Hausenstein, "Der Geist des Edgar Degas," *Pantheon,* v. 7, no. 4 (April 1931), pp. 161–66.

Healy 1892. George P.A. Healy, "Thomas Couture," *Century Illustrated Monthly Magazine,* v. XLIV (n.s. XXII) (May 1892), pp. 4–13.

Heins 1906. Maurice Heins, "Joseph Paelinck," in *Biographie nationale de Belgique.* Brussels: H. Thiry-van Buggenhoudt, 1906.

Held 1984. Julius S. Held, René Taylor, James N. Carder, *Museo de Arte de Ponce, Fundación Luis A. Ferré: Catalogue of Paintings and Sculpture of the European and American Schools.* Ponce (Puerto Rico), 1984.

Held and Posner n.d. Julius S. Held and Donald Posner, *Seventeenth and Eighteenth Century Art.* Englewood Cliffs: Prentice-Hall, Inc., n.d.

Hellebranth 1976. Robert Hellebranth, *Charles-François Daubigny, 1817–1878.* Morges: Editions Matute, 1976.

Herbert 1964. Robert L. Herbert, ed., *Modern Artists on Art: Ten Unabridged Essays.* Englewood Cliffs: Prentice-Hall, Inc., 1964.

Herbert 1984. Robert L. Herbert, Eleanor S. Apter, and Elise K. Kenney, *The Société Anonyme and the Dreier Bequest at Yale University, A Catalogue Raisonné.* New Haven/London: Yale University Press, 1984.

Herbert 1988. Robert L. Herbert, *Impressionism. Art, Leisure, and Parisian Society.* New Haven/London: Yale University Press, 1988.

Herriot 1905. Edouard Herriot, *Madame Récamier et ses amis,* 2 v. Paris: Plon, 1905.

Hodin 1966. J.P. Hodin, *Oskar Kokoschka: The Artist and his Time.* London: Cory, Adams and Mackay, 1966.

Hoffmann 1947. Edith Hoffmann, *Kokoschka: Life and Work.* London: Faber and Faber Limited, 1947.

Hofmann 1957. Werner Hofmann, *Caricature from Leonardo to Picasso.* New York: Crown Publishers, 1957.

Holme 1902. Charles Holme, ed., with critical essays by Gustave Geffroy and Arsène Alexandre, *Corot and Millet.* London: The Studio, 1902.

Hoog 1967. Michel Hoog, *Paris, Musée National d'Art Moderne: Robert et Sonia Delaunay,* Inventaire des Collections Publiques Françaises, no. 15. Paris: Editions des Musées Nationaux, Palais du Louvre, 1967.

Horticq 1910(?). Louis Horticq, *Manet.* Paris: Librairie Centrale des Beaux-Arts, n.d. [1910? 1911? or 1912?].

Horticq 1930. Louis Horticq, *Delacroix, l'oeuvre du maître.* Paris: Librairie Hachette, 1930.

Houston, MFA, 1958. Houston, Museum of Fine Arts, *The Human Image,* October 9–November 23, 1958.

Houston, Rice, 1969. Houston, Institute for the Arts, Rice University, *Raid the Icebox 1 with Andy Warhol,* October 29, 1969–January 4, 1970; New Orleans, Isaac Delgado Museum, January 17–February 15, 1970; Providence, Museum of Art, Rhode Island School of Design, April 23–June 30, 1970.

Howe 1951. Jerome Willard Howe, Jr., "Thomas Couture: His Career and Artistic Development." Unpublished M.A. thesis, University of Chicago, 1951.

Howells 1866. William Dean Howells, *Venetian Life,* v. 1. Boston/New York: Houghton, Mifflin and Co., 1866 (reprinted 1892).

Hungerford 1980. Constance Cain Hungerford, "Meissonier's First Military Paintings: I–'The Emperor Napoleon III at the Battle of Solferino' and II–'1814, The Campaign of France,'" *Arts Magazine,* v. 54, no. 5 (January 1980), pp. 89–97, 98–107.

Hunter 1956. Sam Hunter, *Modern French Painting.* New York: Dell, 1956.

Huret 1891. Jules Huret, *Enquêtes sur l'évolution littéraire.* Paris: Charpentier, 1891.

Hutchinson 1968. Sidney C. Hutchinson, *The History of the Royal Academy, 1768–1968.* London: Chapman & Hall, 1968.

Huyghe 1934. René Huyghe, Germain Bazin, et al., *Histoire de l'Art Contemporain: La Peinture.* Paris: Libraire Félix Alcan, 1934.

Il Popolo 1895. "Silvestro Lega," *Il Popolo* (Florence), September 25, 1895.

Illustrazione Popolare 1887. "Giacomo Favretto," *Illustrazione Popolare Artistica dell'Esposizione di Venezia 1887,* no. 8 (June 19, 1887).

Immerzeel 1855. J. Immerzeel, Jr., *De Levens en Werken der Hollandsche en Vlaamsche Kunstschilders, Beeldhouwers, Graveurs en Bouwmeesters,* 2 parts. Amsterdam: B.M. Israel, 1974 (reprint of original 1855 edition).

Iowa City, UIMA, 1985. Daniel Robbins, intro. by Joann Moser, *Jean Metzinger in Retrospect,* Iowa City, University of Iowa Museum of Art, August 31–October 13, 1985; Austin, Archer M. Huntington Art Gallery, University of Texas, November 10–December 22, 1985; Chicago, David and Alfred Smart Gallery, University of Chicago, January 23–March 9, 1986; Pittsburgh, Museum of Art, Carnegie Institute, March 29–May 25, 1986.

Iowa City, UIMA br., 1985. Joann Moser, exh. brochure for *Jean Metzinger in Retrospect,* Iowa City, University of Iowa Museum of Art, August 31–October 13, 1985.

Isaacson 1978. Joel Isaacson, *Claude Monet. Observation, Reflection.* Oxford: Phaidon, 1978.

Isarlov 1932. George Isarlov, *Georges Braque,* Collection Orbes, no. 3. Paris: José Corti, 1932.

Ives 1974. Colta Feller Ives, *The Great Wave: The Influence of Japanese Woodcuts on French Prints.* New York: Metropolitan Museum of Art, 1974.

Jacksonville, Cummer, 1964. Jacksonville, Cummer Gallery of Art, *Artists of the Paris Salon,* January 7–February 2, 1964.

Jamot 1908. Paul Jamot, "Carpeaux, peintre et graveur," *Gazette des Beaux-Arts,* 50e année, IIe semestre, v. XL (September 1, 1908), pp. 177–97.

Jamot 1927. Paul Jamot, "Etudes sur Manet (1er article)," *Gazette des Beaux-Arts,* ser. 5, v. XV (January 1927), pp. 27–50.

Jamot and Wildenstein 1932. Paul Jamot and Paul Wildenstein, *Manet,* 2 v. Paris: Les Beaux-Arts, 1932.

Janis 1968. Eugenia Parry Janis, *Degas Monotypes.* Cambridge: Fogg Art Museum, Harvard University, 1968.

Janson 1937. H.W. Janson, "The Putto with the Death's Head," *Art Bulletin,* v. XIX (1937), pp. 423–49.

Jean-Aubry 1968. G. Jean-Aubry with Robert Schmit, *Eugène Boudin.* Neuchatel: Editions Ides et Calendes, 1968.

Jedlicka 1941. Gotthard Jedlicka, *Edouard Manet.* Zurich: Eugen Rentsch Verlag, 1941.

Jerrold 1891. Blanchard Jerrold, *Life of Gustave Doré.* London: W.H. Allen & Co., 1891.

Johnson 1963. Lee Johnson, "Delacroix's North African Pictures," *Canadian Art,* v. XX, no. 1 (January–February 1963), pp. 20–24.

Johnson 1970. Lee Johnson, "A Copy after Van Dyck by Géricault," *Burlington Magazine,* v. CXII, no. 813 (December 1970), pp. 788, 793–97.

Johnson 1986. Lee Johnson, *The Paintings of Eugène Delacroix, A Critical Catalogue,* 4 v. Oxford: Clarendon Press, 1986.

Kahnweiler 1920. *Der Weg zum Kubismus.* Munich: Delphin Verlag, 1920. (Trans. Henry Aronson, *The Rise of Cubism.* New York: Wittenborn, Schultz, 1949.)

Kamakura, Museum of Modern Art, 1987. Kamakura, Museum of Modern Art, *Géricault,* October–December 1987; Kyoto, National Museum of Modern Art, February–March 1988; Fukuoka, Museum of Art, March–April 1988.

Keith 1953. D. Graeme Keith. "Two Sculptures by Dalou," *Museum Notes, Rhode Island School of Design,* v. XI, no. 1 (Fall 1953), n.p.

Kelder, L'Héritage, 1986. Diane Kelder, trans. Solange Schnall, *L'Héritage de l'Impressionnisme, les sources du XXe siècle.* Paris: La Bibliothèque des Arts, 1986.

Kelder, Post-Impressionism, 1986. Diane Kelder, *The Great Book of Post-Impressionism.* New York: Abbeville Press, n.d. [1986].

Keynes 1957. Sir Geoffrey Keynes, compiler,

William Blake's Illustrations to the Bible: A Catalogue. Boissia, Clairvaux, Jura: The Trianon Press for The William Blake Trust, 1957.

Keynes 1966. Sir Geoffrey Keynes, ed., *The Complete Writings of William Blake.* London/ New York, etc.: Oxford University Press, 1966.

Keynes 1971. Sir Geoffrey Keynes, ed., *Blake Studies: Essays on his life and work,* 2nd ed. Oxford: Clarendon Press, 1971.

Klagsbrun 1958. Francine Lipton Klagsbrun, "Thomas Couture and the Romans of the Decadence." Unpublished M.A. thesis, New York University, 1958.

Kloner 1968. Jay Martin Kloner, "The Influence of Japanese Prints on Edouard Manet and Paul Gauguin." Unpublished Ph.D. dissertation, Columbia University, 1968.

Knyff 1976. Gilbert de Knyff, *Eugène Boudin raconté par lui-même.* Paris: Editions Mayer, 1976.

Kolb 1937. Martha Kolb, *Ary Scheffer et son temps, 1795–1858.* Paris: Boivin et Cie, 1937.

La Farge 1950. Henry A. La Farge, "The Emancipating Nineteenth," *Art News,* v. XLIX, no. 1 (March 1950), pp. 30–31.

La Rochelle, Nouveau-Monde, 1989. La Rochelle, Musée du Nouveau-Monde, *Révolution Française,* April 14–June 20, 1989; Blérancourt, Musée National de la Coopération franco-américaine, July 7–September 29, 1989.

La Vie parisienne 1885. "La Femme à Paris: Exposition Tissot," *La Vie parisienne,* May 2, 1885, p. 255.

L'Artiste 1852. "Mouvement des Arts," *L'Artiste,* ve série, v. IX, no. 5 (October 1, 1852), p. 79.

L'Artiste 1862. *L'Artiste* (April 15, 1862).

Lafenestre 1902. Georges Lafenestre, "Marcellin Desboutin (1823–1902)," *Revue de l'Art ancien et moderne,* v. XII (July–December 1902), pp. 401–16.

Lafond 1919. Paul Lafond, *Degas.* Paris: H. Floury, 1919.

LaGrange 1861. Léon LaGrange, "Salon de 1861," *Gazette des Beaux-Arts,* v. x (1861).

Lambert 1937. Elie Lambert, *Delacroix et les femmes d'Alger.* Paris: Laurens, 1937.

Lami 1910. Stanislas Lami, *Dictionnaire des sculpteurs de l'Ecole française au XVIIIe siècle,* 2 v. Paris: Librairie Ancienne Honoré Champion, 1910–11.

Lami 1914–21. Stanislas Lami, *Dictionnaire des sculpteurs de l'Ecole française au dix-neuvième siècle,* 4 v. Paris: Librairie Ancienne Honoré Champion, 1914–21.

Lane 1860. Edward William Lane, *An Account of the Manners and Customs of the Modern Egyptians,* 5th ed. London: John Murray, 1860.

Lane 1939. James W. Lane, "Notes from New York," *Apollo,* v. XXX, no. 176 (August 1939), pp. 71–72.

Lang 1959. Y. Cecil Lang, *The Swinburne Letters,* v. 2. London: Oxford University Press, 1959.

Langner 1978. Johannes Langner, "La Vue par dessous le pont. Fonctions d'un motif Piranésien dans l'art français de la seconde moitié du XVIIIe siècle," in Georges Brunel, ed., *Actes du Colloque. Piranèse et les Français.* Rome, 1978, pp. 293–302.

Laporte 1948. Paul M. Laporte, "The Classic Art of Renoir," *Gazette des Beaux-Arts,* ser. 6, v. XXXV (March 1948), pp. 177–88.

Laver 1937. James Laver, *French Painting and the Nineteenth Century.* New York: Charles Scribner's Sons, 1937.

Lawrence, UKA, 1958. Lawrence, Museum of Art, University of Kansas, *Thirtieth Anniversary Exhibition,* February 22–March 30, 1958.

Lawton 1906. Frederick Lawton, *The Life and Work of Auguste Rodin.* London: T. Fisher Unwin, 1906.

Le Brun 1980. Charles Le Brun, *A Method to Learn to Design the Passions.* London, 1734. (Reprinted by William Andrews Clark Memorial Library, Augustan Reprint Society, nos. 200–01. Los Angeles, 1980.)

Leblanc 1931. Henri Leblanc, *Catalogue de l'oeuvre complet de Gustave Doré.* Paris: Ch. Bosse, 1931.

Ledoux-Lebard 1947. C. Ledoux-Lebard, "Chinard et ses rapports avec les Récamier," *Bulletin de la Société de l'Histoire de l'Art français* (1947–48), pp. 72–77.

Leeds, City Art Gallery, 1979. Leeds, Leeds City Art Gallery, *Atkinson Grimshaw, 1836–1893,* 1979.

Lega 1910. Antonio Lega, "L'Odissea di un precursore–Il pittore Silvestro Lega," *Il Secolo XX* (June 1910).

Léger 1929. Charles Léger, *Courbet.* Paris: Les Editions G. Crès et Cie, 1929.

Legg and Williams 1959. L. G. Wickham Legg and E. T. Williams, eds., *Dictionary of National Biography, 1941–1950.* London: Oxford University Press, 1959.

Lemmen 1891. Georges Lemmen, "Walter Crane," *L'Art Moderne,* v. 11 (March 1891), pp. 67–69, 83–86.

Lemoisne 1919. Paul-André Lemoisne, "Les Statuettes de Degas," *Art et Décoration,* v. 36 (September–October 1919), pp. 109–17.

Lemoisne 1946–49. Paul-André Lemoisne, *Degas et son oeuvre,* 4 v. Paris: Paul Brame and C. M. de Hauke, Arts et Métiers Graphiques, 1946–49.

Lenoir 1872. Paul Lenoir, *Le Fayoum, Le Sinai et Petra; Expédition dans la Moyenne Egypte et l'Arabie Pétrée sous la direction de J. L. Gérôme.* Paris: Henri Plon, 1872.

Lenormant 1859. Madame Lenormant, *Souvenirs et correspondance tirés des papiers de Madame Récamier,* 2 v. Paris: Michel-Lévy, 1859.

Lenormant 1867. Madame Lenormant, ed. and trans. Isaphène Luyster, *Memoirs and Correspondence of Madame Récamier.* Boston: Roberts Brothers, 1867.

Lexington, UKY, 1973. Intro. by Robert Allen Salyer, essay by Clifford Amyx, *Reality, Fantasy and Flesh: Tradition in Nineteenth Century Art,* Lexington, University of Kentucky Art Gallery, October 28–November 18, 1973.

Leymarie 1961. Jean Leymarie, trans. James Emmons, *Braque,* Skira Taste of Our Time Collection. Cleveland: World Publishing Company, 1961.

Leymarie 1966. Jean Leymarie, trans. Stuart Gilbert, *Corot.* Geneva: Skira, 1966.

Lischka 1972. Gerhard J. Lischka, *Oskar Kokoschka: Maler und Dichter.* Gern, Frankfurt a.M.: Peter Lang, 1972.

Lister 1975. Raymond Lister, *Infernal Methods: A Study of William Blake's Art Techniques.* London: G. Bell & Sons Ltd, 1975.

Lister 1986. Raymond Lister, *The Paintings of William Blake.* New York: Cambridge University Press, 1986.

Liverpool, Walker, 1915. Liverpool, Walker Art Gallery, *45th Autumn Exhibition of Modern Art,* December 1915.

Livy. Livy, trans. John Freinsheim, *The History of Titus Livius,* 3 v. London: W. Green and T. Chaplin, 1814.

Loeffler 1964. Elaine P. Loeffler, "Frith's Salon D'Or, A Note," *Bulletin of Rhode Island School of Design, Museum Notes,* v. 50, no. 3 (March 1964), pp. 10–14.

London News 1963. "Delacroix–the Centenary of a Great Romantic Painter," *The Illustrated London News,* v. 242, no. 6440 (January 5,

1963), p. 25.

London, Arts Council, 1962. Arts Council of Great Britain, *Kokoschka: A Retrospective Exhibition of Paintings, Drawings, Lithographs, Stage Designs and Books,* London, Tate Gallery, September 14–November 11, 1962.

London, Arts Council, 1968. Arts Council of Great Britain, *Matisse,* London, Hayward Gallery, July 9–September 8, 1968.

London, Arts Council, 1973. Arts Council of Great Britain, *The Impressionists in London,* London, Hayward Gallery, January 3–March 11, 1973.

London, Barbican, 1984. Krystyna Matyjaszkiewicz, ed., *James Tissot,* London, Barbican Art Gallery, November 15, 1984–January 20, 1985; Manchester, Whitworth Art Gallery, February 2–March 17, 1985; Paris, Musée du Petit Palais, April–June 1985.

London, British Institute, 1817. Cited in Earland 1911, p. 345.

London, Fine Art Society, 1928. See note in Museum files, Augustus Edwin John.

London, Hayward, 1980–81. London, Hayward Gallery, *Pissarro,* October 30, 1980–January 11, 1981; Paris, Galeries Nationales du Grand Palais, January 30–April 27, 1981; Boston, Museum of Fine Arts, May 19–August 9, 1981.

London, Hayward, 1985. London, Hayward Gallery, *Renoir,* January 30–April 21, 1985; Paris, Galeries Nationales du Grand Palais, May 14–September 2, 1985; Boston, Museum of Fine Arts, October 9, 1985–January 5, 1986.

London, Hazlitt, 1983. London, Hazlitt, Gooden and Fox, *Gustave Doré,* April–May 1983.

London, Jeffress, 1959. London, Arthur Jeffress Gallery, *Etchings by J. J. Tissot,* 1959.

London, Lefevre, 1969. London, Lefevre Gallery, *Claude Monet, The Early Years,* May 8–June 7, 1969.

London, Leicester, 1923. Pref. by Walter Sickert, *Exhibition of the Works in Sculpture of Edgar Degas,* London, Leicester Galleries, February–March 1923.

London, Maas, 1978. London, Maas Gallery, *Victorian Fairy Paintings,* March 6–31, 1978.

London, Marlborough Fine Arts, 1970. London, Marlborough Fine Arts, Ltd., *Eugène Carrière, 1849–1906,* May–June 1970.

London, National Gallery, 1983. Michael Wilson, *Manet at Work,* London, National Gallery, August 10–October 9, 1983.

London, National Portrait Gallery, 1988. Richard Ormond and Carol Blackett-Ord, *Franz Xaver Winterhalter and the Courts of Europe 1830–70,* London, National Portrait Gallery, 1988.

London, Royal Academy, 1800. Cited in Graves 1972.

London, Royal Academy, 1871. Cited in Graves 1972.

London, Royal Academy, 1932. London, Royal Academy of Arts, *Commemorative Catalogue of the Exhibition of French Art, 1200–1900,* January–March 1932.

London, Royal Academy, 1972. Arts Council of Great Britain, *The Age of Neo-Classicism,* London, Royal Academy of Arts and Victoria and Albert Museum, September 9–November 19, 1972.

London, Royal Academy, 1986. Nicholas Penny, ed., *Reynolds,* Paris, Galeries Nationales du Grand Palais, October 9–December 16, 1985; London, Royal Academy of Arts, January 16–March 31, 1986.

London, Stoppenbach and Delestre, 1982. London, Stoppenbach and Delestre Ltd., *Homage to A. A. Hébrard,* 1982.

London, Tate, 1957. London, Tate Gallery,

Claude Monet, An Exhibition of Paintings, September 20–November 3, 1957.

London, Tate, 1983. Douglas Cooper and Gary Tinterow, The Essential Cubism 1907–1920: Braque, Picasso and Their Friends, London, Tate Gallery, April 27–July 9, 1983.

London, Tate, 1986. London, Tate Gallery, Oskar Kokoschka, 1886–1980, June 11–August 10, 1986.

London, Tate, 1990. Elizabeth Cowling and Jennifer Mundy, On Classic Ground: Picasso, Léger, de Chirico and the New Classicism 1910–1930, London, Tate Gallery, June 6–September 2, 1990.

London, Tooth, 1886. London, Arthur Tooth and Sons, Pictures of Parisian Life by J. J. Tissot, 1886.

Lord 1900. Augustus M. Lord, An Address commemorative of Jesse Metcalf and Helen Adelia Rowe Metcalf, delivered under the auspices of the Board of Directors and the Alumni Association of the Rhode Island School of Design, May 17, 1900. Providence: Snow & Farnham, 1901.

Los Angeles, LACMA, 1955. Los Angeles, Los Angeles County Museum of Art, Renoir, July 14–August 21, 1955; San Francisco, San Francisco Museum of Art, September 1–October 2, 1955.

Los Angeles, LACMA, 1958. Los Angeles, Los Angeles County Museum of Art, An Exhibition of Works by Edgar Hilaire Germain Degas, 1834–1917, March 1958.

Los Angeles, LACMA, 1970. Douglas Cooper, The Cubist Epoch, Los Angeles, Los Angeles County Museum of Art, December 15, 1970–February 21, 1971; New York, Metropolitan Museum of Art, April 7–June 7, 1971.

Los Angeles, LACMA, 1971. Los Angeles, Los Angeles County Museum of Art, Géricault, October–December 1971; Detroit, Detroit Institute of Arts, January–March 1972; Philadelphia, Philadelphia Museum of Art, March–May 1972.

Los Angeles, LACMA, 1980. Peter Fusco and H. W. Janson, eds., The Romantics to Rodin, French Nineteenth-Century Sculpture from North American Collections, Los Angeles, Los Angeles County Museum of Art, March 4–May 25, 1980; Minneapolis, Minneapolis Institute of Arts, June 25–September 21, 1980; Detroit, Detroit Institute of Arts, October 27, 1980–January 4, 1981; Indianapolis, Indianapolis Museum of Art, February 22–April 29, 1981.

Los Angeles, LACMA, 1984. Richard Brettell, Sylvie Gache-Patin, Scott Schaefer, et al., A Day in the Country, Impressionism and the French Landscape, Los Angeles, Los Angeles County Museum of Art, June 28–September 16, 1984; Chicago, Art Institute of Chicago, October 23, 1984–January 6, 1985; Paris, Galeries Nationales du Grand Palais, February 4–April 22, 1985.

Los Angeles, UCLA, 1986. Los Angeles, Frederick S. Wight Art Gallery, University of California, Los Angeles, The Macchiaioli: Painters of Italian Life, 1850–1900, February 25–April 20, 1986; Cambridge, Harvard University Art Museums, June 21–August 6, 1986.

Loudun 1855. Eugène Loudun, Le Salon de 1855. Paris: Ledoyen, Editeur, 1855.

Luzi and Carrà 1971. Mario Luzi and Massimo Carrà, L'opera di Matisse, dalla rivolta 'fauve' all'intimismo, 1904–1928. Milan: Rizzoli, 1971.

Lyons, Beaux-Arts, 1981. Giuliano Matteucci, Silvestro Lega, Lyons, Musée des Beaux-Arts, March 1981.

Lyons, Beaux-Arts, 1986. Lyons, Musée des Beaux-Arts, Portraitistes Lyonnais, 1800–1914, June–September 1986.

Lyons, Beaux-Arts, 1988. Ekkehard Mai, Anke Repp-Eckert, Guy Cogeval, and Philippe Durey, Triomphe et Mort du Héros: La peinture d'histoire en Europe de Rubens à Manet, Lyons, Musée des Beaux-Arts, May 18–July 17, 1988.

M. A. B. 1929. M. A. B., "Virile Work by Augustus John," Bulletin of the Rhode Island School of Design, v. XVII, no. 2 (April 1929), pp. 14–15.

Maas 1969. Jeremy Maas, Victorian Painters. London: Barrie and Rockliff, The Cresset Press, 1969.

MacDonagh 1973. Intro. by Oliver MacDonagh, Emigration in the Victorian Age: Debates of the issue from 19th Century Critical Journals. Hants: Gregg International Publishers Limited, 1973.

Maltese 1965. Corrado Maltese, Delacroix. Milan: Edizioni per il Club del Libro, 1965.

Manchester, Currier, 1949. Manchester, Currier Gallery of Art, Monet and the Beginnings of Impressionism, October 8–November 6, 1949.

Mangin 1973. Nicole S. Mangin (Worms de Romilly), Catalogue de l'oeuvre de Georges Braque: Peintures 1916–1923. Paris: Maeght Editeur, 1973.

Manners 1913. Lady Victoria Manners, Matthew William Peters, R. A.: His Life and Work. London: The Connoisseur, 1913.

Manners and Williamson 1924. Lady Victoria Manners and Dr. G. C. Williamson, Angelica Kauffmann, R. A. New York, 1924.

Mantz 1856. Paul Mantz, "Théodore Chassériau," L'Artiste, VIe série, v. II (October 19, 1856), pp. 221–25.

Mantz 1873. Paul Mantz, "Le Salon (3e article)," Le Temps (Paris), May 24, 1873.

Mantz 1878. Paul Mantz, "L'Exposition universelle: la peinture française," Gazette des Beaux-Arts, v. XVIII (1878), p. 437.

Marabottini 1984. Alessandro Marabottini, Lega e la Scuola di Piagentina. Florence: Cassa di Risparmio di Firenze, 1984.

Marandel 1980. J. Patrice Marandel, "The Death of Camille: Guillaume Guillon Lethière and the 1785 Prix de Rome," Antologia di Belle Arti, v. IV, nos. 13–14 (1980), pp. 12–17.

Marcel 1911. Henry Marcel, Chassériau. Paris: Jean Gillequin & Cie., La Renaissance du Livre, 1911.

Marmori 1976. Giancarlo Marmori, "Grandi ritorni: Fattori, Signorini, Lega e soci," L'Espresso (Rome/Milan), May 23, 1976.

Martelli 1873. Diego Martelli, "Gli ultimi momenti di G. Mazzini. Quadro del Sig. Silvestro Lega," Il Giornale Artistico, v. I, no. 16 (October 25, 1873).

Martelli 1885. Diego Martelli, "Silvestro Lega," La Commedia Umana, v. I, no. 45 (October 25, 1885).

Masson 1965. Georgina Masson, The Companion Guide to Rome. New York: Harper & Row, 1965.

Matteucci 1977. Giuliano Matteucci, "Il lungo esilio del Mazzini morente di Silvestro Lega," Pantheon, v. XXXV (April 1977), pp. 142–51.

Matteucci 1987. Giuliano Matteucci, Lega, L'Opera Completa, 2 v. Florence: Giunti, 1987.

Mauclair 1908. Camille Mauclair, "La femme dans l'oeuvre de Manet," L'Art et les Artistes, v. VI (October 1907–March 1908), pp. 472–78.

Mauclair 1937. Camille Mauclair, Degas. Paris: Hypérion, 1937.

Maus 1926. Madeleine Octave Maus, Trente années de lutte pour l'art, 1884–1914. Brussels: Librairie L'Oiseau Bleu, 1926.

Maxon 1954. John Maxon, "The Museum Revisited," Museum Notes, Rhode Island School of Design, v. II, no. 3 (Spring 1954), n. p.

Maxon 1959. John Maxon, "English Vision," Bulletin of Rhode Island School of Design, Museum Notes, v. 45, no. 3 (March 1959), pp. 4–9.

Meier-Graefe 1899. Julius Meier-Graefe, "Die Stellung Eduard Manets," Die Kunst für Alle, v. XV (November 1899).

Meier-Graefe 1904. Julius Meier-Graefe, Manet und sein Kreis. Munich: Bard. Marquardt & Co., n. d. [1904].

Meier-Graefe 1911 and 1920. Julius Meier-Graefe, Auguste Renoir. Munich: R. Piper and Co., 1911 and 1920.

Meier-Graefe 1912. Julius Meier-Graefe, Edouard Manet. Munich: R. Piper and Co., 1912.

Meier-Graefe 1929. Julius Meier-Graefe, Renoir, 2nd ed. Leipzig: Klinkhardt und Bierman, 1929.

Memphis, Dixon, 1987. Lisa D. Simpson, From Arcadia to Barbizon, A Journey in French Landscape Painting, Memphis, Dixon Gallery and Gardens, November 22, 1987–May 15, 1988.

Merling 1986. Mitchell F. Merling, "An Allegory of the Foundation of the Louvre by Hubert Robert." Unpublished M. A. thesis, Brown University, 1986, in RISD Museum files.

Merson 1861. Olivier Merson, Exposition de 1861: La Peinture en France. Paris: E. Dentu, 1861.

Mesirca 1975. Giuseppe Mesirca, Mi pareva d'esser vecchio senz'anni. Cittadella (Padua): Rebellato Editore, 1975.

Metzinger 1910. Jean Metzinger, "Note sur la peinture," Pan (October–November 1910).

Metzinger and Robbins 1990. Fritz Metzinger, Daniel Robbins, and Jean Metzinger, Die Entstehung des Kubismus: Eine Neubewertung. Frankfurt a.M.: R. G. Fischer Verlag, 1990.

Miami, Center for Fine Arts, 1984. Miami, Center for the Fine Arts, In Quest of Excellence, January 14–April 22, 1984.

Michel 1919. Alice Michel, "Degas et son modèle," Mercure de France (February 1, 1919), pp. 457–78; (February 16, 1919) pp. 623–39.

Michel 1945. M. G. Michel, Les Grandes Epoques de la peinture moderne. 1945.

Middletown, Davison, 1964. Middletown, Davison Art Center, Wesleyan University, Oskar Kokoschka, April 1–23, 1964 (no cat.).

Milan, Palazzo, 1988. Dario Durbé, Giuliano Matteucci, et al., Silvestro Lega: Dipinti, Milan, Palazzo della Permanente, March 5–May 1, 1988; Florence, Palazzo Strozzi, May 7–July 10, 1988.

Milani n.d. Alfredo Milani, Pittura Italiana Antica e Moderna, v. IV. Milan: Hoepli, n.d.

Millar 1967. Oliver Millar, Zoffany and his Tribuna. London: Routledge & Kegan Paul, 1967.

Millar 1982. Oliver Millar, Kings and Queens. London: The Queen's Gallery, Buckingham Palace, 1982.

Millard 1976. Charles W. Millard, The Sculpture of Edgar Degas. Princeton: Princeton University Press, 1976.

Milner 1988. John Milner, The Studios of Paris. New Haven: Yale University Press, 1988.

Milwaukee, Art Institute, 1957. Milwaukee, Milwaukee Art Institute, An Inaugural Exhibition, September 12–October 20, 1957.

Minervino 1970. Fiorella Minervino, L'opera completa di Degas. Milan: Rizzoli, 1970.

Minneapolis, Institute, 1970. Minneapolis, Minneapolis Institute of Arts, Eugène Carrière, February 22–April 5, 1970 (no cat.).

Minto 1970. W. Minto, ed., Autobiographical Notes of the Life of William Bell Scott, 2 v. New York: AMS Press, 1970.

Misfeldt 1971. Willard E. Misfeldt, "James Jacques Joseph Tissot: A Bio-critical Study." Unpublished Ph.D. dissertation, Washington

University, 1971.

Misfeldt 1982. Willard E. Misfeldt, *The Albums of James Tissot.* Bowling Green: Bowling Green University Popular Press, 1982.

Misfeldt 1986. Willard E. Misfeldt, "James Tissot and Alphonse Daudet: Friends and Collaborators," *Apollo,* v. 73, no. 288 (February 1986).

Modigliana 1926. Modigliana, *Mostra Leghiana e Mostre Retrospettive di vari artisti romagnoli, 1ª Biennale Romagnola d'Arte,* August 15–September 30, 1926.

M[ohl] 1862. Madame M[ohl], *Madame Récamier, with a sketch of the history of Society in France.* London: Chapman and Hall, 1862.

Molmenti 1895. Pompeo Gherardo Molmenti, *Esposizione Internazionale d'Arte in Venezia. Giacomo Favretto.* Rome: A. Malcotti e Figlio Editori, 1895.

Monaco, Sotheby's, 1989. Monaco, Sotheby's, *Importants Tableaux Anciens,* sale, December 2–3, 1989.

Monkhouse 1978. Christopher Monkhouse, "Napoleon in Rhode Island, The Harold Brown Collection at the Rhode Island School of Design," *Antiques,* v. CXIII, no. 1 (January 1978), pp. 192–201.

Monkhouse and Michie 1986. Christopher P. Monkhouse and Thomas S. Michie, *American Furniture in Pendleton House.* Providence: Museum of Art, Rhode Island School of Design, 1986.

Monneret 1978. Sophie Monneret, *L'Impressionnisme et son époque: Dictionnaire International Illustré.* Paris: Denoël, 1978.

Mont-de-Marsan, Donjon, 1981–82. Mont-de-Marsan, Donjon La Cataye, Musée Despiau-Wlerick, *La femme artiste d'Elisabeth Vigée-Lebrun à Rosa Bonheur,* November 1981–February 1982.

Monteverdi 1975. Mario Monteverdi, *Storia della pittura italiana dell'Ottocento.* Busto Arsizio: Bramante Editore, 1975.

Monti 1984. Raffaele Monti, *Signorini e il Naturalismo Europeo.* Florence: Cassa di Risparmio di Firenze, 1984.

Montreal, Fine Arts, 1950. Montreal, Montreal Museum of Fine Arts, *So this is Paris,* October 4–29, 1950.

Moore 1893. George Moore, *Modern Painting.* London: Walter Scott, Ltd., 1893.

Moreau 1873. Adolphe Moreau, *E. Delacroix et son oeuvre.* Paris: Librairie des Bibliophiles, 1873.

Moreau-Nélaton 1926. Etienne Moreau-Nélaton, *Manet raconté par lui-même,* 2 v. Paris: Henri Laurens, 1926.

Moreau-Nélaton n.d. Etienne Moreau-Nélaton, *Catalogue manuscrit de l'oeuvre de Manet.* Paris: Bibliothèque Nationale, Département des Estampes, n.d.

Morisot 1950. Berthe Morisot, *Correspondance de Berthe Morisot avec sa famille et ses amis.* Paris: Quatre Chemins, 1950.

Mortier 1974. Roland Mortier, *La Poétique des ruines en France.* Geneva: Librairie Droz, 1974.

Mras 1963. George P. Mras, "The Delacroix Exhibition in Canada," *Burlington Magazine,* v. CV, no. 719 (February 1963), pp. 71–72.

Munaro 1887. G. A. Munaro, "Giacomo Favretto, I. Qualche cenno biografico-critico," *L'Esposizione Artistica Nazionale Illustrata–Venezia 1887,* no. 9 (May 29, 1887).

Munhall 1968. Edgar Munhall, "Savoyards in French Eighteenth Century Art," *Apollo,* v. LXXXVII, no. 72 (February 1968), pp. 86–94.

Munich, Haus der Kunst, 1958. Munich, Haus der Kunst, *Oskar Kokoschka,* March 14–May 11, 1958.

Munich, Haus der Kunst, 1975. Munich, Bayerische Staatsgemäldesammlungen und Ausstellungsleitung Haus der Kunst, *Toskanische Impressionen, Der Beitrag der Macchiaioli zum europäischen Realismus,* October 18, 1975–January 4, 1976.

Munich, Neue Künstlervereinigung, 1910. Henri Le Fauconnier, "Das Kunstwerk" (cat. pref.), Munich, Neue Künstlervereinigung II, September 1910.

Munich, Städtische Galerie, 1958. Munich, Städtische Galerie, *Auguste Renoir,* 1958.

Nagoya, City Art Museum, 1988. Nagoya, Nagoya City Art Museum, *Renoir,* October 15–December 11, 1988; Hiroshima, Hiroshima Museum of Art, December 17, 1988–February 12, 1989; Nara, Nara Prefectural Museum of Art, February 18–April 9, 1989.

Nares 1957. Gordon Nares, "Ingestre Hall, Staffordshire," *Country Life,* v. 122 (October 17, 24, 31, 1957), pp. 772–75, 874–77, 924–27.

Nash 1906. Joseph Nash, ed. Charles Holme, *The Mansions of England in the Olden Time.* London: The Studio, 1906.

Nazione 1960. "Quadro di Silvestro Lega ritrovato in America," *La Nazione* (Florence), May 25, 1960.

"Nécrologie" 1902. "Nécrologie (Marcellin-Gilbert Desboutin)," *Chronique des arts et de la curiosité,* no. 8 (February 22, 1902), p. 63.

New Haven, CBA, 1977. J. H. Plumb, Edward J. Nygren, and Nancy Pressly, *The Pursuit of Happiness. A View of Life in Georgian England,* New Haven, Yale Center for British Art, April 19–September 18, 1977.

New Haven, YUAG, 1982. Helen Cooper, ed., *John Trumbull. The Hand and Spirit of a Painter,* New Haven, Yale University Art Gallery, October 28, 1982–January 16, 1983.

New York Public Library 1974. New York Public Library, *Dictionary Catalog of the Dance Collection,* v. 4. Boston: G. K. Hall & Co., 1974.

New York Public Library 1986. New York Public Library, *Liberty: The French-American Statue in Art and History.* New York: Harper and Row, 1986.

New York Times 1885. "Tissot's Novel Art Work," *New York Times,* May 10, 1885, p. 10.

New York, AAA, 1886. New York, American Art Association, *Works in Oil and Pastel by the Impressionists of Paris,* April 10–25, 1886.

New York, AAA, 1927. New York, American Art Association, *The John Quinn Collection: Paintings and Sculptures of the Moderns,* February 9–11, 1927.

New York, AAA, 1935. New York, American Art Association, Anderson Galleries, Inc., sale no. 4141, January 4, 1935.

New York, Acquavella, 1968. New York, Acquavella Galleries, Inc., *Four Masters of Impressionism: Monet, Pissarro, Renoir, Sisley, for the Benefit of the Lenox Hill Hospital,* October 25–November 30, 1968.

New York, American Art Galleries, 1886. New York, American Art Galleries, *The Catalogue of Modern Paintings belonging to Mr. Beriah Wall and Mr. John A. Brown of Providence, R.I.,* March 30–April 1, 1886.

New York, Art Center, 1926. New York, Art Center, *Memorial Exhibition of Representative Works Selected from the John Quinn Collection,* January 7–30, 1926.

New York, Carstairs, 1935. New York, Carroll Carstairs Gallery, *The French Impressionists and After,* December 1935–January 1936.

New York, CCFRS, 1943. New York, Coordinating Council of French Relief Societies, *Paris, A Loan Exhibition,* December 9, 1943–January 9, 1944.

New York, Durand-Ruel, 1895. New York, Durand-Ruel Galleries, *Paintings by Edouard Manet,* March 1895.

New York, Durand-Ruel, 1913. New York, Durand-Ruel Galleries, *Loan Exhibition of Paintings by Edouard Manet,* November 29–December 13, 1913.

New York, Durand-Ruel, 1916. New York, Durand-Ruel Galleries, *Exhibition of Painting and Pastels by Edouard Manet (1832–1883) and Edgar Degas (1834–),* April 5–29, 1916.

New York, Durand-Ruel, 1938. New York, Durand-Ruel Galleries, *Cézanne, An Exhibition for the Benefit of Hope Farm,* 1938 (no cat.).

New York, Durand-Ruel, 1939. New York, Durand-Ruel Galleries, *Portraits by Renoir,* March 29–April 3, 1939.

New York, Durlacher, 1961. New York, Durlacher Bros., *William Etty–Atkinson Grimshaw,* October 3–28, 1961; Providence, Museum of Art, Rhode Island School of Design, November 5–December 10, 1961.

New York, Duveen, 1941. New York, Duveen Brothers, Inc., *Renoir Centennial Loan Exhibition,* 1941.

New York, Grolier, 1922. New York, Grolier Club, *Prints, Drawings, and Bronzes: by Degas,* January 26–February 28, 1922.

New York, Guggenheim, 1964. Daniel Robbins, *Albert Gleizes, 1881–1953: A Retrospective Exhibition,* New York, Solomon R. Guggenheim Museum, 1964; San Francisco, San Francisco Museum of Art; St. Louis, City Art Museum of St. Louis; Champaign, Krannert Art Museum, University of Illinois; Columbus, Columbus Gallery of Fine Arts; Ottawa, National Gallery of Art; Buffalo, Albright-Knox Art Gallery; Chicago, Arts Club of Chicago; Paris, Musée National d'Art Moderne; Dortmund, Museum am Ostwall.

New York, Guggenheim, 1968. Robert L. Herbert, *Neo-Impressionism,* New York, Solomon R. Guggenheim Museum, February 8–April 8, 1968.

New York, Guggenheim, 1986. New York, Solomon R. Guggenheim Museum, *Oskar Kokoschka, 1886–1980,* December 9, 1986–February 15, 1987.

New York, Hutton, 1964. William A. Camfield and Daniel Robbins, *Albert Gleizes and the Section d'Or,* New York, Leonard Hutton Galleries, September 26–October 22, 1964.

New York, IBM, 1988. New York, IBM Gallery of Science and Art, *18th–20th Century European and American Painting and Sculpture: Highlights from the Collection of the Museum of Art, Rhode Island School of Design,* July 5–September 10, 1988 (no cat.).

New York, Kent, 1990. Robert Rosenblum, *The Private World of Eugène Carrière,* New York, Kent Fine Art, May 8–June 30, 1990.

New York, Knoedler, 1915. New York, M. Knoedler & Co., *Loan Exhibition of Masterpieces by Old and Modern Painters,* April 6–24, 1915.

New York, Knoedler, 1931. New York, M. Knoedler & Co., *French Landscape of the 19th and 20th Centuries,* October–November 1931.

New York, Knoedler, 1955. Foreword by John Rewald, *Edgar Degas, Original Wax Sculptures,* New York, M. Knoedler & Co., November 9–December 3, 1955.

New York, Knoedler, 1973. John Golding, *Ozenfant,* New York, M. Knoedler & Co., April 5–28, 1973.

New York, Marlborough-Gerson, 1966. New York, Marlborough-Gerson Gallery, Inc., *Oskar Kokoschka,* October–November 1966.

New York, MMA, 1978. New York, Metropolitan Museum of Art, *Monet's Years at Giverny: Beyond Impressionism,* April 22–July 9, 1978; St. Louis, St. Louis Art Museum, August 1–October 8, 1978.

New York, MMA, 1988–89. Jean Sutherland Boggs, Douglas W. Druick, Henri Loyrette, Michael Pantazzi, and Gary Tinterow, *Degas,* Paris, Galeries Nationales du Grand Palais, February 9–May 16, 1988; Ottawa, National Gallery of Canada, June 16–August 28, 1988; New York, Metropolitan Museum of Art, September 27, 1988–January 8, 1989.

New York, MOMA, 1936. Alfred H. Barr, Jr., *Cubism and Abstract Art,* New York, Museum of Modern Art, 1936 (reprinted Boston: New York Graphic Society, 1974).

New York, MOMA, 1942. New York, Museum of Modern Art, *Twentieth Century Portraits,* December 9, 1942–January 24, 1943.

New York, MOMA, 1949. Henry R. Hope, *Georges Braque,* New York, Museum of Modern Art, March 30–June 12, 1949.

New York, MOMA, 1951. New York, Museum of Modern Art, *H. Matisse,* November 13, 1951–January 13, 1952; Chicago, Art Institute of Chicago, April 1–May 1, 1952; San Francisco, San Francisco Museum of Art, May 15–July 6, 1952.

New York, MOMA, 1977. New York, Museum of Modern Art, *Cézanne, the Late Work,* October 7, 1977–January 3, 1978; Houston, Museum of Fine Arts, January 26–March 19, 1978. [For accompanying publication see Rubin 1977.]

New York, MOMA, 1986. Kirk Varnedoe, *Vienna 1900: Art, Architecture and Design,* New York, Museum of Modern Art, July 3–October 21, 1986.

New York, MOMA, 1989. William Rubin, *Picasso and Braque, Pioneering Cubism.* New York: Museum of Modern Art, 1989.

New York, Moore's Art Galleries, 1886. New York, Moore's Art Galleries, *Catalogue of the Collection of Thomas Robinson of Providence, R.I., High Class Paintings, Mostly of the French School . . . ,* November 16–18, 1886.

New York, NAD, 1883. New York, National Academy of Design, *Pedestal Fund Art Loan Exhibition,* December 3–31, 1883.

New York, NAD, 1988. New York, National Academy of Design, *Ogden Codman and the Decoration of Houses,* December 7, 1988–January 29, 1989.

New York, Parke-Bernet, 1966. New York, Parke-Bernet Galleries, Inc., *G. David Thompson Collection,* May 23–24, 1966.

New York, Parke-Bernet, 1967. New York, Parke-Bernet Galleries, Inc., sale no. 2539, April 5, 1967.

New York, Rosenberg, 1948. New York, Paul Rosenberg and Co., *Loan Exhibition of Masterpieces by Delacroix and Renoir for the Benefit of the New York Heart Association,* February 16–March 13, 1948.

New York, Rosenberg, 1950. New York, Paul Rosenberg and Co., *The 19th Century Heritage,* 1950.

New York, Rosenberg, 1954. New York, Paul Rosenberg and Co., *The Last Twenty Years of Renoir's Life,* March 8–April 3, 1954.

New York, Rosenberg, 1956. New York, Paul Rosenberg and Co., *Loan Exhibition of Paintings by J.B.C. Corot (1796–1875),* November 5–December 1, 1956.

New York, Shepherd, 1972. Intro. by John Minor Wisdom, Jr.; cat. by John Ittmann, Robert Kashey, Martin L. H. Reymert; Corot entries by Victor Carlson; *The Forest of Fontainebleau, Refuge of Reality. French Landscape, 1800 to 1870,* New York, Shepherd Gallery, 1972.

New York, Shepherd, 1975. Martin Reymert and Jon Hutton, *Ingres and Delacroix through Degas and Puvis de Chavannes: The Figure in French Art, 1800–1870,* New York, Shepherd

Gallery, May 7–June 28, 1975.

New York, Shepherd, 1985. New York, Shepherd Gallery, *Nineteenth Century French and Western European Sculpture in Bronze and other Media,* 1985.

New York, Shepherd, 1988. New York, Shepherd Gallery, *French Nineteenth Century Drawings, Watercolors, Paintings and Sculpture,* Spring 1988.

New York, Sotheby's, 1988. New York, Sotheby's, *19th Century Furniture, Decorations and Works of Art,* October 12, 1988.

New York, Weitzner, 1936. New York, Julius H. Weitzner, Inc., *A Selection of Paintings,* 1936.

New York, Wheelock Whitney, 1986. New York, Wheelock Whitney & Co., *Nineteenth Century French Paintings,* May 22–June 20, 1986.

New York, Wildenstein, 1943. New York, Wildenstein & Co., *From Paris to the Sea Down the River Seine, An Exhibition for the Benefit of L'Ecole Libre des Hautes Etudes,* January 28–February 27, 1943.

New York, Wildenstein, 1944. New York, Wildenstein & Co., *Eugène Delacroix, Exhibition in Aid of the Quaker Emergency Service,* October–November 1944.

New York, Wildenstein, 1945. New York, Wildenstein & Co., *A Loan Exhibition of Paintings by Claude Monet, for the Benefit of the Children of Giverny,* April 11–May 12, 1945.

New York, Wildenstein, 1948. New York, Wildenstein & Co., *A Loan Exhibition of Manet for the Benefit of the New York Infirmary,* February 26–April 3, 1948.

New York, Wildenstein, 1949. New York, Wildenstein & Co., *A Loan Exhibition of Degas for the Benefit of the New York Infirmary,* April 7–May 14, 1949.

New York, Wildenstein, 1958. New York, Wildenstein & Co., *Renoir. An Exhibition for the Benefit of the Citizens' Committee for the Children of New York, Inc.,* April 8–May 10, 1958.

New York, Wildenstein, 1960. Foreword by Kermit Lansner, essay and chronology by Daniel Wildenstein, *Degas: the Citizens' Committee for Children of New York, Inc.,* New York, Wildenstein & Co., April 7–May 7, 1960.

New York, Wildenstein, 1962. New York, Wildenstein & Co., *Modern French Painting Exhibition for the Benefit of Poses Institute of Fine Arts, Arts Scholarship and Grants Funds,* Brandeis University, April 10–25, 1962; Waltham, Rose Art Museum, Brandeis University, May 10–June 13, 1962.

New York, Wildenstein, 1969. New York, Wildenstein & Co., *Corot, A Loan Exhibition for the Benefit of the Citizens' Committee for Children of New York, Inc.,* October 30–December 6, 1969.

New York, Wildenstein, 1970. New York, Wildenstein & Co., *One Hundred Years of Impressionism. A Loan Exhibition for the Benefit of the New York University Art Collection,* April 2–May 9, 1970.

New York, Wildenstein, 1974. New York, Wildenstein & Co., *Renoir. The Gentle Rebel. A Loan Exhibition for the Benefit of the Association for Mentally Ill Children,* October 24–November 30, 1974.

New York, Wildenstein, 1988. Georges Bernier, *Hubert Robert. The Pleasure of Ruins,* New York, Wildenstein & Co., November 15–December 16, 1988.

New York, World's Fair, 1940. Walter Pach, *Catalogue of European and American Paintings,* New York, World's Fair, May–October 1940.

Newport, Art Association, 1948. Newport,

Art Association of Newport, *The Turn of the Century,* August 14–September 6, 1948.

Nice, Chéret, 1986. Nice, Musée des Beaux-Arts Jules Chéret, *Catalogue promenade,* 1986.

Nicodemi and Dufflocq 1935. Giorgio Nicodemi and E. M. Dufflocq, *Le Arti italiane nel XIX e XX secolo.* Milan: Casa Editrice Dottor Francesco Vallardi, 1935.

Nicolson 1968. Benedict Nicolson, *Joseph Wright of Derby.* London: Paul Mellon Foundation for British Art, 1968.

Noakes 1978. Aubrey Noakes, *William Frith, Extraordinary Victorian Painter. A Biographical and Critical Essay.* London: Jupiter, 1978.

Nochlin 1966. Linda Nochlin, *Impressionism and Post-Impressionism, 1874–1904, Sources and Documents.* Englewood Cliffs: Prentice-Hall, Inc., 1966.

Nochlin 1983. Linda Nochlin, "The Imaginary Orient," *Art in America,* v. 71, no. 5 (May 1983), pp. 119 ff.

Nolhac 1910. Pierre de Nolhac, *Hubert Robert, 1733–1808.* Paris: Goupil et cie, 1910.

Northampton, Smith, 1933. Northampton, Smith College Museum of Art, *Edgar Degas,* November 28–December 18, 1933 (no cat.).

Northampton, Smith, 1934. Northampton, Smith College Museum of Art, *Bulletin,* no. 15 (June 1934).

Northcote 1813. James Northcote, *Memoirs of Sir Joshua Reynolds.* London, 1813.

Novotny 1970. Fritz Novotny, *Cézanne und das Ende der wissenschaftlichen Perspektive.* Vienna/Munich: Verlag Anton Schroll & Co., 1970.

Omaha, Joslyn, 1951. Omaha, Joslyn Memorial Art Museum, *Twentieth Anniversary Exhibition: The Beginnings of Modern Painting, France 1800–1910,* October 4–November 4, 1951.

Oreffice 1887. Pellegrino Oreffice, "Giacomo Favretto, II. Inno in prosa," *L'Esposizione Artistica Nazionale Illustrata–Venezia 1887,* no. 8 (May 29, 1887).

Orienti 1967. Sandra Orienti, *L'opera pittorica di Edouard Manet.* Milan: Rizzoli, 1967.

Ozenfant 1931. Amédée Ozenfant, trans. John Rodker, *Foundations of Modern Art.* 1931 (reprinted New York: Dover Publications, 1952).

Ozenfant 1968. [Amédée] Ozenfant, *Mémoires, 1886–1962.* Paris: Editions Seghers, 1968.

Pach 1924. Walter Pach, *Raymond Duchamp-Villon, Sculpture 1876–1918. Imprimé pour John Quinn et ses Amis.* Paris: Jacques Povolozky, 1924.

Pach 1938. Walter Pach, *Queer Thing, Painting Forty Years in the World of Art.* New York: Harper Bros., 1938.

Pach 1958. Walter Pach, "Renoir, Rubens and the Thurneyssen Family," *Art Quarterly,* v. XXI, no. 3 (Autumn 1958), pp. 278–82.

Pach 1964. Walter Pach, *Pierre-Auguste Renoir.* New York, 1964 (concise ed., 1983).

Pagani 1955. Severino Pagani, *La pittura lombarda della Scapigliatura.* Milan: Società Editrice Libreria, 1955.

Paley 1978. Morton D. Paley, *William Blake.* Oxford: Phaidon; and New York: E. P. Dutton; 1978.

Palm Beach, Four Arts, 1958. Palm Beach, Society of the Four Arts, *Loan Exhibition of Paintings by Claude Monet,* January 3–February 2, 1958.

Paloscia 1975. Tommaso Paloscia, "Pellegrinaggio nell'Ottocento," *La Nazione* (Florence), October 1, 1975.

Paloscia 1976. Tommaso Paloscia, "Considerazioni sulla mostra al Belvedere–I Macchiaioli," *Arti e mercature,* v. XIII, no. 5 (May 22, 1976).

Paris, André Groult, 1914. Paris, Galerie André Groult, *Exposition de Sculptures de R. Duchamp-*

Villon—Aquarelles, Dessins, Pastels d'Albert Gleizes et Jean Metzinger—Gravures de Jacques Villon, April 6–May 3, 1914.

Paris, Art Nouveau, 1896. Paris, Salon de l'Art Nouveau, *Exposition Constantin Meunier,* February 16–March 15, 1896.

Paris, Bernheim-Jeune, 1901. Paris, Galerie Bernheim-Jeune, *E. Carrière. Exposition d'oeuvre récente,* June 1–April 15, 1901.

Paris, Bernheim-Jeune, 1903. Paris, Galerie Bernheim-Jeune, *Exposition d'oeuvres de l'Ecole Impressionniste,* April 1903.

Paris, Bernheim-Jeune, 1921. Paris, Galerie Bernheim-Jeune, *Monet,* 1921.

Paris, Bernheim-Jeune, 1925. Paris, Galerie Bernheim-Jeune, *Oeuvres des xixe et xxe siècles,* 1925.

Paris, Brame & Lorenceau, 1988. Paris, Galerie Brame & Lorenceau, *xive Biennale Internationale des Antiquaires,* Paris, Galeries Nationales du Grand Palais, September 22–October 9, 1988.

Paris, Cailleux, 1929. Paris, Galerie Cailleux, *Exposition Hubert Robert,* 1929.

Paris, Charpentier, 1938. Paris, Galerie Jean Charpentier, *Collection du Duc de Trévise, Catalogue des tableaux et dessins du xixe siècle,* May 19, 1938.

Paris, Delessert, 1869. Paris, *Catalogue des tableaux composant la galerie Delessert,* March 17–18, 1869.

Paris, Durand-Ruel, 1922. Paris, Galerie Durand-Ruel, *Séquestre Goetz,* February 23–24, 1922.

Paris, Ecole des Beaux-Arts, 1884. Paris, Ecole Nationale des Beaux-Arts, *Exposition des oeuvres d'Edouard Manet,* January 6–28, 1884.

Paris, Ecole des Beaux-Arts, 1885. Paris, Ecole Nationale des Beaux-Arts, *Exposition Eugène Delacroix,* March 6–April 15, 1885.

Paris, Ecole des Beaux-Arts, 1907. Paris, Ecole Nationale des Beaux-Arts, posthumous exhibition of the work of Eugène Carrière, May–June 1907.

Paris, *Exposition Universelle,* 1855. Paris, Palais des Beaux-Arts, *Exposition Universelle de 1855,* May 15–November 15, 1855.

Paris, *Exposition Universelle,* 1878. Paris, *Exposition universelle internationale de 1878 à Paris. Catalogue officiel. Oeuvres d'art,* 1878.

Paris, *Exposition Universelle,* 1900. Paris, Exposition Universelle de 1900, *Centennale de l'art Français, de 1800 à nos jours.*

Paris, Fischer-Kiener, 1985. Paris, Jacques Fischer-Chantal Kiener, *Peintures françaises de la Revolution au Second-Empire,* December 11–24, 1985.

Paris, Lebrun, 1826. Paris, Galerie Lebrun, rue des Jeuners, 1826.

Paris, Georges Petit, 1884. Paris, Galerie Georges Petit, *Exposition Meissonier,* May 24–July 24, 1884.

Paris, Georges Petit, 1893. Paris, Galerie Georges Petit, *Exposition Meissonier,* March 1893.

Paris, Georges Petit, 1894. Paris, Galerie Georges Petit, *Catalogue des tableaux et pastels composant la collection de M. Théodore Duret,* March 19, 1894.

Paris, Georges Petit, 1911. Paris, Galerie Georges Petit, *Catalogue des sculptures par Joseph Chinard de Lyon formant la Collection de Penha-Longa,* December 2, 1911.

Paris, Georges Petit, 1919. Paris, Galerie Georges Petit, *Atelier Edgar Degas: 3ème Vente. Catalogue des tableaux, pastels et dessins par Edgar Degas et provenant de son atelier,* April 7–9, 1919.

Paris, Grand Palais, 1974. Paris, Galeries Nationales du Grand Palais, *French Painting, 1774–1830: The Age of Revolution,* November

16, 1974–February 3, 1975; Detroit, Detroit Institute of Arts, March 5–May 4, 1975; New York, Metropolitan Museum of Art, June 12–September 7, 1975.

Paris, Grand Palais, 1975. Paris, Galeries Nationales du Grand Palais, *Sur les traces de Jean-Baptiste Carpeaux,* March 11–May 5, 1975.

Paris, Grand Palais, 1980. Paris, Galeries Nationales du Grand Palais, *Hommage à Claude Monet,* February 28–May 5, 1980.

Paris, Grand Palais, 1983. Paris, Galeries Nationales du Grand Palais, *Manet, 1832–1883,* April 22–August 8, 1983; New York, Metropolitan Museum of Art, September 10–November 27, 1983.

Paris, Grand Palais, 1983–84. Paris, Galeries Nationales du Grand Palais, *Raphaël et la France,* November 15, 1983–February 13, 1984.

Paris, Grand Palais, 1986. Anne Pingeot et al., *La Sculpture française au xixe siècle,* Paris, Galeries Nationales du Grand Palais, 1986.

Paris, Hébrard, 1921. Paris, Galerie A.-A. Hébrard, *Exposition des sculptures de Degas,* May–June 1921.

Paris, Hodebert-Barbazanges, 1928. Paris, Galerie Hodebert-Barbazanges, *Amédée Ozenfant,* 1928.

Paris, Hôtel Drouot 1872. Paris, Hôtel Drouot, *Collection Michel de Trétaigne, Catalogue des Tableaux Modernes,* February 19, 1872.

Paris, Hôtel Drouot, 1875. Paris, Hôtel Drouot, *Catalogue des tableaux, études, esquisses, dessins et eaux-fortes par Corot dressés par M. Alfred Robaut, artiste lithographe, et des tableaux, dessins, curiosités diverses composant sa collection particulière,* May 26, 1875, and following days. [Facsimile of copy annotated and illustrated by Alfred Robaut, published in Robaut 1905 (1965), v.]

Paris, Hôtel Drouot, 1885. Paris, Hôtel Drouot, *Catalogue des tableaux, études et esquisses, aquarelles, dessins & sculptures laissés dans son atelier par feu Gustave Doré,* April 10–11, 14–15, 1885.

Paris, Hôtel Drouot, 1893. Paris, Hôtel Drouot, sale, coll. Lenormant, November 29, 1893.

Paris, Hôtel Drouot, 1906. Paris, Hôtel Drouot, *Catalogue. Succession de Feu M. Jules Dalou, Sculpteur,* December 23–24, 1906.

Paris, Hôtel Drouot, 1911. Paris, Hôtel Drouot, *Catalogue des objets d'art . . . provenant de la collection Delessert,* 1911.

Paris, Hôtel Drouot, 1917. Paris, Hôtel Drouot, *Catalogue de sept tableaux par Théodore Chassériau . . . provenant de la succession de Madame X . . . ,* May 22, 1917.

Paris, Hôtel Drouot, 1921. Paris, Hôtel Drouot, *Vente Wilhelm Uhde,* May 30, 1921.

Paris, Institut Néerlandais, 1980. Paris, Institut Néerlandais, *Ary Scheffer, 1795–1858. Dessins, aquarelles, equisses à l'huile,* October 16–November 30, 1980.

Paris, la Boëtie, 1912. Paris, Galerie de la Boëtie, *Salon de La Section d'Or,* October 10–30, 1912.

Paris, Louvre, 1930. Paris, Musées Nationaux, Musée du Louvre, *Exposition Eugène Delacroix,* June–July 1930.

Paris, Louvre, 1963. Paris, Musée du Louvre, *Centenaire d'Eugène Delacroix, 1798–1863,* May–September 1963.

Paris, Louvre, 1989. Paris, Musée du Louvre, and Versailles, Musée National du Château, *Jacques-Louis David, 1748–1825,* October 26, 1989–February 12, 1990.

Paris, Manzi, 1913. Paris, Galerie Manzi, *Catalogue de sculptures originales . . . par J.-B. Carpeaux,* December 8–9, 1913.

Paris, Musées Nationaux, 1979. Marie-Catherine Sahut, *Le Louvre d'Hubert Robert,*

Paris, Réunion des Musées Nationaux, June 16–October 29, 1979.

Paris, Orangerie, *Chassériau,* 1933. Paris, Musée de l'Orangerie, *Exposition Chassériau, 1819–1856,* 1933.

Paris, Orangerie, *Delacroix,* 1933. Paris, Musée de l'Orangerie, *Voyage de Delacroix au Maroc, 1832,* 1933.

Paris, Orangerie, *Robert,* 1933. Intro. by Charles Sterling, *Exposition Hubert Robert, à l'occasion du deuxième centenaire de sa naissance,* Paris, Musée de l'Orangerie, December 1933–February 1934.

Paris, Petit Palais, 1953. Paris, Musée du Petit Palais, *Un siècle d'art français,* 1953.

Paris, Petit Palais, 1955–56. Anney Marvaud-Braunwald and François Pérot, *Exposition J.-B. Carpeaux, 1827–1875,* Paris, Musée du Petit Palais, 1955–56.

Paris, Pigalle, 1930. Paris, Galerie Pigalle, *Exposition Cézanne, 1839–1906,* 1930.

Paris, Place d'Alma, 1900. Cat. by Arsène Alexandre, prefaces by Eugène Carrière, Jean-Paul Laurens, Claude Monet, and Albert Besnard, *Exposition de 1900: L'Oeuvre de Rodin,* Paris, Place d'Alma, 1900.

Paris, *Salon,* 1935. Paris, *Salon de l'Art Mural,* 1935. Cited in Saint-Quentin, Lécuyer, 1985, p. 102.

Paris, Salon de 1850–51. Paris, Salon de 1850–51, *Explication des ouvrages de peinture, sculpture . . . des artistes vivants, exposés au Palais National.* Paris: Vinchon, fils, 1850.

Paris, Salon de 1855. Paris, Salon de 1855, *Explication des ouvrages de peinture, sculpture . . . des artistes vivants exposés au Palais des Champs-Elysées.* Paris, 1855.

Paris, Salon de 1861. Paris, Salon de 1861, *Explication des ouvrages de peinture, sculpture . . . des artists vivants exposés au Palais des Champs-Elysées.* Paris: Charles de Mourgues Frères, 1861.

Paris, Salon de 1873. Paris, Salon de 1873, *Explication des ouvrages de peinture, sculpture, architecture . . . des artistes vivants exposés au Palais des Champs-Elysées.* Paris, 1873.

Paris, Sedelmeyer, 1885. Paris, Galerie Sedelmeyer, *Exposition J.-J. Tissot: Quinze Tableaux sur la Femme à Paris,* April 19–June 15, 1885.

Paris, Vollard, 1901. Intro. by Gustave Coquiot, *Exposition de tableaux de F. Iturrino et de P. R. Picasso,* Paris, Galeries Ambroise Vollard, June 25–July 14, 1901 (reprinted in Daix and Boudaille 1967, pp. 156–59.)

Pasini 1973. Piero Pasini, "Bologna onora Silvestro Lega," *Romagna* (July 1973).

Pavan 1873. Antonio Pavan, "Lavori d'Arte recentissimi," *L'Arte in Italia,* v. v, nos. 10–11 (October–November 1873).

Payne 1987. Sandra K. Payne, *Atkinson Grimshaw, Knight's Errand.* Wokingham: Corporate Link, 1987.

Pelandi 1912. I. Pelandi, *La galleria d'arte moderna del Castello Sforzesco di Milano.* Bergamo: Istituto Italiano d'Arti Grafiche Editore, 1912.

Penrose 1962. Roland Penrose, *Picasso: His Life and Work.* New York: Schocken Books, 1962.

Penrose and Golding 1973. Roland Penrose and John Golding, eds., *Picasso 1881–1973.* London: Paul Elek Ltd., 1973.

Pensiero Mazziniano 1960. "Il Mazzini morente di Silvestro Lega," *Pensiero Mazziniano* (December 15, 1960).

Perer 1957. Maria Luisa Perer, *Silvestro Lega.* Milan, 1957.

Perocco 1976. Guido Perocco, *Venezia nell'epoca romantica,* v. 3. Venice: La Stamperia di Venezia, 1976.

Perocco 1986. Guido Perocco, biographical sketch by Renzo Trevisan, *Giacomo Favretto,* Archivi dell'Ottocento. [Turin:] Umberto

Allemandi & C., n.d. [1986].

Perruchot 1959. Henri Perruchot, *La Vie de Manet*. Paris: Hachette, 1959.

Pevsner 1974. Nikolaus Pevsner, *The Buildings of England: Staffordshire*. Harmondsworth: Penguin, 1974.

Philadelphia, PMA, 1934. Philadelphia, Philadelphia Museum of Art, *Exhibition of the Works of Cézanne,* November 10–December 10, 1934.

Philadelphia, PMA, 1939. Elizabeth Mongan and Edwin Wolf 2nd, intro. by A. Edward Newton, *William Blake 1757–1827; A Descriptive Catalogue of an Exhibition of the Works of William Blake Selected from Collections in the United States,* Philadelphia, Philadelphia Museum of Art, February 11–March 20, 1939.

Philadelphia, PMA, 1966. Ann Coffin Hanson, *Edouard Manet, 1832–1883,* Philadelphia, Philadelphia Museum of Art, November 3–December 11, 1966; Chicago, Art Institute of Chicago, January 13–February 19, 1967.

Philadelphia, PMA, 1968. Frederick Cummings and Allen Staley, *Romantic Art in Great Britain: Paintings and Drawings 1760–1860,* Detroit, Detroit Institute of Arts, January 9–February 18, 1968; Philadelphia, Philadelphia Museum of Art, March 14–April 21, 1968.

Phillpotts 1978. Beatrice Phillpotts, "Victorian Fairy Painting," *The Antique Collector,* v. 49, no. 7 (July 1978), p. 80.

Pinkney 1972. David H. Pinkney, *Napoleon III and the Rebuilding of Paris*. Princeton: Princeton University Press, 1972.

Pirenne 1948. Henri Pirenne, *Histoire de Belgique,* v. III. Brussels: La Renaissance du Livre, n.d. [1948–52].

Pissarro 1943. Camille Pissarro, ed. John Rewald, *Camille Pissarro, Letters to his son Lucien*. New York: Pantheon Books, 1943.

Pissarro and Venturi 1939. Ludovic Rodo Pissarro and Lionello Venturi, *Camille Pissarro, son art, son oeuvre,* 2 v. Paris: Paul Rosenberg, 1939.

Pittsburgh, Carnegie, 1908. Pittsburgh, Carnegie Institute, *Exhibition of Painting by the French Impressionists,* February 10–March 10, 1908.

Pittsfield, Berkshire, 1946. Pittsfield, Berkshire Museum, *French Impressionist Painting,* August 2–31, 1946.

Platte 1958. Hans Platte, "Robert Delaunay und Lyonel Feininger: Zu zwei Bildern in der Hamburger Kunsthalle," *Jahrbuch der Hamburger Kunstsammlungen,* v. 3 (1958), pp. 39–42.

Pool 1967. Phoebe Pool, *Impressionism*. New York: Frederick A. Praeger, 1967.

Portland, Art Museum, 1944. Portland (Oregon), Portland Art Museum, *Eight Masterpieces of Painting,* December 1944.

Portland, Art Museum, 1970. Portland (Oregon), Portland Art Museum, *Picasso for Portland,* September 21–October 25, 1970.

Posner 1984. Donald Posner, *Antoine Watteau*. Ithaca: Cornell University Press, 1984.

Poughkeepsie, Vassar, 1962. Poughkeepsie, Vassar College Art Gallery, *Hubert Robert, 1733–1808. Paintings and Drawings,* October 9–November 11, 1962.

Pouillon 1982. Nadine Pouillon and Isabelle Monod-Fontaine, *Braque: Oeuvres de Georges Braque (1882–1963),* Paris, Musée National d'Art Moderne, Centre Georges Pompidou, 1982.

Praz 1969. Mario Praz, *On Neoclassicism*. Evanston: Northwestern University Press, 1969 (reprinted from the Italian, first published 1940).

Proust 1897. Antonin Proust, "Edouard Manet: Souvenirs," *La Revue Blanche* (February–May 1897), pp. 125–35, 168–80, 201–07,

306–15, 413–24. (Later published in expanded form as *Edouard Manet, Souvenirs*. Paris: H. Laurens, 1913.)

Proust 1913. Antonin Proust, *Edouard Manet, Souvenirs*. Paris: H. Laurens, 1913.

Providence 1947. Providence Sunday Journal, February 2, 1947.

Providence, May 1947. Providence Sunday Journal, May 4, 1947.

Providence, Brown, 1975. Providence, Museum of Art, Rhode Island School of Design, and Department of Art, Brown University, *Rubenism,* Bell Gallery, List Art Center, Brown University, January 30–February 23, 1975.

Providence, Brown, 1981. Providence, Department of Art, Brown University, *Edouard Manet and the "Execution of Maximilian,"* Bell Gallery, List Art Center, Brown University, February 21–March 22, 1981.

Providence, RISD, 1897. Providence, Rhode Island School of Design, *Catalogue of Paintings and Engravings on view at the Rhode Island School of Design, At the opening of the new galleries,* March 11, 1897.

Providence, RISD, 1913. Providence, Rhode Island School of Design, *Memorial Exhibition of Works of Art given by Isaac Comstock Bates,* February 28–April 13, 1913.

Providence, RISD, 1930. Providence, Museum of Art, Rhode Island School of Design, *Modern French Paintings and Drawings,* March 10–March 31, 1930.

Providence, RISD, 1931. Providence, Museum of Art, Rhode Island School of Design, *Paintings, Drawings, and Prints by Henri Matisse,* December 14–28, 1931.

Providence, RISD, 1942. Providence, Museum of Art, Rhode Island School of Design, *French Art of the 19th and 20th Centuries. An Exhibition Held in Cooperation with the R.I. Chapter of France Forever to Honor the Cause of De Gaulle for Free France,* November 1942.

Providence, RISD, 1949. Gordon Washburn, *Isms in Art Since 1800,* Providence, Museum of Art, Rhode Island School of Design, February 3–March 9, 1949.

Providence, RISD, 1950. Providence, Museum of Art, Rhode Island School of Design, *A Century of Sculpture, 1850–1950,* March 30–May 18, 1950.

Providence, RISD, 1956. Providence, Museum of Art, Rhode Island School of Design, *Paintings by Gustave Courbet,* November 28, 1956–January 2, 1957.

Providence, RISD, 1957. Providence, Museum of Art, Rhode Island School of Design, *The Age of Canova, An Exhibition of the Neo-Classic,* November 6–December 15, 1957.

Providence, RISD, 1967. Providence, Museum of Art, Rhode Island School of Design, *Exhibition of Recent Acquisitions,* September 1967 (no cat.).

Providence, RISD, 1968. David S. Brooke, Michael Wentworth, and Henri Zerner, *James Jacques Tissot 1836–1902: A Retrospective Exhibition,* Providence, Museum of Art, Rhode Island School of Design, February 28–March 29, 1968; Toronto, Art Gallery of Ontario, April 6–May 5, 1968.

Providence, RISD, 1970. Providence, Museum of Art, Rhode Island School of Design, *Raid the Icebox 1 with Andy Warhol,* April 23–June 30, 1970; Houston, Institute for the Arts, Rice University, October 29, 1969–January 4, 1970; New Orleans, Isaac Delgado Museum, January 17–February 15, 1970.

Providence, RISD, 1972. Providence, Department of Art, Brown University, *To Look on Nature. European and American Landscape 1800–1874,* Providence, Museum of Art,

Rhode Island School of Design, February 3–March 5, 1972.

Providence, RISD, 1973. Providence, Museum of Art, Rhode Island School of Design, *Art for Your Collection XII,* December 6–16, 1973.

Providence, RISD, 1975. Providence, Museum of Art, Rhode Island School of Design, *Selection V: French Watercolors and Drawings from the Museum's Collection, ca. 1800–1910,* May 1–25, 1975.

Providence, RISD, 1977. Providence, Museum of Art, Rhode Island School of Design, *Selection VII: American Paintings from the Museum's Collection, c. 1800–1930,* March 31–May 8, 1977.

Providence, RISD, 1978. Providence, Museum of Art, Rhode Island School of Design, *Napoleon in Rhode Island,* February 23–March 26, 1978 (no cat.).

Providence, RISD, 1979. Diana L. Johnson, *Fantastic Illustration and Design in Britain, 1850–1930,* Providence, Museum of Art, Rhode Island School of Design, March 29–May 13, 1979; New York, Cooper-Hewitt Museum, June 5–September 2, 1979.

Providence, RISD, 1983. Judith Hoos Fox, *The Katherine Urquhart Warren Collection,* Providence, Museum of Art, Rhode Island School of Design, March 11–27, 1983.

Purchase, Neuberger, 1986. Suzanne Delehanty, *The Window in Twentieth Century Art,* Purchase, Neuberger Museum, State University of New York, September 20–December 20, 1986; Houston, Contemporary Arts Museum, April 18–June 29, 1987.

Purrmann 1930. Foreword by Hans Purrmann, *Henri Matisse*. Berlin: Galerien Thannhauser, 1930.

Quinn 1924. Estate of John Quinn, *Catalogue of the Art Collection Belonging to Mr. Quinn,* July 28, 1924. Unpaginated inventory compiled from financial records for the executors of the Quinn Estate, John Quinn Memorial Collection of the New York Public Library.

Quinsac 1973. Annie-Paule Quinsac, "Nineteenth Century Italian Painting in America," *Art Journal,* v. XXXII, no. 3 (Spring 1973), pp. 302–04.

Rabelais 1873. François Rabelais, ill. Gustave Doré, *Oeuvres de [François] Rabelais contenant la vie de Gargantua et celle de Pantagruel*. Paris: Garnier frères, 1873.

Ragg and Ragg 1923. Lonsdale Ragg and Laura M. Ragg, *Things Seen in Venice*. London: Seeley, Service & Co., Ltd., 1923.

Rawson and Lock 1989. Claude Rawson and F.P. Lock, eds., *Collected Poems of Thomas Parnell*. Newark: University of Delaware Press, 1989.

Rearick 1964. Janet Cox Rearick, *The Drawings of Pontormo,* 2 v. Cambridge: Harvard University Press, 1964.

Reff 1963. Theodore Reff, "Degas's Copies of Older Art," *Burlington Magazine,* v. CV, no. 723 (June 1963), pp. 241–51.

Reff 1964. Theodore Reff, "New Light on Degas's Copies," *Burlington Magazine,* v. CVI, no. 735 (June 1964), pp. 250–59.

Reff 1968. Theodore Reff, "The Pictures within Degas's Pictures," *Metropolitan Museum of Art Journal,* 1 (1968).

Reff 1969. Theodore Reff, "More Unpublished Letters of Degas," *Art Bulletin,* v. LI, no. 3 (September 1969), pp. 281–89.

Reff 1970. Theodore Reff, "Degas's Sculpture, 1880–1884," *Art Quarterly,* v. XXXIII, no. 3 (Autumn 1970), pp. 277–95.

Reff 1976. Theodore Reff, *The Notebooks of Edgar Degas,* 2 v. Oxford: Clarendon Press, 1976.

Reff 1987. Theodore Reff, *Degas, The Artist's*

Mind. Cambridge/London: Belknap Press of Harvard University Press, 1987.

Reitlinger 1964. Gerald Reitlinger, *The Economics of Taste. The Rise and Fall of the Picture Market, 1760–1960.* New York: Holt, Rinehart & Winston, 1964.

Renoir 1958. Jean Renoir, trans. Randolph and Dorothy Weaver, *Renoir, My Father.* Boston: Little, Brown and Co., 1958.

Renonciat 1983. Annie Renonciat, pref. by Maurice Rheims, *La Vie et l'oeuvre de Gustave Doré.* Paris: ACR, 1983.

Reudenbach 1979. Bruno Reudenbach, *G.B. Piranesi. Architektur als Bild: der Wandel in der Architekturauffassung des achtzehnten Jahrhunderts.* Munich: Prestel-Verlag, 1979, pp. 82–97.

Reuterswärd 1948. Oscar Reuterswärd, *Monet, En konstnärhistorik.* Stockholm: Albert Bonniers, 1948.

Review 1990. Review 1990, London, National Art Collections Fund, 1990.

Rewald 1936. John Rewald, *Cézanne et Zola. (Thèse pour le doctorat d'université).* Paris: A. Sedrowski, 1936.

Rewald 1939. John Rewald, *Cézanne, sa vie, son oeuvre, son amitié.* Paris: Albin Michel, 1939.

Rewald 1944. John Rewald, *Degas, Works in Sculpture. A Complete Catalogue.* New York: Pantheon Books, Inc., 1944.

Rewald 1946. John Rewald, *The History of Impressionism.* New York: Museum of Modern Art, 1946.

Rewald [194?]. John Rewald, trans. Margaret H. Liebman, *Paul Cézanne.* London: Spring Books, n.d. [194?].

Rewald 1956. John Rewald, *Post-Impressionism from Van Gogh to Gauguin.* New York: Museum of Modern Art, 1956 (third ed. 1978).

Rewald 1961. John Rewald, *The History of Impressionism.* New York: Museum of Modern Art, 1961.

Rewald 1973. John Rewald, *History of Impressionism,* 4th rev. ed. New York: Museum of Modern Art, 1973.

Rewald 1976. John Rewald, ed., *Paul Cézanne, Letters.* New York: Hacker Art Books, Inc., 1976.

Rewald 1983. John Rewald, *Paul Cézanne, The Watercolors.* London: Thames and Hudson, 1983.

Rewald 1986. John Rewald, *Cézanne, A Biography.* New York: Harry N. Abrams, 1986.

Reynolds 1966. Graham Reynolds, *Victorian Painting.* New York: Macmillan Company, 1966.

Richmond, Fine Arts, 1944. Richmond, Virginia Museum of Fine Arts, *Nineteenth Century French Painting,* January 19–February 20, 1944.

Richmond, Fine Arts, 1981. Pinkney L. Near, *Three Masters of Landscape. Fragonard, Robert, and Boucher,* Richmond, Virginia Museum of Fine Arts, November 10–December 27, 1981.

Ripa 1971. Cesare Ripa, ed. Edward A. Maser, *Baroque and Rococo Pictorial Imagery. The 1758–60 Hertel Edition of Ripa's "Iconologia."* New York: Dover Publications, Inc., 1971.

RISD 1935–36. *Museum Report for the Year 1935–1936.* Providence: Rhode Island School of Design, 1936.

RISD, *Bulletin,* 1913. *Bulletin of the Rhode Island School of Design,* v. I, no. 2 (April 1913).

RISD, *Bulletin,* 1922. *Bulletin of the Rhode Island School of Design,* v. X, no. 4 (October 1922).

RISD, *Bulletin,* 1923. *Bulletin of the Rhode Island School of Design,* v. XI, no. 2 (April 1923).

RISD, *Bulletin,* July 1923. *Bulletin of the Rhode Island School of Design,* v. XI, no. 3 (July 1923).

RISD, *Bulletin,* 1924. *Bulletin of the Rhode Island School of Design,* v. XII, no. 2 (April 1924).

RISD, *Bulletin,* April 1926. *Bulletin of the Rhode Island School of Design,* v. XIV, no. 2 (April 1926).

RISD, *Bulletin,* October 1926. *Bulletin of the Rhode Island School of Design,* v. XIV, no. 4 (October 1926).

RISD, *Bulletin,* 1928. *Bulletin of the Rhode Island School of Design,* v. XVI, no. 1 (January 1928).

RISD, *Bulletin,* 1929. *Bulletin of the Rhode Island School of Design,* v. XVII, no. 2 (April 1929).

RISD, *Bulletin,* 1930. *Bulletin of the Rhode Island School of Design,* v. XVIII, no. 3 (July 1930).

RISD, *Bulletin,* 1931. *Bulletin of the Rhode Island School of Design,* v. XIX, no. 3 (July 1931).

RISD, *Bulletin,* 1938. *Bulletin of the Rhode Island School of Design,* v. XXVI, no. 1 (January 1938).

RISD, *Museum Notes,* January 1943. *Museum Notes, Rhode Island School of Design* (January 1943), n. p.

RISD, *Museum Notes,* February 1943. "Honfleur, le vieux bassin, by Corot," *Museum Notes, Rhode Island School of Design* (February 1943), n. p.

RISD, *Museum Notes,* April 1943. "1943 Accessions–First Quarter," *Museum Notes, Rhode Island School of Design* (April 1943), n. p.

RISD, *Museum Notes,* 1955. *Bulletin of Rhode Island School of Design, Museum Notes,* v. 42, no. 2 (November 1955).

RISD, *Museum Notes,* 1956. *Bulletin of Rhode Island School of Design, Museum Notes,* v. 43, no. 2 (December 1956).

RISD, *Museum Notes,* 1957. *Bulletin of Rhode Island School of Design, Museum Notes,* v. 43, no. 4 (May 1957).

RISD, *Museum Notes,* 1959. *Bulletin of Rhode Island School of Design, Museum Notes,* v. 45, no. 3 (March 1959).

RISD, *Museum Notes,* 1962. *Bulletin of Rhode Island School of Design, Museum Notes,* v. 49, no. 2 (December 1962).

RISD, *Museum Notes,* 1964. *Bulletin of Rhode Island School of Design, Museum Notes,* v. 50, no. 4 (May 1964).

RISD, *Museum Notes,* 1967. *Bulletin of Rhode Island School of Design, Museum Notes, Recent Accessions 1966–1967,* v. 54, no. 2 (December 1967).

RISD, *Museum Notes,* 1980. *Bulletin of Rhode Island School of Design, Museum Notes,* v. 67, no. 2 (October 1980).

RISD, *Museum Notes,* 1984. *Bulletin of Rhode Island School of Design, Museum Notes,* v. 71, no. 2 (October 1984).

RISD, *Museum Notes,* 1987. *Bulletin of Rhode Island School of Design, Museum Notes,* v. 74, no. 2 (October 1987).

RISD, *Museum Notes,* 1988. *Bulletin of Rhode Island School of Design, Museum Notes,* v. 75, no. 2 (October 1988).

RISD, *Report.* Association of the Rhode Island School of Design, *Report.* Providence: published annually, 1890–1944.

RISD, *Treasures,* 1956. *Treasures in the Museum of Art, Rhode Island School of Design.* Providence: Museum of Art, Rhode Island School of Design, 1956.

Robaut 1885. Alfred Robaut and Ernest Chesneau, *L'Oeuvre complet d'Eugène Delacroix.* Paris: Charavay frères, 1885.

Robaut 1905 (1965). Alfred Robaut, *L'Oeuvre de Corot par Alfred Robaut. Catalogue raisonné et illustré, précédé de l'histoire de Corot et de ses oeuvres par Etienne Moreau-Nélaton orné de dessins et croquis originaux du maître.* Paris: H. Floury, Editeur, 1905 (reprinted, 5 v., Paris: Léonce Laget, 1965).

Robbins 1983. Daniel Robbins, "The *Femme Assise* by Raymond Duchamp-Villon," *Yale University Art Gallery Bulletin,* v. 38, no. 3 (Winter 1983), pp. 22–30.

Robertson 1978. David Robertson, *Sir Charles Eastlake and the Victorian Art World.* Princeton: Princeton University Press, 1978.

Robertson 1988. Alexander Robertson, *Atkinson Grimshaw.* Oxford: Phaidon, 1988.

Robinson 1990. Margaret Robinson, *Courbet's Hunt Scenes: The End of a Tradition.* Providence, 1990.

Rocher-Jauneau 1978. Madeleine Rocher-Jauneau, *Joseph Chinard au Musée des Beaux-Arts de Lyon.* Lyons: Musée des Beaux-Arts, 1978.

Rocher-Janeau, BMML, 1978. Madeleine Rocher-Jauneau, "Joseph Chinard et les Bustes de Madame Récamier," *Bulletin des Musées et Monuments Lyonnais,* v. VI, no. 2 (1978), pp. 133–45.

Rochester, Memorial Art Gallery, 1987. Donald A. Rosenthal, *La Grande Manière: Historical and Religious Painting in France,* Rochester, Memorial Art Gallery of the University of Rochester, May 2–July 26, 1987.

Rod 1895. Edouard Rod, "Marcellin Desboutin," *Gazette des Beaux-Arts,* ser. 3, v. XIII (January 1895), pp. 33–39.

Rod 1898. Edouard Rod, "L'Atelier de M. Rodin," *Gazette des Beaux-Arts,* ser. 3, v. XIX (May 1898), pp. 419–30.

Rodenbach 1899. Georges Rodenbach, "M. Rodin," in *L'Elite.* Paris: Charpentier, 1899, pp. 273–91.

Rogers 1878. J. Hope Rogers, *Opie and His Works.* London: Paul and Dominic Colnaghi & Co., 1878.

Roland-Michel 1978. Marianne Roland-Michel, "De l'Illusion à 'L'inquiétante Etrangeté': Quelques remarques sur l'évolution du sentiment et de la représentation de la ruine chez des artistes français à partir de 1730," in Georges Brunel, ed., *Actes du Colloque. Piranèse et les Français.* Rome, 1978, pp. 475–98.

Rome, Palazzo Venezia, 1982. Sandra Pinto et al., *Garibaldi, Arte e Storia,* Rome, Museo del Palazzo Venezia and Museo Centrale del Risorgimento, June 23–December 31, 1982.

Roosevelt 1885. Blanche Roosevelt, *Life and Reminiscences of Gustave Doré.* London: Sampson, Low, Marsten, Searle, & Rivington, 1885.

Rosenblum 1976. Robert Rosenblum, *Cubism and Twentieth-Century Art.* Englewood Cliffs: Prentice Hall, Inc.; and New York: Harry N. Abrams, Inc.; 1976.

Rosenfeld 1987. D.R. [Daniel Rosenfeld], "Portrait of an Artist and his Son," *Bulletin of Rhode Island School of Design, Museum Notes,* v. 74, no. 2 (October 1987), pp. 28–29.

Rosenfeld 1988. D.R. [Daniel Rosenfeld], "Self-Portrait," *Bulletin of Rhode Island School of Design, Museum Notes,* v. 75, no. 2 (October 1988), pp. 32–33.

Rosenfeld, "Ile de la Cité," 1988. D.R. [Daniel Rosenfeld], "View of the Ile de la Cité," *Bulletin of Rhode Island School of Design, Museum Notes,* v. 75, no. 2 (October 1988), pp. 31–32.

Rosenfeld 1989. D.R. [Daniel Rosenfeld], "Hope," *Bulletin of Rhode Island School of Design, Museum Notes,* v. 76, no. 1 (October 1989), p. 35.

Roskill 1985. Mark Roskill, *The Interpretation of Cubism.* Philadelphia: Art Alliance Press, 1985.

Roslyn, Nassau County Museum, 1984. Constance H. Schwartz, *The Shock of Modernism in America,* Roslyn, Nassau County Museum of Fine Art, 1984.

Rothenstein 1944. John Rothenstein, *Augustus John.* London: G. Allen and Unwin, Ltd., 1944.

Rouart 1941. Louis Rouart, *Berthe Morisot.*

Paris: Librairie Plon, 1941.

Rowe 1922. L. Earle Rowe, "At the Pawn-broker's," *Bulletin of the Rhode Island School of Design*, v. x, no. 1 (January 1922), pp. 1–3.

Rowe 1923. [L. Earle Rowe] "Examples of Degas's Art," *Bulletin of the Rhode Island School of Design*, v. XI, no. 4 (October 1923), pp. 38–39.

Rowe, "Renoir," 1923. L. Earle Rowe, "Renoir in the Museum," *Bulletin of the Rhode Island School of Design*, v. XI, no. 2 (April 1923), pp. 18–20.

Rowe 1929. L. E. R. [L. Earle Rowe], "A Chassériau Painting," *Bulletin of the Rhode Island School of Design*, v. XVII, no. 4 (October 1929), pp. 40–42.

Rowe 1932. L. Earle Rowe, "Pastel Group by Degas," *Bulletin of the Rhode Island School of Design*, v. XX, no. 2 (April 1932), pp. 18–19.

Rowe 1933. L. Earle Rowe, "Cézanne at Aix," *Bulletin of the Rhode Island School of Design*, v. XXI, no. 4 (October 1933), pp. 50–52.

Rowe 1937. L. Earle Rowe, "Boudin, Vinton and Sargent," *Bulletin of the Rhode Island School of Design*, v. XXV, no. 1 (January 1937), pp. 2–5.

Roworth 1983. Wendy Wassyng Roworth, "The Gentle Art of Persuasion: Angelica Kauffmann's *Praxiteles and Phryne*," *Art Bulletin*, v. LXV, no. 3 (September 1983), pp. 488–92.

Roworth 1988. Wendy Wassyng Roworth, "Artist/Model/Patron in Antiquity: Interpreting Ansiaux's *Alexander, Apelles, and Campaspe*," *Muse*, v. 22 (1988), pp. 92–106.

Rubin 1977. William Rubin, ed., *Cézanne, the Late Work*. New York: Museum of Modern Art, 1977.

Rubin 1980. William Rubin, ed., *Pablo Picasso, A Retrospective*. New York: Museum of Modern Art; and Boston: New York Graphic Society; 1980.

Russell 1959. John Russell, *G. Braque*. London: Phaidon Press Ltd., 1959.

Russoli and Minervino 1972. Franco Russoli and Fiorella Minervino, *L'opera completa di Picasso cubista*. Milan: Rizzoli, 1972.

Rutherston 1927. Albert Rutherston, gen. ed., *Contemporary British Artists: Eric Gill*. New York: Scribner's Sons, 1927.

Sabatier-Ungher 1851. F. Sabatier-Ungher, *Salon de 1851*. Paris: privately printed, 1851.

St. Louis, City Art Museum, 1947. St. Louis, City Art Museum, *40 Masterpieces. A Loan Exhibition of Paintings from American Museums*, October 6–November 10, 1947.

St. Louis, City Art Museum, 1957. St. Louis, City Art Museum, *Claude Monet, A Loan Exhibition*, September 25–October 22, 1957; Minneapolis, Minneapolis Institute of Arts, November 1–December 1, 1957.

Saint-Quentin, Lécuyer, 1985. Saint-Quentin, Musée Antoine Lécuyer, *Amédée Ozenfant*, October 5–December 2, 1985; Mulhouse, Musée des Beaux-Arts, December 15, 1985–February 15, 1986; Besançon, Musée des Beaux-Arts, March 1–May 1, 1986; Mâcon, Musée des Ursulines, May 15–July 15, 1986.

San Francisco, AMAA, 1986–88. Daniel Rosenfeld and Robert G. Workman, *The Spirit of Barbizon: France and America*, circulated by Art Museum Association of America, San Francisco: Monterey, Monterey Peninsula Museum of Art Association, June 14–August 17, 1986; Gainesville, University Gallery, University of Florida, September 6–November 1, 1986; Miami Beach, Bass Museum of Art, December 6–January 31, 1987; Owensboro, Owensboro Museum of Fine Art, March 1–April 26, 1987; Elmira, Arnot Art Museum, May 10–September 13,

1987; Montgomery, Montgomery Museum of Fine Arts, November 8, 1987–January 3, 1988.

San Francisco, de Young, 1964. San Francisco, M. H. de Young Memorial Museum, California Palace of the Legion of Honor, *Man, Glory, Jest and Riddle–A Survey of the Human Form through the Ages*, May 10, 1964–January 3, 1965.

San Francisco, Fine Arts, 1984. Margaretta M. Lovell, *Venice: The American View, 1860–1929*, San Francisco, Fine Arts Museums of San Francisco, October 20, 1984–January 20, 1985.

San Francisco, Fine Arts, 1989. San Francisco, Fine Arts Museums of San Francisco, *Géricault 1791–1824*, January–March 1989.

San Francisco, Legion of Honor, 1944. San Francisco, California Palace of the Legion of Honor, *Paintings by Pierre Auguste Renoir*, November 1–30, 1944.

San Francisco, Museum of Art, 1936. San Francisco, San Francisco Museum of Art, *Survey of Landscape Painting*, June 2–30, 1936.

Sandblad 1954. Nils Gösta Sandblad, *Manet: Three Studies in Artistic Conception*. Lund, 1954.

Sandoz 1974. Marc Sandoz, *Théodore Chassériau, 1819–1856, Catalogue raisonné des peintures et estampes*. Paris: Arts et Métiers Graphiques, 1974.

Sandoz 1985. Marc Sandoz, *Antoine-François Callet*. Paris: Editart-Les Quatre Chemins, 1985.

Sandoz 1986. Marc Sandoz, *Portraits et visages dessinés par Théodore Chassériau*. Paris: Editart-Les Quatre Chemins, 1986.

Santa Barbara, Museum, 1976. Santa Barbara, Santa Barbara Museum of Art, *Louis Eugène Boudin: Precursor of Impressionism*, October 8–November 21, 1976; Corpus Christi, Art Museum of South Texas, December 2, 1976–January 9, 1977; St. Petersburg, Museum of Fine Arts, January 18–February 27, 1977; Columbus, Columbus Gallery of Fine Arts, March 10–April 24, 1977; San Diego, Fine Arts Gallery of San Diego, May 5–June 12, 1977.

Sassi 1926. Antonio Sassi, "Silvestro Lega," *Arte Romagnola*, special ed. (March 21, 1926).

Saturday Review 1871. "The Royal Academy," *Saturday Review*, v. 31 (May 20, 1871), p. 634.

Saturday Review 1887. "Giacomo Favretto," *Saturday Review*, v. 64 (October 1, 1887), p. 447.

Schapiro [1963]. Meyer Schapiro, *Paul Cézanne*. New York: Harry N. Abrams, Inc., n.d. [1963].

Schick 1986. Joseph Schick, "The Mystique of Baccarat," *Seven. The Lifestyle Magazine of Caesars World* (November–December 1986), pp. 30–38.

Schindler 1988. Richard Allen Schindler, "Art to Enchant: A Critical Study of Early Victorian Fairy Painting and Illustration." Unpublished Ph.D. dissertation, Brown University, 1988.

Schmit 1973. Robert Schmit, *Eugène Boudin 1824–1898*, v. III. Paris: Galerie Schmit, 1973.

Schmit 1984. Robert Schmit, *Eugène Boudin 1824–1898*, premier supplément. Paris: Galerie Schmit, 1984.

Schneider 1984. Pierre Schneider, *Matisse*. New York: Rizzoli, 1984.

Schoch 1975. Rainer Schoch, *Das Herrscherbild in der Malerei des 19. Jahrhunderts*. Munich: Prestel-Verlag, 1975.

Schvey 1982. Henry I. Schvey, *Oskar Kokoschka: The Painter as Playwright*. Detroit: Wayne State University Press, 1982.

Schwarz 1961. Heinrich Schwarz, "Die graph-

ischen Werke von Egon Schiele," *Philobiblon*, v. v, no. 1 (March 1961), pp. 50–69.

Scott 1977. William P. Scott, "Berthe Morisot: Paintings from a Private Place," *American Artist*, v. 41 (November 1977), pp. 66–70, 95–108.

Séailles 1889. Gabriel Séailles, "Eugène Carrière: L'Homme et l'artiste," *Revue de Paris* (1889), pp. 162–63.

Seattle, World's Fair, 1962. Seattle, World's Fair, Fine Arts Pavilion, *Catalogue, Masterpieces of Art*, April 21–September 4, 1962.

Seiberling 1988. Grace Seiberling, *Monet in London*, Atlanta, High Museum of Art, October 9, 1988–January 8, 1989.

Seitz 1960. William C. Seitz, *Claude Monet*. New York: Harry N. Abrams, Inc., 1960.

Selz 1957. Peter Selz, *German Expressionist Painting*. Berkeley/Los Angeles: University of California Press, 1957 (reprinted 1974).

Selz 1990. Jean Selz, *Matisse*. New York: Crown Publishers, Inc., 1990.

Seznec 1937. J. J. Seznec, "Youth, Innocence and Death," *Journal of the Warburg and Courtauld Institutes*, v. 1 (1937–38), pp. 298–303.

Seznec 1943. J. J. Seznec, "The Romans of the Decadence and their Historical Significance," *Gazette des Beaux-Arts*, ser. 6, v. XXIV (1943), pp. 221 ff.

Shaw 1912. G. Bernard Shaw, "Sur Rodin," *Gil Blas* (Paris), November 24, 1912.

Sheffield, Graves, 1955. Arts Council of Great Britain, *Paintings, Drawings and Etchings by James Tissot*, Sheffield, Graves Art Gallery, 1955.

Sicco 1887. G. Cesare Sicco, *Giacomo Favretto e le sue opere*. Turin: G. Cesare Sicco, 1887.

Signorini 1896. Telemaco Signorini, *Per Silvestro Lega, ricordo*. Florence: Stabilimento di Giuseppe Pellas, 1896.

Smart 1965. Alastair Smart, "Dramatic Gesture and Expression in the Age of Hogarth and Reynolds," *Apollo*, v. 82, no. 42 (August 1965), pp. 90–97.

Somarè 1935. Enrico Somarè, *I Maestri della Pittura italiana dell'Ottocento: Favretto*. Milan: A. Mondadori Editore, n. d. [1935].

Somarè 1938. Enrico Somarè, *I Grandi Maestri del colore. Giacomo Favretto*. Bergamo: Istituto Italiano d'Arti Grafiche Editore, 1938.

Somarè n. d. Enrico Somarè, *Favretto*. Milan: A. Mondadori Editore, n. d.

Southampton, Parrish, 1984. Maureen C. O'Brien and Patricia C. F. Mandel, *The American Painter-Etcher Movement*, Southampton, Parrish Art Museum, June 10–July 22, 1984; Albany, Albany Institute of History and Art, September 9–November 2, 1984; Yonkers, Hudson River Museum, November 11, 1984–January 20, 1985.

Southampton, Parrish, 1986. Maureen C. O'Brien, *In Support of Liberty: European Paintings at the 1883 Pedestal Fund Art Loan Exhibition*, Southampton, Parrish Art Museum, June 29–September 1, 1986; New York, National Academy of Design, September 18–December 7, 1986.

Spate 1979. Virginia Spate, *Orphism: The Evolution of Non-Figurative Painting in Paris 1910–1914*. Oxford: Clarendon Press, 1979.

Spear 1967. Athena Tacha Spear, *Rodin Sculpture in the Cleveland Museum of Art*. Cleveland: Cleveland Museum of Art, 1967.

Spear 1974. Athena Tacha Spear, *A Supplement to Rodin Sculpture in the Cleveland Museum of Art*. Cleveland: Cleveland Museum of Art, 1974.

Springfield, MFA, 1939. Springfield (Massachusetts), Museum of Fine Arts, *The Romantic Revolt: Gros, Géricault, Delacroix, Daumier, Guys*, February 7–March 5, 1939.

Springfield, MFA, 1980. Organized by Albert Boime and Robert Henning, Jr., *Enrollment of the Volunteers: Thomas Couture and the Painting of History*, Springfield (Massachusetts), Museum of Fine Arts, April 13–June 8, 1980; Detroit, Detroit Institute of Arts, July 1–August 3, 1980; Williamstown, Sterling and Francine Clark Art Institute, September 20–November 2, 1980.

Stainton 1974. Lindsay Stainton, *British Artists in Rome, 1700–1800*. Kenwood: The Iveagh Bequest, 1974.

Staley 1973. Allen Staley, *The Pre-Raphaelite Landscape*. Oxford: Clarendon Press, 1973.

Stark 1979. David Stark, "Belgische Bilder aus dem Jahre 1848," in Neue Gesellschaft für bildende Kunst, *Arbeit und Alltag: Soziale Wirklichkeit in der Belgische Kunst, 1830–1914*. Berlin, 1979, pp. 193–200.

Stella and Molmenti 1887. Alessandro Stella and Pompeo Gherardo Molmenti, *Zig-Zag per l'Esposizione artistica e d'Arte applicata all'Industria. Sala VII*. Venice: Stab. Tip. Lit. F.lli Visentini Editori, 1887.

Sterling and Adhémar 1958. Charles Sterling and Hélène Adhémar, *Musée du Louvre: Peintures, Ecole Française, XIXe Siècle*, 5 v. Paris: Editions des Musées nationaux, 1958.

Stevens 1984. MaryAnne Stevens, ed., *The Orientalists: Delacroix to Matisse; European Painters in North Africa and the Near East*. London: Royal Academy of Arts, published in association with Weidenfeld and Nicolson, 1984.

Storia degli Italiani 1976. "Riassume un secolo: il colore dei Macchiaioli," in *Storia degli Italiani*. Milan: Fratelli Fabbri Editori, 1976.

Strahan 1879. Edward Strahan (pseudonym for Earl Shinn), *Art Treasures of America*, v. 1. Philadelphia: George Barrie, Publisher, 1879.

Strahan 1879–82. Edward Strahan (pseudonym for Earl Shinn), *The Art Treasures of America*, 3 v. New York: Selmar Hess, 1879–82.

Strahan 1881–83. Edward Strahan (pseudonym for Earl Shinn), *Gérôme, A Collection of the Works of J. L. Gérôme in One Hundred Photogravures*, 10 folios. New York: Samuel L. Hall, 1881–83.

Strasbourg, Musée d'Art Moderne, 1983. Strasbourg, Musée d'Art Moderne, Cabinet des Estampes, *Gustave Doré, 1832–1883*, June–September 1983.

Strazdes 1986. Diana Strazdes, "The Other Cubist, Jean Metzinger in Retrospect," *Carnegie Magazine* (March/April 1986).

Strong 1978. Roy Strong, *And when did you last see your Father? The Victorian Painter and British History*. London: Thames and Hudson, 1978.

Stuckey and Scott 1987. Charles F. Stuckey and William P. Scott, *Berthe Morisot, Impressionist*. New York: Hudson Hills Press, 1987.

Sutton 1986. Denys Sutton, *Edgar Degas, Life and Work*. New York: Rizzoli, 1986.

Tabarant 1931. Adolphe Tabarant, *Manet, Histoire catalographique*. Paris: Editions Montaigne, 1931.

Tabarant 1947. Adolphe Tabarant, *Manet et ses oeuvres*. Paris: Gallimard, 1947.

Tancock 1976. John L. Tancock, *The Sculpture of Auguste Rodin*. Boston: David R. Godine, in association with the Philadelphia Museum of Art, 1976.

Ternois 1965. Daniel Ternois, *Ingres et son temps (artistes nés entre 1740 et 1830). Inventaire des collections publiques françaises. Montauban, Musée Ingres*. Paris: Editions des Musées nationaux, 1965.

Thétard 1947. Henry Thétard, *La Merveilleuse Histoire du cirque*, v. 1. Prisma, 1947.

Theunissen 1912. Corneille Theunissen, "Les Terres Cuites de Carpeaux," *La Grande Revue*, v. 73 (June 25, 1912), pp. 827–30.

Thiébault-Sisson 1921. François Thiébault-Sisson, "Degas sculpteur par lui-même," *Le Temps* (Paris), May 23, 1921.

Thiery and van Dievot 1909. A. Thiery and E. van Dievot, *Catalogue Complet des Oeuvres Dessinées, peintes et sculptées de Constantin Meunier*. Louvain: L'Imprimerie Nova Vetera, 1909.

Thomas 1963. David Thomas, *Monet*. London: The Medici Society, Ltd., 1963.

Thuillier 1980. Jacques Thuillier, "Pompiers: Peinture et Sculpture," *Encyclopedia Universalis*. Paris, 1980, pp. 1177–80.

Thurnher 1966. Eugen Thurnher, ed., *Angelika Kauffmann und die deutsche Dichtung*. Bregenz: Eugen Russ, 1966.

Tietze 1935. Hans Tietze, *Meisterwerke Europäischer Malerei in Amerika*. Vienna: Phaidon-Verlag, 1935.

Tinterow 1990. G. Tinterow, "Géricault's Heroic Landscapes," *Metropolitan Museum of Art Bulletin*, v. XLVIII, no. 3 (1990).

Tinti, *Lega*, 1926. Mario Tinti, *Silvestro Lega*. Milan: S.E.A.I, 1926.

Tinti, March 1926. Mario Tinti, "Silvestro Lega," *Il Meridiano* (Rome), March 29, 1926.

Tinti 1931. Mario Tinti, *Silvestro Lega*. Rome: Istituto Nazionale L.U.C.E., 1931.

Tokyo, Isetan, 1986. Charles F. Stuckey and Juliet Wilson Bareau, *Edouard Manet*, Tokyo, Isetan Museum of Art, June 26–July 29, 1986; Fukuoka, Fukuoka Art Museum, August 2–31, 1986; Osaka, Osaka Municipal Museum of Art, September 9–October 12, 1986.

Tokyo, Isetan, 1987. Nicholas Watkins and Xavier Girard, *Henri Matisse*, Tokyo, Isetan Museum of Art, October 22–November 17, 1987; Yamaguchi, Yamaguchi Prefectural Museum, November 20–December 27, 1987; Osaka, Daimaru Museum of Art, January 3–18, 1988; Yokohama, Sogo Museum of Art, February 10–March 27, 1988.

Tokyo, Odakyu, 1989. Gabriel P. Weisberg, François Pomerède, Vincent Pomerède, Kenneth McConkey, *J.B. Camille Corot*, Tokyo, Odakyu Grand Gallery, Shinjuku, September 13–October 1, 1989; Osaka, Navio Museum of Art, October 20–November 14, 1989; Miyazaki, Miyazaki Prefectural Museum, November 23–December 24, 1989; Yokohama, Sogo Museum of Art, January 18–February 25, 1990.

Toledo, Museum, 1936. Toledo, Toledo Museum of Art, *Exhibition of Cézanne-Gauguin*, November 1–December 13, 1936.

Toronto, Art Gallery, 1940. Toronto, Art Gallery of Toronto, *Great Paintings*, November 15–December 15, 1940.

Toronto, Art Gallery, 1944. Toronto, Art Gallery of Toronto, *Loan Exhibition of Great Paintings*, 1944.

Toronto, Art Gallery, 1962. Lee Johnson, *Eugène Delacroix, 1798–1863*, Toronto, Art Gallery of Toronto, December 1, 1962–January 7, 1963; Ottawa, National Gallery of Canada, January 24–February 9, 1963.

Tourneux 1909. M. Tourneux, "La Collection de M. le Comte de Penha-Longa. Bustes, médaillons et statuettes de Chinard," *Les Arts*, v. 8, no. 95 (November 1909), pp. 2–32.

Trapp 1971. Frank Anderson Trapp, *The Attainment of Delacroix*. Baltimore/London: Johns Hopkins Press, 1971.

Tucker 1982. Paul Hayes Tucker, *Monet at Argenteuil*. New Haven/London: Yale University Press, 1982.

Tucker 1989. Paul Hayes Tucker, *Monet in the '90s: The Series Paintings*. Boston: Museum of Fine Arts; and New Haven: Yale University Press; 1989.

Utrillo 1901. Pincell [Miguel Utrillo], "Pablo R. Picasso," *Pèl y Ploma*, no. 77 (June 14–17, 1901). (Trans. in Daix and Boudaille 1967, p. 333.)

Vaillat 1913. Léandre Vaillat, "L'Oeuvre de Théodore Chassériau (Collection Arthur Chassériau)," *Les Arts*, no. 140 (August 1913), pp. 13–15.

Valenciennes 1800. P. H. Valenciennes, *Eléments de la perspective pratique*. Paris, 1800.

Valmy-Baysse 1930. J. Valmy-Baysse, *Gustave Doré*. Paris: Marcel Seheur, 1930.

Valsecchi and Carrà 1971. Marco Valsecchi and Massimo Carrà, *L'opera completa di Braque dalla composizione cubista al recupero dell'oggetto, 1908–1929*. Milan: Rizzoli Editore, n.d. [ca. 1971]. (French edition: Massimo Carrà, pref. by Pierre Descargues, *Tout l'oeuvre peint de Braque, 1908–1929*. Paris: Flammarion, 1973.)

Van Braam 1960. F. A. van Braam, ed., *World Collectors Annuary*, v. 12 (1960).

Van der Essen 1916. Léon van der Essen, *A Short History of Belgium*. Chicago: University of Chicago Press, 1916.

Van Dyke 1896. John C. Van Dyke, *Modern French Masters*. New York: Century Co., 1896.

Van Thiel 1976. Pieter J.J. van Thiel, ed., *All the Paintings of the Rijksmuseum in Amsterdam: A Completely Illustrated Catalogue*. Amsterdam: Rijksmuseum; and Maarssen: Gary Schwartz; 1976.

Vauxcelles 1908. Louis Vauxcelles, "Exposition Braque. Chez Kahn Weiler [sic]," *Gil Blas* (Paris), November 14, 1908.

Vauxcelles 1909. Louis Vauxcelles, "Salon des Indépendants," *Gil Blas* (Paris), March 25, 1909.

Venice 1887. Venice, *Esposizione Nazionale Artistica*, 1887.

Venturi 1936. Lionello Venturi, *Cézanne, son art–son oeuvre*, 2 v. Paris: Paul Rosenberg, 1936.

Venturi 1939. Lionello Venturi, *Les Archives de l'Impressionnisme*, 2 v. Paris/New York: Durand-Ruel, 1939.

Vienna, *Exposition Universelle*, 1873. Vienna, *Exposition Universelle de Vienne, 1873. France. Oeuvres d'art et manufactures nationales*, Paris, 1873.

Vienna, Kulturamt, 1961. Vienna, Kulturamt der Stadt Wien, *Paul Cézanne, 1839–1906*, Vienna, Osterreichische Galerie, Oberes Belvedere, April 14–June 18, 1961.

Vienna, Künstlerhaus, 1958. Vienna, Künstlerhaus, *Oskar Kokoschka*, May 19–July 13, 1958.

Vienna, Secession, 1903. Vienna, *Entwicklung des Impressionismus im Malerei u. Plastik XVI. Ausstellung der Vereinigung Bildender Künstler Osterreichs Secession Wien*, January–February 1903.

Vincent 1981. Claire Vincent, "Rodin at the Metropolitan Museum of Art, a History of the Collection," *Metropolitan Museum of Art Bulletin*, v. XXXVIII, no. 4 (Spring 1981).

Vitali 1953. Lamberto Vitali, *Lettere dei Macchiaioli*. Turin: Einaudi, 1953.

Viviani 1946. Raul Viviani, "Testimonianze di Silvestro Lega," *L'Araldo dell'Arte* (February 1946).

Vollard 1918. Ambroise Vollard, *Tableaux, pastels et dessins de Pierre-Auguste Renoir*, 2 v. Paris, 1918.

Vollard 1924. Ambroise Vollard, *Degas*. Paris: G. Crès et Cie, 1924.

Vollard 1925. Ambroise Vollard, trans. Harold van Doren and Randolph T. Weaver, *Renoir. An Intimate Record*. New York: Alfred A. Knopf, 1925.

Vollard 1927. Ambroise Vollard, trans.

Randolph T. Weaver, *Degas, an Intimate Portrait.* New York: Greenberg, 1927.

Vollard 1938. Ambroise Vollard, *En écoutant Cézanne, Degas, Renoir.* Paris: Bernard Grasset, 1938.

Vriesen and Imdahl 1967. Gustav Vriesen and Max Imdahl, *Robert Delaunay: Light and Color.* New York: Harry N. Abrams, 1967.

Wagner 1981. Anne M. Wagner, "Courbet's Landscapes and Their Market," *Art History,* v. 4, no. 4 (December 1981), pp. 410–29.

Wagner 1986. Anne M. Wagner, *Jean-Baptiste Carpeaux, Sculptor of the Second Empire.* New Haven: Yale University Press, 1986.

Wahlen 1844. Auguste Wahlen, *Ordres de la Chevalerie et Marques d'honneur.* Brussels: Librairie Historique-Artistique, 1844.

Walch 1977. Peter Walch, "An Early Neoclassical Sketchbook by Angelica Kauffmann," *Burlington Magazine,* v. CXIX, no. 887 (February 1977), pp. 98–111.

Waldmann 1923. Emil Waldmann, *Edouard Manet.* Berlin: Paul Cassirer, 1923.

Wall 1884. *An Illustrated Catalogue of the Art Collection of Beriah Wall, Providence, R.I.* Providence: J. A. & R. A. Reid, Printers, 1884.

Wallis 1957. Neville Wallis, ed., *A Victorian Canvas. The Memoirs of W.P. Frith, R.A.* London: Geoffrey Bles, 1957.

Waltham, Rose, 1967. Daniel Robbins and William Seitz, *Exchange Exhibition / Exhibition Exchange: From the Collections of the Rose Art Museum / Museum of Art, Rhode Island School of Design,* Waltham, Rose Art Museum, Brandeis University, and Providence, Museum of Art, Rhode Island School of Design, February 15–March 31, 1967.

Waltham, Rose, 1972. Waltham, Rose Art Museum, Brandeis University, *English Portraits in New England Collections,* October 1–29, 1972.

Washburn 1942. Gordon B. Washburn, "Providence Salutes France Forever," *Art News,* v. XXXXI, no. 13 (November 15–30, 1942), pp. 15, 29.

Washburn 1945. Gordon B. Washburn, "A Late Painting by Renoir," *Museum Notes, Rhode Island School of Design,* v. 3, no. 6 (October 1945), n. p.

Washburn 1949. Gordon B. Washburn, "'Ism's' in Art Since 1800," *Museum Notes, Rhode Island School of Design,* v. 7, no. 1 (February 1949), n. p.

Washington, Federal Reserve, 1979. Washington, D.C., Federal Reserve Board, *An Exhibition of Works from the RISD Museum of Art at the Federal Reserve Board,* July 23–September 14, 1979.

Washington, National Gallery, 1957. Washington, D.C., National Gallery of Art, *The Art of William Blake: A Bi-Centennial Exhibition,* October 18–December 1, 1957.

Washington, National Gallery, 1979. E.A. Carmen, Jr., *Mondrian: The Diamond Compositions,* Washington, D.C., National Gallery of Art, July 15–September 16, 1979.

Washington, National Gallery, 1980. Washington, D.C., National Gallery of Art, *Post-Impressionism: Cross-Currents in European and American Painting 1880–1906,* May 25–September 1, 1980.

Washington, National Gallery, 1982. Isabelle Monod-Fontaine and E.A. Carmean, Jr., *et al., Braque: The Papiers Collés,* Washington, D.C., National Gallery of Art, October 31, 1982–January 16, 1983.

Washington, National Gallery, 1986. Washington, D.C., National Gallery of Art, *The New Painting: Impressionism 1874–1886,* January 17–April 6, 1986; San Francisco, M.H. de Young Memorial Museum, April 19–July 6, 1986.

Washington, National Gallery, 1987. Washington, D.C., National Gallery of Art, *Berthe Morisot,* September 6–November 27, 1987. [For accompanying publication see Stuckey and Scott 1987.]

Watson 1926. Forbes Watson, ed., *John Quinn, 1870–1925* [sic]. *Collection of Paintings, Watercolors, Drawings and Sculpture.* Huntington: Pidgeon Hill Press, 1926.

Weinberg 1984. H. Barbara Weinberg, *The American Pupils of Jean-Léon Gérôme.* Fort Worth: Amon Carter Museum, 1984.

Weisberg 1980. Gabriel P. Weisberg, *The Realist Tradition, French Painting and Drawing, 1830–1900.* Bloomington: Cleveland Museum of Art in cooperation with Indiana University Press, 1980.

Weitzenhoffer 1986. Frances Weitzenhoffer, *The Havemeyers. Impressionism Comes to America.* New York: Harry N. Abrams, 1986.

Wentworth 1978. Michael J. Wentworth, *James Tissot: Catalogue Raisonné of his Prints.* Minneapolis: Minneapolis Institute of Arts, 1978.

Wentworth 1984. Michael J. Wentworth, *James Tissot.* Oxford / New York: Clarendon Press, 1984.

Werner 1959. Alfred Werner, "Kokoschka's Baroque Expression," *Arts,* v. 33, no. 10 (September 1959).

Westheim 1953. Paul Westheim, *Claude Monet, Sechs Mehrfarbige Wiedergaben.* Zurich: Rascher Verlag, 1953.

White 1969. Barbara Ehrlich White, "Renoir's Trip to Italy," *Art Bulletin,* v. LI, no. 4 (December 1969), pp. 333–51.

White 1984. Barbara Ehrlich White, *Renoir, His Life, His Art, His Letters.* New York: Harry N. Abrams, 1984.

Whitley 1928. William T. Whitley, *Art in England 1800–1820.* New York: Macmillan Company, 1928.

Whitley, Artists, 1928. William T. Whitley, *Artists and Their Friends in England 1700–1799,* 2 v. London: Medici Society, 1928.

Wiesbaden 1921. Wiesbaden, *Exposition de l'art français,* June–August 1921.

Wildenstein 1974. Daniel Wildenstein, *Claude Monet, Biographie et catalogue raisonné,* 4 v. Lausanne / Paris: La Bibliothèque des Arts, 1974, 1979, and 1985.

Wilenski 1954. R.H. Wilenski, *Modern French Painters,* 3rd ed. London: Faber and Faber, 1954.

Williamstown 1972. *List of Paintings in the Sterling and Francine Clark Art Institute.* Williamstown: Sterling and Francine Clark Art Institute, 1972.

Williamstown, Clark, 1974. Williamstown, Sterling and Francine Clark Art Institute, long-term loan, November 1974–January 1976.

Williamstown, Clark, 1978. Williamstown, Sterling and Francine Clark Art Institute, *Tissot: The Complete Prints,* August 5–September 17, 1978 (no cat.).

Williamstown, Clark, 1982. David B. Cass and John Wetenhall, *Italian Paintings 1850–1910 from Collections in the Northeastern United States,* Williamstown, Sterling and Francine Clark Art Institute, October 30–December 5, 1982.

Williamstown, Clark, 1989. Williamstown, Sterling and Francine Clark Art Institute, *A Romance with Realism: The Art of Jean-Baptiste Carpeaux,* May 6–August 27, 1989; Brunswick, Bowdoin College Museum of Art, October 12–December 17, 1989.

Wilson 1981. John Montgomery Wilson, *The Painting of the Passions in Theory, Practice and Criticism in Later Eighteenth Century France.* New York / London: Garland Publishing, Inc., 1981.

Wingler 1956. Hans Maria Wingler, *Oskar Kokoschka: Das Werk des Malers.* Salzburg: Galerie Welz, 1956. (English edition: *Oskar Kokoschka: The Work of the Painter.* London: Faber and Faber, 1958.)

Winnipeg, Art Gallery, 1987. Winnipeg, Winnipeg Art Gallery, *1912: The Break-Up of Tradition,* August 6–October 4, 1987.

Wolfsburg, Rathaus, 1961. Wolfsburg, Rathaus Stadt Wolfsburg, *Französische Malerei von Delacroix bis Picasso,* April 8–May 31, 1961.

Wood 1976. Christopher Wood, *Victorian Panorama. Paintings of Victorian Life.* London: Faber and Faber, 1976.

Wood 1986. Christopher Wood, *Tissot.* Boston: Little, Brown & Company, 1986.

Woodward and Robinson 1985. Carla Mathes Woodward and Franklin W. Robinson, eds., *A Handbook of the Museum of Art, Rhode Island School of Design.* Providence: Museum of Art, Rhode Island School of Design, 1985.

Woodward and Sanderson 1986. William McKenzie Woodward and Edward F. Sanderson, *Providence, A Citywide Survey of Historic Resources.* Providence: Rhode Island Historical Preservation Commission, 1986.

Worcester 1946. *Worcester Art Museum News Bulletin and Calendar,* v. XII, no. 3 (December 1946), p. 1.

Worcester, January 1947. "Exchange Exhibitions with the Rhode Island School of Design," *Worcester Art Museum News Bulletin and Calendar,* v. XII, no. 4 (January 1947), p. 15.

Worcester, March 1947. *Worcester Art Museum News Bulletin and Calendar,* v. XII, no. 6 (March 1947), p. 24.

Worcester, April 1947. *Worcester Art Museum News Bulletin and Calendar,* v. XII, no. 7 (April 1947), p. 28.

Worcester, Art Museum, 1946. Worcester, Worcester Art Museum, *Exchange Exhibition,* December 1946–April 1947 (no cat.).

Worcester Telegram 1947. *Worcester Telegram,* May 11, 1947.

Wynne 1974. Michael Wynne, "The Milltowns as Patrons," *Apollo,* v. 99, no. 144 (February 1974), pp. 104–11.

Yorke 1982. Malcolm Yorke, *Eric Gill: Man of Flesh and Spirit.* New York: Universe Books, 1982.

Zambelli 1956. Folco Zambelli d'Alma, "Gusto di una collezione–Silvestro Lega," *Arbiter* (October–November 1956).

Zanelli 1926. Renato Zanelli, *Modigliana e la sua gente.* Modigliana: Tip. Roncoroni e Argalia, 1926.

Zanelli, Arte Romagnola, 1926. Renato Zanelli, "Modigliana e Silvestro Lega," *Arte Romagnola* (May 30, 1926).

Zerner 1968. Henri Zerner, "The Return of 'James' Tissot," *Art News,* v. LXVII, no. 1 (March 1968), pp. 32–35, 68–70.

Zervos 1938. Christian Zervos, *Histoire de l'art contemporain.* Paris: Editions "Cahiers d'Art," 1938.

Zervos 1942. Christian Zervos, *Pablo Picasso,* v. II *(Oeuvres de 1906 à 1912).* Paris: Editions "Cahiers d'Art," 1942.

Zervos 1957. Christian Zervos, *Pablo Picasso,* v. I *(Oeuvres de 1895 à 1906).* Paris: Editions "Cahiers d'Art," 1957.

Zilczer 1978. Judith Zilczer, *"The Noble Buyer": John Quinn, Patron of the Avant-Garde.* Washington, D.C.: Smithsonian Institution Press, 1978.

Zilczer 1980. Judith Zilczer, "Raymond Duchamp-Villon: Pioneer of Modern Sculpture," *Philadelphia Museum of Art Bulletin,*

v. 76, no. 330 (Fall 1980), pp. 3–24.

Zurcher 1988. Bernard Zurcher, trans. Simon Nye, *Georges Braque: Life and Work*. New York: Rizzoli, 1988.

Zurich, Kunsthaus, 1912. Zurich, Kunsthaus, *Moderner Bund,* July 1912.

Zurich, Kunsthaus, 1917. Zurich, Kunsthaus, *Französische Kunst des XIX. u. XX. Jahrhunderts,* October 5–November 15, 1917.

Zurich, Kunsthaus, 1952. Georges Besson, René Wehrli, *et al., Claude Monet, 1840–1926,* Zurich, Kunsthaus, May 10–June 15, 1952.

Zurich, Kunsthaus, 1986. Zurich, Kunsthaus, *Oskar Kokoschka, 1886–1980,* September 4–November 9, 1986.

List of Entries by Artist's Name

Photography Credits

European Painting and Sculpture,
ca. 1770–1937

was designed by Gilbert Associates
and printed at Meridian Printing
on Gleneagle dull paper.

The typeface is Linotype Bembo, a face
based on the fifteenth-century work
of Francesco Griffo of Bologna.
The book was bound by Zahrndt's, Inc.

2,000 copies for the Museum of Art,
Rhode Island School of Design

August 1991